CW00765860

The Works of James Gillray, the Caricaturist; With the History of His Life and Times

shag

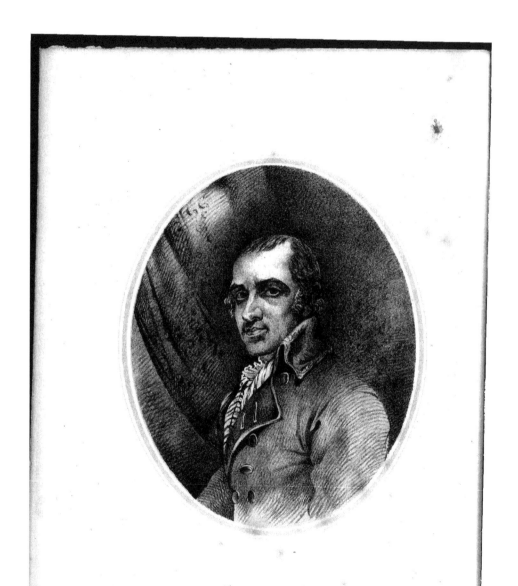

JAMES GILLRAY

THE WORKS

OF

JAMES GILLRAY, THE CARICATURIST;

WITH THE

HISTORY OF HIS LIFE AND TIMES.

EDITED BY

THOMAS WRIGHT, ESQ., M.A., F.R.S.

With over Four Hundred Illustrations.

London:
CHATTO AND WINDUS, PUBLISHERS.
(SUCCESSORS TO JOHN CAMDEN HOTTEN.)

LONDON :

SAVILL, EDWARDS AND CO., PRINTERS, CHANDOS STREET,

COVENT GARDEN.

INTRODUCTION.

THE records of 1757 are of absorbing interest to the historian. In that year there were many indications of the changes which were so soon to alter the attitudes of the different European powers. English interests were sacrificed in Germany; while the consideration of our advancement at home was treated as a matter of secondary importance. The whole energy of the Government was directed to the preservation of the "turnip field," as the Electorate of Hanover was derisively styled. The Continent was one scene of ruin,—the horrors of the "Seven Years' War" had already commenced. The works of nature, the industry of man, and the achievements of civilization, were regarded as but so many fragments of a gigantic and reckless campaign. Cities, rivers, the forest, the pasture, and the mountain pass, were esteemed only as they might afford strategic facilities; and the fairest capitals represented strong-

William, Duke of Cumberland, abandoning Hanover. From a caricature published in the year of Gillray's birth.

holds to be alternately besieged, defended, or destroyed, regardless of the sacrifice of life and property.

The martial spirit of Frederick the Great was shaping the foundations of an Empire whose growth had distanced the boldest calculations of his neighbours. The subsidies paid by England in support of these campaigns materially increased our burdens, whilst Frederick prudently avoided saddling his youthful kingdom with the incubus of a national debt.

In 1757, the fate of "the Protestant Hero," and the stability of his empire, appeared to tremble on the verge of destruction; the ruins of his ambition threatened to crumble on every side before the force of overwhelming combinations. The Courts of Versailles, Vienna, and St. Petersburg, then flourishing in the fulness of their reputation, were uniting to crush the dangerous rival growing up in their midst. Our sovereign, the Second George—brave, decisive, and clear-sighted by nature—choleric, boorish, and, above all, devotedly German—tranquilly holding the title and power of King of Great Britain—directed his aspirations, and poured out the resources of the kingdom he had acquired, to maintain his dignity as Elector of Hanover, and to support his German relations.

Our naval supremacy was made subordinate to the necessity of raising constant levies of men and money to protect the Electorate, and to furnish subsidies for the assistance of Frederick. The Duke of Cumberland, by a disastrous campaign terminating in the disgraceful convention of Closter-seven, left Hanover in possession of the French, and exposed the harassed forces of the Prussian monarch to the unchecked advances of his enemies.

The same year witnessed the triumph of the hard-pressed Frederick over the Austrian forces at Lissa. France already exhibited indications of the passions which a few years were to develop into the ferocities of the Revolution. Damiens, who was evidently of unsound mind, attempted the assassination of Louis XV.; and the barbarities inflicted on the wretched madman, the craving for blood, and the

diabolical impulses exhibited on that occasion, were prophetic of the frenzy and butchery so soon destined to degrade the nation which has ever claimed the palm for refinement.

In 1757 Clive was assuring our Indian Empire by a series of brilliant victories. In America our successes were reversed; Montcalm, aided by his savage allies, and our own mismanagement, had inflicted a series of disasters, which were shortly to be redeemed in the glories of Quebec.

At home a concession had been made to the popular voice in the employment of Secretary Pitt, who enjoyed the confidence of the people. George the Second—occupied in court routine, and practising a by no means austere morality—delighted in reviewing his troops and chatting in his native language, in happy unconsciousness of the apoplectic stroke which was shortly to terminate the anxieties of the Electorship.

His grandson, the heir apparent, "a shy youth of dull parts," was pursuing a narrow-minded training under the auspices of his inflexible mother, assisted by her Groom of the Stole—Lord Bute, the unpopular "Lothario," who deserved so ill of his country. The fruits of this education—altogether unsuited to the requirements of a constitutional prince—were fated to bring mortifications on the well-disposed pupil, who, until the moment of his accession to the throne, was kept in complete ignorance of practical statecraft.

We have thus briefly recapitulated the events which in 1757 were occupying the universal theatre, shortly to become the scene of some of the most thrilling political dramas and the bloodiest tragedies which history is likely to chronicle.

In this same year was registered the birth of JAMES GILLRAY, whose name was destined to become familiar as household words in his own country and in foreign courts, whose works were to have a significance of their own during the most critical period of our annals.

At the period of our history when England occupied her proudest position—when her senators rivalled, in ability and eloquence, the greatest examples bequeathed to us by antiquity; when her commerce was unrivalled, while the combined fleets of the world were unable to humble her proud supremacy on the sea; when her seamen were like lions, whom no power but death could subdue; when, disturbed by bitter faction at home, it was reserved for her firm attitude to resist, with equal success, the encroachments which were threatened from the throne, and the revolutionary and subversive principles which were advocated by the advanced party among the people; when her steady perseverance and exhaustless financial resources were eventually to control the confusions of an entire continent, and to retrieve the disasters of her allies; when, as army after army was swept away, she alone was destined to ride mistress of the storm, and finally to impose a limit to the career of the greatest conqueror of any age;—at the period of our most critical dangers—when revolution and invasion threatened us hand-in-hand at home, while the coalitions, which the energetic diplomacy of Pitt had built up at uncounted sacrifices, dissolved like phantoms before the name and daring of Bonaparte, and became incorporated with his strength—it was reserved for this unknown James Gillray to afford us by his genius the most graphic records of these contests; his pencil was to trace a life-like reflection of our attitude, which should render the eventful panorama then unrolling before him almost as familiar to succeeding times as it was to the actual performers.

The art of caricature has been extravagantly praised, though at the same time its tendencies have not escaped the strictures of adverse criticism. But practical exemplification has proved that the preservation of the feelings excited at the moment when an event occurred is invaluable to a proper realization of its actual importance. It falls to the province of caricature to embalm, not only events, but those who direct them, with a familiarity of expression which is tangible evidence of their existence. If the caricature were simply unlike in resemblance and unfaithful in spirit, it would perish, from want of popularity, in its own day; the designer would obtain no encouragement, the artist and his works would be lost in oblivion. Those creations which survive owe their vitality to the truthful libel, to the grotesque life-like presentment which animates them.

We know that there is some truth on the side of the caricaturists; we find, for example, the fidelity of the resemblances of Gillray's caricatures fully confirmed by the works of the greatest contemporary painters. In the canvases of Reynolds we realize the living originals, and the portraits

his pencil has preserved for us confirm the likenesses traced by Gillray's etching-needle. If we turn from the works of Sir Joshua, or those of his most successful rivals, and consider the files of mediocrity, the galleries of rigid convention, the stereotyped portraits, from which our descendants will gather such lifeless, actionless ideas of the public men of our days, we must congratulate the encouragers of caricature for bequeathing to future generations, in the cartoons of *Punch*, and similar sources, a healthier impression of our times. When it was proposed to erect a statue of Sir Robert Peel, the portrait selected as most characteristic in its resemblance, as most distinctly preserving his natural expression, was found in a humorous cartoon by John Leech, published in *Punch;* and from this likeness the head was accordingly modelled.

That caricature is a dangerous weapon, susceptible of easy perversion, is admissible, but its action will of necessity be limited by public opinion; trespassing beyond reasonable restrictions, it rebounds on itself, and injures rather than promotes the object it would advocate; its very violence provokes sympathy for its victim, if its licence exceeds decent freedom.

The uses of caricature are now well recognised and appreciated—it is unnecessary either to extol or to deprecate its action. When the work is meritorious, we have the encouraging assurance that time will give both value and importance to even the mere trifles elicited by the follies of the hour, if they throw any light on social changes, habits, or history.

Those writers who in future times may find it worth their labour to trace the political tendencies of the present reign, or to illustrate the careers of men whose reputations were established under its influence, will find their task facilitated and animated by the glimpses of the politicians in their every-day aspect furnished in the caricatures by HB (Lieut. John Doyle), by John Leech (most genial of humorists), by John Tenniel, and by the many active pencils which illustrate and familiarize us with every event of our day.

Numerous traces of the satirist's talent are discoverable in the traditions of antiquity, but the skill was feeble and undeveloped—art was in so early a state, that the remains which have reached us are insufficient to throw much light on the intimate history of the times; although the moralist may find plentiful materials for reflection in the pictured records of society preserved on the walls of certain ruined cities of antiquity.

William Hogarth was the first caricaturist of eminence, and his works, regarded as instances of representative art, are to this day without an equal for what may be considered a peculiar individuality of healthy John Bull humour, founded on a basis of strong sense. Hogarth did not, however, produce much which can be claimed as political caricature; his qualifications were not altogether of the order necessary for success in that peculiar branch. The well-known series of the "Times," without gaining much for the cause they were intended to promote, involved the last years of the honest painter's life in bitter persecutions, which so affected his peace of mind as, it is believed, to hasten his death.

Paul Sandby, the rival and antagonist of Hogarth, is best represented by the series he produced to ridicule "Pug" Hogarth* for his unlucky literary venture, "The Analysis of Beauty." The political caricatures of Sayer have thrown considerable light on the history of the earlier part of George III.'s reign; his works occupied the attention of the public during Gillray's boyhood, and they stimulated the energy of the youthful aspirant. Gillray cannot be considered to have looked upon the works of Sayer with jealousy, although, for certain reasons, he may have been glad to let the juvenile productions of his etching-point pass for the works of the better-known satirist. Sayer's cartoons enjoyed considerable popularity in their day, although with the progress of art their inferiority became apparent. Feeble drawing, timid etching, and conceptions not always of an elevated standard of invention, were the short-comings which prevented a multitude of contemporary works from enjoying a lasting reputation. But Gillray's genius soon secured popular attention, and Sayer worked on in opposition to his more inventive and popular rival.

Gillray found political caricature in its struggling infancy; he brought the art to the fullest maturity,

* The sixteen caricatures published by Paul Sandby—in burlesque—of Hogarth, are distinguished by a certain neatness and dexterity which place them rather above contemporary works.

carried it far above the heads of the crowd, and soared to such heights, that we regard his bolder flights with an apprehension which qualifies the admiration that his dexterity must always excite.

It is the intention of this book to offer as complete an insight into the works and times of James Gillray as may be consistent with the limits of one volume, considered in relation to the immense amount of interesting matter presented by the subject—bearing constantly in mind the necessity of compressing the most important results of a prolific career within a restricted space, regarding the diffi- culties of *condensing* the selection of valuable materials, political and social, which the productions of that era present in profusion ; and, finally, not losing sight of the responsibility of rejecting such subjects and matters as, after consideration, seem either too ephemeral and uninteresting to deserve preservation, or too boldly coloured with the coarseness of an age which did not hesitate, in its most polished circles, to treat of subjects that modern refinement has decided to pass over in silence.

The works of Gillray preserve an entire social revolution ; they form the link uniting the habits, fashions, and manners of the past, with the later generation which inaugurated our present ways of life. His pencil registers the gradual extinction of our ancestry of the Georgian era—of a quaint picturesque generation, clad in bright-hued coats of costly material, embroidered waistcoats, silk stockings, and buckle-shoes ; wigs formed after every fashion, and of every shade and size ; powder and pigtails, stars and garters, sedan-chairs and linkmen. His drawings usher in the birth of the innovating younger generation which elected to wear its own hair, which adopted buttoned-up coats of sober cloth, which clad its nether man in topboots, and finally in pantaloons ; which rejected flap-hats, either laced, cocked, or carried under the arm, and substituted a creation of beaver, the progenitor of the tall hat of our own day ; which cashiered the lumbering coaches of its fathers, and instituted tandems, phaetons, and fast-flying four-in-hands. These daring social revolutions—which were in part the offspring of new systems having their birth in France—remove far back into the past of fashion the gay, demonstrative society which held its own in Vanity Fair till the dawning of the present century.

The merry crowd of laced, starched, and powdered beaux, which paid its adoration to the flounced, painted, patched, and be-cushioned belles of Gillray's childhood, had grown into mature men and women when his etching-needle first preserved their effigies, for their own entertainment. They carried on the business of their lives, their pleasures and their profit, while the intrigues and ambitions of their existence were being recorded on Gillray's copper-plates for the enlightenment of a posterity about whom the joyous souls never troubled their heads ; yet they once occupied the little spots in life on which our own parts are now being played out—on which another generation will one day walk, and doubtless, in its turn, examine the method of our lives with a similar antiquarian interest.

The age of Gillray was highly realistic. A great man was known by his exterior. The social grades were distinctly represented ; state and show, strangely blended with slovenly carelessness and with a freedom which often descended to vulgarity, were the most striking characteristics of the out- door world. George III., one of the most homely of men, was as king the most exacting in regard to court ceremonials. Dukes and nobles endeavoured to show themselves worthy of their lofty stations by a reckless extravagance. The retainers of great houses formed quite a court in themselves. Not unfrequently noble lords wore their blue ribbons, their stars, and insignia in every-day intercourse. Bishops were venerable in lawn and horse-hair ; judges were solemn in robes and perukes ; officers of the Army and Navy busied themselves about their private concerns clad in the uniforms of their respective services.

Gillray saw all this outside display abandoned by progressive stages, until its final disappearance altered the aspect of the times more than the lapse of years would have warranted any one in imagining.

Even the vices of the day, which were frankly practised under the flimsiest pretences of decency, were quite different from the indulgences of our time. Gambling was the absorbing passion ; its excesses were beyond all reason, until the disasters it brought in its train finally subdued the evil.

Dissipation of every degree was exhibited in public without any disguise. That husbands should be faithless, that the fair must be frail, were recognised axioms ; that vice should be easy of access, and

in no degree abashed, excited slight comment. Drunkenness was common in every grade of society. These features are sufficient to show that the times were at least out-spoken; and perhaps such characteristics may be prudently dismissed to obscurity. It is, however, comforting to be able to assert that, deplorable as our generation may be, it is modest in comparison with the lives led by the celebrities of the Third George's reign; whose manners may, however, be held to offer a shade of refinement which elevates them above the low level marking the eras of the earlier Georges,—these, again, being modest in contrast with the times of the "Merry Monarch."

The man who has bequeathed such admirable materials for the reconstruction of his contemporaries, strange as it may appear, was treated by the chroniclers of his own times with so much reserve, that it is difficult to seize on the satirist as he may have presented himself personally to the world.

The life of an artist, and especially of one who produced so large an amount of elaborate work in but a short space of time, is chiefly recorded in his labours. His existence is intimately bound up with his craft, which must greatly influence, not only his actions, but the very current of his thoughts. The intervals of recreation are limited, and even they are encroached upon by the requirements of his profession; the man becomes absorbed in the pursuit of his art, in its pleasures, its difficulties, and the constant demands it makes upon his attention.

We have carefully collected all available information in relation to our first caricaturist, and we shall frankly record all we have been able

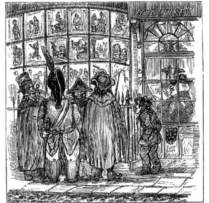

Mrs. Humphrey's Window, St. James's Street.

to learn, insufficient as it is, lest, by hastening from the consideration of the artist to that of his works, it should be deemed that there is good cause for silence regarding his personal career.

Gillray in no degree resembled the hireling stabber who, hiding in dark obscurity, sends forth his poisoned barbs, only venturing out stealthily to collect fresh materials for his venom, and feasting, with ghoul-like enjoyment, on the lacerated reputations of his unprepared victims.

Our artist lived among the subjects of his satire, almost within sight of the palace, whose inmate was aware of the proximity of this Georgian Juvenal; he mixed with the men who possessed the power of suspending his freedom, and was himself as easy of recognition as he had made the faces and figures of those whose caricatures he drew.

The artist was shy and reserved; his mind was creative and imaginative, and its inventive powers were sufficient to absorb his entire energy; his occupation was necessarily retired, sedentary, and solitary. In all his works we recognise the humorist as clearly as we do the bitter satirist.

There is a droll compound of jest and earnest, of fun and fury, tempering the vengeance of his most slashing assaults. His eye was quick to detect the weakest point of the best-armed champion; but the stab was more often playful than cruel. The same quiver furnished shafts for friend and foe alike. Gillray stood alone, and lent his aid to the side which had the greatest need of his weapon. Strengthening and satirizing both factions in turn, to neither side was he a servile champion; his own misfortunes, his gratitude, his necessities, and his weaknesses, were all powerless to confine his satire

to the object of mere party advancement. No curb could control his irony. His works are, however, stamped with one attribute—popularity—which is indispensable to lasting success amidst the fluctuations of opinion. His intuitive knowledge of human nature had convinced him of the expediency of securing this advantage; and by recognising the force of public opinion, he, it may be unconsciously, assumed to a large degree, as his works abundantly prove, the responsibility of shaping and directing it; so far, that is, as the popular voice is subject to individual expression. Gillray and his caricatures enjoyed in their day—allowing for a little excess of colouring to suit the age—the position that the *Times* and *Punch* now fill. His satire has a speciality: it is often heroic, elevating its object far above the heads of his fellow men (as in "The Giant Factotum," "Phæton Alarmed," &c.) in the semblance of a demi-god, dignified and commanding, even when associated with the attributes of burlesque.

The opinions attributed in his day to the eminent subjects of his satire, which are given in the course of this work, are excellent testimonies to his talent. We find the good-natured Colossus, Charles James Fox, quite appreciative; Sheridan, won by the congenial humour and daring of the artist, chuckled over the drolleries of his own pictured figure; Burke treated the satirist with distant respect; Pitt was forbearing and patronizing—the "heaven-sent" minister commanded his indignation when the ends for which he incessantly strove were promoted by a more persuasive eloquence. Canning, who created his most inveterate personal foes by the pungency of his own ill-controlled irony, is said to have had his feelings so sharply stung by Gillray's satire, that the daring wit of the *Anti-Jacobin* called on the caricaturist to remonstrate with him. If this be true, Canning's organization must have been peculiarly sensitive, for it will be found that Gillray generally dignified, rather than degraded, the author of the "Knife-Grinder," which poem was circulated with a spirited illustration by the caricaturist. The two satirists fought under one banner, and, so far as Gillray's impulses would acknowledge obedience, they may have been colleagues. How far the King appreciated the licence of the caricaturist may be conceived from the anecdotes preserved of the royal feelings. The opinion of the monarch, who disliked abuse and enjoyed drollery, much as did his honest subjects, may be considered representative. When the laugh was at his expense, the King looked grave; when his person appeared in undignified and contemptible attitudes, he threatened; if some royal eccentricity was turned into good-natured fun, he joined in the smile. Gillray in opposition was "a very poor artist," according to great George's taste; but when Gillray and the people chose to stand by their sovereign, when exposure was made of the contumacious Prince of Wales, when the Opposition were painted in their worst colours and the Administration received some humorous distinction, when his enemies were degraded and the sovereign was magnified, his opinions changed; Gillray became a truthful and commendable humorist in the royal sight when the mighty Napoleon appeared dwarfed to a very pigmy in the hand of the tallest and stoutest of regal giants.

The circumstantial records of the artist's private life are, as we have hinted, very restricted. Biographies, lives of painters, and similar works, rarely include any reference to the name of Gillray. The edition of "Bryan's Dictionary of Painters" prepared by George Stanley, alone contains a notice of the caricaturist, and this article appears to be the most important authority appealed to by subsequent writers in elucidation of his career.

A selection from the caricatures of Gillray was published in parts by Messrs. Miller, Rodwell and Martin, and Blackwood, of Edinburgh, about 1818. The subjects were copied in a reduced form, and some of the original spirit was necessarily sacrificed. The undertaking, which may have been projected with the intention of reproducing the entire series in smaller plates, came to an end with Part IX. These selections were accompanied by comments written with the familiarity of personal chat; and the descriptions afford us a few contemporary anecdotes, which in some cases throw a ray of light on the artist. The elucidator, even at that date, complains of the difficulties attending the subject, from the absence of individual reminiscences. He compares the task of writing on Gillray to the toil "of bondsmen commanded to make bricks without straw," and is severe on the artist's contemporaries:—

"It is a scandal upon all the cold-hearted scribblers in the land to allow such a genius as Gillray to go to the grave unnoticed; and a burning shame that so many of his works should have become ambi-

guous for the want of a commentator. The political squibs have already lost half of their point for want of a glossary, and many of the humorous traits of private life so characteristic of men and manners are become oblivious to ninety-nine hundredths of those who perambulate the streets of this mighty town."

Thomas M'Clean may be considered to have taken humorous illustration under his special protection— his gallery having formed the last and most popular stronghold of pictorial satire, anterior to the publication of weekly comic journals, whose large circulation and low price have brought the best productions of caricature within the means of the multitude;—he secured the original copper plates of a large proportion of Gillray's works, and published them in a collected form in two volumes in 1830.

Mr. M'Clean compiled a key to his collected series, to which we are indebted for a few allusions which we considered would assist our readers in appreciating certain caricatures. These extracts we have presented in their original form, as they are an approximation to contemporary criticism.

In 1831 a review of James Gillray and his caricatures appeared in the *Athenæum*, commenting ungenerously on the artist's private life, which provoked a reply from Mr. J. Landseer in a following number, vindicating the character of his friend the caricaturist, and furnishing certain details which we shall have occasion to quote.

Mr. Henry G. Bohn, having become the possessor of the original copper plates of the series published by Mrs. Humphrey, which had been reprinted in the edition of 1830, was fortunate enough to obtain several important large plates, chiefly published by Fores, of Piccadilly; and in 1851 the plates were rearranged in two divisions, and issued in one thick volume, the coarser subjects being collected in a supplementary form.

Mr. Bohn secured the co-operation of Mr. Thomas Wright, whose patient researches assist us to realize a perfect picture of our history from the accession of George I. to the downfall of Napoleon; and, with the assistance of Mr. R. H. Evans, whose knowledge of all that concerned the Whig Club rendered his advice of great importance, an account of the caricatures was prepared in an octavo volume, to accompany the plates.

This preservation of Gillray's works might at first sight be deemed sufficient to render any fresh collection superfluous. Mr. M'Clean's set, however, has become very scarce and costly, being frequently valued as high as twenty guineas, whilst Mr. Bohn's edition is so heavy and awkward in size that consultation is a real labour. The price, too (more than 10l. for the set), is beyond the reach of the everyday reader. Another drawback to the folio series is the necessity of constant reference from the caricatures to the key; it is also difficult, on account of their size, to arrange the volumes with other works.

The publisher of the present series was led to believe that a volume of great interest might be formed by condensing the finest works entire; by presenting examples of wider selection than either of the published editions afford; by preserving in many cases only the most pungent parts of certain caricatures; by rejecting a mass of subjects which, from the circumstances of their merely local allusions, or ephemeral nature, are now uninteresting to the general reader; and, more especially, by suppressing those subjects which, from their vulgarity, have injuriously reflected their coarseness upon the choicer examples of graphic humour by which they are accompanied.

This selection, gathered from the best public and private sources, is issued in combination with a summary of the events illustrated by the caricatures, and particulars regarding the personages depicted in them. In many cases the pen will describe the invention of the satirist, where, from the secondary importance of the cartoon, it is deemed expedient to omit the original etching. This compound of pictorial satire and illustrative narrative is indispensable to an appreciation of the more intimate history of England's grandest epoch; it elucidates Gillray, it places the consideration of past times in an entertaining form, and it may be esteemed a useful guide to the works which preserve the cartoons in their original dimensions.

Having now made the reader acquainted with those sources of reference which are known to us, we will proceed with the caricaturist's personal career.

James Gillray was of Scotch descent, but, in opposition to the reputation enjoyed by his compatriots for "holding together" when away from home, we find that the independence of his understanding led him to form a very unflattering opinion of Scotch factions, then in power at court, and of Scotch habits in their own country. The caricaturist may have been prejudiced in his view, or the northern race may have advanced in cultivation since his day.

Gillray's father, christened after the national champion James, was born at Lanark, September 3, 1720. He enlisted in the army at an early age, formed one of the swearing, drinking troopers who were then fighting the French in Flanders under the Duke of Cumberland, and fought at the battle of Fontenoy, where Saxe gained the day. Cumberland returned with his unlucky soldiers, to distinguish himself in the '45 against Charles Edward Stuart. James Gillray came back from Flanders with the loss of one arm, which he had left at Fontenoy, and was consequently spared the mortification of slaughtering his fellow-countrymen at Culloden. At the age of only five-and-twenty he became an out-pensioner of Chelsea Hospital. He also filled the office of sexton to the Moravian burying-ground at Chelsea for forty years, and was there buried in 1799.

The only descendant of the soldier-sexton whose name has been preserved is his son, the subject of this book, born in 1757. The portraits of Gillray, in later life, exhibit a face remarkable for intelligence—shrewd and sharp in outline, in no way resembling the characteristics of portraiture at that date. James Gillray the father lived to find his name universally famous in the works of his son; he saw the triumphs of caricature art in his person, and was spared the contemplation of the artist's premature decay.

Hogarth died when James Gillray was in his seventh year. It is probable that the valiant sexton loved humour, that "The March to Finchley" enlivened his walls, and that, his sympathies being with his compatriot Bute, he had secured a copy of the "Times," which the Serjeant-Painter incautiously put forth to do battle for his unpopular patron. The odium attaching to the Scotch favourite provoked a shower of reprisals on the head of the poor painter, who was stabbed and stung until his life became a burden to him, and the truest of humorists was fain to paint "The End of All Things," and take to his bed and die. It is not difficult to imagine the intelligent lad, with his shrewd face and eager eyes, busily unravelling the allusions which build up the allegorical "Times."

We are inclined to conclude that the loyal soldier did not patronize the prints put forth by Hogarth's antagonists. Young Gillray must have studied in shop-windows, if he studied at all, the counter attacks of Paul Sandby in burlesque of the painter's; and not improbably the neatness of these parodies, and their satiric sharpness, had considerable influence upon his mind.

The bent of the child's future received an early bias; he hankered after the art which could effect such ingenious combinations. Then, having secured a larger experience of Hogarth's works, the fun-loving painter's exhaustless comedies doubtless won his heart, and this Shakspeare of the etching-point became the idol of his ambition. To the end of his life Gillray regarded the works of Hogarth with affection and pleasure. He constantly spoke of the abilities of the sturdy little Englishman in terms of the tenderest respect. The calibre of his mind excluded any suggestion of imitation or rivalry. His own talents were of a different order, and his was the admiration, unmixed with envy—far removed from the littleness of merely imitative minds—which one original genius bestows on the works of another.

"We will give the lad the best education we can afford," the elder Gillray may have said, "and then see what we can make of him. He does nothing but scratch and scribble; he must turn himself to account, and learn to earn an honest living." With the conviction of the value of education which is so conspicuous among the Scotch, he appears to have given young Gillray a good practical foundation, which was not without its profit in after-life.

The father having become convinced that James must follow some profession where his taste for drawing would be available, placed him under the care of a letter-engraver, and Gillray accordingly commenced his career in the footsteps of Hogarth himself.

The future caricaturist must have settled down diligently to his occupation for a time, for he acquired sufficient proficiency in the art to serve him in good stead hereafter. Indeed, Gillray's talents

as an engraver are much above the average. The elaboration of graceful curves and fine flourishing may have pleased his ingenuity for a time, but the restlessness of the creative faculty soon made him weary of his monotonous employment. During this portion of his career he practised drawing, and made experiments in the burlesque style.

No doubt, the youth began to be disillusioned in regard to his first predilection; and, weary of the mechanical character of his occupation, we find his impulsive temperament hurrying him into extravagance; he ran away from his employment, and plunged into the vicissitudes of life in its most chequered guise by joining a company of strolling players.

The picturesque combinations and the negligence exhibited in theatrical costumes—the actions and attitudes of the actors, at once dignified and ludicrous—may have flattered the bent of his mind. He was attracted to the company by the same fascination which attached the elegant cavalier Callot to the rags, patches, and masquerade of misery which distinguished the gipsies and vagabonds whose fortunes he shared. He followed the enchantment which bound Salvator Rosa a captive to the ragged splendour, the daring expeditions, and the gloomy caverns of the Roman banditti.

The qualities Callot and Salvator Rosa had acquired by their vagabond experience more than compensated them for the roughness of their training; and the example of these his predecessors, both knights of the etching-point, is sufficient excuse for the folly the young caricaturist committed in embracing this roving vagabondage. Gillray entered on life as an avowed Bohemian; whatever attractions may have attached him to the troupe, he early acquired an antagonism to restraint which coloured his principles to the end; and this propensity was no doubt fully developed during his connexion with these travelling performers.

After enduring the hardship and indulging the freedom which his new profession held out, Gillray began to realize that misery was one of its accompaniments; he became sensible of a higher ambition, and, awakening from his delusion, he returned to pursue the art which was strongest with him.

We next find him profiting by his past experience, and attacking the studies incidental to his pursuit with the energy and perseverance of a later Scotch painter, David Wilkie.

Gillray obtained admission to the Royal Academy as a student, and commenced toiling up that steep ascent which the art aspirant is doomed to climb. Having surmounted the earlier obstacles, he gradually qualified himself to occupy a high position among his fellow workers. The ease and power exhibited in the drawing of his figures, where any opportunity is given for the exhibition of anatomical knowledge, attest the diligence of his studies in this department; indeed, his skill in delineating the human form enabled him to dispense with models, and to perform feats which his successors in the art judiciously avoid.

While completing his course at the Academy, it is probable that Gillray cultivated the knowledge of engraving. It has been conjectured that he became a pupil of Bartolozzi; and Stanley concludes, from his proficiency of execution in the dotted manner, that he was taught by the unfortunate Ryland.

The first production attributed to Gillray's graver appeared at a very early age. He must have ventured into the field of political caricature before he commenced his theatrical wanderings.

The satirical etchings produced after the death of Hogarth were in general of the weakest description; one artist copied the designs of another, and a general sameness was the natural result. It is, therefore, difficult to decide with any degree of accuracy from whose hand many of these works have proceeded. In the comprehensive series of Gillray's works preserved in the Print Collection of the British Museum, we find many examples which warrant, according to the verdict of "experts," the supposition that Gillray was their originator. The young artist has increased the difficulty of deciding by signing his plates with initials which were intended to mislead or mystify the public. In many of his earlier caricatures he employed a monogram composed of the letters J. S. interlaced, much resembling the signature of his older opponent, Sayer, either with the design of irritating the owner of the initials, or with the view of securing more attention to his engravings. He also, for purposes of disguise or amusement, frequently made use of fictitious names.

The difficulty of recognising certain of his later, as well of his earlier works, is increased by an expedient of questionable probity resorted to by Gillray. He supplied rival publishers with partial

c

copies of his most successful works, in which he ingeniously disguised his art and handiwork; these fabricated plates present all those evidences of imperfect knowledge and weak conception and execution which rendered the works of his amateur imitators comparatively worthless.

Of the etchings ascribed to Gillray's hand—without positive evidence of their authenticity—the earliest is entitled "A Committee of Grievances and Apprehensions." It is signed ID, and appeared June 12th, 1769. Lord North is probably parodied in the centre figure. Although this caricature may be considered precocious, it is the sort of work with which an ambitious youth, with vivid recollections of Hogarth, would be not unlikely to commence his career as political satirist.

Lord North and a Committee of Grievances.

This early instance is followed by an interval, during which Gillray was pursuing his profession as an engraver, as a strolling player, or as a student of the Academy. A few caricatures appeared in 1774, 1775, and 1778, which have also been ascribed to his hand. "Pat on Horseback," which was published in 1779, is pronounced to be Gillray's beyond question, and this work is commonly described as his first production.

We shall refer to his caricatures, in the order of their publication, in the body of this volume. His designs and engravings of a serious character are enumerated at the end of the introductory portion.

Stanley, after alluding to Gillray's skill as an engraver, and the works so produced by him, observes:—

"Admirable as are many of these works, it is as a caricaturist that Gillray is best known. In this art he has no rival; and the exquisite tact with which he seized upon points, both in politics and manners, most open to ridicule, is only equalled by the consummate skill and wit with which he satirized them. His earlier works are more carefully than spiritedly executed, and look like the productions of an engraver only. His improvement was rapid and extraordinary, and he soon obtained a marvellous freedom both of design and in the management of the etching-needle. It is believed that he frequently etched his ideas at once upon the copper, without any previous drawing, his only guides being sketches of the distinguished characters he intended to introduce on small pieces of card, which he always carried about with him."

We are enabled to obtain a glance at the artist's method of working. These pieces of card are of the ordinary playing size, and are pencilled on both sides with clear, slight outlines—which are full of character—of the notorieties he sketched in the House of Commons, in the lobby, in the parks, in Bond-street, at the club windows, and wherever the subjects for his satire might be encountered. A few of these original cards are preserved in the National Print Collection. We are thus in possession of the secret of the wonderful fidelity of his portraits; his memory as well as his pencil must have treasured up every turn of expression, to enable him to give that endless variety of emotions and attitudes in which the likeness is always faithfully preserved.

Of his marvellous powers of invention, of his wondrous combinations, and of his command over a comedy which was often heroic in its development, the reader will have opportunity of judging. Gillray took pleasure, it is stated, in working out the conceptions of noble and distinguished amateurs, or in executing the suggestions of the influential, and this has been hinted in disparagement of his own originality. Gillray was contented to enjoy the greatest amount of retirement he could secure; his reputation had more than satisfied his early ambition, and he was perfectly indifferent to fame or criticism, unless his susceptibilities were roughly wounded; then his favourite weapons were swiftly hurled against the offender.

In all cases he distinctly traces on his plates the initials or name of the originator; "James Gillray, ad vivam," distinguishes a large proportion. He was scrupulous to give others their due, and in cases of mere written suggestions he frequently gave the whole credit of design to the person who indicated the subject. A large number of designs thus submitted to Gillray are preserved in the British Museum,

and a list of the most important, with references to the cartoons thus originated, is given at the end of this notice. The majority of the first sketches are, as the reader will discover, the merest indications; from a few uncertain lines, from an unmeaning stroke or two, with its intention stated in writing, Gillray's practised mind has seized the idea, and his skilful hand has embodied the half-fledged design in a picture which might justly be claimed as his own. In these instances, however, the initials pencilled on the first crude draft are engraved in the corner of the caricatures.

Among the better examples of these suggestive sketches are a few drawings which bear evidence of being early efforts of Rowlandson's pencil. Gillray also executed the best designs of Bunbury for that talented amateur, lending all the value of his own knowledge and power of expression to the humorous conceptions of his friend. The productions introduced to the world under these auspices give a better impression of Bunbury's talent than do the generality of puerile etchings which represent his published works; they are infinitely superior to the plates executed after him, even by Rowlandson. His contemporaries speak of Bunbury in terms of admiration and respect, and we recognise in him the favoured and popular amateur, whose wit and ability were spontaneous. A keen sympathy existed between him and the trained veteran who wielded his pencil and his graver with such incisive certainty and execution.

"It is recorded, by those who are the best authorities on such points, that Gillray, though conscious of his superiority in that style of art which he adopted, rarely troubled himself about the fame or success of his competitors in the same walk. He, however, was a devoted admirer of the works of Hogarth, and fully appreciated the humour of Bunbury, concerning whose designs he always spoke in the highest terms of praise. Bunbury, fully aware of his own deficiency in manual execution, and no less candid, was an equally ardent admirer of Gillray's *forte* in that department; he considered him, moreover, as the brightest genius who ever took up the pencil of satire, saying 'that he was a living folio, every page of which abounded with wit.'"

The interval which elapsed between the appearance of Gillray's earlier and less authentic works, and the publication of his acknowledged caricatures, was marked by the production of various etchings which there is reason to conclude are the evidences of his progressive improvement in drawing, design, and power over the graver. These juvenile efforts were published by different printsellers; doubtless by any one who could be found to purchase the copper plates. The name of Humphrey, at 227, Strand, (1779), appears on some of these prints. J. Kent, W. Brown, Holland of Oxford Street, and Fores of Piccadilly, all published occasional plates by Gillray. Holland and Fores introduced some of his largest and most remarkable works; they were the fashionable printsellers of the day until Gillray cast in his lot with Humphrey, whose family enjoyed a golden return for their early patronage of the promising young artist. It is with Humphrey's name that Gillray's caricatures are most intimately associated; from the Strand to New Bond Street, to Old Bond Street, and finally to that famous stronghold of the satirist, St. James's Street.

Mistress Humphrey's establishment enjoyed the widest reputation, her business was conducted with great success, and her windows gave audience to a crowd of admirers from morning till night. Public men were more frequently met abroad in those days; indeed, they were often brought into compromising and familiar intercourse with representatives of the rougher population, who in their presence applauded or disapproved of their political principles and practices. It must have appeared vastly droll to them to see their own images held up either to bitter ridicule or good-natured commendation, pilloried as it were in this well-known window; while John Bull expressed in unmistakable terms his enjoyment of the satire and his appreciation of its justice. An etching of this window is introduced on p. 5, from a print published a short time before the artist's mental alienation.

A deeper interest is excited in this house from the circumstance of the artist being not unfrequently engaged in launching fresh satires overhead, while the victims were laughing at their friends or themselves in the caricatures they were purchasing in the shop beneath from Mrs. Humphrey, gay in caps, or from her assistant, the giggling Betty.

A West-end pilgrim of Gillray's time thus records his reminiscences:—

"I can well remember when the daily lounger at the eastern sides of Bond Street and St. James's

c 2

Street, upon approaching Humphrey's shop in the latter, had to quit the pavement for the carriage-way, so great was the crowd which obstructed the foot-path to look at Gillray's caricatures. This unrivalled artist had so happy a talent, that he delineated every feature of the human face, and seemed also to have imbibed every attitude and the smallest feelings that actuated the person represented."

Many of the subjects we present in the course of this work are accompanied with anecdotes of the receptions they met with from their subjects, or from the general public. We limit our selection in this introductory portion to a few paragraphs which may convey the impressions of contemporaries, and assist the reader to realize the pictures whose outlines we endeavour to fill in.

Gillray, from his vantage-ground in St. James's Street, commanded a battery the volleys of which constantly rattled amidst friend and foe; striking now at over-strained royal prerogative, now at political or legislative abuses, now at subversive principles, concessions, and reforms; now playing on the follies and frailties of social celebrities, and now firing salutes in honour of worthy actions, in celebration of men whose names are preserved for the enlightenment of future generations.

This licence of comment was jealously regarded: "Ah!" said an old general of the German Legion, reflecting the opinion of the Court, and especially of the King and Queen; "Ah! I dell you vot— England is altogeder von libel!"

"Foreigners who have not visited England would not easily give credit to the tales which, however true, might be related of the audacity of the British press. What would they think were they to hear that within a few yards of the metropolitan palace of the King of England, a manufactory was working the press day and night in throwing off libels against himself, his family, and ministers? and that the members of the legislative body saw themselves publicly pilloried in the window of a satirist on the spot which they frequently passed twenty times in their morning walks. To expose men of distinguished talent, either for the obscurity of their birth or for their professional occupations, is one of the most profitable pursuits of the satirist. This species of personal ridicule is encouraged in proportion to the increase of that pride and folly which are ever salient characteristics of the age."

"These great statesmen, however, were commonly among the first, under the rose, to procure the earliest impressions of these libels against themselves, and many a laugh has been excited at a Cabinet dinner by the inventions of this daring satirist.

"Fox and Burke one morning walked into the little shop in St. James's Street, on the exhibition of a severe attack upon the latter orator. The mistress was behind the counter. At the sudden appearance of these illustrious visitors she found herself not exactly on a bed of roses. 'So, Mrs. Humphrey,' said the man of the people, 'you have got yourself into a scrape at last! My friend here, Mr. Burke, is going to trounce you all with a vengeance.' 'I hope not, Sir,' said the affrighted Mrs. Humphrey. 'No, no, my good lady,' said Burke with a smile, 'I intend no such thing. Were I to prosecute you, it would be the making of your fortune; and that favour, excuse me, Mrs. Humphrey, you do not entirely merit at my hands.'

"The liberty of abusing their betters, the boast of the English, is harmless enough, as ministers well know, so long as their betters maintain the liberty of making them post their ten-per-cents, to preserve them from a foreign yoke. How the caricaturist ever contrived to catch the hasty expression of the political heroes, which he drew in his endless travestie of the modern Iliad, with such seeming identity, is passing strange. This, his extraordinary faculty, almost goes to prove that the sublime may indeed be said to verge on the extreme border of the ridiculous."

Although the opinions preserved are generally not merely tolerant, but encouraging, a few anecdotes are related of the subjects of his satire whose resentment was exhibited with unreasonable violence. A writer, describing the caricature against Fox's revolutionary principles published under the title of "Le Coup de Maître" (November, 1797), in which the Whig leader is practising his aim as a "sansculotte" at the heart of the Constitution, remarks: "When the bust of Samuel Ireland was exhibited at the shop-front in St. James's Street, the irritated author of "The Avon" broke Mrs. Humphrey's windows. It may seem matter of wonder to many that the insulted member for Westminster had not broken the satirist's head."

It is also related that "when Holland, the publisher of caricatures, lived in Oxford Street, his

Grace of Norfolk walked into his shop, accosting him with, 'Well, Holland, have you anything new?' (His Grace was a patron of the shop.) Unluckily there *was* something new, fresh from the press, in which, as Holland's evil genii contrived it, his Grace happened to be the hero. *Diavolo!* 'What have you there?' inquired his Grace, and with a civil sort of force retained one of them, not at all suspecting that it was 'The Lord Lieutenant of Norfolk being Drummed Out of his Regiment!' It was just subsequent to the period when King George III. struck his and some other illustrious names out of the list of the Privy Council. The Duke looked at the libel, then at the shopkeeper, who stood aghast, while his Grace rolled up the print, put it in his pocket, opened the door, and turned his back on his old *protégé* for ever. It is plain that his Grace did not exactly relish the joke, but, as old Carr the shopman dryly observed, 'If he did not *like it*, why did he not *leave it?*'

"Now, Charles Fox, the man of the people, evinced better taste, for he was one of the *dramatis personæ* in this political skit. Fox laughed outright at the joke and pocketed the affront together with the print, but not without paying his eighteenpence, and he took it away to exhibit at his club."

One caricature alone is said to have pained the noble mind of Charles James Fox. It is called "A Democrat, or Reason and Philosophy" (March 1st, 1793), and is certainly indefensibly coarse in expression and attitude.

"Sin, Death, and the Devil" (June 9th, 1792), probably the most daring conception ever executed by any satirist, which was founded on a bold travestie of the scene enacted before hell-gate described in Milton's great epic, gave very justifiable offence at Court—probably less on account of its freedom, than on account of its startlingly truthful realization of the situation.

The King was frequently incensed, sometimes gratified, and generally inclined to be amused by the sallies of Gillray, although the subjects which elicited George's approval were perhaps neither the artist's most truthful nor his best-executed plates. His caricatures are said to have been regularly conveyed to the Court circle at Buckingham House, Windsor, and Weymouth.

The notoriety of the lives of the princes furnished the satirists with abundant texts for their moralities. Of a simple sketch of the heir-apparent, published May 3rd, 1796, under the title of "A Hint to Modern Sculptors, as an Ornament to a Future Square," exhibiting the full proportions of the Prince in one of the uniforms, displaying his rotundity, which the Regent had the bad taste to adopt, a writer remarks: "Satirists may be compared to mischievous bulls, for it is dangerous to cross the paths wherein they range. No spot could be better situated for making game than that chosen by Mrs. Humphrey's mart in St. James's Street; for all that was sublime and all that was ridiculous appertaining to the *beau monde* passed as in the slides of a magic lantern before her window."

It is not difficult to follow out Gillray's working life. We find him sketching his card portraits with most surprising facility, jotting down the vanities of fashion with the keen relish of Hogarth, vigilant to note every turn of the political wheel. We see him etching his conceptions on copper, frequently without any preparatory design beyond the picture treasured up in his imagination.

We sometimes find him engaged in colouring his own caricatures, and giving, by his effective arrangement of tints, a copy for the guidance of his assistants. Again we see him patiently labouring, with the taste of a true artist, on the engravings he executed from his own designs of serious subjects, or from the paintings of his friends. Such were the occupations of his every-day life; and it is not easy to trace the caricaturist apart from his profession, or even away from his abode. In 1792 he engraved a droll representation of "John Bull and his Family Landing at Boulogne" for his friend Bunbury, who no doubt induced Gillray, by his quaint sketches of foreign habits and his descriptions of foreign countries, to think about visiting the Continent.

In the same year De Loutherbourg, one of the artists who were fortunate enough to attract the royal attention, visited France and Flanders to collect materials for his great picture, "The Siege of Valenciennes," by the British and Confederate armies, and Gillray went with him to assist in preserving studies of the soldiers who had been engaged in the action; the portraits of General Count Clairfayt and the Prince of Saxe Cobourg, painted at Villers for Loutherbourg's picture, and published separately in the succeeding year, are mementoes of Gillray's visit. A more characteristic memorial of his tour is

preserved in the two admirable groups known as "Flemish Characters" (Jan. 1st, 1793), in which he has seized with perfect truth the characteristics of the people, which, in a few unfrequented towns, have undergone but little alteration since that date.

At the period preceding the French Revolution the Continent swarmed with English families of fashion; and we trace the travelled society of that day, and the customs of the foreigners among whom they lived, in the studies and sketches of Bunbury. Rowlandson also was quite at home in France, and rendered with grotesque fidelity the oddities of dress and manners of the inhabitants. A contemporary, writing of these Flemish studies just referred to, says: "These characteristic groups, so ably etched, are from the portfolio of 'Sketches from the Life,' made during this artist's tour on the Continent in the year 1792. It is a curious coincidence that Rowlandson and Gillray both happened to be in Flanders at this period, and were each engaged in the same pursuit—that of sketching the national characters of the people in the various towns through which they passed during their route. This circumstance, however, was not known to Rowlandson."

The King considered himself an excellent patron and judge of art, and made great pretensions to taste. His want of judgment—which time has fully demonstrated—has, however, been harshly dealt with. It is certainly true that he neglected Reynolds, the pride of the English school; true that he slighted men of high ability, whilst he showered his favours on mediocrity. He disliked the dignity and independence of honourable merit; it was contrary to the royal creed, for servility was the surest road to kingly patronage. Yet George III. encouraged the liberal arts more than his predecessors. We realize that his intentions were honest in this and in every other respect; that he was obstinate, but well meaning. Many of his faults were due to his illiberal training, or to natural deficiencies in the constitution of his mind, rather than to the perverse partizanship which coloured certain of his more responsible acts.

A Connoisseur Examining a Cooper.

When De Loutherbourg returned from his tour, the King desired that the results of the journey should be submitted to his approval. He bestowed the highest praise on De Loutherbourg's drawings of buildings and landscapes, neatly washed in tint, and palpable to the meanest comprehension. But the prejudices of the sovereign were vastly unfavourable to the daring caricaturist, the ink of whose cartoon exposing the vices of the royal family (1792) was barely dry. He peered at the rough, artist-like jottings, preserving the action of the moment, which Gillray had secured of the French officers; and lifting his spy-glass, with lowering brow he said, "I don't understand these *caricatures!*" and threw down the sketches with contempt.

It seems to us probable that Gillray accompanied his military studies to Court; his caricatures of this period (June, July, &c., 1792) being splendid in accessories which warrant the conclusion that the satirist's mind was much impressed by the general aspect of the regal surroundings. Gillray did not value favour, and he could easily understand that he must be the reverse of a favourite with the Royal Family; but his pride was mortified by the contrast between his reception and that of De Loutherbourg. He returned to his copper-plates in a very defiant mood, and immediately set about his revenge. He drew the famous satire entitled "A Connoisseur Examining a Cooper" (18th June, 1792), in which we see the monarch blinking at the stern features of the arch-enemy of kings, Oliver Cromwell (who was an object of particular abhorrence to George III.), with the dim light of an exhausted candle-end, eked out with fine irony in a golden "save-all," inserted

in a candlestick of massive bullion. "I wonder if the Royal connoisseur will understand this!" said the bitter satirist.

The excesses of the French Revolution enlisted Gillray's graphic power on the side of the Sovereign and the Conservatives. When the satirist did battle with the King's enemies—when he painted the monarch as the father of his people, and encouraged the sympathy which the crowd cherished for "Farmer George"—when he flattered the men whom the monarch was ever particularizing as his "friends"—when, as some have stated, the artist was not indifferent to tangible acknowledgments of royal appreciation, and, with more dignified supporters of the throne, took his share of the good things which were reserved for this favoured few—we find the position strangely altered. The opinions of King George regarding the merits of carica-ture had undergone an entire change. We insert a paragraph, written in regard to that truly John Bull conception, "The King of Brobdingnag and Gulliver" (June 26th, 1803), preserving the popular estimate of the relative positions of "Great George our King" and the pigmy Bonaparte—conqueror as he then was of an entire continent, and terrible as had been the power even of his name, until caricatures, squibs, and patriotic songs had accustomed men to regard

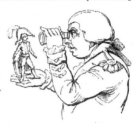

The King of Brobdingnag and Gulliver.

the mighty shadow with a contempt to the full as inconsistent as had been their former terror.

"It has been said, and generally credited, that our good-tempered sovereign, who well knew how to appreciate the merits of the witty caricaturist, was particularly amused with this freedom taken with his own royal person; and that he observed, with a smile, to Lord Westmoreland, 'I have no doubt that the portraits are very like—hey, hey, my lord?' Gillray and old Charles Dibdin (one with his pencil, and the other with his pen) may be fairly said to have served the good cause at home during the French Revolution almost as much as our naval and military heroes abroad. Such ingenious and patriotic worthies richly deserve a niche in the national temple of fame."

The visit to the Continent in company with De Loutherbourg is the only trace we find of Gillray's wanderings abroad. It is true that he induced many people to believe that he had visited Paris to sketch the portraits—which appeared in "The French Triumvirate" (Jan. 1st, 1800)—of Cambacères, Le Brun, Sièyes, and Bonaparte, settling the new constitution; but it is probable that the artist derived the admirable representations which he has preserved of French costume under the Revolution and the Empire from foreign engravings.

We find that Gillray visited Richmond in its palmy days, when it was a sylvan place of fashion; and a correspondent relates that—"During his stay at Richmond, in Surrey, he represented two of its celebrities. The first was Mr. William [John?] Penn (one of the remaining descendants of the great William Penn), then of Saint John's College, Cambridge, who was one of the brightest meteors of his day (see *Gentleman's Magazine*, Nov. 1845, p. 535). Mr. Penn is described by Gillray as a man of Pen-etration (August 6th, 1799). The other individual is styled 'A Master of the Ceremonies at Richmond.' This gentleman was a lieutenant of the Richmond volunteers about the close of the last century. He was master of the ceremonies at the distinguished balls held at the 'Castle.' The figure, manner, address, and gestures of Mr. Charles York (for that was his name) were what might be termed *Frenchified*, and were admirably portrayed by Gillray."

The history of Gillray is essentially preserved in the caricatures which represent his art, but before we leave the artist's every-day occupations, and turn our attention to the work he accomplished, it is necessary to chronicle all we have discovered of his private pursuits, his tastes, pleasures, and associates.

Stanley places it on record that "Gillray was unfortunately an example of the imprudence that so frequently accompanies genius and great talent—his habits were in the highest degree intemperate." This estimate is unfavourable to a generous appreciation of the artist; but the authority is worthy of

respect, and the harsh verdict is not without the confirmation of similar suggestions. Yet, that Gillray should have been an habitual drunkard is simply impossible. We cannot believe that the quick perceptions which secured and treasured the germs of his satires with such facility, which employed these rough materials with so much intelligence and felicity of application, were debased by animal cravings of the lowest order; that the facile, steady hand—faithful alike in executing the most delicate and the most powerful work—belonged to a man of intemperate habits. Gillray's works plainly contradict the assumption of his being habitually immoderate; and his portrait reflects an unusually intellectual face.

We have mentioned that the artist resided with his publisher; from this centre his works were eagerly secured, and circulated not only throughout the kingdom, but all over Europe.

The publisher allowed the satirist every indulgence; yet it is said that, in order to satisfy his cravings for strong drink, he occasionally disregarded the positive engagements which bound him to work for no other interest, and etched plates for Mr. Fores, of Piccadilly; in most cases disguising both his style and his handling with successful ingenuity, and producing what appear to be clumsy piracies of his own designs.

Of Gillray's ordinary life beneath the roof of his entertainers, with whom he resided in remarkable harmony, he exhibits one etching.

The print christened "Twopenny Whist" (January 11th, 1796), introduces us to a modest party of

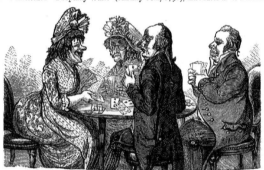

Twopenny Whist. Mistress Humphrey, Betty, &c.

card-players, the simplicity of whose stakes presented such a contrast to the hazards customary in the unlimited gambling of the day, that the wits of "White's" and "Boodle's" were vastly diverted, and the printers had to hurry off impressions night and day to supply the eager demand. This sly private satire engaged the attention of a contemporary writer, and we are informed that—

"The whimsical circumstances that governed the little household in St. James's Street, of which Gillray was a resident member, excited no small amusement in the neighbourhood. Mistress by courtesy, but Miss Humphrey properly—for the old lady died a spinster—her eccentric admirer, and the faithful Betty, the maid-servant, were all hail fellows well met; they lived in common, and only that she managed the culinary and marketing department, it was not always to be determined who ruled the roast. This print, then, describes Mrs. Betty entertaining a party at cards, all well-known characters, in Miss, *alias* Mrs., Humphrey's drawing-room."

The persons represented are Mistress Humphrey, splendid in a white-satin-trimmed cap; her faithful abigail, the "grinning" Betty; a German visitor; and their neighbour Mortimer (the stouter figure), a well-known picture dealer and restorer. He was a particular friend of the artist, whom we may imagine lounging on a sofa while he pencils the group on one of his little cards.

Gillray also introduced the portrait of Mortimer, *con amore*, into his picture of "Connoisseurs Examining a Collection of George Morland's" (November 16th, 1807). These neighbours possibly passed their evenings in the indulgence of congenial tastes: Gillray lounging round to Mortimer's establishment to criticise the pictures of the day, to chat over the narrow straits of genial red-nosed Wilson, the genius and eccentricity of Gainsborough, the glories of Sir Joshua and his masterpieces, young Lawrence's fashionable celebrity, the dandified absurdities of Cosway, the "maccaroni-miniature painter," the questionable excellence of Benjamin West, or Boydell's Shakespeare gallery,—in which neither had confidence;—discoursing of men and pictures which were already becoming forgotten at the date of "Twopenny Whist."

The writer thus continues:—

"The domestic point of this subject is a hit at Mrs. Humphrey by her satirical inmate, who, while indulging in this indiscriminate family compact, could not forego his propensity for quizzing, and exposing her oddities to the admiration of her friends and neighbours. Gillray, it is said, had more than once made nuptial overtures to the mistress of the house, which had not been refused. Indeed, it was asserted that they once proceeded to St. James's Church, to be made one in the holy bands of matrimony, but that, on approaching the door of the sacred place, he whispered to the good lady, 'This is a foolish affair methinks, Miss Humphrey. We live very comfortably together; we had better let well alone;' and, turning upon his heel, he returned to his old quarters, and went coolly to work on his copper. It would be disingenuous, touching the memory of the worthy mistress of the well-known shop, to withhold the fact that, after ministering with liberal kindness to the forlorn state of poor Gillray, who for some years existed under a helpless alienation of mind, and burying him at her own expense, she handsomely provided for Betty, by leaving her an annuity, if report speaks truly, of two hundred pounds."

The reputation of the keen satirist, who exposed the vices and self-seekings of the lives of others, was a fair target to blacken in retaliation. The busy voice of scandal was ready to make the most uncharitable assertions respecting the intimacy existing between the caricaturist and his publisher. But it is satisfactory to have these innuendoes positively contradicted by those who were able to speak from personal knowledge. Stanley repels, as follows, a suspicion that was most cruel to the worthy lady, who sacrificed her own comforts and incurred misrepresentation by humanely ministering to the sufferings of the artist during his distressing malady:—

"It has been whispered that there was a *liaison* between Gillray and Mrs. Humphrey not essential to their relation as designer and publisher; it is due to the memory of the lady to contradict that slander: such a *liaison* did not exist. The writer asserts this from information derived from persons of the strictest morals, who were intimately acquainted with Mrs. Humphrey for more than thirty years, and at whose family table Gillray and Mrs. Humphrey dined on Christmas Day regularly for more than the last twenty years of his life, previous to his insanity."

Gillray's friends represented him as "silent, shy, and inexplicable." The modern Juvenal was a quiet observer, a retiring philosopher; his disposition was not of the superficial order; the depths of his nature were not opened to all comers. It is easy to recognise a gifted intellect which rendered certain phases of society distasteful; his sensibilities were finely strung, and shrank from rough encounters; his temperament was impressible; he was prone, like a spoilt child, to humour his whims and indulge his inclinations without consulting the opinion of his associates. Such offences are sufficient to involve the characters of men of sterling merit in the judgment of the world; they complicate more genial qualities, and render them obscure. This morbid inclination is, unfortunately, developed in some professions by the nature of the work; and instances, sufficiently numerous to fill a volume, might be cited from the lives of artists alone. We are content to give one example of a man who wilfully subjected himself to misrepresentation by his persistent indulgence in similar proclivities. We refer to the relaxations attributed to Turner, who carried landscape painting beyond the boldest conceptions of any previous artist, and whose genius impelled him to strive to achieve effects which were really unattainable.

Gillray chose to lose his own individuality in strange scenes and rough company. He mixed, for diversion, with unknown associates.

D

This necessity of securing a retreat from the toil of the creative faculty drove the greatest master of fiction in our own day to endless expedients to escape the chains of thought, to sever for a time the intimate relationship of mind and body; until, after a struggle which it is affecting to think of, the uncontrollable mental impulses exhausted the beaten frame, and Charles Dickens, when his brain was busy weaving fresh magic spells, was hurried out of existence.

A different fate was reserved for Gillray. The struggle was the same, but the constitution outlived the mind.

While his genius was at its greatest height, while his facility of execution surpassed all credence, when each succeeding creation of this magician of satire surpassed by its novelty and by the surprising assemblage of admirable portraits its most popular predecessors, when printers and colourers worked day and night, when the tide of success flowed incessantly in a substantial stream of profit, when each party was ready to secure the artist at any sacrifice, while the greatest events succeeded each other with bewildering rapidity,—the vanity of life was awfully asserted. The busy brain which was the mainspring of all this activity trembled and lost its balance; and so the body lingered on in the darkness of insanity, until death mercifully released the suffering frame, after six years of mental blindness, rendered doubly harrowing by brief returns of consciousness, which excited only delusive hopes in those who protected the unhappy man from his own violence.

The most touching details have reached us of the sufferings of King George—his poor mind assailed by anxieties he could not control, a prey to nervousness which his organization was too feeble to master, hovering between consciousness and insanity! It is painful to read of the hopeful glimpses of returning sense, until reason forsook her seat, never to be restored. To think of the man who aspired to command both the Old World and the New being reduced to the helplessness of infancy, the misery of his mental darkness rendered heavier by the loss of sight!

In the progress of the great melodrama, we dwell with mischievous enjoyment on the ludicrous struggle between the awkward giant and the skilful Lilliputians—between Great George beating the air in his perplexity, while the shafts of the satirists provoke the King and make sport for his lieges. We smile at the unequal combat, as "Peter Pindar"—the clear-headed Doctor Wolcot, who presented the sovereign to his delighted subjects in the most whimsical and undignified guises—trims the point of his tiny quill. We cannot resist the entertainment of this novel spectacle: the highest personage in the realm bewildered by the bladder of peas, which, in the hands of the gifted antagonists of regal inviolability, rattle round the sacred head of an absolute sovereign, who not unfrequently forgot that his power was derived from his people.

Our mirth melts into sympathy for the touching afflictions which Providence held in reserve for these men, once so conspicuous above their fellows: the King hopelessly mad and blind; Gillray, his reason fled, obliged to be forcibly restrained from self-destruction; "Peter Pindar," the man whose faculties were formed for the fullest appreciation of natural beauty, passing his latter days in sightless obscurity. The judgment of Dr. Wolcot, an artist himself, respecting the painters of his day, appears almost prophetic, so fully have his opinions—which to his contemporaries appeared reckless and unjustifiable—been confirmed by the verdict of time.

An article discoursing of Gillray's works with critical discrimination appeared in the *Athenæum* in 1831. The writer hinted that little was known of Gillray's private life which could be disclosed with propriety, and remarked: " Those with whom he commonly associated have hitherto continued silent respecting him: in silence there is sometimes discretion." This ungenerous conclusion induced Landseer, who had enjoyed the caricaturist's acquaintance, to offer a few authentic anecdotes, which were inserted in the same journal, on behalf of the man who had been suffered to sink into oblivion by his friends, or had been surrounded by his political opponents with an atmosphere which discouraged any attempt to disperse the gloomy shadows which obscure the artist's personal career.

Mr. Landseer's letter defends the memory of Gillray from the imputation of mere sordid impulses. The judgment of this authority will secure the greatest respect; besides which, the letter introduces us to Gillray in one of his social hours:—

" He never appeared to me to be that lover of low society and gross mirth which some writers have

described; but silent and reserved he was, till he discovered that his companions upon any given occasion were frank and liberal. His own patriotism and free principles then began to peer forth, and occasionally rose to enthusiastic fervour. I remember being assembled with him and a few other artists, most of whom are since dead, at the Prince of Wales Coffee-house (then newly opened): the purpose of the meeting was to form a fund and institute a society for the relief of decayed artists, &c., where Gillray discovered no deficiency either of good sense, benevolent feeling, or gentlemanly propriety of conduct; yet there was an eccentricity about him, which, being no unusual concomitant of genius, was felt to be agreeable. After business and supper were concluded, we drank toasts; and when it came to his turn to name a public character, the Juvenal of caricature surprised those who knew him but superficially, by proposing that we should drink David (the French painter)! He was by this time a little elated, having become pleased with his associates, and having drowned his reserve in the flow of soul; and, kneeling reverentially upon his chair as he pronounced the name of the (*supposed*) first painter and patriot in Europe, he expressed a wish that the rest of the company would do the same. This was after our artist had transferred his nominal allegiance to the Pitt party;—before David had been guilty of the worst of those revolutionary atrocities which stain his character, and while his artistic reputation in this country stood much higher than since we have had ocular opportunity of appreciating his professional merits."

Dwelling on the inducements which a summary of Gillray's caricatures should present, the letter continues: "There are passages in these productions so energetic, so luminous, so vivid, and so far elevated above the tenor of caricature, that they deserve to be classed with higher works of art. A critical history of the principal works of Gillray, and of the transactions which gave birth to them, would be very interesting. And mention should be made of Gillray's durance in Wilkinson's garret, from whence, when he descended and took up the trade of caricaturing, he inscribed under his last serious engraving—' Fool that I was to cobble thus my shoe!'."

The last etching by Gillray is dated 1811. Soon after that date he sank into a state of mingled imbecility and delirium. Once, during a paroxysm, he attempted self-destruction by throwing himself from an upper window of the house in St. James's Street. James Stanley, whose notice of the caricaturist we have already cited, happened to be passing at the moment, and witnessed the struggle between Gillray and the persons who prevented him carrying out his intention. It is, however, said that he actually contrived on one occasion to leap out of a window.

Gillray's madness was chequered by lucid intervals, and in these hours of consciousness the busy mind no sooner resumed its empire than the occupations of calmer existence again absorbed his attention. The etching entitled "Interior of a Barber's Shop in Assize Time" (bearing in one corner the figures 1811, and dated, on its deferred publication, May 15th, 1818), was the last plate which engaged his skill. It occupied him at intervals until death released him. The original engraving is of considerable size; and though executed from a sketch by Bunbury, Gillray has infused much of his own spirit and individuality into the etching, which we have engraved in reduced *facsimile* of outline a little later on.

The original plate perhaps exhibits a slight deficiency in the boldness which Gillray's graver had acquired by practice; the touch is more minute and laboured; but, as a whole, it registers no significant decay of manual dexterity, and does not exhibit the slightest diminution, either of comic power or of the artist's remarkable command over grotesque expressions and attitudes. His contemporaries write affectingly of the progress of this engraving, and the mournful circumstances which attended its execution:—

"This, as notified by the plate, is '*the last work on copper by the hand of Gillray*,' which, although the design is from the pencil of Bunbury, owes no small portion of its merit to the characteristic humour infused into each countenance by the congenial feelings of the engraver.

"In contemplating this last graphic effort of Gillray, a sad reflection is excited by the recollection that part of this plate was executed during short lucid intervals of that mental aberration which he experienced during the remainder of his life, which, under this calamity, was protracted for nearly six years. Whilst subject to this malady, Gillray—attended by a friend, who watched him with the kindest

and most sedulous attention—occasionally, his ideas being momentarily collected, would make a morning call upon some one or other of his old friends. Among that number was Mr. Gifford, himself a satirist and translator of Juvenal, who felt the force of the graphic satires of the artist. On one of these occasions, the poet endeavoured to awaken the artist's attention to a subject which had often formerly occurred to him—namely, that of a travestie of all the leading characters found in the dramatic works of Shakspeare.* Gillray's imagination seemed to be re-inspired, and, warmed by the subject, he promised to set about the plan. He made two or three sketches; but the flame of his genius was obscured by his increasing mental darkness; his pencil and graving-tools were destined henceforth to remain undirected by that ingenious hand that had so long and so powerfully commanded them."

Among the evidences preserving the reality of this painful period of Gillray's life, is a large, wild sketch in pen-and-ink of a head, intended for a likeness of a nephew of Mrs. Humphrey. The hand which sustained the quill was, however, tremulous and uncertain, and the brain which should have directed was itself wandering. The lines waver and struggle in a confused maze, while semblances of faces appear in parts of this sad memento of an imbecile genius.

Gillray was last seen, unclad and unshaven, in the shop which his works had rendered universally familiar. The appearance of this poor mad figure—who had evaded the vigilance of his guardians—surrounded by the brilliant conceptions of an intellect then hopelessly departed, is an awful sermon on the frailty of human understanding. He was reconducted to his chamber, and on the same day his troubles came to an end.

Mrs. Humphrey tenderly discharged the last duties toward him, and his body was borne to the churchyard of that very edifice to which we have traced him setting off one morning on a matrimonial expedition.

His grave, near the Rectory House, is marked by a flat stone, on which is engraved the simple inscription—

In Memory of Mr. James Gillray,

THE CARICATURIST,

Who departed this life 1st June, 1815,

AGED 58 YEARS.

There is a certain fitness in the burial place of this man. A few steps alone interpose between the slab which covers the mortal remains of the satirist,—who now lies forgotten, and almost unknown, in the retirement which he courted through life,—and the pavement over which the stream of short-lived wealth, frivolity, and eager ambition, which he satirized in his day, never ceases its bustling progress.

We have thus imperfectly followed the career of James Gillray as an individual; it remains for us

* The quotation, "Oh, that this too, too solid flesh would melt!" was graphically embodied by Gillray, and published on March 20th, 1791. Mr. Thomas M'Lean, a trustworthy authority on art subjects, in his key to the collected edition of Gillray's Caricatures (1830), observes of the public loss sustained by Gillray's want of impulse in that particular direction : "It is extremely to be regretted that this great master of humour did not accomplish his intention, publicly announced, of travestying the characters of Shakspeare. 'Oh, that this too, too solid flesh would melt !' and a few other scraps from his fertile imagination, are sufficient to manifest that a rich treat would have been furnished to the amateurs of graphic humour, had he completed his plan. Wits, however, will neither be coaxed nor driven from their own purposes. Gillray was urged in vain to proceed with this series by many illustrious persons, whose bare recommendation would have moved any other mortal perseveringly to use his pencil or pen in such a service." We are inclined to think that Gillray's respect for the elevated creations of Shakspeare was stronger than the promptings either of his own passion for parody, or the persuasions of the most distinguished amateurs of humour. "Shakspeare Sacrificed," 20th June, 1789, presents the subjects of Boydell's Gallery, without the whimsical exaggerations which the caricaturist had always ready for any emergency. We may believe that "Peter Pindar's" recorded veneration for "Fancy's child"—"a bard I much approve"—was shared by Gillray.

now to take a brief review of his works. Although his productions were avowedly caricatures, it was their high privilege to influence public opinion in a very considerable degree.

That the Administrations who held power during the days of Gillray's fame were conscious of the force of his satires is demonstrated by the immunity with which he attacked both men and measures. That his irony should have been unrestrainedly indulged, at a time of comparative rigour as regards press prosecution, is the best proof that his graphic power was entitled to respect.

Partially guiding, partially forming, and generally reflecting the convictions of the many, Gillray became not only the exponent of his own clear views, but also the recognised mouthpiece of the multitude, exhibiting the shades and changes of public estimation, shedding by turns acclamations of approval or expressions of distrust on the same object.

We find Gillray championing the People against the Sovereign, the Prince of Wales against the King, the Whigs against the Tories, liberal advancement against obsolete restrictions and obstructions. " We must march with the times; we must hail the voice of freedom; forward, ye patriots of France! we too will wave the flag of liberty!" With these conclusions the people at first sympathized, and Gillray expressed the sentiments of the liberal-minded section of the community. But the unreasonable impetuosity of the French character, the impolitic zeal of the patriots at home, opened the eyes of thinking men to the dangerous extremes towards which they might be forced. Innovation worked too unsparingly for solid reform; dangerous theories were advanced, and temperate Englishmen hesitated and recoiled. The King and his people must be united by a cordial sympathy, founded on the distrust of French principles characteristic of monarch and subjects alike. The good Sovereign must regain the hearts of his children; the irregular life and discreditable principles of the Prince must be exposed, and the sybarite Florizel at once becomes an object of contempt to the sturdy mob; good Farmer George is the idol to insure whose stability they will offer their lives and hand over their money-bags to Master Billy Pitt. Gillray exposed the violent tendencies of the Whig aristocracy, and glorified the Tory resistance; at a time when both parties were wavering, he did battle for " good old principles," he proudly pointed to our Constitution, and assailed with inexhaustible satire and animosity the farce of liberty then enacting in France. The people were with Gillray in these opposite principles, or rather Gillray recorded the feelings of the people, the rough sense of a king-loving commonwealth.

The extremes of party feeling, the excesses of reaction, although distinctly preserved in the graphic registers of Gillray's political conversion, are always softened by sound principles and tempered by rational conviction. Of neither side is the satirist a mere partizan, acting just as the leader may direct; friend and foe, Whig and Tory, King George and Bonaparte, Pitt and Fox, all must submit to be censured or praised as the artist may think fit, and while he is striking the one he gives a sly hit at the other.

The songs of Dibdin and the caricatures of Gillray were highly esteemed by Pitt at that critical epoch, and they achieved results rarely compassed by such slight means. The weapons truly were mere toys; but by their opportune assistance they stimulated waverers, encouraged the loyal, enlisted fresh recruits, and led the thickest of the fight.

Men who were themselves actors in the drama then proceeding, and those whose destiny it was to regard the struggle as mere spectators, combine in preserving evidences of the feelings we have indicated.

" There are times and occasions when satire and caricature may be made subservient to the best moral and political purposes. These times we have witnessed, for during the period of the war with the republic of France, when England in common with other nations was threatened with that demoralizing system which was fast spreading over the civilised world, we remember the counteracting influence of the *Anti-Jacobin*, aided by the graphic illustrations of the incomparable Gillray."

" That these political caricatures were serviceable to our Government there can be no cause to doubt, for, however extravagant may appear the consequences of submission to the power of France, under the rulers of that then disturbed empire, as depicted by the graphic invention of the artist, yet, perhaps, the tyranny which would have been practised by the ruffian chiefs who so cruelly lorded it over their own countrymen, had they subdued England, would not have fallen far short of this pictured

state of slavery. The period of dread either of foreign or domestic enemies, however, has long passed away, and we verily believe that it is due to the satiric pencil of Gillray, which exposed the mischievous spirit of French fraternization, and the consequences of that universal anarchy which was attempted here by certain turbulent enthusiasts. We owe to his universal language of picture, together with the lyric pen and loyal sing-song of Dibdin, much of that returning spirit of loyalty amongst the common people which ultimately preserved the country from invasion."

The popular dogma that one Englishman was equal to at least three frog-eating Mounseers was also vividly kept before the mind of the sturdy public by the hearty John Bullism of this accomplished satirist.

Dwelling on " The King of Brobdingnag and Gulliver," a writer records : "Strange as it may appear, this playful effort of the pencil of our caricaturist had a wondrous effect upon the opinions of the common people of England. Bonaparte had been painted to their imagination by his admirers in this country clothed with terror ; the threat of invasion, with his invincible hosts in their flat-bottomed boats, had spread a general consternation in the minds of the multitude ; even many good families passed anxious days and sleepless nights for a certain period, expecting the dread sight of guillotines and Jacobin executioners in every market-place. At length the terror abated ; England single-handed met the foe on our native element, and the proud navy of the republic of France rode at anchor in our ports under the flag of its captors, whilst our prisons were crowded by the boasting invaders. The ruler of France meanwhile manœuvred his flat-bottomed flotilla on his own shores (from the inner basin of Boulogne to the outer, and back again) and John Bull laughed at his pigmy effigy strutting in the hand of good King George.

" When this well-conceived satire upon the braggadocia-invader first appeared, the heads of the gazers before the shop-window of Mrs. Humphray were thrust over one another and wedged close side by side. Nothing could be more amusing than to listen to the remarks of the loitering crowd. It was this print which procured for the mighty chief the lasting title of *Little Boney,* in which familiar designation all the terror of his former name seemed to be entirely swallowed up and forgotten."

The great triumph of Gillray's life was the vigorous enthusiasm which his satires provoked from the multitude ; the people responded manfully, and with the King and his friends alone fought the hard battle against French proclivities which threatened to revolutionize our island.

We trace in these caricatures a realistic representation of the rise and progress of the revolution. We witness the contest with corruption and oppression, the legacy of false glory and vicious pleasure bequeathed by the deceptive glitter of "the Grand Monarque," the depravities of the Regency, and the frivolities of "Louis the Well-beloved ;" we sympathize with a struggling people ground down by a false system ; we see the first germ of French liberty—the early exertions in favour of enlightened liberty, which were universally appreciated, and in England warmly encouraged. Kind-hearted Englishmen were filled with compassion for the past sufferings of their neighbours, although the hostilities of years had bequeathed the bitterest animosity between the nations. The people had no reason to think generously of France, after the injuries she had recently inflicted on us ; but enmity was forgotten in the hearty good wishes which the nation conveyed across the Channel for the political regeneration of our neighbours.

Gillray, whose principles entirely favoured freedom, and who saw clearly the weakness of theories enforced with bayonets and cannon, was foremost in expressing this honourable sympathy. He represented the triumph of freedom in the fall of the Bastille ; liberty restored the crown to a moderate and popular prince, the constitution was granted, corruptions were swept away, and Neckar's financial reforms were relied on for the correction of every evil. This revision abroad of traditional bad government was welcomed by liberal politicians at home as an auspicious concession to the popular voice.

Moderate requirements were satisfied, but the patriots still advanced ; restless agitation, rather than aspirations for a settled government, began to characterize the new system, which was originally conceived to aim at an imitation of our own limited monarchy. The moderate English patriots detected subversive tendencies, they wavered and grew suspicious, and finally their allegiance was restored to

old and tried principles. But Fox, at the head of the powerful Whig Club influence (then flourishing in its most aristocratic form), stood forth, with all the enthusiasm of his eloquence and ability, in support of advanced ideas.

The compromising flight of Louis swiftly followed. Sympathy wavered between the unhappy King and the National Assembly ; of the two parties, the King was, at the moment, considered the more treacherous. Excesses then began to make themselves manifest. A sovereign who should have commanded the respect of the entire community was murdered on the flimsiest pretence, after he had made every possible concession to the popular will. Ruffians and madmen succeeded to patriots and enthusiasts, and made their wild utterances echo abroad. A cry of horror arose on all sides, and those who temporized with the regicides were regarded with corresponding aversion.

Gillray forgot his free impulses in view of the abuses of so-called liberty ; he enlisted his powers on the side of the Tories, and became the champion of kings against democracies and the opponent of Fox's dangerous policy. He excited every animosity that his pencil could provoke against French theories, against the revolution and its leaders, whose ragged and undisciplined hordes—at first fighting for freedom, and soon for meaner objects—shook the Continent to its centre. However, out of the elements of the revolution, arose the genius destined to absorb its chaos into a new and self-consuming power ; Napoleon arose, the phœnix of his age ; and his daring temper, his contempt of seeming impossibilities, gained those victories the glory of which surrounded his name with superstitious terror. Kings trembled, and dynasties which had survived for ages were swept away before him. Gillray burlesqued the glory, and swept off the mantle of terror. He represented the mighty captain as a very pigmy. No lustre of conquest, no halo of success, dazzled the steady eye of the satirist ; Bonaparte was ever to him a mere puppet of ambition, a mannikin who assumed the airs of a monster ; and he did valiant battle against the dreaded Corsican with the weapons that nature had given him. This consistent hostility, which derided and despised every attempt at covenant with the enemy—this war, headed by the King and supported by popular acclamation—was conducted by Pitt with exhaustless energy, in face of the opposition offered by a powerful aristocracy, combined with the most brilliant talents our country has ever witnessed.

Gillray's exertions in promoting and stimulating our triumph over the threatened invader were nobly seconded by the victories over abuses at home, in which also he largely assisted. Whether strengthening the Opposition or supporting the Ministry, his satires were in most cases directed by sound judgment, by a love of rational liberty, and by an aversion to oppressive measures, whencesoever they might emanate.

He was the satirist, and not the supporter, of party influence ; he was fettered by no blind partiality ; his views are digests of the discernment of a population who lived in troubled times, who were obliged to suffer in their own persons for the acts of their rulers, who fought against a despotism which threatened them with slavery (for the state of the people of France under the Empire was worse than serfdom), who at least preserved England from great sufferings when the fate of becoming a conquered people was held before their eyes.

The marvellous aptitude of the caricaturist for the offices his fortunes had assigned him was admitted on all sides in his own day.

"Gillray, though silent, shy, and inexplicable, even to those who knew him best, was an attentive observer of the motives which actuated all degrees of men. To one of his perception life was an ever-varying drama. His discrimination of character was prompt, his humour in describing it was original, and his wit exhaustless. In the vast extent of his political caricatures, which amount to several hundreds, we never find him at a loss for new subjects. He never seemed to labour at composition, his groups and figures grew under his prolific pencil as rapidly as his hand could work ; with the same vigour of thought and execution he transferred his compositions upon the copper, and drew and etched with a mastery that has never been equalled, nor is likely to be surpassed. The slightest tracings on his plate were sufficient when he was constrained to labour against time, and some of his boldest and best caricatures have been the felicitous emanations of a sudden thought, accomplished within the space of a few hours.

"It is worthy of remark that in this burlesque style of composition the designer leads the spectator imperceptibly to tolerate every species of incongruity, and to accept the whimsical aberrations of caricature for real matter of fact. Indeed, so powerfully is the fancy operated upon by these monstrous resemblances, that they frequently seem to be more closely identified with the appearance of their living prototypes than the most faithful portraits. Fox, to speak in the language of art, is only five heads high, and Sheridan of about the same dwarfish proportion; while Pitt and Burke, and some other well-known characters, are at least of double the height; yet do they all appear fitting, even when mingled together in the same group. These subjects were suited to the taste of the times, for broad farce would fill the benches, while the refinements of pure comedy were exhibited to empty houses! How far we may be improved in correct sentiment must be determined by those who appear hereafter."

"It may be truly said, for the happiness of old England, that as long as the politicians laugh, no treason need be feared. Whilst men are prone to laugh, all is going on well. Laughing is a never-failing symptom of happiness and a contented stomach. Whilst Englishmen are well fed, and the wolf of hunger is kept from the door, there will be no civil war. Your dark-souled, gloomy conspirators never laugh. Risibility is a mark of content and satisfaction; and as traitors are never known to be either the one or the other, it is impossible that they should laugh. The saturnine Roundheads never curled their mouths, even into a smile; had a sense of humour given a genial turn to their inflexible characters, it is impossible to surmise what they might have accomplished. Peter Pindar was famous for exciting laughter, so also was Gillray—*ecce signum* on every leaf of his book. He who laughs at kings, ministers, and measures is not to be dreaded as a stirrer up of sedition : a smile disarms wrath."

"Gillray, though from a certain period a satirist of the Opposition, in almost all his political prints represented the person of the Prime Minister erect, haughty, and unbending. Fox and Sheridan, on the contrary, were frequently depicted, even in their Jacobinical garb, as it were in *masks*, under which lurked traits of good humour and fun ; as though indeed they were the creatures of circumstance, rather than the genuine opposers of the system they abused.

"The illustrious son of the great Pitt afforded an everlasting theme for graphic wit; and the liberty of the press, during his long administration, may be very fairly appreciated by the figure he is made to perform in the great political drama at the will of these audacious wights, the Whig and Tory carica-turists; for whatever may be said to the contrary by party prejudice, although the superior talent of Gillray upheld the Government against the Opposition, yet there were ten political squibs published in favour of Fox for one in support of Pitt; at all of which the Minister smiled, either in good humour or contempt, in common with the greatest lovers of liberty among the rest of his Majesty's subjects.

"'Opening the Budget' is one of the political waggeries of our caricaturist, wherein it would be difficult to find out whether he was aiding and abetting or exposing the Minister—whether he was laughing at Whig or Tory, or both, and opening the eyes of Johnny to the alarmists on all sides. If the Prime Minister had felt annoyance at the Whiggish squibs with which he was assailed, he and his colleagues could have stayed the proceedings of the wits in that quarter. But no, he let the wags alone, and under his aristocratic reign the licentiousness of the press attained its climax. Peter Pindar worked the King, and the caricaturists worked his Ministers; Gillray, almost single-handed, defended the Government. Meanwhile the cry was loudest with those who sinned most against liberty, 'the press is in danger.'

"Painting is a universal language; it is a book that is read at a glance. 'Farmer George and the Pigs, or more Pigs than Teats,' exposed the rapacity of the Fox Administration with such convincing argument, that even the lowest mechanics, gazing at Mrs. Humphrey's shop-window in St. James's Street, were convulsed with honest broad grins, exclaiming, 'Well done, Farmer George, and down with the Talents!'"

That Gillray's partizanship of certain principles was the result of personal conviction, the active nature of his allegiance and the dangerous independence of his lance—often directed with playful wilfulness against his own side—are remarkable proofs. His impulse was beyond the control of party his abilities were not to be directed by a coterie. Gold, the irresistible lever employed by Pitt to move the world, was not despised by the Minister in treating with this invaluable, but intractable caricaturist.

If gold was repugnant to the high principles of the man, such patronage was flattering to the pride of the artist. The satirist may have indulged his own ironical temperament by alluring the great Pitt into confidence in the stability of his support.

The Great Commoner condescended in 1789 to humour Gillray—he sat for two pictures; and this distinction would have secured to any ordinary portrait-painter a constantly increasing circle of sitters, whose patronage would have given him both reputation and affluence. The hand of the Crown Minister, however, obtained but slight hold over the satirist's graver until 1796, in which year Gillray ran, as it were in sheer innocence, into the lion's mouth, and only obtained his release by making a sacrifice to the master of the situation.

It is worthy of attention that both Gillray and Peter Pindar indulged their satiric propensities with singular immunity; their brilliant and reckless flights, so dangerous in appearance, were executed without harm to themselves. It was fated that their difficulties should result from more obscure ventures. Peter Pindar was tripped up by his "Epistle to the Earl of Lonsdale," after having, with impunity, regaled the people with the unconstitutional repast of a "roasted" sovereign.

The cartoon which endangered Gillray's liberty must have given offence chiefly by its title. "The Presentation of the Wise Men's Offering" brought the caricaturist within the jurisdiction of a religious court. The Princess Charlotte was born on the 7th of January, 1796; and two days after this event the satirist produced a plate representing the Prince of Wales presenting his infant to Fox and Sheridan, who salute the princess with a servility which certainly is not generally practised. Judged, however, by comparison with other caricatures of the time, the print offers no grave indecorum.

In Mr. Landseer's communication defending the artist from the charge of political apostasy we find:—

"It may not be generally known that Gillray was a reluctant ally of the Tory faction, and that his heart was always on the side of Whiggism and liberty. He did not 'desert to the Tories,' but was pressed into their service by an unfortunate concurrence of circumstances. He had unluckily got himself into the Ecclesiastical Court for producing a politico-scriptural caricature, which he had entitled ' The Presentation of the Wise Men's Offering;' and while threatened on the one hand with pains and penalties, he was bribed by the Pitt party on the other with the offer of a pension, to be accompanied by absolution and remission of sins both political and religious, and by the cessation of the pending prosecution. Thus situated, he found, or fancied, himself obliged to capitulate."

To qualify the partial impressions of contemporaries which we have recorded respecting our satirist, we now give a few passages from the unfavourable review which produced Landseer's kindly testimony:—

"Caricatures have the same resemblance to historical paintings which satiric verse has to epic poetry, and descend farther below than the *beau-idéal* rises above the truth of real life. Britain has the merit, or the demerit, of originating this singular sort of art—it is the offspring of a kindly government and a free constitution; and though but a weed, we have tended it and watered it, till it flourishes better than any flower. In 'The Times' of Hogarth we may see its rise, estimate its characters, and read its fate. The political caricatures of that wonderful man were felt and understood in their day, and made the demagogues of those times writhe and tremble; but to the children of this age they appear only as extravagant riddles, which no one has the patience to solve.

"The mere life of a caricaturist can neither be interesting nor instructive: for who would wish to know of the haunts and habits of a sort of public and private spy ?—and who can desire to learn the secrets of so disreputable a profession? He is a man who closes his heart against the sensibilities of human nature—who holds an inquest on whatever seems weak or blameable in others, for the purpose of holding them up to public derision—who insults inferiority of mind, and exposes defects of body—and who aggravates what is already hideous, and blackens what was before sufficiently dark. He invades, unpunished, the privacy of the throne and the sanctity of the altar: he neither reverences domestic peace, nor dreads the vengeance of public assemblies; and though he is generally regarded as a nuisance, who for his audacious pictures deserves the pillory, he is permitted to walk at large by the courtesy of Government, and our love of fun and freedom.

E

"One of the most distinguished of this class of artists was James Gillray; and his works, commencing with the agitations of the French Revolution, and coming down the political stream as far as 1810, may still be seen in the windows of some of our print-shops; and whatever we may think of the mind which conceived them, it is impossible not to be sensible of their discrimination of character, their ready humour, and their exhaustless wit. They extend over a period of twenty years, and deal with those eventful days of change and terror which followed the French Revolution. They are dipped in the dark colours of party rancour—and sometimes in the more benevolent hues of love of country—they exhibit the fraternal theories of those benevolent citizens Danton and Robespierre, and the political animosities and schemes of our two great leaders, Pitt and Fox. Gillray felt what millions saw—that the French were planting the tree of liberty with bayonet and sword; and that the eloquence of Fox and his companions encouraged the audacity of our enemies, and embarrassed the energies of our Administration.

"To the task of political caricature, Gillray brought excellent working qualities. He had a plain, straightforward, practical understanding, which never rose above the comprehension of the crowd—he never desired to veil his satire in subtleties, nor hide it in thoughts far-fetched and profound. The venom of his shafts was visible—nor did he seek to conceal his poisonous draughts in a gilded cup. All was plain and clear—and all was bitter and biting. The measures of the Tories, and the plans of the Whigs, were to him a daily source of subsistence and satire; out of the bickerings of men for place and power he had his per-centage.

"Our ridiculous expeditions, our modes of raising money, our fears, our courage, our love of liberty, and our hatred of France, were to him so many sources of emolument. He lifted a tax off all public men—and even made Napoleon contribute."

We have now displayed without reserve such scanty records of our first caricaturist as we have been able to gather from the fragments, appreciatory and censorious, which time has spared. That the grains of evidence we have collected will reproduce any genial impression of James Gillray is beyond our anticipation; but though the satirist himself may successfully elude the student, his works, founded on the occurrences of the times in which he lived, offer a sufficiently tangible realization of the world which surrounded him.

Glimpses of new light may be traceable in the progress of these social and political pictures of great George's reign and the past century, revealing in truthful colours certain points of historical interest of which posterity has accepted versions strangely differing from the convictions of contemporary spectators.

We shall congratulate ourselves if we escape the imputation of needlessly dragging forth the name of one who, throughout his career, courted for himself a retirement which it is difficult to penetrate, from an eccentric ambition he had to remain personally unknown, while the playful creations of his genius were universally familiar.

THE WORKS

OF

JAMES GILLRAY, THE CARICATURIST.

1769 TO 1781.

I T is proposed, in this review of the works and times of Gillray, to quote the various caricatures in their order of publication, as far as may be found consistent with a regard for the reader's interest. This arrangement has been adopted as best calculated to preserve, in chronological progression, a review of the Georgian era, as illustrated by our satirist.

A certain proportion of the artist's earlier sketches are uninteresting, whether as pictures or as keys to notable events, when contrasted with his more celebrated and later designs, worked out at times when history was unfolding some of her most exciting spectacles.

The tone of our summary is necessarily influenced by the character of the works we have to elucidate, and the descriptions of the earlier subjects are restricted in proportion to the interest offered by the originals.

From 1769 to 1781, the prints were issued at irregular intervals; and this period produced various etchings, of somewhat questionable authenticity, which we think it better to pass unnoticed. Examples possessing historical value, or giving promise of the caricaturist's future power, are few and far between. A number of pencillings, of slight interest, mark the industry of Gillray's youth; they are uninteresting to all save the print collector, who, in the ardour of his pursuit, may labour to disinter them from obscurity. We have accordingly determined to ignore the cruder etchings, indifferently ascribed to Gillray and to certain of his contemporaries.

In 1782, the cartoons assume a more definite individuality, and for nearly thirty years they embalm every event which attracted the artist's attention, varying in dignity from the centre of the throne to the darkest outer circles of society; from the convulsions of a continent to the eccentricities of a fashionable celebrity.

The earlier etchings which we have to particularize commence with the *Committee of Grievances and Apprehensions*, published by Humphrey, June 12th, 1769, a reduction of which has already been given on p. 10.

June 8th, 1774. *A Rotation Office.*—Five figures seated round a table; the person of one resembling Doctor Johnson. The execution somewhat in the manner of Rowlandson.

1775. *An Emblem of Modern Marriage (Lord Hervey's Reply to Hammond's Verses to Miss Dashwood)*—

> "No smile for us the godhead wears—
> The torch inverted and his face in tears."

The figure of Hymen is in harmony with the couplet. A skeleton bridegroom leads forward a very slim bride. In the distance are indicated a mansion and a coronet—a comment on mercenary marriages.

October, 1777. *The Death of Rochester.*—The dying wit is stretched out in very doleful guise, his face rendered more dismal by a white nightcap. A clergyman, wearing huge horn spectacles, is reading Genesis xix.

October 28th, 1777. *A Trip to Cock's Heath.*—The scene of an encampment.

November 13th, 1778. *Squire Thomas just Arrived.*—A stout country squire has become the unre-

E 2

sisting prey of a bevy of ladies of suspicious character, who are dragging him towards a house bearing the inscription, "Kind and Tender Usage." Published by W. Humphrey (at St. Giles's).

1778. *Grace before Meat, or a Peep at Lord Petre's.*—In 1778, George III. announced his intention of holding a review on Warley Common, and on the 20th of October Lord Petre invited the King and Queen to take up their residence at Thorndon Hall during their progress to Warley. The invitation was accepted, and Lord Petre went to an expense of about 15,000l. in preparing for their reception. Sixty upholsterers were employed for a month in embellishing the apartments for the occupation of the Sovereign. The state bed alone cost two thousand guineas; but their majesties made no use of it, their own field bed having been, according to custom, sent down. Considerable comment was excited by this visit, owing to the circumstance of Lord Petre being the first Catholic peer who had been so honoured since the Hanoverian succession. This mark of esteem was hailed by the Liberal press as an inauguration of the abandonment of ill-founded and obsolete prejudices. A large section of the community was, however, scandalized by this condescension to a Catholic nobleman, occurring, as it did, about the time of the agitation which attended a "Bill for the relief of Roman Catholics." Gillray was strongly biassed against the Catholics; toleration was but little understood in his day, and he resolutely attacked every measure which favoured the adherents of the Romish Church. Indeed, the popular suspicions were generally excited against Catholic influences and reactionary tendencies; even Horace Walpole, writing to Cole in 1718, observes: "May not I, should not I, wish you joy on the restoration of Popery? I expect soon to see Capuchins tramping about, and Jesuits in *high places*. We are relapsing fast to our primitive state, and shall have nothing but our island and our old religion." In Gillray's caricature the King and Queen appear at Lord Petre's dinner-table, seated beneath a canopy which bears the royal arms; their hands are folded, as are those of every one seated at the table; while a sorry-looking monk is invoking a blessing on the meal, as an indication of the ceremonies to which the guests would have to submit. Among the assembled guests, all of whom are broadly caricatured, are portraits of Lord and Lady Petre, Lady Effingham, and Lord Amherst. Lord Petre was one of the greatest philanthropists of his age, and after his death it was discovered that he had spent 5000l. a year in charity.

February 9th, 1779. *The Harlot's last Shift.*—This print, although coarse in subject and expression, is an example of Gillray's growing power; the execution is far above the average of his early works, and gives promise of the proficiency which he afterwards attained. The heroine is very inadequately clothed, with the exception of her head, which is remarkably "full dressed." The hair, cushioned up to the summit of fashionable extravagance, is crowded with beads, bows, streamers, love-knots, flowers, and feathers. The unfortunate fair, who is engaged in washing her last article of apparel, is said to present the features of Lady Wortley Montague, but the resemblance is as questionable as the taste which suggested such an outrage on the reputation of that accomplished lady. The picture exhibits to the full the decayed

fortunes of the Cyprian; the garret she occupies is dilapidated and unfurnished, the tumble-down truckle bed is covered with rags, the single chair and the limited crockery are broken, and her stockings, of the gayest green, are diversified with tatters. A fine out-of-door hat is thrown on the floor, a cat is swearing at the open window, on the panes are pasted a broadside ballad setting forth the "Comforts of a Single Life," whilst a torn print of "Ariadne Forsaken" completes the suggestions of misfortune.

March 4th, 1779. *Paddy on Horseback.*—In 1779 the subject of relief for Ireland was one of the most prominent questions, and an outcry was raised for new commercial regulations, the Irish trade being much depressed by the American war. This produc-

Paddy on Horseback.

tion, which has been incorrectly described as Gillray's earliest work, appears to be a double reference to the agitation just referred to, and to the popular notion that the sons of the sister isle came to England

as fortune-hunters, in which character they were abundantly satirized by the novelists and play-writers of the period. The etching, which is somewhat stiff in execution, may, with certain of Gillray's earlier plates, be considered rather as an example of his engraver's training, than as an instance of his facility as an artist.

September 5th, 1779. *The Church Militant.*—A stout Archbishop, in full canonicals, mounted on a prancing horse, and conducting his warriors with drawn sword, demands, "Bella, Horrida Bella." The clerical veterans march to battle chanting in true ecclesiastical style, although their version of the National Anthem cannot be considered altogether episcopal, and two choristers (Hogarthian in type) lead off with the verse commencing—

> "O Lord our God, arise !
> Scatter our enemies."

"Give us good beef in store," carols a portly champion; while the musket-bearing bishops and canons conclude the verse in allotted parts—

> "When that's gone, send us more,
> And the key of the cellar door,
> That we may drink !"

This satire is aimed at the zeal expressed by the members of the State Church for a crusade against the American colonies and against Spain.

Cornwallis Archbishop of Canterbury, Markham Archbishop of York, and Butler Bishop of Oxford, adherents of Lord North, are probably indicated amongst the clerical levies.

October 15th, 1779. *Liberty of the Subject.*—A picture of the violation of personal freedom which was at that date an every-day incident, calculated to temper the bellicose proclivities of the "war party." A body of the press-gang are crimping "lands-men" and waterside helpers to serve in the royal navy. The gang, consisting of an officer, a boat-swain, and numerous sailors, armed with for-midable cudgels, have captured an unhappy tailor, and are forcing him away from his trade and family; his wife is offering no despicable resistance to this abduction of the bread-winner.

December 8th, 1779. *Implements for Saddling an Estate. A piece of still life addressed to the Jockey Club.*—"The piece" is composed of a saddle and stirrups, a jockey-cap and whip, and a prize silver cup and cover. In the background is a racing escutcheon, consisting of two blacklegs, the ace of diamonds, and a brace of pistols. "The painter has drawn these implements with some degree of success, but they are very seldom successful to any

Liberty of the Subject.—The Pressgang.

but a painter; the cap is made of so happy a size as to fit any blockhead," &c. We learn from the commentary offered by this etching and the inscription which accompanies it that the effects of turf speculation were considered as deplorable in the "infancy" of horse-racing as in our own day they have proved to be.

The earlier works of Gillray (1769–80) are mostly upon social subjects, and were published without any regular connexion. From 1780 the progress of the political events then transpiring may be readily studied, as regards outline, in the caricatures which the artist began to issue with some approach to systematic publication, although the intervals between the appearances of the various satires were somewhat irregular.

June 4th, 1780. *John Bull Triumphant.*—The English Bull, represented as greatly infuriated, has tossed the Spanish "Don" high into the air, and the dollars of the latter are dropping from his pockets.

Members of Lord North's Administration vainly try to restrain the triumphant animal by hanging on to his tail; and a Dutchman, seated on a tub of Hollands, is grinning at the position of affairs. In the foreground Gillray has delineated the typical Frenchman and American of that era, each exhibiting consternation. The whole caricature conveys an idea of the hopeful state of feeling at the commencement of 1780, when our successes over the Spaniards, and the partial progress of our arms in America against the allied colonists and their foreign supporters, inspired delusive hopes of success. The following jingling couplets explain the situation :—

> "The bull, see, enraged, has the Spaniard engaged,
> And giv'n him a terrible toss ;
> As he mounts up on high, the dollars see fly,
> To make the bold Briton rejoice.

> "The Yankee and Monsieur at this look quite queer,
> For they see that his strength will prevail ;
> If they'd give him his way, and not with foul play
> Still lug the beast by the tail."

Monsieur and the Yankee.

The encouraging state of our arms abroad is pursued in a caricature which followed the "Enraged Bull" on March 8th, 1780, entitled, *Triumphant Britons.*—The Guards have overcome the Spanish and French troops in a victorious charge. This drawing is very spirited, and is usually printed in sepia, in imitation of an original sketch.

A certain want of reliance on the wisdom of the King, and mistrust of the Scotch faction, in whose hands the monarch at that time reposed, were not allayed by the success of our arms; and we find the popular view of the situation summed up in a caricature published May 15th, 1780, entitled *Argus.* King George is helplessly asleep ; the Scotch party have already secured the sceptre of power, and are cautiously removing the crown from the slumberer's head. "What shall be done with it ?" asks a chief, who figures in a plaid and Scotch bonnet (probably intended for Lord Bute). "Wear it yourself, my laird," suggests a high legal functionary ; but the most prominent of the plunderers observes, "No, troth, I'se carry it to Charley, and he'll not part with it again." A miserable figure in rags on the opposite side, supposed to be a personification of the English community, clasps his hands, and cries, "I have let them quietly strip me of everything." An Irishman, departing with the harp under his arm, protests, "I'll take care of myself and family." A representative of the estranged colonists, smiling at the helpless position of the monarch, says, "We in America have no *crown* to fight for or lose." Behind the hedge which forms the background, a Dutchman feeds upon honey, during the absence of the bees from their hives. In one corner Britannia sits weeping, and her lion reposes in chains close to a map of Great Britain, from which America is torn.

Earl of Hertford.

In May and June appeared a few neat little etchings of public celebrities, which, both in character and execution, equal any works of this order. The portrait of *Lady Cecilia Johnston*—

Britannia Dejected.

to whom, as later caricatures unmistakeably exhibit, Gillray had some personal antipathy—first appeared in this form.

In June was published a portrait of *Francis Earl of Hertford*, whose name is rather notorious amongst the chronicles of his day.

On June 9th, 1780, appeared, *No Popery, or a Newgate Reformer—*

> "Tho' he says he's a Protestant, look at the print,
> The face and the bludgeon will give you a hint ;
> Religion ! he cries, in hopes to deceive,
> While his practice is only to burn and to thieve."

A Reformer.

This caricature is the only record Gillray has preserved of the agitation and dismay excited in the minds of the citizens of London by the actions of the barbarous ruffians who, under the title of "No Popery" reformers, brought about the "Gordon" riots. The hesitation and ignorance of the administrative bodies permitted these rioters to plunder and set fire to buildings for an entire week before measures were taken for their dispersion. We need hardly say that Charles Dickens in his novel of "Barnaby Rudge," has given a graphic picture of the rise and progress of the Gordon rioters and the so-called "Protestant Association," with the ultimate fate of the rioters.*

The year 1781 is not rich in caricatures by Gillray. In July, however, he published a portrait of *General Lafayette.* There was an interest excited in this adventurous leader, which increased its hold on the public mind as the events of the French Revolution and the advance of principles founded on an admiration for American institutions, brought this apostle of new theories into prominent notice. The rulers of

* We extract the following from Mr. Wright's "Caricature History of the Georges:" " For some time the dread of Popery had been gaining ground, excited in some degree by the outcries of those who were opposed to the question of Catholic emancipation, which was now beginning to be agitated. Some bigoted people were even weak enough to believe that King George himself had a leaning towards the Church of Rome. This was especially the case in Scotland, where there had been serious no-Popery riots in the beginning of 1779. It was a Scottish madman, the notorious Lord George Gordon, whom Walpole designates as 'the Jack of Leyden of the age,' who led the cry in England, and who had placed himself at the head of what was called the Protestant Association. After having troubled the House of Commons with inflammatory speeches during the whole of this session, Lord George gave notice on the 26th of May, 1780, of his intention on the 2nd of June to present a petition against toleration of Roman Catholics, signed by above a hundred thousand men, who were all to accompany him in procession to the House. We are told that the only precaution taken against the threatened mob was an order of the Privy Council on the previous day, empowering the First Lord of the Treasury to give proper orders to the civil magistrates to keep the peace, which the First Lord of the Treasury forgot to put into effect.

"On Friday, the 2nd of June, an immense multitude assembled in St. George's Fields, where Lord George addressed them in an inflammatory style, and then they marched in procession, six abreast, over London Bridge and through the City to Old Palace Yard, where they behaved in a most riotous manner. Many members of both Houses were ill-treated, and one or two narrowly escaped with their lives. The confusion within doors, especially in the House of Lords, was very great ; the Lords broke up without coming to any resolution, and made their escape. The House of Commons behaved with more firmness. But it was not till late in the evening that the mob were prevailed upon to disperse. On their way home they attacked and burnt two Catholic chapels, that of the Bavarian Ambassador in Warwick Street, Golden Square, and that of the Sardinian Ambassador in Duke Street, Lincoln's Inn Fields. The mob assembled again on the night of Saturday, in the neighbourhood of Moorfields, and continued during the night to molest the Catholics who inhabited that part of London. Some military were ordered to the spot on Sunday morning, but no efficient measures were taken to suppress the rioters, and on Monday morning, when there was a drawing-room for the King's birthday, the disturbances had become much more serious. Under the cry of 'No Popery,' all the worst part of the population of the metropolis had now collected together, and London was entirely in their power during the rest of the day and the whole of the following night. Early on Monday morning they robbed and burnt the house of Sir George Saville, in Leicester Fields, because he had been the prime mover of a proposed act for showing religious tolerance towards the Catholics. Several chapels and some private houses were plundered and destroyed, and fires were seen in various parts of the town. Both Houses met, but some of the members were attacked on their way, and Lord Sandwich fell into the hands of the populace, and was with difficulty torn from them after he had been severely hurt. The House of Lords adjourned immediately ; but in the Commons there were hot debates, and several strong resolutions were passed. As evening approached, the mob, which had increased, and consisted now of all the lowest rabble of London, rushed to Newgate, set fire to the prison, which was entirely destroyed, and liberated all the criminals. These joined the rioters, who now became more ferocious, and went about ravaging and plundering in the most fearful manner. The new prison at Clerkenwell

France were doomed to reap a bitter harvest of retribution from the popularity of the new American republic, which they had contributed to establish.

About the time of the appearance of Lafayette's curiously elongated portraiture Gillray also produced a happy likeness of *Pensionary Van Berkel*, which he published in a well-finished etching.

On July 12th, 1781, appeared the portrait of *Sir Samuel House*, executed in red and black, in imitation of a drawing; the motto is, " Libertas et natale solum." On the punch-bowl of the patriotic publican is inscribed, " Fox for ever." We shall meet honest Sam House performing a very disinterested part in 1784, at the famous Westminster election. His eccentric figure is prominent amongst the hosts of caricatures put forth in the course of that exciting contest, during which Sam kept open house at his own expense, and was honoured by entertaining nearly all the distinguished members of the Whig aristocracy and their followers. Sam House was remarkable for his perfectly bald head, over which he never wore hat or wig. His unvaried dress consisted of nankeen jacket and breeches, and brightly

General Lafayette.

polished shoes and buckles; he had his waistcoat constantly open in all seasons, and wore remarkably white linen. His legs were generally bare; but, when clad, were always in stockings of the finest quality of silk. In Gillray's portrait the sturdy publican sits calmly enjoying his punch, displaying all his characteristics of eccentric costume and shining round poll. In the epoch of bushy artificial wigs and shaven crowns, the appearance of a natural bald head was considered a remarkable spectacle.

November 19th, 1781. *Charity Covereth a Multitude of Sins.*——This social sketch is aimed at the frailties of the time. The picture represents two pretty and gracefully drawn nymphs, leaning out of " Mrs. Mitchell's" window. A smart young officer, who is knocking at the door and smiling at the damsels, has just contributed alms to a group consisting of a sailor on crutches, an organ-grinder, and a " hurdy-gurdy" woman.

August 1st, 1781. *Les Plaisirs du Ménage.*

" Give me the sweet delights of love."

The author of the catch thus illustrated aspires to the possession of

" A smoky house, a failing trade,
Six squalling brats, and a scolding jade."

The unhappy husband, a pitiable object, stands in bewilderment surrounded by the combined blessings referred to in the song.

1782.

In 1782 the productions of Gillray's graver were more numerous, and they began to assume a character of greater importance.

January 25th, 1782. *A Meeting of Umbrellas.*—(The umbrella was then a fashionable novelty.) We have a consultation of a soldier, a citizen, and a *petit-maître*, all following the mode.

was also broken into, and the prisoners set at liberty. They next attacked and plundered the house of Sir John Fielding, the police magistrate, and burnt down the house of Lord Mansfield in Bloomsbury Square, destroying in it, among other things, a valuable library of ancient manuscripts. All day on Tuesday, and throughout Tuesday night, the populace went about robbing, and burning, and drinking,—and this latter occupation only added to their fury. On Wednesday, the King's Bench, the Fleet, and other prisons were burnt, and two attacks were made on the Bank of England, but the assailants were driven back with great loss by the soldiers who guarded that important building. Various other public buildings were marked for destruction. People now, however, began to recover from their panic, and voluntarily armed in defence of their property, and troops, as well of the regulars as of the militia, were pouring into London; yet during the Wednesday night the town was on fire in no less than thirty-six places, and the destruction of property was immense. On Thursday, the 8th of June, after many had been killed by the soldiery, and a still greater number had perished through intoxication in the burning houses, tranquillity was restored, and the capital was saved from the hands of a mob which seemed at one moment to threaten its entire destruction. On Saturday, Lord George Gordon was committed to the Tower; and he was subsequently brought to trial for high treason, but was allowed to escape conviction; and he eventually showed sufficient proofs of mental derangement."

March 10th, 1782. *Old Wisdom blinking at the Stars.*—Doctor Johnson, represented as a purblind owl, blinks at the busts of Milton, Pope, &c., surrounded by the stars of immortal fame; the claws of the nocturnal bird rest on the "Lives of the Poets," the narrow-minded Introductions in which reflect so little credit on the Doctor's name. The great Doctor was no favourite among the liberal

Old Wisdom.

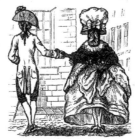

Crossing the Street.

thinkers of his day; his hostility to talent in others, his disparaging opinions of the merits of his contemporaries, and his unpopular political tendencies, drew upon him much disapproval. His pension, the subject alike of reproach and of envy, provoked the satire of Churchill :—

> " Some, dead to shame, and of those shackles proud
> Which Honour scorns, for slavery roar aloud;
> Others, half palsied only, mutes become,
> And what makes Smollett write, makes Johnson dumb."

The famous interview between the lexicographer and the King, fondly dwelt upon by the former, excited the irony of Peter Pindar, and brought upon the time-serving Doctor many severe allusions to his muzzle.*

March 14th, 1782. *Sir Richard Worse than Sly.*—This sketch, although rather bold as regards the subject, is executed with a certain delicacy. It preserves the record of a scandal which attracted a large share of public attention in 1782. It transpired, in a case tried before Lord Mansfield—the Lord Penzance of a day when Divorce Courts were not—that Sir Richard and a certain captain had played the part of the Elders with Susanna in regard to the wife of the former gentleman. The magazines and the daily press busied themselves with this case, which gained an unhealthy notoriety, and provoked a thick volume of satires and verses on the conduct of the parties concerned.

Guy Vaux.—This caricature appears to be Gillray's first political work of any significance; and in it the young artist has made some exertions to preserve tolerable likenesses of his *dramatis personæ.* In earlier political skits the portraits are merely conventional types, borrowed or stolen from one caricaturist by another. George III. appears here in the kingly presentment which Gillray's works were destined to stamp as the familiar image of the Sovereign.

Lord North had remained Minister, with various changes among his colleagues, from 1770 to 1782— that is, during the whole of the American war. His firm hold of office was universally understood; although his Government was badly supported—his majorities being of the smallest, and his successes few, while his failures were numerous—it was known that his easy subservience to the Royal will made

* "The story goes that Sam, before his *political* conversion, replied to his present Majesty, in the library at Buckingham House, on being asked by the monarch why he did not write more, 'Please your Majesty, I have written *too much.*' So candid a declaration, of which the sturdy moralist did not believe one syllable, procured him a pension and a muzzle."—*Dr. Wolcot.*

F

the Sovereign loth to part with so complaisant a Minister; and the difficulties of dislodging the somnolent North from his repose on the Treasury bench were complicated by the circumstance that the monarch treated the attacks of the Opposition as blows aimed at his own person.* The caricature of Guy Vaux indicates the position of affairs previous to the overthrow of the North Administration. The

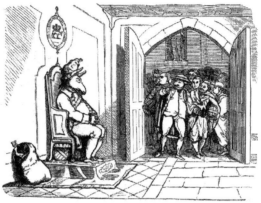

Guy Vaux.

King is asleep, his hands are tied, and his throne is undermined, while the regalia and insignia of royal authority are packed up for removal. A donkey supporting the crown burlesques the royal escutcheon. The intriguing leaders of the Opposition appear beneath the picture of Catiline. Fox enters stealthily, with a dark lantern; on his right is the Duke of Richmond, carrying fagots; behind him is the leering face of Wilkes; Lord Shelburne carries a barrel of gunpowder; Keppel's dark brows peer over his shoulder; and Burke, with his inevitable horn spectacles, has come to assist. The cloaked figure next to Shelburne is believed to represent Dunning, who, in the April of 1780, had carried the famous resolution against the overgrown influence of the Crown. As Dunning rarely appears in the series of Gillray's political designs, it is proper to record that he received a pension of upwards of 3000*l.* a year from Lord Shelburne's Government, which succeeded that of the Marquis of Rockingham in 1782. The authorship of "Junius's Letters" was ascribed to Dunning, among others.

April 5th, 1782. *The German Dancing Master.*—An eccentric figure performing on a kit, or dancingmaster's fiddle, said to represent Jansen, the famous "Maître de Ballet Allemand."

April 12th, 1782. *Banco to the Knave.*—The North Administration resigned in March, and was succeeded by a Ministry under Lord Rockingham, which embraced both sections of the Opposition. The negotiations terminating in the overthrow of Lord North's party were conducted between the King and Lord Shelburne, whose views accorded more nearly with his own than did the liberal principles of Lord Rockingham. Three conditions had been insisted on in forming this Administration, and to these stipulations the King's consent had been obtained: (1) Peace with the Americans, and the acknowledg-

* It was widely believed that the King's will had for some time been the rule according to which his Ministers shaped their measures, and that he showed the greatest reluctance to admitting to any share in the government of the country those who were not "his friends." Most of the leaders of the Liberal party were to him objects of personal animosity.

ment of their independence; (2) A substantial reform of the Civil List expenditure; and (3) Diminution of the influence of the Crown. "Banco to the Knave" represents the *political* position. Lord North, who has been holding the bank, is completely bankrupt from the stakes due to the players seated round his gambling-table, by each of whom a winning card is held. Fox, who has been playing for heavy stakes, observes, "Gentlemen, the bank is mine, and I will open every night at the same hour." There is a large assemblage of the leading politicians of the day, whose portraits are slightly indicated. One of the Secretaries of the Treasury, Sir Grey Cooper, exclaims, "I want a new master." Gillray has inscribed the name of "Sir Grey Parole" on his chair, because he usually sat on the left hand of Lord North on the Treasury Bench; and when that statesman, who trusted to his memory for the principal facts elicited in the debates, had become the victim of the constitutional somnolency which afforded the House so much amusement, the Secretary supplied the deficiency of notes by suggesting the subject, or *parole*. The "Shuffler," who sits with his back to the spectator, and exclaims, "Alas, what a deal!" is intended for the Chancellor, Lord Thurlow, who retained his office in both administrations. The reforms taken in hand by the new Ministry were very unpalatable to the King, who offered constant opposition through Lord Thurlow, with whom Fox was very reluctant to take office. Thurlow was the special representative of the royal obstinacy; the monarch found in the vehement Chancellor a formidable ally, and he accordingly clung to the "black-browed thunderer," in the face of popular opposition. We shall find this compact illustrated in the progress of the caricatures, until ten years later the contest resolves itself into a duel between William Pitt and Thurlow, respectively protected by the Queen and the King. The active will of the valiant little Charlotte was law in this and in many similar matters, and the "Wolsey of the woolsack" realized the fate of the Cardinal in his fall.

April 24th, 1782. *St. Cecilia.*—Lady Cecilia Johnston, who constantly, for some unexplained reason, came under the satire of Gillray, is burlesqued in a travestie of Sir Joshua Reynolds's charming conception of St. Cecilia, painted from Mrs. Sheridan, whose sweet voice was highly lauded in her day. "Hers was truly a voice of the cherub choir," writes one who had the happiness to hear her sing. Sir Joshua has introduced into his picture two interesting children (the little daughters of Mr. Coote), to mark the gentleness of his Cecilia; Gillray's parody has substituted two cats, which are dismally squalling.

May 4th, 1782. *Parsons the Comedian.*—A clever little etching, preserving all the character and humour of the comedian's remarkably pliant face.

May 10th, 1782. *Britannia's Assassination, or the Republican Amusement.*—Britannia is represented as a statue, headless, and falling to pieces; her spear is broken, and Lord North is carrying off her shield. Fox, represented as one of his four-footed namesakes, is tearing her with his teeth; Wilkes is assailing her with a libel; Lord Sydney hurls "Sydney on Government" at the bust; the Duke of Richmond is despatching her with the butt-end of a musket, crying, "Leave not a wreck behind!" Keppel is hauling down her flag, observing, "He that fights and runs away," &c.; the Chancellor and his colleagues are hauling down the image with ropes; America is running away with Britannia's head, her arms, and her laurels. The conventional figure which was employed to indicate this

Parsons the Comedian.

new power is thus addressed by France: "You dog, you run away with all the branch!" whilst Spain makes off with one of the legs in the general dismantlement.

The caricature of "Britannia's Assassination" is a very slight over-statement of the despondent feelings then prevalent. People were thoroughly disheartened; the position of England was discouraging on every side; her enemies, both in America and in Europe, declined to come to any terms which were not degrading to this country. Rodney, a staunch Tory, was recalled from the fleet in the West Indies, where he had not yet performed what had been anticipated; and the new Liberal Administration sent out Admiral Pigot, their own partizan, to supersede Lord North's commander. In the midst of these embarrassments, on the 18th of May, the whole country was thrown into "a delirium of joy," by the news of Rodney's splendid victory over De Grasse, off Guadaloupe, on the 12th of April, which had

annihilated the French fleet, defeated their junction with the Spanish forces, preserved what remained of our West Indian possessions, and in one day restored to England the sovereignty of the seas. This action, which was fought with the utmost heroism on both sides, lasted from the 9th to the 12th of April.

May 31st, 1782. *Rodney Invested, or Admiral Pig on a Cruise.*—Rodney, standing on a rock, restores her spear to Britannia, who is seated on the globe, once more grasping the laurels of victory: " Go, generous, gallant Rodney," she says; " go on, pursue, maintain your country's noble cause ;" whilst Neptune, rising from the deep and surrendering his trident into the hands of the Admiral, bids him— "Accept, my son, the empire of the main." The British lion is tearing the standard of France, cast beneath Rodney's feet. In the background Admiral Pigot, with the head of a pig, is cruising in a boat made of playing cards, a knave of hearts forming the main-sail, and dice being painted on the ensign ; Fox, who appears in the distance, holding an IOU for 17,000*l.*, asks, " Does the Devonshire member want reasons ? 17,000*l.* contains cogent ones !" The reference is to a scandal concerning Fox's gaming-table.

May 31st, 1782. *Rodney Triumphant, or Admiral Lee Shore in the Dumps.*—Rodney is receiving the sword of De Grasse, who had fought bravely to the last ; behind the French Admiral stand files of captives—for the French fleet was crowded with troops, and, although the carnage was frightful, there were numerous prisoners. The British seamen bear cases of louis d'or, and behind them appear the captured fleet, with the Union Jack flying at the peak above the French ensign. Richmond, Fox, and Keppel stand by with sulky expressions. Keppel, who wears a crape band in mourning for the occasion, mutters, " This is more than we expected, more than we wished ;" Richmond observes, " 'Tis the last fleet he shall have the opportunity of beating, however ;" and Fox exclaims, "D— the French for coming in his way, say I." Above Rodney's head is a baron's coronet, with the words " From *Jove.*"

June 7th, 1782. *Rodney introducing De Grasse.*—The conqueror presents his illustrious captive at the foot of the throne. According to the drawing a fresh feather is added to the monarch's crown. Fox, on the King's right hand, observes, " This fellow must be recalled ; he fights too well for us, and I have obligations to Pigot." Keppel is reading the list of captures, and he frowningly remarks of the *Ville de Paris* (De Grasse's flag-ship), " This is the very ship I ought to have taken on the 27th of July."

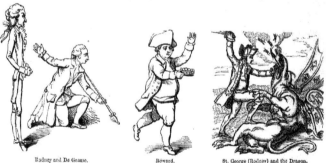

Rodney and De Grasse. Reward. St. George (Rodney) and the Dragon.

June 13th, 1782. *St. George and the Dragon.*—George Rodney in the grasp of a ferocious monster is smiting it with his sword, and making the dragon disgorge hosts of frogs; in reference either to the popular theory of French frog-eaters, or to the relinquishment of certain Dutch possessions. This monster is highly fanciful, and is a good example of Gillray's ingenuity in the construction of fabulous creatures. Fox, rushing up with great impetuosity, cries, " Hold, my dear Rodney, you have done

enough. I will make a Lord of you, and you shall have the happiness of never being heard of again." Rodney, who had pursued one of the most distinguished careers, commencing with the destruction of Havre de Grâce, and who had patriotically declined the most munificent proposals from the enemies of his country, was so lightly esteemed, for party reasons, by the patriots at home, that he received only a formal vote of thanks, a pension of 2000*l.* a year, and the lowest step of the peerage. Sir George Rodney was then dismissed into obscurity, and the command of the fleet was entrusted to Lord Howe.

June 13th, 1782. *Irish Gratitude.*—The Lord Lieutenant, followed by Lord Charlemont and others, presents a deed inscribed "Grant of the sum of 100,000*l.* to H. Grattan, Esq." He addresses the patriot, "To you, Sir, as the deliverer of our country, and the establisher of our peace, the senate and people of Ireland dedicate this small token of their gratitude." Behind Grattan representatives of the populace are kneeling, headed by a monk, a Jew, and a minister of the Protestant Church. The Parliament of Ireland voted on the 31st of May the sum of 50,000*l.*, "for purchasing an estate and building a mansion thereon, to be settled on Henry Grattan and his heirs as a reward for his exertions in the cause of Irish independence."

In 1780 Lord Charlemont had organized the Irish Volunteers, avowedly to resist foreign invasion; it soon became evident, however, that the "Volunteers" constituted a deliberative body, whose determinations it was dangerous to resist. Mr. Grattan was the suggester and framer of their political demands, which were directed to a complete legislative independence. Lord North's Administration ignored these claims, and civil war appeared imminent, when the accession of Lord Rockingham's party to power resulted in the removal of all the Irish grievances, and the concessions prayed for in their address to the throne were granted. Thus terminated this remarkable contest, in the grant of a constitution which was destined shortly to be fused in the union carried out at a later date under the immovable Pitt. Both the Irish House of Commons and the Lord Lieutenant appeared to compete for popular favour by their acknowledgments of the patriot's services, and by the munificence with which they proposed to recognise his exertions. Grattan's name as an orator of the most energetic order will be highly appreciated for ages. His figure reappears in Gillray's caricatures in 1798 (Irish Rebellion), and 1805 (Catholic Emancipation).

July 15th, 1782. *Monuments lately Discovered on Salisbury Plain.*—We are here introduced to a contemporary scandal concerning the Prince of Wales's pointed attentions to the Marchioness of Salisbury. As the gallantries of the heir apparent appear prominently in the works of Gillray, we feel justified in giving the outlines of a few of the notorious attachments which then provoked public comment, and, as a rule, were doubly interesting to the nation from the costly extravagance of the princely *roué*. These matters occupied so large a share of the attentions of the fourth George that his *liaisons* and their consequences constitute nearly the entire history of Prince, Regent, and King alike; and the circumstances are so completely admitted, that we feel secure of escaping any charge of indecorum in referring to subjects which are now historical, and which in their day engaged the largest share of popular notoriety.

The monuments represented on Salisbury Plain, and numbered as if from a museum of antiquities, are (1) the Marchioness of Salisbury, and (2) the Prince of Wales, who exclaims, "Oh, let me thus —— eternally admiring, fix and gaze on those dear eyes, for every glance they send darts through my soul." The descriptive catalogue explains: "The figures No. 1 and 2 are judged by connoisseurs to have been lately animated with the celestial fire." (3) The Marquis of Salisbury, represented as a clumsy figure of stone, is depicted stamping in a fit of jealousy. His face is a mere blank, but two suggestive buds are beginning to sprout from his temples. Bate Dudley, in his "Vortigern and Rowena," remarks of the ill-used Marquis, "He is so great a naturalist, that he knows the *budding* season by the note of the propheticke cuckoo." The catalogue continues: "No. 3 is an unfinished resemblance of the human form; from the vacancy of countenance and roughness of workmanship, this figure cannot be supposed to have been ever intended as a companion to No. 1." "Zounds, Sir, leave my wife alone, or I'll tell the old Whig" (the King), exclaims the enraged husband.

A fourth figure, in a posture expressive of astonishment and dismay, cries, "To leave me thus!" "No. 4," says the description, "from the attitude, &c., is supposed to represent some forlorn Dido or

forsaken Ariadne of quality," &c. The figure is generally believed to be intended for Mrs. Mary Robinson.

The name of Mrs. Robinson deserves more than the casual reference found in this caricature. Great interest surrounds the fate of this gentle and unfortunate lady. Her beauty, the vicissitudes of her youth, the brilliancy of her appearance on the stage, the devotion of the Prince, her sorrows, her desertion, her successes in literature, and the cruel disease which terminated a career distinguished by the charms of popular applause, of dazzling elevation, of the society of the greatest geniuses of an age of which she was considered by some as one of the brightest stars, combine to invest with romantic interest the memory of Perdita.

The "British Sappho," at her decease in 1800, left four volumes of memoirs, published in the ensuing year, in which

A bird of Paradise.—Understood to represent Perdita.

the story of her life is simply and artlessly told. Although her earlier lyrics are disfigured by the false taste of the "Della Crusca" school, her later productions exhibit elegant versification and rich imagination, and her prose composition is natural and fluent. She was born at Bristol. Her father was a man of position, who, as a merchant, displayed too sanguine a disposition. He was the projector of the noted Labrador whale fishery scheme, and finally retired to America. Mr. Robinson, an attorney, who represented himself as the heir to a good estate, and whose command of money and credit was deceptive enough to impose on her stepmother, obtained the hand of Perdita when she was but fifteen years old. Her husband proved to be an illegitimate son and an adventurer, and he exposed his wife to a thousand temptations, and to such dangerous companionship as the premature collapse of his credit entailed. The abandoned Lyttleton chiefly contributed to the ruin of Mr. Robinson, hoping in this way to succeed in the seduction of the child-wife. But her fidelity at this period appears to have been beyond suspicion.

She had already enjoyed the friendship of Garrick, and the advantage of his abilities in developing her qualifications for the stage, which had at one time been contemplated as her future career; and the embarrassments from which she suffered, her husband having now become the inmate of a jail, caused her once more to direct her attention to the theatre. Sheridan was strongly attracted by her grace and accomplishments, and favoured her pretensions in this direction; and the last days of Garrick's life were devoted to perfecting his former pupil in the part of Juliet, in which character Sheridan had decided she should appear. Within a week or so of his death Garrick sustained the part of Romeo in order to prepare her for the ordeal of a first performance.

Her graceful person and her unaffected elocution won golden opinions from the audience. Her abilities were applauded, her beauty was admired, while the means she obtained from her profession supported her abandoned husband in every kind of dissipation. Some simple, touching verses on captivity, which she wrote about this time, secured her the friendship of the Duchess of Devonshire.

The most eventful evening of her life arrived. The Royal Family occupied the State box to witness the performance of the "Winter's Tale," in which the favourite of the people was to appear as Perdita. The Prince of Wales, young, charming, and as yet unspoiled by indulgence, occupied a seat with his uncle the Duke of Cumberland, and his brother Frederick, Duke of York and Bishop of Osnaburg. Lord Malden met and complimented the engaging Perdita even before the performance had commenced,—the royal circle were all smiles and gracious appreciation; the poor girl was completely dazzled, and Prince George at once surrendered his heart to the captivating actress.

The story of this pair, both of whom were idolized by a thousand flatterers, is perfectly clear. The attentions of the Prince were encouraged by the surrounding circle. Burly Cumberland curried favour by humouring one who, had up to that time been kept under a restraint as fraught with danger as was the licence which he shortly assumed. The Prince

> "Gazed on the fair
> Who caused his care,
> And sigh'd and look'd, and sigh'd again."

Lord Malden, with apologies for his office, conveyed numerous tender messages from Florizel, but for some time the intrigue continued without the principal actors meeting.

The public were full of excitement. The press teemed with hints about the favour of Mrs. Robinson with "one whose manners were resistless, and whose smile was victory!"

The Prince sent by the same Lord Pander his portrait in miniature, by Meyer; within the case was a small heart cut in paper, on one side of which was inscribed, "Je ne change qu'en mourant," and on the other, "Unalterable to my Perdita through life." Poor Perdita in 1800, crippled and dying, in a rapid consumption, still treasured these boyish tokens. But the beaming Florizel was then hardly less changed than poor Sappho; a career of dissipation and confirmed selfishness had caused all his graces to fade, and had left him with a nature neither estimable nor improving to contemplate.

The two lovers at last obtained an interview by stealth. The Prince was under the strictest surveillance, and the rendezvous had to be contrived with some cunning. Lord Malden carried Perdita to Kew, then the favourite residence of the King, a boat conveyed her to the royal precincts, and from the iron gates of old Kew Palace

emerged the Prince of Wales and the irreverent Prince-Bishop, his brother. The meeting took place in the evening. Writing in 1783 to a friend in America, Mrs. Robinson dwells tenderly on "his melodious yet manly voice—the irresistible sweetness of his smile." But the persuasive tones of that captivating voice were cut short by an alarm of intruders, and away scampered this Decameron-like assembly—the light-footed Perdita to her skiff, which Leporello rows swiftly into the darkness, and the princes hastily retire to their irksome seclusion.

These nocturnal promenades were continued. Sometimes the Prince sang (Perdita records, "with exquisite taste"), and his harmonious voice—quavering out some of the quaint love-songs of that period—was borne on the stillness of the night and floated down the river. It is a simple picture, this dashing Prince carolling plaintive ditties to his Perdita, who also sang with artless tenderness. George was proud of his voice, and sang tender ditties when constant potations had spoilt his voice, and his love-songs lost their appositeness. In his later years he became very vain of his singing powers, and if his friends were too cold in their applause was deeply mortified, as numerous anecdotes testify.*

At these stolen interviews of Florizel and Perdita the performers were prudently dressed in dark cloaks, to avoid detection, and it is laughable to see the sturdy York already asserting his independence. Perdita and the rest of the party, draped like conspirators in black, "were almost universally alarmed by the appearance of the Bishop ingeniously displaying a buff coat, the most conspicuous of colours!"

Poor Perdita may be indulged, without severe recriminations, in the happiness of these interviews, which were soon discontinued. One day she received a letter containing a bond for 20,000*l.*, to be paid when his Royal Highness should come of age. She at that time resided in the house in Cork Street, Burlington Gardens, formerly inhabited by the Countess of Derby, when divorced from her lord.† A separate establishment for the Prince was now the popular topic; he was "coming of age,"‡ and Carlton House was preparing. Poor Perdita fancied her happiness was secure. She had forsaken her husband (who richly merited that disgrace), she had abandoned her profession, and had forfeited her good name; and she now hoped soon to take up her residence at Carlton House. But the Prince showed entire indifference alike to the claims and the affections of this poor Ariadne. To do the lady justice, she appears to have been deeply attached to the Prince, and to have possessed a generous and disinterested disposition, but scandal was naturally severe on her reputation after her admirer's desertion. One evening she sent for the Prince, and he came. He was once again natural and affectionate, and a thousand little projects for the future were arranged. The next day Perdita met him driving in the Park, and he affected not to recognise her.

Then Charles James Fox appears on the scene; the gifted friend of the Prince, the companion of his pleasures, and his eloquent advocate in the House. Fox arranged an annuity of 500*l.* as an equivalent for the resignation of the 20,000*l.* bond. The step was taken, but Perdita was not consoled; she must drive once more to the shades of Kew. Florizel is there; but, alas! another divinity has conquered his susceptible heart. "The Prince was engaged with Mrs. A.," she writes. This initial may stand for the name of a lady who also enjoyed the friendship of the head of the Whig Club.

This occurred in 1781, when Perdita was still only twenty-three years of age. Fox remained an admirer of this Dido after the departure of the Prince, and one of the caricatures of the day represents her driving her own phaeton with the statesman by her side, intimating that the establishment was maintained at her expense.§ Mrs. Robinson next formed a *liaison* with a noted officer, by whom her fortune was speedily dissipated; travelling to relieve her suitor from a temporary embarrassment which detained him at a seaport, she journeyed thither on a severe winter's night in a carriage with open windows, and in great agitation of mind. From exposure to the cold and damp, she received a deadly chill, producing rheumatism, which deprived her limbs of motion. She then withdrew to the Continent, to which refuge many of the butterflies of fashion of the Georgian era retired, to die alone, unfriended and broken-hearted. The English Sappho returned after an absence of five years; and although from the age of twenty-four she never recovered the use of using her limbs, her cultivated mind consoled her with the distractions of poetry, until her reputation was rendered as respected through her lyrics as it had previously been notorious from her connexion with the heir to the crown. She enjoyed the friendship of the illustrious in literature, in the same degree as she had before attracted the admiration of those placed by fortune in the most exalted positions. Peter Pindar wrote admirable letters to her, and trolled off verses on tender or humorous themes alike with an honest feeling of respect for poor Sappho. Coleridge, Tickell, Beresford, Porter, and even General Burgoyne, dedicated

* "How did I sing that?" inquired Great George of Cannon (the *protégé* of Thurlow and one of the King's chaplains), who had accompanied him. Cannon was a man of musical taste as well as talent, and perhaps he was weary of ministering to the royal appetite for flattery. He ran over the keys and was silent. "I asked you, Mr. Cannon, how I sang that last song. I wish for an honest answer," repeated the Prince. Cannon, thus appealed to, could no longer remain silent. "I think, Sire," said he quietly, "I have heard your Royal Highness succeed better." "Sale and Attwood," observed the King, sharply, "tell me I sing that as well as any man in England." "They, Sire, may be better judges than I pretend to be," replied Cannon. The King was full of dignified offence, and poor Cannon's visits to Carlton House were abruptly discontinued.

† Lord Derby plays a notable part in the succeeding caricatures, both social and political.

‡ On the 1st of January, 1781, the Prince, though little more than eighteen, had been declared of age, on the ground that the heir apparent knows no minority.

§ Selwyn, when this circumstance was commented on to him, said, "Nothing could be fitter; the man of the people should of course live with the woman of the people."

"Poetical Tributes" to her—a method of celebration highly popular in those times. Her decline was rapid, and in 1800 she was glad to escape from a world in which she had been allotted an unusual share of praise and censure, of pain and pleasure, of cruel struggles, of transitory fortune, of brief power, and prolonged helplessness. She was only forty-two at her death. An extract from some verses composed by herself was engraved on her monument in Old Windsor Churchyard :

> "O thou, whose cold and senseless heart
> Ne'er knew affection's struggling sigh,
> Pass on, nor vaunt the Stoic's art,
> Nor mock the grave with tearless eye.
>
> * * * * * * * *
>
> Yet o'er this low and silent spot,
> Full many a bud of spring shall wave ;
> While she, by all save One forgot,
> Shall snatch a wreath beyond the grave !"

Gillray's caricatures pursue the political vicissitudes of the year. The sudden death of the Marquis of Rockingham on the 1st of July again brought on a ministerial crisis. It was soon felt that the King, who favoured Shelburne because the Minister's proclivities were more nearly allied to his own wishes, especially as regarded the continuance of the struggle in America, intended to put him at the head of the Cabinet. Fox had already complained of being placed in a situation where his principles were thwarted by the influence of the Crown ; and Shelburne being nominated Premier, Fox, who had been accused of aiming at that position, refused to act under any conditions, and resigned, although his pecuniary embarrassments increased the severity of the sacrifice. The retirement of Fox was followed by that of Burke, Lord John Cavendish, and other adherents.

July 22nd, 1782. *Gloria Mundi, or the Devil addressing the Sun.* ("Paradise Lost," Book iv.)— Fox—with the character of the Evil One grafted on his own, scowling at the rising sun, in whose centre appears the head of Lord Shelburne—is declaiming the lines from Milton :—

> "To thee I call,
> But with no friendly voice, and add thy name—
> Shelburne! to tell thee how I hate thy beams,
> That bring to my remembrance from what state I fell !"

The emptied pockets proclaim his necessities, and the E.O. table accounts for his difficulties.

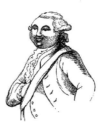

Gloria Mundi, or the Devil addressing the Sun. Lord Shelburne.

August 2nd, 1782. *The Jubilee.*—The resignation of Fox, which the King is said to have received with unconcealed satisfaction, at once set the organs of Lord Shelburne circulating misrepresentations of those who had retired. Fox had calculated that his example would be followed by the Duke of Grafton, General Conway (Commander-in-Chief), and other members of the Administration, whom Shelburne, however, induced to remain in office. The "Jubilee" represents Fox as "Reynard" hanging on a

gibbet inscribed "*Sic transit gloria mundi.*" Around this sacrifice dance a ring of the new Administration, the younger members with the heads of rats, in allusion to their alleged desertion of principle and party. One of them cries, "Zounds, I'm almost afraid of this gunpowder Guy Fox, though he be dead." Lord Shelburne prances merrily at the head, with a Janus-face, of which the reverse, presenting the leer of Satan, cries, "Unthinking fools! who will as tenderly be led by the nose as asses; but if he (at whose overthrow they rejoice) scourged them with whips, they shall find I will chastise them with scorpions." Shelburne leads General Conway (whom Burke had compared, in the debate on the Barré pension, to Little Red Riding Hood, who mistook a wolf for her grandmother) by the nose, blindfold and hood-winked. The side of the Premier's face bearing his own likeness exclaims—

> "Huzza, my friends! the monster's dead, and we
> Full merrily will dance around the fatal tree;
> Honours, thick falling, shall our steps attend—
> Come where I lead, to glory we'll ascend!"

The General cries, "What, I'm—Political Innocence—to be sure! I'm the last to observe what's obvious to all the world, am I?" The Duke of Grafton observes with a leer,

> "All my prayers are not in vain,
> For I shall have my place again!"

August 12th, 1782. *The Victualling Committee Framing a Report.*—On the conviction of Christopher Atkinson (to which Peter Pindar refers), M.P. for Heydon, Yorkshire, of peculation in his office of cornfactor to the Victualling Board. The print is highly finished, and gives the portraits of twenty-one members. It is, however, of no special interest at this date. Atkinson was finally tried at the King's Bench for perjury, found guilty, and expelled from the House of Commons (1784).

August 20th, 1782. *The Thunderer.*—Representing the Prince of Wales, to whom Major Topham (it is believed), in the character of Captain Bobadil, is recounting the famous calculation of his method of disposing of a hostile army. Major Topham may have been involved in the Perdita episode; perhaps he wrote on behalf of the neglected lady, for as proprietor of the *World* newspaper he used his pen with no less valour than he here professes with the sword as the Thunderer. Topham was a man of extreme fashion, and enlivened his paper with high-life scandal; his portrait will be found in Gillray's caricature of "Election Troops bringing their Accounts to the Pay-table" (August 14th, 1788).

Crumbs of Comfort, or Old Orthodox restoring Consolation to his Fallen Children (August, 1782), represents the Evil One—in the coloured plates his apparel is a sober Quaker drab—supplying Fox and Burke with the means of employing their leisure profitably. Fox holds out his hand for the dice and box, to which it was insinuated he would now be driven in order to support his exhausted resources; and Burke extends his hat, in which the friendly Satan deposits a flagellum and a rosary, implying that his retirement would be favourable for the indulgence of his supposed Jesuitical tendencies. From this date Burke is characterized in all the prints as a disguised Jesuit.

August 23rd, 1782. *Cincinnatus in Retirement; Falsely Supposed to represent Jesuit Pad driven back to his Native Potatoes.*—The metamorphosed orator is taking his frugal meal out of a utensil inscribed "Relic No. 1, used by St. Peter," surrounded with various emblems of fanaticism and whisky-drinking. Beneath the table appear three "jolly devils," executing a dance of triumph. We may notice that Gillray always exhibits great inventive power in the construction of supernatural beings. The Ministers were very severe on the retiring patriots, and, in return, Fox and Burke accused Lord Shelburne of treachery and selfishness. These charges were re-echoed in satires which came more directly from the Tories, and attacked indiscriminately both divisions of the now divided Whig party.

Thus, in a print entitled *Guy Vaux and Judas Iscariot, or Dialogues of the Dead* (August, 1782), Shelburne, in the character of Judas, is walking off with a bag inscribed "Treasury," while Guy Fox is detecting the traitor by the light of his lantern. The Fox exclaims, "Ah! what, I've found you out, have I? Who armed the high priests and the people? who betrayed his mas ?" Judas retorts, "Ha, ha! poor Gunpowder's vexed—he, he, he! Shan't have the bag, I tell you, old Goosetooth." With similar sentiments, others looked upon these rapidly changing ministries as so many

parties of mischief-makers. There were apprehensions that, elated by Rodney's victory over the French fleet, Lord Shelburne, who had always been opposed to the recognition of American independence,

Recrimination.

might be induced to yield to the King in countenancing the sovereign's favourite measure of the war against America. The signal overthrow of the French navy had struck the Americans with dismay, and some of them began to despair; but, encouraged by the conduct of Washington, they still looked with coldness on all conciliatory advances. On this side the Atlantic, the King of Spain had risen almost to an imbecility of self-confidence in the magnitude of his preparations for the reduction of Gibraltar; and he and the King of France put forward pretensions to which the English Ministry could on no conditions listen.

August 22nd, 1782. *The Castle in the Moon.* A New Adventure not mentioned by Cervantes.—The fortress of Gibraltar, on its rock, is displayed in the moon. Don Quixote, who represents Spain, appears the saddest and leanest of knights, seated astride a sorry nag. He observes to his squire, "Sancho, we'll sit down before the castle and starve them out!" A corpulent Dutchman is the squire; he is mounted on a hungry jackass, and the contents of his capacious saddle-bags are already exhausted. "Starve them out! O Lord! we're like to be starved out ourselves first. There's not a mouthful left in the wallet, and I'm grown as thin as a shotten herring." France, as a gaily-dressed monkey, strutting on the head of the Don's steed, vainly lunges with a toy rapier at the castle in the moon. We thus realize the contemporary opinion of the Spanish and French forces during the blockade in August, before the siege was raised. Other successes attended our fleets at sea; and the hopes of our confederated enemies were at length entirely broken down by the memorable defeat of the Spanish armament against Gibraltar in the grand attack on the 13th of September, 1782, and by the subsequent arrival of the fleet under Lord Howe for the relief of the garrison, actions which have made the names of General Elliot and Admiral Howe immortal.

The aspiring William Pitt—who had stood out of the Rockingham Administration, and was evidently expecting great things—succeeded Lord John Cavendish as Chancellor of the Exchequer. As he was then only twenty-three years of age, his youth and elevation naturally excited comment; he was already called the "Famous Boy." His first appearance in Gillray's caricatures was in September of this year.

September 11th, 1782. *Jove in his Chair.*—Shelburne, as the Sun, is driving a car, on which is quartered the Fleur-de-lis of France; his feet trample on Britannia's shield, and he observes, "In my presence scoundrel peasants shall not call their souls their own." He is whipping two jaded animals bearing the faces of Dunning (Baron Ashburton) and (probably) General Conway. Colonel Barré, in the character of Mercury, as "running footman," leads the triumph, holding in his hand the pension for 3000*l.* which had excited so much antagonism, both from the section of the Whigs who had withdrawn under Fox, and from the Tories, who indignantly compared this liberal provision, conferred for no apparent service to the State, with the meaner sum doled out to Rodney for one of the grandest victories of the age. Behind the car of Jove is a figure introduced as a lackey, intended for young William Pitt. Under his arm he holds two rolls, inscribed "Chancellor of the Exchequer" and "Ways and Means," while in his hand he holds a board containing the A B C, to indicate his inexperience.

December 12th, 1782.

> "*Aside he turned,*
> *For envy yet, with jealous leer malign,*
> *Eyed them askance.*"

Once more Milton's lines on Satan are employed in reference to Fox in his exile from office. The patriot dives his hands into his empty pockets with a threatening frown, which portended mischief for the tranquil pair, Shelburne and young Pitt, who are represented seated in paradise, enjoying the

delights of telling their money-bags on the Treasury table. The outcast has evidently fixed his aspirations on the re-acquisition of power, and the smiling sun of Shelburne hastens to its eclipse.

While pursuing the political satires which Gillray put forth in 1782 we have omitted a few social subjects, whose introduction would have interrupted the series of cartoons provoked by the estrangement in the Whig camp.

August 26th, 1782. *The Westminster Just-asses a-Braying, or the Downfall of the E.O. Tables.* N.B. The Jackasses are to be indemnified for all the mischief they do by the Bulls and Bears of the City.—In this satire on the exertions of the Westminster justices to suppress the private gambling establishments, which were ruining all sections of society, the artist slyly strikes at the public toleration of gambling on the Stock Exchange. The Justices (Wright and Addington) are assisting their followers to destroy the tables with heavy mallets. The details of "play" at this time present incidents which now appear incredible. Gamblers played day and night, sometimes for six-and-thirty hours at one sitting. Rowlandson, the caricaturist, frequently played for thirty hours at a stretch. In the higher circles, and in the clubs, the faro banks often in one evening brought ruin upon the possessors of ample estates. Fox, who played as persistently and with as fatal results as the most renowned of his contemporaries, lost thousands with immovable

Envy.

placidity. Members of the aristocracy sat night after night round the table, their laced coats laid aside, wearing holland or baize sleeves and aprons, like butchers'-men, with round straw hats on their heads to protect their eyes from the glare. In the ante-room waited money-lenders, to offer accommodation on such terms as the necessities of the losers might render possible. Fox christened the apartment assigned to these usurious harpies his "Jew-dea."

N.D. *Samson Overcome by a Philistine.*

> "If e'er we want a very valiant knight,
> Have we not Sampson—bold Sir Sampson Wright?"

This caricature forms a sequel to "the Westminster Just-asses." A gentleman of commanding figure menaces the alarmed justice; his fist is thrust into the magistrate's face, and he exclaims, "You rascal, I'll break every bone in your body." Sir Sampson's son cries out, "O Lord! my poor pap'll be kill'd." From the dedication it appears that the warrants granted by the Bow Street magistrates to enter private houses in search of faro tables and implements of gaming may have been carried to the excess of violating the establishment of Lord Onslow. This licence was decided to be illegal, and would of course render the offended persons little scrupulous about threatening the justices who granted the informal warrants. Sir Sampson Wright succeeded Sir John Fielding, under whom he had officiated as clerk. He appears to have discharged his duties with credit to himself and advantage to the community. He died in 1793.

N.D. *Bombardinian Conferring on State Affairs with one in Office.*

> "Important blanks in nature's mighty roll."—CHURCHILL.

Sir Grey Cooper, communicating with Sir Robert Hamilton, whispers to the lengthy General, "Then,—my Lod and I—his Ledship introduced the affair you and I know of." The Colossus replies, with mysterious importance, "Hum, ay, mum!" This print refers to some contemporary scandal of a tender nature, in which it is possible Sir Robert had accommodated the Minister in an undignified capacity.

The circumstance, and the publication of the caricature on the subject, evidently occurred in the early part of 1782.

November 27th, 1782. *Judge Thumb, or Patent Sticks for Family Correction; warranted Lawful!—*

Justice Buller publicly expressed his opinion that a man might lawfully beat his wife with a stick if it were no thicker than his thumb. Gillray represents the judge in his robes, carrying two bundles of sticks surmounted with thumbs; he cries, "Who wants a cure for a rusty wife? Who buys here?" In the distance a husband is thrashing his wife, who screams "Murder!" but the chastiser persists, "'Tis law; it's no bigger than my thumb." A countess is reported to have sent for the measurement of the justice's thumb, that she might know the precise extent of her husband's right.

N.D. *Regardez-moi.*—Old Vestris is giving a lesson to the huge Lord Cholmondeley, the hero of "Corporeal Stamina" (April, 1801). His lordship's portrait occurs in certain succeeding caricatures (the "Union Club," "Dilettanti Theatricals," &c.) Lord Cholmondeley appears here as a huge goose; his apartment contains various works of lax morality, and a gambling picture indicates his tastes. "Regardez-moi" was the characteristic admonition of Vestris. His belief in his genius (the French had christened him the "Dieu de la Danse" in honour of his saltatory achievements) carried him into the most irrational absurdities. It was his favourite axiom that there were three great men in Europe, "Le Roi de Prusse, Monsieur Voltaire, et moi-même." The only mark of modesty is that "moi-même" does not take precedence of the other two. He regarded the son of so eminent a genius as himself much after the fashion in which Lord Chatham, Lord Holland, and Alderman Beckwith ("the richest commoner") did *their* sons. When he condescended to favour the rising generation by the introduction of a successor to his fame, in the person of his son, this prince of ballet-masters appeared in full court-dress, with a sword by his side; he addressed a grandiloquent oration to the spectators on the sublimity of his art, and then, turning to the young débutant, he exclaimed, "*Allons donc, mon fils, montrez votre art; ton père te regarde.*" This son gave his name to the charming grand-daughter of Bartolozzi, the celebrated engraver, a lady who appeared in our own time as Madame Vestris, afterwards the wife of Charles Mathews, the comedian.

The new year, 1783, found the preliminaries of peace already signed between Great Britain and the American Colonies. The independence of the United States of America was thus acknowledged; but the King had acceded to the wishes of his subjects with very bad grace, and the irritation still existing in the royal mind had been evident in the Speech from the Throne on the opening of Parliament in December, 1782.

This peace was a death-blow to the Administration of Lord Shelburne. From the moment when the leaders of the old Rockingham party separated from Shelburne, the latter was looked upon by most people as little more than a provisional minister; and young William Pitt, who had been aiming at popularity by his repeated advocacy of reform in the Parliamentary representation (which was now beginning to be the watchword of a party), seems already to have been fixed in the King's mind as the minister of his choice. But William Pitt was hardly yet in the position to command a party, even though backed by the King.

As the time for the meeting of Parliament approached, people began to look with anxiety to the position which each of the three parties that now divided it was likely to take. It was roughly estimated that the Ministerial votes in the House of Commons were about a hundred and forty, that about a hundred and twenty members followed the standard of Lord North, and ninety that of Fox; the remainder being uncertain; and it was evident, under these circumstances, that Fox could give the majority in the House to either of the two parties with which he chose to join. Lord North professed moderation, and a wish to stand on neutral ground; and he did not threaten the Court with any serious attack. When Parliament met on the 5th of December, the preliminaries of the peace were made known, and the King's speech was warmly attacked by Fox and Burke, to whom a spirited reply was made by Pitt; but the Opposition showed itself but slightly till after the Christmas recess. When the House met again towards the end of January, the interval had produced a union of parties which seems to have struck most people with surprise. The preliminaries of peace had been signed in Paris on the 20th of January, 1783, and their consideration in the House of Commons was fixed for the 17th of February, when the Ministers moved an address of approval. The amendment, which accepted the treaty, but demanded further time to consider the terms before expressing a judgment upon them, and was evidently

intended as a mere trial of strength, was moved by Lord John Cavendish. The debate which followed was long and animated, and merged into strong personalities. The famous coalition between Fox and North, which had for some days been talked of, was now openly avowed; and both parties attacked the peace with the greatest bitterness. It was observed that, during the earlier part of the debate, Fox and North spoke of each other in terms of indulgence to which they had long been strangers; and the Ministerial speakers, in their reply, fell with the greatest acrimony upon what they termed the monstrous alliance between two men who had previously made such strong declarations of political hostility. Burke first spoke in defence of the coalition. He was followed by Fox, who openly avowed it; and he and Lord North declared that, even when they were most opposed to each other, they had regarded one another personally with mutual respect; that their ground of enmity—the American war—being now at an end, it was time for their hostility to cease also, and that they had joined together for the good of the country. The debate was prolonged through the whole night, and it was nearly eight o'clock in the morning when, on a division, the amendment was carried by a majority of sixteen. Four days after this, on the 21st of February, the united Opposition brought forward a motion of direct censure on the terms of the treaty and on the conduct of Ministers, which lasted till after four in the morning, and was carried by a majority of seventeen. The coalition was again the main subject debated; it was now defended warmly by Lord North, and bitterly attacked by Pitt, who called it "a baneful alliance" and an "ill-omened marriage," dangerous to the public safety.

Gillray has bequeathed to us a condensed view of the situation:—

March 9th, 1783. *War.*—We are here presented with the characteristic attitudes of the great leaders on both sides of the House, during the delivery of their most energetic orations. Fox and Burke thunder forth their denunciations against North on the conduct of the American war. The Opposition integrity is thus expressed: "I should hold myself infamous if I ever formed a connexion with him!—deserve the axe!—disgrace!—infamy!—shame! —incapacity!—ignorance!—corruption!— love of place!—blunders!—wants!—weaknesses!—gross stupidity!—hardly conceivable that so much pride, vice, and folly can exist in the same animal!" The Minister's condemnation of his adversaries is equally plain-spoken: "Want of candour—illiberality— our misfortunes entirely owing to Opposition!" In the second plate, *Neither War nor Peace!*

War.

we are introduced to the coalition which gave rise to so much astonishment. Fox, Burke, and North, in almost identical attitudes of impassioned eloquence, are arrayed side by side, condemning the treaty and the Ministerial party. The preliminaries of peace appear on a long scroll, surmounted with laurels. At the bottom of the roll appears an almost historical dog*—hero of oft-told anecdotes— "bow-wowing" at the triumvirate.

The motion for direct censure on the terms of the treaty, which was carried by the new coalition, as illustrated above, completed the defeat of the Ministry, and Lord Shelburne immediately resigned. The King, who literally hated Fox, and who was enraged at the coalition, made a fruitless attempt to

* The dog is said to be intended as an allusion to an occurrence in the House of Commons during the last defensive declamation of Lord North, on the eve of his former resignation. A dog, which had concealed itself under the benches, came out and set up a hideous howling in the midst of his harangue. The House was thrown into a roar of laughter, which continued until the intruder was turned out; and then Lord North coolly observed, "As the new member has ended his argument, I beg to be allowed to continue mine." The dog is made to accompany Lord North in some of the subsequent caricatures.

form a ministry under Pitt. In the beginning of March the King had several interviews with Lord North, whom he attempted to detach from his new alliance, and then he tried to form a half coalition ministry, from which Fox was to be excluded. On the 24th of March, when the country had remained more than a month without a cabinet, an address was voted in the House of Commons almost unanimously praying the King to form immediately such an administration as would command the confidence of the country. The King, however, remained obstinate in his personal animosities, and on the 31st of March another and much stronger address was moved by the Earl of Surrey; upon which Pitt, who had all this time retained his office of Chancellor of the Exchequer, and whom it was evidently the King's wish to make prime minister, announced that he had that day resigned. On the 2nd of April, the King again sent for Lord North, and through him gave full authority to the Duke of Portland, who was considered as the head of the Rockingham party, or Old Whigs, to form an administration. The Duke of Portland himself was made First Lord of the Treasury, with Lord North as Secretary of State for the Home Department, and Fox as Secretary for Foreign Affairs. Lord John Cavendish was made Chancellor of the Exchequer, Keppel First Lord of the Admiralty, Lord Stormont (the only person admitted into the Cabinet to please the King) President of the Council, and the Earl of Carlisle Lord Privy Seal. Lord Thurlow was rejected and the great seal was put in commission, the commissioners being Lord Loughborough, Sir W. H. Ashurst, and Sir Beaumont Hotham. The other members of the Ministry were, the Earl of Hertford, Lord Chamberlain; Viscount Townshend, Master-General of the Ordnance; the Honourable Richard Fitzpatrick, Secretary at War; Edmund Burke, Paymaster of the Forces; Charles Townshend, Treasurer of the Navy; James Wallace, Attorney-General; Richard Brinsley Sheridan and Richard Burke, Secretaries to the Treasury; the Earl of Northington, Lord-Lieutenant of Ireland; William Windham, Secretary for Ireland; and William Eden—who is said to have been the chief negotiator in the formation of the coalition—Vice-Treasurer.

The coalition provided Gillray with a fresh field for his satire, which was impartially distributed on all sides.

April 2nd, 1783. *A Warm Berth for the Old Administration.* "Take the wicked from before the King, and his throne shall be established in righteousness."—The monarch, under the shadow of his state canopy, drops fast asleep, with a book, entitled "Pinches on Snuffers," between his fingers; the crown is put out of sight, and the sceptre falls. Fox, in court dress, with the "grapes" overhanging his capacious pockets, drags forward the corpulent figure of Lord North, who is blowing hot and cold (in his pocket is a bar of soap, in allusion to his proposal for taxing this commodity). Fox has placed his disengaged hand on the shoulder of the Evil One, who is in court costume of the most fashionable character, and evidently officiates as chamberlain to the King. On the introduction of North, Fox congratulates the fiend on his acquisition: "This is Boreas; he'll make an excellent pair of bellows, old boy!" The palace terminates in the gates of Pandemonium, ready with flames, scorpions, &c., to receive the retiring Ministers. One demon hurries off a figure in Scotch costume, with the assistance of his prong, crying, "Gee up, lazy *Boots!*"—exhibiting the tenacity of the public aversion to even the suspicion of "Bute" influence.[*] An imp is dragging Thurlow by the wig, and a broad-backed devil expeditiously carries off Lord George Germaine, and other members of the late Government, to a "hot latitude."

A Slumbering Monarch.

April 3rd, 1783. *The Lord of the Vineyard.*—The Duke of Portland, as the nominal head of the new Ministry—which the King had accepted without any sincerity—appearing above the gates of

[*] Lord Bute had retired from the administration of public affairs, for which he was thoroughly unsuited, on the death of the Princess of Wales, mother of King George.

Portland Place, abandons the fruits of office, saying, "Take it between ye." The greedier Fox has secured the huge bunch of grapes, and is devouring his share; while North vainly tiptoes in his exertions to participate.

> "Says the Badger to Fox,
> We're in the right box,
> These grapes are quite charming and fine.
>
> "Dear Badger, you're right,
> Hold them fast, squeeze them tight,
> And we'll drink of political wine!"

Lord North was often represented as a Badger.

April 5th, 1783. *Coalition Dance.*—Rejoicing at the accession of the triumvirate to the land of promise, Burke, Fox, and North gaily dance round the bust of the King mounted on a pedestal, while a diminutive "Pan" fiddles away to enliven the celebration. The bust of George is inscribed, "K. Wisdom 3rd;" an owl is perched on the monarch's head, while his face is entirely obscured by the "Whole Duty of Man," which entirely obstructs his vision.

> "Let us dance, and sing
> God bless the King,
> For he has made us merry men all!"

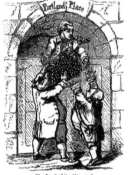

The Lord of the Vineyard.

The monarch, however, proved that his submission to this state of affairs was quite opposed to his prejudices. Burke, who, as we have already seen, from the period of his exertions in favour of Catholic emancipation, was recognised under the guise of a Jesuit, is chanting from the fable of "Little Red Riding Hood."

A Jesuit.

April 14th, 1782. *The Times, anno* 1783.—The position of John Bull's relations abroad is briefly set forth. He regards America for the last time. Already a powerful devil, in red culottes (implying revolution), flies off with that important Continent. Britannia's anchor has sustained a fracture, and poor Bull is inconsolable, and cries, in allusion to the separation of America, "'Tis lost, irrecoverably lost!" while France tauntingly offers a pinch of snuff with the grace of a *petit-maître*; and Spain, in high dudgeon, pointing to Gibraltar and her fine flotilla of ships in flames, exclaims, "By St. Anthony, you have made me the laughing-stock of Europe!"

April 22nd, 1783. *Bonus—Melior —Optimus; or, the Devil's the Best of the Bunch!*—The superlative degree represents an ingenious demon, who, perched on a stool, is employed in making the fire burn, and at the same time executing a slightly garbled version of the National Anthem, with which he intersperses objurgations on the obstinacy of the broth, "which will never boil!" Over the fireplace is suspended a version of the famous "Coalition Medal," life size. Fox as Melior, reposing on "Pandora's box," occupies the position of the satyr in the fable who found a host who blew both hot and cold with one breath; he does not, however, exhibit the indignation of his fabulous prototype, "Blow hot, blow cold, he, he!" with the self-same breath. "My Lord, give me a sup of your soup; I have often cooled your porridge, my Lord. Hey? He! he!" Bonus, seated on the

Coalition Medal.

Budget, replies affably, with a certain obscurity, "My dear Reynard, you are welcome to a spoon-

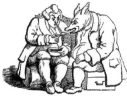

ful! Be cautious; a little of my broth goes a great way—'tis highly seasoned—look at my cook—he and my friend—hum! with the consent of the—hum! did both—hum! the Nation!"

May 2nd, 1783. *The Right Honourable Catch-Singers.*—Fox and North, seated on an ale-house bench, are convivially grasping a foaming tankard (inscribed with the crown and G.R.), which forms a two-handled loving cup, sustained by both Ministers. North is blowing away the froth, which obscures the Royal initials, and runs over on a "Westminster petition" lying on the table. The catch, which is executed

Boon Companions.

with great goodwill in concert, runs thus :—

> " Bring every flower that can be got,
> Pinks, hyacinths, and roses ;
> We two will drink out of one pot,
> And fuddle both our noses.

> " With Treas'ry juice the pot shall foam,
> For Reynard and for North ;
> The people still may wish for some,
> And they shall have—the froth !"

May 5th, 1783. *A Block for the Whigs; or, the new State Whirligig.*—The pole of the new whirligig is supplied by a wooden post bearing a blank effigy of the King, supported by wedges marked "Treasury, Navy, and Army." Seated on the "round-about" are the Ministers. Fox leads the riders, holding a capacious money-bag, and contemptuously flourishing his profuse "bush," which has flapped off the wig of stout North, who rides second. Burke, as a half-skeleton Jesuit, rides third, deeply immersed in the pages of the "Sublime and Beautiful." Keppel, mounted on Balaam's ass, appears but an indifferent equestrian; he characteristically complains, "D—d rough sailing this! I shall never be able to keep my seat till the 27th of July" (an allusion to Keppel's partial engagement of that date with the French, on which occasion he was declared by the Tories to have exhibited incapacity, if not cowardice). Behind the Admiral is the chair of the President, surmounted by the crown, which forms a receptacle for Scotch thistles. A nondescript person in Highland garb is probably suggestive of the Bute faction. John Bull, lolling on his threshold, appears as a gouty roysterer, with pipe and tankard, singing,

> " 'Tis liberty, 'tis liberty,
> Dear liberty alone."

Meanwhile his house is being plundered at noonday.

June 8th, 1783. *A Sun Setting in a Fog, with the Old Hanover Hack Descending.*—This caricature, which is overstrained and gloomy, is interesting as showing that French principles were, even at that period, attributed with no small violence to the patriotic member for Westminster. Fox, as head of the Foreign Office, is driving a jaded hack (the old white horse of Hanover) from the Pinnacle of Glory to the Valley of Annihilation. He is sporting the "fleur-de-lis" of France ; his boots are of Spanish leather; his saddle-bags, labelled "Enjoyments," are stuffed with foreign gold, annuities, and subsidies; both reins and stirrups are broken. Fox is crying, "Aut Cromwell aut nihil—so come up, old Turnips!" Behind him is a basket containing "Hopes and Expectations," the crown deposed, and Magna Charta in shreds. The King's head, surmounted by the Gallic cock, is thrown into the basket, ready mounted on a pike.

July 11th, 1783. *Jack o' both Sides.*—The figure of Lord North forms the fulcrum of a political balance ; the King, as Justice, in the clouds (his crown suspended and his eyes blinded with a Scotch bandage), poises the scales from the peak of North's wig. Fox, as a portly body, cries, "D—n the

Tories!" His side of the balance quite outweighs the scale containing his rival Shelburne, indicated as "Nobody," who d——s the Whigs; while North surreptitiously directs an enveloping "anathema" against the Minister whom his coalition had overbalanced.

We have already dwelt on the successes obtained by Grattan, and noted his popularity in 1782. Irish faction had advanced with so little consistency, that the hero of one year lost his credit the next—*in the face of ultra-patriotic fanaticism, which rebelled even against its own pet Legislature.* Grattan appears in the attitude of resisting the encroachments of the "extra-democratic" Irish faction, whose demands were advanced through their Parliamentary delegate, Henry Flood. The speeches of the two leaders are printed beneath their portraits, and they offer characteristic examples of Hibernian political eloquence.

October 28th, 1783. *Irish Patriots.* Vide Debates in the Irish House of Commons on Sir H. Cavendish's motion for retrenchment of public expenses.—The virtuous Grattan is indignantly denouncing his rival and opponent: "Sir, your talents are not so great as your life is infamous; you might be seen hovering about the dome like an ill-omened bird of night, with sepulchral notes, a cadaverous aspect, and broken beak,* ready to stoop and pounce upon your prey. The people cannot trust you; the Ministry cannot trust you. You deal with the most impartial treachery to both; I therefore tell you, in the face of your country, before all the world, nay, to your beard, you are not an honest man!"

Flood's response is equally animated, and no less Hibernian in its style: "I have heard a very extraordinary harangue indeed, and I challenge any man to say that anything half so unwarrantable was ever uttered in this House. The right honourable gentleman set out with declaring that he did not wish to use personality; and no sooner has he opened his mouth than forth issues all the venom that ingenuity and disappointed vanity, for two years brooding over corruption, have produced. But it cannot taint my public character. As for me, I took as great a part with the first office of the State at my back, as ever the right honourable gentleman did with mendicancy behind him!" After delivering his speech the honourable member withdrew.

Grattan.

Flood.

Pursuing the progress of politics at home, we find that the new fusion of Fox and North engaged general attention. "There seemed to be much greater cordiality in the alliance of the two parties than had been visible in any former coalition of the same kind; and, to all appearance, the new Ministry might have been an efficient one and beneficial to the country, had it not been regarded from the first with bitter dislike by the King, who took little pains to conceal his intention of getting rid of it as soon as possible. Still there was something anomalous in its character, which was far from giving general satisfaction, and at first the Liberal leaders lost much of their popularity. In the middle of July Parliament separated, and the new Ministers were left to prepare in quiet the great measures which they intended to bring forward for the consideration of the Legislature.

"The chief of these were two bills for the better regulation of our extensive possessions in the East. The public had been long dazzled by the brilliance of our conquests in Asia, and astonished at the riches which were daily brought home; but, in the transition from a company of traders to a body which held sovereign power over mighty empires, the India directors now stood in a position which called for the interference of the British Legislature. India had hitherto been looked upon chiefly as an extensive field of plunder and aggrandizement, and it was known to the mother-country principally

* Flood's nose had a suspicious depression; *vide* portrait.

H

by the so-called English ' nabobs,' who returned home with immense fortunes, which they had amassed by every description of injustice and rapacity. The vices of this system had attracted attention for some time, and the measures now brought forward by Fox were intended to bring a remedy. He proposed to vest the affairs of the East India Company in the hands of certain commissioners, for the benefit of the proprietors and the public, who were to be nominated first by the Parliament and subsequently by the Crown, and whose power was to last during limited periods; and to add to them other officers for the more immediate government of India, with powers and under responsibilities which were calculated to put an end to tyranny and oppression, and to improve the condition of the people throughout our Indian possessions. The plan was, of course, obnoxious to the Company, and they employed freely their immense riches in raising up opposition : it was even hinted at by many that the King himself had indirectly taken money from the Company to overthrow it.

" Parliament met on the 11th of November, and the first measure brought forward was the bill for the regulation of India. Pitt, Dundas, Jenkinson, and other members of the Opposition, spoke with warmth against it, yet it passed through the House of Commons with large majorities, the third reading taking place on the 8th of December. But anxiety was already felt for its fate in the Lords. Walpole writes on the 2nd of December : ' The politicians of London, who at present are not the most numerous corporation, are warm on a bill for the new regulation of the East Indies, brought in by Mr. Fox. Some even of his associates apprehended his being defeated, or meant to defeat him ; but his marvellous abilities have hitherto triumphed conspicuously, and on two divisions in the House of Commons he had majorities of 109 and 114. On *that* field he will certainly be victorious ; the forces will be more nearly balanced when the Lords fight the battle ; but though the Opposition will have more generals and more able, he is confident that his troops will overmatch theirs ; and in Parliamentary engagements a superiority of numbers is not vanquished by the talents of the commanders, as often happens in more martial encounters. His competitor, Mr. Pitt, appears by no means an adequate rival. Just like their fathers, Mr. Pitt has brilliant language, Mr. Fox solid sense, and such luminous powers of displaying it clearly, that mere eloquence is but a Bristol stone when set by the diamond reason.'

" The main grounds of opposition to this India Bill were, that it was an infringement of vested rights as regarded the Company, and that its tendency, and probably its object, was, by the immense influence it gave to Ministers, who had the appointment of the India governors, to increase their power to such an extent as to make them independent of the Crown. Some people hesitated not to say that Fox aimed at establishing in his own person a sort of supreme Indian dictatorship, and they gave him the title of Carlo Khan. On this occasion the monarch descended from the integrity of his office, and actively engaged himself in the obscurity of an intrigue.

" The sentiment which is said to have weighed most with King George, after his personal dislike to his Ministers, was the dread of diminishing the influence of the Crown, which was often and carefully instilled into him by Lord Thurlow ; for the King held private communication with the chiefs of the Opposition, with whom he was concerting measures for bringing them back to power. The King's behaviour to his present Ministers was, indeed, most uncandid. He never informed them that he disapproved of the India Bill ; yet when the 15th of December, the day appointed for the second reading in the House of Lords, approached, he gave Lord Temple, with whom he had had several private interviews, a note in his own handwriting to the effect ' that his Majesty would deem those who voted for the bill not only not his friends, but his enemies ; and that if Lord Temple could put this in still stronger words he had full authority to do so.' This note was shown pretty freely to all those peers who were supposed to be influenced by the royal inclinations. Some strong remarks on the intrigues of the backstairs, and on the note understood to have been given by the King to Lord Temple, were made in the House of Lords ; but the House of Commons proceeded much more energetically. On the 17th of December, the very evening when this underhand pressure was brought into play in the other House, a violent debate arose upon the subject in the Commons, and they passed, by a majority of nearly two to one (the numbers being one hundred and fifty-three to eighty), a resolution, ' That it is now necessary to declare that to report any opinion, or pretended opinion, of his Majesty upon any bill, or other proceeding, depending in either House of Parliament, with a view to influence the votes of the members,

is a high crime and misdemeanour, derogatory to the honour of the Crown, a breach of the fundamental privileges of Parliament, and subversive of the constitution of this country ;' and further, ' That this House will, upon Monday morning next, resolve itself into a committee of the whole House, to consider the state of the nation.' This was followed by a resolution equally strong, and carried by a majority in the same proportion, declaring the necessity of a legislative act for the government of India."

In addition to the unconstitutional influence thus brought to bear upon all those who were disinclined to stand forth as personal opponents of the Crown, the King further commanded the Lords of the Bed-chamber to vote against his Ministers. The consequence was that the latter were beaten by a majority of eight. On the 17th of December the bill was finally thrown out by a majority of nineteen. In the night of the 18th the King dismissed his Ministers and gave the seals into the hands of Lord Temple.

On December 29th, 1783, Gilray published his version of *New Slides for the State Magic Lanthorn*, in a series of small subjects, in the style of transparencies, ridiculing the coalition and the fate of its projectors. The subjects of these slides are as follows :—

Vox Populi (as Fox was christened) *out of Doors.*—The great Whig, with the mask of a fox, accompanied by a mountebank, the regular attendant of a perambulating juggler, is addressing his eloquence to the mob.

The First Coalition.—North is coming forward with his followers (a flock of lambs led by a string), to join Fox, who also is bringing his supporters (a flock of geese, similarly conducted).

Vox Populi Indoors.—The masked Fox is now seen in his best-known oratorical attitude, addressing the Commons.

Emblems of Liberty.—Fox, beneath the red bonnet of Democracy, is burning the India Charter (in allusion to the great struggle consequent on Fox's India Bill, and the downfall of his Ministry following its rejection).

New State Idol.—The political friends, both bodies in one coat, are placed on the pedestal of power, beneath which lie the crown and sceptre, indicating the compulsory nature of the tolerance this new "Dagon" would have enforced on the sovereign.

New State Idol.

Coalition Candidates Rejected.

Political Montgolfier.—Fox is ascending into the clouds, in the aëronaut's new balloon.

His Fall into the Pit. — Implying the destruction of Fox's power by the Court faction, directed in the House of Commons by young Pitt.

The Coalition Candidates Rejected by Britannia. — The emblem of Great Britain is pointing to the gallows and the block, as an appropriate termination to their careers.

The Last Coalition.—We see Fox, North, and Burke being driven in the cart for condemned criminals to their destination at the foot of the gibbet.

A final cartoon exhibits their occupations in Hades. Burke is allotted the part of Tantalus, Fox is represented as Ixion, and North toils at the labours of Sisyphus.

1784.

The year 1784 is remarkable for an animated struggle between the King, on one hand, obstinately fighting in support of overstrained prerogative, and ranking among his followers the select circle styled "his friends," and those youthful aspirants for distinction (of whom William Pitt was the foremost),

who were strengthened by Court influence—assisted by such demonstrations of the mob as were procurable either by bribery or by appeals to rally round a sovereign who was represented as "assailed by regicides;" whilst, on the other hand, Charles James Fox—the Demosthenes of his age, who valiantly stood in the breach for the liberty of the subject—was in conspicuous opposition to the Crown.

The earlier caricatures of this year may be more correctly assigned to the history of 1783, dwelling as they do on the Coalition Ministry which was hurried from office on the defeat of Carlo Khan's great India Bill in December.

Then followed, on the dismissal of the Coalition Cabinet, a contest of the most irritating character, in which the absolute tendencies of the Sovereign—resented by one section of the community—were warmly encouraged by another section, who exhibited a certain infatuation in their support of the prerogative. The details of this struggle are of historical importance. They exhibit the resolution of the King, who, it was declared, had determined to retire to Hanover if he failed in upholding his own will over the decisions of the people as represented in the House of Commons.

A further unjustifiable extension of the influence of the Throne was soon made, which resulted in the Crown agents securing, by threats, favours, and deceit, the return of those nominees who were dependents of the Court faction, and the rejection of those members who, standing on patriotic principles, formed the Opposition before the dissolution of Parliament. These antagonists were disarmed and dispersed by the expedient of forcing Ministerial placemen into the seats which the general election of 1784 had compelled them to relinquish. No Ministerial artifice was ever attended with more complete success. The Opposition was, for a time, powerless; and the Government, which had been in the former Parliament unable to face its opponents, now commanded an overwhelming majority. The caricatures published by Gillray commence with rejoicings over the broken Coalition Ministry.

January 4th, 1784. *The Fall of Dagon, or Rare News for Leadenhall Street.*—The unnatural image lies prone on the ground before the "ark," or, according to the satirists, upon the grass of Tower Hill. Its double head, bearing the faces of Fox and North (the latter in an undisturbed slumber), is broken from the body, the hands are cut off, and its pedestal is displaced; on its base appears the inscription, "Broadbottom," a term with which, as a political byword, we shall become familiar as the series of these caricatures advances. A slight background exhibits Mr. Bull tranquilly smoking his pipe at the door of his inn, as he is usually drawn; only in this case the sign of the house

The Fox and Badger Quarter their Arms.

is an executioner's axe. The Tower is indicated as the ark; and an execution, directed of course against the heads of the late Coalition, is numerously attended.

January 7th, 1784. *The Loves of the Fox and the Badger, or the Coalition Wedding.*—This set of scenes, also in compartments, after the manner of "Slides for the Magic Lanthorn," constitutes a kind of general review of the much-discussed combination, which was destroyed (at no inconsiderable personal sacrifice) by the hostility of the King, before the nation had time either to derive advantage from its administration or to discover whether the community was likely to become a sufferer from its retention in power. In the first scene a fox is struggling with a sleepy badger, amidst the applause of a legislative assembly; this is described as *Ye Fox beats ye Badger in ye Bear Garden.* Then comes *The Fox's Dream*, which takes place on Hounslow Heath. The vision offers a choice of evils—the bars of a prison for the dreamer, or a head on a pole. *The Badger's Dream*, which takes place more comfortably on a couch, presents a gibbet on one hand and a block on the other. Doubtless,

the implication is similar to that of *The Fox's Vision. Satan Unites Them.*—A very impish minister of Satan, who is joining their paws with due solemnity, pronounces the magic solution, "Necessity." *They Quarter their Arms.*—Each of the contracting parties is credited with an ambition to share the temptations of the "Treasury bag," which is suspended from the asinine ears of John Bull, who suffered considerably from most of his ministries, but beyond question most of all from that which succeeded the coalition. *The Priest Advertizes ye Wedding.*—The same infernal personage presides at the pay-table, where he acknowledges the services of the press; the *Chronicle* and the *Post* obtain their share of the spoil, and one gentleman observes, "Harry will take *both* sides." *The Honeymoon* is celebrated by a bonfire on Eddystone Lighthouse. *The Churching* takes place in the assembly which formed the arena of their former combats. The members are represented by a row of heads stuck on poles, described as a "mopstick majority;" while the new "Orator Henley," addressing the bridal pair from the elevation of a tub (supported by the same representative of darkness), holds out a charter with the memorable doctrine, "A charter is nothing but a piece of parchment with a great seal dangling to it," in allusion to the modifications proposed by Fox in the organization of the East India Company, which had thrown all the influence of the jealous corporation into the hostile faction. *The Wedding Dance and Song*, which concludes this pictorial epic, represents the approaching end of the union ; the black gentleman, who it is insinuated originally formed the alliance, is dancing with his clients, whilst he unsuspectedly leads them in his own direction by a line attached to their noses. A cheerful verse concludes the "Wedding Series :"—

> " Come, we're all rogues together,
> The people must pay for the play ;
> Then let us make hay in fine weather,
> And keep the cold winter away."

January, 1784. *Hudibras and his Squire.*—Fox and Burke being dismissed from office, are now exposed in the stocks. "Otium cum dignitate" is archly inscribed over this undignified instrument of punishment, and above the knight's head is suspended a scourge, with lashes bearing the titles, "Prerogative" and "Vox populi ;"while above the squire is the advertisement—"This day is published, 'An Essay on ye Sublime and Beautiful,' by Ralph B."

> " Sure, none that see how here we sit,
> Will judge us overgrown with wit ;
> For who, without a cap and bauble,
> Having subdued a bear and rabble,
> And might with honour have come off,
> Would put it to a second proof !
> A politic exploit right fit
> For Coalition zeal and wit."—HUDIBRAS.

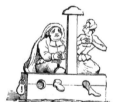

Hudibras and his Squire.

January 23rd, 1784.—*The Times, or a View of the Old House in Little Britain, with Nobody going to Hanover.*—The times were decidedly somewhat "out of joint" in the beginning of this year. Fox and his friends had been dismissed on the rejection of the India Bill, but the Court factions, which had effected this consummation by their underhand devices, were too weak to form a ministry commanding a majority. Lord Temple, the mouthpiece on this occasion of the King's views, had himself resigned after the censure passed by the Commons on "back-stair" influence, and it was discovered, on a question of adjournment, that the Court minority was so small that the new Ministers dared not divide. Such was the critical position of the Government at the Christmas recess. On the 12th of January, the first day of meeting after Christmas, when there was a full attendance of members, the Court having made every exertion to increase its number of votes, there was a majority of thirty-nine against the Ministers on the question of going into committee to consider the state of the nation. Fox then stated that it was necessary to come to some specific resolution to prevent the present Ministry from making an improper use of their power during

"the short time they had to exist;"[*] and moved, "That it was the opinion of the committee, that any person in his Majesty's Treasury, Exchequer, Pay-office, Bank of England, or any person whatever entrusted with the public money, paying away, or causing to be paid, any sum or sums of money voted for the service of the present year, in case of a dissolution or prorogation of Parliament, before a bill or bills were brought in for the appropriation of such sums, would be guilty of a high crime and misdemeanour, highly derogatory to the honour of the House and contrary to the faith of Parliament." This resolution was carried without a division, as well as another, "That it is the opinion of the committee, that there should be laid before them an account of all sums of money expended for the use of the public service between the 19th of December, 1783, and the 12th of January, 1784, specifying each sum, and for what expended." In moving this resolution, Fox said that it might appear an extraordinary method; but, as extraordinary measures had been taken by the present Ministry to come into power, it required extraordinary motions to prevent them doing mischief now they were in power. Other resolutions were passed, especially two moved by the Earl of Surrey, "That it is the opinion of the committee, that in the present situation of his Majesty's dominions, it is highly necessary that such an administration should be formed as possesses both the confidence of this House and of the public;" and "That it is the opinion of the committee, that the late changes were preceded by extra-ordinary rumours, dangerous to the constitution, inasmuch as the sacred name of Majesty had been unconstitutionally used for the purpose of affecting the deliberations of Parliament; and the appoint-ments that followed were accompanied by circumstances new and extraordinary, and such as were evidently calculated not to conciliate the affections of that House." This last motion was violently opposed by Pitt, Dundas, and Scott, but it was carried by a majority of fifty-four. On the 15th of January, Pitt obtained leave to bring in his India Bill. On the 16th the House again resolved itself into a committee, and, after a very warm debate, the following resolution was passed by a majority of twenty-one: "That it is the opinion of this committee, it having been declared by this House, that, in the present situation of his Majesty's dominions, an administration should be formed which possessed the confidence of this House and the public,—and the present Administration being formed under circumstances new and extraordinary, such as were not calculated to conciliate the affections or engage the confidence of this House,—that his Majesty's present Ministers still holding high and responsible offices, after such a declaration, is contrary to true constitutional principles, and injurious to his Majesty and his people." The debates on these resolutions were sometimes exceed-ingly violent, and led to much personal recrimination, especially between Pitt and Fox; but the former bore everything with the passive coldness for which he was remarkable, and the King remained obstinate in pursuing his own course. On the 23rd of January Pitt's India Bill was thrown out by a majority of eight, and Fox obtained leave to bring in a new bill on the same subject. The House was still labouring under the fear of a dissolution; and on the 26th of January a resolution was passed to avert it, on which Pitt declared that he should not advise his Majesty to dissolve the Parliament.

These details are unavoidable in defining the position of affairs represented in "The Times." The old house, bearing the sign of a broken-down "Magna Charta," appears somewhat insecure. It is, however, propped up by two sturdy supports, "The Lords" and "The Prerogative of the Crown." "Two Lawyers" have succeeded in disturbing this latter security. The roof is heavily tiled with taxes. A gaudy new balcony, upheld by the bending prop of "Coalition," supports a disorderly harlequinade; and a flag attached to this "show" is inscribed, "Man of the People," the emblem of the champion being a gigantic feather. On a stone marked "Protector" sits a fox, attached by a chain to the Coalition pillar; he points to a padlock placed on the "Funds," which is inscribed on the barred gates of public credit. The Crown is exposed on a stone, with an intimation that it is "to be sold."

[*] It is a curious circumstance that the *ad interim* premiership of Pitt should have proved to be the longest adminis-tration recorded, with one exception, that of Walpole (who remained Prime Minister twenty-one years), continuing from December, 1783, until March, 1801, with Pitt as recognised chief, and lasting virtually till the death of that Minister in January, 1806.

The only avenue to the old building is through a turnstile, across which stout North is seated, singing,

> " Give me my ease,
> And do as you please."

The King (backed by a declining sun) departs in the royal carriage for his Hanoverian dominions, while the people vainly invoke his protection. Popular feeling was now inconsistently turned against its own champions; as these satires show, the two deposed leaders were treated with general mistrust. Young Pitt was regarded hopefully by the people, and the integrity of his private life seems to have convinced an overwhelming majority of all classes of the community that he alone was the " pilot to weather the storm." Succeeding caricatures will show that this assurance was tolerably well-founded; the unswerving nature of the young Minister's policy encouraged the energetic support which was for years accorded to his leadership.

February, 1784. *Britannia Aroused* exhibits a fresh attack on the Opposition in the person of its chiefs. The Court party represented their opponents as a mere faction, and they expressed their conviction that the national appeal to a general election would result in the manifestation of their own popularity. Britannia is treating the Opposition leaders as enemies to the stability of that freedom which is symbolized at her side.

There was a certain party of moderation, which to a large degree had remained neutral, dreading, on the one hand, the violent and subversive encroachments of democracy, and opposing, on the other hand, an extension of the

Britannia Aroused.　　　　　　　Young Hercules and the Serpents.

royal prerogative and a relapse towards the absolute tendencies of the Stuarts, to which the King was predisposed by his ill-advised training, and by the arrogance which the impolitic Bute had engrafted on a disposition originally conciliatory and temperate.

February 3rd, 1784. *The Infant Hercules.*—On the shield of Chatham reposes his promising son, strangling the twin serpents of deceit, whose coils are respectively inscribed " American War" and " East India Bill." The creatures exhibit venom even in their overthrow, and the infant Hercules observes, with the intention of enlightening the public understanding on the dangerous character of the pair, " These were your Ministers !"

> " Lord North, for twelve years, with his war and contracts,
> The people he nearly had laid on their backs;
> Yet stoutly he swore he sure was a villain,
> If e'er he had bettered his fortune a shilling. .
> > Derry down, down, down, derry down.

> " Against him Charles Fox was a sure bitter foe,
> And cried, that the empire he'd soon overthrow ;
> Before him all honour and conscience had fled ;
> And vow'd that the axe it should cut off his head.
> > Derry down, &c.

> " Edmund Burke, too, was in a mighty great rage,
> And declared Lord North the disgrace of the age;
> His plans and his conduct he treated with scorn,
> And thought it a curse that he'd ever been born.
> > Derry down, &c.

> " So hated he was, Fox and Burke they both swore,
> They infamous were if they enter'd his door;

But, prithee, good neighbour, now think on the end,
Both Burke and Fox call him their very good friend!
　　　　　　　　　　Derry down, &c.

" Now Fox, North, and Burke, each one is a brother,
So honest, they swear there is not such another;
No longer they tell us we're going to ruin,
The people they *screw* in whatever they're doing.
　　　　　　　　　　Derry down, &c.

" But Chatham, thank heaven! has left us a son ;
When *he* takes the helm, we are sure not undone ;
The glory his father revived of the land,
And Britannia has taken Bill Pitt by the hand.
　　　　　　　　　　Derry down, &c."

The contest which had occurred over the proper measures to be applied for the regulation of our East Indian possessions continued with great bitterness. The question involved enormous interests. The government of the Company was evidently vicious and corrupt, and the illegitimate influence of bribery was liberally exercised in its interest by supporters at home. Warren Hastings, the much-discussed Governor-General, had already chosen to pay no regard to the resolutions which had been carried in Parliament for his recall. Commissioners had also been appointed to circumscribe his authority when it was exerted unworthily, but they had been treated with no respect. Hastings defied control, and for some time chose to administer according to the dictates either of his judgment or of his rapacity.

February 7th, 1784. *East India House.*—Fox and Pitt are kicking up the East India House (Leadenhall Street) as a football. Fox conceals a dice-box, and his playing cards are strewn on the floor to indicate his gambling propensities; while Pitt, who is represented as a remarkably slim lad, has just left his desk, where he was studying " Blackstone."

March 8th, 1784. *Master Billy's Procession to Grocers' Hall.*—This episode represents a " bid" for popularity. In anticipation of the forthcoming elections, Master Billy, in a high car drawn by " King's men," is proceeding in noisy state to a banquet at Grocers' Hall. A gold box heads the procession, and one of the Court party is distributing handfuls of coin. Sir Watney (his car drawn by imps) and Sir Burney form part of the train. The inscriptions on the banners are, " Pitt and Prerogative," " Youth is a most enormous crime," " Pitt and plum-pudding for ever," " King for ever," &c.

This caricature forms one of a rather numerous series which, although frequently incorporated with Gillray's works (indeed, the original drafts of several of these election cartoons were found among the artist's papers after his death), are sufficiently characteristic of Rowlandson's manner to leave no doubt of their parentage on one side. It is not difficult to discover the key to these composite works. Rowlandson at this date (1784) was a man of fashion, while Gillray's means of subsistence depended on his own exertions. Rowlandson, who moved amongst the youthful aristocrats of his day on the familiar terms promoted by the intercourse of gambling tables, of drinking bouts, and other dissipations, was probably encouraged by these associates on the eve of the election to become the partizan of one side or the other, according to their principles; and as Sayer had already enjoyed certain emoluments from Pitt as an acknowledgment of his services in the field of political caricature, Rowlandson was probably induced to try his own skill in that direction. However, his circumstances at that date permitted indulgence, and as he preferred to devote the greater part of his time to pleasure, he doubtless consulted his friend Gillray, whose more developed powers commanded his respect; and the result was that Rowlandson produced rough drafts of certain subjects, which Gillray remodelled, or simply preserved in firmer drawing, and transferred to copper, securing the influence of his own publishers for the works originated in this manner. The entire series of cartoons belonging to the " Westminster Election" may be assigned to this composite authorship ; in all these joint productions the peculiarities of Rowlandson's style are clearly distinguishable.

In the earliest of these subjects, published March 11th, 1784, Fox, *The Champion of the People,* represented as armed with the sword of justice and the shield of truth, is combating the many-headed hydra, whose various mouths breathe forth " Tyranny," " Assumed prerogative," " Despotism," " Oppression," " Secret influence," " Scotch politics," " Duplicity," and " Corruption." Several of the

monster's heads are already cut off. Behind the dragon, a Dutchman, a Frenchman, and other foreign enemies are seen dancing round the standard of sedition. The champion has on his side strong bodies of English and Irish, bearing aloft the "standard of universal liberty;" the former shout, "While he protects us, we will support him;" the latter, "He gave us a free trade, and all we asked; he shall have our firm support." More immediately attached to Fox, the native East Indians are on their knees praying for the success of their advocate.

The series was continued in another cartoon published March 26th, 1784, entitled *The State Auction.* Pitt, as the young auctioneer, is knocking down with the hammer of "Prerogative" most of the valuables of the Constitution. Dundas, as his assistant, is holding up for sale a heavy lot, entitled "Lot 1, the Rights of the People." Pitt cries, "Show the lot this way, Harry—a-going, a-going—speak quick, or it's gone—hold up the lot, ye Dund-ass!" To which the assistant replies, "I can hould it na higher, sir." On the left, the "chosen representers," as they are termed, are leaving the auction-room, muttering complaints or encouragements, such as "Adieu to liberty!" "Despair not!" "Now or never!" Fox alone stands his ground, and makes a last effort. "I am determined to bid with spirit for Lot 1; he shall pay dear for it that outbids me!" Beneath the auctioneer stand what are termed the "hereditary virtuosis;" the foremost of whom (apparently intended to represent the Lord Chancellor) leads them on with the exhortation, "Mind not the nonsensical biddings of those common fellows." The auctioneer's secretary observes, "We shall get the supplies by this sale."

Another caricature, proceeding from the combined talents of Gillray and Rowlandson, published on the 31st of March, when the elections were beginning, alludes more especially to the dissolution which had just taken place. It is entitled "*The Hanoverian Horse and British Lion;* a scene in a new play,

The British Lion and its Rider.

lately acted in Westminster with distinguished applause. Act 2nd, scene last." Behind is the vacant throne, with the intimation, "We shall resume our situation here at pleasure, Leo Rex." In front, the Hanoverian horse, without bridle or saddle, neighing "Pre-ro-ro-ro-ro-rogative," is trampling on the safeguards of the Constitution, and kicking out with violence its "faithful Commons." The young Minister, mounted on the back of the prancing animal, cries "Bravo! go it again! I love to ride a mettled steed; send the vagabonds packing." On the opposite side of the picture Fox is borne in, with more gravity, on the back of the British lion, and holding a whip and bridle in his hand. The indignant beast exclaims, "If this horse is not tamed, he will soon be absolute king of our forest!" The lion's rider warns his rival horseman of his danger. "Prithee, Billy, dismount before ye get a fall, and let some abler jockey take your seat."

March 29th, 1784. *The Drum-Major of Sedition.*—A caricature of Major John Cartwright, one of the most persevering and disinterested of reformers, a man of extensive knowledge and cultivated intellect. He was the first who developed the principle of making the slave-trade piracy. Fox, in presenting a petition from this champion of the "inherent rights of man," fervently declared, "he is one whose enlightened mind and sound constitutional knowledge place him in the highest rank of public character, and whose purity of principle and consistency of conduct through life command the most respectful attention to his opinions." In this caricature of the worthy Major he is

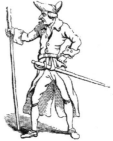

Major Cartwright.

haranguing in favour of the Court party, represented in the person of their *protégé*, Admiral Hood, who, holding out his hat before the hustings, betrays "Two Faces under a Hood!"

I

Cartwright is employed in enlisting levies for his opponents, and he offers somewhat equivocal inducements to electors:—

"All gentlemen—and others—electors for Westminster, who are ready and willing to surrender their rights and those of their fellow-citizens to Secret Influence and the Lords of the Bedchamber, let them repair to the Prerogative Standard lately erected, the Cannon Coffee House, where they will be kindly received until their services are no longer wanted. This, gentlemen, is the last time of asking, as we are determined to abolish the power of the House of Commons, and in future be governed by Prerogative, as they are in France and Turkey.

"Gentlemen, the ambition of the enemy is now evident. Has he not within these few days stolen the Great Seal of England while the Chancellor* was taking a bottle with a female favourite, as all great men do? I am informed, gentlemen, that the enemy now assumes regal authority, and by virtue of the Great Seal, which he stole, is creating peers and granting pensions—a most shameful abuse, gentlemen, of that instrument. If you assist us to pull down the House of Commons, every person who hears me has a chance of becoming a Great Man, if he is happy enough to hit the fancy of Lord Bute or Mr. Jenkinson. Huzza! God save the King!"

April 4th, 1784. *Incurable.*—Fox in a strait jacket, with straw in his hair, is represented as hopelessly mad; he is singing:—

> "My lodging is on the cold ground, and very hard is my case,
> But that which grieves me most is the losing of my place."

A court physician (Dr. Munro), surveying the patient through his gold eye-glass, says, "As I have not the least hope of his recovery, let him be removed amongst the *Incurables.*" The verses printed below the figures have about hit the truth:—

> "Dazzled with hope, he could not see the cheat
> Of aiming with impatience to be great;
> With wild ambition in his heart, we find
> Farewell content and quiet of his mind;
> For glittering clouds he left the solid shore,
> And wonted happiness returns no more."

William Pitt,† though only in his twenty-fifth year, was now, by the royal will, firmly established Prime Minister of England. His colleagues were either those who were already well known as "the King's friends," or those young aspirants to power who were willing to tread in their steps. Pitt joined

* Lord Thurlow.

† We append a brief synopsis of the qualities of William Pitt, from the pen of Lamartine, whose cultivated understanding and fine discrimination have combined to make his historical writings the clearest and most fascinating reviews of the past: "Son of the most eloquent statesman of modern times, Lord Chatham, Pitt had inherited talents as great as those of his father. If the first Chatham had the inspiration, the second had the qualities of government; less enthusiastic, more commanding; less eloquent, more convincing than his father, Pitt personified to perfection that haughty, patient, enduring will of a predominating aristocracy, which defends its power and follows out its grandeur with a pertinacity that recalled the perplexity of the Senate of Rome. Pitt had assumed the government at one of those desperate moments when the ambition which acquires power resembles the patriotism which mans the breach to perish or save a country. England was at the lowest ebb of exhaustion and humiliation. She had just signed a shameful peace with Europe; the French were her rivals in India; America had escaped from her clutches; the French fleets disputed the seas with her; the majority of the House of Commons, corrupted by preceding ministries, had neither the patriotism to protect itself nor the discipline necessary to accept a master. Pitt, unable to lead, had the audacity to contend against it, and the good fortune to overcome it, by an appeal to the nation. The newly-elected chamber submitted to him. In ten years he had pacified the Indies, diplomatically and commercially reconquered America, soothed the seditious irritation of Ireland, recruited the finances, concluded with France a treaty of commerce which imposed on one half of the Continent the tribute of using English productions, and finally snatched Holland from the protection of France, and made of the United Provinces an addition to Britannic policy on *terra firma.* His grateful country applauded his administration; the confidence in the hand which had raised the nation from her low position was perfect. Passions never troubled his mind, or rather all his passions were absorbed in one—the aggrandizement of his country."

It must be remembered that this testimony is paid by the minister of democracies, and the framer of a republic, to one who was essentially the champion of aristocracies, the statesman who baffled revolutions, and drove republican theories out of favour.

in himself the offices of First Lord of the Treasury and Chancellor of the Exchequer. Lord Camden was President of the Council; Viscount Sydney and the Marquis of Carmarthen were Secretaries of State for Home and Foreign Affairs; Earl Gower, Privy Seal; Earl Howe, First Lord of the Admiralty; Lord Thurlow, Chancellor; the Duke of Richmond, Master-General of the Ordnance; Mr. W. Grenville and Lord Mulgrave, joint Paymasters of the Forces; Mr. Dundas, Treasurer of the Navy; Mr. (afterwards Lord) Kenyon, Attorney-General; and Mr. Pepper Arden, Solicitor-General. The Opposition were fully aware of the disadvantages under which they would labour in a general election at that moment, and they had been anxious to avert a dissolution. Their fears were confirmed by the event. The elections were in many cases severely contested; but Court influence, and even the King's name, were used openly; and from being the majority, the party which had been led by Fox and North soon numbered but a comparatively small minority in the House of Commons. A few passages from Horace Walpole's correspondence will give us the best picture of the feelings of the day. On the 30th of March he writes: "My letters, since the great change in the Administration, have been rare, and much less informing than they used to be. In a word, I was not at all glad of the revolution, nor have the smallest connexion with the new occupants. There has been a good deal of boldness on both sides. Mr. Fox, convinced of the necessity of hardy measures to correct and save India, and coupling with that rough medicine a desire of confirming the power of himself and his allies, had formed a great system, and a very sagacious one; so sagacious, that it struck France with terror. But as this new power was to be founded on the demolition of that nest of monsters, the East India Company, and their spawn of nabobs, &c., they took the alarm, and the secret junto at Court rejoiced that they did. The Court struck the blow at the Ministers; but it was the gold of the Company that really conjured up the storm, and has diffused it all over England. On the other hand, Mr. Pitt has braved the majority of the House of Commons, has dissolved the existent one, and, I doubt, given a wound to that branch of the Legislature which, if the tide does not turn, may be very fatal to the Constitution. The nation is intoxicated; and has poured in addresses of thanks to the Crown for exerting the prerogative *against* the palladium of the people. The first consequence will probably be, that the Court will have a considerable majority upon the new elections. The country has acted with such precipitation, and with so little knowledge of the question, that I do not doubt but thousands of eyes will be opened and wonder at themselves." And, on the 11th of April: "The scene is wofully changed for the Opposition, though not half the new Parliament is yet chosen. Though they still contest a very few counties and some boroughs, they own themselves totally defeated. They reckoned themselves sure of 240 members; they probably will not have 150. In short, between the industry of the Court and the India Company, and that momentary phrenzy that sometimes seizes a whole nation, as if it were a vast animal, such aversion to the coalition, and such a detestation of Mr. Fox, have seized the country, that, even where omnipotent gold retains its influence, the elected pass through an ordeal of the most virulent abuse. The great Whig families, the Cavendishes, Rockinghams, Bedfords, have lost all credit in their own counties; nay, have been tricked out of seats where the whole property was their own; and, in some of those cases, a *royal* finger has too evidently tampered, as well as singularly and revengefully towards Lord North and Lord Hertford. . . Such a proscription, however, must have sown so deep resentment as it was not wise to provoke; considering that permanent fortune is a jewel that in no crown is the most to be depended upon."

The most remarkable event in the history of these elections was the obstinate contest for Westminster, which agitated the metropolis during several weeks. Westminster had been represented in the Parliament just dissolved by Fox and Sir Cecil Wray; the latter had been nominated by Fox, but had deserted the standard of his political leader.

April 8th, 1784. The Rival Candidates.—The Court was resolved, if possible, to turn Fox out of the House, and Wray and Lord Hood (the Admiral) were on the present occasion proposed for Westminster, the former being more especially held forth as the antagonist of the "Man of the People." The poll was opened on the 1st of April, and continued without intermission until the 17th of May. For the first few days, in consequence of the extraordinary exertions of their party, the two Ministerial candidates were decidedly in the majority; but afterwards Fox gradually gained ground, until, at the close of the election, he had a majority of 236 votes over his rival, Sir Cecil. For a great portion of

the six weeks during which this contest lasted, the western part of the town, and more especially the streets in the neighbourhood of Covent Garden (where the election for Westminster always took place), presented a scene of indescribable riot and confusion. At the beginning of the election, Lord Hood had brought up a considerable body of sailors, or, as others represented them, chiefly hired ruffians dressed in sailors' clothes, who occupied the neighbourhood of the hustings, and hindered many of Fox's friends from approaching to register their votes. When not thus employed, they paraded the street, insulting and even striking Fox's partisans. On the third day they came in greater numbers, armed with bludgeons, and surrounding "The Shakspeare," where Fox's committee met, committed various outrages during the day. At night they besieged "The Shakspeare" still more closely, until the gentlemen within, provoked by their insulting behaviour, sallied out and dispersed them. This defeat only added to the excitement, for on the morning of the fourth day of the election the sailor mob made its appearance with a great accession of force, and took up its position about the hustings as usual. But there was a mob on the other side also; for the hackney-chairmen, a numerous body, who were chiefly Irishmen, were almost unanimous in their support of Fox; and, aggravated by the conduct of the sailors, when the latter, at the close of this day's poll, commenced their usual outrages, the chairmen, whom the newspapers in the interest of the Opposition termed the "honest mob," fell upon them and handled them so roughly, that we are told several had their skulls fractured, and others were afterwards picked up with arms, legs, and ribs broken. The sailors then left the neighbourhood of Covent Garden, and proceeded to St. James's Street, where the chairmen mostly plied for custom, with the avowed intention of breaking their chairs; but the chairmen beat them again, and the riot was at length put an end to by the arrival of a body of the Guards. The next day, which was Tuesday, the sailors re-assembled in a threatening attitude in Covent Garden; but when, towards the end of the poll, the rival mob, composed now of a multitude of butchers, brewers, and other people, in addition to the chairmen, made its appearance, the sailors left Covent Garden, and hastened towards Charing Cross, to intercept Fox, who was understood to be on his way to Westminster to canvass. Fox escaped by taking refuge in a private house; and the mob, having visited Westminster without meeting with the object of their search, returned to the Strand, where another combat took place between the adverse factions, and the sailors were again defeated. They met with no better success in two other battles that occurred in the course of the same evening. Wednesday presented a similar scene of riot, and in the evening a still more obstinate battle was fought in Covent Garden between the two mobs, in which the sailors were utterly defeated, and twenty or thirty of them are said to have been carried to the hospitals with severe injuries. Next day but few sailors made their appearance, and the rioting was practically at an end. Measures were now taken by the civil authorities to prevent any outbreak of popular feeling which might occur at the close of the poll. The special constables were assembled at the places where Hood and Wray's committee met, and behaved in a manner so evidently hostile to the friends of Fox, that their presence tended rather to provoke riot than otherwise.

On the 10th of May, a party of constables were brought from Wapping by order of Justice Wilmot,[*] in opposition, it was said, to the opinions of the other magistrates, and they went about shouting "No Fox!" and impeding and insulting the Liberal voters. Just as the poll closed, a slight disturbance gave the excuse for an attack by the constables. The sound of marrow-bones and cleavers, the old signal for an insurrection of the populace, was immediately heard, and a rather serious scuffle ended in the death of one of the constables. The party of Fox's opponents endeavoured to fix the

[*] "Justice Wilmot" appears to have had no great reputation for the extent of his judicial capacity. One of the Foxite newspapers pretends that, a short time before the catastrophe mentioned in the text, he had addressed to one of the chief booksellers in London a note worded as follows :—

"MR. EVANS,

"Sir, I expects soon to be calld out on a Mergensey, so send me all the ax of parlyment re Latin to a Gustis of Piece. "I am,

 "Yours to command, &c.,

 "GUSTIS WILMOT."

death of the constable on some individuals of the Foxite mob, who were indicted for the murder, but acquitted; and it appeared tolerably evident on the trial that the victim had been knocked down in mistake by one of his fellow-constables in the heat and confusion of the moment. But the violence of party faction was so great, that one or two men of notoriously bad character were brought forward, apparently hired, to swear that they had seen the constable killed by the persons indicted; and a further attempt was made to create a new affray, by carrying the body for burial to Covent Garden Church, attended by a tumultuous cavalcade, with flags and incendiary handbills, on the 14th of May, in the midst of the day's polling. This was prevented by the firmness of the parish officers, and by the proposal to close the poll at two o'clock on that day.

Perhaps no single occasion ever drew forth, in the same space of time, so many political squibs, ballads, and caricatures, and so much personal abuse on both sides, as this election for Westminster. The newspapers were filled daily with the subject, which seemed exclusively to occupy all the wits and fashionable politicians of the metropolis. The popular charges against Sir Cecil Wray were, his ingratitude towards Fox, for which his opponents branded him with the title of Judas Iscariot; a proposal which he was said to have made to suppress Chelsea Hospital; and a projected tax upon maid-servants. To these were added the more general cries against his party, of undue elevation of the prerogative, and back-stairs influence. The particular crimes laid against Fox, were the Coalition and the India-bill; but he was taxed with private immorality and with revolutionary principles. His opponents represented that his attack on the East India Company's charter was but the commencement of a general invasion of chartered rights of corporate bodies:—

> " This great Carlo Khan,
> Some say, had a plan,
> To take all our charters away;
>
> " But his scheme was found out,
> And you need not to doubt,
> Was opposed by the staunch Cecil Wray."

It was but a new link in his chain of political delinquencies; his whole life, they said, had been characterized by the same want of sober principles:—

> " When first young Reynard came from France,
> He tried to bow, to dress, to dance,
> But to succeed had little chance,
> The courtly dames among;
> 'Tis true, indeed, his wit has charms;
> But his grim phiz the point disarms,
> And all were filled with dire alarms
> At such a *beau garçon.*
>
> " He left the fair, and took to dice;
> At Brooks's they were not so nice,
> But clear'd his pockets in a trice,
> Nor left a wreck behind.
> Nay, some pretend he even lost
> That little grace he had to boast,
> And then resolved to seize some post,
> Where he might *raise the wind.*
>
> " In politics he could not fail;
> So set about it tooth and nail;
> But here again his stars prevail,
> Nor long the meteor shone.
> His friends—if such deserve the name—
> Still keep him at a losing game;
> Bankrupt in fortune and in fame,
> His day is almost done."

The grand enemy of the Crown, the Court agents said, was no doubt at his last gasp, and they began already to sing their triumph over his grave:—

" Dear Car, is it true,
 What I've long heard of you ?
' The man of the people,' they call you, they call you !
 How comes it to pass,
 They're now grown so rash,
At the critical moment to leave you, to leave you ?

" Oh ! that curs'd India Bill !
 Arrah, why not be still ?
Enjoy a tight place and be civil, be civil ;
 Had you carried it through,
 Oagh ! that would just do,
Then their charters we'd pitch to the Devil, the Devil."

The exertions of the Court against Fox were of the most extraordinary kind. The King is said to have received almost hourly intelligence of what was going on, and to have been affected in the most evident manner by every change in the state of the poll. The royal name was used very freely in obtaining votes for Hood and Wray, even in threats. On one occasion, two hundred and eighty of the Guards were sent in a body to give their votes as householders, which Horace Walpole observes "*is legal, but which my father (Sir Robert), in the most quiet seasons, would not have dared to do.*" All dependents on the Court were commanded to vote on the same side as the soldiers. When the popular party cried out against this sort of interference, their opponents charged Fox and his friends with bribery, and with using various other kinds of improper influence ; they insulted his voters by describing them publicly as the lowest and most degraded part of the population ; and their language became more violent as Fox gradually rose on the poll. " It is an absolute fact," one of their papers said, " that if a person, on going up to the Shakspeare, can shew a *piece* of a shirt *only*, the committee declares him *duly qualified.*" Another paper announces, " This day the *elegant* inhabitants of Borough-clink, Rag-fair, Chick-lane, &c., go up with an address to Mr. Fox, at his *ready-furnished lodgings,* thanking him for his interest in the late extraordinary *circulation of handkerchiefs.*" Forgetting their old sailors, they exclaimed against the employment of persons of no better character than Irish chairmen ; and after the unfortunate affair on the 10th of May, they headed their bills with such titles as, " No murder !" " No club law !" " No butchers' law !" " No petticoat government !"

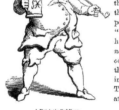

The young Prince of Wales, who was now the intimate friend of Fox and the warm supporter of the Coalition, exerted himself as actively against the Court in this Westminster election as his father's Ministers did in favour of it, and his conduct is said to have given extreme provocation to the King and Queen. Members of his own household were employed in canvassing for voters ; and some of the Ministerial papers, which in their paragraphs showed little respect for his character, declared that he had canvassed in person. One of them states, with an appended observation the wit of which is not very remarkable, that " the Prince appeared at Ranelagh last week with a *Fox cockade* in his hat, and a sprig of *laurel :* if he should ever be sent a *bird's-nesting* by Oliver, it is to be expected he will prefer the *laurel* to the *oak.*" At this time is said to have arisen the hostile feeling which the Prince ever afterwards entertained towards Pitt, and which was increased by the Minister's stiff and haughty bearing towards him. The Prince gave a magnificent party in honour of Fox's triumph at Westminster.

A Patriotic Publican.

Another active and remarkable partizan of Fox was "honest" Sam House* the publican, an old resident in Westminster, remarkable for his oddities and for his political zeal. During this election he kept open house at

* The picture of Sam House occurs in many caricatures of the time. The portrait here given is copied from a plate by Gillray.

his own expense, and was honoured with the company of many of the Whig aristocracy. An early caricature by Gillray, entitled "Returning from Brooks's," represents the Prince of Wales in a state of considerable inebriety, wearing the election cockade, and supported by Fox and the patriotic publican. The wit of the Ministerial papers was often expended on honest Sam. At the beginning of the election, when Fox seemed to be in a hopeless minority, one of them inserted a paragraph stating that the publican had committed suicide in his despair. He is said to have been a very successful canvasser in the course of the election.

> "See the brave Sammy House, he's as still as a mouse,
> And does canvass with prudence so clever :
> See what shoals with him flocks, to poll for brave Fox ;
> Give thanks to Sam House, boys, for ever, for ever, for ever !
> Give thanks to Sam House, boys, for ever !

> "Brave bald-headed Sam, all must own, is the man,
> Who does canvass for brave Fox so clever ;
> His aversion, I say, is to *small beer and Wray !*
> May his bald head be honour'd for ever, for ever, for ever !
> May his bald head be honour'd for ever !"

Many anecdotes are related of Fox's encounters with rough wits and the rude pleasantries which formed the charms of electioneering in the past :—

"Mr. Fox, on his canvass, having accosted a blunt tradesman, whom he solicited for his vote, the man answered, 'I cannot give you my support ; I admire your abilities, but d—n your principles !' Mr. Fox smartly replied, 'My friend, I applaud you for your sincerity, but d—n your manners !' "

"Mr. Fox having applied to a saddler in the Haymarket for his vote and interest, the man produced a *halter*, with which, he said, he was ready to oblige him. Mr. Fox replied, 'I return you thanks, my friend, for your intended present ; but I should be sorry to deprive you of it, as I presume it must be a *family piece.*' "

The most active and successful of Fox's canvassers, and the most ungenerously treated by the opposite party, was the beautiful and accomplished Duchess of Devonshire (Georgiana Spencer).

Bribery.

Attended by several other beauties of the Whig aristocracy, she was almost daily present at the election, wearing Fox's cockade, and she went about personally soliciting votes, which she obtained in great numbers by the influence of her personal charms and her affability. The Tories were greatly annoyed at her ladyship's proceedings ; they accused her of wholesale bribery, and it was currently reported that she had in one instance bought the vote of a butcher with a kiss, an incident which was immediately exhibited to the people's eyes, with more or less of exaggeration, in multitudes of pictures.

April 12th, 1784. *The Devonshire, or the most approved Method of securing Votes.* — Nothing could be more disgraceful than the profusion of scandalous and indecent abuse which was heaped upon the Duchess of Devonshire by the Ministerial press, especially by its two great organs, the *Morning Post* and the *Advertiser.* The Queen, who had all the caricatures at this time brought to her, and was extremely amused by the manner in which the opponents of the Court

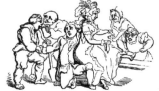

A Group of Canvassers.

were ridiculed, is said to have been much shocked by some coarse allusions to the Duchess which had been accidentally brought to her among the other political prints. The "canvassing Duchess"

figured also in many caricatures of a less objectionable character. Thus, in one entitled "Wit's Last Stake, or the cobbling voters and abject canvassers," the Duchess is represented seated on Fox's knee, and holding her shoe to be mended by a cobbler, for which she is paying his wife with gold; Fox is shaking hands with another voter, who is treated by Sam House with a pot of porter.

April 4th, 1784. *Lords of the Bedchamber.*—The charming Duchess, seated beneath the well-known portrait of her husband by Sir Joshua Reynolds, is pouring out tea for her privileged visitors, Fox and Sam House. The latter is sitting very formally on a sofa, with his hat on his knee, stirring his tea; while the popular candidate gives him an encouraging pat on his bald head.

April 30th, 1784. *Procession to the Hustings after a Successful Canvass.*—The cavalcade is heralded by a band of marrow-bone and cleaver performers; then comes the Duchess of Devonshire bearing a novel standard for the "Man of the People." Another fair lady is carrying a board with the inscription, "Fox and the Rights of the Commons." A third raises aloft a cap and apron, inscribed (in allusion to Sir Cecil Wray), "No tax upon servants." Then follow the voters, with Fox favours in their hats, bearing a device of the "key of the backstairs," in ridicule of the opposing candidates.

May, 1784. *The Poll.*—The Duchess of Devonshire (a very pleasing figure) and Mrs. Hobart (a stout personage, Sir Cecil's canvasser) occupy the extremes of a "see-saw." The weight of the latter lady, who is exhibited in another caricature of the same origin as a balloon, has elevated the Duchess considerably.

The broadsides directed against the Court candidates were almost as numerous; they chiefly represented Sir Cecil Wray as suffering from the retributive attacks of Chelsea pensioners with their crutches, of maid-servants with their mops, and of contemptuous brewers' draymen, enraged by the small-beer question. Wray's shifted adherence, and his betrayal of Fox, who had originally brought him forward, naturally provoked numerous recriminations against the "renegade," who usually figured as Judas Iscariot.

The opposite party, by dwelling continually on Sir Cecil's project of saving money to the State by abolishing Chelsea Hospital, arrayed against him the numerous class who, in one way or another, derived benefit from that establishment; and they loudly represented that his proposed tax on maid-servants would throw a great number out of employment, and be productive of various other evils. There was also a satirical story of his keeping nothing in his cellar but small-beer; and some other little incidents were made objects of ridicule, if not of odium; nor was the old symbol of France and slavery—wooden shoes—forgotten. The following, put out early in the canvass, may serve as an example; the allusion being more especially to the extensive polling of soldiers for Hood and Wray at the beginning of the election:—

"All *Horse-guards, Grenadier-guards, Foot-guards,* and *Black-guards* that have not polled for the destruction of *Chelsea Hospital* and the *tax on maid-servants,* are desired to meet at the Gutter Hole, opposite the Horse-guards, where they will have a full bumper of '*knock-me-down*' and plenty of *soap-suds,* before they go to poll for Sir Cecil Wray, or eat.

"N.B.—Those that have no shoes or stockings may come without, there being a quantity of *wooden shoes provided for them.*"

The obnoxious tax upon the maids was a sufficient set-off to the new taxes, especially that on receipts, which had been proposed by Fox while in office, and was loudly cried down by his Tory opponents:—

"For though he opposes the stamping of notes,
'Tis in order to tax all your petticoats;
Then how can *a woman* solicit our votes
For Sir Cecil Wray?"

The ladies are, therefore, especially warned against countenancing such a pretender, whose only claim was the love of back-stairs intrigue, and whose crooked politics were not even embellished by generous feelings:—

"For had he to women been ever a friend,
Nor by taxing *them* tried our old taxes to mend,
Yet so *stingy* he is, that none can contend
For Sir Cecil Wray.

"The gallant Lord Hood to his country is dear,
His voters, like Charlie's, make excellent cheer;
But who has been able to taste *the small beer*
Of Sir Cecil Wray?

" Then come ev'ry free, ev'ry generous soul,
 That loves a fine girl and a full flowing bowl,
 Come here in a body, and all of you poll
 'Gainst Sir Cecil Wray !

" In vain all the arts of the Court are let loose,
 The electors of Westminster never will choose
 To run down a Fox, and set up a *Goose*
 Like Sir Cecil Wray."

It was, however, the turn of the Foxites to triumph in their increasing numbers of votes, and a shower of exulting squibs and songs fell upon their opponents. Placards like the following were scattered abroad before the end of April :—

" *Oh! help Judas, lest he fall into the Pitt of Ingratitude ! ! !*

" The *prayers* of all bad Christians, Heathens, Infidels, and Devil's-agents, are most earnestly requested
for their dear friend,

JUDAS ISCARIOT, *knight of the back-stairs,*

lying at the period of political dissolution ; having received a dreadful wound from the exertions of the lovers of liberty and the Constitution, in the poll of the last ten days at the Hustings, nigh unto the Place of Cabbages."

They published caricatures, many of which may be attributed to the Gillray-Rowlandson alliance, in which all parties were satirized indiscriminately. The unsuccessful candidate was driven away by a maid-servant's broom and a pensioner's crutch ; or pursued by a hooting crowd, bearing on their banners, "No tax on maid-servants," &c., as already described ; or he was seen riding dolefully on a slow and obstinate ass, while the successful candidates are galloping onwards to the end of the race on high-mettled horses, leaving him far in the distance. Even the Irish chairmen had their fling at the discomfited candidate in a " new " ballad, entitled " Paddy's Farewell to Sir Cecil :"—

" Sir Cecil, be aisy, I wont be unshivil,
 Now the Man of the Pnple is chose in your stead ;
 From swate Covent Garden you're flung to the Divil,
 By Jasus, Sir Cecil, you've bodder'd your head.
 Fa-ra-lal, &c.

" To be sure, much avail to you all your fine spaiches,
 'Tis nought but palaver, my honey, my dear,
 While all Charlie's voters stick to him like laiches,
 A friend to our liberties and our *small beer.*
 Fa-ra-lal, &c."

The ladies are then represented as rejoicing in his defeat, with the exception of his canvassing friend, Mrs. Hobart ; and the songster concludes :—

" Ah now ! pray let no jontleman prissent take this ill,
 By my truth, Pat shall nivir use unshivil wards ;
 But my varse sure must plaise, which the name of Sir Cecil
 Hands down to oblivion's latest recards.
 Fa-ra-lal, &c.

" If myshelf with the tongue of a prophet is gifted,
 Oh ! I sees in a twinkling the knight's latter ind !
 Tow'rds the varge of his life div'lish high he'll be lifted,
 And after his death, never fear, he'll discind.
 Fa-ra-lal, &c."

May, 1784. *The Westminster Deserter Drum'd out of the Regiment.*—This cartoon may be considered as illustrating the last act of that prolonged comedy which ended in the discomfiture of the Court party and the triumph of the " Man of the People." Sir Cecil Wray, handcuffed as a deserter, is running the gauntlet of the regiment, from which Sam House drums him with right good will. " Help, Churchill ! Jackson, help ! or I am lost for ever," exclaims the rejected candidate, whom we shall meet once more in these caricatures, in July, 1791 (" Hopes of the Party "), when he will be again wearing the colours of the Opposition, to whose ranks he had then returned. The Chelsea pensioners are scowling at Sir Cecil Wray ; they bear a flag inscribed, " May all public deserters feel public resentment ;" files of domestic servants scoff, and the supporters of Fox hoot the unpopular candidate. Charles Fox bears a standard on which figure the image of Britannia and the words " Champion of the People." The

K

attitude of the orator is earnest, and his expression cordial. "Friends and fellow citizens," he says, "I cannot find words to express my feelings to you upon this victory."

But the hostility against Fox at Westminster did not end with the election; the Court party had, from the first, declared their intention of demanding a scrutiny if Fox succeeded, because it was known that, under the circumstances, this would be a long, tedious, and expensive affair. The returning officer acted partially, and, on the demand of Sir Cecil Wray for a scrutiny, refused to make a return. Fox had been elected member for Kirkwall in Scotland, so that he was not hindered from taking his seat in the House; and, after some months' delay, the High Bailiff was not only obliged to return him as a member for Westminster, but Fox brought an action against him, and recovered heavy damages.

We ought not to pass over another zealous actor in this turbulent scene, who at least helped to enliven it, the convivial songster Captain Morris, whose effusions were unfortunately not always of an unexceptionable character. We shall soon meet with him again as one of the boon companions of the heir apparent. The Captain had begun his career as a political songster in the ranks of the Tories, and had composed a bitter song against the Fox and North Administration, under the title of "The Coalition Song." His conversion to the, other party was probably effected by the example of the Prince of Wales. During the Westminster election of 1784 he was a constant attendant at Fox's convivial parties, for which several of his best political songs were composed, especially one against the King and his young Minister Pitt, entitled "The Baby and Nurse," which was enthusiastically called for over and over again at the election dinners; and, oddly enough, while he was himself singing this new song to the Whigs, the Tories were singing his old song against the Coalition. Another song against Pitt, by Captain Morris, was popular during and after the election, under the title of

"BILLY'S TOO YOUNG TO DRIVE US.

"If life's a rough journey, as moralists tell,
 Englishmen sure made the best on't;
On this spot of earth they bade liberty dwell,
 While slavery holds all the rest on't.
They thought the best solace for labour and care
 Was a state independent and free, sir;
And this thought, though a curse that no tyrant can bear,
 Is the *blessing* of you and of me, sir.
 Then while through this whirlabout journey we reel,
 We'll keep unabused the best blessing we feel,
 And watch ev'ry turn of the politic wheel—
 Billy's too young to drive us.

"The car of Britannia, we all must allow,
 Is ready to crack with its load, sir;
And wanting the hand of experience, will now
 Most surely break down on the road, sir.
Then must we, poor passengers, quietly wait,
 To be crush'd by this mischievous spark, sir,
Who drives a *d—d job* in the carriage of State,
 And got up like a thief in the dark, sir?
 Then while through this whirlabout, &c.

"They say that his judgment is mellow and pure,
 And his principles virtue's own type, sir;
I believe from my soul he's a son of a ——,
 And his judgment more rotten than ripe, sir.
For all that he boasts of, what is it, in truth,
 But that mad with ambition and pride, sir,
He's the vices of age, for the follies of youth,
 And a d—d deal of cunning beside, sir?[*]
 Then while through this whirlabout, &c.

"The squires, whose reason ne'er reaches a span,
 Are all with this prodigy struck, sir;
And cry, 'It's a crime not to vote for a man
 Who's as chaste as a baby at suck,' sir.[†]
 * * *

"It's true, he's a pretty good gift of the gab,
 And was taught by his dad on a stool, sir;
But though at a speech he's a bit of a dab,
 In the State he's a bit of a tool, sir.
For Billy's pure love for his country was such,
 He agreed to become the cat's-paw, sir;
And sits at the helm, while it's turned by the touch
 Of a reprobate fiend of the law,[‡] sir.
 Then while through this whirlabout, &c.'"

The results of this hard-fought contest were not very gratifying to the King. Fox was returned to represent his old constituents, and his party were overwhelmed with congratulations. The Prince of Wales threw open Carlton House, and also attended the rejoicings which celebrated the occasion at

[*] To explain some parts of this song, it may be necessary to state, that, although very strongly addicted to the bottle, Pitt, who was of a cold, phlegmatic disposition, had none of the wild habits of the young men of his day, and was held up by the Court as a contrast to the irregularities of Fox and his companions.

[†] Two stanzas and a half are omitted here.

[‡] An allusion to Lord Thurlow, who was celebrated for his swearing propensities.

the Duke of Devonshire's family mansion. In the exultations of success the invaluable assistance of Fox's graceful canvasser was appropriately acknowledged; nor did the satirists neglect this opportunity for the indulgence of playful raillery; and in a caricature published immediately after the election, entitled *Every Man has his Hobby-horse*, the successful candidate is borne in triumph by his fair and zealous supporter. Charles Fox may truly be said to have been carried into the House of Commons in 1784 by the Duchess of Devonshire.*

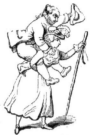

The Successful Candidate

The political events of 1784 were centred in the general elections, which resulted in the return, in most instances, of the Ministerial candidates.

The Westminster election was a most remarkable struggle, and is an event of importance in the Parliamentary history of the last century, because it was the only very serious check that the Court met with at this time in its successful attempt to obtain a strong Tory House of Commons. The superior power of the Crown in the Legislature and the political influence of William Pitt were from this moment firmly established. The principal measures of the new Ministers during the year 1784 (with the exception of Pitt's India Bill, a performance so crude that his own friends were obliged to alter it from beginning to end as it passed through the House, and several acts were subsequently called for to explain it) were of a financial

* As neither the caricatures of Gillray nor the accompanying remarks will bring the beautiful and accomplished Georgiana Spencer before the reader again, we are anxious here to produce as realistic an impression of the lady as may lie in our power.

Little Miss Burney, tripping away from the Court on a visit to the country, had the happiness to meet the Duchess of Devonshire; and although the authoress of "Evelina" respected the royal prejudices (as became a "companion" of the Queen), her insight into human nature overcame the bias of party influence. On her first interview, Miss Burney was not so much impressed by the Duchess's beauty; but though she failed to discover the graces she had anticipated, she was much struck by her unusual frankness of expression:—

"Her openness of countenance announced her endowed, by nature, with a character intended wholly for honesty, fairness, and good purposes."

On a second visit the acquaintance became delightfully cordial, and she conversed with the fascinating leader of the Regency Court, the queen of that combination of youth, beauty, wealth, and high rank which, estranged from the hum-drum Royal Court, had inaugurated a rival and more brilliant court of its own.

Miss Burney had the temerity to refer to these transgressions of the fair opponent against the circle claiming her own allegiance, and the amiability of the Duchess was only increased. Writing from Bath, the centre of fashion in those days, Miss Burney records:—

"I now saw the Duchess far more easy and lively in her spirits, and consequently far more lovely in her person. Vivacity is so much her characteristic, that her style of beauty requires it indispensably; the beauty, indeed, dies away without it. I now saw how her fame for personal charms had been obtained; the expression of her smiles is so very sweet, and has an ingenuousness and openness so singular, that, taken in those moments, not the most rigid critic could deny the justice of her personal celebrity. She was quite gay, easy, and charming; indeed, that last epithet might have been coined for her. This has certainly been a singular acquaintance for me, that the first visit I should make, after leaving the Queen, should be to meet the head of the opposition public, the Duchess of Devonshire."

It is interesting to learn anything relating to the husband of a lady who enjoyed so brilliant a reputation. After his retirement from Court and his memorable quarrel with Lord Bute, the Duke does not appear to have cared for a popular reputation, and he carefully avoided the chance of becoming conspicuous even in his own party, the Whigs.

A quiet, tranquil-minded nobleman, content to enjoy the good things which fortune had liberally allotted him, he is rarely seen on the turbulent stage of public life. Miss Burney encountered the Duke at a private "rout," and she has preserved an anecdote characteristic of his impassive temperament:—

"The Duke of Devonshire was standing near a very fine glass lustre in the corner of a room, at an assembly, and in a house of people who were by no means in a style of living to hold expense as immaterial; and by carelessly lolling back he threw the lustre down and it was broken. He showed, however, not the smallest concern or confusion at the accident, but coolly said, 'I wonder how I did that!' He then removed to the opposite corner, and to show, I suppose, he had forgotten what he had done, leaned his head in the same manner, and down came the opposite lustre. He looked at it very calmly, and, with a philosophical dryness, merely said, 'This is singular enough;' and walked to another part of the room without either distress or apology."

character, and their object was to provide by new taxes, or commutations of old ones, for the debts incurred in the late war. A feeble opposition was made to the Government plan of taxation, and the public began to cry out loudly against the burdens under which they laboured. "Master Billy's Budget" was the subject of more than one satirical song; and the following lines "On the Taxes," published towards the end of the year, give a tolerably comprehensive view of the various items of which it consisted :—

> " Should foreigners, staring at English taxation,
> Ask why we still reckon ourselves a *free nation*,
> We'll tell them, we pay for the light of the sun ;
> For a horse with a saddle—to trot or to run ;
> For writing our names ;—for the flash of a gun ;
> For the flame of a candle to cheer the dark night ;
> For the hole in the house, if it let in the light ;
> For births, weddings, and deaths ; for our selling and buying ;
> Though some think 'tis hard to pay threepence for dying ;
> And some poor folks cry out, ' These are Pharaoh-like tricks,
> To take such unmerciful tale of our bricks !'
> How great in financing our statesmen have been,
> From our ribbons, our shoes, and our hats may be seen ;
> On this side and that, in the air, on the ground,
> By act upon act now so firmly we're bound,
> One would think there's not room one new impost to put,
> From the crown of the head to the sole of the foot,
> Like Job, thus John Bull his condition deplores,
> Very patient, indeed, and all cover'd with sores."

The Opposition, indeed, seemed at this moment to be sunk so low in public opinion, that the patriot's "occupation" might truly be said to be gone. Serious papers and burlesque caricatures joined in treating the efforts of the "country party" with contemptuous derision. The support this party derived from the Prince of Wales was the only thing which gave uneasiness, and it provoked the King and Queen in the highest degree. They looked upon Fox with abhorrence as the corruptor of the royal youth ; and Gillray published a caricature, at the conclusion of the Westminster election, entitled *Preceptor and Pupil*, representing the Opposition leader, in loathsome form, whispering into the ear of the sleeping heir to the throne, " Abjure thy country and thy parents, and I will give thee dominion over many powers. Better to rule in hell than serve in heaven !"

Preceptor and Pupil.

After the flood of Ministerial and Opposition squibs produced on the election, political caricature began to flag. The aspect of the newly-elected Parliament offered but few opportunities to Gillray for the exercise of his art ; and from the great improvement in his designs after 1784, as regards both conception and execution, it may be concluded that not only were his powers maturing, but also that the interval was devoted to close study at the Academy.

December 6th, 1784.—The progress made by Gillray was manifested in a character-portrait of Mrs. Siddons published at this date, the execution of which is considerably in advance of anything he had previously produced. The actress, represented as Melpomene, exhibits her portrait in profile ; the expression of the face being very carefully given. The picture, however, conveys an ungenerous accusation of avarice against the Queen of Tragedy. "Melpomene Siddons," with the noblest of faces, grasps with outstretched hand a purse, suggestively held out at the tip of a pitchfork ; and while one ample pocket is bursting with bank-notes, the other overflowing with sovereigns, the dagger and goblet, emblems of tragic passion, are quite disregarded. An approving "encore" ascends from the smoky pit ; but the Temple of Fame, shaken to its foundation, is collapsing in ruin.

1785.

The earliest caricature applying to the new Session is christened *Secret Influence directing the New Parliament.* (This work appears to conclude the electioneering series projected under the Rowlandson-Gillray alliance of 1784.) The King composedly observes from the throne, "I trust we have got such a House of Commons as we wanted." Secret influence is represented by a huge serpent whispering to the monarch. A human face, which tops the reptile, is probably intended for Mr. Jenkinson, the notorious "Jenky," who afterwards figures in the cartoons as Lord Hawkesbury, and finally as Lord Liverpool. Lord Thurlow, as a gigantic bird of prey, ejaculates, with the profanity which is always attributed to his speeches, "D—n the Commons! the Lords shall rule," while George's Scotch adviser, partially concealed behind the throne, cries, "Very gude, very gude! D—n the Commons." The unconscious Britannia, reposing on her shield, is roughly admonished by the popular representative, "Thieves! thieves! Zounds! awake, Madam, or you'll have your throat cut!"

The Anti-ministerial wits were briskly at work out of doors (although in the House everything was quiet), and many clever satires reflecting on the King and his partisans were put into circulation.* Among the most brilliant of the Opposition luminaries may be cited the names of Sir John Hawkins and Joseph Richardson. A few examples illustrate the feelings against the Pitt Cabinet which were expressed outside the Parliamentary circle :—

ODE OF HORACE, IMITATED BY THE KING.

"Jenky, I own, divides my heart,
Skilled in each deep and secret art
 To keep my Commons down.
His views, his principles are mine ;
For these I'd willingly resign
 My kingdom and my crown."

"POLITICAL RECEIPT BOOK. 1784-5.

"*How to make a Premier.*—(Pitt.) He must subscribe to the doctrine of passive obedience, and to the exercise of patronage independent of his approbation; and be careless of creating the most formidable enemies, if he can gratify the personal revenge and hatred of those who employ him, even at the expense of public ruin and general confusion.

"*How to make a Chancellor.*—(Thurlow.) Take a man of great abilities, with a heart as black as his countenance. Let him possess a rough inflexibility without the least tincture of generosity or affection, and be as manly as oaths and ill-manners can make him. He should be a man who will act politically with all parties, hating and deriding every one of the individuals which compose them.

"*How to make a Treasurer of the Navy.*—(Henry Dundas, afterwards Lord Melville.) Take a man composed of most of the ingredients necessary to enable him to attack and defend the very same principles in politics, or any party or parties concerned in them, at all times and upon all occasions. Mix with these ingredients a very large quantity of the root of interest, so that the juice of it may be always sweet and uppermost. Let

* Horace Walpole writes on the 30th of October : " As to your little knot of poets, . . . we have at present here a most incomparable set, not exactly known by their names, but who, till the dead of summer, kept the town in a roar, and, I suppose, will revive by the meeting of Parliament. They have poured forth a torrent of odes, *epigrams*, and part of an imaginary epic poem, called the 'Rolliad,' with a commentary and notes, that is as good as the 'Dispensary' and 'Dunciad,' with more ease. These poems are all Anti-ministerial, and the authors very young men, and little known or heard of before. I would send them, but you would want too many keys : and, indeed, I want some myself ; for, as there are continual allusions to Parliamentary speeches and events, they are often obscure to me till I get them explained." The principal writers of these satires were, we are told, Mr. Ellis, a lawyer named Lawrence, Colonel R. Fitzpatrick, and John Townshend, second son of George Viscount Townshend.

him be one who avows a pride in being so necessary an instrument for every political measure, as to be able to extort those honours and emoluments from the weakness of a government which he had been deliberately refused, at a time when it would have been honourable to have obtained them."

The Duke of Richmond (Master-General of the Ordnance) was especially censured for his sudden change of party, and for his readiness to accept office under every administration :—

INSCRIPTION FOR THE DUKE OF RICHMOND'S BUST TO THE MEMORY OF THE LATE
MARQUIS OF ROCKINGHAM.

"Hail, marble ! happy in a double end !
Raised to departed principles and friend :
The friend once gone, no principles would stay;
For very grief, they wept themselves away !
Let no harsh censure such conjunction blame,
Since join'd in life their fates should be the same.
Therefore from death they feel a common sting,
And Heaven receives the one, and one the King."

The King and his Minister deemed it prudent to reward the fidelity of their new adherents, and by the same policy to strengthen the Court influence. A batch of new peerages were accordingly created, to which the more influential supporters of the royal party were elevated. Pitt obtained his first seat in Parliament (1781) by the influence of Sir James Lowther, called by Junius " the contemptuous Tyrant of the North." In acknowledgment of his obligation—procured at the request of the Duke of Rutland, Pitt's fellow-student at Cambridge—the young Premier raised Sir James to the House of Peers by the title of Earl Lonsdale, thus overleaping the two inferior stages of the peerage. It might have been supposed that this reward was commensurate with his pretensions, but Lord Lonsdale's name appearing at the bottom of the list of the newly-created earls published in the *Gazette*, he threatened to reject the earldom, and means were with difficulty found to appease his irritation. The wits much enjoyed this circumstance :—

"*Hints from Dr. Prettyman to the Premier's Porter.* (Pitt's secretary, afterwards Bishop of Lincoln.)—' Let Lord Lonsdale have *my Lord* and *your Lordship* repeated to his ear as often as possible; the apartment hung with *garter-blue* is proper for his reception ! The other new peers to be greeted only plain *Sir !* that they may remember their late *ignobility*, and feel new gratitude to the benefactor of honours ! The Treasury messengers to carry the *red-box*, as usual, to Charles Jenkinson before it is sent to Buckingham House.' "

The tactics of the new Ministry are cleverly set forth, in parody, by extracts from Lord Graham's Diary :—

"May 21, 1784.—Bought a tooth-pick case, and attended at the Treasury Board; nothing at the House but swearing.* Rode to Wilberforce's at Wimbledon. Pitt, Thurlow, and Dundas—water suchy—away at eight—Thurlow's horse started at a windmill—he off.

"N.B.—To bring in an Act to encourage water mills—Thurlow home in a dilly—we went after his horse—children crying *Fox for ever !*—Dundas stretching to whip them—he off, too.

"*Qy. House.*—We settled to always make a noise when Burke gets up—we balloted among ourselves for a sleeping committee in the gallery—Steele always to call us when Pitt speaks."

The consequences of the defeat of the Liberal party in the elections of 1784 were very apparent in the Parliamentary Session of 1785, and are well described in a few words written by Horace Walpole on the 2nd of February. "The Parliament," he says, "is met, but as quietly as a quarter

* Parliament being just opened, the members were taking the oaths.

session; the Opposition seems quelled, or to despair." Rarely indeed has an entire change in popular feeling been effected in so short a space of time; but it was not long before a reaction set in. Under the absurd persecution of the Westminster scrutiny, the popularity of Charles Fox was already beginning to revive; and the proud and scornful bearing of the young Minister was not calculated to gain himself esteem. When, at the beginning of April, the scrutiny ended in favour of Fox, the defeat of the Court was celebrated by a general illumination on two successive nights, attended with some rioting.

July 30th, 1785. *Ahitophel in the Dumps.*—"And when Ahitophel saw that his counsel was not followed, he saddled his ass, and arose, and went and hanged himself," &c. Fox, in his new character, is journeying to the foot of a gibbet, inscribed, "Let desert mount!" beneath is an executioner's axe and block.

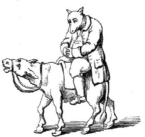

Ahitophel in the Dumps.

The weakness of the ex-Minister's party after the elections of 1784 was the occasion of unmerciful satire. No fewer than a hundred and eighty of Fox's ordinary supporters had been thrown out in these elections, and replaced by new members, who had not been in the House before. The rejected candidates received the appellation of *Fox's Martyrs.*

The generous, warm-hearted member for Westminster could not help a feeling of abandonment at the loss of his zealous friends. On one occasion (in March) he broke into an ironical commendation of the Parliament, a large proportion of which consisted of new faces. He said that he highly approved of their general conduct, although they had been "called together by an unfortunate political delusion:" "they were gentlemen with whom he was entirely unacquainted, men whose faces were unknown to any person; but, *emerged from obscurity* as they had, he was happy to find that they possessed great candour and impartiality." Pitt replied in rather an angry tone, which led to violent altercations. These fresh members were recruited from the antiquated "country party," and their opinions were made the subject of much entertainment.

From a supposititious letter—ascribed to a new country member, writing to his friends in the provinces—we obtain an admirable view of the oratorical merits and defects of the two rivals, Pitt and Fox: "As you desire to have my impartial sentiments respecting the eloquence of Mr. Pitt and Mr. Fox, I must fairly own that I cannot hear, without indignation, any comparison made between 'em; and I assure you Mr. Pitt has a very decided preference in the opinion of most of the new members, and especially we country gentlemen. We could all see Mr. Pitt was an orator in a moment. The dignity of his deportment when he first rises from the Treasury Bench, with his head and eyes erect, and arms extended; the regular poise of the same action throughout the whole of his speech; the equal pitch of his voice, which is full as sonorous and emphatic in expressions of the least weight; above all, his words—which are his principal excellence—are really longer and finer than can be conceived, and clearly prove him, in my judgment, to be far superior to every other orator. Mr. Fox, it seems, in perfect despair of imitating the expressions and manner of his rival, never attempts to soar above a language that is perfectly plain, obvious, and intelligible to the meanest understanding; whereas I give you my word, I have more than once met with several who have frankly owned to me that Mr. Pitt's eloquence was often beyond their capacity to comprehend. In addition to this it is observable that Mr. Pitt has the happy art of expressing himself, even upon the most trifling occasion, in at least three times as many words as any other person uses in an argument of the utmost importance, which is so evident an advantage over all his adversaries that I wonder they persist in so unequal a combat."

The overbearing temper of the Minister on one side, and the mortification of the Opposition on the other, caused the debates in the House of Commons during the Session to degenerate much more than was usual into attacks and recriminations of a personal character. On the 9th of February, 1785;

when Fox complained of the Westminster scrutiny as an act of persecution against himself, Pitt, scornfully turning up his nose (a characteristic of the orator which is never forgotten in the caricatures in which he figures), fell upon his rival in the following insulting language: "I am not surprised if he should pretend to be the butt of Ministerial persecution; and if, by striving to excite the public compassion, he should seek to reinstate himself in that popularity which he once enjoyed, but which he so unhappily has forfeited. For it is the best and most ordinary resource of these political apostates to court and to offer themselves to persecution for the sake of the popular predilection and pity which usually fall upon persecuted men. It becomes worth their while to suffer, for a time, political martyrdom, for the sake of the canonization that awaits the suffering martyr; and, I make no doubt, the right honourable gentleman has so much penetration, and at the same time so much passive virtue about him, that he would be glad not only to seem a poor, injured, persecuted man, but he would gladly seek an opportunity of even really suffering a little persecution, if it be possible to find such an opportunity." Such scenes were of frequent occurrence.

The mortifications to which the leaders of the diminished Opposition were now exposed were freely ridiculed in caricatures; and Gillray published a pair of pendants, cleverly stippled in aquatint to imitate Indian-ink drawings:—

Evening Consolation depicts the resources to which the Opposition may possibly have been driven in despair of effecting any good in the House. It represents Fox in a most disconsolate attitude; in one hand he holds an empty purse (the dice-box peeping out of his hat accounts for this misfortune), in the other hand is a speech containing some fresh attack from Pitt, who, in the arrogance of his inexperience and his elevation in the royal favour, was ignoble enough to despise and insult his great opponent, whose nobility of soul, in spite of his numerous short-comings, was always conspicuous. Pitt in the future learned more than one lesson of magnanimity from the Whig chief; and when the great Commoner's pride and asperity of disposition had been corrected by experience, his hostility to Fox was moderated by his recognition of the gentle heart and forgiving nature of his antagonist, and a reconciliation was effected which might have had great results but for Pitt's unexpected death. The alleviation of Burke's conscience is found in a Jesuitical observance of penance before a breviary inscribed "Reform;" while the fashionable North, beneath a view of St. James's Park, is indulging in softer consolations.

Morning Preparation represents the triumvirate bracing their energies for a fresh contest. Fox, confronting a cracked mirror, is practising his eloquence, and we see him rehearsing both attitude and expression. Burke, whose resources may have been reduced by his enforced retirement, is frugally patching his old clothes, in order to reappear decently in St. Stephen's. Lord North, seated in an easy-chair, with a pair of cracked bellows suspended above his head, to indicate the broken fortunes of "Boreas," is violently exerting himself to shake off the slumbers in which he has been indulging.

Among the many difficult questions with which the new Ministry had to contend, the state of Ireland was the most complicated. We have already glanced at the rival factions represented by Grattan and Flood. The more violent democrats were dissatisfied with the reforms contemplated by the House of Legislature accorded to that country under the Rockingham Administration, and they had established a separate assembly for their factious deliberations. This convention, which afterwards, in still closer imitation of the Americans, took the title of a national congress, continued to hold its ground, and was acknowledged by a large portion of the population of Ireland as the true parliament of the island. There were thus two rival governments existing at the same time. Pitt brought forward in the Session of 1785, as a measure of pacification, the two propositions, that we should allow the produce of our colonies to be imported into England through Ireland, and that free trade should be established between Ireland and Great Britain; in return for which advantages Ireland was to contribute a certain annual sum out of her revenue towards the general expenses of the empire. These proposals (which seem to have been, in their original form, very defective) excited the jealousy of the British merchants, and they were heard by counsel in Parliament; numerous petitions against the measure were presented, and it was attacked bitterly in both Houses. The Minister was obliged to yield in some degree to the

popular feeling, and he modified his measure, and brought it forward in an entirely new form on the 12th of May.

In the early part of the Session (February 14th, 1785) Gillray published a caricature representing *The New Westminster School, or Dr. Busby settling accounts with Master Billy and his Playmates.*—The overwhelming majority commanded by the Court party was not at that time so thoroughly understood in its action. Confidence in the eloquence and ability of the Whig chief was unshaken by considerations of the hopelessness of opposition in a Parliament which contained a preponderance of Ministerial nominees.

Fox accordingly appears in the Westminster School, seated beneath the figure of Justice (who holds a rod in her hand), wielding the birch, as Dr. Busby. "Rods in pickle" are in readiness for the disobedient. The leaders of the Opposition are giving their assistance to "horse" the Ministers, and the members of the Government are mounted on their backs, prepared for Fox's stinging chastisement. The Premier, who is extended across the sturdy knee of his rival, supplicates leniency, and cries, "Oh, pardon me, and I'll promise you on my honour that I will honestly and boldly endeavour a reform." Fox does not suspend his correction, but proceeds, "That's all twaddle! so here's for your India task; there—there's for blocking up the old women's windows and making them drink tea in the dark; there's for a hundred accounts I have to settle!"

There was, however, little sincerity in Pitt's promised "reform." A plan for amending the representation of the people had been his favourite instrument, when in opposition, for embarrassing the Ministry, and now that he was in office he had an excellent opportunity for carrying out what he had advocated. But during this Session he made his last show of attachment to Liberal principles by bringing forward a bill for a reform in Parliament; it was, however, so inefficient a measure, that it was only ridiculed by the Opposition; and as he did not use his own Parliamentary influence to support it, it was clear he never intended it should pass. He was ever after a resolute opponent of Parliamentary reform, in whatever shape it was presented. In other matters, the young Premier met with several slight crosses and disagreements. The foreign policy of his Ministry was incessantly attacked by the Liberal Opposition; and a plan of national fortifications, brought forward by the Duke of Richmond, who had deserted his old colleagues to take office as Master-General of the Ordnance, was an object of great ridicule.

The change which had been effected in the young Minister's patriotism by the inducements of royal favour, exerted through its chosen instrument, Jenkinson, is ironically set forth in one of the political lyrics of that date:—

"THE STATESMAN—AN ECLOGUE.

BETWEEN PITT AND LORD LANSDOWNE, LATE LORD SHELBURNE.

"In early youth, misled by Honour's rules,
That fancied Deity of dreaming fools,
I simply thought, forgive the rash mistake,
That kings should govern for their people's sake.
But Reverend *Jenky* soon these thoughts supprest,
And drove the glittering phantom from my breast;
Jenky! that sage, whom mighty *George* declares,
Next *Schwellenburgen*, great on the back-stairs:
'Twas *Jenkinson*—ye Deacons catch the sound!
Ye Treasury scribes the sacred name rebound!
Ye pages sing it—echo it, ye Peers!
And ye who best repeat, Right Reverend Seers!
Whose pious tongues no wavering fancies sway,
But like the needle, ever point one way!"

The disagreements amongst the members of the reigning house occupied a large share of popular attention in 1786, as may be traced in the numerous caricatures bearing upon the subject. The economy of the royal household, pushed in trifling matters to the extreme of parsimony, although it excited general derision, did not incline the people to support more patiently the fresh applications which the King made to Parliament this year for the discharge of his debts, and for an extension of the civil-list

allowance. The reckless prodigality of the Prince of Wales, the extravagances of Carlton House, his numerous liaisons, the perversity of his political alliances, and his notorious financial entanglements, were subjects of sufficient interest to reconcile the public to the quietness of our foreign relations and the tameness of the Parliamentary Session.

The Duke of Richmond and his fortifications were once more brought before the public in a caricature entitled *An Ordnance Dream, or planning Fortifications* (March 7th, 1786). The Master-General of Ordnance, who appears as a sort of weak Uncle Toby, is fast asleep in his arm-chair. A box of tobacco-pipes is lying at his feet, and a number of rolled-up plans of proposed fortifications are disposed behind him. Two views of the forts ornament his walls; one picture represents the works in progress, with labourers, wheelbarrows, and the skeletons of a projected fleet; the second picture presents the fortifications completed, and furnished with men, guns, and ammunition; while a bulwark of our famed wooden walls offers a further security, the one on which John Bull had so long relied. The promising state of preparation on paper is badly sustained in practice. A pile of card-houses disposed round the Duke's table do duty for fortresses; broken pipe-bowls and stems represent the stoneworks and their guns. The creation of this imaginary system of protection may be accounted for by an emptied decanter standing in the middle of the fragments. A cat, perched on the muzzle of a sample gun of the famous leather ordnance, which the Duke is said to have ordered from a snuffbox-maker, destroys the visionary defences by clawing at the table-cloth. In the Parliamentary battles which were fought over the Duke's plans, more allusions were directed to his recent political apostasy than to the inefficiency of his propositions—illustrating the proportion of party spirit which qualified professed patriotism.

The caricatures now approach a subject which is frequently dismissed with a hint suggestive of its romantic nature. We have considered it indispensable to the elucidation of many of Gillray's cartoons to trace the outlines of an attachment which not only affected the Prince's immediate interests, but carried its influence to a large degree through his career as Prince, Regent, and King.

Perdita being dismissed from the scene, a new beauty enlisted the affections of Prince Lothario. The case of Perdita offered certain pleas which might be urged in mitigation of a severe judgment, as, the inexperience of the lover and the novelty of the attraction. Florizel's intrigue, which took its rise amidst the changing passions of the drama, exhibited to its end all the fictitious glitter and inconstancy of a dramatic situation. Florizel and Perdita merely wandered from the stage-boards to play out their pastoral in a world which had conspired to humour their hearts' impulses.

A graver error was committed in regard to Mrs. Fitzherbert, whose name became a by-word in 1786, when the particulars of the Prince's frigidly calculated liaison first began to excite attention. The Prince, by his own act, surrounded himself with entanglements of the most formidable character; he betrayed the object of his affection, and he inflicted an injury on his own reputation which could not be repaired. The prospect of his union with a Catholic was the most bitter sting he could inflict on the heart of the King; it embarrassed the Prince's chosen supporters, it alienated the sympathies of the people, and threatened his accession to the throne. In after years it was destined to convert his marriage with an attractive and high-spirited princess into a bond of mutual strife and resentment, to continue through life an expensive encumbrance, a dark moral stain, and a lasting evidence of his descent to wanton duplicity. The marriage between the Prince of Wales and Mrs. Fitzherbert is an established fact, although the royal husband constantly equivocated on the subject; the legality of the union, however, is a point on which jurists have been unable to decide. The Church of Rome received them as man and wife; the King and his consort had confidence in the efficacy of the ceremony, and treated the lady with respect and consideration; and Caroline of Brunswick declared her conviction that Mrs. Fitzherbert was the victim of a deception, and argued that the earlier claim was more legitimate than her own.

The King was peculiarly sensitive to *mésalliances* in the Royal Family. The interest he felt in preserving a distinct and unembarrassed succession was demonstrated by his displeasure at the unions of his two brothers, the Dukes of Cumberland and Gloucester, with subjects. He had forced the stringent "Royal Marriage Act" through the Legislature in 1772, against the most determined resistance.

The Prince's error had exceeded the passionate violation of an unpopular law; the union of the heir-apparent with a Roman Catholic was a bar to his claim to the throne. Yet the ceremonial had

taken place for the satisfaction of the lady, whose name from this date was systematically brought before the public.*

A certain portion of Mrs. Fitzherbert's career is pictorially displayed in Gillray's caricatures; she also makes her appearance in the political and social history of the times briefly and at intervals. Publicity was peculiarly offensive to her disposition; she was extremely sensitive; her pride was constantly wounded;† and occasionally her resentment, carried to the length of public prosecution of her detractors, increased the evil she sought to avoid.

In that pamphleteering and scandalous age, chronicles purporting to be truthful narrations of her life were published with disagreeable frequency. The Prince was persuaded to use his influence for the suppression of these real or fictitious anecdotes, and annuities are said to have rewarded the champions whose pens were employed against those writers who impertinently exhibited the lives of the exalted for the entertainment of the curious.

Mrs. Fitzherbert was the daughter of William Smythe, of Tonge Castle, and niece of Sir E. Smythe, Bart., of Acton Burnel, Salop. Her sister had married Sir Carnaby Haggerstone, Bart. The family from which the Prince's favourite descended was highly reputable and ancient, and professed the Catholic faith. At an early age Mary Ann Smythe was married to Mr. Weld, of Lulworth Castle, Dorset. On the decease of her first husband, who did not long survive the union, she again entered the matrimonial state, this time with Mr. Fitzherbert, of Swinnerton, Leicestershire, a remarkably striking person, who died either of over-exertion in a walk from Bath to town, or from some imprudence at the burning of Lord Mansfield's house, in the riots of 1780. Mrs. Fitzherbert, who is always represented as a rigid Catholic, spent a certain number of years on the Continent after the death of her second husband. On her return to England the twice widowed lady went to reside near Richmond, and it is said the song "The Lass of Richmond Hill" was inspired by her attractions, and that the lines

> " I'd crowns resign to call thee mine,
> Sweet Lass of Richmond Hill,"

have a special reference to her situation.

The Prince was introduced by chance to this fair heroine, and with his usual impetuosity he at once declared his life devoted to her service. Mrs. Fitzherbert considered it judicious to avoid this compromising admiration, and she discreetly withdrew to the Continent. The enforced separation,

* The following are the titles of some of the tracts which were employed to flourish the name of Mrs. Fitzherbert before the eyes of a community entirely antagonistic to her influence, jealous of her power, and embittered by the cost of her maintenance :—

(Dr. Withers) : "Alfred's Appeal, containing his Address to the Court of King's Bench on the subject of the Marriage of Mrs. Fitzherbert and her Intrigue with Count Bellais." 1789.

Horne Tooke's "Narrative concerning her Royal Highness the Princess of Wales, commonly called Mrs. Fitzherbert." 1789.

"Alfred's Apology. Summary of a Trial for Libel on the Prosecution of Mrs. Fitzherbert, of 9, Queen Street, Grosvenor Square."

"An Appeal, with a Farther Address on the Subject of M. A. Fitzherbert and her Intrigue with Count Bellais." "Fitzherbert, or Anecdotes of Real Characters." 1806.

"Of many Circumstances relating to the Prince of Wales and Mrs. Fitzherbert. To which is added a Letter to Mrs. Fitzherbert on the Influence of Example." By Nathaniel Geffery (late M.P. for Coventry). 1806.

"A Letter to Mrs. Fitzherbert, in answer to a Complaint that her Feelings have been Hurt, &c., by the Above." 1806.

"Facts are Stubborn Things." 1808. By Nathaniel Geffery (once Jeweller to the Prince of Wales).

† A characteristic instance is related of the insults which Mrs. Fitzherbert was forced to encounter : "During the mayoralty of Alderman Gills, Mrs. Fitzherbert, in company with the Duchess of Cumberland and her party, went to hear the trials at the Old Bailey. The Lord Mayor extended the hospitality of the City to these distinguished personages. After the feast was disposed of, their entertainer, exhilarated by the toasts he had proposed, and flattered by the condescension of his illustrious guests, called for a bumper all round ; then, winking his eye most significantly at Mrs. Fitzherbert, he proposed "The Prince of Wales." The judges endeavoured to preserve their gravity, and the company tittered. The self-composure of the judges and the smiles of the company shortly gave way to a general burst of laughter, when the Lord Mayor, observing that his dignified visitor had not emptied her glass, exclaimed, with a familiar chuckle, ' What, wont you drink to your own friend !'" This anecdote is a fair example of numerous paragraphs which found their way into the magazines at the time.

however, did not cure the Prince's passion; he threatened numerous acts of folly; and her return, after a lengthened absence, was deemed the most prudent course by her friends. This occurred at the close of 1785.

The Prince proposed the most romantic schemes. He would dispose of everything he could realize; he would cede the right of succession to his brother Frederick, and retire as a private citizen to America, there to live in pastoral happiness with his captivator. Mrs. Fitzherbert advised her admirer for his own advantage; she laughed at his extravagances and resisted his importunities. But nothing except his own way would content the Prince. One morning two of his friends drove to Park Lane, to request the lady to hurry to Carlton House, for the Prince had stabbed himself in despair. Mrs. Fitzherbert called on her confidante, the Duchess of Devonshire, and they decided to obey the summons. They found the royal "victim of love" in bed, with a knife and some traces of blood not far off.* The whole scene was arranged in highly theatrical fashion. The violence of the Prince's passion, his reckless declaration, his entreaties, and the melting tears which the stout sentimentalist had always at command, convinced the lady that it would be dangerous to offer further resistance. The terms of surrender were accordingly arranged, and on the 21st of December, 1785, a clergyman and some near connexions of Mrs. Fitzherbert were invited to her house in Park Lane, and the ceremony was performed, partly according to the Protestant service and partly according to the rites of the Church of Rome.† A wedding-ring, overlooked in their impetuous haste, was borrowed from the Duchess of Devonshire; and the Prince was formally married to Mrs. Fitzherbert. The particulars of the nuptial ceremony have been variously given; the marriage contract is, however, in existence, and the names of the witnesses (relatives of the bride) appended to it are evidences of its authenticity. The Prince does not appear to have himself attached much importance to this ceremony. His conscience was elastic; he denied the probability of his marriage, within a day of its celebration; and whenever he escaped from the lady's immediate influence, it pleased him either to equivocate on the question or to ridicule "the absurd report."

The union was afterwards sanctioned directly by the Pope, and the bride's faith continued unshaken. On the Prince's separation from Caroline of Brunswick, the Rev. Mr. Nassau, of Warwick Street Chapel, was sent to Rome to consult the Pope on the legality of the intimacy with Mrs. Fitzherbert being renewed. The answer was in the affirmative, and the parties were again associated at intervals, often disturbed by fresh gallantries on the part of the royal Sybarite. "The lady was high-bred and handsome," we are told, "though by seven years the Prince's elder; and, with the formidable drawback of having been twice a widow, her attractions might justify the civilities of fashion. But her rank and her religion were barriers which she could not have expected to overstep." Mrs. Fitzherbert appears to have been the Madame de Maintenon of this self-indulgent Prince, and her influence was certainly superior to that of the succession of favourites to whom his handkerchief was tossed in turn.

The Rev. George Croly, in his "Personal History of George IV.," assigns interested motives to the individuals whom he assumed to have been the promoters of this transaction, and his words glow with a certain indignant commiseration for the Prince: "The theme is repulsive. But the writer degrades his moral honour, and does injustice to the general cause of truth, who softens down such topics into the simplicity of romance. Yet between the individuals in question there can be no comparison. The Prince was in the giddiest period of youth and inexperience; he was surrounded by temptation; it was laid in his way by individuals accomplished in every art of extravagance and ruin.

"In this most unhappy intercourse originated all the serious calamities of the Prince's life. From its commencement it openly drew down the indignation of his excellent father; it alienated his general popularity in an immediate and in an extraordinary degree; it shook the confidence of the wise and good in those hopes of reformation which such minds are the most generous to conceive and the most unwilling to cast away; the cold gravity of this unlover-like connexion gave it the appearance of a

* Mrs. Fitzherbert declared that a scar, the memento of this "mock-heroic," was distinguishable on the Prince's breast through life.

† The marriage was performed by the Rev. Samuel Johnes, younger brother of Colonel Johnes, of Hafod, translator of "Froissart," &c. He afterwards assumed the name of the Knights of Hereford, from whom he was descended on the maternal side. He became vicar of Allhallows Barking, and rector of Welwyn, Herts.

system, and its equivocal and offensive bondage was obviously a fixture for life. It embarrassed him with the waste of a double household when he was already sinking under the expenses of one, and precipitated him into bankruptcy. It entangled him more and more inextricably with the lower members of that cabal who gathered round him in the mask of politics only to plunder; and who, incapable of the dignified and honourable feelings that may attach to party, cared nothing for the nation or for political life, beyond what they could filch for their daily bread from the most pitiful sources. It disheartened all his higher political friends, the Duke of Portland, Fox, Grey, Burke, and the other leaders of the Opposition ; while it betrayed the Prince's name and cause into the hands of men who could not touch even royalty without leaving a stain. Finally, it destroyed all chance of happiness in his subsequent marriage, and was the chief ingredient in that cup of personal anxiety and public evil which was so sternly forced to his lips even to the close of his days."

Having sketched—with the intention of inflicting no wanton injury on the reputation of the chief performers, and with an endeavour not to slight the dictates of propriety—so much of the details of this connexion as may be judged indispensable for a proper consideration of the comments elicited beyond the royal circle, we will now give a short account of the successive caricatures provoked by it.

March 13th, 1786. *The Follies of a Day; or the Marriage of Figaro.*—The young Prince is seen placing the wedding-ring on the finger of Mrs. Fitzherbert, whose head-dress is composed of the three plumes, and the motto "Ich Dien." Colonel George Hanger, fashionably dressed, with his huge military hat inordinately cocked, a pistol in his pocket, and the bludgeon which he christened his " supple jack " in readiness for arguments, is giving away the bride.* Another figure, officiating as clergyman, is probably intended to represent Edmund Burke ; he is reading the service, evidently with an eye to oratorical effect, from the portion of " Hoyle's Games" devoted to "Matrimony," and his crucifix is represented by an enormous corkscrew (an innuendo aimed at the convivialities of the bridegroom). Mr. Weltjies (the Prince's house-steward and head-cook), with his naturalization papers in his pocket, is assisting at the performance. A slight portrait of Perdita hangs over the sofa; a picture of "Leda and the Swan" is half concealed behind a curtain; and the playbook of "Love's Last Shift" is lying on a cabinet.

March 20th, 1786. *The Royal Toast*—"*Fat, fair, and forty !*"—A separate portrait of the object of general curiosity. We do not reproduce it, because we have selected for illustration contemporary portraits, at various dates, which give a more reasonable representation of the lady. The characteristic of Mrs. Fitzherbert's dress is the introduction of the extravagant foreign taste then prevalent. The costume of " the reigning favourite" became the standard for imitation. The monstrous French fashion of distorting the figure by the addition of enormous pads, which was thus imported, extended even to the arrangement of the hair. This fashion was not unwisely selected by Mrs. Fitzherbert ; it subdued a certain prominence in profile, and in some degree disguised the embonpoint for which her figure became remarkable. The age of forty, ascribed to the favourite, is an exaggeration. She was then but little past thirty—about seven years older than her admirer.

March 21st, 1786. *'Twas Nobody saw the Lovers Leap and Let the Cat out of the Bag.*—This title, which refers to the first disclosure of the scandal, is literally treated in the print. Fox appears as "nobody," and a cat is seen escaping from the bag. The Whig chief, with whom, as the occasional companion of the young Prince's excesses, the public were not slow to connect the transaction, is encouraging Florizel to " leap over the broomstick" with Mrs. Fitzherbert. The ex-favourites, in a second apartment, surmounted by the Prince's crest, tranquilly regard the coming change. " All I desire of mortal man is to love whilst he can !" is the sentiment of one lady. " Well said, Robby," remarks a gentleman at table ; " his father will broomstick him !"

April 1st, 1786. *The April Fool, or the Follies of a Night,* as performed at the Theatre Royal, Carlton House, for the benefit of the Widow Wadman.—The Prince and his lady are dancing an

* We shall have numerous opportunities of meeting "Colonel George," who was conspicuous amongst the companions of the heir apparent in his more juvenile frolics. He persevered gaily in his own way of life, and when in reduced circumstances condescended to set up as a coal-merchant, advertising his new trade, and explaining the reasons of the undertaking, in some curious discursive memoirs which he thought proper to publish before he succeeded to his title as Lord Coleraine.

appropriate reel; Colonel Hanger is drumming his bludgeon on the salt-box; and Burke, who is performing a violin solo on the gridiron with the fire-tongs, cries, "Burn the pan!—is it not beautiful!"

Another gentleman executes a voluntary on a warming-pan with the butt of a pistol. The bludgeons and offensive implements which often occur in this series imply that pressure had been put on the Prince. The farces of "A Bold Stroke for a Wife," "I'll have a Wife of my Own," and "Clandestine Marriage," are opened as companion comedies to the "Follies of a Night." Two pictures from "Hamlet" hang on the wall; in one the Prince and his inamorata are represented as Hamlet and Ophelia, in the other Polonius is addressing King George—"I will be brief—your noble son is mad!"

The Follies of a Night. Mrs. Fitzherbert and the Prince.

April 3rd, 1786. *The Padlock; or, To be, or not to be, a Queen, is the question.*—The Prince and the widow are traversing a churchyard leading to the sacred porch. The Prince has made a suggestion of postponing the ceremony. Mrs. Fitzherbert, who carries a cane and a colossal padlock, resolutely conducts him towards the church, crying—

> "Oh fie, my dear! let's go unto the altar,
> And then you know our conscience cannot falter!"

Burke is observing the scene behind a tombstone bearing the symbol of the cross. Fox and George Hanger are watching the group from a family vault; the former demands in doubt, "Will they stop in the porch?" Lord North is slumbering over a grave, his pillow a headstone bearing the inscription, "He is not dead, but only sleepeth."

April 29th, 1786. *The Farm-yard.*—We are here introduced to the Home Farm, Windsor. The King is feeding his litter of pigs, while the Queen sparingly scatters barley amongst the poultry. One of the Guards is carrying a string of turnips, suspended over his shoulder at the end of his sword. The crown, turned upside down in front of a farm building, forms a lodgment for pigeons; and a formidable announcement of man-traps and spring-guns hangs from a pole, as evidence of the royal anxiety to preserve their agricultural produce.

The extreme frugality of the King and Queen in private life, and the meanness which often characterized their dealings, had already become subjects of popular satire, and contrasted strongly with the reckless extravagance of the Prince of Wales. This became still more generally a subject of conversation when, in the Session of 1786, an application was made to the House of Commons for a large sum of money to clear off the debts which, in spite of the enormous Civil List, the King had latterly incurred. As there was no visible outlet by which so much money could have disappeared, people soon made a variety of surmises to account for King George's heavy expenditure; some said that the money was spent privately in corrupting Englishmen in order to pave the way to arbitrary power, and others believed that the monarch was making large savings out of the public revenues, and hoarding them up either here or in Hanover. It was said that the royal pair were so greedy in the acquisition of money, that they condescended to make a profit by farming; and the kingly farmer and his wife figured rather extensively in prints and songs, in which they were represented as haggling with their tradesmen and cheapening their merchandize.

Carlton House presented a very different scene, for the Prince of Wales seemed ambitious only of taking the lead in every wild extravagance and fashionable vice that characterized the age in which he lived. Following the tradition of the family feuds which seemed inseparable from the history of the House of Brunswick, the Prince was on very bad terms with the King, his father, and on even worse

terms with the Queen. They disliked him because he was profligate; they disliked his politics; and they disliked him still more because he took for his companions the very men towards whom King George nourished the greatest aversion. In 1783, when the Coalition Ministry was in power, and the Prince had just come of age, the Ministers proposed that he should have a settlement of a hundred thousand a year; but the King insisted on allowing him no more than fifty thousand, making him dependent on his bounty for the surplus. From this moment the Prince became the inseparable friend and companion of Charles Fox, and among his principal associates were Sheridan and Lord North. The King and Queen were further irritated by the report of the Prince's private marriage with Mrs. Fitzherbert. This was a sore subject at Court; and even Pitt was encouraged to look at the Prince with disdain. The Ministerial writers were by no means sparing in their allusions, and the failings of the heir apparent were laid open to the public in frequent paragraphs in the newspapers.

As might be expected, the Prince was rapidly involving himself in debt, and his difficulties had become so great in the summer of 1786 that he found it necessary to apply to the King for assistance; but he met with a peremptory refusal. In his distress the Duke of Orleans, proverbial for his immense riches and for his dissipation, who had been in England as Duke of Chartres in 1783 and 1784, and had then formed a close intimacy with the Prince of Wales, and who was now again on a visit to this country, offered his assistance, and the Prince appears to have been only prevented by the earnest expostulations of some of his private friends from borrowing a large sum of money of the French prince to relieve his more pressing liabilities.

April 21st, 1786. *A New Way to Pay the National Debt.* Dedicated to Monsieur Necker.—The King and Queen, attended by their band of pensioners, are issuing from the Treasury gateway, all so laden with money that it is rolling out of their pockets. Pitt, neverthe-less, is adding large bags of the national revenue to the royal stores, to the evident joy of their Majesties. On the wall, on one side of the picture, are several torn placards, one entitled " Charity, a romance ;" another containing the commencement of " God Save the King." One, that is not torn, has the announcement, " From Germany, just arrived, a large and royal assortment ;" and another professes to contain the " Last dying speech of fifty-four malefactors executed for robbing of a hen-roost ;" an allusion to the severity with which the most trifling depredators on the King's private farm were prosecuted. Beneath them is seated a crippled soldier, seeking in vain for relief. On the other side of the picture, a little in the background, we see the Prince, all tattered and torn, left by his father in poverty, and receiving the offer of a cheque for two hundred thousand pounds from a foreigner, the courtly Duke of Orleans. Behind them, the walls are also placarded. On one bill we read, " Œconomy, an old song ;" on another, " British Property, a farce ;" on a third, " Just published, for the benefit of posterity, The Dying Groans of Liberty ;" and two torn bills immediately over the

Poverty Relieved.

Prince's head bear, one, the Prince's feathers, with the altered motto, " Ich starve ;" the other, two hands joined, with the word " Orleans" underneath. This bitterly satirical picture is stated to be " design'd by Heliogabalus," and " executed by Sejanus." The allusions are sufficiently obvious.

Two views are offered of the respective characters of the Prince of Wales and the Duc d'Orléans, the representative black sheep of the reigning houses of England and France.

The Duke had visited England, nominally on a tour of pleasure, in compliance with an order to that effect issued by the French Cabinet, under the suspicion that he was already sowing disaffection, both at Court and out of doors, against the circle of "intrigants." He had been summoned back to France by order of the King, after a few months' absence, and returned laden with English fashions, and followed by a train of race-horses, jockeys, and a complete travelling establishment, which he displayed to the horror of those accustomed to the *ancien régime* of jackboots and diligences, and to the delight of the Parisians, who read victory in this invasion of Newmarket caps and dock-tailed horses. Anglomania became

popular, because to the Parisian intellect it implied English bourgeois costume, clipped hair, betting, prize-fighting, a constitution—and finally, a democracy.

In return the Duke had assisted the Prince with his knowledge of play, and considerable sums were lost at the Clubs, at Carlton House, and afterwards at the Pavilion. From this a transaction arose in which, under the various names of a loan, a debt, and a present, the Duke was said to have made an offer of a large sum to his royal highness; but the offer was finally declined, by the advice of Sheridan and the Duke of Portland. In England the Duke was regarded with alarm as the corruptor of a prince sufficiently ill-advised already.

In France, the example of the Prince of Wales and of the democratic principles of the Opposition party were considered pernicious to the Duke; indeed, in his "History of the Girondists," Lamartine ascribes to the influence of these associates the changes which converted the Palais Royal into the cradle of that revolution which owed much of its development to the encouragement that the Duc d'Orléans extended (as Lamartine maintains, without any projects of personal ambition), to disaffection and to innovation, which became first a fashion, then a mania, until its doctrines were preached by the cannon's mouth or enforced by the arguments of the guillotine, in the reign of terror to which France was with headlong frenzy tending.

Lamartine writes: "Persecuted by the animosity of the Court, the Duc d'Orléans was more and more driven to retirement. In his frequent visits to England he formed a close intimacy with the Prince of Wales, heir to the throne, who took for his friends all the enemies of his father; playing with sedition, dishonoured by debts, of scandalous life; prolonging beyond the usual term those excesses of princes—horses, the pleasures of the table, gaming, and intrigue; abetting the schemes of Fox, Sheridan, and Burke, and prefacing his advent to royal power by all the audacity of a refractory son and a factious citizen.

"The Duc d'Orléans thus tasted the joys of liberty in a London life. He brought back to France habits of insolence against the Court, a taste for popular disturbances, contempt for his own rank, familiarity with the multitude, a citizen's life in a palace, and that style of dress which, by abandoning the uniform of the French nobility, and blending attire generally, soon destroyed all inequalities of costume among citizens.

That neither of these spoiled princes—both of whom possessed much original goodnature, perverted by indulgences which their stations made fatally accessible—was improved by their mutual intercourse is historical. Orleans possessed the more dangerous arts, as his unfortunate career demonstrated. The Prince of Wales was unlikely to push his faults to the dangerous extremes of Egalité-Orleans; we have the testimony of his after-life to prove the simple, unambitious character of his mind.

When he found that no assistance was to be expected from the King, the Prince of Wales determined to make a show of magnanimity, and adopted the resolution of suppressing his household establishment and retiring into a life of strict economy. The works at Carlton House were stopped, the state apartments shut up, and his race-horses, hunters, and even coach-horses, sold by public auction. He at the same time invested forty thousand a year—the greater part of his income—for the payment of his debts. The Prince's friends, and a large portion even of the populace—for, in spite of his irregularities, the Prince was at this time far from unpopular—trumpeted him forth as the model of honesty and self-denial. But the King was highly displeased, and the Prince's conduct was represented at Court as a mere peevish exhibition of spleen, and as an attempt to make the King and his Ministers unpopular. The press—that portion of it which was under Government influence—published the Prince's failings in an indecent manner; his riotous life, his promiscuous amours, his connexion with Mrs. Fitzherbert, were commented upon; and the prejudices of the multitude were excited by representations of the dangers which menaced the Constitution from the marriage of the heir apparent with a Catholic.

The impetuosity of the Prince was ill-advised. It is very evident, from his subsequent behaviour, that no sincere reform was contemplated; the wilfulness of his entanglements, and the bad faith which characterized his subsequent promises to avoid incurring fresh liabilities, aggravated opinion against him.

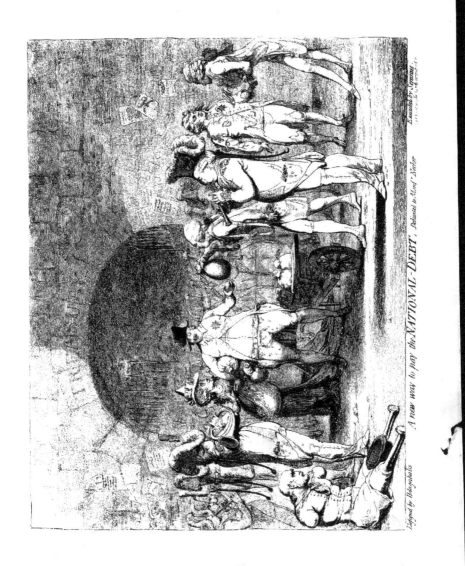

Design'd by Bolus chalie

A new way to pay the NATIONAL-DEBT, Dedicated to Monsr Necker

Exhibited by Seymer

For the moment the effect of the proceeding answered the expectations of the cabal to whose counsel this novel revenge doubtless owed its first suggestions.

The School for Scandal, published at this date, is a happy parody of the scene from Sheridan's comedy in which Charles Surface knocks down his ancestors with sprightly coolness. The work evidently forms one of the series in which Gillray has ingeniously disguised his style to accommodate a rival of his publisher. Colonel Hanger is officiating in his "knocking down" capacity, as auctioneer (the Careless of the comedy); and Lot 1, a portrait of the Prince's parents, who are

| Farmer George and his Wife. | Mrs. Fitzherbert. | Perdita (Mrs. Robinson). |

represented as a very homely couple, is held up for sale. The mock auctioneer cries, "Going for no more than one Crown!" and the Prince, with easy indifference, is encouraging the Colonel: "Careless, knock down the Farmer." A group of "dilettanti" amateurs patronize the sale, and one of them bids five shillings for the royal pair. Lot 2 is a portrait of Mrs. Fitzherbert, and Lot 3 is probably intended for Perdita. The domestic Lares are thus disposed of. Through the open door is seen Tattersall's, where the Prince's equipages were dispersed. A fashionable cabriolet is numbered Lot 1000, suggesting the extravagant profusion with which the stables of the royal prodigal were supplied.

May 9th, 1786. *The Prince's Nursery, or Nine Months After*, forms one of the many ludicrous comments on the reported marriage; suggesting, to the more discontented section of the community, the dangers attending this union. The happy father is smiling complacently on a "little stranger," while Mrs. Fitzherbert, in whose lap the baby reposes, pinches its cheeks with maternal affection. This additional embarrassment, however, the Prince escaped.

May 16th, 1786. *A Sale of English Beauties in the East Indies.*—This caricature formed a broad but cleverly executed satire on certain indulgences which were attributed to the dwellers in our East Indian possessions. To the home public India was then a fabulous country, identified in their minds with the descriptions found in the Arabian Nights' Entertainments, to which in popular belief the amusements patronized by Anglo-Indians bore a close resemblance. India was at that time attracting unusual attention; the battle over Warren Hastings and his iniquities had already assumed formidable dimensions, and the subsequent arrival of the late Governor-General only increased the excitement.

The group we have selected from this picture requires no further comment. The papers peeping out of the stout deputy-surveyor's pocket (who is computing the lady's height) purport to be "instructions from the Governor-General." The portion of the picture not included in our selection represents an auctioneer, whose rostrum consists of bales of books of doubtful repute. To the right of the picture is seen the vessel whose miscellaneous cargo is supposed to be in the act of unloading. A warehouse is erected on the quay, which bears the inscription "For unsaleable goods. N.B. To be returned by the next ship;" and a number of ladies, whose appearance falls short of the required standard, are very unwillingly consigned to this depôt. The business-like manner of procedure is shown by the

process of weighing : a beauty in the Rubens style, "fat, fair, and forty," weighs down one scale, while lacs of rupees are piled up in the other to restore the equilibrium.

Arrival of English Beauties in the East Indies.

Returning to the embarrassments at home, we find that a schedule of the Prince's debts was by the King's commands laid before him ; but some of the items were so inconsistent with the moral principles of George the Third, that the negotiation ended in his positive refusal to assist the Prince, and the heir apparent gained nothing by his application but the displeasure of the King. The alleged poverty of the Prince, it was said, had not put a stop to his riotous living, and his doings at Brighton during the autumn—for Brighton was already his favourite place of residence— were not overlooked. In one print, said to be by Gillray, the party at Brighton are pictured (in allusion to the Prince's circumstances) as "The Jovial Crew ; or, Merry Beggars." The Prince's companions are Mrs. Fitzherbert, Fox, Sheridan, Burke, Lord North, Captain Morris, and two others.

November 1, 1786. *Non-commissioned Officers Embarking for Botany Bay.*—The Prince and his followers are indicated as setting out on their travels, their destination being a penal settlement. The crew are jovial and mock-heroic ; the Prince, who wears a fool's cap surmounted by his own plume, is seated on a butt of "Imperial Tokay." Burke, as his spiritual adviser, wears a bishop's mitre. Sheridan and Morris command the military escort of "men in armour from Drury Lane." Fox is accoutred in heavy mail, exceeding the equipment of Falstaff in its completeness ; he wears a heavy scimitar, labelled "Chop Logic," and on his helmet appears the legend "We escape." North, Burke, and Colonel Hanger complete the retinue. On the shore stands Mrs. Fitzherbert, abandoned like another Ariadne, while a tribe of Jewish harpies are baulked by the departure of their victim.

November 26th, 1786. *Landing at Botany Bay.*—The Prince and his party are now arrived at

Landing at Botany Bay.

their destination. A man who takes the lead carries a standard inscribed, "The Majesty of the People." He is followed by Burke, with his mitre and pastoral staff, who reads the service from the Newgate Calendar. Captain Morris comes next, with the legs and lower extremities of a goat. The Prince is carried on shore on the shoulders of two convicts, supported on each side by Fox and North, the former equipped in armour. The ship which had borne them over the ocean is entitled the "Coalition transport—Cⁱ Morris, Commander."

Their situation is not, however, unattended with danger ; a sailor cries out to the transport, which is still riding in the bay, "Send off the long-boat ; Lord George (Germaine) is preaching free-will to the convicts !"

We have already referred to Captain Morris. He was the lyrist of Opposition ; and although some of his songs are unhappily tainted by objectionable allusions, his versification was graceful, winning, and

poetic. The Captain became the constant attendant of the Prince's convivial circle; he was its brightest ornament, and one of its most deserving members. He thus playfully acknowledges the inspiration of his gallant Anacreontics :—

> "The jolly muse her wings to try no frolic flights need take,
> But round the bowl would dip and fly, like swallows round a lake."

Gillray published a separate portrait of the jovial songster in 1790, which we give in the order of its publication.

November 22nd, 1786. *Jack Sheppard.*—Pursuing his professional travels to the precincts of Newgate Jail, we find Gillray producing a portrait of a possible successor of the famous highwayman Jack Sheppard, who was executed in 1724.

December 1st, 1786. *Andrew Robinson Bowes, as he appeared when brought up at the King's Bench to answer the articles exhibited against him by his wife, the Countess of Strathmore.*—Miss Bowes, of Durham, was at that time the richest heiress in Europe; she had a fortune of 1,040,000*l.*, with the prospect of additions on her mother's death, and immense estates on the demise of her uncle. She married the Earl of Strathmore on the 25th of February, 1766. Upon the Earl's death, she married Mr. Stoney, who, like the first husband, assumed the name of Bowes, in compliance with the will of her father. A. R. Bowes, and other armed men, forcibly carried her off on November the 10th, 1786. She was brought up to the King's Bench by *habeas corpus* and released, and he committed to prison on November 23rd. The lady recovered her estates, which she had assigned to Stoney Bowes, under the influence of terror, in May, 1780. Gillray has represented the abductor brought before the Court in an assumed dying state. The artist afterwards published a separate portrait of A. R. Bowes (1799), in which the face presents evidence of cunning and effrontery. Bowes is fastidiously dressed in the most complete mourning, and wears a cocked hat and fan-like cockade.*

November 10th, 1786. *Paille d'Avoine !*—One of the cries familiar in French towns, exhibited in the person of an old peasant, with Norman shoes, wooden shoes, and a bundle as big as herself. The sketch, doubtless from life, is by an amateur; Gillray has probably strengthened the drawing and engraved it for the original designer. It has thus been published with his works.

November 21st, 1786. *A Masonic Anecdote.*—Count Cagliostro—Prince Trebisond—Joseph Balsamo, or by whatever name the pretended necromancer chose to describe himself, is represented, surrounded by Frenchmen, assisting at the festivities of a London masonic meeting (the Lodge of Antiquity). The Count, as a Freemason, attended the lodge with his friends, when Brother Mash, an optician, waggishly gave an imitation of a travelling mountebank, which convulsed his English brethren; but the foreign guests resented the pleasantry as a personality aimed at their apostle, and the Count and party retired in confusion. Mash exclaims, "Are you shot through the heart? take a drop of my Balsamo!" Gillray's engraving preserves all the humour of the situation at the moment of the Count's indignant retreat. Balsamo pretended to hold communion with spirits, and to have discovered the fabulous "elixir vitæ," or balsam of life. After extorting large sums of money by the subtle schemes which he practised upon fashionable credulity, he was indiscreet enough to visit Rome. Here, by the agency of his wife—a woman no less profligate than himself, and the confederate of his schemes—he was thrown into the Inquisition, and died within its walls in 1792.

* Andrew Robinson Stoney Bowes was originally possessed of good estates, which very soon became involved. On his marriage with the Countess, with whom he had previously had an intrigue, he lived in "unequalled splendour;" he held a seat in Parliament, and was to have been raised to the peerage by the Marquis of Rockingham. After the downfall of his fortunes, his residence in the Fleet, where he was detained for debt, was rendered as easy as possible by the authorities. The Countess obtained a divorce, and Stoney married a girl of fifteen (daughter of a fellow prisoner), by whom he had five children. He settled 100*l.* a year on his wife, and left some provision for his young family from the residue of his estates. He had also one legitimate son by the Countess. He died in his house within the "Fleet rules." During his captivity he occupied the "state-room" of the prison, which served him "for kitchen and parlour and all." The Duke of Norfolk was his firm friend, and did not forsake him in adversity; Bowes frequently received his visits in the Fleet.—See *Gentleman's Magazine,* 1810.

1787.

1787 witnessed a continuation of the struggles between the Prince of Wales, the King, and the Parliament.

On the 18th of January, 1787, appeared a caricature representing the Prince as *The Prodigal Son*, compelled to associate with swine, ministering to the comforts of his coarse companions. Near him is the plume of feathers trampled in the dirt, and the inscription on his Order of the Garter is curtailed to the word "Honi."

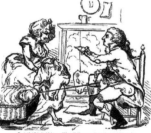

January 16th, 1787. *Anticipation, or the approaching fate of the French Commercial Treaty.*—We are here introduced to the interior of St. Stephen's. The members are represented as dogs enjoying their bones, or as curs snarling at their more favoured brethren. The Commercial Treaty with France forms the object of contention among the more formidable animals. On one side are the Ministerial dogs. Pitt, on whose collar is "Fawning Bill," and his colleagues, Dundas (Treasurer of the Navy), Pepper Arden (Attorney-General), and Macdonald (Solicitor-General)—all of whom bear their offices stamped on their collars—resolutely cling to the Treaty with the force of their united teeth. The Opposition members are savagely tearing the document.

The Prodigal Son.

Lord North, couched in one corner, appears as a bulky animal, deliberately mangling his way through the Treaty. Fox, as a bulldog, set on by little curs, is actively demolishing the work, while Burke and Sheridan ("School for Scandal" on the collar of the latter) are shaking and angrily rending the Treaty.

February 26th, 1787. *Love's last Shift.*—A farther allusion to the necessities of the Prince, and his probable straits in the absence of relief either from the King or from Parliament. A calf's head, which the royal "bon vivant" is turning on a string, suggests the royal profile. The surroundings betoken the last stage of poverty, and Colonel Hanger has been sent out to fetch a very small mug of beer.

March 6th, 1787. *Honi soit qui mal y pense.*—The Duke of Richmond is seated before his fortifications, while the Marquis of Lansdowne (late Lord

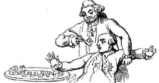

Love's Last Shift. The Prince and Mrs. Fitzherbert. A Bitter Dose.

Shelburne) is forcing this unpalatable dish on the Master-General of the Ordnance. On one side a veteran soldier, with a wooden leg and only one arm, leads in Colonel Barré, who lost his sight from the wounds he sustained by the side of Wolfe at the battle of Quebec, where he assisted as Adjutant-General. In the vexed debates on these same fortifications, the practical Colonel exposed the inefficiency of Richmond's plans, he ridiculed his inexperience, and inquired "if the

Duke ever commanded an army or led one to victory?" A plan of the fortifications of Cherbourg significantly hangs on the wall. Richmond and Lansdowne had been led into an altercation on the Commercial Treaty, and the latter concluded his speech with the remark that, " As to Cherbourg, he thought that representations ought to have been made with regard to the works going on there, and that it might have been done in prudent, wise, and proper terms." The Marquis here struck the popular key ; the destruction of these fortifications had always been a favourite object with patriots. In 1756 the English razed the forts to the ground, and plundered the town. Since that time, as their only Channel station, the French had constantly given their attention to the fortification and security of this haven. The Duke of Richmond's plans were rejected in the Commons by the casting vote of the Speaker, and they long remained a subject for jest.

Colonel Barré (by Sayer).

"In Richmond's Duke, we see our own John Bull,
Of schemes enamoured, and of schemes the gull."—ROLLIAD.

March 12th, 1787.—The Marquis of Lansdowne is at his table signing acceptances. Three Jew money-lenders present his life policies, &c., while a French courier, booted and spurred, secretly sent to him from Paris, hands an early intimation of the date on which the preliminaries of peace will be signed. The Marquis had strenuously defended the French Commercial Treaty, and this caricature—which is entitled *A Noble Lord, on an approaching Peace, too busy to attend to the Expenditure of a Million of the Public Money*—revives a scandal of 1783, to the effect that Lord Shelburne had profited by his speculations in the Funds on the signature of the American Preliminaries in Paris ; and it was stated that these profits, secured by making use of the priority of information obtained in his official position, enabled him to pay for the decorations and furniture of his mansion in Berkeley Square, originally erected by the Earl of Bute out of the money received from France in return for large concessions made by the Peace of Paris in 1763. Lansdowne was supposed to be under heavy obligations to the Jews ; he is represented liquidating these liabilities from the gains of his well-timed speculations in the Funds, which rose very considerably on the public announcement of peace.

March 20th, 1787. *The Board of Control, or the Blessings of a Scotch Dictator.*—Seated at a table in one of the Government offices is Henry Dundas, represented in the act of managing the affairs of India solely by his own will, while Pitt is engaging the attention of Lord Sydney (Secretary of State for Home Affairs) at the frivolous game of " push-pin." A number of Indian papers, &c., have been brushed off the table to make way for this amusement. Among the documents are the claims of Sir Elijah Impey, Major Scott, and others. The inkstands are upset over the papers relating to Warren Hastings.

Various applications to and from the Company, the Dictator's list of (Scotch) " persons to succeed to the Direction," and a memorial from the bakers complaining that all the Scotch journeymen are provided with appointments in India to the injury of their trade, are introduced to illustrate the partiality exhibited by Dundas for his own countrymen. A semi-clad and newly-arrived party of Scots are presenting a petition for employment in the India Department in the highest or lowest capacities, either as porters or as directors.

On April 6th, 1787, appeared a series of four preposterous female fashions, with the motto :—

"That such things are we must allow,
But such things never were till now !"

May 10th, 1787. *Ancient Music.*—

"Monarchs who, with rapture wild,
Hear their own praise with months of gaping wonder,
And catch each crotchet of the birthday thunder.
* * * *
Discord, which makes a king delight in Ode—
Encores himself till all the audience gape,
And suffers not a quaver to escape."—PETER PINDAR.

This celebrated cartoon, representing one of the "Ancient Concerts" dear to the King, presents an accumulation of discord little short of Hogarth's "Enraged Musician." The royal party is seated beneath a crowned canopy. The demon of avarice rattles an accompaniment on his money-bags over their heads. The King is in a devout ecstasy, the Queen is beating time, and Pitt, in his double capacity (First Lord of the Treasury and Chancellor of the Exchequer), is performing on two noisy instruments, the rattle and the whistle of a "coral-and-bells." Miss Jeffs and Madame Schwellenberg are in attendance on the Queen. Three hounds, bearing "G.R. Windsor" on their collars, are in full cry, chasing around the privileged circle a (C. J.) Fox-dog, to whose tail a "Coalition" bow attaches an iron pot, fashioned in the features of somnolent North. Sir Watkin W. Wynn, of Wynnstay, the fashionable and wealthy Welsh baronet, figures as a goat. Madame Mara (prima-donna of her day) is warbling "Anointed Solomon, King over all." Joshua Bates as a bull, and Ashbridge (a celebrated kettle-drummer) as a donkey, respectively discourse sweet sounds. The Duke of Richmond, the Marquis of Lansdowne, and Colonel Barré, as noisy Billingsgate "fish-fags," are going through their recriminative disputes on the "Fortification Plans." Sir J. Mawbey (illustrious for his pig-like head and piping voice) is pulling the tail of a "squeaker." The Attorney-General and the Solicitor-General are singing from one piece of music (Sir Pepper Arden is evidently intoning through his nose). Dundas (as advocate of Scotland) and Lord Loughborough are indulging in a noisy competition with sweeps' brooms and shovels. The fierce Chancellor, Lord Thurlow, is eliciting yells by birching two juvenile offenders "horsed" in the fashion of kettle-drums.

It is a fact that the King found his chief gratification in music. Queen Charlotte—who had been taught by a member of Bach's family—was a tolerable singer, and had been accompanied by Mozart; and she was favourably mentioned by Haydn.[*] The King was said to "play well" on the organ. This solace was mercifully spared to the monarch in later years; and when sense and sight were alike departed, he played and sang the glorious harmonies of Handel, which in the days of his greatness had afforded him the highest pleasure. During the dark years of his mental alienation he would, in calmer moments, perform these airs, declaring that they were "his favourite melodies when he was on earth;" one of the royal sufferer's illusions being a conviction that he had been removed from this world into a happier state.

The Court and the fashionable world were guided entirely in the matter of music by the prevalent "mode," quite irrespective of taste; but Handel's music was persistently preferred by the King. It is said that this partiality for the individual works of but one master, to the exclusion of all others, was formed in childhood. As a boy, George had been much affected by Handel's music at a certain court concert; and the composer, who conducted in person, patted the little prince on the head, saying, "You will take care of my music when I am dead." This injunction was never forgotten, and the anecdotes which associate the monarch with his love for Handel's melodies are among the tenderest fragments of his history. It is well known that the King was visited by both Haydn and Mozart.

May 12th, 1787. *La Belle Assemblée.*—

> "Here love his golden shafts employs; here lights
> His constant lamp, and waves his purple wings;
> Reigns here and revels."—MILTON.

A view of the "Temple of Love," attended by the best-known representatives of the fashionable world of that day. Lady Cecilia Johnston, beneath the Graces, is celebrating on her lyre the sacrifices offered on the erotic altar by the fair votaries of her temple. The Hon. Mrs. Hobart is adding incense to the flame; and Lady Archer, of gambling and hunting notoriety, wearing a riding-habit and armed with a heavy whip, is leading a gentle lamb by a chain of flowers—a contrast to her own notorious irascibility. Lady Mount-Edgecumbe, with the features of a witch, bears a pair of loving turtle-doves, while Miss Jefferies is bringing a floral offering. In the distance appears Apollo, enthusiastically

[*] The old composer made a private memorandum in the diary which was discovered some years after his decease: "As a performer on the harpsichord the Queen played pretty well"—a cautious but not uncomplimentary phrase.

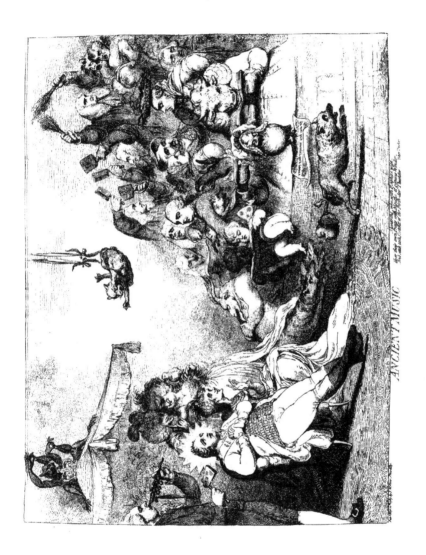

ANCIENT MUSIC.

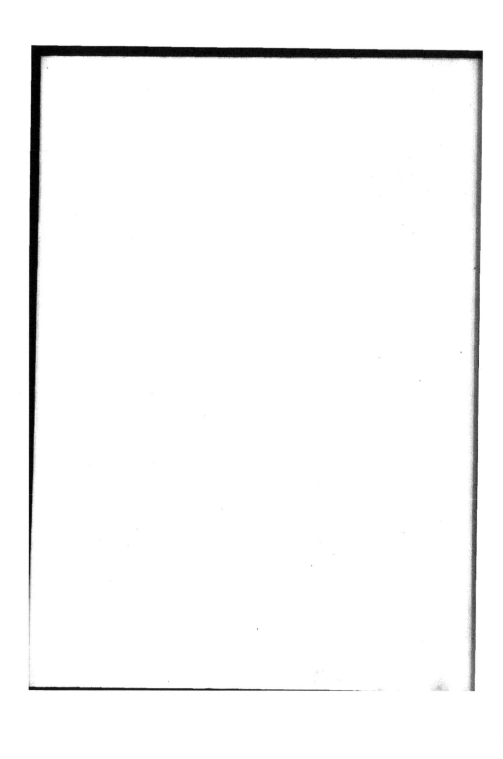

performing on the fiddle. As portraits of the ladies introduced into this satire will be found in other caricatures given by us, it is unnecessary to reproduce this group.

The Assaut d'Armes, or fencing-match, which took place at Carlton House, April 1787, between Mademoiselle la Chevalière d'Éon de Beaumont and Monsieur de St. George.—The latter was an eminent fencer. " No professor or amateur ever showed so much accuracy, such strength of 'lunge,' and such quickness. His attacks were a perpetual series of hits." His opponent, the Chevalier d'Éon, occupied a conspicuous position among "remarkable characters," and his story excited much interest in his day. He had been employed as a soldier and as a negotiator, and had been the hero of certain compromising transactions in connexion with the French Ministry at Versailles. He was also concerned in various legal processes; among others, in connexion with some policies effected on his life as a man. The Chevalier denied that he was a male, and assumed the dress of a female; his death, however, left no doubt of his sex. We are told that he looked a heavy unwieldy figure in female attire, but that his manners were easy and refined. In Gillray's engraving the Chevalier has made a successful thrust, and hit St. George in his sword-arm. A railing divides the combatants from a highly select audience, in which the Prince of Wales occupies the post of honour, while Mrs. Fitzherbert sits on his right hand, and a crowd of political and fashionable worthies exhibit the greatest interest in the match.

After the Prince of Wales had carried on his economical projects for some months, finding that little effect was produced upon the Court, he agreed with his confidential advisers that the subject should be laid before the House of Commons. This was accordingly done on the 20th of April, 1787, by Alderman Newnham, who gave notice of a motion for an address to the King, praying him to take into consideration the Prince's position, and to grant him such relief as he in his wisdom should think fit. This proceeding appears to have thrown the Court into great embarrassment. On the 24th, Pitt brought up the question again, declaring that the Prince would receive no assistance from the Government, pressed Newnham to drop his intended motion, and held out a threat that if he did otherwise, he on his part would be driven to the disclosure of circumstances which he should otherwise have felt bound to conceal. On the 27th, Alderman Newnham acquainted the House with the purport of his intended motion; on which Mr. Rolle, the member for Devonshire, a pertinacious supporter of all the measures of the Court, and the hero of the satire entitled "The Rolliad," spoke against the introduction of such a motion, declaring that the question involved matter tending immediately to affect the Constitution in Church and State. This was understood to refer to the rumoured marriage with Mrs. Fitzherbert. Pitt supported Rolle, and again talked of the delicate investigation which he wished to avoid. On this, the Prince's friends, Fox and Sheridan, fired up, and a warm debate ensued, in the course of which they denied that the Prince was married to Mrs. Fitzherbert; a declaration which was never believed by the mass of the people. Sheridan and Fox declared, moreover, that the Prince was ready to submit to any investigation—a statement which had its desired effect; the Ministry determined not to expose themselves to the inconveniences that might arise from the discussion of the motion itself, and, by the King's desire, Pitt had an interview with the Prince of Wales, who consented that the motion should be withdrawn, on the express promise that everything should be settled to his royal highness's satisfaction. On the 24th of May, the House of Commons agreed to an address to the King to allow the Prince a hundred and sixty-one thousand pounds out of the Civil List to defray his debts, and twenty thousand pounds to complete the works at Carlton House, it being understood that he had promised to refrain from contracting debts in future. Thus ended, not very much to the credit of any party, an affair which for some months had distracted public attention from other matters. The Prince and his friends had sacrificed the character of Mrs. Fitzherbert, much, as it was said, to her indignation; and several pamphlets were published in her defence by her friends.

During the agitation provoked by these topics Gillray was employed in producing ironical criticisms on the conduct of the Royal Family, whose personal affairs claimed so large a share of the attention of their subjects. The enormous amounts demanded for "Supplies," for the Privy Purse, and for the debts of the Prince of Wales, afforded the artist congenial subjects.

May 29th, 1787. *Monstrous Craws at a Coalition Feast.*—The golden meal is displayed before the Treasury gates. The Prince, who is holding two spoons, marked respectively 60,000*l.* and 10,000*l.*

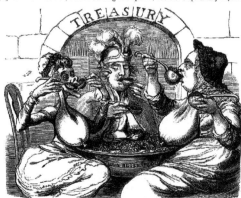

Monstrous Craws at a Coalition Feast.

per annum, appears with his bag perfectly empty; while the saving propensities of his royal parents have secured them a tolerable provision. The ladles employed by the King are especially adapted for exhausting the well-filled dish placed between the greedy trio.

The Prince finding, in the highly critical state of his affairs, that some sacrifice was unavoidable, resolved, rather than submit to the consequences of his imprudence, to exhibit himself in the position of affirming an evident falsehood, and permitting the shame of the situation to rest where the odium would weigh heaviest. He sent for Fox, and positively affirmed that his marriage with Mrs. Fitzherbert was a fiction. Upon this personal evidence Fox stated, during the progress of the debate, that he came armed with "the immediate authority of his royal highness to assure the House that there was no part of his conduct which he was either afraid or unwilling to have investigated in the most minute manner." "As to the allusions," said he, scornfully, "of the hon. member for Devon, of danger and so forth to Church and State, I am not bound to understand them until he shall make them intelligible; but I suppose they are meant in reference to that *falsehood* which has been so sedulously propagated out of doors for the wanton sport of the vulgar, and which I now pronounce, by *whomsoever invented*, to be a miserable calumny, a low malicious falsehood." This unequivocal denial settled the question; the relief was afforded, and the Prince exhibited himself in a meaner light. He requested the withdrawal or modification of this assertion. Endeavouring to make his peace with the injured lady, he cried, "Maria, here's Fox been declaring we are not man and wife." Fox, disgusted with this equivocation, avoided all intercourse with the Prince for some months. Too timid to support Mrs. Fitzherbert's just indignation, the Prince begged Grey, in the most insinuating manner, to soften the aspersion. This, however, he declined to do; and the Prince, in after years, positively denied his share of both transactions, declaring that no such interviews had taken place.

Mrs. Fitzherbert was still unappeased. "If nobody else will, Sheridan must," said the Prince, and Sheridan, it is said, more from deference to others than from moral callousness, pliantly undertook to address the House. In allusion to the Prince's offer, through Fox, to undergo, as a Peer of Parliament, his examination in the House of Lords, Sheridan observed, "that the House deserved credit for decorum in not taking advantage of the offer and demanding such

an inquiry. But while his royal highness's feelings had been, doubtless, considered on the occasion, he must take the liberty of saying, however some might consider it a subordinate consideration, that there was another person entitled in every delicate and honourable mind to the same attention; one whom he would not otherwise venture to describe or allude to but by saying it was a name which malice or ignorance alone could attempt to injure, and whose character and conduct claimed and were entitled to the truest respect."

May 21st, 1787. *Dido Forsaken. Sic transit gloria Reginæ.*—The injured Dido of this delicate situation is seated on her sacrificial pile; her cestus of chastity is cut asunder, her dagger is a crucifix,

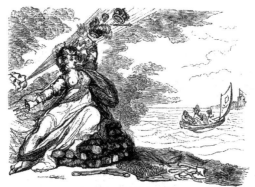

Dido Forsaken. Sic transit gloria Reginæ.

and the storm raised by Ministerial scrutiny is playing around the tragic heroine. Pitt and Dundas, as the originators of the tempest, are directing a blast which rudely hurries off not only the coronet and plume of the Prince of Wales, but with them the prospect of the royal crown. It was commonly reported that Mrs. Fitzherbert's ambition aspired to the throne, but the modesty of her subsequent pretensions seems to disprove this. It was, too, believed that she influenced the Prince in favouring the Catholic claims; and the implements in the foreground, including a terrific harrow, inscribed "For the conversion of heretics," mark the dangerous tendencies of her religion. Had Mrs. Fitzherbert professed any creed but the unpopular Romanist faith, her treatment by those in power might possibly have been modified; but it is impossible to speculate on the real intentions of her royal admirer.

Away from the storm, a bark christened "Honor," carrying a tattered sail, is bearing the Prince and his party to Windsor Castle. Burke (as a Jesuit) is trimming the torn sail, North is asleep, Fox sturdily directs the helm; while the Prince is regarding his victim with nonchalant composure. (In the larger original his features express a bold vacant stare, characteristic of drunken impassibility.) "I never saw her before in all my life," asserts the deserter; Fox is supporting this asseveration, and Burke echoes "Never." Mrs. Fitzherbert in after years never forgave Fox the part into which the Prince had betrayed his friend "Charles." Fox was indignant at the duplicity of the Prince's conduct to both sides, and it is said the Whig chief avoided his unreliable partisan for a year after this discreditable transaction.

June 2nd, 1787. *The Prince at Grass.*—The Prince is evidently in despair at the resistance of the Ministry to the settlement of his debts. Fox is protectingly waving the Magna Charta over the dejected heir apparent; while Burke and North seem to be astounded by the Ministerial behaviour; and one of the Opposition shields the Prince with the Bill of Rights. The new buildings at Carlton House are

stopped, and Pitt, Lord Sydney, and the Duke of Richmond are demolishing the scaffolding; Thurlow is dispersing the builders with a broom, and Dundas is assisting with a whip.

June 2nd, 1787. *The Prince in Clover.*—The heir apparent, relieved from his liabilities, and furnished with fresh grants, very naturally appears in clover. The scaffolding has been replaced at Carlton House, and the works are proceeding rapidly; Thurlow is carrying up building materials, while the Duke of Richmond, as a mason, is disposing them after his fortification plans. A sailor, disabled in the service of his country, clasps a purse, and is gratefully commending the donor to Heaven. His highness is paying his debts with theatrical dignity; and his creditors hold out their hands for purses, and present

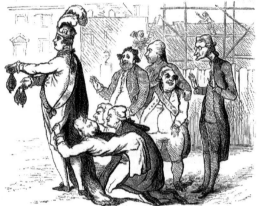

The Prince of Wales in Clover.

their receipts, with an air of profound respect. The workmen are setting up a "huzza" in commemoration of receiving their wages. The Ministers who had granted this relief (out of the national purse) are abject in their submission: Sydney and Dundas are down on their knees, and Pitt appears once more as "Fawning Bill." Fox, North, Burke, and the partisans of the Prince display characteristic gratification at the Ministerial humility.

June 30th, 1787. *Theatrical War.*—A well-conceived representation of the professional warfare carried on by the various stage directors of the day, parodied in an attack on a fortress, and exhibiting likenesses of the individuals engaged in the action.

Aug. 22nd, 1787. *A March to the Bank.*—A humorous picture of the confusion produced by the march of the military guard assigned for the protection of the Bank, in their daily progress up the Strand, Fleet Street, and Cheapside. The mob during the Gordon riots, it may be remembered, attacked the Bank, and were repulsed with considerable loss by the soldiers stationed there for its defence. Since that time a certain number of troops have been set apart for the protection of the building. The Guards originally marched two abreast in the most crowded thoroughfares, jostling from the pavement all who came in their way. The annoyance and discomfort inflicted on the public by this violence was made the subject of complaint in 1787, and by an order from head-quarters the men were directed to walk in single file, as they continue to do to this day.

October 18th, 1787. *Rehearsal in Holland.*—A cartoon in reference to the civil wars which occupied the Dutch from 1787 to 1789. The caricature represents the Dutchmen—who are here exhibited as

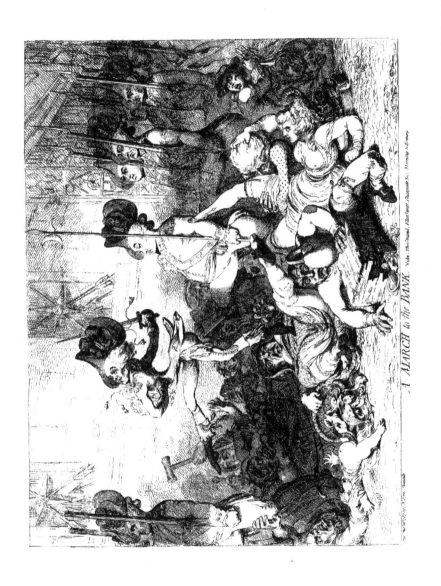

A MARCH to the BANK.

amphibious beings, half sunk in their native dykes—practising the arts of war by firing at the figure of a foreign soldier which is chalked upon a wall. This exercise was a preparation for the struggles between the Prince of Orange and the "patriotic party" which contended for a free government.

November 1, 1787. *Amsterdam in a Damn'd Predicament; or, the Last Scene of the Republican Pantomime.*—This plate is of considerable interest, as exhibiting the nature of the European

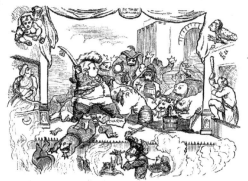

Amsterdam in a Predicament, the last Scene in the Republican Pantomime.

equilibrium, which is at once the most delicate balance to disturb and the most difficult to readjust. The success of the new American Republic and the disgrace inflicted on the mother country strongly prejudiced the public mind against sympathy with aspirations for freedom, especially when they assumed a revolutionary character.

In the autumn of this year the kingdom of the Stadtholder presented the troubled aspect of civil war. The Prince of Orange gained a few successes over the patriots at the commencement of the struggle, but he was finally obliged to retire to England. In 1795 the French army had occupied Holland, and the Dutch then declared for the Republic. A contingent of British troops was furnished for the Prince's assistance in 1799, but the expedition received no support from the Dutch, and the Stadtholder retreated. Gillray's view of the situation represents Holland as the "Theatre of War." The Prince of Orange, who was remarkably corpulent, is here seen making short work of his amphibious subjects with the sword of De Witt. The alarmed Hollanders are bringing in their produce of butter and milk, and submissively giving up the keys of their cities and their treasuries. This view was not borne out by subsequent events. The audience are exhibiting an interest unusual at a mere dramatic representation. A private box adorned with fleurs-de-lis exhibits the King of France, who insists that no interference shall be offered by England or Prussia. King George, with a stout cudgel labelled "Oak," is challenging "Monsieur"—"I'm ready for you!" Frederick the Great, who died in August, 1786, appears from a very warm region, where he is conducting, on his favourite instrument, an orchestra of demons. The rebellious Dutch are plunging headlong into the flames which envelop this grotesque band. The prominence of Turkey has decreased since those days, for we here find the Sultan boldly threatening Catherine of Russia, who is shaking her fist over his head. The Turk cries, "By our holy Prophet and sacred Mecca, I'll curb that wanton spirit!" The violent Empress retorts, "You old goat, to keep so many women shut up!" and expresses her intention of turning the tables. The Emperor of Austria is encouraging the defiance of the Turk.

The Political Banditti assailing the Saviour of India.—This caricature, which is merely dated 1788,

is probably assignable to the end of 1787, as we do not find that Gillray's cartoons in the ensuing year, as a rule, ascribe any patriotic dispositions to Warren Hastings, either in the acquirement or in the disposal of his enormous wealth. Here, however, we discover Hastings, in harmony with Eastern traditions, mounted on a dromedary, and travelling through a dangerous country. He is bearing, as offerings to his sovereign, "Lacs of rupees added to the revenue," gold "saved to the Company," the title-deeds of territories acquired under his rule, and "Eastern gems for the British crown." A select party of bravoes have received intelligence of his return, and they commence their attack by way-laying the ex-Governor. The attitude of the mover of the impeachment is well conceived; Burke, in a composite uniform, chiefly of antique armour, has loaded his capacious blunderbuss with "charges," which he is letting fly full in the face of Hastings, who bears himself unharmed, by interposing the "shield of honour," and Burke's shots rattle against the all-powerful insignia of the crown, under whose protection Hastings was safe from his enemies. Lord North, with his fantastic sword of "American Subjugation," and wearing a theatrical uniform, sleepily stretches his hands to the bag of rupees, while Fox, with a tremendous show of activity and stage ferocity, is making gestures with his dagger, which may either menace the life of the Governor-General, or merely threaten to loosen the string by which his money-bags are confined.

Peter Pindar, who has preserved forcible, if not flattering, criticisms on many of the actors who figure in these scenes, records in his "Ode to Edmund"—

> "Much edified am I by Edmund Burke;
> Well pleased I see his mill-like mouth at work;
> Grinding away for poor old England's good.
>
> * * *
>
> Now may not Edmund's howlings be a sigh,
> Pressing through Edmund's lungs for loaves and fishes,
> On which he long hath looked with longing eye,
> To fill poor Edmund's not o'er-burden'd dishes.
>
> * * *
>
> Give Men a sop, forgot will be complaint;
> Britain be safe, and Hastings be a saint."

1788.

The principal events which provided materials for Gillray's satires in this year were the trial of Warren Hastings, the difficulties which ensued on the King's illness, and the discussions provoked by the Regency Bill. His minor caricatures commence with a sporting subject.

The "Fancy" and the "Prize Ring" were among the tastes cultivated by the leaders of fashion, and boxing-matches were esteemed the most manly diversions by persons of quality. The Prince of Wales was the foremost patron of prize-fighting, but having been present on one occasion when an unhappy "bruiser" fought until he received his death-blow, and expired in the ring, he declared that he would attend no more fights. Gillray etched a few pictures of the "Fancy," besides his large portrait of Mendoza.

January 10th, 1788. *Foul Play; or Humphreys and Johnson a Match for Mendoza.*—The latter appears to have been the champion of his order. In addition to the immediate actors in this scene, portraits are given of Tring, Jacobs, Isaacs, and other fighting celebrities of their day, whose names indicate that the representatives of the science were chiefly recruited from the Jewish race.

January 23rd, 1788. *Wouski.*—Young Prince William Henry, Duke of Clarence (afterwards William IV.), is sharing his hammock on board ship with a Creole beauty. A cask of "Jamaica rum" marks the quarter of the world.

> "Far be the noise
> Of Kings and Crowns from us, whose gentle souls
> Our kinder fates have steer'd another way.
> Free as the forest-birds we'll pair together,
> Without remem'bring who our fathers were,
> And in soft murmurs interchange our souls!"

The royal duke, who exhibited much of the unconventional freedom incidental to a naval training, was especially sailor-like in his early devotion to the fair sex.

February 4th, 1788. *Black Dick turned Tailor.*—Lord Howe (as First Lord of the Admiralty) had passed over certain veteran officers in order to promote their juniors, and there was a debate in the House as to whether a Parliamentary inquiry was not necessary in connexion with the matter. Certain orders relating to naval reforms, and others regulating naval uniforms, were also the subjects of adverse comment. "Black Dick" is seated, needle in hand, on a tailor's work-board, with his implements scattered around him ; a coat is just completed, and other garments are hanging behind him. The Admiral is congratulating himself on the reforms he has in contemplation. Below the board appears the very "hot berth" which is described as prepared for the gallant officer who relieved Gibraltar. An imp, perched on the top of the British ensign, is roasting a hawk. (Howe had served under Sir E. Hawke.) The Evil One observes, in allusion to the unpopular reforms, "And I'll have a general reform soon !"

The affairs of India had been made doubly prominent at this time by the succession of bills for the regulation of that distant empire,—bills which, as we have seen, underwent many vicissitudes ; and attention began to be directed rather towards individuals who had misgoverned, than to the general subject of misgovernment. The delinquencies of the Governor-General had been not unfrequent objects of Burke's declamation, although it was not till the beginning of the year 1786 that he made open declaration of his design to bring this great offender to justice. He had moved for the production of Indian papers and correspondence as early as the month of February in this year, and on the 4th of April he stood up in the House of Commons to charge Warren Hastings with high crimes and misde-meanours, exhibiting against him nine distinct articles of accusation, which in a few weeks were increased to the number of twenty-two. The first charge was brought forward on the 1st of June, and, after a long and warm debate, the House of Commons by a very large majority threw it out as untenable. On the 13th of June, the second charge, relative to the treatment of the Rajah of Benares, was brought forward ; and then an equally large majority declared "that this charge contained matter of impeachment against the late Governor-General of Bengal." Hastings, who was supported by the whole strength of the East India Company, and who was understood to enjoy the King's favour-able opinion in a special degree, had calculated on the support of his Ministers ; and everybody's astonishment was great when they saw Pitt turn round and join with his enemies. Hastings felt this desertion with great acuteness, and it is said that he never forgave it.

The return of the ex-Governor's wife to England had preceded his own, and Mrs. Hastings was received at Court with much favour by Queen Charlotte, who was generally believed to be of a very avaricious disposition, and was popularly charged with having sold her favour for Indian presents. The supposed patronage of the Court, and the manner in which it was said to have been obtained, went much further in rendering Hastings an object of popular odium than all the charges alleged against him by Burke, and they were accordingly made the most of by that class of political agitators who are more immediately employed in influencing the mob. At the very moment when the impeachment was pending, a circum-stance occurred which seemed to give strength—or, at least, was *made* to give strength—to the popular suspicions. The Nizam of the Deccan, anxious at this moment to conciliate the friendship of England, had sent King George a valuable diamond, of unusual dimensions ; and, ignorant of what was going on in the English Parliament, had selected Hastings as the channel through which to transmit it. This peace-offering arrived in England on the 2nd of June, while the first charge against Hastings was pending in the House : and on the 14th of June, the day after the second charge had been decided on by the Commons, the diamond, with a rich bulse or purse containing the Nizam's letter, was presented by Lord Sydney at a levee, at which Hastings was present. When the story of the diamond got wind, it was tortured into a thousand shapes, and was even spoken of as a serious matter in the House of Commons ; and Major Scott, the intimate friend of Warren Hastings, and his zealous champion in the House, was obliged to make an explanation in his defence. It was believed that the King had received not one diamond, but seaveral, and that they were to be the purchase-money of Hastings's acquittal.

The Opposition press abounded with denunciations of this "blood-offering." We print one

"squib," selected from the mass of parodies, songs, and epigrams which were freely circulated on this occasion :—

" I'll sing you a song of a diamond so fine,
That soon in the crown of our monarch will shine;
Of its size and its value the whole country rings,
By Hastings bestow'd on the best of all kings.
 Derry down, &c.

" From India this jewel was lately brought o'er,
Though sunk in the sea, it was found on the shore,
And just in the nick to St. James's it got,
Convey'd in a bag by the brave Major Scott.
 Derry down, &c.

" Lord Sydney stepp'd forth, when the tidings were known—
It's his office to carry such news to the throne ;—
Though quite out of breath, to the closet he ran,
And stammer'd with joy ere his tale he began.
 Derry down, &c.

" ' Here's a jewel, my liege, there's none such in the land ;
Major Scott, with three bows, put it into my hand :
And he swore, when he gave it, the wise ones were bit,
For it never was shown—to Dundas or to Pitt.'
 Derry down, &c.

" ' For Dundas,' cried our Sovereign, ' unpolish'd and rough,
Give him a Scotch pebble, it's more than enough.
And jewels to Pitt, Hastings justly refuses,
For he has already more gifts than he uses.'
 Derry down, &c.

" ' But run, Jenky run ! ' adds the King in delight,
' Bring the Queen and the Princesses here for a sight;
They never would pardon the negligence shown,
If we kept from their knowledge so glorious a stone.
 Derry down, &c.

" ' But guard the door, Jenky, no credit we'll win,
If the Prince in a frolic should chance to step in :
The boy to such secrets of state we'll ne'er call,
Let him wait till he gets our crown, income and all.'
 Derry down, &c.

" In the Princesses run, and, surprised, cry, ' O la !
' Tis as big as the egg of a pigeon, papa ! '
' And a pigeon of plumage worth plucking is he,'
Replies our good monarch, ' who sent it to me.'
 Derry down, &c.

" Madam Schwellenberg peep'd through the door at a chink,
And tipp'd on the diamond a sly German wink;
As much as to say, ' Can we ever be cruel
To him who has sent us so glorious a jewel ? '
 Derry down, &c.

" Now, God save the Queen ! while the people I teach,
How the King may grow rich while the Commons impeach ;
Then let nabobs go plunder, and rob as they will,
And throw in their diamonds as grist to his mill.
 Derry down, &c."

With the Parliamentary Session of 1787 Burke re-commenced his attack upon Warren Hastings. Pitt had already acknowledged that the second charge involved sufficient grounds for an accusation ; and when, on the 7th of February, this second charge, relating to the spoliation of the Begum (or Princess) of Oude, had been brought forward in Sheridan's wonderful speech, admired equally for its length, its perspicuity, and its poetry, in the adjourned debate on the following night, the Premier declared his full conviction of the criminality of the accused ; and charge after charge was carried against him, until at the end of the session it was resolved that ulterior proceedings should be immediately commenced. On the 10th of May, Burke accordingly repaired to the bar of the House of Lords, and, in the name of the House of Commons, impeached Warren Hastings of high crimes and misdemeanours, at the same time announcing that the Commons would with all convenient speed exhibit articles against him.

The trial of Warren Hastings took place in Westminster Hall, which was fitted up for the occasion with great magnificence, and commenced on the 15th of February, 1788. Burke's preliminary speech occupied four days, and produced an extraordinary effect on all his hearers. The Benares charge, and that relating to the Begum of Oude, were proceeded with in February and April. The proceedings, as a matter of course, closed with the Session of Parliament. Domestic events at home, and after them still more extraordinary events abroad, came to retard the progress of the impeachment. The dissolution of Parliament in 1790, while the trial was still pending, created a further embarrassment ; the parties originally united in the prosecution broke up their mutual friendship ; the public indignation, which at first they had so effectively stirred up, gradually cooled, or was turned off into other channels, and, after dragging on feebly through several subsequent years, the matter ended in April, 1795, in an acquittal on all the charges.

The party in Parliament who were believed to represent the King's private feelings, and especially Lord Chancellor Thurlow, had defended Hastings throughout his trial, thus leaving no doubt of

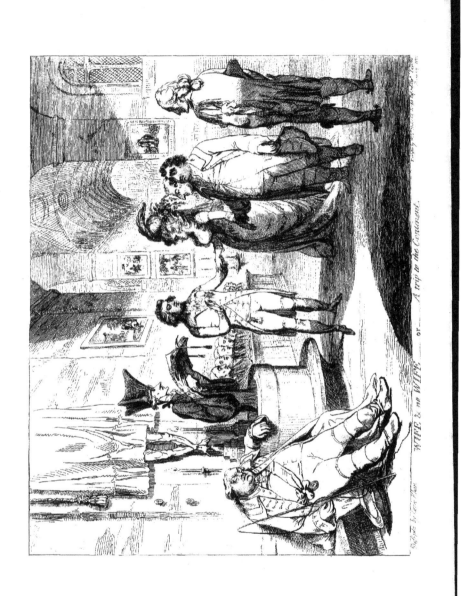

Engraved by Geo. Cruikshank

WIFE & no WIFE; ——— or ——— A trip to the Continent.

London Published by Sherwood & Co

the Royal sentiments. It is difficult to assign any very plausible motives for the part acted by Pitt, and especially for his sudden change of sides at the commencement of the impeachment.

The trial of Warren Hastings was indeed, in its result, a farce, and an expensive one; but it may be that, like many other farces which have little utility in themselves, it was the cause of the reformation of much evil, and led the way to a more enlightened policy with respect to our Eastern Empire.

February 8th, 1788. *Court Cards the Best to Deal with.*—This hint of the Court favour which had been secured by Warren Hastings is literally carried out. The King and his Chancellor are represented as mere pasteboard " shufflers."

February 11th, 1788. *Questions and Commands, or the Mistaken Road to Hereford: A Sunday Evening's Amusement.*—This sketch, which refers to an old scandal of Church preferment through petticoat influence, represents the Duke and Duchess of Gloucester and their son, the young Prince William, surrounded by a circle of Sunday guests, including a large proportion of the clergy. Butler, a native of Hamburgh, had been collated to the see of Oxford by his patron North, against the wish of the Oxonians. The new Sunday's diversion represents the means taken by Butler to secure a translation to Hereford. Playing-cards are scattered on the tables.

February 18th, 1788. *There's more Ways than One.* Vide " Coalition Expedients."—This satire exhibits the alarm of the Ministry at Fox's growing popularity, increased by his support of the charges against Warren Hastings. Pitt and Thurlow appear at the door of " the Crown " Inn. The sign is suspended on a post, which bears a remarkable resemblance to the gallows. A vine wreathes this suggestive structure, from which depend the grapes of office, clustering round the Crown. A Fox, slyly raising himself upon vast bundles of papers, consisting of " Libels," " A Review of the Charges against Warren Hastings, published by Stockdale," &c., is just high enough to drag one of the branches so near that the largest bunch of grapes hangs at a tantalizing distance above his mouth. Pitt, as a skeleton-like potboy, in his terror, is dropping a beer measure bearing the Crown stamp—to imply his abandonment of the Court faction in the case of the impeachment.

March 1st, 1788. *Blood on Thunder Fording the Red Sea.*—Thurlow, " the Thunderer," charged with the commands of the " Mighty Jove" of his adoration, is plunging boldly through a sea of blood in which float the gory bodies of Hastings's victims, whose woes the Opposition pathetically set forth in Westminster Hall. Thurlow bears on his shoulders " the protected " of the King and of " John Company." Hastings is carefully keeping his person from defilement, while armsful of millions secure his safe conduct, and trim his balance on the shoulders of his advocate.

Blood on Thunder.

March 27th, 1788. *Wife or No Wife; or a Trip to the Continent.* Designed by Carlo Khan (Fox).—North, the State coachman, who has evidently acted as driver, has relapsed into his customary repose. Burke, dressed as a Jesuit, presides at the altar. The Prince of Wales is about to place a wedding-ring of unusual dimensions on the fair bride's finger (possibly in allusion to the actual circumstances: the ring used in the Park Lane ceremonial was said to have been borrowed for the emergency). Fox is bestowing the hand of Mrs. Fitzherbert (a conventional portrait) on the Prince of Wales. It was hinted and popularly credited that Fox had planned this trap to secure a larger share of influence over the Prince; but the facts of the case disprove any connivance on the part of the Whig leader, and in this instance his conduct has been unjustly reprobated. Colonel Hanger, who in the caricatures of the heir apparent's early extravagances plays the part of an attendant " Hector," is of course present at this consummation. A bucolic captain, with a bottle in each pocket, is an unconcerned witness. The pictures which adorn the cathedral are appropriate to the situation of the performers. " David viewing Bathsheba, the Wife of Uriah," " The Temptations of Saint Anthony," and " Eve Tempting Adam with the Apple" refer to the bridal pair. " Judas Betraying his Master" appears over the head of Fox.

We have already spoken of this complicated marriage. By it the Prince had rendered himself—in addition to the constitutional offence of espousing a Catholic, which would prevent his succeeding to the throne—liable to the double consequences of a breach of the Royal Marriages Act. Whether he realized the consequences of his act, and wilfully defied them, whether he deliberately betrayed the lady in submitting to ceremonies which he had no intention of respecting, or whether his passion blinded him to consequences, it is impossible to decide. The shallowness of his deceptions would suggest a combination of these feelings. It is, however, certain that he denied the truth of the common reports to his most intimate supporters, at the very time when he was arranging for the solemnization of the marriage; and his declarations were no less equivocal when the union was sanctioned by the Church of Rome.

It is quite certain that the King and Queen believed in the marriage, and it is on record that they regarded Mrs. Fitzherbert as a daughter; and while the Prince was tender and indifferent by turns, they afforded her the unvarying protection of their favour. When the Prince neglected her claims, denied his obligations, and behaved like the fickle, faithless, and false debauchee that he too frequently allowed himself to appear, the good-natured Duke of York obtained for her a provision of 6000*l.* per annum, secured by a mortgage on the Pavilion at Brighton. The Prince, who had thanked heaven witnesses were still alive to testify to his marriage, on some occasions demanded that this union should be respected (witness Sheridan's contemptible task); but even during the lifetime of those who kept silence that he might be spared, the Prince audaciously ridiculed "that absurd story, his supposed marriage." When George IV. was lying in his last illness, Mrs. Fitzherbert wrote to him. The King appeared moved with this mark of affection, which had survived neglect and ill-usage, and he placed the letter under his pillow. On his death it was discovered that one of the three portraits in miniature of Mrs. Fitzherbert which he was known to possess was missing, and the faithful lady was consoled by the belief that she was not unremembered at last; that this sentimentalist, whose tears were ever ready for emergencies, had taken her image with him to his last home. Mrs. Fitzherbert survived her lover seven years; she died at the age of eighty-one, at Brighton, March 29th, 1837.

On the King's decease, his executors, the Duke of Wellington and Sir William Knighton, came into possession of the evidence confirming the marriage. The legality of the question has divided the opinions of the most eminent lawyers, and on that point no decision can well be obtained. By mutual consent between the executors of George IV. and Mrs. Fitzherbert, the following documents were lodged with Messrs. Coutts, the bankers:—

1. A mortgage on the Pavilion at Brighton.
2. A certificate of the marriage, dated 21st December, 1785.*
3. A letter signed by the Prince relating to the marriage.
4. A will written by him.
5. A memorandum written by Mrs. Fitzherbert, attached to a letter written by the clergyman who performed the marriage ceremony.

These documents were finally enclosed in a box and sealed by the executors of the late King, and by the Earl of Albemarle and Lord Stourton (her relative), as nominees of Mrs. Fitzherbert. The Hon. Charles Langdale, when preparing his "Memoirs of Mrs. Fitzherbert," was desirous of vindicating the reputation of his relative by publishing these papers, but the representatives of the deceased nominees doubted their own authority, and the seals securing this remarkable packet, it is believed, remain unbroken to this day.

April 5th, 1788. *The Morning after Marriage ; or, a Scene on the Continent.*—Gillray has here produced a sequel to the foregoing tableau. The grace of the picture must be the apology for a certain Hogarth-like suggestiveness, which may be considered of questionable decorum.

April 25th, 1788. *The Royal Joke ; or Black Jack's Delight.*—This caricature illustrates a scan-

* The signatures had been cut off at the request of the witnesses, to protect them from the penalties to which they were exposed under the Statute of Præmunire ; but the autographs were preserved, and re-attached.

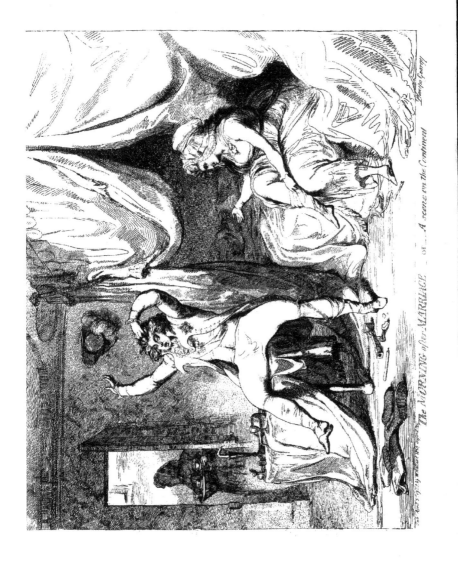

The MORNING after MARRIAGE — or — A scene on the Continent

dalous scene at Carlton House. The Prince, seated in the centre, is treating a lady to a very unceremonious correction. Lady Archer is offering her riding whip. Behind the Prince stand Mrs. Fitzherbert, Fox, Colonel Hanger, and Mrs. Armistead (afterwards Mrs. Fox), enjoying the "joke." "Black Jack," from whose pocket hangs a piece of music, "The Reform, a new motion," is fiddling his appreciation.

April 27th, 1788. *The Westminster Hunt.*—The gate of St. James's Palace, where Pitt and Dundas stand sentry, affords an asylum to the hunted Warren Hastings, on whose collar is the word "Hyæna."

A bag of diamonds and rupees attached to his tail increases the excitement of the chase. Thurlow, as huntsman, is thundering "Back! back!" to the hounds. The Chancellor is mounted on a figurative donkey, with the crown embroidered on his saddle, and wearing the "George" round his neck; the face leaves no doubt that this patient animal is meant for the King, whom Thurlow is urging with his spur among the hounds, producing a diversion for Hastings, and treading down and riding over the two officious dogs. North has rolled over in a fatal sleep. One of the donkey's hoofs crushes Burke, whilst another

The Westminster Hunt.

kicks Fox out of the path. The "Law-chick" (M. A. Taylor) and "Drury Lane" (Sheridan) are escaping in alarm. One dog is "giving cry:" this animal bears the face of Sir Philip Francis, one of the commissioners appointed to control the Governor-General in India, and on his return the instigator and chief promoter of the "charges." To Sir Philip Francis, whose irony and penetration were universally respected and feared, has been attributed the authorship of "Junius's Letters."[*]

This "Westminster Hunt" appears to have been the most fashionable amusement during the earlier years of the trial. It was in Westminster Hall that Gainsborough, sitting near an open window, received a chill which, developing into cancer, deprived England of one of her most accomplished artists.

It was here, too, during his own exertions against the "oppressor," that the Whig chief appeared as a suitor. "Fox, though he remained long unmarried, aspired to have entered into that state much earlier in life if his efforts for the purpose had not proved unsuccessful. During the early part of the trial of Warren Hastings in 1787, he raised his eyes and hopes to the Duke of Newcastle's box in Westminster Hall, where usually sat Miss Pulteney, afterwards created by Pitt Countess of Bath in her own right, then justly esteemed one of the richest heiresses in the kingdom. After displaying his great powers of oratory as a public man in the manager's box below, he sometimes ascended in his private

[*] During Grey's speech at Westminster Hall, in 1790, against Warren Hastings, which was a complete panegyric on Sir Philip Francis, we find the ex-Governor-General, sufficiently free from anxiety to be able to indulge in stinging epigrams. He is said to have written an impromptu on Grey's allocution :—

> " It hurts me not, that Grey, as Burke's assessor,
> Proclaims me Tyrant, Robber, and Oppressor,
> Tho' for abuse alone meant :
> For when he call'd himself the bosom friend,
> The friend of Philip Francis, I contend
> He made me full atonement."

capacity to try the effect of his eloquence under the character of a lover. All his friends aided a cause which, by rendering their chief independent in his fortune, would have healed the wounds inflicted by his early indiscretion. General Fitzpatrick, with friendly solicitude, usually kept a place for him near the lady; and for some time the courtship assumed so auspicious an appearance that Hare, when speculating on the probable issue of the marriage, humorously said 'that they would be inevitably duns, with black manes and tails,' alluding to the lady's fair complexion and red hair contrasted with Fox's dark hue. The member for Westminster was of all public men the one whose movements excited the greatest interest. Paragraphs appeared in the prints announcing he had escorted the fair heiress to the opera and to Ranelagh. It was evident that Fox had become a dangler,' and was exhibiting himself in the fetters of a soft captivity. Nevertheless the affair terminated without success."

The proceedings against Warren Hastings were the only subject which produced much excitement during the spring and summer of the year 1788. The Ministers continued to carry all their measures by large majorities or without division, and the Opposition in the House was reduced almost to an opposition of words. Out of Parliament, however, the feeling of discontent at this state of things was gaining ground; and the subject of Parliamentary reform, which had been driven out of the House of Commons, was in public canvassed more and more every day. The more general publication of the debates in Parliament fostered the liberal spirit, and gave the speeches of the Opposition a weight out of doors which they seemed no longer to possess within. The accusations against the Court and Ministers, of purchasing power by corrupt means, were repeated more extensively, and it was commonly believed that no small portion of the burdensome Civil List was expended for this purpose.

May 2nd, 1788. *Market Day. Sic itur ad astra.*—Gillray has here delighted the public with a spirited comment on the alleged venality of Parliament. The pliability of the members, which rendered the debates cold and insipid, led out of doors to rather uncomplimentary conclusions, and finally this mistrust produced violent, and occasionally seditious, meetings. The voice of the people being little heard within the House, they commenced to agitate without, and the clamour steadily increased with succeeding years. In "Market Day, or Every Man has his Price," we are introduced to the sordidness of the peers.

The busy scene of Smithfield Market is admirably travestied. The occupants of the cattle pens are the members of the Upper House, wearing their peers' robes. Their faces all bear a most persuasive expression, their heads being turned longingly to the black-browed Chancellor, who stands forward with a heavy purse—a scowling buyer. The docile peers seem to solicit a bid. Among the cattle may be traced Lord Sydney, the Duke of Grafton, Lord Amherst, Lord Sandwich, and the Duke of Norfolk. Lord Derby, distinguished by his remarkable head and "pigtail," seems refractory, and is bellowing "I move an adjournment till after the next Newmarket meeting." The Marquis of Lansdowne is pulling the market-bell which announces the sales.

A Buyer of Cattle.

Warren Hastings is seen making off as fast as possible, past the sign of the "Triple Balls" over the words "Money Lent." He has made a purchase, a calf with the features of the King, which is thrown across his horse.

On the balcony of a public-house, offering "Good Entertainment for Man and Beast," are Pitt and Dundas, a pair of jovial drovers, whose business is despatched, making merry over pot and pipe. The Opposition trio have been surveying the scene as guardians of the people from the top of their watch-box, but the rush of greedy cattle has upset their stronghold. The watchman, Fox, is dropping his rattle and lantern, while Burke and Sheridan are ludicrous spectacles of helpless downfall.

May 6th, 1788. *A Bow to the Throne, alias the Begging Bow.*—Sayer, Gillray's rival, whose talents, far from superlative, had been enlisted exclusively in the Court interest, for the confusion of the Opposition, had met his reward in a lucrative sinecure. He persistently ridiculed the charges brought

against Hastings. On May 1st, he published a caricature entitled "The Princess's Bow, alias the Bow Begum." The Begum of Oude (who figured largely in the charges preferred against the ex-Governor), is seated in the position Hastings here occupies, receiving the homage of Burke, Fox, and Sheridan ; Sir Philip Francis, the mover of this machinery, is shown below her seat, saying, "I am at the bottom of all this;" while a picture hanging on the wall illustrates the proverb, "Parturiunt montes, nascetur ridiculus mus." In Gillray's version Warren Hastings is distributing the good things of India ; Thurlow and Pitt are eager worshippers of "Pagodas and Rupees." "Dear gentlemen," declares the idol, "this is too little ; your modesty really distresses me." Representatives of every department of the State are among "the faithful ;" their hats are eagerly held out to share the spoils. The

A Bow to the Throne, alias the Begging Bow.

Queen is stooping lowest of all in her adoration of Mammon, and her devotion is repaid—the famous Benares diamond is in her possession. The King is crying, "I am at the bottom of it." Sayer's picture and its motto are both parodied—

> "Out it came—
> Not a little tiny Mouse, but a Mountain of delight."

A more ingenious satire on the efforts of Opposition eloquence was published by Sayer on May 6, entitled *The Galantee Show. Redeunt spectacula mane.* It represents Burke as the showman, exhibiting, by means of a magic lantern, the magnified figures of different objects on the wall. The objects are, "A Benares Flea," which takes the form of an elephant ; "A Begum Wart," as large as Olympus, Pelion, and Ossa piled one on the other ; "Begum's Tears," of proportionate dimensions ; and "An Ouzle," which appears in the semblance of a whale. The spectators are delighted with the exhibition. One remarks that the objects are "finely magnified;" another exclaims, with

A Benares Flea. A Begum Wart. Begum's Tears. An Ouzle.
OBJECTS MAGNIFIED.

poignant feelings, on observing the dimensions of the tears, "Poor ladies! they have cried their eyes out!" a third, evidently intended to represent Lord Derby, remarks that the last object is "very like an ouzle."

Gillray continued the contest by publishing a counter attack—

May 9th, 1788. *A Camera Obscura. Minor fuit infamia vero.*—Warren Hastings is entertaining his patrons by displaying the curious diminishing powers of his "Camera Obscura," by which a life-sized elephant is dwarfed into a flea; Mount Ossa appears no larger than a wart; Begums in tears—families slaughtered, and their possessions plundered—are reduced by the diminishing glass to skinned mice; and a whale is shown "in little" as an ouzle. Thurlow, as a professor in the same walk, approvingly remarks, "Charmingly diminished!" the Queen, clasping her hands, exclaims, "Poor mice! I shall cry my eyes out!" and the King, staring through his spy-glass, says, "Very like an ouzle!"

May 16th, 1788. *State Jugglers.*—

> " Who wrought such wonders as might make
> Egyptian sorcerers forsake
> Their baffled mockeries, and own
> The palm of magic ours alone."—CHURCHILL.

The performers in Hastings's trial are represented as mountebanks. A plank is balanced on the sign of "The Crown," and the King and Queen (the latter in ecstasies with a snuff-box) are playing at see-saw as Punch and Judy. On a platform below, Thurlow, in his Chancellor's robes, is expelling flames in the form of his ordinary volleys of imprecations. Warren Hastings, kneeling in the middle, has attracted the greatest interest; he is breathing streams of gold, which the spectators are eagerly trying to catch in their hats. Dundas, Lansdowne, Sydney, &c., are foremost before the booth, while at the back Fox, mounted on the shoulders of Burke and supported by the Duke of Norfolk, is endeavouring to procure a share of the golden shower on the sly. Pitt, the third juggler, has a smaller audience struggling for the ribands he is producing from his mouth.

May 20th, 1788. *Opposition Coaches.*—This satire represents the position of the two parties on the impeachment of Hastings. The coach containing the opponents of the late Governor-General is in a very discouraging state; it is half-sunk in a quagmire, and the Opposition team are dragging it to the Slough of Despond. Burke is lashing his horses, and Fox, with the recklessness of a bravo, is on the roof with a huge blunderbuss. Magna Charta, the Bill of Rights, and the Impeachment of W. H. have been thrown into the boot. On the door appears, "Licensed by Act of Parliament;" "O Liberty! O Virtue! O my Country!" Thurlow is urging the Ministerial team towards the Temple of Honour. The horses of both coaches present the faces of the Parliamentary leaders. Warren Hastings and his wife are travelling safely inside the coach, which bears the inscription, "Licensed by Royal Authority." The Queen is seated on the roof; she is hugging a basket of golden eggs, with a golden coop, containing a goose which is "hissing;" the King, who is riding in the boot as guard, is armed with musket and bayonet.

May 22nd, 1788. *A Lady at a Card Party.*—One of Gillray's smaller etchings, evidently from life. The lady is gaping from sleepiness or ennui; the expression of the yawn is life-like.

May 28th, 1788. *A Dish of Mutton Chops.*—The King's head is served up at table as a tempting dish. The "feeders" are greedily carving for themselves, each selecting his approved morsel. Pitt is calmly appropriating the tongue; Thurlow, using his spoon with both hands, is scooping out the brains; Hastings, whose fortune has brought him to the feast, is daintily picking out the eyes with a golden fork—a suggestion that the King has been conveniently blinded by golden influence.

July 1st, 1788. *The Fall of Phaeton.*—The Prince in driving his curricle has upset Mrs. Fitzherbert, and is sharing her downfall.

August 14th, 1788. *Election Troops bringing in their Accounts to the Pay-table.*—The appointment of Lord Hood, in the beginning of July, to a seat at the Admiralty Board rendered a new election for the City of Westminster necessary. Hood, as the Court candidate, enjoyed the advantage of Ministerial influence; the Opposition, however, strongly supported Lord John Townshend, who canvassed in the Whig interest. The result of the election was a severe defeat to the Ministers, who are said to have employed every means for the return of Hood. Ten days after the close of the poll, Gillray published a print in exposure of the corruption of the Court agents. Pitt, at the gates of the Treasury, is receiving the claimants with closed gates; he plausibly declares, "I know nothing of you, my friends. Lord Hood pays all the expenses himself." Then in a whisper, "Hush! Go to the back door in Great George Street—under the *Rose.*"* Major Topham heads the gang; he is presenting a bill for "puffs and squibs, and for abusing Opposition." He holds the *World* newspaper—of which the fashionable Major was proprietor, editor, and gossip-monger—to show the active support he had given the Government during the contest. A news-boy from the *Star* brings an account "for changing sides, for hiring ballad-singers and Grub Street writers;" three of the Guards, with gory bayonets, demand payment "for the attack in Bow Street;" a publican brings in a scrawl "for eating and drinking for jackass boys;" ballad-singers demand "five shillings a day;" a cobbler presents his bill "for voting

* Sir George Rose was Pitt's secretary and factotum.

three times;" Hood's sailors require payment "for kicking up a riot;" and a clothesman is demanding money "for perjury, and procuring Jew rioters."

Westminster Election. Bringing Accounts to the Pay-table.

It was just at the moment when the proceedings against Warren Hastings absorbed public attention, that Gillray published a remarkable caricature, the only object of which appears to have been to bring together, in a sort of unnatural familiarity, the figures of the persons at that moment most strongly contrasted by political antipathies, personal intrigues, or other causes. This print, which has now become one of the rarest of Gillray's works (probably because its form renders it more difficult to preserve from injury), is entitled *The Installation Supper, as given at the Pantheon by the Knights of the Bath on the 26th of May,* 1788. To explain the title, it may be observed that there had been a grand installation of Knights of the Bath in Westminster Abbey on the 19th of May, and that the satirist supposes them to have given a supper in consequence. The Pantheon, the well-known scene of Mrs. Cornelys's masquerades, had witnessed many assemblies which presented an appearance equally anomalous with that here offered to our view. At a long table, not over-well provided with the good things of this world, the company is distributed in groups of gentlemen and ladies in familiar conversation, generally so selected as to form the greatest outrage upon probability. Near one extremity, the leaders of the two great political parties, Fox and Pitt, whose mutual personalities so frequently disturbed the equanimity of the House of Commons, are quietly hobnobbing behind the back of the gruff Chancellor, Thurlow, while the latter is eagerly employed on the contents of his plate, totally unaware of the singular reconciliation. Almost at the other end of the table sit the ex-Governor of India, Warren Hastings, and his lady, all bedizened with diamonds. Hastings has appropriated to himself a whole ham, and his antagonist, Burke, who sits solitary and unserved on the opposite side of the table, is in vain petitioning for a share in the spoil. Others of the remarkable men and women are easily recognised. The Duke of Richmond is seen in close conference with his political

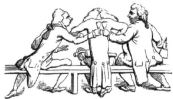

Friendship behind the Back.

antagonist, Lord Rawdon; Lord Shelburne shakes hands with Lord Sydney; and Lord Derby is closely engaged in conversation with Lady Mount Edgecumbe, an antiquated member of the *bon-ton,*

who still dreamt of conquest. The princes are each seated between a couple of ladies: the Prince of Wales, besieged by Lady Archer (of gambling memory) on his right, and Lady Cecilia Johnston on

his left, is listlessly picking his teeth with his fork. Next to them Mrs. Fitzherbert is conversing with the most amiable familiarity with the ex-patriot, Alderman Wilkes.

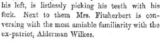
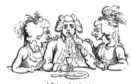

Want and Abundance.　　　　　　　　　　A Prince close beset.

Since the arrangement of his debts, and while the unsupported eloquence of the Opposition fell harmless upon the all-powerful Ministers, the Prince of Wales had become to a certain degree reconciled with his father, and he was received at Court; but a few months brought about a new and very serious cause of rupture. On the 11th of July the King had prorogued the Parliament to the 25th of September, and it was afterwards further prorogued to the 20th of November. The two Houses met at that time under circumstances of extraordinary embarrassment. As early as the month of July a change was observed in the King's health which gave considerable uneasiness to his physicians, who recommended a visit to Cheltenham, in the hope that he might derive benefit as well from the change of scene as from drinking the mineral waters. He had at an early period in his reign given some slight indications of a tendency to mental derangement; and that tendency seems to have been confirmed, rather than relieved, by the excitement caused by the enthusiastic greetings with which he was received in the country through which he had to pass. At the beginning of October, after his return, the symptoms became much more alarming, and by the end of the month the truth began to be whispered abroad, and hints of his insanity found their way into the newspapers. At length, on the 5th of November, while seated at the dinner-table with his family, the King became suddenly delirious, and from that time he remained in a state in which he could be communicated with by none but his physicians. When the two Houses met on the 20th of November, they adjourned to the 4th of December, without entering upon business of any kind; on that day a report of the Privy Council relating to the King's malady was laid on the table, and they adjourned again till the 8th. From this time Parliament was occupied in anxious deliberation, without even taking its usual holidays at Christmas.

His unhappy malady crept upon the monarch in the midst of domestic merry-makings in connexion with the birthdays of two of the princesses. The Princess Sophia's was on the 3rd of November, and the Princess Augusta's was to be kept on the 8th; but in the midst of the preparations this awful blow fell upon his family.

The details of the affliction are terrible and affecting; and Miss Burney, the sensitive little companion to the Queen, has recorded them with life-like actuality:—

"The King is very sensible of the great change there is in himself, and of the Queen's disturbance at it. It seems, but Heaven avert it! a threat of a total breaking up of the constitution. This, too, seems his own idea. I was present at his first seeing Lady Effingham on his return to Windsor this last time. 'My dear Effy,' he cried, 'you see me all at once an old man. But the Queen,' said he, 'is my physician, and no man need have a better; she is my *friend*, and no man can have a better.'

" The King is better and worse so frequently that everything is to be apprehended, if his nerves are not some way quieted. The Queen is almost overpowered with secret terror. I am affected beyond all expression in her presence, to see what struggles she makes to support serenity.

" The Princes both came to Kew, in several visits to the King. The Duke of York has also been here, and his fond father could hardly bear the pleasure of thinking him anxious for his health. ' So good,' he says, ' is Frederick !'

" At noon the King went out for an airing in his chaise. I looked from my window to see him; he was all smiling benignity, but gave so many orders to the postilions, and got in and out of the carriage twice with such agitation, that again my fear of a great fever hanging over him grew more and more powerful. Alas how little did I imagine how I should see him no more for so long—so black a period.

" When I went to my poor Queen, still worse and worse I found her spirits. She had been greatly offended with some anecdote in a newspaper—the *Morning Herald*—relative to the King's indisposition. She declared the printer should be called to account. She bid me burn the paper, and ruminated upon who could be employed to represent to the editor that he must answer at his peril such treasonable paragraphs.

" Soon after, suddenly arrived the Prince of Wales. He came into the room. He had just quitted Brighthelmstone. Something passing within seemed to render this meeting awfully distant on both sides. She asked him if he should not return to Brighthelmstone. He answered yes, the next day.

" At seven o'clock the same evening Colomb, the valet, came to tell me that the music was all forbid, and the musicians ordered away.

" This was the last step to be expected, so fond as his Majesty is of his concert, and I thought it might rather have soothed him. I could not understand the prohibition; all seemed stranger and stranger."

Later on Miss Burney is informed of the dismal history. " The King, at dinner, had broken forth into positive delirium, which long had been menacing all who saw him most closely; and the Queen was so overpowered as to fall into violent hysterics. All the princesses were in misery, and the Prince of Wales had burst into tears."

The next morning Miss Burney was sent for by the Queen. " She looked like death, colourless and wan; she was too ill to rise, and the King was in the next apartment, attended by Sir George Baker and Dr. Heberden. He kept on talking incessantly. His voice was lost in hoarseness and weakness, it was rendered almost inarticulate; but its tone was still all benevolence, all kindness, all touching graciousness."

Miss Burney was bidden by her Majesty to hear what the King was saying and doing. " Nothing could be so afflicting as this task; even now it brings fresh to my ear his poor exhausted voice. ' I am nervous,' he cried; ' I am not ill, but I am nervous. If you would know what is the matter with me, I am nervous. But I love you both very well; if you would tell me the truth. I love Dr. Heberden best, for he has not told me a lie. Sir George has told me a lie—a white lie, he says, but I hate a white lie! If you would tell me a lie, let it be a black lie!'

" The King rose in the middle of the night and would take no denial to walking into the next room, according to the Prince of Wales's account. There he found the Queen's attendants, amazed and in consternation; he demanded what they did there. This was followed by the warmest *éloge* on his dear son Frederick, his favourite, his friend. ' Yes,' he cried, ' Frederick is my friend !' and this son was then present amongst the rest, but not seen ! Sir George Baker was privately exhorted to lead the King back to his room, but he had not courage. He attempted only to speak, and the King penned him into a corner, told him he was a mere old woman, that he wondered he had ever followed his advice, for he knew nothing of his complaint, which was only nervous !"

The collapse of the King's reason produced a feverish effect on the political world. The two great political parties were suddenly opposed to each other under very extraordinary circumstances. It was generally feared that there was no hope of the King's recovery; and the Prince of Wales being of age, was naturally the person who would be selected to exercise the royal authority as regent. Pitt,

who was neither personally nor politically the Prince's friend, knew well that his nomination to the regency was tantamount to the dismissal of the Ministry, and the return of the Whigs under Fox to power. He was anxious, therefore, either to shut the door against him, or, if that could not be done, to, as much as possible, restrict his power of action. He hardly condescended to conceal his motives from the world. The Opposition, on the other hand, were already exulting in the prospect of place; and Fox, who was on a tour in Italy for the benefit of his health, was hurried home in a condition ill able to bear the fatigue and excitement which awaited him. In their haste to drive out their opponents, the leaders of the Liberal party blindly took up a position quite inconsistent with their usual principles, and which, under other circumstances, they would have combated with the greatest pertinacity; they asserted that the Prince, as next heir to the throne, had an inherent right to the regency, and that his right did not depend upon the will of the Parliament; and, in defence of this doctrine, Fox poured forth his eloquence, and Burke his invective. Pitt and the Tories, with equal inconsistency, stood by the most popular principles of the Constitution, and asserted that the Prince had no more power himself to assume the government than any other individual in the country; but that the right of providing for the government, in cases where it was thus suddenly interrupted, belonged to the Peers and to the nation at large, through its representatives, and was to be regulated entirely by their discretion. The debates were warm, and often personal. Fox, at the commencement, had rashly used words seeming to imply that the Prince of Wales possessed the inherent right to assume the government. Scarcely had the words escaped his lips, when the features of the Premier lighted up with an unusual smile, and, slapping his thigh with exultation, he exclaimed to a member sitting near him, " I'll un-Whig the gentleman for the rest of his life." During the rest of the debates he confuted Fox's arguments by asserting the extreme doctrines of the Liberal party. Fox's remarks were commented upon in the same spirit by Lord Camden in the House of Lords. On the 12th of December Fox rose in his place in the House of Commons and, recurring to this matter, protested against the construction which had been placed upon his words; he stated that he did not say that the Prince might *assume* the administration in consequence of his Majesty's temporary incapacity, but that the *right of administration* subsisted in him; that he had the right, but not the possession, which latter he could not legally take without the sanction of Parliament.

This explanation was far from answering the full purpose for which it was designed; people still looked upon Fox's original declaration as a temporary assertion of ultra-Tory principles to serve an object, and they now accused him of trying to escape the consequences by eating his own words. Among the multitude of caricatures which appeared on this occasion one represents him under the title of " The Word-eater," exhibiting his skill before the assembled Legislature, and holding in his hands his " speech " and his " explanation." It is accompanied with an

" ADVERTISEMENT EXTRAORDINARY.

" This is to inform the public, that this extraordinary phenomenon is just arrived from the Continent, and exhibits every day during the sittings of the House of Commons before a select company. To give a complete detail of his wonderful talents would far exceed the bounds of an advertisement, as indeed they surpass the powers of description. He eats single words and evacuates them so as to have a contrary meaning—for example, of the word *treason* he can make *reason*, and of *reason* he can make *treason*. He can also eat whole sentences, and will again produce them either with a double, different, or contradictory meaning; and is equally capable of performing the same operation on the largest volumes and libraries. He purposes, in the course of a few months, to exhibit in public for the benefit and amusement of the electors of Westminster, when he will convince his friends of his great abilities in this new art, and will provide himself with weighty arguments for his enemies."

November 25th, 1788. *Filial Piety.*—George the Third is in bed, and a bishop is reading prayers for the restoration of his health. The Prince of Wales bursts in with drunken violence, saying, "Damme, come along, I'll see if the old fellow's —— or not?" Colonel Hanger (bearing a bottle) and Sheridan, his boon companions, are following. A picture of the "Prodigal Son" completes the significance of this satire.

November 29th, 1788. *King Henry the Fourth's Last Scene* presents Bardolph, Shallow, Sir John Falstaff, and Pistol engaged in a consultation. Sheridan, in the appropriate character of Bardolph, is

the first to begin his congratulations. "O joyful day! I would not take a knighthood for my fortune." The Duke of Norfolk, as Shallow, expects he will recover the loans he has advanced to Falstaff—"Sir John, I hope you'll pay me back my thousand pounds!" Fox, who makes a truly admirable Falstaff, is inclined to boast—"The laws of England are at my commandment; happy are those who have been my friends, and woe to my Lord Chancellor!" Colonel Hanger, as a highly burlesque Pistol, is crying, "Sir John, thy tender lambkin now is king! Harry the Fifth's the man. I speak the truth; when Pistol lies do this, and fig me like the Spaniard!"

December 12th, 1788. *Bologna Sausages.*—Fox is exhibited rushing out of the Commons with unceremonious precipitation. The face of Pitt appears in the doorway, declaring, "The Prince of Wales has no more right to a succession to the regency than any other subject (without the consent of Parliament), and whoever asserts the contrary speaks little less than Treason—I repeat, than Treason!" Fox, in his hurried departure, cries (eating his own words), "I never said he had a right to the regency; I didn't, indeed! indeed I didn't!" Mr. Weltjie, the Prince's house-steward and head cook, a remarkably portly German, marching with his sauce ladles and bill of fare, is quite confounded by the position of affairs. "No right to de regency? Den, by Got, we shall lose all de sausages!" Sheridan, Burke, and the occupants of the Opposition benches listen to Pitt's assertion with consternation.

December 20th, 1788. *The Prospect before us.*—Gillray's shafts appear to be alternately dealt at Ministry and Opposition. In "the prospect" anticipated by this cartoon the crown is split in half; Pitt, under the petticoat protection of the Queen, has one half suspended over his head, while the other settles on her Majesty, who is trampling the Prince of Wales's feathers, with the inscription "My son's right," under her feet. Madame Schwellenberg, her favourite, the head of the royal household, the special aversion of the people, and the constant butt of the wits, has appropriated the Lord Chancellor's mace; in this series the caricaturist seems to insinuate that the German courtier was likely to occupy Thurlow's influential position under the patronage of the Queen and Pitt. Thurlow was clearly out of favour, the sincerity of his allegiance was mistrusted, and his intrigues with the Regency party were soon evident.

December 26th, 1788. *The Political Hydra.*—Fox, the most prominent man of the situation, is presented in the guise of the many-headed monster. "Out of place, and in character," the Whig chief appears with his black crop rough and unpowdered; "In place, and out of character," he is smiling beneath the courtly white-powdered "toupi;" "As he might have been," his head under the red cap of Republicanism; "As he would have been," under a Prince's coronet; "As he should have been," the head guillotined and the red bonnet drawn over his eyes; "As he will be!" the triumphant Whig wearing the coronet and triple plume of the Prince of Wales. This brilliant anticipation was, however, doomed to bitter disappointment!

December, 1788. *The Political Blood.*—The friends and advocates of the Prince appear in a whimsical travestie, carrying out the performance of the notorious Colonel Blood, who planned the abduction of the regalia. The high connivance which has been hinted in the case of Blood is not wanting in the allusions of Gillray's version. Fox is sturdily making off with the royal crown; it may be in the interest of the Prince, or it may be in his own. Colonel Hanger, wearing a laced waistcoat and mon-

The Political Blood.

strous cocked hat, bears in one hand the torch with which he set the Tower on fire; while under his arm is a sack of coin, with which he trips jauntily away. Burke is making off, with

Jesuitical stealthiness and solemnity, with the sceptre; while Sheridan, with a pantomime-like leer, is thrusting the orb into his pocket somewhat after the fashion practised by Signor Grimaldi, once " Sherry's " clown, and peculiarly in the best manner of " Young Joe,"* his distinguished successor.

December, 1788. *Prince Pitt.*—The intrepid young Minister, supported on the shoulders of the Dukes of Grafton and Richmond, who are treading upon the prostrate figure of the Prince of Wales, is enabled by this elevation to reach the British Crown, which has been laid on the " shelf." Pitt is asserting, " The Prince of Wales has no more right literally to the regency than I have." In his hand appears a list of his most unpopular measures, " Shop Tax, Window Tax, Candle Tax, Horse Tax, Hat Tax, Westminster Scrutiny," &c. Appended to this anti-Pittite caricature are some verses espousing the cause of the Prince with considerable zeal :—

> " See here Prince George, our Sovereign's darling son,
> Old England's hope, and heir to Britain's throne,
> Trod under foot the Royal victim lies;
> The while Prince Pitt above him dares to rise,
> Our rightful Prince, the heir apparent, down,
> This new Pretender hopes to filch the crown.
> Two base-born Dukes, of the curs'd Stuart breed,
> Bend their vile necks to help him to the deed.
> 'Tis Grafton's Duke upon the left you see,——
> The most renowned for greatest treachery;
> But he who shows his bald pate on the right
> Is Richmond's Duke, who never yet would fight;
> May God eternally confuse their scheme,
> And make them vanish like an empty dream !
> Rouse, Britons, rouse! hands, hearts, in chorus join,
> To guard our laws, and save the Brunswick line :
> Huzza! my boys! Our courage never fails :
> God save the King! God bless the Prince of Wales!"

December 10th, 1788.—*A Pig in a Poke. Whist! Whist!*—Sir Joseph Mawbey, seated with three companions, is playing a political game of whist. The print is obscure in its allusions, and the details would be of no interest at this date. Sir Joseph Mawbey, distiller, was member for Surrey. He entered Parliament under Fox, but on the dismissal of the Coalition he went over to Pitt. He was remarkable for uniting a pig-like expression with a squeaking voice.

> " A sty of pigs, though all at once it squeaks,
> Means not so much as Mawbey when he speaks ;
> And history says he never yet had bred
> A pig with such a voice, or such a head !
> Except, indeed, when he essays to joke,
> And then his wit is truly pig-in-poke."

Towards the end of the year, a number of caricatures were launched against the adherents of the Prince of Wales, satirizing their eagerness for power, their presumed designs, and the prospects of the country under such a government as the Whigs desired. One of these, entitled *A Touch on the Times,* and published on the 29th of December, 1788, appears to have been very popular, and there was at least one imitation of it. Britannia is represented as handing the Prince to the throne, which her lion seems to bear with anything but equanimity. The foundation step of the throne, on which the Prince is placing his foot, is " The voice of the people ;" the second step, " Public safety," is cracked and broken ; the emblem of virtue, inscribed on the back of the throne, is a full purse. The Prince is backed by a motley group of pretenders to patriotism, who seek to benefit by his accession : one, who carries the ensign of liberty, is taking the Prince's handkerchief from his pocket. The genius of commerce sits in the corner, a victim to gin-drinking.

* " Old Joe," as Signor Grimaldi's son is known to posterity, was only nine years old at the date of this carica-ture. The father's death had left the family without provision. Sheridan, always kind-hearted, retained the child at Drury Lane, and considerately allowed him a pound a week.

When the Minister had demonstrated by the force of his majorities that the appointment of a regency was a matter entirely at the discretion of Parliament, he brought forward a string of resolutions which, though obstinately opposed, were passed on the 19th of January, and had the effect of placing the executive in the hands of the Prince of Wales, under restrictions which deprived him of any substantial power, the latter being either placed in abeyance, or given to the Queen, who was Pitt's friend. These resolutions were: "That as the personal exercise of the authority of the crown is retarded by the illness of his Majesty, the Prince of Wales be

Commerce under the Regency.

requested to take upon himself, during the continuance of his Majesty's illness, and in his name (as a regent), the execution of all the royalties, functions, and constitutional authorities of the King, under such restrictions as shall be hereafter mentioned. That the Regent shall be prevented from conferring any honours or additional marks of royal favour, by grants of peerage, to any person, except to those of his Majesty's issue who shall attain the age of twenty-one. That he shall be prevented from granting any patent place for life, or any reversionary grant of any patent place, other than such as is required by law to be for life, and not during pleasure. That the care of his Majesty being to be reposed in her Majesty, the officers of his Majesty's household are to be under the direction of her Majesty, and not subject to the control of the Regent. That the care of his Majesty be reposed in the Queen, to be assisted with a council."

Pitt made no secret that his restrictions were mainly intended to abridge the power that would fall into the hands of what he almost openly designated as a cabal, and the speeches of the Ministerial party generally assumed that the Prince would be surrounded by bad advisers. The Prince himself was in a very ill humour with the Minister, and held frequent consultations with the Opposition. When Pitt communicated his intentions to him, on the 30th of December, the Prince consented to take the regency, but expressed his dissatisfaction at the restrictions, in a letter which is understood to have been written by Sheridan.* The general feeling out of doors, except among the staunch adherents of the Opposition in Parliament, seems to have been against the Prince; but there were a few bitter caricatures on what was looked upon by some as an unnecessary spoliation of the crown which he was virtually to wear.

1789.

The commencement of 1789 found the political world still occupied in struggling over the restrictions on the regency; the latter part of the year is remarkable for the advance of the new French constitution, and for the sympathy exhibited in England for those aspirations for freedom which were no longer regarded as mere sentiment.

January 3rd, 1789. *The Vulture of the Constitution.*—Pitt as a vulture, whose crop is overgorged with the Treasury, mounted on the crown, and secretly clutching the sceptre, is crushing the Prince of Wales's crown, and depriving it of the feathers. The Magna Charta is torn and trampled under the creature's claws.

The Vulture of the Constitution.

February, 1789. *Rival Queens. A Political Heat for Lege and Grege.*—Madame Schwellenberg, the Queen's German favourite, armed with the Chancellor's mace, is engaged in desperate conflict with Mrs. Fitzherbert, whose instrument of defence, in allusion to her faith, is represented as a crucifix.

* "There was not a word of the Prince's letter to Pitt mine. *It was originally Burke's,* altered a little, but improved by Sheridan and other critics."—LORD MINTO.

Pitt officiates as a very animated second to the stout "Lady of the Robes," and the Prince of Wales is, of course, backing his own favourite.

The greatest of political rats was Lord Chancellor Thurlow. In the conviction that the King was past recovery, he at first held himself aloof under different excuses from the consultations of the Cabinet, and entered into secret communication with the Prince, with the view of securing the Chancellorship under the Regency, to the exclusion of his rival, the Whig Lord Loughborough, who, it was universally understood, was to take the office of Lord Chancellor whenever his party came into power. The Prince's advisers snatched at the prospect of detaching Thurlow from the Ministerial party, and gave encouragement to his advances. When Fox arrived from Italy, he found things in this state ; and, strongly prejudiced against Thurlow, he was only with difficulty persuaded to use his influence with Lord Loughborough in inducing him to waive his claims. The Whigs, however, soon grew distrustful of Thurlow, and Loughborough was restored to his hopes of the Chancellorship. Thurlow, now perceiving that he was losing ground with his own party, without gaining ground with the other, and seeing that there was a prospect of the speedy restoration of the King to health, suddenly appeared on the woolsack with all his old zeal for the Ministers, and gave his utmost support to Pitt's Regency Bill. This bill, which was brought into the House of Commons on the 5th of February, increased the number of restrictions, and enumerated them in greater detail. One clause restrained the Regent from marrying a Papist, and in committee the zealous Mr. Rolle, still harping upon the old story of Mrs. Fitzherbert, moved to introduce a paragraph providing that the Regent should be incapacitated if he "is or shall be married in law or fact to a Papist." This amendment, though rejected at once, was a fruitful subject of new scandal out of doors. After several very hot debates, the bill passed the Commons on the 12th of February. It had scarcely reached the other House, when reports of the King's recovery began to get about, and the Lords adjourned from day to day until the 10th of March, when the complete restoration of the King was officially announced, and Parliament regularly opened by commission with a speech from the Throne. The Regency Bill was immediately thrown aside, and the country was relieved from a great embarrassment, which must, under the circumstances, have led to much confusion. One important result of the agitation of the question was the establishment of a great principle in the Constitution, stamped with the sanction of that party in the State which might have been expected to be most decidedly opposed to it. The rejoicings throughout England on the King's recovery were loud and universal, and the joy was certainly sincere. The metropolis was brilliantly illuminated on the 12th of March ; and the way in which the grand procession to St. Paul's on the 25th of April, the day fixed for public thanksgiving, was received by the people, showed how much the King had gained in popularity.

The popularity of the Ministers, however, did not increase in the same proportion, for it was evident to every one that they had been actuated more by the spirit of political faction than by true patriotism.

April 22nd, 1789. *Restoration Dresses.*—The King's recovery, at a moment of extreme agitation, was universally hailed as a happy solution of the difficulties by which the course of pacific government had been threatened. The fairer portion of the community exhibited their loyalty by wearing ribands to celebrate the King's convalescence, printed with the sentiments, "God save the King!" "The King restored to health!" &c.

April 29th, 1789. *The Funeral Procession of Miss Regency.*—The hopes of the party are carried to their untimely grave in a burlesque funeral convoy. In this political lottery the supporters of the Prince were, by a turn of chance, thrown into exile.

At the head of the procession marches the Regency doctor, "Liberty Hall," the *ci-devant* apothecary, whose portrait will be found in ".Blue and Buff Charity" (June 12th, 1793). Burke, as spiritual adviser, walks second, in the character of Ignatius Loyola, studying "An Ode upon his Majesty's Recovery.' Then follow two "noviciates of St. Giles's," bearing flowers, shedding tears, and chanting a dirge—

"When we've cried o'er the grave as long as we're able,
We'll kiss and we'll wipe Charley's tears all away."

Then follows the "body" of the deceased, borne by "Six Irish Bulls," referring to six Irish peers—Ministerial deserters*—"the Bull riders," who are served up in epigram as the "Glorious Half-dozen."

> "Six rogues have come over our pockets to pick,
> And dispose of their second-hand ware;
> To play the buffoon, and jump, tumble, and trick:
> But they've come—the day after the fair."

The six Irish peers, acting as pall-bearers, are represented with the heads of bulls; they are weeping and howling the national "Hullabaloo." On the pall are displayed two dice, a dice-box, the Prince of Wales's coronet, and an empty purse. Two "noviciates of St. Giles's" follow. The chief mourner, Mrs. Fitzherbert, described as the "Princess of Wales," is buried in tragic grief at the downfall of the power she had anticipated. The "Second mourners," Fox and Sheridan, are in the deepest dejection, shedding tears. Sheridan, however, is ungenerous in his affliction; he thus accuses Fox—

> "Ah! Charley, hadst thou never been seen,
> This never had hap'd to me;
> I would that Pitt had sealed my eye
> Ere I had joined with thee."

Fox, in this Brutus and Cassius-like argument, expresses a nobler emotion: "Ah me! I can no more! Die, Charley, die—for Sherry grudges thou shouldst live so long!"

The mourning household succeed next. The Prince's hairdresser (Mails) inquires—

> "Dear Charley, oh! tell us how long d'ye think
> King George will remain on his throne?"

> "Vor by Got ve do pine, and in sadness ve tink
> Dat it's long till de Prince vear de Crown"—

concludes the "Clerk of the Dishclouts" (Weltjie), who carries a huge stewpan. A Remnant of the Forty-five, or the would-be Chancellor (Lord Loughborough), with sorrowing visage, precedes Lord Stiletto (Lord Moira), who is the most composed of any member of the group. With him walks the little Marquis of Lothian; and the rear of the lugubrious procession is brought up by the Blue and Buff Trainbearer, a dark imp of the grotesque order Gillray excelled in designing, who is singing to his fiddle, "Such a fine sight as this my old daddy will gladly see!"

On the Woolsack.

Pitt relentlessly employed his first leisure to punish those of his own party who had given indications of "ratting." The Duke of Queensberry, Lords Carteret and Malmesbury, and the Marquis of Lothian were summarily dismissed; and in Ireland, where the defection had been more glaring, the deserters were cashiered in all directions. All time-servers were cleared out of office, and the Minister was justly said to have "made more patriots in a day than patriotism had ever made in a year."

The Regency question disgusted the Prince with political intrigue; it cured his taste for public life, and drove him away from the ambitions of party. No experiment could be more disheartening;

* The embarrassment of the situation was increased by the somewhat factious conduct of the Parliament of Ireland, where both Houses, it has been supposed at the secret instigation of Burke, and by the active intervention of Grattan, had passed resolutions, in the precise spirit of the Opposition in England, for addresses to the Prince of Wales, requesting him to assume of his own right the regency of Ireland without any restrictions. The Lord Lieutenant refused to be the medium of transmission; and the two Houses elected a deputation to wait on the Prince in London, where he received them with marked favour, but informed them of the circumstances which now rendered their measures unnecessary. This was contrasted with the cold manner in which he had received the English deputation under Mr. Pitt. The Prince's conduct throughout had been most obnoxious to the Queen, and gave great offence to the King, who, after his recovery, expressed his displeasure very openly.

in future the Prince's love for excitement was turned to channels where, although the objects were less dignified, the gratifications were more easily obtained. The Prince became a greater voluptuary than ever; in revenge for his mortifications, defying the reprobation his conduct provoked from the King and Queen.

The trial of Warren Hastings was still in its infancy, and allusions to its continuance occur occasionally.

May 8th, 1789. *Cooling the Brain.*—Burke, treated as a maniac, is having his head shaved by an officer (possibly of the East India Company's Service) in one of the cells of a madhouse. He is heavily fettered to the floor of the dungeon by chains forged from "Censure of the Commons" and "Contempt of the Lords." On the prison wall is chalked a rude design of a gibbeted figure of Warren Hastings. He is addressing his culprit in imagination—"Ha! miscreant, murderer of Nundocamor—where wilt thou hide thy head now?" The ex-Governor in a picture is exhibited being welcomed at St. James's, to which he is carrying a sack marked four millions.

May 30th, 1789. *Prince and Poltroon.*—At this date a duel was fought on Wimbledon Common between the Duke of York and Colonel Lennox (nephew of the Duke of Richmond). The Marquis of Hastings was the Duke's second; the Earl of Winchelsea seconded his opponent. The dispute arose from some trifling difference between the Colonel and the Duke as commander-in-chief. It is said that Lennox's ball grazed one of York's side curls; the Duke, after receiving the fire of his antagonist, declined to return it. The Duke of York's popularity was increased by his conduct, and Colonel Lennox had to submit to various unpleasant comments. Another affair of honour unfortunately arose out of this. Mr. Swift, a collateral descendant of the famous Dean, reflected on the Colonel's behaviour; a second duel ensued, and Swift was wounded in the body. The Prince of Wales was particularly hostile in his treatment of his brother's antagonist; the Duke of York behaved more leniently. Gillray, under the titles of "Prince and Poltroon," published three caricatures of this subject on the popular side, reflecting on Lennox and representing York as little less than the victim of an assassination. Colonel Lennox succeeded his uncle as Duke of Richmond; he appears to have been a supporter of the popular Pitt Administration. He was made Lord Lieutenant of Ireland in 1808, and afterwards Governor-General of British America, where in 1819 he had the misfortune to perish of hydrophobia, it was assumed from the bite of a pet dog, inflicted five months before the paroxysms seized the victim.

June 27th, 1789. *Lord Chancellor Thurlow.*—The Thunderer, seated on the woolsack in solitude, is peering under his projecting brows with an air of sorrowful reflection. This sketch, probably a facsimile of one of Gillray's pencil outlines taken in the House, introduces the Chancellor, with more than the fidelity of a photograph, at the time when his political tergiversations had brought him into contempt with both parties,—when his vituperations deservedly provoked general resentment. According to an epigram:—

> "Here bully Thurlow flings his gall
> Alike on foes and friends;
> Blazing, like blue devils at Vauxhall,
> With sulphur at both ends."

June 20th, 1789. *Shakespeare Sacrificed; or the Offering to Avarice.*—It has been said of this elaborate and talented cartoon that "it might be deemed as prophetic as it is pertinent—all its leading anticipations being since so thoroughly confirmed in the opinion of the public."[*] Mr. Wright, in the Key to Gillray's Caricatures which accompanies Mr. Bohn's Edition, observes: "It is impossible to refuse our unqualified admiration of the extraordinary talent exhibited in the design and execution of this print; the felicity displayed in the selection and grouping of the subjects, and the concentration of so many objects in one point of view, strike the spectator, and give additional poignancy to the satire."

Alderman Boydell—a whole-length portrait (considered an admirable resemblance of his person and manner), dressed in the aldermanic gown he assumed in his Gallery—is preparing an oblation before the altar of his devotion.

Raised on a pile of the portfolios of "Modern Masters," stands the huge volume of "Subscribers to

* Athenæum.

the Sacrifice" (*i.e.*, to Boydell's Shakspeare). The demon of Avarice, perched on this elevation, is hugging his money-bags, while the figure of Puck, wearing a crown of peacock feathers, is blowing bubbles of "immortality," which the work was to achieve for its projector. The aldermanic high-priest is standing within a magic circle, the plays of the immortal bard provide fuel for the sacrificial

Shakspeare Sacrificed. Alderman Boydell's Offering to Avarice.

incense, and a figure bearing the cap of Folly is slyly fanning the blaze. The fumes of the incantation have obscured the figure of Shakspeare, who stands pointing to the quotation, "The cloud-capt towers, the gorgeous palaces, the solemn temples—yea, the great globe itself shall dissolve, and like the baseless fabric of a vision, leave not a rack behind." In the thick volumes of smoke raised by Boydell's agency we find numerous parodies of the well-known subjects which formed the Gallery. These groups ingeniously seize those points of the works most open to criticism, and reproduce the subjects selected without any extreme exaggeration of their faults. In the left-hand corner is Gillray's version of "The Infant Shakspeare," originally (mal-)treated by Romney. The wily Duke of Gloucester (Richard III.) is literally taken from Northcote; his figure bears a strong resemblance to an ape. Another subject from the same artist represents the most noticeable features of the picture in which Tyrrell has despatched Edward V. in the Tower. King Lear is seated upon a throne, which appears

with a smoking chimney on either side, and Cordelia is driven forth. A second figure offers a remarkably breezy head of hair. The President, Sir Joshua Reynolds, who was induced by a handsome retaining fee to contribute to the Gallery, does not escape the shafts of the satirist. His painting of the Death of Cardinal Beaufort, now at Dulwich, has its contorted perspective brought under the lash, and his Macbeth does not escape. Fuseli also shares the honours of travesty; his illustrations of Caliban ("Tempest"), Midas ("Midsummer Night's Dream"), and Hamlet are distinguishable in the midst of the holocaust. The flames of a lower region threaten to engulf all these remarkable productions; and Death, as the gravedigger in "Hamlet," is preparing the resting-place which awaited the promoter of the sacrifice. Above the temple of Fame the god is blowing all the great bubles of previous ages into space; while he showers a deluge of "puffs," as the only effectual instruments of modern reputation. In the foreground a snail is seen crawling over the works of "Ancient Masters." The brilliancy of this conception is more notable than its justice. The state of the fine arts had before Boydell's time been at a very low ebb; but his persevering industry largely contributed to spread abroad a better appreciation for this branch of refinement. Engraving, under his auspices, not only proved a profitable speculation, but was also the means of advancing popular taste; and solid encouragement was now extended to men of talent by the general public.

The royal patronage was expended on the works of the courtly West; and, encouraging the mediocrity which would condescend to flatter him, the King neglected those greater names which posterity has proved to be the worthiest examples of our school. Reynolds, Gainsborough, and Wilson were passed unnoticed, while West, Hudson, Cosway, and lesser men were set in the high places. Peter Pindar thus congratulated the Sovereign on his mistaken patronage :—


"TO THE KING.

"An't please your Majesty, I'm overjoy'd
 To find your family so fond of Painting;
I wish her sister Poetry employ'd—
 Poor, dear neglected girl ! with hunger fainting.
Your royal grandsire (trust me, I'm no fibber)
 Was vastly fond of Colley Cibber.

"For subjects, how his Majesty would hunt !
 And if a battle grace'd the Rhine or Weser,
He'd cry, 'Mine poet sal mak Ode upon't !
 Then forth there came a flaming ode to Cæsar.

"Thrice happy times, when monarchs find them hard things,
 To teach us what to view with admiration ;
And, like their heads on halfpence and brass farthings,
 Make their opinions current through the nation ! "


But to resume : King George awoke from his mental darkness to be a witness of the most fearful social storm that had struck Europe since the days when Rome was overrun by the barbarian hordes of the North. To the eyes of profound observers, France had long been labouring under a complication of evils which must eventually lead to some great calamity. Reckless corruption and a selfish contempt on the part of their governors had, during many years, been aggravating the irritation of the people, while a school of so-called philosophers were as industriously disseminating principles which tended to undermine and dissolve the existing frame of society. Amid so many elements of discord, it was the misfortune of France to be governed by a weak monarch, in every respect unfitted to grapple with the difficulties of his position—a people ill-disposed, an enormous national debt, and an administration filled with abuses.

A winter unusually severe, accompanied with famine and other disasters, ushered in the year 1789, and drove the mass of the people almost to despair. The French King endeavoured to avert the danger by repeated concessions, which always came too late, and only exposed his weakness to his discontented subjects. The attention of Englishmen had been called off from the affairs of France, first by the serious calamity which threatened them at home, and then by the rejoicings after they had been relieved from their fears by the King's recovery; for several months the news from France had occu-

pied but a secondary place in public interest, when the extraordinary revolution of the months of June and July suddenly burst upon the world.

The French revolution at first excited considerable sympathy here, although, as its true character became developed, that sympathy soon diminished. During the latter part of the year 1789, the tone of the moderate English papers was decidedly favourable to the movement, which, it was believed, would end in the establishment of free institutions. Thus, the *European Magazine* makes the following reflections in the month of September: "The political phenomenon exhibited by France, at this moment, is perfectly unparalleled throughout the annals of universal history. If the constitution now forming, under circumstances so peculiarly favourable, be finally established, if the deliberations and wisdom of the philosopher be not circumscribed by the intrigues of the politician, or destroyed by the sword of faction, the result will be a *chef-d'œuvre* of government."

July 27th, 1789. *Freedom and Slavery.*—A pair of pictures designed by Gillray on a theory completely opposed to the principle regulating similar subjects in the English mind during the days of Hogarth; they are, too, a perfect contrast to Gillray's cartoon introduced under the same title in December, 1792.

Freedom was recognised by the English patriots in 1789 as exclusively belonging to the French nation. Necker, the Controller of Finance, dismissed by the Government, for a time became the idol of the people, who insisted on his recall to office. He is drawn returning from the overthrow of the Bastille, the synonym of tyranny and oppression, with the cap of Liberty, as the symbol of the newly inaugurated freedom, in one hand, and the crown, purified by reforms, held out in the other to a forgiven monarch. The Duke of Orleans, then considered a great patriot, appears as one of Necker's supporters. Pitt, bold, unsparing, and inflexible to his enemies, had at that time obtained the reputation of an aristocratic oppressor, which was soon forgotten when opportunity revealed him in his more popular aspect. In Gillray's cartoon, which doubtless has some truth in it, the young Minister is trampling on the crown; his ensign is a flag on which are emblazoned fetters and instruments of tyranny and torture. King, nobility, and people are alike bound in chains of gold and iron. Pitt well knew how best to employ these powerful agents.

August, 1789. *The Offering to Liberty.*—A highly patriotic allegory on the revision of the French Constitution, the downfall of oppression, and the dismissal of the agents of intrigue and corruption. The goddess of Liberty, seated on the ruins of the hated Bastille, "restores the crown to a repentant monarch," making at the same time a fine speech, the realization of which people were far from anticipating:—"Receive from Liberty your crown again, and He that wears the crown immortally long guard it yours." Necker, as the personification of Virtue, and the Duke of Orleans as the representative of Honour, are dragging a female in fetters—"Messalina drinking Rhenish" (an unjust and ungallant reference to Marie Antoinette of Austria, who, as the descendant of feudal sovereigns, was then most unpopular both in France and in England, where the fictions propagated against the fame of this injured Queen found ready credence). "The pests of France and Great Britain, German toad-eaters and German councillors," are represented by a mob of courtiers in chains, their pockets overflowing with the wealth of a people amongst whom they were favoured aliens; envied, mistrusted, and disliked on all sides by the nation on whom they were thrust. Lafayette, the general of a free people, appears as a popular liberator; he bears a white flag on which "Libertas" is inscribed. A fraternal army of patriot soldiers and free citizens are displayed as the "Extirpators of Tyranny."

This caricature is highly interesting because of the confidence people were prepared to accord to the new order of things then inaugurated. With prudence on the one side and rational moderation on the other, every confidence was felt in the establishment of a constitution which would confer the stability of our own well-tried monarchy, with an increased freedom for which patriots at home were eagerly agitating. A few months undeceived the world in their reliance on the permanency of this happy condition of affairs in France.

October 28th, 1789. *The Sergeant Recruiter.*—Philippe Egalité, in a gay hussar uniform, and bearing an axe in his hand, is addressing eloquent appeals to the fish-fags of Billingsgate. The *poissardes* or fish-wives of Paris were already exciting some attention in Europe. In 1789 the Duke of Orleans,

whose character seems destined to remain an enigma, visited England for the last time. France was then labouring under the first symptoms of disturbance; and the Duke's presence was considered hazardous to the Court interests. Marie Antoinette, haughty and implacable, was his enemy, and under the pretext of a mission from the King he was ordered to quit Paris. The National Assembly were already assuming the sovereign power, and a passport from them was necessary. It was considered surprising that the fashionable regenerator should leave France when her wings were already spread for that illusory flight which was to have soared to political and social perfection. The mob—a more sovereign power than either King or National Assembly—rapidly proclaimed its authority. The *poissardes* of Boulogne arrested the royal envoy, nullified the King's commission on the spot, impounded his passport, and marched the Duke to the confinement of his hotel. A deputation was dismissed to Paris, and returned bearing the national sanction for the departure of Orleans. The fishwomen were satisfied. The Duke reappeared in England amidst the intoxications of the Prince of Wales's circle. Happy had it been for the Duke if his ambition had suffered him to prolong his exile from Paris, after his first experience of a "reign of terror."

In the early part of this year (January 19th, 1789) Gillray published a portrait of Dr. Messenger Monsey, leaning on the shoulder of a Chelsea pensioner, whom the Doctor used to call his crutch. This eccentric physician is said to have possessed much of the humour of Dean Swift; he was physician to Chelsea Hospital for forty-seven years. He died at the age of ninety-five (December 26th, 1788). Dr. Monsey's will directed that his body should undergo dissection, and that "*the remainder of his carcass*" (his own expression) "*should be put in a hole.*" A lecture was accordingly delivered in Guy's Hospital by Mr. Forster, the surgeon to whom he had assigned this singular charge. Peter Pindar seized the eccentric testamentary dispositions of the physician for the production of an epitaph in three verses, which are added to the plate.

> "Here lie my old limbs—my vexation now ends,
> For I've lived much too long for myself and my friends;
> As to churchyards and grounds which the parsons call holy,
> 'Tis a rank piece of priestcraft, and founded on folly.

> "In short, I despise them, and as for my soul,
> Which may mount the last day with my bones from this hole,
> I think that it really hath nothing to fear
> From the God of mankind, whom I truly revere.

> "What the next world may be little troubles my pate;
> If not better than this, I beseech thee, O Fate,
> When the bodies of millions fly up in a riot,
> To let the old carcase of Monsey be quiet."

1790.

In 1787 was published a witty work, under the title of "The Probationary Odes," to which reference has already been made. As the verses do not belong specially to that year, but serve as humorous indexes to the characters of the great political personages, who a few years later came more prominently before the public, and found their way—doubtless against their wills—into Gillray's graphic satires, we selected a later date for their introduction. They afford sprightly sketches of the principal actors who at this date occupied the public platform. The "Probationary Odes" were especially clever; the vacancy in the laureateship was supposed to have called forth a host of candidates in rivalry of Thomas Warton (who succeeded to it), and each of his Majesty's Ministers enters into the competition and contributes an ode more or less characteristic of himself or descriptive of his political conduct. First in the list of candidates stands Sir Cecil Wray, who appears, by the election squibs of the preceding year, to have been guilty of some attempts at poetry, and who now takes a magnificent flight in the regions of namby-pamby. After a somewhat magniloquent exordium, he goes on to flatter the King:—

> "Yes, Joe and I
> Are em'lous!—Why?

It is because, great Cæsar, you are clever—
Therefore we'd sing of you for ever !
 Sing—sing—sing—sing—
 God save the King !
Smile then, Cæsar, smile on Wray !
Crown at last his *poll* with bay !—
Come, oh ! bay, and with thee bring
Salary, illustrious thing !—
Laurels vain of Covent Garden,
I don't value you a farding.
 Let sack my soul cheer,
 For 'tis sick of small beer !
Cæsar ! Cæsar ! give it !—do !—
Great Cæsar, giv't all !—for my muse 'doreth you !"

After being wrapt for a while in the poetical contemplation of his own grandeur, he ends by a sublime threat against the presumption of his rival :—

 " Yet if the laurel prize,
 Dearer than my eyes,
 Cursed Warton tries
 For to surprise,
By the eternal God, I'll *scrutinize !* "

Michael Angelo Taylor, known as the "Law Chick," who appears constantly in these caricatures, was not loved by either party, owing to his pompous manners. His favourite employment was attending committees in the capacity of chairman, and the most notable incident of his personal career was his rejection, when a candidate for the Speaker's chair. (See *The New Speaker*, February 15th, 1800) :—

" Hail, all hail, thou natal day !
Hail the very half-hour, I say,
 On which great George was born !
Tho' scarcely fledged, I try my wing—
And tho' alas ! I cannot sing,
 I'll *crow* on this illustrious morn !

" Sweet bird, that chirp'st the note of folly,
 So pleasantly, so drolly !—
Thee oft the 'Stable-yards' among,
I woo and emulate thy song !
Thee, for my emblem still I choose !
Oh ! with thy voice inspire a *chicken of the muse !*

" Avaunt, ye Wrens, ye Gostlings, and ye Pies !
 The *Chick of Law* shall win the prize !
The Chick of Law shall peck the bays !
So, when again the State demands our care
Fierce in my laurel'd pride, I'll take the chair.

" Lo ! how I shine, St. Stephen's boast !
 There, first of *chicks,* I rule the *roast !*
 There I appear,
 Pitt's *Chanticleer,*
The *bantam-cock* to oppositions !
 Or like a *hen,*
 With watchful ken,
Sit close and watch—the Irish propositions !"

These minor constellations are all thrown into the shade by the appearance of the Scot, Dundas :—

" Hoot ! hoot awaw !
 Hoot ! hoot awaw !
Ye Lawland bards ! wha' are ye aw ?
What are your sangs ? what aw your lair to boot ?
Vain are your thoughts the prize to win,
Sae dight your gabs, and stint your senseless din ;
 Hoot ! hoot awaw ! hoot ! hoot !
 Put oot aw your attic feires,
 Burn your lutes and brek your leyres ;
A looder and a looder note I'll streike :—
Na watter draughts fra Helicon I heed,
Na wull I mount your winged steed,—
I'll mount the Hanoverian horse, and ride him whare I
leike !

" Come then, aw ye Poors of vairse,
Gi' me great *Geourge's* glories to rehearse ;
And as I chant his kingly awks,
 The list'nan warld fra me sall lairn
Hoo swaft he rides, hoo slow he walks,
 And weel he gets his Queen wi' bairn.
Give me, with all a Laureat's art to jumble,
Thoughts that soothe, and words that rumble,
Wisdom and Empire, Brunswick's royal line,
Fame, honour, glory, Majesty divine !"

Major John Scott, who had recently returned from India, contributes an Ode :—

" Grand is thy form—'bout five feet ten,
Thou well-built, worthiest, best of men !

Thy chest is stout, thy back is broad—
Thy pages view thee and are aw'd !

Lo ! how thy white eyes roll !
Thy whiter eye-brows stare !
　　Honest soul !
Thou'rt witty, as thou'rt fair.

" North of the Drawing-room a closet stands :
The sacred nook St. James's Park commands !
Here in sequester'd state, great George receives
Memorials, treaties, and long lists of thieves !
Here all the force of sov'reign thought is bent,
To fix reviews, or change a government !

" Now shall the levee's ease thy soul unbend,
　Fatigued with Royalty's severer care !
Oh ! happy few ! whom brighter stars befriend,
　Who catch the chat—the witty whisper share !

　　Methinks I hear,
　　In accents clear,
Great Brunswick's voice still vibrate on my ear—
　' What ?—what ?—what ?
　　Scott !—Scott !—Scott !
　　Hot !—hot !—hot !
　　What !—what !—what ! '
Oh ! fancy quick ! oh ! judgment true !
Oh ! sacred oracle of regal taste !
So hasty, and so generous too !
Not one of all thy questions will an answer wait !
Vain, vain, oh Muse, thy feeble art
To paint the beauties of that head and heart !
That heart where all the virtues join !
That head—that hangs on many a sign !"

Among the candidates of higher note appears the Chancellor, Lord Thurlow, whose harsher strains pour forth such streams of profane invective that we feel bound to apologize for their insertion. The faithful picture they afford the reader of the violence of party prejudice in those stormy "downright" times, is the only excuse for reproducing this picture of the Thunderer's outrageous blasphemy :—

" Damnation seize ye all,
Who puff, who thrum, who bawl and squall !
Fired with ambitious hopes in vain,
The wreath that blooms for other brows to gain,
　Is Thurlow yet so little known ?
By G—d ! I swore, while God shall reign,
The Seals, in spite of changes, to retain,
Nor quit the woolsack till he quits the throne.
　And now, the bays for life to wear,
Once more, with mightier oaths, by G—d, I swear ;
Bend my black brows, that keep the Peers in awe,
Shake my full-bottom wig, and give the nod of law.

" '*Tis mine to keep the conscience of the King ;*
To me, each secret of his heart is shown :
Who then like me shall hope to sing
　Virtues to all but me unknown ?
Say, who like me shall win belief,
To tales of his paternal grief,
When civil war with slaughter dy'd
The plains beyond th' Atlantic tide ?
Who can like me his joy attest,
(Though little joy his looks confest),
When *Peace*, at *Conway's* call restor'd,
Bade kindred nations sheathe the sword ?

" How pleas'd he gave his people's wishes way,
And turn'd out *North* (when *North* refused to stay) !
How in their sorrows sharing too, unseen,
For Rockingham he mourn'd at Windsor with the
　Queen !

" To Thurlow's lyre more daring notes belong.
　Now tremble every rebel soul !
　While on the foes of George I roll
The deep-toned execrations of my song.
　　*　　　*
Lo ! Wedgewood, too, waves his *Pitt-pots** on high !
Lo ! he points, where the bottoms yet dry,
　The visage immaculate bear !
Be Wedgewood d—d and double d—d his ware.
　D—n Fox and d—n North ;
　D—n Portland's mild worth,
　D—n Sheridan's wit,
　The terror of Pitt ;
D—n Loughb'rough, my plague,—would his bagpipe
　were split !
　D—n Derby's long scroll,
　Fill'd with names to the brims :
　D—n his limbs, d—n his soul,
　D—n his soul, d—n his limbs.

The caricatures of 1790 are not numerous. The Ministers were strong enough to carry their measures without any violent contests, and the Opposition, which has been shown to have been very feeble at the commencement of the new Parliament, was now becoming weaker.

The French revolution was advancing with red-hot violence, but perhaps the secession of Burke from his party was the most notable political feature at home.

February 15th, 1790. *Lieutenant-Governor Gallstone inspired by Alecto ; or the Birth of Minerva.*— Philip Thicknesse, Governor of Landguard Fort, a frontier garrison which has long disappeared, obtained an unenviable reputation for the bitterness of his personal quarrels, for violent abuse, for the

* " 'I am told that a scoundrel of a potter, one Mr. Wedgewood, is making 10,000 vile utensils with a figure of Mr. Pitt in the bottom ; round the head is to be a motto—
　　　　　' We will spit
　　　　　On Mr. Pitt.' "

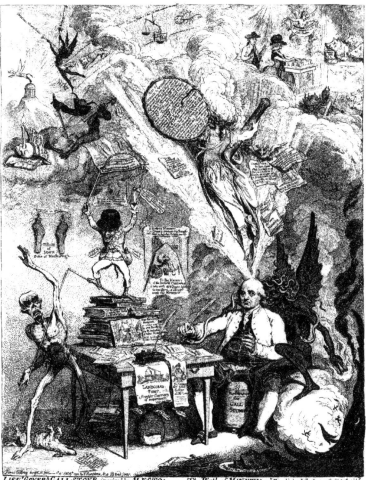

LIEUᵗ GOVERᴺᵒ'ʳ GALL-STONE, inspired by ALECTO; _or_ _ The Birth of MINERVA. _From his head she sprang, a Goddess Arm'd : xxx_
To the Opinions of The right honᵇˡᵉ EDWARD, LORD THURLOW, the EARLS CAMDEN, BUTE, BATHURST, and COVENTRY, George Touchet BARON
AUDLEY, and PHILIP THICKNESSE, hon.ᵇˡᵉ Esqʳˢ to the LITERATI, the ROYAL SOCIETY, the MILITARY, MEDICAL, and OBSTETRIC Brethren, this attempt
to Elucidate the properties of HONOR and COURAGE, INTELLIGENCE and PHILANTHROPY, is most respectfully submitted, by their humble servant, J. Gillray.

misrepresentations which he heaped on his opponents or on those who had displeased him, and for the spiteful writings in which he proclaimed his fancied injuries.

We are not acquainted with the positive circumstances in which this bitter and ingeniously elaborate satire on Thicknesse originated. It is not improbable that a "Sketch of the Life of Gainsborough" published by the Lieutenant-Governor is the real offence which provoked this personal attack. Whether the painter consulted Gillray, or whether the latter took up the cudgels for his own diversion, we are uninformed.

The sketch of the artist's life published by Thicknesse is the only cause of its author's name having reached our day. The reputation attaching to that eccentric work is no credit to the writer. Gainsborough was studying from nature in the neighbourhood of Landguard Fort; the Governor made the acquaintance of the young artist and gave him a commission to paint his fortress, a place neither interesting, picturesque, nor important. Gainsborough, for two or three pounds, made a large picture, in which he introduced the greatest possible amount of landscape and the least proportion of fortress contrivable. This picture Thicknesse pushed into notoriety, and the view was engraved. The fate of the picture was peculiar. It was hung on a wall, the lime of which had been mixed with salt water, and, according to Thicknesse, the painting was entirely obliterated. In Gillray's satire the Governor is seated at his table composing "Extortive Epistles" and "Incendiary Letters." Alecto, emerging from the flames of a burning region, is instilling a poisoned ink with which a serpent tips the author's pen. Under the table are seen bags of money, "100*l.* per annum from Lord Camden, 100*l.* from Lord Bute, Lord Bathurst, &c.," and a file of "Extortive Letters," implying the sources of this income. "Landguard Fort, a Frontier Garrison of Importance, vide own Memoirs," appears as a mouse-trap. Books of questionable morality represent the writings of Thicknesse. The body of his dog is introduced "horsewhipped to death," according to an elegy. A grim figure of Death is regarding a dwarfed monster in dismay, who has broken his spear. This figure is offering laudanum, hellebore, and hemlock as "preservatives of life." A devil is fiddling on a viol-de-gamba (Gainsborough purchased one of these instruments of the Governor, and the matter was afterwards disputed) from "Friendship, a solo to the memory of Gainsborough and Sterne." Sterne's works are "Chopfallen," and Yorick's skull is turned into a candle-holder. Fame proclaims, "Imprimis, a young Coward, and finis, an old Rogue." Minerva, fully equipped, issues from Thicknesse's brain. She bears a wooden gun and a cracked shield, which records his "Acts of courage and wisdom," with charges of an outrageous nature against Thicknesse. The allusions scattered throughout the print are in the highest degree personal. It is one of the earliest works to which, "as designer and executioner," Gillray has appended his name. It is somewhat astonishing that he should have ventured to publish these objectionable charges, and especially that no hostile consequences appear to have followed.

April 9th, 1790. *John Bull baited by the Dogs of Excise.*—The Bull, a stout powerful beast, has his horns blunted, his eyes bandaged, and, wearing a secure muzzle, he is snorting "Liberty, liberty, and no Excise—huzza!" His legs are heavily tethered with iron chains to a post marked "Excise." Pitt, in his own person, is hurrying out of the Treasury to encourage the sport. He cries, "At him! At him! Tally-ho!" In his hand is displayed a bundle of massive chains, "New Excise Fetters for John Bull." From Pitt's pocket hangs a scroll of new objects "for duty;" the list includes nearly every article of daily consumption. George Rose, the secretary (a rose is substituted for his head), is mounted on a ladder, busily painting, in "King's yellow," "Excise Office" over the word "Treasury." A dark fierce hound (Thurlow), with "Snap Dragon" on his collar, is starting from a tub labelled "Tobacco." The Chancellor is holding a large bone of Office, marked "Opposition" at one end and "Ministry" at the other, to illustrate his intention of retaining office irrespective of party obligations. The Excise Dogs are headed by Grenville with his pen behind his ear. Dundas has secured a firm hold; "Jenky" has also made a seizure. Richmond, as an "Ordnance" hound, has the Bull by the ear. Pepper Arden is worrying the tail. Sydney, Grafton, Camden, and others are tearing "full cry" from the Treasury kennels to assist in the sport. This caricature is founded on an attack made by Sheridan upon Pitt's Excise Dues, on the occasion of a petition for the repeal of the duty on tobacco.

May 10, 1790.—*The Monster going to take his Afternoon's Luncheon.*—At the date when this plate

was issued a miscreant, Renwick Williams, excited public terror and indignation by prowling about the West End, cutting and maiming unprotected females. Williams's trial excited great attention; he was sentenced to six years' imprisonment for wounding a young lady in St. James's Street. In Gillray's spirited etching on this subject the monster, who has a very sanguinary expression, is just about to wound a fair victim whom he has secured in his clutches. In his right hand is a gigantic carving-knife. Ladies are running away in alarm. Gillray afterwards made a spiteful use of this allusion against Alderman Boydell. (See April, 1791.)

May 20th, 1790. *Swearing to the Cutting Monster, or a Scene in Bow Street.*—The monster is represented, but by a few touches the face is converted into a horrified likeness of Fox, who is placed handcuffed at the bar. A fashionable young lady, mounted on a stool, is exhibiting her injuries to the Grand Inquisitor and the authorities of Bow Street, and testifying to the identity of the prisoner.

July 23rd, 1790. *Captain Morris.*—

> " When the fancy-stirring bowl
> Wakes its world of pleasure,
> Glowing visions wake my soul,
> And life's an endless treasure."

The gallant songster is here represented in a moment of conviviality. In the larger original his chair

Captain Morris.

is placed on the table. It is a subject for sincere regret that the accomplished Captain did not fall upon less boisterous times, and it is no less unfortunate that his genius should have been encouraged by so dangerous a circle. His muse was content to minister to the licence of the day, to lend her inspiration for purposes of mere party glorification. The happiness of the poet was to grace the table of the heir apparent with the charms of his anacreontics, his wit, and his voice. Had his melodies been turned to worthier aims his poetic versification would undoubtedly have secured him a foremost rank amongst writers of ballads.

The veteran songster in his old age found time to reflect on the dangerous tendencies of his anacreontics; he recalled the errors of his judgment (his heart was always enlisted on the side of gentleness), and died highly respected for his virtues and piety. An example of Captain Morris's political ballads has been given in the summary of the Westminster election of 1784. As a devoted "bon vivant" the Captain had but little chance of cultivating sentiments beyond those pertaining to the "erotic school"—

> " ——— to entwine
> The myrtle of Venus with Bacchus's vine."

It was observed at the conclusion of one of the florid lyrics which his companions loved, that it was a matter for surprise that the songster did not attempt any other order of harmony—" Oh, Morris could not write in any other strain." He replied that at the next gathering he would refute this opinion by singing a different note. Prompted by this pledge he composed the tender lines published in the "Lyra Urbanica," 1840, as

" SENSIBILITY'S TEAR.

" Though Bacchus may boast of his care-killing bowl,
 And Folly in thought-drowning revels delight,
Such worship, alas! hath no charms for the soul,
 When softer devotions the senses invite.

" To the arrow of Fate, or the canker of Care,
 His potions oblivious a balm may bestow;
But to Fancy, that feeds on the charm of the Fair,
 The death of Reflection is birth of all Woe.

" What soul that's possessed of a dream so divine,
 With riot would bid the sweet vision begone?
For the tear that bedews Sensibility's shrine,
 Is a drop of more worth than all Bacchus's wine.

 * * *

" Come, then, rosy Venus, and spread o'er my sight
 The magic illusions that ravish the soul;
Awake in my breast the soft dream of delight,
 And drop from my myrtle one leaf in my bowl.

" Then deep will I drink of that nectar divine,
 Nor e'er jolly god, from thy banquet remove;
But each tube of my heart ever thirst for the wine,
 That's mellowed by Friendship and sweetened by Love."

September 14th, 1790. *Philip Thicknesse, Esq.—*

" —— absentem qui rodit amicum,
Hic niger est, hunc tu, Romane, caveto !"—HORAT.

" No ties can hold him, no affection bind,
 And *Fear* alone restrains his coward mind;
Free him from *that*, no monster is so fell,
 Nor is so sure a bloodhound found in hell."

A small portrait in oval of the Lieutenant-Governor. Gillray's animosity, probably excited by the injuries done to Gainsborough, did not appear to cool quickly. The portrait is carefully executed, and the likeness is no doubt a faithful one. A scowl of the most malignant character pervades the expression of every feature.

The leaders of both the great political parties seem at first to have accepted the French revolution as a good omen for the future prospects of Europe, although their eyes were soon opened to the real character of the movement, and the dangers that were engendered by it. For some time, however, they spoke with caution, and seemed anxious to avoid every occasion of bringing the subject into discussion, however strongly several of them may have expressed themselves in private. When the Parliament opened on the 21st of January, 1790, the speech from the throne omitted even the name of France, though it spoke of the "continued assurances of the good disposition of all foreign powers," and a passing allusion was made to "the internal situation of different parts of Europe." The addresses of both Houses were agreed to with slight discussions; the movers spoke of the excellence of the English Constitution, and compared the constitutional liberty enjoyed in this country with the anarchy and licentiousness which reigned in France. Most of the speakers took it for granted that it had been the intention of the revolutionists to form a government in imitation of our Constitution. The House of Commons next proceeded to the consideration of the slave trade, for the abolition of which Wilberforce was now contending; and no further allusion to France was made until the 5th of February, when a discussion arose upon the army estimates.

Although the Ministerial speakers had expressed no disapprobation of the attempt of the French people to relieve themselves from a ruinous and despotic government, it was well known that their private sentiments were hostile to the existing state of things. The atrocious character which the popular movement in France had now taken had already disgusted a large portion of those who at first viewed it with favour, and was destined to break up, in a more disastrous manner than any previous question, the ranks of the Opposition. The grand explosion of hostility against the French revolution came from a quarter in which it might have been least expected. In the debate just alluded to, Fox praised the conduct of the French soldiers in refusing to act against the people, and said that it took away many of his objections to a standing army. This dangerous sentiment drew forth some severe remarks, especially from the military part of the House. Fox, it was well known, had accepted the revolution, in spite of all its sinister accompaniments, as the dawn of European regeneration; and to the last he defended its principles, and persisted in his hopes of its favourable termination, while he disapproved of the conduct of those who had driven it into so many excesses and calamities. One section of the Whig party fully partook in his sentiments on this subject; but there were many of his old friends who disagreed with him. When the debate on the army estimates was resumed on the 9th of February, Fox repeated his remark on the conduct of the French soldiers, and openly avowed his opinion of the revolution, declaring that he exulted in the successful attempt of our neighbours to deliver themselves from oppression, and at the same time intimating his confident belief that the present convulsions would, sooner or later, give way to constitutional order. This declaration roused Edmund Burke, who deprecated the countenance given to the French revolution by his old political friend and leader, made an eloquent declamation on the errors and dangers of that extraordinary catastrophe, and expressed his

fears that the movement might eventually reach our own country, where, he said, there were people watching only for the opportunity to imitate the French. When Burke rose, he was evidently labouring under great agitation of feeling; and, in the warmth of his declamation, he declared that he was prepared to separate himself from his oldest friends, in order to defend the Constitution of his country against the encroachments of the democratic spirit which had produced so much havoc in France. Fox replied with moderation, reasserted his own sentiments on the subject, and lamented in feeling terms the difference of opinion which had arisen between them; but Sheridan, less temperate, burst into something like an invective against Burke, and described his speech as one disgraceful to an Englishman, a direct encomium of despotism, and a libel on men who were virtuously engaged in labouring to obtain the rights of men. Burke rose again, expressed great indignation against Sheridan, and declared that he considered their political friendship at an end for ever.

Pitt had sat quietly on the Treasury bench, inwardly rejoicing at the division which had taken place among his opponents; but he rose after Burke's second speech, and, without making any direct attack upon the French, spoke of the necessity of rallying round our own Constitution, complimented Burke on the sentiments he had that day expressed, and declared that he had earned the gratitude of his country to the latest posterity. Several others of the Ministerial party followed Pitt in applauding Burke's conduct. Fox felt personally for the disagreement, and the whole Whig party took the alarm. Great exertions were made to effect a reconciliation, but without any satisfactory results, for Burke continued cold and distant; and Sheridan, who seems to have displeased his own party by his violence on this occasion, took little part in the Parliamentary proceedings during the remainder of the Session.

Burke was correct in stating that there were a number of discontented people in this country who admired the conduct of the Gallic democrats, and were most anxious to establish their principles in this country. The political agitation of the earlier part of the reign of George III., and the warm partisanship to which it had led, had given an impetus to the formation of clubs and private societies for the discussion of political questions, which were scattered over the country, and not only assisted the Opposition in elections, but were extremely useful allies in getting up petitions to the House on questions likely to embarrass the Ministers. Beyond this their influence was not great, and there was nothing in their character to cause any apprehensions. Some of them were at times attended, and even presided over, by distinguished members of the Opposition in both Houses of Parliament. One of the most remarkable and the oldest of these clubs was that known by the name of the Revolution Society, which consisted of a number of the old Whig party, who met every year on the 4th of November to celebrate the memory of the revolution of 1688. In 1788 this society celebrated the centenary anniversary of that great event with more than usual solemnity, and with a very large attendance; among those present were a Secretary of State and several persons high in office and confidence at Court. The sentiments expressed on this occasion were of a most loyal description; but a year seems to have altered very much the complexion of the society. Most of the members shared in Fox's opinion of the French Revolution; and, by a strange misunderstanding of its true character and of that of the French populace, they imagined that it would bear a strict comparison with that which had hurled James II. from the English throne. The society met as usual on the 4th of November, 1789, under the presidency of Lord Stanhope, a nobleman whose love of republican principles was carried almost to insanity. Among the more enthusiastic members of this society was an old man, a preacher of the gospel, who (singularly enough) had been, on more occasions than one, the financial adviser of young William Pitt, who had not taken alarm at his zeal for the cause of American independence as he now did at those outbursts of the same zeal which merited for him the title of

"That revolution sinner—Dr. Price."

On the morning of the anniversary dinner of the Revolution Society in 1789, in the midst of the excitement produced in this country by the earlier acts of the French Revolution, Dr. Price preached at a Dissenting chapel in the Old Jewry, before the members of the society, a sermon "On the love of our country," which was subsequently printed, and was the cause of considerable agitation. In this

discourse, Price accepted the French Revolution as a glorious event in the history of mankind, as one fraught with unmixed good to the whole human race. At the conclusion he burst into a rhapsody of admiration :—"What an eventful period is this! I am thankful that I have lived to it: and I could almost say, 'Lord, now lettest thou thy servant depart in peace, for mine eyes have seen thy salvation.' I have lived to see a diffusion of knowledge which has undermined superstition and error; I have lived to see the rights of men better understood than ever, and nations panting for liberty which seemed to have lost the idea of it; I have lived to see thirty millions of people indignantly and resolutely spurning at slavery, and demanding liberty with an irresistible voice; their king led in triumph, and an arbitrary monarch surrendering himself to his subjects. After sharing in the benefits of one revolution, I have been spared to be a witness to two other revolutions, both glorious; and now methinks I see the ardour for liberty catching and spreading, and a general amendment beginning in human affairs— the dominion of kings changed for the dominion of laws, and the dominion of priests giving way to the dominion of reason and conscience. Be encouraged, all ye friends of freedom, and writers in its defence! The times are auspicious. Your labours have not been in vain. Behold kingdoms admonished by you, starting from sleep, breaking their fetters, and claiming justice from their oppressors! Behold the light you have struck out, after setting America free, reflected to France, and here kindled into a blaze that lays despotism in ashes and warms and illuminates Europe!"

Such were the sentiments which at this moment were gaining ground in England; and the enthusiasm of the preacher seems to have communicated itself to his audience. At the meeting of the society, which was very fully attended, a motion proposed by Dr. Price was agreed to by acclamation for a formal address of "their congratulations to the National Assembly on the event of the late glorious revolution in France." This address was transmitted by the chairman, Lord Stanhope, and was received with strongly marked satisfaction by the body to which it was sent; but it had the double effect of misleading the revolutionary government as to the real feelings of the population of this country in their subsequent transactions with England, and of encouraging those attempts at political propagandism which soon followed. A close correspondence was soon established between the discontented party in this country and the democrats in Paris, from which Fox himself was not altogether free; and many new political societies were formed in different parts of the island, some of them much more violent in their language and professed objects than the London Revolution Society. Counter societies were likewise established to combat the revolution societies with their own weapons of agitation. We shall soon witness the effects of this popular antagonism.

Two other individuals stood prominent among the violent revolutionists of this country. The first was a man of low origin, only half educated, but skilled in that style of writing which has its effect among the classes of society which were now most agitated, and reckless in his attacks on all existing institutions, political or religious. This was Thomas Paine, originally a stay-maker at Thetford, who had subsequently been an exciseman, then a sailor, after which he emigrated to America, where his ardent revolutionary propensities had been fanned into a blaze. He had now returned to England, was active among the political clubs, and had attracted the notice of the chiefs of the Opposition, having even been admitted to a certain degree of intimacy by Edmund Burke.

The second, Joseph Priestley, merited a more honourable celebrity by his researches and discoveries in science, than by his political and religious opinions, in both of which he was violently opposed to the established order of things. Dr. Priestley was a Unitarian preacher, resident at Birmingham, and belonged to a sect which had become numerous in various parts of England, and which generally entertained political opinions of a very liberal character. In the hands of people like these the clubs multiplied, and became more violent in their language; among the more celebrated of these were the Constitutional Society, the "Club of the 14th of July" (the day of the capture of the Bastille), and the Corresponding Society, the latter being the most violent of all.

At the same time that these clubs were doing all they could to spread democratic opinions through England, King George's disinclination to making concessions to the Liberal party seemed to increase with age and infirmities; and he now adopted the conviction that the concessions on the part of the

R

Crown had been the chief cause of the French Revolution. The clergy, terrified by the fate of their Romish brethren on the other side of the Channel, seconded the King's resolution with the cry that the Church was in danger; they had been for some years looking with alarm at the increase in the Dissenting body, and they now began to agitate against them, and to call for measures of persecution. In face of this feeling from above, other large and intelligent portions of the community called loudly for legislative reform, and for religious toleration. The revolution in France was set up as a sufficient argument against reform in England; the real or pretended designs of some of the Dissenters were made to justify the continuance of the Test and Corporation Acts; and even Wilberforce's favourite measure for the abolition of slavery was stifled by an appeal to the horrors perpetrated in French republican St. Domingo.

On the 2nd of March, 1790, Fox brought forward in the House of Commons a motion for the repeal of the Test and Corporation Acts in a very able speech, to the principles of which no objection was made. Some members avowed their approval of the measure, but said they considered themselves bound to obey the will of their constituents, who, in various instances, had held public meetings, and directed their representatives to oppose all concession to the Dissenters. Pitt declared that his feelings were in favour of toleration, but he was afraid that in granting their wishes he might be overthrowing one of the barriers of the Constitution. It was Burke who, on this occasion, took upon himself the task of religious persecutor. He also made an apology for the part he was taking, and then he flew off to his favourite subject, the horrors and crimes of the French Revolution; he avowed opinions totally at variance with the views of those with whom he had acted for so many years, declared that there was no such thing as the natural rights of men, and condemned the whole body of Dissenters in the strongest terms, as discontented people whose principles tended to the subversion of good government. He even supported his opinions by calling to memory the proceedings of the mad Lord George Gordon; and to prove the danger with which the Constitution was now threatened, he spoke of the celebrated sermon of Dr. Price on the love of our country, and of some political writings of Dr. Priestley. The motion was rejected by a majority of nearly three to one.

The agitation against the Dissenters, and the alarm caused by the disorderly and sanguinary turn which the revolution in France had taken, were seized as offering a favourable opportunity for the elections, and Parliament was dissolved on the 10th of June. The new Parliament seems to have differed little in its character from the old one; and the only incident of much importance, as depicting the political movement of the day, was the appearance of John Horne Tooke (so well known in the earlier part of the reign as Parson Horne of Brentford), who offered himself as a candidate to contest Westminster with Fox and Lord Hood. Neither Fox, nor his seconder, Sheridan, were a match in mob eloquence with Tooke, and the latter held his place manfully on the hustings; but at the end of the poll he was in a considerable minority.

Horne Tooke, who is best known to the public by his "Diversions of Purley," had been in the political contentions of the beginning of the reign a violent Wilkite; he had subsequently quarrelled with Wilkes, and done everything in his power to vilify his private and public character; from that time he seemed almost to have disappeared from the political stage, until the French Revolution and the English political societies again brought him to life. On his rejection at Westminster he presented a petition against the return, in a tone that gave great offence to the House of Commons. We shall soon see him still more active in the political factions of the day. The Westminster election of 1790 was, like its predecessors, the scene of much mobbing and violence, and produced abundance of electioneering squibs. A few poor caricatures were directed chiefly against Fox, who, it was pretended by his opponents, gained his election by coalescing with Lord Hood. When the Tories wished to be very severe on their great Parliamentary enemy, they tried to get up some charge of a "coalition."

The new Parliament met on the 26th of November, when any direct allusion to the affairs of France was again omitted in the King's speech, and the subject seemed to be avoided for a time in the debates in either House. But, while it appeared thus to have been discarded by the Court, it had absorbed the mighty intellect of Burke, who, a short time before the opening of the Session, had published his

eloquent "Reflections on the French Revolution." In this remarkable production he had painted in exaggerated colours its errors and enormities, and had undoubtedly exaggerated the danger of extension of republican principles to this country. The English political societies, the Dissenters, and their acknowledged or covert designs, and especially Dr. Price's sermon, all became objects in turn of his indignant declamations. Perhaps no single book ever produced so powerful an effect as these "Reflections;" their publication marked an epoch in the history of the country; and we find that immediately after the appearance of this pamphlet, not only did the general feeling throughout England become more decidedly hostile to democratic France, but the English Government began to take bolder steps for the suppression of sedition at home.

December 3rd, 1790. *Smelling out a Rat, or the Atheistical Revolutionist Disturbed at his Midnight Calculations.*—Dr. Price is seated at his study table preparing a discourse " On the Benefits of Anarchy, Regicide, Atheism, &c." The penetrating nose and luminous spectacles of Burke, topped by his "Reflections," are dispelling the darkness of the Doctor's secret doings, the light of the crown in one hand and of the cross in the other.

The King and his Ministers, and all the Tory party, expressed unbounded admiration of Burke's splendid defence of their policy; but it gave great dissatisfaction to the ultra-Whigs, who complained that he had misrepresented the conduct of the French in order to render them odious, and that he had advanced principles which led to despotism and arbitrary power. Burke's book was answered in an essay by Mackintosh, who then figured as one of the boldest Whigs, and more violently and coarsely in " The Rights of Man," by Thomas Paine, who, having studied republicanism and democracy in the Congress of America, and in the worst clubs in Paris, had returned to England, hoping to find here a soil fitted for their reception. Dr. Priestley also entered the field against Burke's "Reflections," and a number of more insignificant writers took up the pen.

The year 1790 thus ended unfavourably for the Whig faction; their great light, the former "Jesuit" of the Tory satirists, was now enlisted under the banners of the Ministry, an apostle preaching from his new texts the duty of submission, the heresy of free thought, the will of the King, and unquestioning obedience to those set in power. The rewards of virtue loomed temptingly before him, while the reproaches of his friends hastened his final desertion to the ranks of Pitt's elect.

1791.

Gillray's graver was busily at work in 1791. He produced a large number of designs which belong to the order of social " hits;" his political satires are also numerous. In these caricatures the chief events of the year can be clearly traced. We see Wilberforce bringing in his bill for the abolition of slavery, a measure which had to fight its way through many successive Sessions before the efforts of its philanthropic supporters were crowned with success. We find the estrangement of Burke an established fact, and, strangely enough, prosperity and rewards now soothed the angry workings of Edmund's restless energy. The advance of the French Revolution, and the withdrawal of English sympathy from a cause which moderation could no longer approve, is illustrated in its rapid stages by the extravagances practised under the name of rational liberty. The aim of the English revolutionary societies is made manifest. The career of the Prince of Wales, the amours of the Duke of Clarence with Mrs. Jordan, the avarice of the King and Queen, and the excitement consequent on the marriage of the popular Duke of York with a princess of Prussia, sum up the topics of the year as indicated in Gillray's works for 1791.

February 28, 1791. *Bandelures.*—This caricature introduces us to the Prince's establishment. The heir apparent, negligently stretched on a couch, is amusing himself with the new toy, a wheel attached to a long string. The Prince is leaning on the lap of Mrs. Fitzherbert, who shares his sofa. The coronet and plume are on the favourite's brow. One arm lightly encircles her royal lover, the other hand is encouraging Sheridan, the Prince's confidant, who, leaning over the back of the couch, is imprinting a kiss on the lady's cheek. A bust of Claudius, a dice-box, and a figure of Bacchus suggestively line

the mantel; a relievo of a horse race alludes to the pastime over which the Prince squandered thousands :—

> " —— thus sits the Dupe content!
> Pleases himself with toys, thinks Heav'n secure,
> Depends on woman's smiles, and thinks the man
> His soul is wrapp'd in can be nought but true.

> " Fond fool, arouse! shake off thy childish dream;
> Behold Love's falsehood, Friendship's perjur'd truth;
> Nor sit and sleep, for all around the world
> Thy shame is known, while thou alone art blind."—BLACKMORE.

A scandal *à la mode* was afforded the gossipers in 1791, by what may be called the " Gunning intrigue." The handsome Miss Gunning, daughter of General Gunning (brother to the famous toasts, " The Three Graces," " The lovely Miss Gunnings " of an earlier period), was favoured with numerous admirers, and among others the Marquis of Blandford, the eldest son of the Duke of Marlborough, and the Marquis of Lorne, eldest son of the Duke of Argyll. The lady finally gave her preference to the former. The Duke of Argyll, who had married the Duke of Hamilton's widow (one of the original " lovely Miss Gunnings," sister to the General), asked General Gunning whether the Duke of Marlborough was apprized of his son's matrimonial projects, and if he approved of the alliance. The General admitted he did not know, and stated his intention of addressing his Grace on the subject, promising that if he expressed disapproval of the match, he would at once put an end to the affair. General Gunning's groom carried a letter to the Duke in this sense, and returned with an answer expressive of his entire approval of his son's choice, and his deep sense of the young lady's good qualities. The Duke of Argyll, to whom this letter was shown, expressed his suspicions of its authenticity. General Gunning questioned his wife and daughter; they declared that the letter was genuine, or they had been imposed upon. The groom, confessed the paper had been furnished him by Miss Gunning; it was, in fact, a clumsy forgery. The General now turned his daughter out of the house, and shortly after separated from his wife. Mrs. Gunning, with whom the Duke of Argyll declined to hold any further communication, published an absurd pamphlet addressed to the Duke as a letter, in which she attributed the forgery, without any proof, to Captain and Mrs. Bowen, with whom she was on hostile terms. The integrity of the General sustained a severe blow in the following year. An action for adultery having been brought against him by James Duberley, Esq., the jury awarded 5000l. damages, and Lord Kenyon, who was honestly antagonistic to all descriptions of fashionable vice, described the General's conduct as " hoary, shameful, and detestable."

May 5th, 1791. *The Siege of Blenheim, or the new System of Gunning Discovered ; vide, A Bold Stroke for a Husband.* Dedicated to the Duke of Argyll.—Miss Gunning is seated on a field-piece directed against Blenheim House. Her mother is applying a pen as a fusee ; and a discharge of forged letters is aimed against the Duke of Marlborough, who is replying with a counter fire. Miss Gunning, in great alarm, proposes an immediate retreat, and lays the fault on her mother, who declares, " Who could have thought the siege of a coronet would have ended in smoke ? Well, I'll take my affidavit that I know nothing at all about the matter !" General Gunning is stealing away. He exclaims, " I find our stratagem wont take effect, and therefore I'll be off and manœuvre; any common soldier can lead on an attack, but it requires the skill of a general to bring off his forces with honour after a defeat."

March 25th, 1791. *Margaret's Ghost.*—Miss Gunning is lying indisposed, and her mother is sitting at the bed-side. A sudden apparition of her sister, Miss Margaret Minifie, who was mixed up in the matter as " Margaret's Grimly Ghost," has struck terror into the good lady's mind, and caused her to destroy a bottle of brandy, the comforter of her affliction. " What's the matter, Auntee Peg ? What makes you put on such a long face ?" is Mrs. Gunning's terrified exclamation, in burlesque of her own letter—" says my dear-chaste-adorable-kind-beneficent-enchanting-heart-feeling-beneficent-paragon of goodness—she broke upon us the dishonourable-infamous-impudent-false accusations, and the cruel, most cruel, messages that accompanied them," &c. &c.

March 25th, 1791. *Betty Gunning revived, or a Peep at the Conjuration of Mary Squires and the Gipsy Family.*—A female necromancer, in a composite costume of witch and camp-follower, seated on

a drum, is sealing a letter, while a devil under the table is holding a candle for that purpose. The demon is crying "Swear!" to Miss Gunning, who, seated opposite to Betty, is kissing a pack of cards in confirmation of her testimony. "I swear that I never wished or tried, directly or indirectly, to get a coronet; that I never saw or writ to Lord B. or Lord L. in all my life," &c. Betty observes, "Well done, Bett! We'll get thro' the business, I warrant you. We can write all sorts of hands, we've got all kinds of seals, and with the assistance of our old friend under the table we shall be able to gull them yet, daughter; but I must be mum!" A conjuration is proceeding at the fire-place. Mrs. Gunning is fanning the flame with a pair of bellows, made of her "Letter to the Duke of Argyll;" she is offering encouragement to the persecuted heroine. "That's right, my sweet innocent angel! say Grace boldly; make haste, my dear little lovely lambkin. I'll soon blow up the fire, while Nauntee Peg helps to cook up the coronets. We'll get you a nice little tit-bit for dinner before we've done, my dear little deary." Miss Minifie, as a half-clothed hag, is attending with her ladle to the cauldron in which the coronets are being served up. "Puff away, sister," she cries; "the soup will soon boil. Lawa me, how soft the green peas do grow, and how they jump about in the pot when you puff your bellows." A picture of the stocks and similar allusions are pasted on the walls. The groom is standing outside at the foot of a sign-post pointing to Blenheim. He is remarking, "I'm ready to ride or swear!"

March 20th, 1791. *Oh! that this too, too solid flesh would melt! Designed for the Shakspeare Gallery.* —A remarkably obese suitor, whose form is perfectly spherical, is kneeling, with no hope of rising unassisted, sighing at the feet of an equally stout lady. This burlesque construction of the passage in our bard has been frequently described with high commendation; it is probably intended merely as a shaft aimed at Alderman Boydell and his Shakspeare Gallery, which provoked the determined hostility of the satirist.

April 20th, 1791. *Taming the Shrew. Katharine and Petruchio—The Modern Quixotte, or What You Will.*—The intentions of Russia towards Turkey had long been a cause for European uneasiness. The dangers and difficulties which threatened this question have already been noticed. (Nov. 1, 1781.) We find the subject brought forward in a more decisive form amongst the politics of this year. Catherine of Russia, supported by the Emperor of Austria and by France, is giving way before the demands of Pitt and his allies; while Turkey, which had suffered from Catherine's ambition, takes refuge, in the person of the Sultan, behind the Hanoverian horse, a sorry, battered, broken-down steed, overridden, and bending beneath the combined weight of Holland and Prussia, headed by the valiant Pitt, who, in allusion to the Turkish crescent, which the Empress has assumed as a head-dress, is crying—

> "Katharine, that cap of yours becomes you not;
> Off with that bauble, 'tis my royal will."

A drawn sword lies across a plan of Oczakow. The Hanoverian horse, which appears the greatest sufferer, is observing tearfully, "Heigho! to have myself thus rid to death by a boy and his playmates, merely to frighten an old woman! I wish I was back in Hanover," &c.

April 21st, 1791. *The Balance of Power, or the Posterity of the Immortal Chatham turned Posture-master.* Vide Sheridan's Speech.—Pitt is dancing on a single cord and supporting a balancing-pole, which bears the Sultan on one end and on the other the Empress Catherine. Both these potentates are offering the Minister bribes to influence the balance in their favour. Pitt, who is quite indifferent to their wishes, replies that nothing will influence the "level of his pole." Sheridan, as clown to the posture-master, is looking with envy at the Premier's chance of filling his pockets.

April 23rd, 1791. *Barbarities in the West Indies.*—A brutal overseer has thrown a young negro into a copper of boiling sugar-juice, and he is forcing him below the surface of the fluid with the butt end of his many-tailed lash; he cries, "Can't work because you're not well? but I'll give you a warm bath to cure your ague," &c. Ears and hands of negroes are nailed to the wall by the side of vermin. The statement embodied in this sketch is somewhat extreme; it is questionable whether Gillray has designed the picture to excite horror against colonial barbarities, or to ridicule the speeches of those who supported Wilberforce's motion for the abolition of the slave trade.

Gillray's antagonism to Boydell and the Shakspeare Gallery did not diminish with the progress of

the undertaking. The Alderman's opponents, indeed, accused him not only of puffing, but of resorting to all kinds of expedients to call public attention to his gallery. In the spring of 1791, it appears that an evil-minded person had gained admission for the purpose of damaging some of the pictures, and a malicious report was set abroad that Boydell himself was the perpetrator of this act of Vandalism. The notoriety of Renwick Williams, the "Cutting Monster," suggested an appropriate allusion. The wily Alderman's portrait was accordingly published in this suggestive form.

April 26th, 1791, *The Monster Broke Loose, or* a Peep into the Shakespeare Gallery.*—The accu-

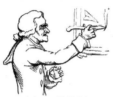

An Amateur of the Fine Arts.

sation this etching is intended to convey, and the motives supposed to have led to it, will be understood by the soliloquy here put into Boydell's mouth : "There, there!—there's a nice gush! There!—ah! this will be a glorious subject for to make a fuss about in the newspapers; a hundred guineas reward will make a fine sound;—there! there! O there will be fine talking about the gallery; and it will bring in a rare sight of shillings for seeing of the *cut* pictures; there! and there again!—egad, there's nothing like having a good head-piece!—here! here!—there! there!—and then these *small* pictures wont cost a great deal of money replacing; indeed one would not like to cut a large one to pieces for the sake of making it look as if people envied us; no! that would cost rather too much, and my pocket begins—but, mum!—that's nothing to nobody—well, none can blame me for going the cheapest way to work to keep up the reputation of the gallery; there! there! there!—there! there!"

In his memorial to the House of Commons, at the beginning of the present century, praying for an Act to enable him to dispose of his stock in trade of the fine arts by lottery, Boydell stated that he had expended more than four hundred thousand pounds in encouraging talent in this country. The gallery was eventually dispersed by public sale. At a later period he was obliged to appeal to the law to compel many of his subscribers to continue their subscriptions to his series of Shakspeare illustrations, which they refused to do on account of the length of time that had elapsed before the publication was completed.

These caricatures, necessarily touching on many topics, skip lightly from scandal to politics, from Boydell and his Gallery to Burke and his Reflections.

The satisfaction which Burke's pamphlet gave to Ministers was soon increased by his entire defection from the Opposition standard. The Whigs seemed to have designedly urged him on to his grand outbreak on this subject. For weeks their journals teemed with attacks on his book, and with hints at his apostasy from the cause of freedom. When he rose in the House to speak on French politics, they put him down by their murmurs, although Fox and Sheridan were ready to seize upon any occasion of declaring their admiration of the revolution. Burke kept silence during a large part of the Session, or said little; the more moderate of the Whig party counselled him to act thus, in order to avoid making a schism in their ranks. But it was a task in which Edmund Burke was not the man to persist, and, after entering into a warm debate on the subject on the 15th of April, in connexion with the pending measure for the government of Canada, and having given one or two intimations that his heart was full of a burthen which he was resolved to discharge, on the 16th of May he delivered his second grand philippic in the House of Commons against the French Revolution and its authors. He dwelt especially on the horrible massacres which had devastated the French Isle of St. Domingo, and returned from them to depict the state of France, which at that time was every day sinking deeper in anarchy and blood. He was interrupted for a while by the impatience of some members of the Opposition, and Fox seized the opportunity of declaring how entirely he differed from him on this grand topic, and of speaking somewhat disrespectfully of his book. It was then that Burke rose again, with more warmth than ever, and after complaining of the interruptions and attacks to which he had been exposed, proceeded to dilate in eloquent and forcible language on the new principles promulgated in France, and the way in

* These first five words of the title are crossed through in the engraving, as though to be erased.

which they were propagated; on the treasonable conduct of certain Unitarian and other Dissenting preachers in this country, who corresponded with the French democrats, and held them up for imitation—he alluded, of course, to Priestley and other instigators of sedition; Dr. Price had died on the 19th of April;—and on the danger that the French might be tempted to use a portion of their large military force in assisting to revolutionize England. He said that love of his country was a feeling above private affections, and proclaimed that his friendship with Fox and his party was at an end. Fox, than whom no man possessed a kinder or more affectionate heart, rose to reply with tears rolling down his cheeks; he appealed to their long friendship and familiar intercourse, to his own unaltered attachment; he cited Burke's former opinions and exertions in the cause of liberty, and he deprecated the idea that their personal friendship should be destroyed by a difference of opinion on one particular subject. He, however, intermixed his reply with some personal recriminations and observations which only increased the irritation; Burke remained cold and inexorable, and all intercourse between the two statesmen was discontinued.

The loss of Burke was a severe blow to his party, and a subject of no small exultation to the Ministry and the Court. He became an object of unbounded admiration in the Tory papers, while those of the Opposition were equally pertinacious in their attacks and in their abuse. Several clever caricatures remain as testimonies of the former feeling. One of those in which the sentiment is more coarsely expressed, entitled "The Wrangling Friends; or Opposition in Disorder," published on the 10th of May, and an evident attempt at imitating the style of Gillray, depicts the affecting scene in the House of Commons in broad caricature, and shows favour to neither of the two principal actors. Pitt, seated quietly on one side, exclaims, "If they'd cut each other's throat, I should be relieved from these troublesome fellows."

An Impeachment.

May, 1791. *The Impeachment; or the Father of the Gang turned King's Evidence.*—Burke is laying his hands on his two confederates, and declaiming his fine-sounding denunciation: "Behold the abettors of revolutions, see the authors of plots and conspiracies, and take cognizance of the enemies of both Church and State; I know them all, and I have awhile upheld the unyoked humour of their wickedness; I have borne with them till the measure of their iniquity is full, but now I bare them before the justice of injured humanity. I will prove unequivocally that there exists at the present moment a junta of miscreant Jacobites, who are aiming at the overthrow of the British Constitution."—Vide Burke's speech on the Quebec Bill.

Fox, dissolved in emotion, is sobbing, "Oh, the devil! I'm quite overcome and stupified with grief! To think that the man who has been my dearest friend and my chum in all infamy for twenty-five years should now turn snitch at last! Good lack-a-day!" Sheridan, the real provoker of the quarrel, whose intemperance had widened the breach beyond hope of reconciliation, is alarmed for his own security. "Ha! what's that? Miscreants, Jacobites, plots, conspiracies, revolution! Oh, damnation! we're all found out. Ah, Joseph, Joseph! I fear you've brought your neck to a fine collar!"

The Vigilant Watchman.

May 14th, 1791. *Guy Vaux discovered in his Attempt to Destroy the King and the House of Lords.* His Companions Attempting to Escape.—N.B. His associates were all taken afterwards and executed.—Burke, in his new office as vigilant State watchman, is throwing the light of Vaux's own dark-lantern into his face at the moment when he is applying a torch, formed of the Rights of Man, to the barrels of gunpowder laid in the Parliament

cellars in preparation for the explosion. Burke, who may from this date be considered specially retained for the Crown, is springing his rattle to expose the incendiary: "Hold, miscreant! I arrest thee in the name of the British Constitution, which thou art undermining; I arrest thee in the name of human nature, which thou hast most cruelly outraged; I arrest thee in the name of that monarch whom thou dost wish to deprive of dignity, and of that people whom thou hast most basely deluded! Nay, no fawning!—thy tears and thy hypocrisy make no impression on the mind of truth and loyalty. Therefore, enemy of all good! yield to that punishment which has long waited those crimes which are as yet unwhipt of justice!"

Our limits compel the exclusion of the majority of these speeches; we regret this circumstance, as many of them are as characteristic of the orators' eloquence as the caricatures are of their features. It is amusing to compare the extracts from the famous speeches and their burlesques which accompany the designs. Fox, in "Guy Vaux Detected," cries, "What have I done? Answer me that. Dare you accuse me only for what I intended to do? Have I ever assassinated the King or blown up the Lords! As to this gunpowder, I only intended to set fire to it merely to clear the nation of bugs! For goodness sake let me go, or if I must suffer, do let it be without holding up my own dark-lantern in my face, for my eyes are so weak with crying to think I should be charged with such villany, that I cannot bear the light!" Both Fox and Sheridan were looked upon as Burke's disciples, and he was regarded as their political parent. This action on his part was therefore more remarkable to both sides of the House. Sheridan seceded for a time from the Opposition after this quarrel, which his violence had embittered; and in this print he is seen stealing up the cellar stairs, muttering his reflections: "I must be off while I can. As to my friend there, why, if he does go to pot, there's the more room for me! I wish I could squeeze out a tear or two as well as he, it might impose on the mob if they should stop me; but I've come that humbug so often before that my eyes—bless my eyes!—there's not a drop left in them!"

A Bad Measurer.

May 23rd, 1791. *The Rights of Man.* Humbly dedicated to the Jacobin Clubs of France and England. "These are your gods, O Israel!"—Encouraged by the desertions which were weakening the Opposition in Parliament, and by the extraordinary effect produced throughout the country by Burke's "Reflections," the Government now began to take a higher tone towards France, and their agents neglected no means of exciting the popular feelings throughout the nation against Dissenters and revolutionists. The caricaturists began now to be unusually active in their satires; the leaders of the Opposition in Parliament were ranked in the same category as the incendiaries of the clubs, they were all equally democrats and king-haters. The four leaders—associates in counsel and in arms —were Fox, Sheridan, Priestley, and Paine. Gillray burlesqued the latter in a cartoon entitled *The Rights of Man; or Tommy Paine, the American Tailor, taking the Measure of the Crown for a New Pair of Revolution Breeches.* Paine is here represented with the conventional type of face which in the caricatures of this and the subsequent period was always given to a French democrat; his tricoloured cockade bears the inscription, "Vive la liberté!" and the following almost incoherent soliloquy is placed in his mouth:—

"Fathom and a half! fathom and a half! Poor Tom! ah! mercy upon me! that's more by half than my poor measure will ever be able to reach!—Lord! Lord! I wish I had a bit of the stay-tape or buckram which I used to cabbage when I was a prentice, to lengthen it out. Well, well, who would ever have thought it, that I, who have served seven years as an apprentice, and afterwards worked four years as a journeyman to a master tailor, then followed the business of an exciseman as much longer, should not be able to take the dimensions of this bauble!— for what is a crown but a bauble! which we may see in the Tower for sixpence apiece. Well, although it may be too large for a tailor to take measure of, there's one comfort, he may make mouths at it, and call it as many names as he pleases!—and yet, Lord! Lord! I should like to make it a Yankee-doodle nightcap and breeches, if it was not

so d—d large, or I had stuff enough. Ah! if I could once do that, I would soon stitch up the mouth of that barnacled Edmund from making any more Reflections upon the Flints—and so Flints and Liberty for ever! and d—n the Dungs! Huzza!"

June 27th, 1791. *French Democrats Surprising the Royal Runaways.*—A ludicrous version of a subject which terminated far more seriously than the caricaturist anticipated. To but few moments in history can be assigned a graver importance than those which were occupied by Drouet in recognising the unfortunate King at Varennes, at the very moment his safety was about to be assured in the camp of De Bouillé. That fatal accident was the signal which let loose the full violence of the revolutionary current—sweeping down the Royal Family, the successive leaders of the people, the people themselves, and carrying slaughter and anarchy throughout Europe. We have here only to consider the event; its consequences soon make themselves manifest in the progress of these pictured records. Louis XVI., Marie Antoinette, and the Dauphin are seated in the apartment of M. Sausse. The Democrats, armed with swords, blunderbusses, daggers, brooms, hammers, and other instruments, are breaking into their chamber. There is no doubt that up to the moment of Louis XVI.'s recapture, popular feeling, although prejudiced against everything "French," was more on the side of the people than of the King and his unhappy family; but the arrest of Louis, and the barbarities by which a few hours after the mob expressed their patriotism, diverted the whole weight of opinion in England to loyal sentiments. The long-threatened limitation of King George's prerogative was at once pronounced "treasonable" by the voices of a large majority.

June 28th, 1791. *The National Assembly Petrified and the National Assembly Revivified.*—This spirited caricature, in burlesque of the extremes of emotion expressed by the French, enjoyed great popularity at the date of its publication. In the earlier subject an indignant barber is crying, "De King is escape! de King is escape!" The sequel shows an excited cook, who is singing, "Aha! be gar, de King is retaken! Aha! Monsieur Lewis is retaken, aha!"

The National Assembly Petrified—"De King is escape!"

The utmost consternation was exhibited in Paris when the flight was known. The elements of agitation burst forth in all their terror. It was anticipated that Louis was now about to take his revenge and inflict a fearful chastisement on his rebellious subjects; that their late captive would return to France at the head of a foreign host; that Paris would be besieged; that the King would enter the city and regain his throne, swimming in torrents of blood, poured forth in the cause of Liberty. Unhappily for justice, for France, and for humanity, the sacrifice was destined to fall on more gentle victims.

Fox sturdily defended what he felt to be the national cause. He looked upon the agitation in France as "the rougher convulsions which merely preceded the sunny times of Utopian liberty and universal brotherhood." He steadfastly ignored the violence of the means; his imagination became dazzled with the chimera which he and the patriots of France confidently expected to realize.

The National Assembly Revivified—"De King is retaken."

S

July 4th. *Alecto and her Train at the Gate of Pandæmonium; or the Recruiting Sergeant enlisting John Bull into the Revolution Service.*—Pandæmonium is represented by the Crown and Anchor Tavern in the Strand, the grand meeting place of the Revolutionary Societies. Fox, as a drummer, and Sheridan, as the smallest of pipers, are beating up recruits. Fox wears the Fleur de Lis (soon to be banished from France by the tricolour), and his drum is ornamented with the head of Medusa. Alecto, the recruiting sergeant, wears a French uniform over her own demoniac figure. On her halbert appears the cap of Liberty; her hair is a fantastic tangle of hissing vipers. In her hand she extends a parcel of the new French "assignats" to corrupt John Bull, who, in the typical emblem of a rustic, in smock and gaiters, is scratching his head in awkward perplexity at Alecto's offer. "Come, my brave lad, take this bounty money and enter into my company of gentlemen volunteers, enlisted in the cause of Liberty. I'll find you present pay and free quarters. Nay, man, never talk about your old master, the Farmer; I'll find you hundreds of masters as good as he. Zounds, I'll make you one of the masters of England yourself!" &c. John Bull is half-persuaded, yet lingers in his good faith to "Varmer George;" the noise of the drum, the fine cockade, the promised freedom, and the paper money are evidently tempting inducement to the raw recruit.

Lord Stanhope, whose strong republican principles brought him prominently into the foremost ranks of agitators, had married Lady Hester Pitt, daughter of the first Lord Chatham and sister to the Tory chief. At this period he was believed to hesitate as to the side he should embrace. In the recruiting party Stanhope is stealing off under the influence of a letter from William Pitt, containing a threatening caution, which has given him great uneasiness. He is proposing to quit the red party before their review is held.

July 14th, 1791. *The Hopes of the Party prior to July 14th. From such Wicked Crown and Anchor Dreams, good Lord, deliver us !*—It was represented that those who were opposed to Pitt's government aimed directly at the overthrow of the Throne and the Constitution, that reform was a mask of republicanism, that dissent from the Church was equivalent to atheism. Fox and his party, in the prints which were now spread about the country, appeared as regicides in embryo, and the fate of Charles I. and the sins of the Puritans were made to ring constantly in people's ears. These anticipations were set forth graphically in a large engraving by Gillray, entitled *The Hopes of the Party,* published in July, 1791. Amid the horrors of the successful revolution here pre-supposed, the Queen and the Prime Minister are seen on one side, each suspended to a lamp. This was an example borrowed from recent proceedings of the French democrats. It was commonly believed that Pitt and Queen Charlotte were closely leagued together to pillage and oppress the nation, and she was far less popular than the King, whose infirmity produced a general sympathy, and who had many good qualities that endeared him to those with whom he came in contact. Temple Bar is in flames. A sea of heads belonging to noisy patriots surround a scaffold on which the interest of the tragedy is centred. The King, evidently more astonished than alarmed at his situation, is not sufficiently lucid to understand his danger; while Sheridan is holding the royal head down to the block by the ear, the King inquires in wonder, "What! what! what! What's the matter now?" Horne

A Pair of Pendants.

Martyrdom.

Tooke is supporting the stout figure of the monarch wheelbarrow fashion, but Fox rather hesitates. "If I should not succeed, why nobody can find me out in this mask, any more than the man who chopped the calf's head off a hundred and forty years ago!" Sheridan is encouraging his confederate.

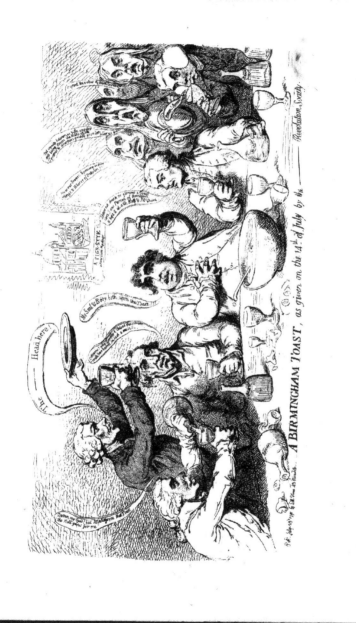

A BIRMINGHAM TOAST, as given on the 14th. of July by the ———— Revolution Society.

"Don't be afraid! Give a home stroke and then throw off the mask. Zounds, I wish I had hold of the hatchet!" Dr. Priestley, as chaplain, is holding his tract on a "Future State;" he is exhorting the monarch to submit with resignation and not to be alarmed at his situation. Sir Cecil Wray, who at that period joined the Opposition, has brought a barrel in readiness to catch the "small-beer" when it is tapped.

July 23rd, 1791. A Birmingham Toast as given on the 14th of July by the Revolution Society.—Fox is chairman; a punchbowl is placed before him, and at his back hangs the picture of "a pigstye, St. Paul's Cathedral transformed," an allusion to Dr. Price's fold. Dr. Priestley, with a brimming chalice in one hand, is holding out the salver, and gives as his toast "The Head here." Sheridan, who has emptied numerous bottles, cries "I'll pledge that toast!" Sir Cecil Wray, frugally drinking "small-beer," exclaims "Why! I would empty a Chelsea pensioner's small-beer barrel in such a cause!" Fox is pledging the toast with emphasis. Horne Tooke, who is drinking "Hollands," is equally enthusiastic: "I have not drunk so glorious a toast since I was parson of Brentford!" Dr. Lindsey, drinking a bumper of brandy, cries "Amen!" to the toast. Representatives of Dr. Priestley's flock, a select Puritanical body, with exaggerated sanctimony, are giving utterance to such pious sentiments as, "Put enmity between us and the ungodly, and bring down the heads of all tyrants and usurpers quickly, good Lord!" "Oh, hear our prayers, and preserve us from kings and women of Babylon!" "Oh, grant the wishes of Thine inheritance!" &c.

Dr. Priestley then resided at Birmingham. This town was the place of all others where it was easiest to get together a mob that would hesitate at nothing, with the prospect of mischief and plunder before it. A number of Priestley's friends in Birmingham agreed to celebrate the second anniversary of the capture of the Bastile on the 14th of July, 1791, by a dinner, which it was understood would be accompanied with revolutionary toasts and songs. There were many people in the town who disliked the persons who were to assemble on this occasion as much as they hated the cause in which they were engaged, and the announcement of this dinner caused considerable agitation. It can hardly be doubted that a plot was formed by persons in a better position in society to get up a popular demonstration for the purpose of insulting (at the least) the friends of democratic principles. Two or three days before the appointed time a violently seditious paper, of which Priestley's friends declared themselves entirely innocent, and which there seemed reason to believe had come from London, was distributed about the town. On the 14th, which was a Thursday, about eighty persons sat down to dinner, but Dr. Priestley himself was not present. A mob had already assembled round the tavern at which the dinner was to be held, who shouted "Church and King!" and insulted the guests as they came to the door. The magistrates, instead of taking measures to preserve the peace, were dining at a neighbouring tavern with a party of red-hot loyalists. The mob kept from violence until both parties had broken up; but then, encouraged by the loyalists, who were heated with wine and enthusiasm, they broke into the tavern in search of Dr. Priestley, who was not there, and then, disappointed in their design of seizing the arch-revolutionist (as they considered him), they rushed to his chapel, the New Meeting-house, and burnt it to the ground. It was now evening, and the mob was greatly increased, having been joined by large bodies of labourers who had ended their day's work. They then burnt the Old Meeting-house, and proceeded to the house of Dr. Priestley, about a mile and a half from the town, which they also destroyed, with his library, papers, and philosophical instruments. Priestley and his family had fled; he reached London in safety, and took charge of Dr. Price's congregation at Hackney. Birmingham was now in the hands of the mob, and for several days they paraded the town and its neighbourhood, burning and destroying without interruption, until the following Monday (the 18th), when a strong body of military arrived and the rioters dispersed. An inclination to follow the example of Birmingham was exhibited in some other places, and the outcry against Dissenters and revolutionists became loud from one end of the kingdom to the other. The ultra-radicals were strongest in London and in Scotland.

In the autumn a domestic event came to throw a gleam of joy amid the bitterness of political and religious faction which reigned throughout the land. On the 29th of September, the Duke of York was married at Berlin to the eldest daughter of the King of Prussia, and he arrived with his bride in

London on the 19th of October, where they were received amid the congratulations of all classes of society. For some time nothing was talked of or sung of but the new Duchess, and her portrait was to be seen in every print-shop. The marriage soon became the subject of a variety of prints and caricatures.

November 14th, 1791. *The Soldier's Return, or Rare News for Old England.* " See the Conquering Hero comes."—The Duke of York, who was the first of the King's children to enter the married state, is returning from Berlin decked in his military uniform; he is using his sword as a walking-stick, and carries an enormous pack of money on his back ! He is affectionately leading his young bride, who also bears a bag marked " Pin Money, 50,000*l*. per an." The amount of the dower is overstated. The sum given by the King of Prussia was 20,000*l*., and even this was to be restored if the Princess died before her husband. She was also to have 20,000*l*. from England, 6000*l*. to buy jewels, a private purse of 4000*l*. a year, and a jointure of 8000*l*. a year with a residence and an establishment. The lady was enthusiastically welcomed, and for a time became the popular idol. Every fashion she adopted was frantically admired and immediately followed. The beauty of the Duchess and her diminutive foot were the universal topics of conversation.

November 22nd, 1791. *The Introduction.*—The royal pair, seated on the throne in undignified attitudes of expectancy, as here indicated, are receiving the Duke and his attractive bride. Their admiration is exclusively engaged by the tempting load of gold pieces which her apron contains. Behind the young couple towers a stupendous figure, one of the original Prussian giant guards, who bears a sack under each arm containing the dower.

Expectation.

December 14th, 1791. *The York Minuet.*—The stout Duke and his bride are figuring in full court dress at the state ball which welcomed their return. The grace and dignity of the minuet afforded a favourable opportunity for a somewhat liberal display of the Duchess's diminutive foot.

December 27th, 1791. *The York Reverence, or City Loyalty Amply Rewarded.*—The newly-married pair are placed on the daïs of a throne, receiving the congratulatory address presented on the 19th December by the Lord Mayor, the Aldermen, Sheriffs, and Common Council of the City of London. The civic authorities appear as sleepy bulls, while a donkey is braying the address. The distinguished couple are acknowledging this attention with bewildering condescension. The Duke's bow presents his body in a curve which brings his head almost to the ground, and converts his pig-tail into the semblance of a bell-pull. The Duchess is not outdone in graciousness; her curtsey absolutely sinks into the ground, till nothing but her head remains visible.

It was during this period of danger for thrones and princes, that poets and artists joined in heaping ridicule and satire on the persons of King George and his family. Among the former, by far the most remarkable was Dr. Wolcot, better known by his pseudonym of Peter Pindar, whose clever but daring infractions of royal inviolability have not yet ceased to amuse his countrymen. These satirists invaded the most private recesses of the palace, and dragged before the world a host of ridiculous incidents furnished them by the royal eccentricity, which were calculated rather to bring royalty into contempt than to add to its splendour. It appears that both the King and the Queen were in the habit of attending to various minutiæ of domestic economy which are more consistent with a low station in life than with the public dignity of the Crown, and scenes of this description were brought before the eye of the public with the most provoking impertinence.

> " And who, pray, knows that George our gracious King,
> Said by his courtiers to know everything,
> May not, by future times, be call'd a fool ?"—Pindar.

November 21st, 1791. *Going to Market.*—King George, as a rough farmer, is driving the market-cart; the Queen is seated by his side with her poultry-coop, and two of the Horse Guards form an

escort, with their swords drawn, not for protection, but to suspend the bundles of turnips and carrots. The produce is evidently being taken to London for disposal. The King feelingly observes, "You should have given a shilling with the bunch of turnips to the old soldier you relieved just now; turnips, Charley, are very insipid without a bit of mutton." After this kindly admonition the King gives his mind to rustic harmony. "I like Tom Durfey's songs best of all things, Charley; he was a pleasant writer:—

> ' Hand in hand, sir, o'er the land, sir,
> As they walked to and fro;
> Tom made jolly love to Dolly,
> But was answered ' No, no, no!' "

"Dolly was a wise girl, my love," says Queen Charlotte, discreetly, and the guards and their royal charges all join in the chorus unaffectedly :—

> "No, Tom ! no, Tom ! no."

The royal pair were described as cheapening bargains and exulting in the saving of shillings and sixpences. When at their favourite watering-place, Weymouth, they were said to have had their provisions brought from Windsor by the mail free of carriage, because Weymouth was a dear place. So, at least, says Peter Pindar :—

> " The mail arrives !—hark ! hark ! the cheerful horn,
> To majesty announcing oil and corn ;
> Turnips and cabbages, and soap and candles,
> And lo ! each article great Cæsar handles !
> Bread, cheese, salt, catchup, vinegar, and mustard,
> Small beer and bacon, apple-pie and custard :
> All, all, from Windsor greets his frugal grace,
> For Weymouth is a d—d expensive place."

According to the satirist, no occasion of driving a hard bargain was suffered to escape, even if the royal visitor met with it in his ordinary walks. Thus he meets a drove of cattle going to the market for sale :—

> " A batch of bullocks !—see great Cæsar run :
> He stops the drover—bargain is begun.
> He feels their ribs and rumps—he shakes his head—
> ' Poor, drover, poor —poor, very poor indeed !'
> Cæsar and drover haggle—diff'rence split—
> How much ?—a shilling ! what a royal hit !
> A load of hay in sight! great Cæsar flies—
> Smells—shakes his head—' Bad hay—sour hay'—he buys.
> 'Smell, Courtown — smell — good bargain — lucky load—
> Smell, Courtown—sweeter hay was never mow'd.'

> " A herd of swine goes by !—' Whose hogs are these?
> Hay, farmer, hay ?—' Yours, measter, if you please,'
> ' Poor, farmer, poor—lean, lousy, very poor—
> Sell, sell, hay, sell ?'—' Iss, measter, to be zure !
> My pigs were made for zale, but what o' that?
> You caall mun *lean* ; now, zur, I caall mun *vat*—
> Measter, I baant a starling—can't be cort ;
> You think, agosh, to ha' the pigs vor *uort.*'
> Lo ! Cæsar buys the pigs—he slily winks—
> ' Hay, Gwinn, the fellow is not *caught*, he thinks—
> Fool, not to know the bargain I have got !
> Hay, Gwinn—nice bargain—lucky, lucky lot !' "

The want of dignity, the blunt simplicity of the monarch, and his unpolished manners and appearance, were always a remunerative theme in the hands of Gillray and Wolcot. Their satires on this royal theme never miss their point from obscurity ; the strokes of their wit are sharp, bold, and incisive. The popularity of these sallies at the time of publication was unequivocal. Peter Pindar discovered, "although he was a bad subject to the King, the King was a capital subject to him !"

November 23rd, 1791. *Frying Sprats, vide Royal Supper*, and *Toasting Muffins, vide Royal Breakfast.*—

> " Ah ! sure a pair was never seen,—so justly formed to meet by nature !"

The originals of these two famous subjects, which our limits compel us to reproduce in outline, enjoyed the highest reputation. The etchings are small but very effective, and when coloured have the force of excellent pictures. The Queen, whose overloaded pockets are too full for security, is frying a very modest dish of sprats, which are to form the royal supper. In the companion print, the Monarch, in

nightcap and dressing-gown, wearing the half-secured Garter of his order, is solemnly toasting one of three muffins which are provided for the royal breakfast of himself and " Charley."

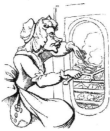

Frying Sprats. Toasting Muffins.

October 11th, 1791. *Nauticus.*—

" Those lips were made for kissing, ladies !"

Although the critic may censure this portrait on the ground of exaggeration, it is one of the happy efforts of the artist in respect both to expression and resemblance. The Duke of Clarence, at the time he sat for Nauticus, was a boisterous "royal sailor," a "middy-prince" on a land cruise. Prince William Henry when he appears in Miss Burney's Diary is all fun, frolic, and kindness — everybody must drink, everyone must be happy; and the Duke confirms these generous sentiments by hearty expletives that would rejoice a son of Neptune. The royal sailor was a great favourite amongst the members of his family, with the exception of his grand brother, the Prince of Wales, who affected to despise his elastic spirits and boisterous manners. The good-nature of Clarence won upon all. At one time we find the royal circle rejoicing over his brilliant talents : " William was to become a great orator," and his future triumphs were to be earned in the Senate !

A Sailor Prince.

October 24th, 1791. *The Devil to Pay ; or Neptune Reposing after Fording the Jordan.*—Mrs. Jordan was a highly accomplished lady, possessed of great natural attractions, with whom the Duke of Clarence formed a notorious connexion, which from its publicity gave great offence. In this caricature, surrounded by indications of her new distinction, she is evidently hardly able to realize the elevated rank of her lover. One of her famous theatrical successes had been in a piece called " Jobson and Nell," and the Duke and his favourite generally figure as these attached characters. Mrs. Jordan is bidding farewell to the fictitious Jobson :—

" In all this pomp and state, " Then, Jobson, now adieu,
New scenes of joy arise Thy cobbling still pursue,
Which fill me with surprise, For hence I will not, cannot, no,
That husband I despise ! Nor must not buckle to !"

November 1st, 1791. *The Jordan.*—The Duke of Clarence, in his naval uniform, crying " Yeo, yee, yeo !" is rushing with great ardour to embrace a coarse symbolism of Mrs. Jordan. From this date the Prince rarely appears in this series unless accompanied by Mrs. Jordan.

November 16th, 1791. *A Uniform Whig.*—"I preserve my consistency, by varying my means to secure the unity of my end !" *Burke's Reflections.*—The figure of Burke, his features contracted in

scowling reflection, is presented with a double-sided aspect. On the left-hand half the patriot stands in his old character as the advocate of freedom; his coat is old and torn, his breeches are in rags, his shoe worn down to a sandal, and what is worse, his pockets, emptied, hang inside out. On the "ragged philosopher's" side he grasps a broken pole and the cap of Liberty. There is a certain dignity in the attitude. The right side, which inclines more to ease than to sternness, is clothed in a fashionable laced coat; his arm is resting carelessly on a massive pedestal, with a bust exhibiting the unintellectual features of the Sovereign. On the patriot's right hand appears the solution of this transformation—"Burke on the French Revolution." His pockets flow over with the wealth which has been crammed into them, while his extremities are trimly clad. Fame is drawn with two trumpets balancing on the sails of a windmill, to imply the instability of Burke's political principles.

Gillray liberally bespattered the deserters from either Whig or Tory faction, and the changed opinions of Burke no doubt excited his suspicion. Nor did Pitt always escape his satire. The young Minister, who had so suddenly risen to the summit of power, and now somewhat haughtily lorded it over his fellow statesmen, seems to have given offence to the artist, who on the 20th of December, 1791, carica-tured him as an upstart fungus, springing suddenly out of the hotbed of royal favour, which is somewhat rudely compared to a dunghill. The print is entitled *An Excrescence—a Fungus, alias a Toadstool upon a Dunghill.* The thin, meagre figure of the Prime Minister was no less fruitful a matter for jest than that of his fat and slovenly opponent, Fox. A fortnight later, the unimpressible Premier was again presented to the public.

A Fungus.

January 3rd, 1792. *A Sphere Projecting against a Plane.*—The figure of Pitt accommodated the artist with an illustration of a plane, while the flowing proportions of Lady Buckinghamshire realized the description of a sphere: "A sphere is a figure bounded by a convex surface; it is the most perfect of all forms; its properties are generated from its centre. A plane is a perfectly even and regular surface; it is the most simple of all figures; it has neither the pro-perties of length or breadth, and when applied ever so closely to a sphere can only touch its superficies without being able to enter it."

December 23rd, 1791. *Weird Sisters; Ministers of Darkness; Minions of the Moon.* "They should be women, and yet their beards forbid us to interpret that they are so!" To H. Fuseli, Esq., this attempt in the caricature-sublime is most respectfully dedicated.—Thurlow, Pitt, and Dundas, partially concealed beneath their hoods, are contemplating the rising moon; the orb is almost eclipsed. On the side presented to the Ministers appear the features of the Queen graciously smiling, while the averted head

of the King is overshadowed in darkness. This parody, grafted on Fuseli's well-known picture, does not sacrifice any of the merits of the original, and the print was highly approved. "Wraxall's Posthumous Memoirs" con-tain a detailed description of this plate. He writes: "The circumstance of Dundas being ranked with Pitt and Thurlow sufficiently indicates the degree of political con-sideration he attracted, and how much higher he stood in the public estimation, as a man possessed of power or influence, than any of the remaining Cabinet Ministers. He was, in fact, far superior to either of the Secretaries of State in real weight and consequence." Dundas was so intimate an associate of Pitt that the two appear politically inseparable. Their public acts were concerted in familiar

The Weird Sisters.

intercourse; and it was asserted that while Pitt enjoyed the leading part, Dundas was the man who, unperceived, frequently pulled the strings. Pitt took refuge in the family circle of Dundas

when he wished to escape the anxieties and tedium which attacked him at his own house at Wimbledon.

Among the minor social sketches of this year we may particularize a portrait of the Duke of Norfolk published September 21st, 1791, as *A Natural Crop*, alias *a Norfolk Dumpling*. The "crop" refers to the Duke's hair, which he chose to wear short and unpowdered, a remarkable eccentricity in those times. Gillray's portrait indicates a stout round little figure with a prepossessing countenance, wearing a slouched hat and holding the bâton of Earl Marshal. His figure frequently occurs. Of the Duke's peculiarities, both noble and ignoble, a diverting but not altogether edifying history might be written. His uniform dress consisted of a grey coat turned up with a black velvet collar, black breeches, and black silk stockings; he likened his exterior to that of a country curate. This modest attire only made his indulgences the more conspicuous. He was known as the "Royal Duke," his condition generally verging on the regions of inebriety. He would be seen in the worst society and in the most dissipated resorts. The Duke not unfrequently retired without taking the trouble to undress, and it is said that the footmen of his noble establishment took advantage of the occasions of his drunken insensibility to familiarize his face with soap and water, for one of his eccentricities was indifference to washing. Apart from these disreputable traits he was recognised as a man of great and generous mind; he possessed a clear and cultivated intellect, which his bodily vigour preserved in defiance of mighty potations. His hospitality was princely, and on trying occasions the sybarite Duke asserted the dignity of his rank with true nobleness. Bate Dudley, in his "Vortigern and Rowena," gives a spirited and graphic sketch of Norfolk: "Should a man in these hurlie-burlie daies be permitted to weare a heade on his shoulders, let him not quarrel about the colour of it; but if they powder mine, they shall eate it into the bargaine! I'll wear my nob as long as I can, in sable, for the frailties of my bodie! The knaves knewe that my sole delights were in *rape* and *canarie*, and therefore have they clapped a double taxe on our women and wine!" As Earl of Surrey the Duke had sturdily opposed Pitt's tax on maid-servants, and in conjunction with Fox and Sheridan he obtained its repeal.

September 29th, 1791. *The Finishing Touch.*—Lady Archer, the heroine of Gillray's play-scandals and one of the best whips of her day, was notorious for her enamelled face. In this caricature she is seated in her driving costume before the toilet, applying with a brush the final bloom of carmine before taking her equipage into the Park. Bate Dudley has drawn a picture of the lady:—

> "—— Mine was the earlie arte
> To banish Nature's blushes from the cheeke.
> I learnt it of a *dyer's* wife in *Spaine*,
> Whose face in Tyrian die was so engrain'd,
> That *Turkie cocks* assail'd her as she past."

October 3rd, 1791. *La Dernière Ressource; or Van Butchell's Garters.*—The Hon. Mrs. Hobart, better known in the fashionable world as Lady Buckinghamshire, is trying on a garter, which was possibly supposed to possess galvanic properties. Van Butchell, an eccentric practitioner, was one of the remarkable characters of his day. Details of his extravagances are found in contemporary magazines, in Kirby's "Wonderful Museum," and in similar works. He was notorious for his fantastic advertisements, for a long beard (noticeable in a close-shaven era), and for riding a white horse spotted with patches of paint. He began life as a *valet de place*, and realized a sum of money while employed as groom of the chambers to Viscountess Talbot. Van Butchell then attended the lectures of the celebrated John Hunter. He first practised as a dentist, and finally extended his attention to the most unusual subjects.

At the same date (October 4th) Gillray etched two small plates, *At the Opera*, and *At Church*, which are remarkable for point and expression. The extreme wakefulness of a lady attending the opera is contrasted with the unconscious attitude of a beauty, fat, fair, and forty, who is slumbering in her pew

October 11th, 1791. *An Angel gliding on a Sunbeam into Paradise.*—

> "Down thither, prone in flight,
> Lo! Schwelly speeds, and with her brings
> The gems and spoils of heaven."—MILTON.

Madame Schwellenberg, the chief favourite of the Queen, and the member of her suite most detested by the public at large, is gliding from the royal Sun, bearing the handsome pickings she had accumulated to the beloved Hanover of the reigning family.

Peter Pindar has favoured this unpopular lady with the candid opinions prevalent regarding her qualities ; and the highly correct Miss Burney preserves in her diary a tolerable picture of the coarse and selfish nature of the German protégée.

October 17th, 1791. *A Witch upon Mount-Edge. Vide Fuseli.*—Lady Mount-Edgecumbe, seated on a bundle of brooms, is drawn as a witch. This lady was certainly no favourite with the artist.

November 1st, 1791. *Les Trois Magots.*— A group consisting of " A Hell-gate Blackguard," " A Newgate Scrub," and " A Cripplegate Monster." The persons represented are the Earl of Barrymore and his two brothers, three of the wildest rakes of the day. One appears as a boxer, another as a zany. A sister nicknamed " Billingsgate " completed this

Madame Schwellenberg Gliding into Paradise.

noble family, whose exploits seem to have been marked by the most fantastic and boisterous extravagance.

1792.

The works of Gillray increased in number this year. His industry found congenial employment in recording the kingly prejudices, the royal parsimony, the vices of the princes, the fall of Thurlow, the financial schemes of Pitt, the progress of change in France, and the advocacy of revolutionary principles at home. The violence enacted in the name of Freedom, the writings of Tom Paine, the fashionable scandals, and the novelties of the year all formed materials for his satire.

January 24th, 1792. *Fashionable Contrasts ; or, the Duchess's little shoe yielding to the magnitude of the Duke's foot.*—A picture of the jewelled slipper of the Duchess of York was engraved, natural size. The popularity of the Duke's bride continued, and Gillray published a very pleasing portrait in oval of the fortunate princess; the design is ascribed to Charlotte Zithen. Her royal highness is leaning on a table in an easy attitude. Her right hand holds " Il Penseroso," her left arm uplifted displays the beauty of her hand ; one small foot is also partially displayed.

Later on (July 12th, 1792) Gillray produced a satire entitled *The Visit to Piccadilly, or a Prussian Reception ; representing Shon-ap-Morgan, Shentleman of Wales, introducing his old Nanny-goat into high company.*—The Prince of Wales, in a farmer-like costume, wearing a leek in his hat, is leading a slightly abashed goat by a chain of flowers, for the purpose of introducing her to his sister-in-law ; the Duchess of York is refusing to admit this lusus naturæ, which bears a human countenance surmounted by the coronet and plume of the Prince of Wales. " O dunder and wonder ! what cratur is dat which you are bringing here ? Relation of mine indeed ! No, no; me know no Nanny-goat Princess ! So set off with your bargain, you poor Toasted-Cheese, you; for she shan't come in here to poison the house. Off ! off ! off !" The Prince of Wales is greatly amazed at this reluctance. " Not open the toor ! Cot splutter-n-nails ! when Nanny is come to see you herself ! Why, isn't Nanny a princess too, and a Velch princess ? And hur is come to visit hur brothers and hur sisters ! and not to let hur in ? Vy, the voman is mad, sure !" The face of this enigmatical Nanny strikingly resembles that of Mrs. Fitzherbert, and the diadem supports this conjecture. The circumstances of the Duchess of York's refusal

to hold intercourse with that lady bear out this impression. She refused to acknowledge or admit Mrs. Fitzherbert under any consideration. This gave great offence to the Heir-apparent, and a coolness between the royal brothers resulted from these disputes; although the warm heart of York was deeply attached to his brother, the Prince did not return this affection with the same sincerity, and after this quarrel he took occasion to speak slightingly of the King's "favourite Frederick." Mrs. Fitzherbert was more considerately treated by the King and Queen, and on the occasion of a state ball, the Duchess of York having declined beforehand to sit down at the same table with this lady, a public rupture was threatened; the King avoided this contretemps by providing a separate table, the invitations to which were issued by the Prince of Wales and Mrs. Fitzherbert. We may mention that this caricature has been referred to a reported intrigue between the Prince of Wales and Lady Wynn, wife of Sir Watkin W. Wynn of Wynnstay, who figures frequently in this series. The lady was sister to the Marquis of Buckingham and Lord Grenville. The features of Nanny are said to have resembled those of Lady Wynn.

January 20th, 1792. *The Pacific Entrance of Earl Wolf into Blackhaven.*—Sir James Lowther, to whom we have already had occasion to allude, on his elevation to the peerage as Earl Lonsdale, is the Earl Wolf designated by the caricaturist. Gillray's cartoon refers to an episode in the history of boroughmongering, in which art Lord Lonsdale acquired much celebrity in connexion with Whitehaven. The Earl, wearing his coronet on his head, as well as on his carriage, is drawn with the head of a wolf He exclaims, "Dear gentlemen, this is too much; now you really distress me!" His wheels are passing over "Peter Pindar's Epistle;" behind him appears a rough mob of miners and others, armed with bludgeons, cheering vociferously. His law agent, a clerical-looking personage, in whose pocket is seen "Blackstone," occupies the box. He is using a formidable whip of many thongs, inscribed "Littledale versus Lonsdale," "Sham Trials," &c., and is driving a team consisting of the tradesmen of Whitehaven, round whose necks are the reins. Fair canvassers head the procession, bearing banners inscribed "The Good Samaritan," "The Lion and the Lamb."

> "The blues are bound in adamantine chains,
> But freedom round each yellow mansion reigns."

Lonsdale's cottages, marked "Lodgings to Let," are tumbling down from neglect. Pindar's "Epistle" referred to a difference between the nobleman and his borough, in which the Earl brought the townsmen' to submission by suspending the working of the coal-mines. The "Rolliad" remarked, "his declaration that he was in possession of the land, the fire, and the water of the town of Whitehaven will not be forgotten."

> "E'en by the elements his power confessed,
> Of mines and boroughs Lonsdale stands possessed;
> And one sad servitude alike denotes
> The slave that labours and the slave that votes."

Junius calls him the Contemptible Tyrant of the North. Peter Pindar attacked the Earl in his celebrated "Epistle" and in other verses with his usual pungent wit and severity. This brought the nobleman down on the poet with an action for libel. Peter Pindar, knowing the strong influence the Court would exert against him, and their many reasons for desiring his silence, took fright at the danger which assailed him and endeavoured to condone his offence. Gillray, more daring, undeterred by the risk which had arrested his fellow satirist, exposed both sides to ridicule.

May 8th, 1792. *Satan in all his Glory, or Peter Pindar crouching to the Devil.*—Doctor Wolcot, in rags, is kneeling at the feet of Lord Lonsdale. In the poet's pocket appear "Odes of Importance, alias Conciliatory Odes;" "Odes on Cowardice." Peter Pindar is making an abject subjection:—

> "O Lonsdale kick, me, cuff me, call me rogue,
> Varlet and knave, and vagabond and dog;
> But do not bring me, for my harmless wit,
> Where greybeards in their robes terrific sit!"

"Earl Wolf," as Satan, bears the objectionable "Epistle," burning like a torch, his foot resting on a sack of coals "from the infernal Pitt." He is repulsing the poet's supplication:—

> "No, Peter, no, in vain you sue;
> 'Tis my turn now, the Deil must have his due!"

An advocate is writing the name of Peter Pindar on his "Black List." After this humiliating submission, Lord Lonsdale consented to suspend proceedings, on the understanding that the bard was never to mention him again in his writings.

Gillray's immunity from the consequences of his reckless attacks is somewhat surprising. It must be remembered that Pitt and the Court party retained one caricaturist on handsome terms, and it was conceded that Sayer's cartoons had, on emergencies—such as Fox's India Bill—been most service-able to the Administration, and particularly injurious to the Opposition. Gillray, as a free-lance, probed the Ministry or attacked their opponents at will. Sayer was very inferior to the younger artist, and Pitt not improbably intended to secure Gillray to himself. A certain respect existed between them; Gillray was never bitter against Pitt, although he treated his person, oratory, pride, and peculiarities with amusing irony. Pitt, however, is drawn in his true magnitude when triumphing over danger, or when attacking the evils which Gillray himself dreaded—such, for example, as the revolutionary mania. This may account for his mysterious security. Later on we know that the Minister courted the cari-caturist both by gentle and by stern measures. The Premier gave him sittings for his portraits (1789), while the Ecclesiastical Court involved the caricaturist in an expensive prosecution (1796). The success of Pitt's tactics is sufficiently evident in Gillray's later works.

February, 1792. *The Power of Beauty. St. Cecilia Charming the Brute, or the Seduction of the Welsh Ambassador.*—Lady Cecilia Johnston, the lady against whom Gillray ungallantly aimed all his stray shots, is here exerting her powers of fascination over a Welsh goat, Sir W. W. Wynn, who took a prominent part in the affairs of the principality.

February 1st, 1792. *A Good Shot, or Billy Ranger the Gamekeeper, in a Fine Sporting Country.* "He shoots a good shot, it will do a man's heart good to see him; he will charge you and discharge you with the motion of a pewterer's hammer; and when he has his game in view he will about, and come you in," &c.—Lord Grenville, who had been elevated to the peerage in 1790, is ridiculed in this satire. He was first cousin to Pitt, who probably facilitated his rise. Lord Grenville married the Hon. Anne Pitt, sister to Lord Camelford. His lordship was believed to have a predilection for lucrative offices; he held the post of Ranger of St. James's and Hyde Parks, as well as that of Secretary of State, &c. This eagerness for emolument was the cause of Gillray's irony. The Ranger is shooting in St. James's Park. A quill-pen forms the feather of his hat; the prizes of his sport are hung round him—birds with money-bags for bodies—"Sinecures, 9000*l.* per annum," &c. A tribe of fawning dogs are follow-ing the sportsman. Buckingham House, the King's residence, stands in the background; from the smoke of one chimney is issuing a coronet, from another mounts a whole covey of profitable places, represented by money-bags on the wing. The Ranger has just discharged his piece and succeeded in marking the entire flock. Many admirable portraits of this accomplished nobleman will be given in later cartoons.

Loud and continued agitations now became the order of the day; the Court party exhibited their determination to resist liberal measures, the Opposition recovered much of its vigour, and the fate of the Pitt Administration was anticipated. Gillray preserves a record of this impression.

March 16th, 1792. *Malagrida Driving Post.*—The old Palace of St. James's is the scene of the expedition. The appearance of a dove bearing an olive-branch of peace has thrown Pitt into agony, and disconcerted Dundas, who is acting as coachman in the hurried Ministerial retreat. The Marquis of Lansdowne was reported as the pro-bable head of the new administration; we have already traced his popularity with the King when acting in that capacity as Lord Shelburne. After the failure of the hopes which this cartoon illus-trates, the Marquis appears to have resigned his political ambition. The name of "Malagrida,"

Pitt Driven out of Office.

T 2

which persistently clung to him, was first applied (1767) by "Junius," who described Shelburne as "Heir-apparent to Loyola—a perfect Malagrida." The name was originally that of a famous Portuguese Jesuit. There is a well-known story to the effect that Goldsmith, whose unconscious simplicity was often more amusing than the choicest flashes of his wit, once characteristically inquired of Lord Shelburne how the people ever came to nickname him "Malagrida;" "for," said Goldy, "I have always heard that Malagrida was a very good sort of man!" The hero of the situation is driven by a coachman in a French livery, with three footmen to correspond; his dark face is thrust out of window. He cries, "Drive, you dog! drive!—now or never! Aha! the coast is clearing! Drive, you dog!" The leaders of the Opposition, eager to share in the good fortune of the imaginary Premier, are shouting unheeded after the coach. Fox is vociferating "Stop, stop, and take me in; stop!" Sheridan and M. A. Taylor vainly follow.

March 16th, 1792. *The Bottomless Pitt.*—The young Minister is again turned into a subject for personal ridicule by his friend the caricaturist. An equivocal phrase, "If there is a fundamental deficiency," &c., which had unguardedly escaped Pitt in the warmth of debate, was twisted into a joke at the expense of his person. The sketch is said to give a realistic impression of his figure and gesture when engaged in argument.

The Opposition in Parliament, in spite of many defections, became—under its old leaders, Fox and Sheridan, and some of the young and rising debaters, such as Grey, Erskine, Lord Lauderdale, Whitbread, and others—louder and more menacing. Within Parliament, every question that would admit of debate was contested with the greatest obstinacy. The session of 1792 was first occupied with the foreign policy of the preceding year, which, whether in Europe or in India, was analysed and bitterly attacked. Wilberforce's question of the abolition of negro slavery embarrassed the Ministers, whose

A Bottomless Pitt.

chief argument against it was that it numbered among its advocates some of the revolutionary reformers, and among the rest Thomas Paine; they disposed of it eventually by a motion for gradual abolition. The detection of a number of flagrant instances of improper interference in elections gave a new force to the question of Parliamentary Reform, which was brought forward at the end of April by Grey and Fox, and violently opposed by Pitt and Burke. The arguments reproduced by each successive speaker on the Ministerial benches were, the impolicy of the time at which the question was brought forward, and the danger of making concessions to popular violence; and the Court in 1792 seemed resolved to raise the reputation and importance of Thomas Paine and his "Rights of Man," in the same way that it had, more than twenty years before, raised John Wilkes, his *North Briton*, and "Essay on Woman." Burke, who opposed this motion with great warmth, and who declared his belief that the House of Commons was as perfect as human nature would permit it to be, flew out against French revolutionists and English political societies, and talked of the factious men with whom England abounded, who were urging the country towards blood and confusion. In the heat of party faction the Ministers exaggerated greatly the real danger they had to apprehend from people of this description, while it was equally undervalued by their opponents.

Caricatures upon the Royal Family appeared at intervals, breaking up the political series, which might otherwise have grown monotonous. The people liked their King none the less for a little lighthearted laughter at his expense; his family cost John Bull a round sum—a little fun was not a very extravagant return. The middle and lower classes of that day respected the Sovereign for his very eccentricities. Seeing the King engaged in occupations much resembling their own, they learned to respect this condescension, which was unaffectedly natural on the part of both their Majesties, though the sagacious Consort could, on State occasions, act up to the regal dignity.

March 27th, 1792. *Anti-Saccharites, or John Bull and his Family Leaving Off the Use of Sugar.* To the Masters and Mistresses of Families in Great Britain, this Noble Example of Economy is Respectfully Submitted.—It was agreed on all hands that the princesses were the most charming examples of their kind ever seen. Miss Burney has sketched their figures with no unfaithful hand; their amiability appears

ANTISACCHARRITES, — or — JOHN BULL and his Family leaving off the use of SUGAR

To those Masters & Mistresses of Families in Great Britain, this Noble Example of OECONOMY, is respectfully submitted.

to totter under this rigorous "saccharite" reform. The frugal Queen, who finds the contemplated saving far sweeter than sugar, is setting an encouraging example: "Oh, dear creatures, do but taste it! You can't think how nice it is without sugar! And then, consider how much work you'll save the poor Blackamoors by leaving off the use of it! And, above all, remember how much expense it will save your poor papa! Oh, it's charming, cooling drink!" The King is enchanted with the experiment: "Oh, delicious! delicious!" he cries, while his features express a pantomimic gratification worthy of his favourite Joseph Grimaldi, whose feats afforded the King such delight that it is said the lovely princesses were obliged to moderate the royal paroxysms by praying that "His gracious Majesty would be pleased to try and compose himself!"

The agitation on the slave question was possibly the first hint of the conception, but the humour of the production and the drollery of this hit upon royal economy had the immediate effect of diverting the interest from emancipation.

"Peter Pindar, when the print of 'Anti-Saccharites' first appeared, wrote some appropriate lines, and intended to put them into print; but from some qualms of conscience, instead of so doing, he put them into the fire. One evening, at the merry board of Mitchell, the banker, in his private house at the bottom of Beaufort Buildings, this subject being pinned over the fireplace, Peter thus apostrophized the group: 'He would belie you, fair damsels, who denied you beauty; yet were he a liar who would say, 'Behold their *sweet* faces!' for, by all that's holy, their pouting lips 'set one's teeth on edge.' "

The late King was regularly supplied—privately, of course—with all the effusions of Gillray's wit. When this print was delivered at the breakfast-table and handed round. The smiles, not to say laughter, which it provoked, exhibited a lively picture of beauty, beyond the powers of the satirist's personification.

Peter Pindar always alluded to the princesses with emphatic gallantry. He wrote a kindly letter to poor Perdita a few days before her death, in which he dwelt on the graces of these young ladies, who were not unmindful of the sad story of their elder brother's love. "The princesses," said the satirist, "are models of good nature, gentleness, and affability." "You well know that George's daughters are great favourites of the Muses. One is a poetess, a second a painter, a third a musician, and so on; so that Buckingham House is another little school of Athens." Thackeray, who sternly lashed the littleness of the Georgian sovereigns, writes tenderly of these well-favoured princesses: "The history of the daughters, as little Miss Burney has painted them to us, is delightful. They were handsome—she calls them beautiful; they were most kind, loving, and lady-like; they were gracious to every person, high and low, who served them. They had many little accomplishments of their own. This one drew; that one played; they all worked most prodigiously, and fitted up whole suites of rooms —pretty smiling Penelopes—with their busy little needles." The family sketches which have come down to us preserve a prospect of smiling, affable maidens, determined to please. When either of their stout brothers paid them a visit, they admired everything these not over-refined gentlemen were pleased to do or say. A chat with their cousins of Gloucester, or with their sister-in-law of York, afforded them the most simple gratification. Every birthday which occurred within the palace was acknowledged; congratulations, graceful little presents, &c., were offered to every one associated with the affable princesses. To their royal parents they showed the most courtly respect, and "gracious Majesty" was the familiar address permitted by etiquette. The darling of their circle, the little Princess Amelia, is one of the sweetest figures, not only of George's day, but of all history; her untimely death reduced the poor King to such distraction, that his agony brought on that final relapse of his malady which, in 1810, ended his reign. The pretty princess wrote verses, so gaily apostrophized by Pindar; the gentle sufferer pictured her condition in some pretty plaintive lines, more affecting than greater lyrics:—

"Unthinking, idle, wild, and young,
 I laughed, and danced, and talked, and sung;
And proud of health, of freedom vain,
Dreamed not of sorrow, care, or pain;
Concluding, in those hours of glee,
That all the world was made for me.

"But when the hour of trial came,
 When sickness shook this trembling frame,
When folly's gay pursuits were o'er,
And I could sing and dance no more,
It then occurred, how sad 'twould be
Were this world only made for me!"

From the consideration of the princesses we turn to the Heir-apparent. A few days after the publication of "Anti-Saccharites," Gillray introduced a decided contrast to that simple family circle.

March 31st, 1792. *Modern Hospitality, or a Friendly Party in High Life. The Knave wins All!* "O woman! woman! everlasting is your power over us; for in youth you charm away our hearts, and in after years you charm away our purses!"—Lady Archer, with her enamelled face, is entertaining a select circle of friends, whom she is victimizing at her card-tables. The bank is richly stocked, and the stakes of the players have apparently found their way to the hostess. Large sums are on the green cloth, but Lady Archer has completed the general consternation by turning up the knave, which "wins all." The spectators are evidently portraits of persons then well known. The Prince of Wales is sitting on the left of the hostess. A solitary piece represents his last stake. Lady Buckinghamshire has divided her pile upon two cards. She is furiously indignant. Play-rumours are not unassociated with this lady's reputation. Poor Fox, reduced to three pieces, is plunged into pathetic despair at the extinction of his last chance. The gambling propensities of that era were amongst its most baneful features. The sums said to have been lost by the Prince and by Fox are almost beyond credence. The Duke of York was deeply affected with a passion for gambling, and he suffered the consequences by which this vice is generally attended.

April 11th, 1797. *The News of Shooting the King of Sweden.*—Pitt is rushing unceremoniously into the presence of Royalty with affrighted expression, bearing a despatch—"Another monarch done over." The King is panic-stricken; a spasm contracts the royal person. He gasps, "What? Shot! What? what? what? Shot! shot! shot!" The Queen is no less moved.

It may be remembered that the consternation produced by the news of the assassination of Gustavus the Third of Sweden was increased by the appearance of affairs on the Continent. Gustavus had concluded a peace with Russia, with the object of forming a federation of Sweden, Russia, Prussia, and Austria, for the purpose of extinguishing the French Revolution and restoring Louis XVI. Placed at the head of this coalition, there is little doubt that the unanimous action of these powers and his own dashing impetuosity would have crushed the Revolution before the success which it afterwards obtained had inflated the mind of the nation with ideas of the invincibility of its arms.

A meeting of "the Estates" was held at Gefle, and the wishes of Gustavus were fully concurred in. It was here that a band of conspirators agreed on the King's assassination. Count Horn, with other members of the old nobility, determined to murder Gustavus and restore the ancient aristocracy, which he had successfully set aside by a previous revolution. Ankaström begged that the execution of the plot might be entrusted to him. A masked ball held at Stockholm on the 15th of March, 1792, was chosen for the crime. The King received a warning note, but he attended in a private box, and, discovering no indications of disturbance, entered the hall. Here a crowd of maskers surrounded him. Count Horn struck him upon the shoulder, with the words, "Good night, mask!" and Ankaström mortally wounded him with a shot through the back. Gustavus, who survived until the 29th, tranquilly arranged all the business of the succession and signed an order for proclaiming his son King. The coalition on the Continent was destroyed for want of a leader who could cement its elements; the allies made war indifferently on their own account without any definite plan, and the French obtained victories over them in detail. A second regicide, the murder of Louis XVI., swiftly followed the assassination of the chivalrous King of Sweden.

Lamartine, in his "History of the Girondists," assigns their full weight to the disposition of the King and the consequences of his assassination : "The romantic and adventurous character of Gustavus is still the greatness of a restless and struggling soul in the pettiness of its destiny. His death excited a shriek of joy among the Jacobins, who deified Ankaström; but their burst of delight on learning the end of Gustavus proved how insincere was their affected contempt for this enemy of the Constitution."

Parliamentary Reform had now become the watchword of several of the political clubs, which were increasing in numbers as well as in the violence of their language. A few weeks had seen the formation of the "Corresponding Society," which placed itself in immediate communication with some of the most violent clubs in Paris, and which openly demanded universal suffrage and annual parliaments; and now, in the month of April, 1792, arose the "Society of the Friends of the People," which was more

moderate in its language and demands, and counted in its ranks several noblemen and leading members of Parliament, and many other persons distinguished in literature and science. It was at the desire of this latter society that Grey and Erskine, who were both members, brought the question of Reform before the House of Commons in the spring of 1792; and it was resolved that they should bring forward a more formal motion on the subject in the ensuing session.

The Ministry dreaded the way in which the Opposition was thus strengthening itself with political associations, and determined to take measures to counteract them, and to suppress the large quantity of inflammatory material which was now spread about the country in the shape of seditious writings. The gradual and effective manner in which the Ministers paved their way for hostile steps against sedition at home and designs from abroad, by addressing themselves to people's passions and exciting their

apprehensions, is deserving of admiration. They even contrived to make the odium of sedition recoil heavily upon the heads of the leaders of the Opposition in Parliament, who were represented as nourishing concealed views of ambition, and as close imitators of the worst of the ultra-democrats of France. In a caricature by Gillray published on the 19th of April, 1792, and entitled *Patriots Amusing themselves, or Swedes* Practising at a Post,* Fox and Sheridan are perfecting themselves in the use of firearms. Dr. Priestley stands behind holding two pamphlets in his hand, entitled "On the Glory of

Patriots Amusing Themselves.

Revolutions," and "On the Folly of Religion and Order;" and says to his colleagues, "Here's plenty of wadding for to ram down the charge with, to give it force, and to make a loud report." Fox, bearing the French cockade with the inscription "*Ca ira,*" is firing a blunderbuss; while Sheridan, loading his pistol, exclaims, "Well! this new game is delightful!—O heavens! if I could but once pop the post:—

> "Then you and me,
> Dear brother P.,
> Would sing with glee,
> Full merrily,
> *Ca ira! ça ira! ça ira!*"

The post at which they are shooting is rudely moulded into the form of King George, surmounted by the royal hunting-cap. The success which these attempts on people's fears and prejudices met with encouraged the Ministry to proceed, and they soon ventured to make a direct attack on the liberty—or rather, in this case, on the licence—of the press. On the 21st of May appeared a royal proclamation against seditious meetings and writings, which, however, was more especially aimed at the societies above mentioned. It spoke particularly of the correspondences said to be carried on with designing men in foreign parts, with a view to forward their criminal purposes in this country. This proclamation was violently condemned in Parliament by the Opposition, as an injudicious and uncalled-for measure; and it produced debates in both Houses which showed a number of desertions from the popular party. Among the most important in the House of Lords were the Duke of Portland and the Prince of Wales, who both spoke energetically in favour of the proclamation.

May 12th, 1792. *Austrian Bugaboo funking the French Army.*—After the assassination of Gustavus, the Emperor of Austria commenced the campaign in Flanders. The revolutionists at first sustained a few reverses, which impressed their opponents with a false estimate of patriot soldiers. Gillray has made the most of this partial triumph over the Sansculottes! The ragged rabble, alarmed by a composite monster who is puffing them away like smoke, are destroying one another in their flight. They exclaim, "La Liberté! la Liberté! de s'en fuir."

* An allusion to the political faction which succeeded in assassinating the King of Sweden.

" While loyal honour warm'd a Frenchman's breast,	" To die or conquer was a soldier's right.
The field of battle was a glorious test;	A strange reverse the Democrats display,
Nobly ambitious for his king to fight,	And prove the right of man—to run away ! "

The allies injudiciously commenced the campaign—in ignorance of their opponent's resources, without any distinct principle of action. The old soldiers, who had become veterans under the banners of the Republic, declared, in after years, that the Austrians resigned themselves to be slaughtered like " flocks of orderly sheep."

Sir John Bull and his Family Landing at Boulogne.

The Continent had for many years been the resort of English fashion; an untravelled person was esteemed a mere untutored " John Bull." The polish conferred by a trip across the Channel was popularly allowed to pass current for higher qualifications. Paris was the spot in which every order of vice and extravagance was concentrated. From this " finishing school" the half-bred scoundrel returned a perfect " chevalier de l'industrie ;" the gambler brought back the newest tricks of play, and doubtful characters of either sex returned as unequivocal profligates. The society from whence the Republic sprang was an undoubted hotbed of corruption, social and political. An attempt at reform would, it had been prophesied by Sir John Sinclair, " be attended with a revolution." The evils were attacked, reform was inaugurated, and the chaos of the revolution intervened. The Continent was then closed to pleasure-seekers, and when the idlers returned to their favourite resort the old aspect of affairs had assumed a new front. It is therefore interesting to obtain a glimpse of French characteristics as they presented themselves to the traveller anterior to the Revolution.

May 31st, 1792. *The Landing of Sir John Bull and his Family at Boulogne-sur-Mer.*—This group, possibly sketched from life, is designed by Henry Bunbury, a most observant artist, whose feeling for humour was superior to his manipulative skill. Some of his finer studies were submitted to his friend Gillray, who supplied those elements in which the amateur was deficient; he etched these productions with the dexterity derived from his experience and training.

Bunbury had numerous opportunities of visiting the Continent, and he was quite at home among the quaint figures which formed no mean part of its attractions. The boat landing in the surf, the persuasions offered by the long-queued Frenchman, the labours performed by the sturdy wives of Boulogne, are all in graphic keeping. The crowd on the shore is a complete epitome of a French seaport-town. The postilion, with his breezy hair, his clubbed tail, short jacket with ruffled sleeves, his thin legs buried in huge jack-boots, his whip, the " Poste-Royale" list of stages, and the fleur-de-lis on his arm, all characterize a creature of a bygone age. The hotel cook, too, with his white cap, jacket, and apron, the preposterous bow to his queue, the mimic " chapeau à corne," carried beneath the arm with the air of a marquis, the indispensable ruffles, and the hotel card, are all in perfect keeping. The dwarf " tout," with his pigtail and huge sabots half stuffed with straw, the mendicant monk—one of these orders who sent forth their bare-footed, half-clad representatives to limp over the surface of

every city, town, and hamlet, until revolution rooted up monastic institutions with reckless fury. It is interesting to find so perfect a realization of the customs of the past.

In the caricatures on more general subjects of a later period than that of which we are now speaking, we shall often find these personal weaknesses of the Royal Family—the love of money, the homely savings, the familiar air, the taste for gossip—introduced. A caricature by Gillray, published in 1792, after the arrival of the news of the defeat of Tippoo Saib in India, represents Dundas, within whose province the Indian affairs lay, bringing the joyful intelligence to the royal huntsman and his consort. It is entitled, *Scotch Harry's News; or, Nincompoop in high glee.* The exulting Secretary of State, who is thus designated, announces that " Seringapatam is taken—Tippoo is wounded—and millions of pagodas secured." The vulgar-looking King, with a strange mixture of ideas of Indian news and hunting, breaks out into a loud " Tally ho! ho! ho! ho!" while his Queen whose head is running entirely on the gain likely to result from these new conquests, exclaims, " O the dear, sweet pagodas!"

Joyful News.

At this moment some divisions showed themselves also in the midst of the Ministerial camp. There had never been any cordiality between the Premier and the Chancellor since the treacherous conduct of the latter on the occasion of the Regency Bill; and Thurlow not only spoke contemptuously of Pitt in private society, but more than once attacked his measures in the House. The King had a great disinclination to parting with his Chancellor, and things were allowed to go on for some time, until, in the session of 1792, the latter made a gross attack in the House of Lords on some of Pitt's law measures. It is even said that the King, knowing the mutual feelings of his two Ministers, and attached by long habit to Thurlow, had hesitated more than once which of them should be the sacrifice; but the Queen was a firm friend to Pitt, and when at length, at the beginning of the session, the provoked Premier forced the King to an alternative, it was notified to Thurlow that he must resign. Thurlow obeyed, much against his inclination; though, on account of business pending in the Court of Chancery, he consented to remain at his post till the end of the session. On the day of prorogation, the 15th of June, he gave up the seals, which were placed in commission, but which were subsequently given to his old rival, Lord Loughborough, who was one of the deserters from the Whig phalanx. The caricatures on the dismissal of Thurlow were bitterly sarcastic.

May 24th, 1792. *The Fall of the Wolsey of the Woolsack.*—Thurlow's appearance as Wolsey was well deserved. Upon the King's recovery, three years previously, he contrived, without losing his place, to cheat both Ministers and Opposition. The black-browed diplomatist marched down to the House, " proclaimed himself the inalienable servant of the Throne, and obtested Heaven, in language little short of blasphemy, that whenever he forgot his King, might his God forget him!" " The man who," according to Pitt, " opposed everything and proposed nothing," accelerated his own downfall by over-estimating his influence. Pitt's Bill for the continuance of the " Sinking Fund" had passed the Commons with approval. The Chancellor opposed it most unexpectedly in the Lords, and it was only carried by a majority of six. Thurlow harangued against the measure of his chief with indecent acrimony. He ridiculed the presumption of attempting to bind future parliaments, crying, " None but a novice, a sycophant, a mere reptile of a minister would allow this Act to prevent his doing what the circumstances of the country might require at the time. The inaptitude of the project is equal to the vanity of the attempt."

The Chancellor and the young Premier had long been at variance. Thurlow despised Pitt; he considered the young Premier's inexperience would render the assistance of a chancellor who carried so much secret weight with the King a matter of necessity; if either gave way it would be the younger champion, who would fall a sacrifice to his own presumption. Pitt might have proved the weaker; but a more influential champion was found in the Queen, who had forgotten neither the tergiversations

U

of Thurlow on the Regency question, nor Pitt's steadfast allegiance on that critical occasion. The Queen, of course, exercised more confidential influence than Thurlow, with all his devotion to the "backstairs." Pitt procured his dismissal ; there was a struggle, but the Queen triumphed. Thurlow was amazed at the King's acquiescence, he told Lord Eldon (then Sir John Scott), "I did not think that the King would have parted with me so easily. As to that other man, he has done to me just what I should have done to him—if I could."

The fall of Wolsey, according to Gillray's caricature, takes a very practical form. Thurlow clings to the insignia of his office, but the King is sturdily tugging off the latter in front; while Pitt and Grenville, in the rear, are dragging away the woolsack and the Chancellor's wig. The King is surprised at Thurlow's resistance. "What! what! what! Pull against me, Neddy? No, no, no! 'twont do, Neddy! 'twont do! Leave go, leave go, Neddy! Don't put me in a passion, Neddy, but leave go, Neddy!"

Thurlow recites, with the pathos of the humiliated Cardinal :—

"Take it, ingrate ! and then farewell ! O ! d—n—n,　　　"I haste now to my setting. I shall fall, d—n—n,—
I've touch'd the highest point of all my greatness, d—n—n,—　Like a bright exhalation in the evening, d—n—n,—
And from that full meridian of my glory, d—n—n,—　　And no man see me more—D—n—n ! O ! d—n—n !"

Pitt is crying, "Yes! yes! this one pull more, Billy Ranger, and we shall secure everything into our own family, and then leave me alone to take a pull at Old Nobbs and John Bull." Lord Grenville, whose numerous lucrative appointments excited general comment, is observing, "Bravo! cousin Billy! pull away! now again! I have a mighty fancy for this wig! I think it would add dignity to my Ranger and Secretaryship!"

The "Fall of Wolsey" gives an obvious version of Thurlow's defeat, but a few days later the more occult movements of the Chancellor's ejectment were displayed in a travesty verging on the sublime, which has not inaptly been described as "the boldest effort of caricature."

June 9th, 1792. *Sin, Death, and the Devil.* Vide *Milton.* The above performance, containing portraits of the Devil and his relatives, drawn from the life, is recommended to Messrs. Boydell, Fuseli, &c., as necessary to be adopted in their classic embellishments.—Pitt, as Death, and Thurlow, as Satan, are engaged in the stupendous contest before Hell-gate described by the great epic poet; the Queen, in the presentment of Sin, interposes with her Cerberus whelps for the protection of Death, baffling the power of Satan, the more terrific of the twain. The verses below signalize this stage of the struggle :—

"So frown'd the mighty combatants, that hell　　　"Had not the snaky sorceress that sat
Grew darker at their frown : And now great deeds　　Fast by Hell-gate, and kept the fatal key,
Had been achiev'd, whereof all hell had rung,　　　Ris'n, and with hideous outcry, rush'd between."

Verses selected to describe the individual actors appear above this terrific picture. The figure of Pitt as King Death explains itself. The sceptre, tipped with the lily of France, is his weapon. Lightnings issue from its radiant point; a serpent, interwoven with the crown, is darting forth its venom to sting Satan unperceived. Satan's figure is massive and finely proportioned. His buckler, entwined with double serpents, which are darting their venom both at the Queen and at Pitt, is emblazoned with the purse and woolsack, insignia of his office. This shield averts the thrust of Death's spear ; but his own offensive weapon, the Chancellor's mace, is broken in his powerful grasp. The form of Sin is the most repulsive of the three. Her hair is a tangle of wriggling vipers; the convolutions of scaly coils in which her extremities terminate stretch far and wide in fatal rings. The key of Hell-gate, which is of formidable dimensions, is suspended round the waist of Sin, and is labelled, "The instrument of all our woe ;" it is evidently intended for the key of the backstairs.

The three-headed monster, creature of the Queen, bears on its triple front the faces of Dundas, Grenville, and the Duke of Richmond. The original etchings were effectively coloured ; the depths of hell deepened with impressive shade, mysterious masses of dense smoke heightened the effect of the forked tongues of flame which played round the awful opponents, and threw up their figures in fierce relief, while a glare of liquid fire swept over the margin of Satan's kingdom.

This astonishing conception of "Sin, Death, and the Devil," is said to have given great offence at

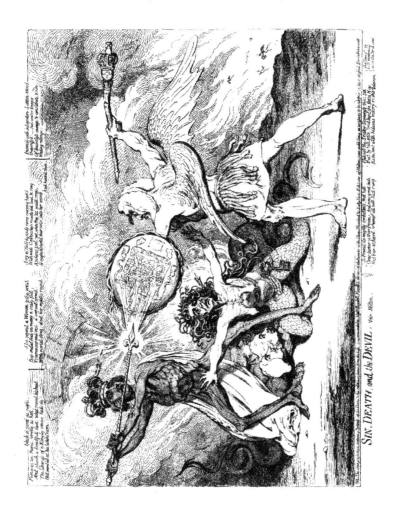

SIN, DEATH, and the DEVIL. – Vide Milton.

Court, and with reason. Caricatures more slanderous and more objectionable have been frequently issued, but it is difficult to imagine a more daring allegory founded on a basis of substantial truth. The power of irony could go no farther; this may be considered the climax of travesty, the very apogee of parody.

Pitt doubtless felt dismayed at Gillray's wilfulness, whom he desired to tame for his own support. Time brought the remedy. This retiring, self-contained satirist, this dangerous, unmanageable weapon—keen, double-edged, and treacherous to handle—found a cause for his energetic hostility in the revolutionary terrors then culminating. In Napoleon, the subduer not only of the Republic, but almost of the whole world, Gillray recognised a foe worthy of his steel—a hero whom it was true patriotism to assault, a champion reckless as himself—with this material difference, that Napoleon carried out on the theatre of the actual world conceptions quite as startling as those worked out by the artist in mere printers' ink and perishable paper.

After his dismissal Thurlow relinquished politics, and disappeared from Gillray's collection of State puppets. The ex-Chancellor spent the remainder of his life—he survived his fall some fourteen years—in retirement, chiefly residing at his favourite seat of Knight's Hill.

That Pitt should have engaged giants of such calibre as Fox, Thurlow, and Napoleon in contests where "quarter" was denied speaks volumes for his fearlessness. The conquests he obtained for his country's cause are worthy of everlasting admiration.

An epitaph, one of the most pungent ever written, appeared from an unknown pen at the time of Thurlow's political evasions; it expresses public feeling by concentrating his several demerits, as patriot, peer, guardian, judge, Christian, and Briton, into a few pithy lines.

"TO THE MEMORY OF THURLOW.

" Here lies, beneath the prostituted mace,
 A patriot, with but one base wish—place :
Here lies, beneath the prostituted purse,
 A peer, with but one talent—how to curse :
Here lies, beneath the prostituted gown,
 The guardian of all honour—but his own ;
Statesman, with but one rule his steps to guide—

" To shun the sinking, take the rising side ;
 Judge, with but one base law—to serve the time,
And see in wealth no weakness, power no crime ;
 Christian, with but one value for the name,
The scoffer's prouder privilege – to blaspheme ;
 Briton, with but one hope—to live a slave,
And dig in deathless infamy his grave."

The proclamation issued by the King, May 21st, 1792, against seditious meetings and writings had been especially aimed at the "Friends of Liberty" and sympathizers with the Jacobins; it provoked hostility and animadversion both at home and abroad. Gillray, as the earnest advocate of rational freedom, assumed the popular task of making the restrictions recoil on the heads of the Royal Family.

May 21st, 1792. *Vices Overlooked in the New Proclamation.* To the Commons of Great Britain this representation of Vices which remain Unforbidden by Proclamation is dedicated, as proper for imitation, and in place of the more dangerous ones of Thinking, Speaking, and Writing, now Forbidden by Authority.—The print is divided into four compartments, each appropriated to a distinct vice. *Avarice* is represented by King George and Queen Charlotte, who are hugging their hoarded millions; a book is lying between them, containing an "account of money at interest in Germany." *Drunkenness* is exemplified in the Prince of Wales, supported from a tavern, bearing his arms as sign, by two watchmen, who are lighting his helpless footsteps. *Gambling* is illustrated in the person of the Duke of York, who is in a den of ill-repute, surrounded by associates of disreputable appearance; the Prince-Bishop is dashing down his fist in a fury of ill success. The Duke of Clarence, toying with Mrs. Jordan, forms the last picture, *Debauchery.*

Avarice.

The caricaturist who thus burlesqued Royalty had a pique against George III. very similar to that

of Hogarth against George II. Gillray had accompanied Loutherbourg into France, to assist him in making sketches for his grand picture of the siege of Valenciennes. On their return the King, who made great pretensions to be a patron of the arts, desired to look over their sketches, and expressed great admiration of the drawings of Loutherbourg, which were plain landscape sketches sufficiently finished to be perfectly intelligible. When he came to Gillray's rough but spirited sketches of French officers and soldiers, he threw them aside with contempt, merely observing, "I don't understand these caricatures." The mortified artist took his revenge by publishing a large print of the King examining a portrait of Oliver Cromwell executed by Cooper, to which he gave the title of "A Connoisseur examining a Cooper." The royal countenance exhibits a curious mixture of astonishment and alarm as he contemplates the features of the great overthrower of kings, whose name was at this moment put forth as the watchword of revolutionists. The King is burning a candle-end on a save-all ! This print was published on the 18th of June, 1792. The circumstances attending its appearance are fully detailed in the Life which precedes this work, where a reduction is given in fac-simile from the original plate.

Gillray evidently enjoyed the excitement attending these venturesome attacks on the supposed inviolability of Royalty. The wit of his conceptions, the grace and power of his execution, were most conspicuous when engaged in these his favourite tournaments. Genius in his case overleapt the distinctions of rank, and the obscure satirist utterly routed and held up to public derision the very head of the monarchy, with all that was unworthy of respect. A fortnight had barely elapsed after the publication of the print representing the monarch blinking at the arch-enemy of kings, ere Gillray's Quixotic lance was urged against another branch—then in contumacious opposition—in the person of the heir apparent.

A Voluptuary under the Horrors of Digestion.

July 2nd, 1792. *A Voluptuary under the Horrors of Digestion.*—Prince Florizel, the royal Sybarite, is reclining in voluptuous repletion after the exertions of an extravagant repast. Champagne flasks lie emptied beneath the table ; well-picked bones, a huge jorum of port, a decanter of brandy, an appetizing ham, and a castor of stimulating "chian" illustrate the gluttony of the performance. Through the window a view is obtained of Carlton House, the expensive works still incomplete. Behind the Prince are seen his unpaid bills, from purveyors and doctors, all of prodigious length. On the ground are thrown a dice-box, a list of "debts of honour" unpaid, a "Newmarket List," and the famous "Faro-partnership Account," inscribed "Self, Archer, Hobart, & Co."

Ugly stories were hinted against the Prince, in accordance with the allusions of this picture, especially with regard to his famous racer "Escape" and his jockey Chifney, but it is generally agreed that in this respect at least he was "more sinned against than sinning."

The walls of this apartment (some of the rooms of Carlton House were hung with figured lemon satin) display comments on the text of the satirist. A portrait of a venerable ascetic, "L. Cornaro, ætat 99," is drawn enjoying a bumper of water; a knife and fork form the supporters of the triple plume, and a bottle and glass are employed as "taper-holders."

The Prince's habits were well known to be self-indulgent and extravagant in no ordinary degree, and the print was esteemed one of Gillray's finest productions; it is now very scarce, and is sought by collectors for the beauty of its execution. The success of this work induced the artist to prepare a companion picture, which was equally admired and sought after.

July 26th, 1792. *Temperance enjoying a Frugal Meal.*—The august monarch and his consort are discussing their daily repast, and the splendour displayed by the accessories of this picture—which are in the coloured originals represented of solid bullion, gold glittering on all sides and forming the material of the commonest implements—is apt to give an impression of costly profusion. A second glance, and the ludicrous contrast between the simple fare and the splendid appointments is exposed in all its drollery. A brace of eggs, served up on solid gold, form a banquet very easy of digestion, and a salad of "sauerkraut," served up in a golden bowl, is in truth but poor fare. A lilliputian pat of butter is lost sight of in the magnificence of a golden trowel. A golden ewer handsomely chased, of trophy-like dimensions, with the words "Aqua Regis," enlightens us as to the Sovereign's beverage. The King, in his comely Windsor uniform—occupying an arm-chair literally bespattered with the precious metal—loses in splendour under the same attention; the carefully turned-up table-cloth protects, bib-

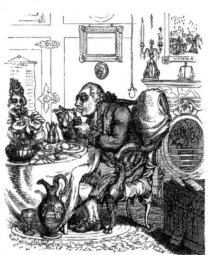

Temperance Enjoying a Frugal Meal.

like, any possible injury to the royal garments; the cautiously placed coat-tails display a clumsy patch inserted in that part of the royal small-clothes most liable to wear. The handsome chair is enveloped in coverings—back, seat, and legs wrapped up with the care bestowed on the clothing of a racehorse. A splendid mat is spread beneath the royal feet, to protect the carpet from crumbs. The ingenuity with which each accessory is designed to convey the story is worthy of remark. A vase of flowers decorates the fireplace; that a fire would be a more cosy appendage is imparted by the little monster over the hearth, represented thrusting its hands into a muff. The mantel ornaments are a pair of scales for detecting light sovereigns, and a candelabrum, probably of the King's peculiar design—a figure of Munificence supporting two commodious cornucopiæ, both empty. In one candle-holder is a taper yet unlighted; the other contains the single light which has illuminated the royal vigils; an extinguisher of gold, surmounted with the crown, proves the saving care with which it has been husbanded. Even the bell-pull is secured from tarnish in a little bag. The pictures adorning the solidly wainscoted apartment form a history of themselves. Over the mantel is the subject of "The Fall of

Manna," treated after the King's view; the Israelites being true Benjamin West-like Jews of the tribe of Houndsditch, with "'old clo'" bags to catch the manna, which the artist has assumed to have been golden pieces.

"Epicurus" and "Parting the Loaves and Fishes" are naturally hung out of sight., "The Triumph of Benevolence" is represented by an empty frame, while a miniature, intended for the Man of Ross (a highly ascetic personage, very popular in those times), contains the picture of King George in profile. More positive proofs of hoarding are furnished by the remainder of the pictures. Massive iron bolts secure the door of a "strong room," while behind the Queen is suspended the finest picture in the room, a prodigious "Table of Interest at 5 per cent."——

"5 millions 250,000*l.*
3 millions 150,000*l.*"——

and so on, up to a formidable total. These sums were popularly believed to represent the results of royal economy, augmented by the addition of large sums annually set apart as "Secret Service Money," "Privy Purse," "Sinecure Fund," &c. A huge iron chest of the most secure construction, doubly locked and padlocked, occupies the foreground—a clumsy object, but doubtless delightfully picturesque to the royal eyes. Upon this chest are the works which the King best appreciated—"Life of Old Elwes the Miser," "Doctor Cheyne on the Benefits of a Spare Diet," and an "Essay on the Dearness of Provisions."

Having particularized the satires which Gillray published this year in playful exposure of the Royal circle, we have now to consider his more critical subjects—the march of Republicanism, misguided patriotism, which had been fanned by those wild aspirations into fanatic wildness, and the encroachments of anarchy, which threatened, at the early part of the democratic era, to keep pace at home with the strides of socialism in France. Gillray's judgment detected the weakness of these systems, which were offered in exchange for well-tried institutions. His impulses were no less healthily directed towards securing rational freedom; but he clearly saw that the dreamers, who were at the head of the furious multitude, offered no substitute for the monuments of gradual progress which they proposed to destroy. Our Constitution satisfied Gillray, and he did battle with its detractors. The King was the head of the edifice, and any violent interference with the crowning ornament provoked the artist's hostility. The dogmas of the King may be thus condensed: "My aspirations are for my country's good; I am sincere and determined; I have no thought, no desire but for England's benefit; the man who acts, or thinks, or writes in opposition to me and to my principles is necessarily actuated by dishonest motives—a traitor to his country, the enemy of Britannia and of her appointed ruler." Gillray foresaw the evils descending on France; and as those were the days when compromise was fatal, the caricaturist drew his arms on the side of the King and became the inveterate enemy of French principles. His warfare was savage; waged as it was against determined foes, no scorn was considered too deadly, no weapon was deemed unlawful for his purpose. The combat commenced with a little friendly skirmishing, a few playful passes.

In the month of May the House of Commons narrowly escaped catching fire; an unknown incendiary had inserted a pair of corduroy breeches, in a state of combustion, among the rafters which supported the floor over the closets. The circumstance excited suspicion, and a design to destroy the House of Parliament was attributed to the factious; the real author evaded detection. The corresponding members of the Paris clubs circulated much inflammatory matter, and the attempted arson was attributed to that source.

May 14th, 1792.—*The Bishop of A Tun's Breeches; or, the Flaming Evêque purifying the House of Office!* To the patriots of France and England, this representation of the burning zeal of the holy "Attaché à la Mission" and his colleague, "L'Envoie des Poissardes," is most respectfully dedicated.—Talleyrand, Bishop of Autun, the most intriguing diplomatist of all history, at once the most snake-like and fatal to friend or foe, was at that moment signalizing himself by the assumption of revolutionary zeal. The wily Talleyrand's figure occurs frequently in the satires Gillray directed against French influences. As Bishop of "A Tun" he is here introduced in full canonicals, bearing at the end of his crozier his own breeches, emitting volumes of sulphurous flames. He is seen in the closet under the

House of Parliament, and the Evil One is singing, "Ça ira! ça ira!" One of the fishwives—those historical furies—bears a scroll of instructions from the National Assembly to their "diplomatique." An inflammatory letter provides her with a torch, citizens wearing wooden shoes attend to give their assistance to purify the House—by fire.

Talleyrand, who accompanied M. de Chauvelin, the French Ambassador, to London, was in reality himself the accredited plenipotentiary. The secret instructions and negotiations were confided to him, according to Lamartine: "A confidential letter from Louis XVI. to George III. was in these terms:— 'New bonds must be formed between our countries. It befits two kings, who have manifested during their reigns a continual desire to contribute to the happiness of their people, to form between themselves ties which become stronger as the nations become more enlightened.' M. de Talleyrand was presented to Pitt, and employed all that indirect flattery and pliability of disposition could exercise to interest the Minister in the execution of the plan of alliance he held out to him. He described enthusiastically the glory of the statesman to whom posterity would owe this reconciliation of two nations who set in motion or control the world. Pitt listened with favour mingled with incredulity. 'This minister will be a fortunate man,' said he to the young diplomatist; 'I would fain be minister at that period.' 'Is it possible,' returned Talleyrand, 'that Mr. Pitt believes this period so remote?' 'That depends,' returned the Minister, 'on the moment when your Revolution is finished and your Constitution made available.' Pitt gave M. de Talleyrand clearly to understand that the English Government would not compromise itself in a Revolution yet in ebullition, and whose crises, succeeding every day, gave no certainty of the fulfilment of any engagements entered into with the nation."

Before proceeding with the anti-Republican caricatures it is necessary to recapitulate the outlines of our relations with France.

It was soon seen that Pitt's agitation against revolutionary principles had a further object than the mere repression of domestic sedition. The countenance shown by the Minister towards France was outwardly mysterious and equivocal, though not absolutely threatening; but in secret the English Court was approving, if not abetting, the Continental confederacy which was at the same moment forming with the avowed purpose of restoring monarchy in France by force of arms. A few months left no doubt that England had looked with favour upon the secret treaty of Pilnitz. On the appearance of the Royal Proclamation in May, the French Ambassador, Chauvelin, who had but recently arrived in that capacity, made a formal remonstrance against that part of the document which alluded to the correspondence with persons in foreign parts, as calculated to convey an impression that the English Government gave credit to reports that France was a party to the seditious practices in England, and that England looked upon her neighbour with hostile feelings. The reply of the English Secretary of State for Foreign Affairs, Lord Grenville, breathed the strongest sentiments of peace and amity, and was accompanied with expressions that gave great satisfaction to the French Revolutionary Government, which had suspected a secret understanding between the English Court and those who were leaguing against it on the Continent. Encouraged by Lord Grenville's language on this occasion, the French Government made a subsequent application, through its Ambassador, to engage the English King to use his good offices with his allies to avert the attack with which it was threatened from without. The reply on this occasion was conveyed in a much less satisfactory tone. Lord Grenville said, as an excuse for refusing to accede to the wishes of France, "that the same sentiments which engaged his Britannic Majesty not to interfere with the internal affairs of France, equally tended to induce him to respect the rights and independence of other sovereigns, and particularly those of his allies." Down to this moment the French Government appears to have placed entire faith in the good intentions of this country; but the only sense which it could possibly make of this document was that it could no longer reckon on the friendship of England; and this, joined with the arrogant manifestoes now published by the Courts of Berlin and Vienna, drove the French to desperation, destroyed entirely the little spirit of moderation that remained, and, no doubt, contributed to the disastrous scenes which followed.

The calamities of that unhappy country now succeeded one another in rapid succession. The proclamations of the allies declared, very unadvisedly, that for some months the King of France had been acting under constraint, and that he was not sincere in his concessions and declarations. This

proceeding only tended to aggravate the French populace, and the fearful events of the 10th of August overthrew the throne and established the triumph of Democracy. The English Ambassador was immediately recalled from Paris, on the pretext that his mission was at an end so soon as the functions of Royalty were suspended. The French Government still attempted to avert the hostility of England, and kept their Ambassador in London, although the King and his Ministers refused to acknowledge him in a public capacity. The horrible massacres of September quickly followed to add to the general consternation, and vast numbers of French priests and refugees flocked to this country, to attract the sympathy of Englishmen by their misfortunes and increase the detestation of French Republicanism by their reports of the atrocities which had driven them away. The outrages committed by the Parisian mob in September provoked the first of those sanguinary abominations by which Gillray inflamed the hatred of Englishmen against the "red" faction.

September 29th, 1792. *Un Petit Souper à la Parisienne; or, a Family of Sansculottes refreshing after the Fatigues of the Day.*—The "Petit Souper" is an awful comment on those dainty entertainments of the profligate which were the harbingers of the Revolution. The details of the gory banquet are truly revolting. The table is supported on the maimed trunks of the slaughtered, while miserable, half-naked Frenchmen, with instruments of butchery hung round their waists, are tearing human members with their wolf-like teeth. One patriot is sitting on the lacerated trunk of a female. His *convive* sits on a sack marked "The property of the nation," filled with crowns, mitres, watches, gold pieces, and other spoils; this ghoul has a human head served up for his gratification. Three females are regaling themselves with amputated limbs. Before a fire composed of burning crosses and pictures a harridan is roasting an "aristocratic" baby; three impish children are toying with the refuse. The French sense of humour is exhibited by a rude drawing of "Louis le Grand," a headless figure. Another scrawl is intended for Pétion, the Mayor of Paris during the rule of Pandemonium. The horrors of this scene, questionable as may be the taste which could picture them, fall far short of actual facts. The story of the days of September is a chronicle of blood. The pages of Lamartine concentrate these terrors, bequeathing to posterity the realization of horrors unheard of in the most barbarous ages or amongst the wildest savages. The "égorgeurs"—hired ruffians who laboured as human butchers—incessantly demanded more victims to hack, more heads to cut off, more hearts to tear out; they literally drank blood; their mad frenzies were acted amidst surroundings which turn the brain sick. Women and children sported with death and played with human fragments. A colossal black in two days butchered two hundred victims. The fascinations of these morbid brutalities imposed on even those patriots who were able to reason in their delirium.

The atrocities enacted in Paris were insufficient to satisfy the Jacobins and the multitudes they had excited. Various acts followed which showed too clearly the inclination of the French to propagate their opinions in other countries. In the National Convention, which was called together at the end of September, two members were elected from England, Thomas Paine and Dr. Priestley; the latter declined the nomination, but Paine accepted it, and proceeded to Paris to enter upon his legislative duties. Addresses and congratulations, couched in exaggerated and inflammatory language, were sent to the Convention from some of the English political societies, which laid those societies open to new suspicions; and these suspicions, and the fears consequent upon them, were increased by the successes of the Republican arms and the arrogant tone now taken by the Convention itself. On the 19th of November the Assembly passed by acclamation the famous decree: "The National Convention decree, in the name of the French nation, that they will grant fraternity and assistance to all those peoples who wish to procure liberty; and they charge the executive power to send orders to the generals to give assistance to such peoples, and to defend citizens who have suffered and are now suffering in the cause of liberty." This was a plain announcement of a universal crusade against all established and monarchical governments, and, though itself but an empty vaunt, was calculated greatly to increase the alarm which already existed in this country. The seed which had been sown so widely by Burke's "Reflections" was thus ripened into a deep hatred of France and Frenchmen, which was kept up by the activity of the Government agents throughout the country. Anti-revolution societies were formed, and exerted themselves to spread the flame; and they published innumerable pamphlets, containing exaggerated

narratives of the crimes committed in France, and a variety of other subjects calculated to inflame men's passions in favour of the Crown and the Church. The political societies were described as secret conspiracies against the Constitution, and as the meeting of Parliament approached the Ministers increased the panic by calling out the Militia to protect the Government against what were probably visionary dangers of conspiracy and revolt.

On December 13th the session of Parliament was opened with the evident prospect of a general war; and the King's speech spoke of plots and conspiracies at home fomented by foreign incendiaries, and announced that it had been considered necessary to augment the military and naval forces of the kingdom. The Opposition, which had lost much in numbers, was more moderate than usual in its language; it deplored the occurrence of seditious proceedings wherever they existed, but blamed the Government for magnifying imaginary dangers and for creating unnecessary alarm; it deprecated the haste with which Ministers were hurrying the country into an unnecessary, and probably a calamitous war, and urged the propriety of re-establishing the diplomatic communications between this country and France, with the hope of averting the disasters of war by means of friendly negotiations. All these efforts, however, were in vain; our Ministers rejected the French offers of negotiation with contempt; and at the beginning of 1793, M. Chauvelin, whom the French still considered in the light of an ambassador, was ordered to leave the kingdom. When all hopes of avoiding hostilities between the two countries had vanished, the French Convention anticipated our Government by a Declaration of War on the 1st of February, 1793.

Gillray opposed the revolutionary fever at home and exhibited the true state of things abroad. He was by no means favourably disposed to the war, into which he considered England had been dragged on an insufficient provocation, and without any encouraging hopes of success; it was his aim to illustrate how little glory the nation would derive from a contest of this exasperating nature, which would only provoke the Revolutionists to the ferocity of baffled tigers; he evidently foresaw the conflict was one in which England had much to risk and nothing to gain, while the very difficulties of the situation flattered the prospects of the disaffected at home. Gillray accordingly attacked the hazardous enterprise with all the force of ridicule.

December 19th, 1792. *John Bull Bothered; or, the Geese Alarming the Capitol—*

> " Thus on the rock heroic Manlius stood,
> Spied out the Geese, and prov'd Rome's guardian God."

This was the earliest of a long series of graphic warnings by which the satirist cautioned the people to moderate the warlike inclinations fomented by the Ministers. It represents Pitt working upon the terrors of John Bull, who carries in one arm a gun, while the other hand is deposited in his capacious pocket, and whose whole appearance bespeaks an alarm with the reasons of which he is totally in the dark. That seditious writings had not totally seduced him is evident from the contents of his waistcoat-pockets, in one of which is the so much dreaded "Rights of Man," while the other contains one of the loyal pamphlets, entitled "A Penny-worth of Truth;" his estimate of the danger of cockades is evinced by the simplicity with which he has placed in juxtaposition on his hat the tricolour and the true blue—one inscribed "Vive la liberté!" the other "God save the King!" John Bull and his conductor are placed within a formidable fortification; the latter is looking through a glass at a flock of geese which are seen scattered over the horizon, but which he has metamorphosed into an army of dangerous invaders. The terror of the Minister is exhibited in his incoherent exclamations, a burlesque on his speech at the opening of Parliament: "There, John! there! there they are!—I see them!

A Brace of Alarmists.

—Get your arms ready, John!—they're rising and coming upon us from all parts;—there!—there's ten

thousand sansculottes now on their passage!—and there!—look on the other side, the Scotch have caught the itch too; and the wild Irish have begun to pull off their breeches!—What will become of us, John?—and see there's five hundred disputing clubs with bloody mouths! and twenty thousand bill-stickers with *Ça ira* pasted in the front of their red caps!—where's the Lord Mayor, John?—Are the lions safe?—down with the book-stalls!—blow up the gin-shops!—cut off the printers' ears!—O Lord, John!—O Lord!—we're all ruined!—they'll murder us, and make us into aristocrat pies!" John is alarmed because his master is frightened, but his own plain common sense is only half smothered by his fears: "Aristocrat pies!—Lord defend us!—Wounds, measter, you frighten a poor honest simple fellow out of his wits! gin-shops and printers' ears!—and bloody clubs and Lord Mayors!—and wild Irishmen without breeches—and sansculottes!—Lord have mercy upon our wives and daughters!—And yet I'll be shot if I can see anything myself but a few geese gabbling together.—But Lord help my silly head, how should such a clodpoll as I be able to see anything right?—I don't know what occasion for I to see at all, for that matter;—why, measter does all that for I; my business is only to fire when and where measter orders, and to pay for the gunpowder.—But, measter o' mine (if I may speak a word), where's the use of firing now?—What can us two do against all them hundreds of thousands of millions of monsters?—Lord, measter, had we not better try if they wont shake hands with us and be friends!—for if we should go to fighting with them, and they should lather us, what will become of you and I, then, measter!!!"

The equivocal position was evident to Gillray, and his satires were directed to impress this on the public.

December 21st, 1792. *French Liberty and British Slavery.*—French Liberty is personified by a starved sansculotte, who is warming his feet before a few faggots in a bare garret. The lean features, sunken eyes, lantern jaws, pointed teeth and nails, and lank masses of hair, betray the conventional Frenchman of the satirist. A large cockade is worn on his red bonnet, assignats for three or four sous represent his wealth, while a bundle of raw onions forms the meal he is eagerly devouring. A sword and a fiddle are his sole possessions, and his larder is furnished with snails. This patriot is enthusiastically praising his condition. "Oh! vat blessing be de Liberté. Vive l'Assemblée Nationale! No more tax! no more slavery! all free citizens! ha! ha! How ve live! Ve swim in de milk and honey!"

The French in those days were popularly despised for their poverty, and their food was especially objectionable to English tastes. Dr. Wolcot, certainly a very enlightened observer, and one whose criticisms have been endorsed by posterity, records his own convictions on the subject:—

> "Think not I wantonly the French attack—
> I never will put merit on the rack :
> No—yet I own I hate the shrugging dogs—
> I've lived among them and have eat their frogs!"

British Slavery takes the equally conventional type of a gouty, huge-paunched, red-faced, gormandizing John Bull. The national prototype is seated in an easy-chair in a cosy apartment; he is well clad, and, for comfort, his wig is hung on the arm of his cushioned seat; he is carving a huge slice from a noble sirloin of beef, juicy and smoking, which provokes an appetite even in the picture. A foaming tankard of stout and a decanter of "Hock" support the typical joint. A statuette of Britannia is represented with a sack of "sterling" specie. "Oh! the cursed Ministers," grumbles the alderman, whimsically;—"they'll ruin us with their d—d taxes! Why, zounds! they're making slaves of us all, and starving us to death!"

Towards the close of this year the influx of foreigners into England was remarkable. The greater number of these emigrants were fugitives who had escaped from the turmoil of Paris, members of the aristocracy, the better class of manufacturers, and the peaceful-minded section of citizens, who were happy to sacrifice their possessions for the security of their lives, which were exposed to forfeiture at any hour during the proscriptions in Paris and in other infected centres. No doubt individual emissaries of the Paris Government had also penetrated into London. The Ministers professed to apprehend

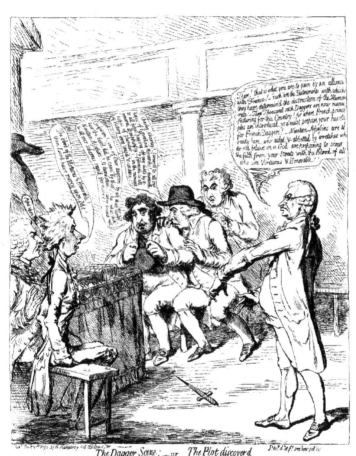

The Dagger Scene! _ or _ The Plot discover'd

disorder from the influx of these representatives of a country which had subverted its Government, laid violent hands on its King, slaughtered the loyal, massacred the professors of religion, and turned liberty into a saturnalia of carnage and lawless passions. The Militia were called out as a precautionary measure, and Earl Granville introduced an Alien Act, empowering Government to dismiss out of the country persons endeavouring to abuse the hospitality of England. The bill passed the Lords, and on the second reading in the Commons Dundas explained its principles, declaring the only object of the Ministry was to secure the safety and tranquillity of the kingdom. Fox denied the necessity of the measure, he attributed the act to the inveterate hostility aimed at the spirit of freedom then springing up. Burke was prepared for the opportunity; his antipathy to the principles of the Revolution had now become notorious. He delivered a philippic against the multifold terrors of Jacobin influence, and, as a grand climax, produced a dagger from his coat, and, dashing it down on the floor of the House with theatrical loathing, went through the oft-quoted dagger scene. This startling exhibition had too much stage effect to produce a respectful impression. It was demanded, in the words of Shakspeare—

> " Art thou but a dagger of the mind, a false creation,
> Proceeding from the heat-oppressed brain ?"

The dagger was of coarse construction, a foot long in the blade and five inches in the handle, and might also serve for a pikehead; its equivocal form suggested a repartee, and the Opposition naturally treated the performance with derision. " You have thrown down a knife," said Sheridan, during a pause; " where is the fork?" This electrified the House with laughter, and weakened the effect of Burke's denunciations. This incident, which is noticed in nearly every history of the time, was a ready-made satire for Gillray's graver. Two days after appeared a pictorial version of the situation.

December 30th, 1792. *The Dagger Scene ; or, the Plot Discovered.*—Burke has dashed down the "Brummagem" weapon; his attitude of nervous scorn is a triumph. The supercilious mouth and the excited features of the orator are given with ludicrous fidelity. The effect upon the House is extraordinary. Ministers and Opposition share the consternation. Readers may consult the speeches put into the mouths of the several actors; Burke's exordium is an admirable parody. He mentioned the circumstance that three thousand daggers had been bespoke at Birmingham, seventy of which were already delivered. It was yet to be ascertained how many of these were to be exported, and how many were intended for home consumption. Producing the dagger, which had been concealed until the effective moment, he threw the weapon on the floor. "This," said he, pointing to the dagger, "is what you are to gain by an alliance with France; wherever their principles are introduced their practices must follow. You must guard against their principles. You must proscribe their persons.' He then displayed the dagger, which he said was never fashioned for fair and open war, but solely for murderous assassination. "It is my object to keep the French infection from this country; their principles from our minds, and their daggers from our hearts." He added, "When they smile I see blood trickling down their faces; I see their insidious purposes; I see that the object of all their cajoling is blood. I now warn my countrymen to beware of these execrable philosophers, whose only object is to destroy everything that is good here, and to establish immorality and murder by precept and example."

Fox, Sheridan, and M. A. Taylor are terror-struck at this denunciation; Pitt and Dundas are virtuously alarmed; while the Speaker has disappeared in the depths of his wig.

It must be confessed, however, that the French democrats on the other side of the Channel, and the demagogues of the clubs on this side, almost daily gave new provocations to justify the conduct of the English Government and the fears which were now spreading universally through English society. It was becoming evident that no country could remain long at peace with the French Republic. In the National Convention on the 28th of September, 1792, on the question of making Savoy into a department of France, Danton declared, amid the loud applauses of the Assembly, "The principle of leaving conquered people and countries the right of choosing their own constitution ought to be so far modified that we should expressly forbid them to give themselves kings. *There must be no more kings in Europe. One king would be sufficient to endanger the general liberty,* and I request that a committee be established

x 2

for the purpose of promoting *a general insurrection among all people against kings.*" It was in this spirit that the Republican Government always made a distinction between the English people and their King and Minister, and showed an inclination to correspond and treat with the people rather than with their governors. It was William Pitt and King George and their aristocrats, they said, who alone were their enemies, it was they alone who made war; and the English people were to be appealed to against them. When General Santerre made his farewell address to the National Convention on the 18th of May, 1793, on his departure to act against the Royalist insurgents in La Vendée, he concluded with the words, "After the counter-revolutionists shall have been subdued, a hundred thousand men may readily make a descent on England, there to proclaim an appeal to the English people on the present war." Similar doctrines were propagated by the revolutionary societies in England, who corresponded with the democrats of Paris as with brothers, and who, in the latter part of 1792, were exceedingly active. Before his election to the National Convention Paine published the second part of his "Rights of Man," in which he boldly promulgated principles which were utterly subversive of government and society in this country. This pamphlet was spread through the kingdom with extraordinary industry, and was thrust into the hands of people of all classes. We are told that, as a means of spreading the seditious doctrines it contained, some of the most objectionable parts were printed on pieces of paper which were used by Republican tradesmen to wrap their commodities in, and that they were thus employed even in wrapping up sweetmeats for children. Proceedings were immediately taken against its author, who was in Paris, for a libel against the Government and Constitution, and Paine was found guilty. He was defended with great ability by Erskine, who, when he left the court, was cheered by a crowd of people who had collected without, some of whom took his horses from his carriage and dragged him home to his house in Serjeants' Inn. The name and opinions of Thomas Paine were at this moment gaining influence, in spite of the exertions made to put them down.

Before the verdict of the judges was pronounced, Gillray favoured the supporters of sedition with a graphic prospect of the punishments reserved for the factions.

December 10th, 1792. *Tom Paine's Nightly Pest.*—The caricature published under this title excited great attention, and numerous copies and piracies attest the popularity of the original, which was remarkably well engraved. Tom Paine is lying on straw; his hands and feet betray the emotions which disturb his slumber; his nightcap is his *bonnet-rouge*, inscribed "Libertas;" his head rests on a truss, bound round with the standard of the Transatlantic Republic, and bearing the words "Vive l'America!" His own worn coat is the only coverlid stretched over the sleeper. In the pocket appears a work on "Common Sense, or Convincing Reasons for Britons turning Sansculottes." Paine's right hand rests on another of his works, "The Rights of Farthing Candles, proving their Equality with the Sun and Moon, and the Necessity of a Reform in the Planetary System." At the head of the bed Fox and Priestley, as two sinister cherubim, are extending their wings over the writer. On a table by his bedside is an inkstand, a candle-end stuck into a gin-measure, and a sheet of paper bearing the title, "The Golden Age, or the Age of Equalizing the Property of Princes and Pikemen." A rat with his head caught in a trap implies the patriot's predicament. A splendid curtain embroidered with fleur-de-lis, the property of despoiled royalty, shuts out the light of the moon, while an imp of sedition is flying from the rude chamber, abandoning the air of "Ça ira" in the alarm produced by the vision which is destroying the tranquillity of Tom Paine's slumbers. Surrounded by an atmosphere of penetrating light which pierces the obscurity of the writer's abode, appears a suggestive trophy of impending punishments. Behind the judicial bar are ranged the wigs of three judges, displaying the indictments on the scrolls: "Charges against Thomas Paine—Libels, Scurrilities, Falsehoods, Perjuries, Rebellions, Treasons, &c. Punishments for Thomas Paine—Corporeal pain, Contempt, Detestation, Extinction from society, &c. Pleas for Thomas Paine—Ignorance, Poverty, Envy, &c." From the centre of the group issues a warning cloud—

> " Know, villain, when such paltry slaves presume
> To mix in Treason, if the plot succeeds
> They're thrown neglected by; but if it fails
> They're sure to die like dogs—as you shall do."

Above are suspended "the cat" and a scourge, the gallows with the noose prepared, and the pillory

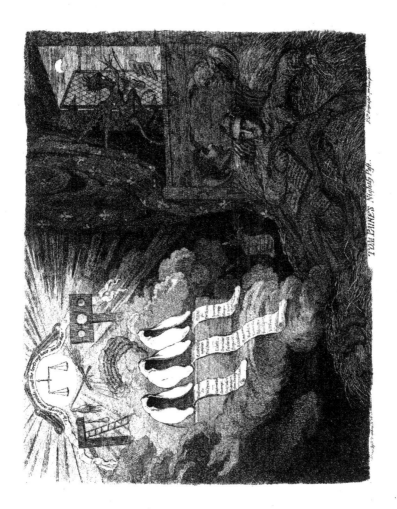

TEN TIMES Nightly!

stand on either side; the scales of Justice appear in a disc of light; the apex of this ingenious structure is formed by pendent fetters and a band bearing these words: "The scourge is inexorable, and the tort'ring hour awaits thee!"

On the 2nd of January another caricature, entitled *Fashions for Ease; or, a Good Constitution Sacrificed for Fantastic Form*, represents Paine fitting Britannia with a new pair of stays. The lady appears to suffer under the operation, and she keeps herself steady by clinging to a ponderous oak. Over the door of a cottage, on one side, is the sign, "Thomas Paine, stay-maker, from Thetford—Paris modes by express." Paine did not venture to return to England, nor did his popularity in France last long; by advocating leniency towards the unfortunate King he fell under the hatred of the violent party, and was soon after thrown into a dungeon by Robespierre and his associates. In his confinement he composed the most blasphemous of his books, the "Age of Reason." An accident alone saved him from the guillotine, and he sought his last asylum

Britannia in Stays.

in America, where he lived many years, to publish harmless abuse of the laws and institutions of his native country.

The extremes resorted to in France rapidly alienated the sympathy of right-thinking men on this side of the Channel. The cause of Reform, which had been urged on for immediate attention, was forgotten or abandoned in the dread which honest patriots experienced of becoming classed with Jacobin agitators. The popular impulse was completely turned by the intemperance of these agitators.

In his speech in court Erskine acknowledged that the voice of the country was against him. The feeling of resistance to Republican propagandism in England had indeed become universal, and the number of loyal societies formed for the purpose of counteracting sedition, and said to have in many instances received direct encouragement from the Government, was increased. Of these the most remarkable was the "Society for Preserving Liberty and Property against Republicans and Levellers," which held its meetings at the Crown and Anchor in the Strand, and which had distributed abroad penny tracts in large numbers. These consisted of popular replies to the insidious doctrines propagated by the disciples of Paine, of encomiums on the excellence and advantages of the British Constitution, of narratives of the horrible atrocities perpetrated by the Republicans in France, and of exhortations to order and obedience. One of the most celebrated and successful of these publications was the tract entitled "Thomas Bull's One Pennyworth of Truth, addressed to his Brother John." These tracts were often accompanied with loyal and anti-revolutionary songs, such as the following, which was one of the most popular:—

"A WORD TO THE WISE.

"The Mounseers, they say, have the world in a string,
 They don't like our nobles, they don't like our King;
 But they smuggle our wool, and they'd fain have our
 wheat,
 And leave us poor Englishmen nothing to eat.
 Derry down, &c.

"They call us already a province of France,
 And come here by hundreds to teach us to dance:
 They say we are heavy, they say we are dull,
 And that beef and plum-pudding's not good for John
 Bull. Derry down, &c.

"They jaw in their clubs, murder women and priests,
 And then for their fishwives they make civic feasts;
 Civic feasts! what are they?—why, a new-fashion'd
 thing,
 For which they remove both their God and their King.
 Derry down, &c.

"And yet there's no eating, 'tis all foolish play—
 For when pies are cut open, the birds fly away;
 And Frenchmen admire it, and fancy they see
 That Liberty's perch'd at the top of a tree.
 Derry down, &c.

"They say, man and wife should no longer be one,—
'Do you take a daughter, and I'll take a son.'—
And as all things are equal, and all should be free,
'If your *wife* don't suit you, sir, perhaps she'll suit *me*.'
 Derry, down, &c.

"But our women are virtuous, our women are fair,
Which is more than, they tell us, your Frenchwomen
 are ;
They know they are happy, they know they are free,
And that Liberty's not at the top of the tree.
 Derry down, &c.

"Then let's be united, and know when we're well,
Nor believe all the lies these Republicans tell.
They take from the rich, but don't give to the poor,
And to all sorts of mischief they'd open the door.
 Derry down, &c.

"Our soldiers and sailors will answer these sparks,
Though they threaten Dumourier shall spit us like
 larks;
True Britons don't fear them, for Britons are free,
And know Liberty's not to be found on a tree.
 Derry down, &c.

"Ye Britons, be wise, as you're brave and humane,
You then will be happy without any *Paine*.
We know of no despote, we've nothing to fear,
For this new-fangled nonsense will never do here.
 Derry down, &c.

"Then stand by the Church, and the King, and the
 laws ;
The old Lion still has his teeth and his claws ;
Let Britain still rule in the midst of her waves,
And chastise all those foes who dare call her sons slaves.
 Derry down, &c."

The success of these tracts was so complete, and the opposition to Government so much weakened, that it began to be believed that the year ninety-two would see the end of faction, and that there would be nothing but unity and loyalty in

"NINETY-THREE.*"

"All true honest Britons, I pray you draw near ;
Bear a bob in the chorus to hail the new year ;
Join the mode of the times, and with heart and voice
 sing
A good old English burden—'tis 'God save the King !'
 Let the year Ninety-three
 Commemorated be
To time's end ; for so long loyal Britons shall sing,
Heart and voice, the good chorus of 'God save the
 King !'

"See with two different faces old Janus appear,
To frown out the old, and smile in the new year ;
And thus, while he proves a well-wisher to crowns,
On the loyal he smiles, on the factious he frowns.
 For in famed Ninety-three
 Britons all shall agree,
With one voice and one heart in a chorus to sing,
Drowning faction and party in 'God save the King !'

"Some praise a new freedom imported from France :
Is liberty taught, then, like teaching to dance ?
They teach freedom to Britons ?—our own right divine !—
A rushlight might as well teach the sun how to shine !
 In famed Ninety-three
 We'll convince them we're free !
Free from every licentiousness faction can bring ;
Free with heart and with voice to sing 'God save the
 King !'

"Thus here, though French fashions may please for a day,
As children prize playthings, then throw them away ;
In a nation like England they never do hurt ;
We improve on the ruffle by adding the shirt !
 Thus in famed Ninety-three
 Britons all shall agree,
While with one heart and voice in loud chorus they
 sing,
To improve 'Ca ira' into 'God save the King !'"

Having mentioned the political caricatures published by Gillray in 1792, it is necessary to glance at the personal and social sketches he produced in the course of the year.

We have noticed Pitt's interposition, in conjunction with Prussia and Holland, in the everlasting Eastern question. Pitt had prepared an armament to enforce his mediation, and to compel the Empress to give up Oekzakow. Fox opposed this policy so successfully that it became a question with Pitt either to abandon his armaments or to resign the premiership. The expedition was sacrificed, but the baffled Minister unhesitatingly asserted that Catharine owed the retention of her conquest to the Parliamentary opposition he had encountered. The Empress was delighted with the results which might be considered due to Fox's powerful eloquence, and his bust was placed in her gallery between the heads of Demosthenes and Cicero. We have already noticed the fashion of comparing Fox to Catiline; Gillray has produced a memento of this circumstance in his *Design for the New Gallery of Busts and Pictures*, published March 17th, 1792.

Between the figures of "Demosthenes against Æschines" and "Cicero against Catiline" appears the bust of Fox, immediately below the imperial crown of Russia, with a design in relief of "Conjugal Love,"

* This song was composed by Charles Dibdin.

SPOUTING.

"Strike home! and I will bless thee for the Blow!"—

a hangman's noose—"A Cure for Hæmerodical Colic." Two pictures appear on the walls—"Justice," representing the Empress disarming the Sultan and seizing sixteen million roubles, and "Moderation," in which she is grasping the provinces of Moldavia, Bessarabia, and Wallachia. The motto to this "Design" is, "And so far will I trust thee, gentle Kate."—*Henry IV.* Some anti-Jacobin lines are added; the concluding verses sufficiently illustrate the subject:—

"Who, then, in this presumptuous hour,	"What chosen name to Tully's join'd
Aspires to share the Athenian's praise ?	Is now announced to distant climes ?
The tool confess'd of foreign power,	Behold to lasting shame consign'd
The Æschines of modern days.	The Catiline of later times ! "

Everything considered, Fox could have well dispensed with the equivocal honour Catharine paid his oratory. This caricature has been dwelt on as it is said to have afforded peculiar pleasure to George the Third, who for many years had regarded the Whig chief as his personal enemy. We have quoted previous instances of this feeling. In 1774 George the Third noticed Fox's impetuosity to Lord North on the vote for committing Woodfall, the printer, to prison, in the following terms:—

"I am greatly *incensed* at the presumption of Charles Fox, in forcing you to vote with him last night; but approve of your making your friends vote in the majority. Indeed, that young man has so thoroughly cast off every principle of common honour and honesty, that he must become as contemptible as he is odious. I hope you will let him know that you are not insensible of his conduct towards you."

On the 24th of February Charles Fox was dismissed from the Treasury Board. It is said on this occasion Lord North wrote him this laconic note : "His Majesty has thought proper to order a new Commission of Treasury to be made out, in which I do not see your name.—NORTH." This ungracious document is said to have been handed to Fox in the House by a Treasury messenger at the very moment he was chatting with North.

May 14, 1792. *Spouting.* "Strike home, and I will bless thee for the blow !"—Fox, in a passion of burlesque frenzy, is menacing with a toy dagger a remarkably rotund lady, so well protected by her own stoutness that it would appear difficult for the instrument to reach a vital part. This portrait, it is agreed, refers to Mrs. Armistead, the companion of Fox's latter career. To the sympathizing heart of this lady did Prince Florizel carry his sufferings when Mrs. Fitzherbert was obdurate, and declined to pity his sufferings under dishonourable conditions. Mrs. Armistead accompanied Fox to Italy, whence he was hurried home to the futile struggles consequent on the Regency Bill. We find portraits of this lady—as Mrs. Fox—at a later period.

A contemporary writer has thus alluded to Gillray's sketch of "Spouting :"—

"This touch of the mock heroic refers to a lovers' quarrel between the Whig chief and his favourite, Mrs. Armistead. Burke's 'dagger-scene was political; Fox's was amatory. There is an excellent portrait of this lady with a child by Sir Joshua Reynolds, which was considered one of his finest examples of colouring."

From Fox and Mrs. Armistead the transition to the Jockey of Norfolk and his favourites is in perfectly natural order. The same month Gillray illustrated the recreations of the "royal" Duke under the title of *La Cochon et ses Deux Petites ; or, Pickings for a Noble Appetite.* Vide Strand Lane, Temple Bar, &c.—The Duke of Norfolk's little dumpling-like person is perched between two superlative beauties, who entirely fill up a capacious sofa. The Duke is clasping the finer lady by the hand ; he is holding a bumper of port, and his official "bâton" is rolling on the floor. The specialities of these truly "great" creatures are indicated by the caricaturist's inscription :—"The Royal Sovereign was formerly to be seen, by all admirers of natural curiosities, at sixpence per head, and is reported to weigh nearly forty stone." Nell, the lighter beauty, is described as "rather under thirty stone ;" but it is hinted that, in the "Great Man's" absence, this lady seeks consolation in the society of Tom Wild, "the celebrated collector on the highway."

These allusions may be deemed in bad taste, but assuming a licence that is inevitable, it is impossible to depict the times of Gillray without a certain candour. The character of Norfolk has been lightly

sketched in these pages. Gillray constantly presents the remarkable Duke as a votary of Bacchus; he is here introduced at the altar of Aphrodite. The Piazza Coffee-house was one of his favourite resorts, and his hospitality was generously exercised in that once-famous haunt of "merry men." After the Duke had emptied his regulation number of bottles, he was accustomed to sally forth in search of gallant adventures; the "royal" Jockey would then be recognised in the saloons of the theatres, or in other public resorts, socially sharing his sofa with a brace of Cyprians, whom he would jocosely toast in his oft-renewed bumpers. The social portrait of the Duke—who inherited a sagacious and cultivated understanding—is neither refined nor reputable. A contemporary writer has added a few details.

"It was said of this hoary debauchee that he did provide, *durante vita* at least, for some few favourite old mistresses; and that an agent at a banker's paid, on a certain day, their quarterly instalments. It is known that on these days the noble Duke commonly sat in the back parlour, and, peeping from behind a curtain, commented on their looks, as they came forward to receive the wages of their iniquity."

The Prince of Wales had once been on the most cordial terms with 'Harry Howard,' the Duke of Norfolk, during the days when the Whigs were doing fierce battle for the Heir-apparent. The Duke quarrelled with 'fine George,' like the rest of the Whig Club, when the Prince exhibited his insincerity, and Thackeray relates a very pretty story of the Prince's hospitality and the gentlemanly feelings he displayed: "A sort of reconciliation had taken place with Norfolk; and now, being a very old man, the Prince invited him to dine and sleep at the Pavilion, and the old Duke drove over from his Castle of Arundel with his famous equipage of grey horses, still remembered in Sussex.

"The Prince of Wales had concocted, with his royal brothers, a notable scheme for making the old man drunk. Every person at table was enjoined to drink wine with the Duke, a challenge which the old toper did not refuse. He soon began to see that there was a conspiracy against him; he drank glass for glass; he overthrew many of the brave. At last the first gentleman in Europe proposed bumpers of brandy. One of the royal brothers filled a great glass for the Duke. He stood up and tossed off the drink. 'Now,' said he, 'I will have my carriage and go home.' The Prince urged upon him his previous promise to sleep under the roof where he had been so generously entertained. 'No,' he said; he had had enough of such hospitality; a trap had been set for him; he would leave the place at once, and never enter its doors more.

"The carriage was called, and came; but in the half-hour's interval the liquor had proved too

A Spencer and a Thread-paper.

potent for the old man. His host's generous purpose was answered, and the Duke's old grey head lay stupefied on the table. Nevertheless, when the post-chaise was announced he staggered to it as well as he could, and, stumbling in, bade the postilions drive to Arundel. They drove him for half an hour round and round the Pavilion lawn; the poor old man fancied he was going home. Fancy the flushed faces of the royal princes as they supported themselves at the portico pillars, and looked on at old Norfolk's disgrace. When he awoke that morning he was in bed at the Prince's hideous house at Brighton."

May 17th, 1792. *A Spencer and a Thread-paper.*—We have already observed that Gillray's sketches of fashion mark the decay of the old days of brocade and gold lace, and the inauguration of the more sombre clothing which has, by gradual stages, been modified into the costume of to-day. When the cocked hat and the full-skirted coat of the earlier Georges declined, the sober splendour of the "Spencer" and the "Thread-paper" astonished the eyes of the uninitiated and rejoiced the hearts of the dandies.

September 14th, 1792. *The Reception of the Diplomatique and his Suite at the Court of Pekin.*— One of the great events of this year was the embassy of Lord Macartney to China. That the objects entertained on the equipment of this mission met with any encouraging success is open to question.

The Royal *Sovereign*, was formerly (to be seen by all admirers of Natural Curiosities) Nell H... s, a very rather stout Thorough-bred, in the dresses of that Great Man, his place is agreeably filled by J. W. & the admirable Theatre in the Highway.

Pub'd May 1791 by H. Humphrey N°: 18 Old Bond Street

Le Cochon et ses deux petits — or — Rich pickings for a Noble appetite. vide. Sinsal Sans. Temple Bear &c &. &c.

It was found that the English were not popular in China, but a considerable amount of information was collected by the mission in spite of unfavourable circumstances; and as China was then almost a *terra incognita*, the observations the travellers were able to make on the country and its customs were welcomed by those at home who desired information. The preparations for the embassy were most carefully deliberated. The ambassador was attended, for dignity of appearance, with a military escort of picked troops, carrying light field pieces; the manipulation of these arms, it was anticipated, might interest the Emperor. The body-guard was commanded by a major and two lieutenants. Draughts-men, secretaries, naturalists, doctors, mathematicians, and interpreters accompanied the expedition. Part of the suite sailed in the *Lion* man-of-war, and the remainder in the *Jackal* brig, her tender. The presents were selected less as valuable trifles and costly " sing-sings" (mechanical toys had already lost their novelty in the Chinese Court) than as representative of the arts, manufactures, and sciences practised in Europe. Among other illustrations of the sciences was a remarkably powerful telescope, the Celestials being known as students of astronomy. A working model of one of the largest English ships of war formed another of the presents. Gilt carriages and sedans were added, as luxuries which would probably meet with favourable attention.

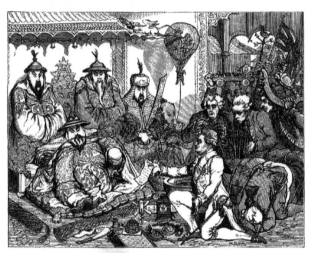

Reception of Lord Macartney and his Suite at the Court of Pekin.

The mission may be considered to have been organized for the benefit of the East India Company. The *Hindostan*, one of the Company's ships, joined the expedition, and the presents were packed on this vessel.

Peter Pindar apostrophized Lord Macartney, the ship, and " Kien Long," the Emperor of China, with his usual humour. We select a few verses of these lyric epistles, in which he prophetically pictures the Emperor's reception of the British envoy :—

Y

" TO THE SHIP.

" O thou, so nicely painted and so trim,
　Success attend our Court's delightful whim ;
　　And all thy gaudy gentlemen on board ;
　With coaches, just like gingerbread, so fine,
　Amid the Asiatic world to shine,
　　And greet of China the Imperial lord.

" Methinks I view thee tow'ring at Canton ;
　I hear each wide-mouth'd salutation gun ;
　　I see thy streamers wanton in the gale ;
　I see the sallow natives crowd the shore,
　I see them tremble at thy royal roar ;
　　I see the very mandarins turn pale.

" I mark, I mark, along the dusty road,
　The glitt'ring coaches with their happy load,
　　All proudly rolling towards Pekin's fair town ;
　And so arriv'd, I see the Emp'ror stare,
　Deep marv'lling at a sight so very rare ;
　　And now, ye gods ! I see the Emp'ror *frown.*

" And now I hear the lofty Emp'ror say,
　' Good folks, what is it that you want, I pray ?'
　　And now I hear aloud Macartney cry,
　' Emp'ror, my Court, inform'd that you were rich,
　Sublimely feeling a strong money-itch,
　　Across the Eastern ocean bade me fly ;

" ' With tin, and blankets, O great King, to barter,
　And gimcracks rare, for Chinaman and Tartar.

" ' But presents, presents are the things we mean :
　Some pretty diamonds to *our gracious* Queen,
　Big as one's fist or so, or somewhat bigger,
　Would cut upon her petticoat a figure—
　A petticoat of which each poet sings,
　That beams on birthdays for the best of kings.

" ' Yes, presents are the things we chiefly wish—
　These give not half the toil we find in trade.'
　On which th' astonished Emp'ror cries, ' Odsfish !
　Presents !—present the rogues the bastinade.' "

" ODE TO KIEN LONG.

" Kien Long, our great, great people, and Squire Pitt,
　Famed through the universe for *saving wit*,
　　Have heard uncommon tales about thy wealth ;
　And now a vessel have they fitted out,
　Making for good Kien Long a monstrous rout,
　　To trade, and beg, and ask about his health.

" This, to my simple and uncunning mind,
　Seems œconomical and very kind !
　　And now, great Emperor of China, say,
　What handsome things hast thou to give away ?

" Accept a proverb out of wisdom's schools :
　' Barbers first learn to shave by shaving fools !'
　　Pitt shav'd our faces first, and made us grin ;
　Next the poor French ; and now the hopeful lad,
　Ambitious of the honour, seemeth mad
　　To try his razor's edge upon *thy* chin.

" Thee as a generous prince we all regard ;
　For every present, lo, returning double :
　　'Tis therefore thought that thou wilt well reward
　The ship and Lord Macartney for their trouble."

According to the handsomely illustrated quarto volumes which were published, under the title of " The Embassy to China," on their return, the interview with the Emperor at Pekin was not a complete success. The Emperor gave instructions that the presents should be so arranged that he might view them without the exertion " of moving his head ;" and having received King George's letter, he returned a gracious answer on yellow silk. He also sent several chests of presents of the useful order, representing the productions of his empire ; and the embassy were not forgotten. This sending of presents was, however, an abrupt dismissal, and the officials hurried the foreigners out of Pekin. Away from the capital they obtained more consideration, and Sir George Staunton, Secretary to the Embassy, was enabled to collect the various materials for the production of his successful work on the subject.

Æneas Anderson, an attaché to this mission, also published an account of the Imperial reception, in which he gives a vivid sketch of the treatment they experienced in the capital. " We entered Pekin like paupers, remained in it like prisoners, and departed from it like vagrants." Gillray's print is a very fine realization of the tableau ; his portrait of Lord Macartney—who was unfortunately suffering from rheumatics during the critical incidents of the tour—is admirable. The prostrations demanded of the suite are well expressed, and the characteristics of the presents, avowedly selected as illustrative of scientific principles, are burlesqued with sly humour. The ignorance of the tastes of the people it was desired to conciliate is conveyed by the selection of gifts—a mouse-trap, a magic lantern, a bat-trap and ball, a windmill, a roulette or E.O. table, a dice-box, an air balloon, a rocking-horse, a weather-cock toy, and a wooden coach and horses. The Union Jack, the cord and bells, and a miniature of the King are appropriately added. Peter Pindar suggested King George should send out some of his Windsor farm produce—a dozen cocks and hens, a pig or two, a brace of turkeys—

" Or possibly a half-a-dozen geese,
　Worth probably a half-a-crown a-piece,
　And that he *probably* may deem enough.—
　Her gracious Majesty may condescend

" Her precious compliments to send,
　Tacked to a pound or two of snuff.
　The history of *Strelitz* too, perhaps ;
　A place that cuts a figure in the maps."

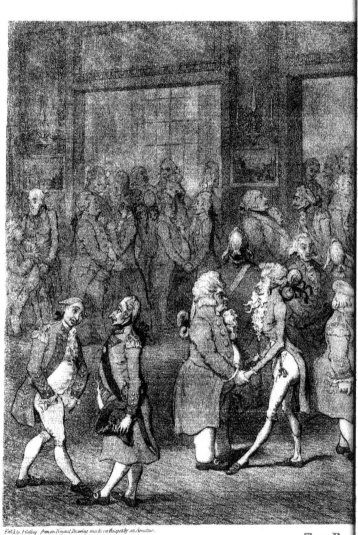

Etch'd by J Gillray from an Original Drawing made on the spot by an Amateur.

The BEN

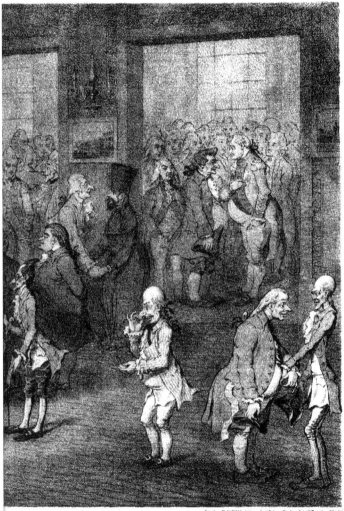

LEVEE.

London. Publish'd Nov'r 9 1795 by I.G. Stacy Graham & by H. Humphrey N.o 66

Alderman Boydell's enterprise is represented by a copy of his " Shakspeare."

Sir George Staunton and Mr. Hüttner, who published his own account of the embassy in German (Berlin, 1797), are the most prominent of the suite. The stolid indifference exhibited on the immoveable faces of the Celestials is discouraging to the unwelcome foreigners. The Emperor's attitude is indicative of contempt. It is said that Lord Macartney had intimated his intention of not conforming to the Chinese etiquette which insists on abject prostrations before the Emperor. When Lord Macartney declined to submit to this ceremonial, as unbecoming of the representative of his sovereign, he was unceremoniously dismissed from the Imperial presence, and was afterwards peremptorily ordered to quit Pekin. The high-class Chinese prejudices against strangers, which have hitherto interposed obstacles in the way of European intercourse with the Celestial Empire, were disagreeably manifested to the early official visitors.

November 9th, 1792. *The Bengal Levee.*—The transition from China to India is comparatively easy. Gillray published a large and very important work under the title of "The Bengal Levee," representing the members of the East India Company in full conclave. Gillray has dated this work from Chelsea, as well as from his publisher's address. The print is executed after the design of an amateur, conjectured to have been General Stevenson. The Governor-General, Lord Cornwallis, is holding a court at the Government House, Calcutta, and no doubt each of the portraits—over fifty in number—represents the characteristic traits of different persons of note engaged in the public service of the presidencies. Colonel Ross, Mr. Wilton, Colonel Achmuty, Mr. Blaquiere, Mr. Ginetti, Sir John Shore, and Mr. Millar are, with the Governor-General, the only individuals identified by name. The print, even in its own day, excepting as a humorous association of caricatured figures, could only have possessed interest for persons connected with the Company's service.

1793.

The interest attaching to home politics in 1793 was almost lost sight of in the excitement attending Continental prospects. The hurried and informal trials instituted by the Revolutionists, ending, in almost every instance, in brutal massacres ; the sanguinary spectacle of a clement and blameless monarch led out to martyrdom by a host of frenzied savages ; the threatening decrees promoting universal anarchy promulgated by the Jacobins ; the astounding success which had attended the revolutionary legions against the trained veterans of ancient dynasties, combined to spread dismay and menace throughout Europe. The operations of the allies in Flanders, where a British contingent, under the Duke of York, had been sent to co-operate with the Duke of Brunswick and the Prince of Coburg ; the forced flight of General Dumouriez into the Austrian camp, after his declaration against the Republic ; and the prospects of foreign intervention held out to the seditious at home, which gradually ripened into a dread of invasion—these were the troubles occupying the attention in 1793 ; and it must be conceded that the terror attending any one of these topics was sufficient to provide the public mind with subjects for a year's reflections.

One of the strongest arguments against the "Friends of Freedom" and the dangers attending any modifications of the legislature was furnished by Gillray in a pair of well-finished subjects, *England* and *France*, exhibiting the most convincing reasoning that could have been advanced in support of the contentment and prosperity enjoyed under a moderate and well-constituted government. England is presented in a truly national picture, the simple happiness of a "harvest home." From the portals of a good old hostelry marches a hearty sample of a jovial host, bearing in each hand a foaming jug of "right October." The village maidens and their gallant swains alternately taste the foaming ale and each other's lips. The reaper returning from his toil, the blacksmith from his forge, and the peasant-maid from her gleaning, all participate in the innocent enjoyments which reward the honest labours of the day. A rich sheaf of wheat is suspended on the inn-sign, in rejoicing for a full harvest, and round it the rustic lads and maidens dance in a merry ring to the music of an old musician's pipe ; a harvest cart and the emblems of husbandry complete the picture, whilst a glimpse of the sea offers a smiling prospect of commerce.

France is represented as a scene of fire, blood, and rapine. A sansculotte is poniarding a venerable

noble, who, despising his own safety, is rushing forward to rescue, by the offer of his purse, his beautiful daughter from the outrages offered by the savage marauders. The château is in ruins, the insignia of rank are defaced, and the more valuable objects are reserved from destruction as booty; axes and daggers are displayed in place of the emblems of industry, and the bodies of two infants are impaled on a spit. The ministers of religion are beaten to death by women armed with the crucifix and with vessels of the altar. The hospitable inn-sign is replaced by a lantern, to which is suspended an entire family, the babe hung round its mother's neck; whilst a gay fanatic, balanced on the lamp top, is fiddling, like Nero, to the flames which are consuming all around.

About this time Gillray strengthened the prejudices he had contributed to awaken by the publication of a remarkable *View in Perspective; the Zenith of French Glory, the Pinnacle of Liberty.* "Religion, Justice, Loyalty, and all the bugbears of unenlightened minds, farewell!" This view in perspective was quickly realized; the prospect held out shortly became a reality. The

anticipation was but little in advance of its fulfilment. " The Pinnacle of Liberty"—a fatally convenient lantern, which, projecting in every street, left the wild democrats no time for reflection and their victims no hope of escape—supports one of the new Apostles of Freedom, who is fantastically celebrating the execution of the *ministers of religion* and of the law. Cardinals, friars, judges, and the sword and scales of justice are suspended alike. Beneath the standard of Equality the fatal guillotine is releasing the suffering Louis Capet from his tormentors, whose red bonnets surround the scaffold. In the distance the destruction of religion is figured in the burning temple. Such were the turbulent spectacles introduced to the nation with the birth of the new year.

Under these circumstances — the people influenced by fear on one side and prejudice on the other—the old popular questions of agitation in Parliament had no longer any chance of success. Economy, liberty, reform were hooted as so many synonyms for spoliation, murder, and republicanism. At the beginning of the year (January 8th, 1793) the history of reform as it would

The Zenith of French Glory, a View in Perspective.

probably terminate—if it were allowed to proceed—was represented in a large print in three compartments. First was " Reform Advised :" the portly figure of John Bull, seated in the midst of comforts, enjoys his beef and plum-pudding, and is only interrupted by three ragged hunters of liberty, who advise him to seek reform. In the second compartment, " Reform Begun," John has entered on the path thus pointed out to him, but the prospect is not encouraging ; he is reduced in his personal appearance, and hobbles forward on a wooden leg; his three advisers have become victorious mob revolutionists : they force him, with daggers and clubs, to eat frogs, a diet to which he has evidently some difficulty in accustoming himself. The movement once begun, John has no longer the power to halt: " Reform Complete" follows, and his three advisers, with the torches of incendiarism blazing in their hands, have thrown him down and are trampling him under their feet.

The Slough of Despond: _Vide. The Patriots Progress._

Such were to be the effects of reform, according to the tracts spread abroad by the Anti-revolution societies; and they inculcated the duty of unbounded gratitude to the Minister then at the helm, who had saved them from such disasters and shielded them against such advisers. It naturally followed that the exertions of the Opposition were not merely futile, but were violently misrepresented. There were numerous secessions from the Whig party, some from conviction, but mostly in consequence of the dismay created by the proceedings of the French patriots. In the caricatures of 1793 the leaders of the Opposition were represented as the advocates of sedition, "English Jacobins;" and they were henceforth pictured as literal and uncompromising sansculottes.

In the debate on the Address from the Throne, Fox's eloquence, in view of his failing hopes, burst forth with warmer feeling and more persuasive eloquence as the complications of his own position became desperate. His party was reduced to a small minority. Gillray took advantage of the evident helplessness in which the great leader was involved by the weakness of his supporters to commemorate his approaching fate in a parody of Bunyan.

January 2nd, 1793. The Slough of Despond; vide, The Patriot's Progress.—Fox, as Christian, is plunged deeply in the slough. The "gunpowder-muzzle" of the Whig chief alone escapes immersion. The new Pilgrim is ragged and unshaven; his hat, with a gay "Ca ira" favour, is already lost in the mire; the "Patriot's Staff—the Whig Club" has floated out of his reach and is sinking; the "Gospel of Liberty," containing the writings of his four evangelists—St. Paine, St. Price, St. Priestley, and St. Petion—affords him no spiritual support. The figure of the Pilgrim is stalwart, but the weight of his pack is beyond all bearing, filled as it is with "French gold, French loyalty, French daggers, and crimes more numerous than the sands upon the ocean shore." His face is turned from the "Patriot's Paradise"—a fortified gate surmounted with the cap of Liberty, enclosing a ladder to reach the emblem of ideal freedom, the rising moon. The Patriot Pilgrim, a "sinner trapped in his sin, sinks into Despondency under the burden of his own wickedness." "Help! help!" cries Fox, in despair. "Will no kind power lend a hand to deliver me? Oh! what will become of me? All my former friends have forsaken me. If I try to go on I sink deeper in the filth, and my feet are stuck so fast in the mire that I cannot get back, though I try. Ah me! this burden upon my back overwhelms me, and presses me down! I shall rise no more! I am lost for ever, and shall never see the Promised Land!" These gloomy forebodings were prophetic of Fox's struggles, and such must have been in all probability the patriot's fate had not the death of Pitt, in 1806, allowed Fox a brief admission to office—the statesman's "Land of Promise."

January 12th, 1793. Sansculottes Feeding Europe with the Bread of Liberty.—This print, in five compartments, represents the propagandism of Republican principles which the French Directory had determined to force on every nation, by invasion, or by encouraging rebellion against existing governments, "until monarchies were extinguished and not a single king remained in Europe." We here learn the practical method of enforcing the bread of liberty on surrounding powers. Holland, a corpulent figure, blindfolded, is being held back by one ragged sansculotte, a second is forcing the objectionable bread at the point of a bayonet; while a third transfers the contents of the Dutch-man's well-filled pockets into his own cap of liberty. Savoy, a stout organ-grinder, is secured by the ears, the bread of liberty is enforced at the point of a spit, and a ragged patriot is taking possession of the Savoyard's instrument. A stronger body of the Republican legions are pursuing Germany and Prussia, flying with broken swords and lowered colours; from the rations of liberty thrust after them at the points of innumerable pikes. Their conversions in Italy are no less expeditious. One half-clad patriot is stamping on the Pope's toe, and with a blunderbuss discharges the bread of

Compulsatory Feeding.

liberty straight into the jaws of the Father of the Church. The papal tiara and St. Peter's keys are secured at the same moment, while the emblematic dove is escaping in alarm. John Bull is attended by his own particular patriots; he is the victim of persuasion rather than force. With

an air of doubtful resignation the national prototype folds his hands and opens his capacious mouth in terror; Fox and Sheridan, veritable sansculottes, are introducing their bread of liberty into the Bull's jaws, at the same time dipping their hands into his pockets.

February 13th, 1793. *A Smoking Club.*—This caricature of the position of affairs in the House of Commons is a clever view of the smoke in which the chiefs of either side freely clouded their antagonists. The Lord Chancellor—Loughborough, who succeeded Thurlow—is seated above the common table (a nice distinction of the Upper House), whilst he is directing a double puff of smoke to either side, in reflective contemplation over the respective inducements of Fox or Pitt, Lord Loughborough having acted with the Whigs before taking office under the Tories. Below the Chancellor, Pitt, seated on the Treasury bench, is directing a prolonged volume of smoke, which passes over his opponent's head, while the stout Fox is discharging a dense cloud full at the head of Pitt. Sheridan and Dundas keep up their cross-fire in equal volleys. Pitt and his colleague have the advantage of keeping the good things on their side. A few pinches of tobacco—the food for smoke—is all that is left for the Opposition chiefs. This print is remarkable for the careful attention Gillray has given to the portraits. The massive nobleness of Fox and the droll vivacious spirit of Sheridan are peculiarly successful.

The trial of Louis XVI. had already taken place; a majority of 7 votes in 727 had condemned the unfortunate monarch to death. One voice, that of the Duc d'Orleans, his cousin, alone drew an exclamation from the King. Had the man either voted for the lesser sentence of banishment, or had he remained silent, the fate of the King might have been altered. After exhibiting the resignation and forbearance of a martyr in the last interviews with his family, Louis XVI. was brought to the scaffold, January 21st, 1793. This last act of vengeance was completed with more solemnity than the Revolutionists displayed either in earlier or later executions. The heavy weight of the responsibility was evident on all sides. The King, who had previously been more remarkable for private worth and virtue than for strength of character, met his death with dignity and calmness. Sixty drummers surrounded the scaffold. The King glanced at the guillotine as he passed, and, turning suddenly, he faced the palace and the side where the greatest body of the populace could see and hear him, and making a gesture of silence to the drummers, they obeyed him mechanically. "People," said Louis XVI., in a voice that sounded far in the distance, and was distinctly heard at the extremity of the square, "People, I die innocent of all the crimes imputed to me! I pardon the authors of my death, and pray to God that the blood you are about to shed may not fall again on France!" He would have proceeded; a shudder ran through the crowd. At that moment an officer of the staff ordered the drums to beat, and a loud roll drowned the voice of the King and the murmurs of the multitude. It is a coincidence worthy of remark that the officer, Beaufranchet, Comte d'Oyat, who gave this order, was himself a natural son of Louis XV. by a favourite named Morphise.

The plank sank, the blade glided, and the head of one of the worthiest of mankind rolled on to the scaffold.

Lamartine, who reasons deeply on this act, thus concludes: "History cannot mistake, amongst all the political consequences of the death of Louis XVI., that there was a power in this scaffold: it was the power of despairing parties and desperate resolutions. This execution devoted France to the vengeance of thrones, and thus gave the Republic the convulsive force of nations, the energy of despair. Europe heard it, and France replied. Doubt and negotiation ceased, and Death, holding the regicidal axe in one hand and the tricolour in the other, became the negotiator and judge between the Monarchy and the Republic—slavery and liberty—between the past and the future existence of nations."

The abhorrence universally excited by this deliberate murder was strongly felt in England. Gillray promoted this feeling by a finely-executed plate (Feb. 16th, 1793), *The Blood of the Murdered Crying for Vengeance.* The guillotine is faithfully pictured, the knife has made its fatal descent, and the head of the King—his features bearing a sad but not repulsive impression—is on the scaffold. An ocean of blood is mounting on high, surrounding the instrument of death, and making this feeling appeal to heaven: "Whither, O whither! shall my blood ascend for justice? My throne is seized by my murderers, my brothers are driven into exile, my unhappy wife and innocent infants are shut up in the horrors of a dungeon, while robbers and assassins are sheathing their daggers in the bowels of my country! Ah!

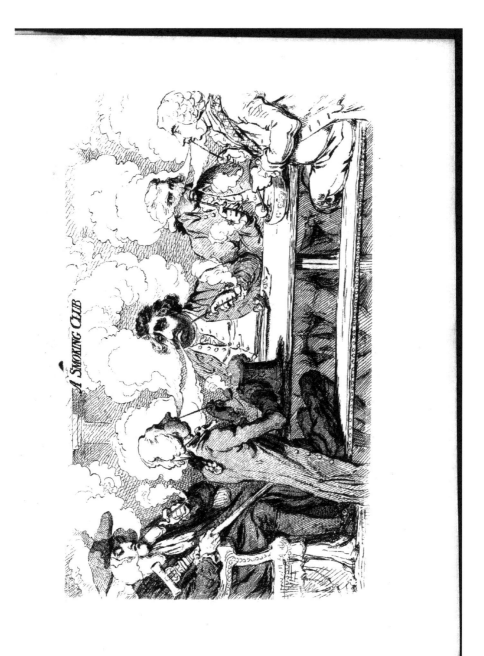

A SMOKING CLUB

ruined, desolated country, dearest object of my heart! whose misery was to me the sharpest pang in death, what will become of thee? O, Britons! vice-regents of eternal justice! arbiters of the world! look down from that height of power to which you are raised, and behold me here deprived of life and of kingdom. See where I lie full low, festering in my own blood, which flies to your august tribunal for justice! By your affection for your own wives and children, rescue mine; by your love for your country, and the blessings of that true liberty which you possess, by the virtues which adorn the British crown, by all that is sacred and all that is dear to you, revenge the blood of a monarch most undeservedly butchered, and rescue the kingdom of France from being the prey of violence, usurpation, and cruelty!"

This appeal, no doubt, assisted to direct the flow of public sympathy towards the unfortunate King, and promoted hostile feelings against his assassins; it certainly helped to disgust the body of the English people with revolutionary proceedings. This ambition to revenge the death of Louis caused the monarch's last wishes to be overlooked. "Humanity towards those who had been his executioners were the dying injunctions of the King, bequeathed to his unhappy family in their sad final interview; repeated in recommendations to sacrifice all vengeance to God, if ever the fickleness of the people, which is the fortune of kings, should place his enemies in their power."

The representation of the guillotine, which is described as "an exact picture of the instrument of refinement in assassination," is correct in every detail. Gillray must have been at some trouble to secure accuracy.

After the execution of the King, any expressions of sympathy with the revolutionary movement were met by the extreme party with the most coarse and indiscriminate attacks. Fox remained faithful to his admiration for the French theoretical state of freedom, recognising, according to his views, that it was through this ordeal—turbulence and cruelty—that good order and universal brotherhood were to be ultimately established in permanence and universally. This attitude provoked the irony of Gillray.

March 1st, 1793. *A Democrat; or, Reason and Philosophy.*—The democrat is, as a matter of course, rendered in the person of the great Whig chief. Fox's hairy, Esau-like frame is liberally displayed in *négligés* as a rabid sansculotte, chanting the democratic burden of "Ca ira," and philosophically expressing his universal contempt by a coarse gesture. On his head is a rapscallion fur-cap bearing the Republican cockade, a black patch is on his temple, his beard is unshaven, and his mouth is coarsely moulded to the expression of the song, and a remarkable likeness of this great man is recognised in spite of the disguise. This portrait is the only instance in which offence was taken by the magnanimous Fox, who, with his own great powers of fancy, never employed "his wit to wound;' he expressed great pain at the coarse treatment the caricaturist and the Pittites had combined to inflict on him in this cartoon. Gillray published, on March 20th, a second portrait, which may be accepted as a companion to the "Democrat," *The Chancellor of the Inquisition Marking the Incorrigibles.* The Chancellor is Burke, who, as we have already found, was generally stigmatized as "the Jesuit," after his open championship for the recognition of the Catholic claims in Ireland. The Chancellor bears a novel purse of office, suspended on hangman's rope, and emblazoned with arms of Gillray's designing. Four skulls adorn the corners, the lion and unicorn support the motto and diadem, while a crown and anchor fills the centre shield. The British Inquisition, which the Grand Inquisitor is entering, exhibits the familiar front of the Crown and Anchor—head-quarters alike of Whig and Tory meetings. A box for "anonymous letters" is suggestively introduced, and Burke is holding a very formidable "Black List;" sourly scowling through his spectacles he is inscribing, in parody of the Black List in Shakspeare's *Richard the Third*, "Beware of Norfolk! Portland loves us not! The Russells will not join us! The Man of the People has lived too long for us! The friends of the people must be blasted by us! Sheridan, Ersk—" the list is unfinished. This satire is aimed, in part, at the Ministerial measures and the associations formed against all political societies which advocated adverse tenets; but its chief force is directed against Burke's zealous support of the party he now served, and the severity he expressed against his old allies "the friends of freedom."

In the same month we find Gillray perplexing his admirers by one of his double strokes, levelled at one party, it is true, but obviously damaging their opponents,

March 30th, 1793. *Dumourier Dining at St. James's, on May 15th, 1793. Vide his own Declaration as Printed by the Anti-levelling Societies.*—The Crown and Anchor pamphlets, promulgating Anti-Jacobin opinions, appear from this satire to have alarmed the public by rumours of the intentions of General Dumourier, and of the immediate destruction of Throne, Church, and State which would come about on his landing in Great Britain.

According to the forebodings of the Loyal Societies—to whom the artist has playfully dedicated his print—Dumourier, the great Republican general, has arrived in England; his ragged sansculotte uniform is suggestive of the miserable levies he had led to victory. The rapacious commander is seated in the old palace of ceremony, the cap of liberty taking the place of the royal arms; coronets and ecclesiastic vessels are employed as utensils of the table. Fox, Sheridan, and Priestley, as Republican cooks, are serving the conqueror with dishes peculiar to their culinary skill, best suited to the appetite of their new master. The head of Pitt, an admirable portrait, nicely garnished with frogs, is held out by his stout rival; Sheridan has made a pretty hash of the crown, while Priestley dishes up the archbishop's mitre. This print is a favourable example of the artist's more careful execution.

Dumourier's proceedings engaged at this date the attention of all sides. He had saved the Republic by his brilliant victories over the Austrians, Prussians, and united emigrants; and in the beginning of 1793 this Proteus puzzled all parties alike by his movements, which were believed to threaten the Revolution; indeed, it had been generally expected that he would have made an effort to rescue the King in January. It soon became evident that Dumourier had contrived an understanding with the Prince of Coburg. Republican commissioners arrested him at the frontier, but he placed them under restraint, and he issued a proclamation proposing the restoration of the constitutional monarchy in the person of the heir to the crown. He had unfortunately acted without securing his position; the Versaillists turned their guns against the General, who escaped over to the Austrian lines. The Convention set a price of 300,000 livres on his head. Dumourier retired to Brussels, thence to Cologne, and through Switzerland. He arrived in England in June, but Lord Grenville ordered him to quit the kingdom in forty-eight hours. The restless activity of the General was distrusted at home. It appears, however, that he received a pension of 1200*l.* from the British Ministry. His life, which was prolonged to the age of 85, was tormented by disappointed genius; he tendered his advice on every war which harassed the Continent, and his experience and assistance were disregarded by every power. He left Hamburg, where he had lived for many years, when Napoleon threatened that city, and returned to England, residing tranquilly at Turville Park, near Henley-on-Thames, until his death in 1823. Dumourier, as an exile, witnessed the rise of Napoleon, his great successor; he saw this Phœnix soar higher than his own ambition had planned; he lived to witness his triumph over the very parties which had defeated his own aspirations; he wrote against Napoleon as Emperor, and actively communicated plans to the English and to their Spanish and Portuguese allies; it was his fortune to see even Napoleon's proud head brought down, and the edifice of the Corsican's ambition crumble as his own projects had fallen in '93. He outlived Napoleon; his death occurred only one year before that of Louis the Eighteenth, whose house he had plotted to restore.

Gillray's appreciation of Pitt's courage and skill in steering the threatened bulwark of the Constitution through a safe channel between the imminent extremes which menaced Britannia's tranquil course is expressed in a beautiful allegory, which assisted to bring the objects the artist symbolized as dangerous into disfavour, while it contributed to that unquestioning confidence which was afforded to Pitt in an exceptionable degree, until he became the most trusted statesman of all time.

April 8th, 1793. *Britannia between Scylla and Charybdis; or, the Vessel of the Constitution Steered Clear of the Rock of Democracy and the Whirlpool of Arbitrary Power.*—Pitt, "the pilot that weathered the storm," is steering Britannia, in *propria personâ*, through the treacherous waters, seated in that compactly built craft, the British Constitution. The undue influence of the Crown is represented as the Whirlpool of Charybdis, which is surging in fatal circles; but Britannia regards them not; her fears are all absorbed in contemplating Scylla, the jagged and mischievous rock of the Republic, having a red cap as its beacon, while the angry billows beat a tempest around it. The dogs of Scylla, ready to absorb the victims who are broken on their rock, present the features of the political trio—Fox, Sheridan, and

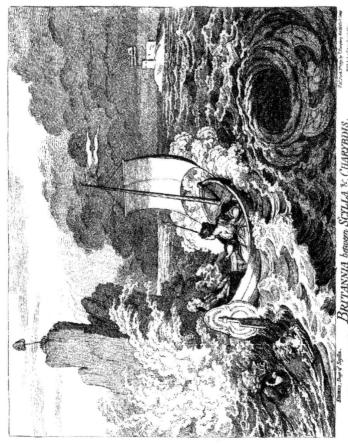

Scylla, Dog of Scylla.

BRITANNIA *between* **SCYLLA** & **CHARYBDIS.**

or . The Wreck of the Constitution steered clear of the Rock of Democracy, and the Whirlpool of Arbitrary Power.

Priestley. Pitt is resolutely holding his helm, undismayed by the surrounding difficulties; his face is turned from the sharks, whose advance is baffled by the swiftness of his course, and his gaze is fixed on the tranquil waters beyond, gilded by the sun and sheltered within the haven of public safety.

The Reign of Terror which now prevailed in France was but too vivid a commentary on these exaggerated representations of the dangers of political innovation. Nevertheless the war in which this country had engaged was far from being popular. It was soon seen that our Government had hurried into it without being well prepared for hostilities, and that they carried it on without much skill. Proceedings on both sides were for awhile guided almost more by accident than by design, and a considerable diversion was made at the beginning of April by the defection of the French commander, Dumourier.

Gillray consistently deprecated warfare and bloodshed. He felt, with the less enthusiastic section of the community, that it was sufficient for England to extend her naval co-operation to the allies; as mistress of the seas her empire was almost invulnerable; to expose troops to defeat was impolitic, and the danger of sending an army out of the country at a very critical moment was treated by the caricaturist as an unwise venture. The commander-in-chief, though deservedly popular as a brave and noble-hearted soldier, was not esteemed an experienced leader by the majority at home. The invasion of Holland by Dumourier, owing to the close and essential connexion then existing between the Dutch and England, produced much the effect of an attack on our own shores. It amounted to a declaration of war against England. A British contingent was immediately sent out to co-operate with our German allies then forming the grand army under the Prince of Saxe-Coburg. The Duke of York was assisted in his command by Sir Ralph Abercrombie, Sir William Erskine, and other officers of distinction. The earlier operations of the campaign were eminently successful. The French were driven out of Holland, and Dumourier's army began to exhibit symptoms of that disorganization which preceded the General's defection. The crowning success of the Duke's army was reached in the siege and capture of Valenciennes, the stronghold of the North. The combined valour was conspicuously manifested on this occasion, and had the success been followed by the much-talked-of "march to Paris," it appears from subsequent knowledge that this determined step would have finished the war at one stroke. No force interposed between Valenciennes and the very throne of Revolution. "Paris lay in helpless terror; the Republicans saw the sword of Europe flashing in their eyes; the peasantry were alienated by the merciless extortions practised under colour of the law; the friends of the deposed Government, still powerful, were prepared to aid the blow that was to crush the head of the tyranny; but the time for the deliverance of Europe was not yet at hand." When the critical moment had been past without the allies following up their advantage, they laid siege to Quesnoy, and finally concentrated their forces for the investment of Dunkirk, a fatal step which reversed their successes and proved the salvation of the Republic. Fortune, which is seldom offered a second time, was lost. France had recovered from her terror; the Jacobin Government, reprieved, had concentrated all its energies and roused the wildest passions of the Revolutionists; their fanaticism was never equalled; the calm contempt of death and the unity of action were such as history seldom repeats; the "levée-en-masse" met an enthusiastic response, the Republic was saved, and the invaders were hurled from France, pursued far into their own fastnesses, and in their turn became assailed.

We have been compelled to trace the outlines of the famous "campaign in Flanders" thus far to illustrate the impulse which guided Gillray in the caricatures published on these events. The artist was familiar with his subject. He was travelling in Flanders at the time, producing portraits of the commanders and studies of the soldiers engaged in the siege. A few weeks before Valenciennes fell Gillray expressed the popular view of the scenes then enacted in the Low Countries in his famous picture of the *Fatigues of the Campaign in Flanders*, published May 20th, 1793. The Duke of York, as commander of the expedition, is enjoying in his tent the relaxations of martial life. His sword is in the possession of one of the spherical beauties of the country, whom he is pledging in a bumper. The Duke is seated on a drum, his foot rests on the torn ensign; the muskets are tied up in bundles, and their owners, the British Foot-guards, lean and hungry veterans, are impressed into the service, bearing the arms Bacchus employs to vanquish his thousands—bowls of punch, flasks of spirits, and the

z

accompaniments of a carouse. The black cymbal-player who for many years was a conspicuous personage in the Guards is clashing his instruments, a piper discourses shrill notes, and with the royal trumpeters contribute to give a noisy splendour to the orgies. The British leaders are all combining love and wine. Our foreign allies are struck off with especial discrimination. The Dutch General, provided with schnapps and tobacco, appears calmly unconscious of his neighbours, while a Prussian hussar, one of those savage troopers whose onslaughts were ever a terror to the French legions, is seated on a dismantled cannon, drinking ardent spirits from a bottle's mouth. His naked sword is laid on the table, having been employed to slice lemons for the Duke's punch. This picture, though from an obviously extreme light, is valuable on grounds beyond its humour. The uniforms are all careful and correct, and illustrate the exterior figure of war in '93. The costumes and characteristics of the Flemish graces are of the most truthful type; the florid beauties of this class are perpetuated in our own day, their tastes but slightly modified by time.

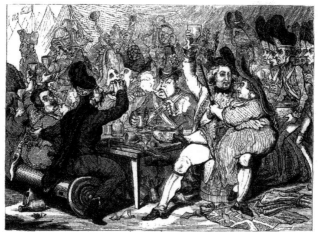

Fatigues of the Duke of York's Campaign in Flanders.

Before we take leave of Gillray in Flanders, and resume the thread of political caricature, we introduce two social sketches produced on this tour.

Flemish Characters tells the story of Belgian life in 1793; the habits of the people bear the same relation to the past which may be noted in our own time. It is Sunday in some quaint city, ancient at the publication of the print; the old Flemish ladies are wending their way to Mass, their persons decked out in the holiday finery of elaborate caps, lacquered pins, great gilt beads, and solemn cloaks, much as they may be seen to this day. A Sunday-school of girls, clad in wooden shoes and black caps, is soberly entering a church under the escort of a rotund matron, who is carrying her breviary and wears a birch at her wrist. The rude sculptured Crucifixion and the black-clad nuns belong to all time.

In the second portion of the "Characters" we have a Flemish town exhibited on a busy day. Five priests dressed in the habits still worn are eagerly reading the news from one sheet; all their hands are

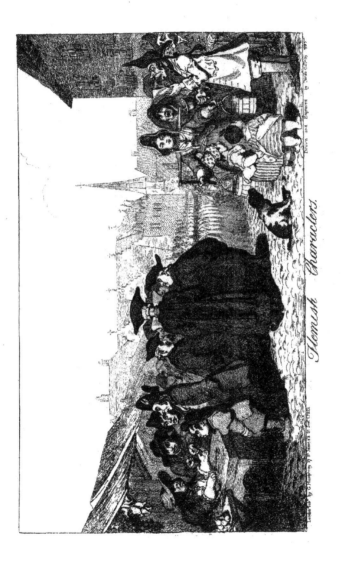

Homish Characters.

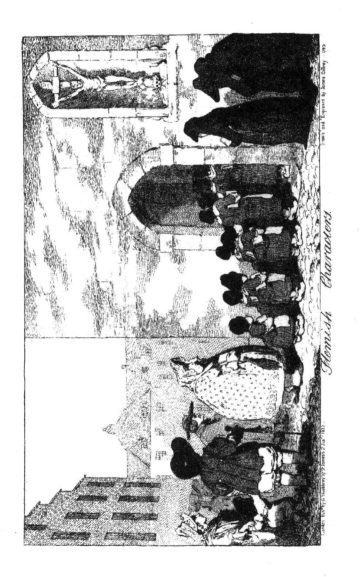

Characters

Flemish

crossed behind their backs in the favourite meditative attitude of ecclesiastics. The male folks appear in the habits of the Georgian era. A bellman is holding forth most comically, and the interest expressed on the faces of the little boors is repeated in the features of their dog. A quaintly-clad milk-maid justifies the proverb "Formosis Bruga puellis." There are stalls for fish and fruit, and round them gaze the rustics; a fat woman is encouraging their gambling propensities with the old table and revolving arrow common at fairs. More priests are seen in the distance, and a monk is paying tender attentions to a fair novice. The British Grenadiers are seen in the "grande place," drawn up under the union-jack.

Gillray's convictions were very positive against military ardour; he did the community no mean service by his pictorial sermons against the warlike fervour which was overrunning the Continent and extending its excitement to our peaceful shores. That peace is prosperity, that war means misery and absolute ruin, were the principles Gillray laboured to teach; one of the best comments on the frivolity of martial aspirations was published by him, in ridicule of the warlike politics of 1793, and of the small gain John Bull was likely to realize for his sacrifices.

June 3rd, 1793. *John Bull's Progress. John Bull Happy.*—The British farmer appears as the hero of a domestic picture, comfortably enjoying his afternoon nap in his arm-chair near the chimney-corner; in his hand is a jug of good "home-brewed;" his hearth gives shelter to a cat and dog, and a magpie in its wicker cage is the toy of his chubby children. Mrs. Bull is spinning industriously, and Dolly, her pretty daughter, has returned from milking the kine.

John Bull Going to the Wars.—The national prototype has become infected with the soldiering mania. His broad back is turned on his peaceful cot, and he is strutting off to imaginary glories, relinquishing for an empty skeleton the substantial happiness within his reach. Though John Bull is admirable as a farmer, he does not appear so well suited for soldiering. He is marched off in the awkward squad. Mrs. Bull is endeavouring by tears, entreaties, and gentle force to detain this ardent warrior; his round-headed boys hang on to his coat-tails, while Dolly's gaiety has forsaken her utterly.

John Bull's Property in Danger.—Mrs. Bull, among other sufferings, is compelled to give her little all to support the war which has taken away her breadwinner: her spinning-wheel and all the household belongings are brought to supply "the Treasury." Dolly is obliged to relinquish her churn, one child is bringing his magpie and cage, and his elder brother bears the rake, fork, spade, and kettle, indicating that husbandry is suspended; and a pig, the last of the live stock, is led into the all-absorbing Treasury gate, over which is inscribed—beneath the triple Lombard balls—"Money lent by authority." The walls are placarded with a "List of Bankrupts" and " Wanted a Number of Recruits," inevitable accompaniments of warfare.

John Bull's Glorious Return.—John Bull, no longer recognisable, has returned, a discharged and tattered mendicant; his frame is emaciated, he walks on crutches, a leg and an eye are both missing. He has begged his way to his former happy home. The cottage is in ruins, his family half-clad and almost famished. His children are reduced to feed on raw turnips, and everything betokens the last stage of abject misery.

Gillray drew such pictures as these from no fancy theories; they were not the distortions either of party or prejudice; they came from an undeniable source of truth. James Gillray the father, as we have already described, had himself experienced this fate, returning from Flanders under parallel circumstances—much as history repeats itself—from the earlier campaigns on those same battle-fields, relinquished by Cumberland at Fontenoy and Closterseven. The elder Gillray, whose life was spared to enjoy his son's reputation, had practically impressed the younger James with the emptiness of glory in his own person: he had returned a beaten and broken man, crippled at the age of twenty-five.

At home the Ministry managed everything according to their own wishes; their acts were endorsed by the national approval, and the terrors of anarchy had already frightened the captious into blindfold confidence. The Government strength increased, and in proportion the Opposition prospects grew more gloomy.

Fox's private circumstances were, in the meantime, becoming more and more embarrassed, and the great statesman—for great statesman he certainly was—was reduced to a condition of absolute poverty.

z 2

He was obliged for awhile to resign even the trifling luxuries of life, and it was doubtful if he would not be compelled to retire from public business. His friends, however, interfered, and in the summer of 1793 a meeting was held at the Crown and Anchor to take his distressed condition into consideration. The popularity which he still enjoyed was proved by a large subscription, with which an annuity was purchased for him. His enemies laughed at his wants, and mocked the charity by which he was supported.

Gillray embodied these sentiments in a caricature published June 12th, 1793—*Blue and Buff*

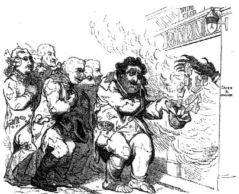

Blue and Buff Charity. The Greek Patriarch Relieved.

Charity; or, the Patriarch of the Greek Clergy Applying for Relief.—The secretary of the Blue and Buff Charity Committee was Mr. Hall, formerly an apothecary in Long Acre, known politically by the sobriquet of "Liberty Hall." He is represented in the caricature as a ragged personage, with a phial in his pocket containing poison for Pitt.

The chairman of the committee for raising a pension for "the champion of liberty," Mr. Sergeant Adair, in the person of the Evil One, is doling out to Fox a bundle of unpaid bonds, dishonoured bills, forged notes, gambler's notes, Blue and Buff bonds, forfeited mortgages, and valueless securities. The recipient is extending a red bonnet for these provisions with one hand, while the other grasps a dagger. In Fox's pocket are his late resources, the cards and dice-box. Others of the party are ranged behind— Sheridan, as a sansculotte highwayman, M. A. Taylor, and Horne Tooke; in the second rank are "Liberty Hall," Dr. Priestley, Earl Stanhope, &c.

The portraits given in this caricature are remarkably faithful, and not only are the persons of the principal actors most skilfully burlesqued, without sacrificing the resemblances, but the speeches made on the occasion are also travestied, still preserving their original characteristics. "Dear Sir," observes the dark benefactor, "seldom have I experienced more heartfelt pleasure than now in executing the wishes of my committee; I flatter myself you will not be displeased with this convincing proof of the esteem of so many and so honourable persons, who, far from imagining they are conferring any obligations upon you, will think themselves honoured and obliged by your acceptance of their endeavours to be grateful for your unremitted efforts to effectuate the *Grand Object* they have so deeply at heart."

Fox is returning his thanks becomingly. "You will easily believe it is not mere form of words when I say that I am wholly at a loss how to express my feelings upon the charity which you are in so kind

a manner showering upon me. In my wretched situation, to receive such a proof of the esteem of the committee, to be relieved at once from contempt and beggary! for such as me to receive a boon which even the most disinterested would think their lives well spent in obtaining, is a rare instance of felicity which has been reserved for me. It is with perfect sincerity that I declare that no manner in which a charity could have been bestowed upon me would have been so highly gratifying to every feeling of my heart," &c.

Sheridan, impatient for his turn, is fawning on the dark personage, and hurries Fox. "Make haste, Charley! for I long to have my turn come on! I have been a Greek emigrant a deuce of awhile, and relief could never come more seasonable; and here's our little chicken (the Law-chick, Taylor, M.A.) wants to peck up a little corn; and our old friend, Blood and Brentford, the orthodox parson (Horne Tooke), swears he has a right to a particle. Here's Clyster-pipe expects to be paid for purging administration; and old Philogistic, the Hackney schoolmaster (Dr. Priestley), expects some new Birmingham halfpence; beside ten thousand more with empty purses—lads fit for any enterprise, who only want engagement, but cannot get a crust before you are served! Make haste, Charley, make haste!"

The French Revolution was still raging to a constantly increasing state of fever. The Reign of Terror was decimating its victims. The bloodhound Marat, with disordered mind and diseased body, was fomenting the worst passions of the people; his denunciations shed torrents of blood, and when his debilitated frame no longer admitted his yelling forth the names of his victims, his activity became more frantic in the proscriptions issued from his press. Marat, with his violence and fanaticism, had become the destiny of the Revolution. His sinister name was a horror in France; in England he was talked of as some leprous ghoule; and when Charlotte Corday relieved the world of this monster it seemed as if a cloud of blood was withdrawn.

"It would seem," writes Lamartine, "that Providence deigned to disconcert men and events by throwing the arm and life of a female athwart the Revolution, as if it designed to mark out the greatness of the deed by the weakness of the hand, and took pleasure in contrasting two species of fanaticism in bodily conflict—the one beneath the hideous guise of popular vengeance, in the person of Marat; the other under the heavenly charm of love of country, in a Jeanne d'Arc of liberty: each, notwithstanding, ending, through their mistaken zeal, in murder, and thus unfortunately presenting themselves before posterity, not as an end, but as a means—not by the aspect, but by the sword—not by the mind, but by blood!"

The romantic story of Charlotte Corday is well known; history has recorded her resolution, her appearance in Paris, how she procured as her only weapon a common knife, and finally obtained access to Marat's house.

It is familiar that the unhappy wretch was in his bath; his offensive body reposed, but his mind was allowed no leisure. His strength was decaying rapidly, but his denunciations had increased in proportion, as if he dreaded leaving a single victim unbutchered ere his body was left to final decay. Marat was writing to the Convention when Charlotte entered, demanding the proscription of the last Bourbons tolerated in France. The materials lay on a rough plank disposed across his bath. The demagogue questioned his assassin on the state of Normandy; he inquired the names of the deputies who had taken refuge at Caen. She gave them to him, and he wrote them down, saying, in the voice of a man sure of his vengeance, "Well, before they are a week older they shall have the guillotine!"

These words appeared to awaken the determination of Charlotte Corday, who acted immediately before and after the deed like one in a trance; and the knife was produced from its sheath and driven with superhuman force to the hilt in Marat's heart.

She made no effort to escape, but stood as if petrified. She was seized, and would have been rent in pieces by the mob but for the guards. "Poor people!" she said, to the furies who were raging for the loss of their "friend." "You desire my death, whilst you owe me an altar for having freed you from a monster. Cast me to that infuriated mob," she afterwards cried to the soldiery; "as they regret him they are worthy to be my executioners."

Paris was overwhelmed with stupor on hearing of this deed. It seemed as though the Republic was thunderstruck, and that dire events must spring from Marat's murder. In London the excitement

was almost as intense. The sacrifice was a fancied prelude to the death of the tyrants who had slain their King, and sympathy with the Spartan murderess was openly and earnestly expressed on all sides at home.

Gillray availed himself of the contrast presented between the appearance of the young and beautiful

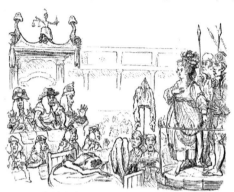

Charlotte Corday on her Trial before the Revolutionary Tribunal.

Charlotte Corday, her hideous victim, and the ruffian-like tribunal which she amazed by her intrepidity. He prepared a cartoon in which English compassion was secured for the accused, and the repugnance attached to murder was directed against her accusers. On the 29th of July, Gillray published his print of "*The heroic Charlotte la Cordé* upon her Trial at the bar of the Revolutionary Tribunal of Paris, July 17th, 1793, for having rid the world of that monster of atheism and murder, the regicide Marat, whom she stabbed in a bath, where he had retired on account of a leprosy with which Heaven had begun the punishment of his crimes."—"The noble enthusiasm with which this woman met the charge, and the elevated disdain with which she treated the self-created tribunal, struck the whole assembly with terror and astonishment."—The artist has recorded the following speech, which was most probably assigned to Charlotte Corday in contemporary accounts: "Wretches! I did not expect to appear before you. I always thought that I should be delivered up to the rage of the people, torn in pieces, and that my head, stuck on the top of a pike, would have preceded Marat on his state-bed, to serve as a rallying point to Frenchmen—if there are still any worthy of that name. But, happen what will, if I have the honours of the guillotine and my clay-cold remains are buried, they will soon have conferred on them the honours of the Pantheon, and my memory will be more honoured in France than that of Judith in Bethulia." Charlotte Corday met death with noble fortitude. The scene was signally impressive. A terrific storm burst over Paris, and in the excitement it appeared as if the elements were appointed to put an end to the Reign of Terror.

We have noticed the disasters which the allied armies suffered as a chastisement for their questionable policy after the capture of Valenciennes. It was felt after these reverses that the sole reliance of England was once more concentrated in the navy; but success seemed for awhile to have forsaken even our old safeguard, the fleet. Lord Howe had cruised the sea for some weeks, but the squadrons of the Republic were allowed to remain in security. An outcry was raised against the "Black Admiral" on the grounds that he had put into Torbay at the moment he ought to have been watching Brest harbour to intercept the French fleet. It became a popular toast at political meetings, "Lord Howe—let him be toasted in port." Party feeling, as we have already traced, biassed every undertaking.

" Howe, the Prince of Dusky Bay,"* known well for his saturnine complexion, repelled friendship and was universally unpopular. Gillray, who had often levelled his satiric shots at the First Lord, embodied the general impression.

December 10th, 1793. *A French Hailstorm, or Neptune Losing Sight of the Brest Fleet.*—Howe, in his admiral's uniform, appears in Neptune's shell-like car. The French fleet is gaining the security of Brest harbour, but Neptune's dolphins are driving in an opposite direction to Torbay. Howe has been obliged to turn his back on Brest; a shower of golden pieces, blown by red-bonneted cherubim, is irresistible. This pactolean stream is so skilfully directed that the Admiral is obliged to protect his eyes, while the tide of gold, beating into his pockets, overflows his coat-tails and fills his car; the union-jack, secured to Neptune's trident, is completely riddled with the golden shots.

"Zounds," cries the Commander, " these d—d hailstones hinder one from doing one's duty ! I cannot see out of my eyes for them. Oh ! it was just such another cursed peppering as this that I fell in with on the coast of America in the last war ;—what a deuce of a thing it is that whenever I'm just going to play the devil, I am either hindered by these confounded French storms or else lose my way in a fog !" The warlike ardour was much damped by these reverses, until enthusiasm was revived and Lord Howe raised to universal favour by the glorious victory of the 1st June, 1794. The social sketches of this year are insignificant, the great events then playing out on the Continent rendered the trifles of the day insipid and unworthy of attention.

We find Gillray satirizing the provisions for the comforts of our army during the approaching winter.

November 18th, 1793. *Flannel Armour; Female Patriotism, or Modern Heroes Accoutred for the Wars.*—It appears that the ladies of Great Britain contributed their patriotic assistance to the clothing department in view of inclement weather. This solicitude for the comfort of the soldiers, who were esteemed as hardy veterans, provoked much sly mirth. Gillray has designed some highly fashionable beauties enclosing their favourite commanders in clumsy flannel coverings.

In 1793 Lady Cecilia Johnston again became the target for a sly shaft. She was represented as *A Vestal of '93 Trying on the Cestus of Venus.* The whole design, which is intended as " a reproduction of a basso-relievo lately found among some fragments of antiquity," is modelled on the classic school. Lady Cecilia Johnston is seated on an ottoman ; in her pocket appears Ovid's " Art of Love ;" behind the lady lies the altar of Vesta, overturned, but still smoking ; a Cupid, with his quiver reversed and the arrows tumbling out, is encircling the vestal with the cestus of Venus :—

> " Upon her fragrant breast the zone was brac'd ;
> In it was ev'ry art and ev'ry charm
> To win the wisest, and the coldest warm."

This cestus is " a pad," an abused fashion then at its height ; an attendant love is assisting to adjust this monstrosity, while another messenger of delight is supporting a mirror, in which the weird vestal is surveying her awkward transports. The incongruity of this subject is explained by the circumstance that the vestal was designed for another lady, but Gillray thought proper to efface her features, and, unwilling to sacrifice his plate, he etched the likeness of his favourite butt and published the print in this complicated state.

Gillray's motives for these repeated attacks in this quarter must be left to conjecture; such persistence is perplexing. The lady's reputation was under redoubtable protection. Her husband, General Johnston, enjoyed the reputation of being the handsomest man and the best swordsman in the army, and his exploits and rencontres of the martial order were of notorious frequency.

1794.

The caricatures published by Gillray in 1794 were neither numerous nor important. A few social sketches, more burlesques of extreme fashion, and two notable political cartoons represent the year.

* Howe's grandmother was a natural daughter of George the First.

The war in Flanders was proceeding unsatisfactorily. The Duke of York had left his army in Ghent, and returned to England to concert measures for the ensuing campaign.

Gillray illustrated the illusory nature of the advantages secured hitherto by a bold and well-founded caricature, published February 10th, 1794, as *Pantagruel's Victorious Return to the Court of Gargantua after Extirpating the Soup-Meagres of Bouille-land.*

The Duke reached London on the 7th February; and the condition in which the satirist has made the commander appear exhibits the opinion popularly conceived of his conduct of the war. The glorious results originally anticipated, and the nature of those obtained, justified the satires of Gillray and the comments of the dissatisfied multitude. The Duke of York is reeling into the royal presence with the inconsequential spoils he has captured; he is handing the keys of Paris to the occupant of the Throne. "Th—th—th—there's Paris for you, damme," hiccups the royal soldier; "did I not say I'd take it? that's all,—a—a—and here's all the plunder of France, and all the heads of the whole nation of sansculottes, damme. If y—y—you will do me any honour, why do it; if not, why, even take the next Paris yourself, damme. Look'e, I expect to be made either a Cæsar or an Alexander, d—d—damme!" George the Third, who is drawn in hunting-garb, to imply that State affairs were not his favourite pursuit, is extending both hands to his dearest Frederick, exclaiming in admiration, "What, what! keys of Paris! keys of Paris! give us hold! Gads, bobs, it's nothing but Veni with you, lad, hay? Veni, vidi; ay, ay; Veni, vidi, vici! ay, ay?" Beside the throne are three huge money-bags, "for horses, hounds, and other knicknackeries." Pitt, seated at his master's feet, is counting up the expenses of the Duke's expedition and of the foreign subsidies; he is proposing taxes on bricks, rum, brandy, water, air, &c., to raise the necessary supplies; "new taxes not to be felt by the swinish multitude." This phrase, incautiously declaimed by Burke in one of his grandiloquent denunciations of democracy, was turned to liberal account by his opponents; it became a watchword among the ultra-reformers. It occurs in various forms in later cartoons.

Behind the throne Queen Charlotte is literally in her "counting-house," surrounded with money-bags; the Father of Evil is gratifying avarice with fresh contributions. An adjutant is bringing in the authentic journal of the successes obtained; he cries, "Here's something like a list of glorious actions! Well, let them that come after us do as much as we have done, and the campaign will soon come to a conclusion." Heads, broken swords, guns, and more equivocal trophies represent the spoils. One trooper is bearing a huge pack of "breeches of the sansculottes;" another brings the "wooden shoes of the 'poissardes;'" while a third is carrying heavy packets of "assignats," a paper currency regarded in England with peculiar contempt.

Towards the middle of 1794 France, by immense exertions, had rendered herself a formidable enemy to the rest of Europe, and England at length was seized with the fear of invasion. Within a few months, indeed, the French had invested, with success, nearly every country that bordered upon the French territory. Howe's victory of the 1st of June came fortunately to support the spirits of Englishmen, who, however, had already become tired of the war. The Opposition in Parliament now raised their heads with exultation, and accused the Government of rashness and imbecility. The Ministerial party subsidized abroad and raised soldiers at home, and they affected to laugh at their Parliamentary opponents as a parcel of quacks, who thought they possessed a nostrum against all the evils with which the country was ever threatened. This nostrum, they said, was Charles Fox, to be applied as Prime Minister. It was an old superstition among the people of Naples, when their fearful neighbour Vesuvius burst into eruption, to bring forth the head of their patron saint, Januarius, and hold it forth as a safe shield against the danger. According to Peter Pindar's version—

> "When Mount Vesuvius* pour'd his flames,
> And frightened all the Naples' dames,
> What did the ladies of the city do?
> Why, ordered a fat cardinal to go
> With good St. Januarius's head,
> And shake it at the mountain, 'midst his riot,

* See Sir William Hamilton's account.

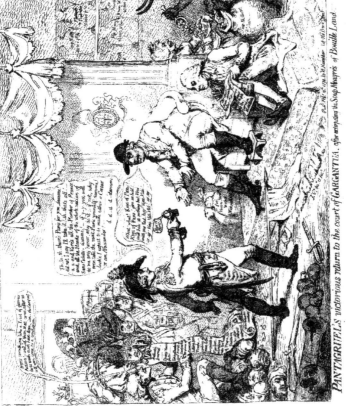

PANTAGRUEL'S victorious return to the court of GARGANTUA, after extirpating the Soap-Boylers of Bœotic Land

" To try to keep the bully quiet.
 The parson went, and shook the jowl, and sped ;
 Snug was the word—the flames at once kept house,
 The fright'ned mount grew mute as any mouse."

Fox was, as it were, the political St. Januarius of the English Liberals.

A caricature by Gillray, published on the 25th of July, 1794, and entitled, *The Eruption of the Mountain, or the Head of the Protector St. Januarius Carried in Procession by the Cardinal Archevêque of the Lazzaroni*, represents the political volcano that was overwhelming and threatening with destruction the nations of the earth, while the head of Fox is brought forth by his followers to stop the course of the danger. The cardinal who officiates is Sheridan ; Lord Lauderdale carries bell, candle, and book ("Lauderdale's Jests"). General Fox is personated as a cur which always smelt fire. Lord Derby and M. A. Taylor officiate as trainbearers to the Cardinal. Lord Stanhope follows, bearing his incendiary torches, and the Duke of Norfolk raises the cap of liberty on his Earl-Marshal's baton. The exorcisms pronounced by this select band have diverted the terrors of the volcano from London, while Berlin, Rome, Vienna, Flanders, and Holland are all suffering from the infernal eruption.

The Head of St. Januarius Carried by the Archbishop.

Encouraged by its strength in Parliament, and by the Conservative spirit that had been spread through the country, the Court had proceeded to measures of domestic policy the wisdom of which might well admit of a doubt. The trial of Thomas Paine was the commencement of a series of State prosecutions, not for political offences but for political designs. To the name of Paine had been given such unenviable notoriety, and it had caused so much apprehension in the minds of quiet people, that his case excited personally no great sympathy, though many dreaded the extension of the practice of making the publication of a man's abstract opinions criminal, when unaccompanied with any direct or open attempt to put them into effect. In the beginning of 1793 followed prosecutions in Edinburgh, where the Ministerial influence was great, against men who had associated to do little more than call for reform in Parliament ; and two persons, whose crimes consisted chiefly in having read Paine's "Rights of Man," and in having expressed partial approbation of his doctrines, were transported severally for fourteen and seven years ! These men had been active in the political societies, and it was imagined that by an individual injustice of this kind these societies would be intimidated. Such however was not the case, for from this moment the clubs in Edinburgh became more violent than ever, and they certainly took a more dangerous character ; so that before the end of the year there was actually a "British Convention" sitting in the Scottish capital. This was dissolved by force at the beginning of 1794, and two of its members were added to the convicts already destined for transportation. Their severe sentences provoked warm discussions in the English Parliament, but the Ministers were inexorable in their resolution to put them in execution. In the similar prosecutions which they now commenced in England the Court was less successful. A bookseller of London who had published a pamphlet of a democratic tendency entitled, "Politics for the People, or Hog's-wash," and some violent democrats of Manchester, for an alleged conspiracy, were all acquitted by the juries which tried them ; and in the latter case one of the Government witnesses was subsequently convicted of perjury and sentenced to the pillory. The public agitation was much increased by these prosecutions, and many parts of the country became the scene of serious riots ; there was always a mob for the prosecuted, and there was in general also a loyal mob—a mob for the prosecutors. This latter, in several instances, committed great outrages on the property of individuals. The illuminations in London, on the occasion of Lord Howe's victory, were attended with considerable uproar, and attacks were made on the houses of some of the so-called Revolutionists. It was generally believed that these attacks were made under

A A

direct incitement from persons of higher rank in society than those who engaged in them. The next day, the unaristocratic and more than eccentric Lord Stanhope inserted the following advertisement in the newspapers:—

"OUTRAGE IN MANSFIELD STREET.

" Whereas an hired band of ruffians attacked my house in Mansfield Street, in the dead of the night, between the 11th and 12th of June instant, and set it on fire at different times ; and whereas a gentleman's carriage passed several times to and fro in front of my house, and the *aristocrat*, or other person who was in the said carriage, *gave money* to the people in the street, to encourage them ; this is to request the Friends of Liberty and Good Order to send me any authentic information they can procure, respecting the names and place of abode of the said aristocrat, or other person, who was in the carriage above-mentioned, in order that he may be made amenable to the law.

"STANHOPE."

Earl Stanhope, the "sansculotte peer," figures in a multitude of caricatures during this and subsequent years. In one from which the accompanying cut is taken, published on May 3rd, 1794, he is represented as the fool of the Opposition, holding for his bauble a standard with the inscription "Vive égalité !" throwing away his breeches as a garment inconsistent with his sansculottism and trampling on his coronet. The print gives him the title of *The Noble Sansculotte*, and is accompanied with " a ballad occasioned by a certain earl's styling himself a sansculotte citizen in the House of Lords:"—

" Rank, character, distinction, fame,
 And noble birth forgot,
Hear Stanhope, modest Earl, proclaim
 Himself a sansculotte.

" Of pomp and splendid circumstance
 The vanity he teaches ;
And spurns, like citizen of France,
 Both coronet and breeches."

A Sansculotte Noble.

Lords Stanhope and Lauderdale were coupled together as the two advocates of extreme democratic principles in the House of Lords.

In the month of May the Government made a direct attack on two of the most violent and powerful of the London societies—the Corresponding Society and the Society for Constitutional Information. Some of their principal members, including the Rev. Jeremiah Joyce (Lord Stanhope's private secretary), Horne Tooke, the afterwards celebrated political lecturer John Thelwall, Thomas Hardy, Daniel Adams, and three or four others, were arrested and thrown into the Tower on the charge of high treason. The papers of the societies were seized and laid by a royal message before Parliament ; and on a very vague report of their contents, the Ministers succeeded, by their overwhelming majorities, in carrying hurriedly that extreme measure under imminent danger, the suspension of the Habeas Corpus Act. All this violence tended, on the one hand, to destroy public confidence by disturbing the country with unnecessary terrors, while, on the other, it was hastening a reaction of the public mind against the temper into which it had been urged by Conservative agitation.

The State trials took place in the months of October, November, and December, and were the cause of very great excitement. The courts were crowded to excess, and mobs assembled out of doors. Hardy, who had been secretary of the Corresponding Society, was first brought to trial, which, after lasting eight days, ended on November 5th in an acquittal by the jury. The evidence amounted to nothing more than charging him with holding certain principles, which he had done in no manner that was absolutely illegal ; and, as it appeared, the papers of the society, on which so much stress had been laid, contained nothing that had not before been printed in the newspapers. Horne Tooke was next acquitted, on November 22nd, and the same fate attended all the other prosecutions. The Court, mortified at this check, relinquished some other similar proceedings which it had already commenced, and certainly gained no popularity by what it had done. Many who were personally hostile to the opinions of the men prosecuted rejoiced with others at their escape, and exulted in the courage and probity of English

juries. The mob carried the prisoners and their legal defenders home from the court in triumph. The chief advocate for the defence in these State prosecutions was Erskine.

In the course of these unwise proceedings the Ministry had received strength from a modification in its ranks, and the admission of some of the more moderate of the old Whig party, who had separated from the Foxites at the same time and on the same grounds with Burke. In July, 1794, the Duke of Portland was made third Secretary of State, Earl Fitzwilliam President of the Council, Earl Spencer received the office of Lord Privy Seal, and Mr. Windham was made Secretary at War. In December following the Ministry underwent some other slight modifications, the chief of which arose from the appointment of Earl Fitzwilliam to the office of Lord Lieutenant of Ireland, and of Earl Spencer to be First Lord of the Admiralty, in place of Pitt's elder brother, the Earl of Chatham, who took the Privy Seal in exchange.

Having given this summary of the political year, we have now to consider the few minor caricatures the artist published on social points.

In the early part of 1794 Gillray etched a pair of portraits preserving the latest French modes, from the designs of an amateur.

A Paris Belle is represented as a fury, her eyebrows uniting, her mouth ferocious, and the whole expression highly tiger-like. Her cap, of the Charlotte Corday fashion, ornamented with a tricolour cockade, is made gayer by the insertion of a reeking dagger-blade. This lady's sentiments are in accordance with her externals. "Des têtes! du sang! la mort! à la lanterne! à la guillotine!—point de Reine! Je suis la Déesse de la Liberté!—l'égalité! Que Londres soit brûle! que Paris soit libre! Vive la guillotine!"

A Paris Beau is represented in the person of a forbidding gallant, his face unshaven, with his hair arranged in a monstrous length of "queue," his eyes glaring, his teeth all exposed as with ogre-like intention; his throat is bare, and he is in his shirt-sleeves. A fine "bonnet-rouge" and a cockade of huge dimensions are his chief pretentions to fashionable ornament. His sentiments also partake of the subversive order—"Vive la République! que tous les tyrans mordent la poussière! Point de religion."

With the opening of the Revolutionary period, the costume of the ladies underwent a very remarkable change in two of its striking peculiarities: the extraordinary thickness and redundancy which had characterized the dress of the succeeding period were suddenly changed for extreme lightness and looseness, and the waist, which had formerly been long, was diminished until it disappeared altogether. The buffonts disappeared also; the bosom, instead of being thickly covered, was allowed to protrude naked from the robe, which was very light, and hung loose from the figure, with thin petticoats only beneath. A turban of muslin was wrapped round the head, surmounted with one, two, or three very high feathers, and often with straw, the manufactures in which had now been carried to great perfection. It appears to have been in 1794 that this fashion first reached so extravagant a point as to become an object of general ridicule; and the caricatures of dress during that and the following years are very numerous.

1794. Exquisites in.

Gillray published a print, May 7th, 1794, with the quotation, *And Catch the Living Manners as they Rise!* in burlesque of this extreme absurdity. The exquisites represented were probably intended for portraits of younger scions of the Manners family. The gentleman is distinguished by the great cravat and the zebra vest made all of a piece, so as to give him the appearance of being as lightly covered as his partner. The immense cravats of the men are caricatured in other prints which appeared during this year.

The turban and its single feather rising high into the air, as well as the naked breasts and the

A A 2

deficiency of waist, are exhibited in the next figure, taken from a caricature entitled *The Graces for 1794*, published on the 21st of July in that year. This lady wears another personal ornament in vogue at this period among the fair—a watch of very large dimensions, with an enormous bunch of seals and chain, suspended from the girdle immediately below the bosom. From this girdle, without any waist, the robe flows loosely, giving the whole person an appearance as if the legs sprang immediately from the bust.

This peculiarity was carried to still greater extravagance towards the end of the year. On the 1st of December, 1794, a caricature entitled, *The Rage, or Shepherds, I have lost my Waist*, represents a lady in this predicament, refusing cakes and jelly offered her by an attendant, because her dressmaker had left her no body wherein to bestow either; it is accompanied with a parody on a popular song :—

No Body.

"Shepherds, I have lost my waist,
　Have you seen my body?
Sacrificed to modern taste,
　I'm quite a hoddy-doddy!

"For fashion I that part forsook
　Where sages place the belly;
'Tis gone—and I have not a nook
　For cheesecake, tart, or jelly.

"Never shall I see it more,
　Till, common sense returning,

"My body to my legs restore,
　Then I shall cease from mourning.

"Folly and fashion do prevail
　To such extremes among the fair,
A woman's only top and tail,
　The body's banish'd God knows where!"

One of the Graces.

This absolute banishment of the body from the female form is exhibited in the adjoining figure of a lady in full promenade dress, taken from a caricature by Gillray entitled *Following the Fashion*, published on the 9th of December, 1794. This caricature, in the original, consists of two compartments. In the first, the figure here given is described as "St. James's Giving the *Ton*, a Soul Without a Body." The second division of the plate, "Cheapside Aping the Mode—a Lady Without a Soul," presents a ruder parody of this etherial fashion, in the person of a stout city dame whose dress is exactly modelled on the "haut ton" of No body.

In November Gillray issued a droll print entitled, *Miss, I have a monstrous Crow to pick with you!* It represents an old and marvellously precise lady, who has detected a flaw in the conduct of her daughter. A literal crow, of highly humorous aspect, is perched under the table, sympathizing with the startled propriety of the more decorous lady, crying, "Oh, too bad!"

1795.

The varied and momentous events of 1795 furnished Gillray with abundant subjects. During this and the succeeding years his labours were unremitting; his printers were fully employed in pulling impressions of the manifold satires which teemed from his fancy without an apparent effort. The Opposition began to exhibit fresh indications of vitality, and the preliminaries of peace with France became the object of popular agitation. We still find sinister designs attributed to Fox and the Whigs, and Pitt was regarded as the preserver of his country; the dearness and scarcity of provisions alienated the confidence of the public, when clamour and mistrust temporarily threatened the patriot's hold of British sympathy. The Royal Family once more obtained a prominence in Gillray's caricatures; the King's eccentricities shared the attention of his subjects with the interest excited by negotiations for the marriage of the heir to the crown with a princess of Brunswick. The Prince of Wales, his dissipations, his debts, and the circumstances attending his espousal of the Princess Caroline, formed fruitful topics, both for Ministers and caricaturists.

Gillray, at the beginning of the year, not only registered his own convictions, but also expressed the modified sentiments of the nation at large, by a pair of views, *Peace* and *War*, inculcating the blessings of a pacific policy. The print is tastefully executed; somewhat in the style of Morland, but sufficiently characteristic of Gillray's individuality. It was circulated by the Crown and Anchor Society. The first picture represents the interior of a cottage home of England. A robust, well-clad, and brisk young farmer, sickle in hand, has returned to the mid-day meal. His comely young wife is extending a chubby infant to kiss the father's cheek, while an elder child is sharing his caress. A faithful hound has placed himself at his master's feet. Substantial fare is spread on the table, and an elder daughter brings from the smoking hearth a fine joint of the national roast beef. The contents of the cottage betoken comfort; and through the open door a well-stocked farmyard displays its contents. "These are the blessings of peace—prosperity and domestic happiness." "Such," relates the inscription, "Britain was!" The curses of war—invasion, massacre, and desolation—introduce the same homestead sadly altered by the lust of conquest. The cottage is demolished, and its pastoral inmates are ruined. The distracted wife and children are, in their misery, gathered round the body of the parent, who lies extended before his own threshold—a French bayonet through his heart. The farmyard is sacked, the Volunteers of Liberty and Universal Brotherhood are marching off the husbandman's flocks and the spoils of his home to their ships. The village and its church are in flames, and all that in the earlier prospect was tranquil and smiling is now desolate and ruined. "Such Flanders, Spain, and Holland are now." "From such a sad reverse," prays the artist, "O gracious God, preserve our country!" The protest conveyed by this print was not thrown away.

The violent and unnatural agitation of the country towards extreme Toryism was now giving way to a gradual reaction, and with the year 1795 the Opposition began for a moment to raise its head again. This was first shown in the increased clamour for peace. Even some of those who sat on the Ministerial benches, such as Wilberforce, expressed their dissatisfaction at the warlike tone in which the session was opened, and at the want of any expression of a pacificatory tendency in the speech from the Throne. The Ministers, in defending themselves, spoke of making peace or alliance with a government like that of France as a thing to which England could hardly condescend; they said that no such peace could be lasting, and they held up again the bugbear of Republican propagandism. During the spring, motion after motion was made in the House of Lords, as well as in the House of Commons, to force upon the attention of the Court the necessity of negotiating with our enemies on the other side of the water. The leaders of the Opposition lost no opportunity of agitating the question, and petitions against the war began to flow in from different parts of the country.

The Court had recourse to the old stratagem of exciting popular terror and throwing discredit on the motives of the "patriots." Most of the old leaders of actual sedition had disappeared from the scene in one manner or other; even Dr. Priestley had now migrated to America. But Fox and Sheridan still fought their old battle in the House of Commons, and they found able supporters among the young statesmen who were coming forward in the political world. The Ministers represented that these men were betraying the interests of their country to France, out of a blind admiration of its Republican institutions, and that it was the wish to see those institutions established at home which led them to advocate peace.

A French Telegraph.

Gillray commemorates this feeling in a caricature published 26th January, 1795, *A French Telegraph Making Signals in the Dark.* Fox, represented as a signal-post, beneath whose base are the daggers or assassins, is taking advantage of the blackness of night to direct the French fleet to London, which lies sleeping in fancied security. The Whig chief is employing a dark lantern, which

throws his proceedings into the shade at home, and acts as a beacon to the Republicans on the opposite shore.

The peace proposals advocated by Fox and his friends were treated with general distrust; it was felt that any terms on which a compact could be entered into with France would end in England being

An Object of Worship.

compelled to submit to the dreaded revolutionary idol. This impression was set forth in a cartoon dated 2nd February, 1795, *The Genius of France Triumphant, or Britannia Petitioning for Peace, vide the Proposals of Opposition.* At the feet of a sansculotte monster, with the cap of liberty for his seat, and the sun and moon as footstools, Britannia is sorrowfully sacrificing her shield and spear, and the crown and sceptre, with the charter of her liberties. The sansculotte trio are raising their red bonnets to this fantastic object of worship. Fox is tendering the keys of the Bank of England; Sheridan is submitting their allegiance. "We promise the surrender of the Navy of Great Britain, of Corsica, of the East and West Indies, and to abolish the worship of a God." Lord Stanhope, whose extreme Liberal principles obtained the prominence formerly held by Priestley, bears "the destruction of Parliament."

Following up this alarmist theory, Gillray issued (2nd March, 1795) an elaborate prospect of a future British Convention, under the title of *Patriotic Regeneration—viz., Parliament Reformed à la Française;* *that is, Honest Men (i.e., Opposition) in the Seat of Justice—vide Carmagnol Expectations.* Parliamentary Reform, from which alarmists anticipated a total subversion of all order, is supposed to have been carried, and Gillray once more turns his steps towards the House of Commons to make studies of the members. The Democratic Assembly presents an animated scene according to the satirist's view; the fanciful sitting is conducted in complete parody of the French National Assembly. Fox, as the chieftain of reform, is seated in the presidential chair; and Pitt, reduced to his shirt, is brought to the criminal's bar with a halter round his neck, accused of treason to the country. The president's features wear an equivocal and Judas-like expression of awakened conscience. Lord Stanhope, the most uncompromising of Republican sympathizers, is displaying his dangerous energy as " public accuser "—the Fouquier-Tinville of the situation—denouncing his brother-in-law, Pitt, and displaying a formidable roll of charges: " 1. For opposing the rights of subjects to dethrone their king. 2. For opposing the right of sansculottes to equalize property and to annihilate nobility. 3. For opposing the right of freemen to extirpate the farce of religion and to divide the estates of the Church, &c. &c." Lord Lauderdale has custody of the prisoner as public executioner. Erskine, as the Republican Attorney-General, is appealing against the accused; he holds a list headed " Guillotine." Sheridan occupies the table as Secretary of the House, the mace is thrown on the floor, and the works of Paine, Price, Priestley, Voltaire, and Rousseau are ready for reference on the new principles of equality and rationalism. The Treasury cash is bound up in bags, to be re-issued in assignats. Grafton, Norfolk, and Derby, seated on their coronets reversed as stools, are warming their hands at a stove fed with the " Holy Bible " and "Magna Charta." The Marquis of Lansdowne, who had deserted the Tory camp, is balancing the crown in the Republican scales against the new French weight, " Libertas." The Prince of Wales's coronet and other insignia of royalty and the ecclesiastic mitres are packed up in sacks for removal. The new members, returned by reformed constituencies, are represented as journeymen butchers, hairdressers, tailors, sweeps, &c., and are all introduced with the implements of their trades. Dissenters or Nonconformists and other sects, who were then regarded as enforcing Cromwellian principles, are introduced as Puritans. On the floor are thrown the title-deeds of " forfeited estates of Loyalists," marked Chatham, Mansfield, Grenville, &c.

The political and religious excitement of the time, with the wonderful events that were passing every day before people's eyes, led some persons into bold and extraordinary hallucinations, and drove others stark mad. When the pulpit of the more sober preachers of the Gospel often resounded with denunciations in general terms of the designs of providence as evinced in the dreadful storm that was now breaking over Europe, and they explained by them the unfulfilled prophecies of Scripture, we need

not be surprised if there were others who believed themselves endowed with the spirit of prophecy, and who undertook to make known more fully the events of the coming age. Among these, one of the most remarkable was an insane lieutenant of the Navy, named Richard Brothers, who declared that he was the "nephew of God" and that he had a divine mission, and boasted that he was unassailable by any human power. He announced that London was on the eve of being swallowed up and totally destroyed, and that immediately afterwards the Jews were to be gathered together into the promised land. It is extraordinary that an enthusiast like this should have been able to work upon the superstitious feelings of the populace so as to make him an object of apprehension to Government; but it is said he was believed to have become the tool of faction, and that he was employed to seduce the people and to spread fears and alarms. On the 4th of March he was arrested by two King's messengers and their assistants and placed under restraint, though they had some difficulty in keeping off the mob who attempted to rescue him. Brothers was afterwards confined in Fisher's Lunatic Asylum, Islington. On the day following his arrest Gillray published—

The Prophet of the Hebrews—the Prince of Peace Conducting the Jews to the Promised Land.— Brothers, with the enthusiasm of madness expressed on his features, is pointing to the fancied gates of Jerusalem, rendered in the picture by a fiery gallows. The prophet bears a sword of flame, and the Book of Revelation is in his hand; his foot is trampling on a seven-headed monster composed of kings, emperors, the Pope, &c. In the "Bundle of the Elect," strapped on his back for conveyance to the Sansculotte Paradise, are the leaders of the Parliamentary Opposition, Stanhope and Lansdowne in the Lords, Fox and Sheridan in the Commons. A crowd of Jew pedlars and a drunken enthusiast from St. Giles's follow the prophet, whose incredible predictions are playfully carried out in the satire. London is in flames, her buildings are toppled over, and a gulf is swallowing the doomed city. The signs of the firmament are remarkable. A band of quaint demons are dancing round the moon; the sun, crowned with the cap of liberty and wearing the ferocious glare of the terrorists, is distilling drops of blood. An owl, with a laurel branch in his mouth, is waving a treaty of peace over the prophet's fool's cap.

The dangerous consequences which threatened this country from a peace with France, and the confusions which, it was anticipated, would follow the importation of rational influences, were represented as melting before the intrepid patriotism of William Pitt. The popularity of that disinterested statesman reached its height at this period. The high price of provisions, the distresses of the poor, the burden of taxation, the general impatience of control, and the impediments which hedged in the patriot's course, all combined, within a few weeks from this date, to lay the foundation for a certain hostility to Pitt throughout the country, while the Opposition in the House grew stronger and more menacing. These difficulties were never known to dishearten the Premier; his dignity and power of handling factious elements increased in proportion to the disadvantages of his threatened popularity. We find Pitt in the future triumphing by his inflexibility, and lording it, after a time, in solitary greatness, but always the master of the situation.

On April 30th, Gillray produced a graceful allegory of Pitt, in the character of Phœbus Apollo driving the car of the sun through the mists of obscurity, under the title of *Light Expelling Darkness —Evaporation of Stygian Exhalations, or the Sun of the Constitution Rising Superior to the Clouds of Opposition.* The sun, rising through the surrounding mists, has for its centre "the King, Lords, and Commons." The fiery steeds harnessed to the chariot of Phœbus are the British lion, with the banner of Britannia on his flank, roaring at the baser spirits before him, and the white horse of Hanover with the arms of England quartered on his cloth, darting lightning flashes into the very centre of darkness. Pitt is guiding, with vigilant eye, the progress of the luminary; he tramples under foot a serpent-twined shield inscribed, "Exit Pithon Republicanus;" his magic lyre is the Magna Charta. Behind the car flutter a pair of cherubim; one bears the Bible, and the other unfolds a scroll of the Brunswick Succession, with the "family tree," continued in "future kings and monarchs yet unborn." Before the car floats the figure of Justice, scattering roses in the patriot's path. In one hand she holds the balance of right, and in the other a naval pennant, the Union Jack flying above the draggled revolutionary ensign. The sansculotte army, buried under caps of liberty, and the French fleet are either flying before the light of day or are mingled in destruction. "Honourable peace or everlasting war" is

the demand of Justice; while confounded beneath the shadow lie the "patriotic propositions"—"Peace, peace, on any terms—fraternization, unconditional submission; no law, no king, no God." Whig nobles are hiding under their red caps. Norfolk, Lauderdale, Grafton, and Derby are in mortal fear. The heavier clouds drifting downwards, "Stygian exhalations" returning to their infernal sources, disclose the features of the trio, Sheridan, Fox, and Stanhope, dropping their daggers. Lansdowne, Erskine, and M. A. Taylor take flight as obscure birds of night; above them are "Jacobin prophecies for breeding sedition in England," "A scheme for raising the Catholics in Ireland," and "A plan for inflaming the Dissenters in Scotland," are scattered into space. The Whig Club, as a black fury of sedition, is making her retreat in despair. The dark pictures of party-conflict—of peace and war—are varied by fresh allusions to the ruling family.

After the agitation on the Prince of Wales's financial embarrassments and his equivocal marriage with Mrs. Fitzherbert, that great personage rather disappeared from the political world. The Prince, it was said, had proposed to accept the viceroyalty of Ireland; but this proposition, if made, was discountenanced. His relatives enjoyed the highest positions in the service, and an application was made for military rank; but this distinction was also denied the Heir-apparent. The factious uses he had made of his earlier opportunities disinclined the King to risk any further collisions. The Prince accordingly lived for his own exclusive indulgence, to which all his fine energies were devoted, with a perseverance highly commendable if exercised in a more patriotic cause. The fatigues of the table, as we have seen from Gillray's satires, were, in sober truth, the sole exertions of the royal sybarite.

Brighton had become his favourite quarters; Carlton House was attended with too much ceremony and publicity; this costly residence was neglected for the attractions of the fantastic Pavilion. The companions of his table—where he had, in the days of his ambition and of his political need, entertained the great Whig leaders—were now recruited from the ranks of juvenile foppery; individuals chiefly distinguished for eccentricity, or for their pliability and subservience to the selfishness and appetite for flattery which characterized their entertainer.

Debts once more entangled the Prince in their provoking coils, and laid the sensitive Florizel at the mercy of his persecutors. This time his contrition took a novel form; the price of his ransom was set on a wife. We have noticed the rejoicings Gillray chronicled on the marriage of the Duke of York; but no children had blessed that union. The monarch admitted, with bitter disappointment, that the succession did not promise to be perpetuated in the descendants of his favourite Frederick; while Clarence, the third son, had become well known as an equivocal family-man following his own inclinations, in his connexion with the amiable Mrs. Jordan. The King, naturally anxious to preserve, amidst all these discordant elements, an undisputed succession, and leave his family in tranquil possession of the throne, strongly urged the Heir-apparent "to select a wife from the royal families of Europe, and thus give a pledge to the empire of that change of habits and that compliance with the popular desire which, in those days of revolution, might even be essential to the public safety."

The Prince, a professed "rebel to matrimony," had flattered himself into fancied immunity from this responsibility. The perplexities of the situation were too weighty for his resolution. He was accomplished in the art of making sacrifices, and escaping from the consequences. The Prince complied with perfect indifference. The King enjoyed his own way completely in this unhappy transaction. The Queen, favouring her own connexions, had proposed her niece Louisa, Princess of Mecklenburg-Strelitz, later Queen of Prussia, who shares with Marie Antoinette a sad pre-eminence for beauty and suffering. The King was much attached to his sister, the Duchess of Brunswick; he corresponded with her court, and proposed for the hand of her daughter, the Princess Caroline Amelia Elizabeth, his niece, who was, besides, a wealthier princess than the Queen's *protégée*.

These clever diplomatists managed the transaction entirely to their own satisfaction. King George and the Brunswick magnates were equally well pleased with their arrangements. Although a reluctant bridegroom, the Prince, to escape the pressure of his liabilities, was ready to sacrifice, not exactly himself, but his future bride. He had his own resources—friends, mistresses—well-tried connexions, as far as they were concerned, to whom he could return if the Princess did not succeed in pleasing him. One person alone expressed any definite forebodings; the rumours which float around the ante-chambers of

courts, hinted a previous attachment, and declared that the Princess Caroline exhibited no trivial disinclination to the match. Lord Malmesbury, the most minute of gossiping diarists, was sent to escort the bride to her longing husband. There was, in this marriage arrangement, *a want of natural feeling* evident above every courtly ceremonial. The journey occupied three months of an inclement German winter. The very setting out was ominous. The ragged legions of the French Republic were pouring over Holland and Germany; the route was altered, and the Princess had to beat through Hanover. At last the squadron arrived at Cuxhaven and Caroline disembarked at Greenwich, after a tempestuous crossing. Among the distinguished attendants who accompanied her journey to London was her future betrayer—the treacherous Lady Jersey. The poor Princess, separated from her court and from the object of her affections, was regarded in a foreign land as the common enemy by the Lothario's favourites; while the ungenerous hostility was suffered to penetrate still farther into society, and was not confined to the Prince's mere dependents. The brilliant circles of which the Duchesses of Devonshire, of Gordon, and of Rutland were the triple suns resented this foreign rival as an intruder.

These three Graces received a devotion which cannot be easily understood in this more prosaic age :—

> " Come, Paris, leave your hills and dells ;
> You'll scorn your dowdy goddesses,
> If once you see our English belles,
> For all their gowns and bodices.
>
> " Here's Juno Devon, all sublime ;
> Minerva Gordon's wit and eyes ;
> Sweet Rutland, Venus in her prime ;
> You'll die before you give the prize."

The Lover's Dream.

This superfine society was prepared to look coldly on the young bride. The only person who exhibited any pleasure was the King, and he remained, in the subsequent bewilderments of poor Caroline's

B B

career, her steadfast and sympathizing friend. With the dismal story which followed this marriage we have no part at present. It is sufficient to find England engaged in 1795 in discussing the prospects of this spoilt child—the Florizel it had begun by petting and ended by despising.

The hopes that this projected union flattered for a time were admirably set forth by Gillray in his cartoon of *The Lover's Dream*, which appeared on January 14th, 1795.

The stout Heir-apparent is dreaming of his bride; the attractive figure of Caroline of Brunswick is floating towards the sleeper; Hymen is acting as her train-bearer, and Cupid is arranging the curtains. According to the quotation from Milton, which appears on the plate—

"A thousand virtues seem to lackey her, Driving far off each thing of sin and guilt."

The vision of King George with a well-filled sack marked 50,000*l*. per annum, and of Queen Charlotte presenting the secret of her handsome offspring, are numbered with the Prince's nocturnal visions.

The darker phantoms which haunt the slumberer are dispelled by the bright presence of the Princess. A barrel of port, on which Bacchus is striding, is rolling into space. Fox with his dice-box and Sheridan as a pantaloon are making their hurried exits. Mrs. Fitzherbert and the Prince's mistresses are discarded with the Newmarket establishment, which absorbed thousands of pounds annually.

Such were the healthy anticipations the people raised on the future reform of George the Magnificent. These hopes were sung about and distributed broadcast in ballads and on printed sheets. The windows of the shops gave evidence of the popularity of these sentiments, which were modified on the publication of the Prince's enormous liabilities then urgently awaiting liquidation.

In the meantime the nuptials were hastened on.

"Among princes," writes Croly, "the hopes and fears of the passion are brief; and his Royal Highness had but three days for romance; for, on the third from the arrival of the Princess, he was summoned to St. James's to be married."

The ceremony was splendid, as such Court celebrations are generally found. The King's gratification was publicly manifested. He was peculiarly interested in the bride, and he gave the Princess to her husband with touching affection. Amid the general munificence it is to be regretted that the Royal Bridegroom should have shortly afterwards applied once more to Parliament to pay for the presents he thought proper to make on this occasion.

No sooner had the Prince of Wales completed his vows of fidelity than a sterner ceremonial was commenced. His debts were to be discharged. Their equivocal nature and their formidable amount struck the King with consternation. At the very moment he deemed it expedient to preserve Royalty inviolate from vulgar scrutiny in the face of the revolutionary spirit of the age, this exposure became inevitable. The debates in the House on the Prince's embarrassments gave a new and fruitful topic to the democrats. The controversy was long and acrimonious. Party feeling was kept in a perpetual ferment for nearly three months, much to the distress of the young bride.

The Duke of Clarence attracted public notice by the generosity with which he adopted the cause of the Princess. "Whatever may be thought," said he, during the debates in the Peers, "of the stipulations for the payment of the debts, there is at least one individual who ought not to be exposed to this harsh and stern inquisition—a lovely and amiable woman, torn from her family; for though her mother is his Majesty's sister, she must still be said to be torn from her family by being suddenly separated from all her early connexions. What must her feelings be, from finding her reception in this country followed by such circumstances, when she had a right to expect everything befitting her rank and the exalted position to which she was called?"

The bride herself, unused to inquiries into the conduct of princes, was alternately indignant and dejected, declaring, with the disinterested impetuosity which distinguished her feelings, "she would rather live on bread and water in a cottage than have the character and conduct of the Royal Family, and especially of her husband, thus severely investigated."

The question was finally arranged much as had happened on previous applications; the Prince promised to incur no fresh liabilities, and his financial entanglements were dismissed, until a recurrence

of the same profuse extravagance entailed the same scandalous publicity and provoked further acrimony on all sides.

The simple and purposeless curiosity of the King was not forgotten among the vicissitudes of foreign wars and of struggles at home.

A caricature, published by Gillray on February 10th, 1795, represents an example of *Royal Affability*. The King and Queen, in their rural walks, arrive at a dirty hut, the occupant of which, no very high sample of humanity, is feeding his pigs with wash. The vacant stare on his countenance shows him overwhelmed with the rapid succession of royal interrogatives: "Well, friend, where a' you going, hay?—what's your name, hay?—where d' ye live, hay?—hay?"

Royal Affability.

The two questions on which, after that of peace, the country was most agitated, were those of the increase of taxation and Parliamentary reform. The necessarily great expenditure of the war—made greater by the utter want of economy shown everywhere in the application of public money—and the extraordinary subsidies given to foreign governments to support them in their exertions against France, were now driving the Minister to every kind of expedient to raise money: duties were levied upon articles which no one ever thought of taxing before. The most remarkable tax of this kind, granted by Parliament in the session of 1795, was the tax upon persons wearing hair-powder, a fashion which was then universal among all who laid claim to respectability in society. This tax could hardly be complained of as a serious burden, or even as a grievance; but it was chiefly remarkable for the extraordinary mistake which the Minister committed in boasting of the great addition which it was to bring to the revenue; for the use of hair-powder was almost immediately discontinued, and the produce of the tax hardly covered the expense of collection. It became at first a party distinction. The Whigs wore their hair cut short behind and without powder, which was termed wearing the hair *à la guillotine*; while the Tories, who continued the use of the hair-powder, were called *guinea-pigs*, because one guinea was the amount per head of the tax. The hair-powder tax was the subject of many songs and *jeux-d'esprit*, as well as of several caricatures, which, from this time to the end of the century, became so numerous that they form a regular history of every event that agitated society, even in a trifling degree. The larger portion of the caricatures of the period alluded to were from the talented pencil and graver of Gillray, and are even superior to those of the preceding or following periods. The hair-powder tax was brought forward by Pitt on the 23rd of February; on the 10th of March Gillray published a caricature under the title of *Leaving off Powder, or a Frugal Family Saving a Guinea*. The household represented is that of a prosperous citizen. The head of the house, his coat-tails extended before the fire-stove, is reading the *Gazette*. A list of bankrupts is turned down, and he is engaged in perusing the list of "New Taxes." On his head appears a scrub wig, black and unpowdered. His son, a dandy of the period, wears the costume introduced under the French Revolution—a tightly-buttoned coat with huge roll collar; a spencer, or short contee, terminating above the waist; a second huge collar, a high-flapped waistcoat, and voluminous folds of cravat; and striped stockings, a bunch of ribands at the knees, and half-boots. His hair is cut short and brushed over his head, after the manner of Napoleon's later fashion. The mistress of the house, seated in her arm-chair, is without her hair; a French barber is bringing in the wig. She is dismayed at its appearance in the absence of hair-powder. Her daughter is similarly shocked at her own unpowdered locks. A portrait of Charles the Second in his monster peruke adorns the walls of the apartment.

On May 28th, Gillray published a portrait of another member of the Royal Family, who just then occupied a considerable share of public attention—*A True British Tar*. "D——n all Bond Street sailors, I say!" &c.—The Duke of Clarence, whose marked features were attractive to the caricaturist, was a devoted Bond Street lounger. The devotion to the flagstones of that favoured promenade sur-

passes credence. All who were fashionable, finely apparelled, or emulous of notoriety, performed their daily pilgrimages down the crowded thoroughfare. The Duke of Clarence appears, from Gillray's evidence, to have cherished the habit for many years. His portraits in the character of a loiterer in Bond Street occur at every period of his life.

It was here that Tommy Onslow, the patron saint of four-in-hands, cleverly picked a devious way for his well-known fashionable and eccentric equipage. Among the multitude of personages who are presented as they passed before the artist, we shall find the names of many notorieties whose reputations had their rise, progress, and decline centred in Bond Street.

In the early part of 1795 the scarcity of provisions and their increasing price began to be felt; the misrepresentations of party animosity affirmed that the Whigs secured supplies for the French Government and increased the difficulty of procuring food at home, adding fresh impulse to the agitations of the discontented. Gillray published (11th May, 1795) a humorous parody of this statement, under the title of *The Real Cause of the Present High Price of Provisions, or a View of the Sea-coast of England, with French Agents Smuggling away Supplies for France.* The actors in this performance appear with a "comedy-smirk" which disarms the imputation of severity. Fox, clad as the Commissioner-General of the French levies, is discovered in the act of completing his purchases; Sheridan and Grey bear the bags of foreign gold employed to betray their country; while Erskine, as a sansculotte secretary, is checking the operations of the chief. Lord Lansdowne is negotiating for the surrender of a flock of sheep; the Duke of Bedford, in hunting garb, seated in the midst of sacks of "Bedfordshire flour for Paris," &c., is telling over the purchase-money with a gratified air; the Duke of Norfolk conveys a supply of smoking Norfolk dumplings; the Duke of Grafton, disguised as a drover, is embarking the live stock; while Lord Stanhope is steering the Republican barge which is to bear the cattle to their ship. Wilberforce, M. A. Taylor, and Lord Lauderdale (at the helm) are rowing off their instalment in a smaller craft. A bundle of muskets thrown on the ground is labelled "Provision for the French Army—of Dissenting manufacture."

On the 18th of May Gillray favoured the public with a portrait of *Polonius*—Lord Salisbury, who held the office of Chamberlain. Polonius bears the wand; his pompous, awkward figure is admirably hit off by the satirist. We do not think it necessary to reproduce this likeness of the high Court functionary, as an admirable sketch of his lordship is furnished later on, in *The King of Brobdingnag and Gulliver* (10th Feb. 1804); his figure also occurs in *The Bridal Night* (18th May, 1797). The official stiffness of Polonius is set off by the addition of an elaborate court-dress, including a sword, a lilliputian three-cornered hat, an enormous bag-wig, and the Chamberlain's key. Polonius is leading the way to St. James's, before the King and Queen and the bevy of princesses—all feathered and flounced in drawing-room splendour.

The discussions provoked on the settlement of the Prince of Wales's debts and the sums to be added to his income on his marriage with the Princess Caroline of Brunswick were peculiarly calculated to inflame the popular mind; taxation was already grievously burdensome, and the critical nature of the situation was unluckily aggravated by the scarcity of provisions.

John Bull Ground Down (1st June, 1795) expressed the general conviction that the people were paying dearly for their rulers. John Bull, jammed into a huge coffee-mill, is undergoing the reducing process at the vigorous hands of Pitt, who is turning the handle without mercy. The Minister rests one leg on a very considerable pile of money, which he appears to have ground out for his own uses. Pitt is stoically singing "God save Great George our King," while the Crown, sending forth its protecting rays, is replying to poor John Bull's entreaties and shouts of "Murder!" "What! what! what! Murder! hay? Why, you poor stupe, is it not for the good of your country? hay, hay? Grind away, Billy!—never mind his bawling; grind away!" The Prince of Wales is the chief recipient; his coronet is held out for the torrent of John Bull's financial blood. The Prince's creditors regard the prospect greedily; jockeys for "debts of honour," Jews for "money lent at 500 per cent.," and Florizel's numerous mistresses are being invited to satisfy their demands. Dundas and Burke, on all-fours, are stealthily appropriating the showers of broad pieces which are scattered in the process.

The popular discontent was expressed in proportion to the scarcity and dearness of provisions. It began to be felt at the beginning of summer, and increased to an alarming degree during the autumn. From

The Real Cause of the present HIGH-PRICE of PROVISIONS;
or, a View on the Sea Coast of England, with French Agents smuggling away Supplies for France.

this cause, and from grievances connected with recruiting and press-gangs, there was much rioting throughout the country. Considerable uneasiness was caused at Birmingham and other places in that part of England in the month of June, by mobs demanding " cheap bread," which led in some cases to collisions with the military. Similar disturbances took place in London, and the feeling of dissatisfaction extended all over the country. The Government appears to have taken no effectual measures against the increasing distress; they merely recommended various expedients to lessen the consumption of bread by employing other substances, and a Bill was passed to prevent, for a period, distillation from grain; but the attention of Parliament was chiefly occupied with providing for the Prince of Wales.

Caricatures and other satirical productions attacked Pitt severely for his apparent neglect, or want of foresight, in not making some better provision against the visitation of famine. The Premier was addicted somewhat immoderately to the bottle, and he, as well as his great opponent, Fox, is said to have taken his place in the House of Commons more than once in a state of absolute intoxication. We are frequently reminded of this failing in the caricatures of the period of which we are now speaking.

When the scarcity of 1795 was just beginning, a print, published by Gillray on the 27th of May, represents one of the jovial scenes at Pitt's country house at Wimbledon, between the Minister and his friend Dundas, who was as great a drinker as himself. It is entitled *God Save the King! in a Bumper, or an Evening Scene Three Times a-Week at Wimbledon.* Pitt is attempting to fill his glass from the wrong end of the bottle, while his companion, grasping pipe and bumper, ejaculates the words, " Billy, my boy—all my joy!" The allowance of bottles to the two toasters is in loyal and liberal excess.

A Minister in High Glee.

We have seen how Pitt was represented to have treated John Bull in his home relations. On the 12th of June Gillray expressed a conviction that his foreign policy entailed similar sacrifices, with equally barren results. *Blind Man's Buff, or Too Many for John Bull,* exhibits the corpulent John Bull, blindfolded and turned adrift by his ruler, exposed to the spoliations of friends and of foes. Pitt's constant demands for supplies to form the basis of new operations with his allies against France, began to weary the country. England was the paymaster in all the coalitions this undaunted Minister built up in bewildering succession. The particular subsidy which engaged the attention at this date was an Imperial loan granted to the Emperor of Austria, who is shown in " Blind Man's Buff" in the act of relieving the perplexed John Bull of his purse; Prussia is grasping a stout money-bag and snapping his fingers at the hapless victim. France and Holland combine to insult the blind man; one of the sansculottes is dexterously inflicting an unexpected kick, while a Dutchman puffs a full volley of smoke into Mr. Bull's face. Pitt has betrayed his master, who does not appear to know how to extricate himself. The Premier has secured the blind man's coat; his hand is in the pocket, while he offers this encouragement to the Continental powers—" Go it, my honies, go it! Supple him a little! supple him !"

The contest on the motion for peace provoked a somewhat venturesome caricature, published June 4th, 1795. *Presages of the Millennium, with the Destruction of the Faithful, as Revealed to Richard Brothers, the Prophet, and Attested by M. B. Hallhead, Esq.* (Mr. Hallhead, a distinguished Oriental scholar, who had pleaded Brothers' case before the House). The travesty is based on the passage from Revelation inscribed on the plate: " And ere the last days began, I looked, and behold a White Horse; and his name who sat upon it was Death; and Hell followed after him; and power was given unto him to kill him with the sword, and with famine, and with death. And I saw under him the souls of the multitude; those who were destroyed for maintaining the word of Truth and for the testimony." The White Horse of Destruction is the emblem of Hanover. Pitt, seated on this steed as Death, is wildly galloping and spreading his fatal influence around; he deals consternation on all sides. On his head is blazing the fire of the destroyer; his weapons are the sword and famine. In the train of the White Horse follow the creatures of Hell—Dundas as Satan, Lords Kenyon and Loughborough as fiends of the

Law, and Edmund Burke as a winged serpent. An imp bearing the Prince of Wales's coronet is urging on the Destroyer; he is grasping a roll, "Provision for the Millennium—125,000*l.* per annum," an allusion to the revenue settled on the Heir-apparent upon the occasion of his marriage. The common herd trodden under foot revive Burke's allusion to "the swinish multitude." The slayer and his atten-

Presages of the Millennium.—Pitt on the White Horse : Destruction of the Faithful.

dant flames are consuming the Opposition and their proposals for peace. Wilberforce, who had moved the peace question, has received a blow from the heel of the Hanoverian steed; Fox is exposed to a similar danger; Sheridan and Lord Lansdowne are both prostrate; while Norfolk, Stanhope, and Grafton are cast into the fire.

After the publication of this parody Gillray contented himself with a few minor subjects. Among these appeared a portrait of Lord Howe, whose brilliant victory of the 1st of June stands foremost in the triumphs of our arms at sea. The French fleet, to the number of twenty-seven vessels, ventured to leave Brest in order to protect a supply of grain and naval stores expected from America. Lord Howe, with a fleet of twenty ships, sighted the French squadron on the 28th of May. The hard fighting did not commence until Howe steered the "Royal Charlotte" alongside of the French admiral, which was effected on the 1st of June. After fifty minutes of the most desperate conflict the French fleet found its position so disadvantageous that it was compelled to abandon the contest. The British ships were disabled from pursuit, their enemies having, as usual, directed their fire against the rigging. Two eighty-gun ships and five seventy-fours were successfully towed into Portsmouth. The Royal Family did Lord Howe the honour to visit his ship and inspect the prizes. A diamond-hilted sword and a gold naval medal were presented to the Admiral by the King at a levee held on board the "Royal Charlotte;" the thanks of both Houses of Parliament, the freedom of the City, and universal acclamations followed this gracious act on the part of the Sovereign. Lord Howe was in his seventieth year at the date of this victory.

Gillray's antipathy to the Admiral was not softened by the action of "the glorious first of June." Howe, notwithstanding his many services, always appears in contemporary memoirs mistrusted and unpopular. *What a Our 'tis!* published June 9th, 1795, represents Lord Howe in his arm-chair at Portsmouth, with pipe and grog, darkly glancing at a gazette of the action of which he was the hero; on the table appears a chart of Torbay. Licking his toe is a subservient cur, wearing a collar inscribed "Black Dick's Dog." The face represents Sir Roger Curtis; it is described as an admirable portrait.

Gillray also published a portrait of Lord Grenville, June 13th, 1795, under the title of *A Keen-sighted Politician Warming his Imagination.* Lord Grenville, depicted as very near-sighted, is peering into a treatise on the "Fundamental Principles of Government for 1795;" on the mantel are two volumes, "Court Cookery" and "Locke on the Understanding;" and above him hangs a confused "Map of British Victories on the Continent." His lordship is standing before the fire nursing the tails of his coat, and enjoying the warmth in a position which appeared to have been a favourite one with the statesman. The quotation sets forth :—

> "Lord Pogy boasts no common share of head ;
> That plenteous stores of knowledge may contain
> The spacious tenement of Pogy's brain !
> Nature, in all her dispensations wise,
> Who form'd his headpiece of so vast a size,
> Hath not, 'tis true, neglected to bestow
> His due proportion on the part below ;
> And hence we reason, that to serve the State
> His top and bottom may have equal weight."

This satire appears almost prophetic of the famous Broad-bottom Administration, which we shall find inaugurated under his lordship in later caricatures. A bowl of gold-fish implies Lord Grenville's much discussed partiality for accumulating official pickings.

In the rioting occasioned by the scanty supply and high price of corn, Pitt's want of forethought in allowing the nation to be surprised without any preparations having been made for lightening the popular distress was roughly censured. The Minister's late action in this matter was also severely criticised.

On July 6th Gillray published a caricature of *The British Butcher Supplying John Bull with a Substitute for Bread.*

> "BILLY THE BUTCHER'S ADVICE TO JOHN BULL.
> "Since bread is so dear (and you say you must eat),
> For to save the expense you must live upon meat ;
> And as twelvepence the quartern you can't pay for bread,
> Get a crown's worth of meat—it will serve in its stead."

Pitt is said to have made suggestions to the Lord Mayor of an equally impracticable nature. The Ministerial butcher, haughtily offering the starving John Bull a joint of dear meat, cries, "A crown ; take it or leave it !" On the block is a list of the high prices of provisions, &c., in 1795, and a table of journeymen's wages, which are out of all proportion with the improved rates of our own day.

On September 28th Austria, England, and Russia initiated a triple alliance to carry on the war more vigorously. The emigrants, who had assembled in the Breisgau, proclaimed the Count of Provence (Louis XVIII.) King of France. The campaign was recommenced, and on the report of an unexpected success Gillray eagerly commemorated the temporary advantage (November 9th, 1795) under the title of *Fatal Effects of the French Defeat—Hanging and Drowning.* Fox, whose circumstances are supposed to have reduced him to a garret, has tied a rope to the roof and is contemplating suicide, after reading an "Account of the Republicans' Overthrow." A rough print of General Pichegru is the only ornament of his chamber. Drowning is illustrated by Pitt and his colleague Dundas, who, beneath the portrait of the King, are rejoicing over the news of "Victory over the Carmagnols." The Ministers are laid low by the bumpers in which they have celebrated the victory. Pitt is fairly swimming in the contents of the numerous bottles he has capsized.

On November 1st Gillray represented William Pitt as a somnambulist, under the title of *The Sleep-walker.* The Premier, clad in his nightcap and shirt, is proceeding down a flight of steps at their extreme margin where a false movement would promise fatal consequences. A dark cellar is shown below. Gillray has adopted this figure to symbolize the dangerous path which Pitt, in the public estimation, seemed to be treading, unconscious of the imminent risks which surrounded his course.

As winter approached the agitation became still greater, and the numerous demagogues who addressed themselves to the populace and lower orders took advantage of the general discontent to

spread abroad their seditious opinions. A numerous meeting had been held in St. George's Fields in June, to petition for annual parliaments and universal suffrage. This sort of agitation went on increasing, and the London Corresponding Society called a meeting on the 26th of October in Copenhagen Fields, where an immense multitude assembled to vote and sign addresses and remonstrances on the state of the country. Three wooden scaffolds were raised in different parts of the field, from which three of the orators of the populace addressed the assemblage in inflammatory language, which no doubt contributed towards urging them to the disgraceful outrage which followed three days later. The most active speaker was Thelwall, who had just escaped from prison. The opening of Parliament was looked forward to with great anxiety. It was called together early, on account of the extreme distress under which the country was labouring. As the time approached popular meetings were held in the metropolis, and preparations were made for an imposing demonstration of mob force. During the morning of the 29th of October, the day on which the King was to open the session in person, crowds of men continued pouring into the town from the various open spaces outside, where simultaneous meetings had been called by placards and advertisements, and before the King left Buckingham House, on his way to St. James's, the number of people collected on the ground over which he had to pass is said in the papers of the day to have been not less than 200,000. The King, attended in his state-carriage by the Earl of Westmorland and the Earl of Onslow, set out for St. James's at twelve o'clock. Mistrust of the intentions of the mob was expressed before his departure. Lord Cranley, one of the King's guard, told his grandfather, Lord Onslow, before setting out, that he feared an insult would be offered to the royal person.

The King's behaviour on this occasion exhibited a contempt of personal danger worthy of his ancestral courage. At first the state-carriage was allowed to move on through this dense mass in sullen silence, no hats being taken off or any other mark of respect being shown. This was followed by a general outburst of hisses and groans, mingled with shouts of "Give us peace and bread!" "No war!" "No King!" "Down with him! down with George!" and the like; and this tumult continued unabated until the King reached the House of Lords, the Guards with difficulty keeping the mob from closing on the carriage. As it passed through Margaret Street the populace seemed determined to attack it, and when opposite the Ordnance Office a shot of some kind, supposed to be a bullet from an air-gun, passed through the glass of the carriage-window.

This scene exhibits the Monarch in a dignified light; his self-command was in no degree disturbed, although, as we have already traced, excitement acted on his deranged nervous system with dangerous effect.

"When his Majesty alighted at the foot of the stairs of the House of Peers," relates a contemporary account, "he very calmly, as if mentioning a mere circumstance, informed the Lord Chancellor, stationed there to receive him, 'My lord, we have been shot at!'"

The tumult was, if anything, more outrageous on the King's return, and he had some difficulty in reaching St. James's Palace without injury; for the mob threw stones at the state-carriage and damaged it considerably. "Such was his Majesty's coolness at this perilous moment, that he took from the cuff of his coat, the instant it had lodged, a pebble which was thrown at him by one of the mob, and, turning to Lord Onslow, said, "I make you a present of this, my lord, as a mark of the civilities we have met with on our journey to-day.'"

After remaining a short time at St. James's he proceeded in his private coach to Buckingham House; but the carriage was stopped in the Park by the populace, who pressed round it, shouting, "Bread! bread! peace! peace!" until the King was rescued from this unpleasant situation by a strong body of the Guards.

The Lords were much agitated at this gross insult offered to the royal person, and were some time before they could calm themselves sufficiently to proceed to business. The Tories made a new cry against the spread of revolutionary principles and the dangerous designs of seditious men; and they said that it was the opposition shown to Ministers in Parliament that encouraged the mob out of doors.

The artist took advantage of this attack—which it was apprehended preceded more formidable demonstrations—to bring fresh ridicule upon the pretensions of the Opposition. A caricature was at

once prepared and published (November 1st, 1795), under the title of *The Republican Attack.* The state-coach is represented on its journey; the King and his attendants are inside. Pitt is on the box, an awkward, reckless driver; his horses have overthrown the figure of Britannia, and the chariot-wheels are crushing her shield. The state footmen, who are unable, in their position of "hangers-on," to assist even themselves, are presented in the persons of Lord Loughborough (the Chancellor), Grenville, Dundas (with a bottle in his pocket), and Pepper Arden.

The more outrageous rioters are—by the pictorial licence which Gillray was ever ready to assume— the members of the Opposition. Lord Lansdowne, as a sansculotte, is boldly discharging an immense blunderbuss through the window. The King's features express the most vacant unconsciousness of his danger; Earls Westmorland and Onslow look on with dismay. The panels are broken and the gilt crown is knocked to pieces. Fox and Sheridan, wielding portentous bludgeons, have seized the chariot. Lords Lauderdale, Stanhope, and Grafton have fixed their hold on the wheels. Sticks, stones, and dead cats are directed at the carriage. Two standards appear, which were most probably displayed on the occasion; one is inscribed, "Peace and Bread!" the other consists of a loaf of bread borne on a fork and festooned with bows of crape.

The Ministers took advantage of this riot to bring forward new Bills for the defence of his Majesty's person, and to prevent assemblies of an inflammatory character where papers were circulated and speeches made calculated to irritate the minds of his Majesty's subjects against his person and government. This measure met with the most violent opposition, and it was extremely unpopular throughout the country. People said that there were already laws enough for the protection of the Crown, without any further infringement of the liberty of the subject; they beheld the Government forming itself into a sort of inquisition, from the eyes of which no one would be safe, and they augured that King George and William Pitt were goading and irritating the people, until they would produce that very Revolution of which they professed to entertain such profound fears. The political clubs throughout the kingdom began immediately to agitate against Pitt's new Bill; and the London Corresponding Society called another public meeting. Pitt is said to have shown the greatest symptoms of alarm on this occasion.

A print indicating the order of the agitators and of their disciples was published by Gillray on November 16th, 1795, under the title of *Copenhagen House,* with the quotation, "I tell you, citizens, we mean to new dress the Constitution and turn it, and set a new nap upon it." This plate was a burlesque of the meeting called on the 13th of November to protest against the convictions of the Bill for the protection of the King's person. Petitions addressed to both Houses were prepared. On a rude booth, in Gillray's picture of this assembly, stands the celebrated Thelwall, while Gale Jones, with a barber's comb in his hair, exhibits the "Resolutions of the London Corresponding Society." The audience is composed of the lowest classes. Hoardings arranged at intervals form rostrums for the speakers. A butcher is holding forth on "the Rights of Citizens." A perambulating stall-keeperess has opened a halfpenny gambling-table marked "Equality, and no Sedition Bill." The signatures attached to the petition are "Jack Cade," "Wat Tyler," "Jack Straw," &c.; three sweep-boys, with "Thelwall" on their black caps, are affixing their crosses to the roll.

An Orator.

The opponents of the Ministry were not restricted to the noisy rabble; beyond the mob-orators and their followers were the rich, influential Whig aristocracy. We have noticed the earnestness of the Dukes of Devonshire, Norfolk, and Grafton, Earl Derby, Lords Lansdowne, Stanhope, and Lauderdale; Fox, Grey, Sheridan, Erskine, &c. A recruit was now added in the person of the wealthy Duke of Bedford, nicknamed the "Leviathan."

c c

Gillray published a satire on this accession, as *The Republican Rattlesnake Fascinating the Bedford Squirrel* (November 16th, 1795), with this quotation: "The Rattlesnake is a creature of the greatest subtilty; when it is desirous of preying upon any animal which is in a situation above itself, it fixes its eye upon the unsuspecting object, and by the noise of its rattle fascinates and confounds the unfortunate victim, till, losing all sense and discernment, it falls a prey into the mouth of the horrid monster.—See Pliny's Nat. Hist., vol. 365."

Fox, delineated as a most formidable rattlesnake, has wound his coils round the tree upon which the squirrel is perched. The likeness of Fox is well preserved; his mouth is opened to receive the victim. The squirrel has abandoned his secure elevation and is leaping into the monster's jaws.

Pitt's temerity in provoking John Bull by so many coercive measures was satirized on the 21st of November, in a caricature entitled *The Royal Bull-fight.* The inscription is a parody on an account of a Spanish bull-fight: "Then entered a bull of the true British breed, who appeared to be extremely peaceable till opposed by a desperado mounted upon a white horse, who, by numberless wounds, provoked the animal to the utmost pitch of fury, when, collecting all his strength into one dreadful effort and darting upon its opponent, it destroyed both horse and rider in a moment." Such, it was foretold, would be the fate of King George (the white horse of Hanover) and his rider Pitt, if they urged John Bull too far.

Pitt, represented as a bull-fighter, is endeavouring to control his famous Hanoverian barb; the furious bull, excited to wrath by numerous irritating gashes, has terrified the horse and unmanned the rider; the battle is going against them. The King and his advisers are shadowed forth in an upper circle.

The defeat of Pitt and the anticipated triumph of the Whig leaders were set forth (26th of November, 1795) in a print called *Retribution; Tarring and Feathering, or the Patriot's Revenge.* Pitt is supposed to be abandoned to the mercies of his political rivals; the fate of his Bill against "Seditious Meetings" had exposed him to the roughest treatment. "Nay, and you'll stop our mouths; beware of your own." The Minister is stripped; Fox has tarred him, with a mop labelled "Remonstrances of the People," from a huge cauldron of the "Rights of the People," heated by Pitt's "Ministerial Influence," "Sedition Bill," "Informations," and other inflammatory documents. Sheridan has supplied his antagonists with a covering of feathers from a red bonnet of "Liberty." A rope is round the Premier's neck, for immediate suspension to a "Crown and Anchor lantern." A moving remonstrance addressed to the Whig chief is effectually stifled by a rough application of the tar-brush.

The Ministers carried their Bill "to prevent seditious meetings" through every stage by large majorities; but in the course of the debates the most unconstitutional publication that turned up was a pamphlet entitled "Thoughts on the English Government," by John Reeves—a Government placeman, and chairman of the Loyal Association held at the Crown and Anchor "for punishing the authors of libels and those found attending seditious meetings," which stated, with impolitic loyalty, that "the monarchy of England was like a goodly tree, of which the Lords and Commons were merely branches; that they might be lopped off, and that the kingly government may go on in all its functions without their aid." A member proposed the libel should be burnt by the common hangman. The whole pamphlet was read before the House of Commons, and excited considerable warmth; but, after several debates, the author was sent from the tribunal of the House to a court of justice, in which he was prosecuted for a libel on the Constitution; but he was acquitted by the jury, on the ground that his motives were not such as were laid in the information, though the jury condemned the pamphlet as "a very improper publication."

Two days after these proceedings Gillray published *The Crown and Anchor Libel Burnt by the Public Hangman,* dedicated to the chairman and members of the Loyal Association. Pitt is represented as the common hangman, throwing Reeves's pamphlet into a bonfire, which is blown by the combined breaths of Fox, Erskine, and Sheridan. The principles of the objectionable treatise are set forth. "No Lords, no Commons, no Parliament—damn the Revolution;" while a trunk shorn of its branches and topped by the crown is introduced as "The Royal Stump." Pitt's forced abandonment of his satellite

The DEATH of the Great WOLF.

"We have overcome all Opposition!—" exclaimed the Messengers—"I'm satisfied"—said the Dying Hero, & Expired in the Moment of Victory.

"Vide West Esq' President, the Royal Academy, his attempt to Emulate the Bombast of his stupendal Picture of the Death of Gen! Wolfe, is most respectfully inscribed by the Author."

to the prosecution of his Attorney-General is indicated by a book peeping out of the executioner's pocket— "Ministerial Sincerity and Attachment, a Novel." Reeves is escaping into the Crown and Anchor; from his coat-tail hangs a "List of Spies, Informers, Reporters, Crown and Anchor Agents;" "400*l.* per annum;" and instructions to the "Chairman of the Loyal Association." He cries, "O Jenky, Jenky! (Mr. Jenkinson, the hydra of secret influence) have I gone through thick and thin for this!" Pitt is declaiming, "Know, villains, when such paltry slaves presume to mix in treason, if the plot succeeds you're thrown neglected by; but if it fails, you're sure to die like dogs!"

The Ministers were, at the same time, mortified at having their prosecutions for sedition or treason defeated by the juries, who, in almost every instance, gave a verdict of "not guilty." The societies were not destroyed, as was expected, by the Government Bill; on the contrary, they were encouraged by the support of some of the richer and more powerful members of the Parliamentary Opposition, especially of the Duke of Bedford, who now stood foremost in its ranks, and was liberally expending his wealth in the cause of freedom, which was certainly threatened by the Ministerial measures. Pitt's vexations Parliamentary struggles throughout this year were terminated in a grand attack on his "Estimates" in the month of December. The victory was represented as purchased somewhat dearly in the blow received by the hero.

Gillray issued a double shaft—a travesty of Benjamin West's picture of the "Death of General Wolfe"—at the statesman and at the President of the Royal Academy (17th of December, 1795), with the quotation—"'We have overcome all Opposition!' exclaimed the messengers. 'I'm satisfied!' said the dying hero, and expired in the moment of victory!"

Pitt, as the sinking hero, occupies the centre of the picture. The faithful Dundas is vainly offering a parting bumper of the port they loved so well; Burke is supporting his chief with his "Reflections on 3700*l.* per annum." Pepper Arden, whose nose has received an additional twist in the conflict, is attempting to raise his fallen leader. An ensign is bearing the British standard, to which is added the white horse of Hanover galloping over Magna Charta. The friendly Mohawk Indian who figures in West's picture is rendered in the person of Lord Loughborough, who had been won over to Pitt's faction. The messengers are a brace of "Treasury Runners"—the Brothers Long. Lord Grenville, the second in command, is also wounded; he is supported by Windham. The Duke of Richmond, with his leathern ordnance strapped on his back, and another venerable shade wearing a wooden leg, are dissolved in tears. The battle is seen in the distance; the troops fighting under the banner of the Crown have gained the day, and a revolutionary emissary is hurrying forward to surrender the tattered flag labelled "Libertas."

The close of the year 1795 failed to reinstate Pitt and his colleagues in their popularity. Sedition was active, revolution and French invasion were darkly held forth; but even these bugbears were insufficient to establish confidence in the Minister. The improvident Administration which had delivered the people over to dear provisions and starvation was farther charged with want of exertion in alleviating the miseries of famine. Gillray's feelings were always enlisted on the side of the people and allied against the autocrats, who favoured the few and neglected the mass. On the eve of Christmas, when the signs of festivity were generally displayed, Gillray gave a hint of the misery out of doors while the commissioners for distributing relief were comfortably provided within.

December 24th, 1795. *Substitutes for Bread; or, Right Honourables Saving the Loaves and Dividing the Fishes.* "To the Charitable Committee for reducing the high price of corn, by providing substitutes for bread in their own families, this representation of the hard shifts made by the framers and signers of the Philanthropic Agreement is dedicated." We are here introduced to a Ministerial banquet; various "fishes" of the golden order are under discussion. Pitt, seated on a Treasury chest, has the largest portion—an enormous head and shoulders—of golden mouthfuls. At his back Pepper Arden is meditating over a lesser pile; Scotch Dundas— Pitt's favoured colleague, is greedily attacking his pickings with hands and teeth. Good eating deserves good drinking, and bumpers of port, champagne, and burgundy are apportioned to the Scot. Grenville has obtained a handsome plateful; his near-sighted lordship is feeding with characteristic devotion. Lord Loughborough is provided with a capacious bowl of "Royal Turtle-soup," made of golden pieces. The

gigantic sauce-boats, side-dishes, and centre trays are alike filled with golden fishes. Three sacks stand before the table, marked "Product of New Taxes upon John Bull's Property," and "Secret Service Money." Upon them is placed a small basket containing four little loaves, labelled "Potato Bread to be given in Charity." On the wall is a "Proclamation for a General Fast, in order to avert the impending Famine," and a list of "Substitutes for bread—venison, roast beef, poultry, turtle-soup, fish boiled in wine, ragouts, burgundy, champagne, tokay," &c. Through the window are the heads of the suffering poor, bearing a "petition from the starving swine:" "Grant us the crumbs from your table, and a loaf of bread."

In May the artist published a characteristic portrait of the Duke of Queensberry, "Piccadilly's little gamesome Duke," notorious in the worlds of rank and intrigue, at Newmarket and St. Giles's, as "Old Q." This reprobate, whose vices and profligacy flourished, as in the flower of his youth, till the hour of his death, is drawn by Gillray with the leer of a satyr.—(See "Push-pin," April 17th, 1767.)

Under the title of *Modern Elegance—A Portrait,* Gillray furnished a portrait of Lady Charlotte Bury (May 22nd, 1795). The celebrated beauty is drawn in profile, seated in a reclining posture, while a mirror gives back the reflection of her full face. The features are noble and the figure voluptuous. Lady Bury is dressed in the extreme of the "mode," according to Bate Dudley's highly-coloured description in his *Vortigern and Rowena :—*

"LOOK WHAT A SHAPE!"

" Limbes fondlie fashioned in the wanton moulde
Of nature ! Warm in Love's slie wytcheries,
And scorning all the draperie of Arte,
A spider's loom now weaves her thinne attire,
Through which the rogueish tell-tale windes
Do frolicke as they liste !"

The principal interest attaching to this lady's name in our own generation is the attributed authorship of the notorious "Diary Illustrative of the Times of George IV."

The portrait of another celebrity of high life and dashing reputation appeared (June 13th, 1795) in the well-favoured person of the Countess of Buckinghamshire, who we have already met as Lady Hobart. The portly lady is represented in character : "Enter Cowslip, with a bowl of cream— *Vide* Brandenburg Theatricals." Her round person is arrayed in quaint pastoral costume ; she is quoting from the piece, "Ay, here's the Masculine to the Feminine Gender;" and below the print are the lines :—

" As a cedar tall and slender ;
Sweet Cowslip's grace,
Is her nom'tive case,
And she's of the feminine gender."

Lady Buckinghamshire took a prominent part in all fashionable diversions ; she was the inaugurator of every expensive folly, and the drama was her especial hobby.

On June 20th Gillray transferred to his copper the beautiful features of the Duchess of Rutland — the "rose of the fair state"—by universal acknowledgment the loveliest woman of the English Court, at a time when the rivalry amongst famous beauties divided the whole community. It was a bold hand which ventured a mere black and white translation of the lovely face which had bewitched all England. The artist has preserved a wondrously sweet face. The print is christened *Characters in High Life Sketched in the New Rooms, Opera House.* The charming Duchess, a most graceful figure, wears two feathers in her hair, which add to the dignity of her person ; she is leading her sister, Lady Gertrude Manners, whose figure reaches to about one-half the height of the Duchess, but her plume of five enormous feathers even overtops the leading "Grace." The motto is : "Delightful task, to teach the young idea how to shoot!"

The dress of the man of fashion appears to have remained much the same from 1791 until nearly the end of the century, with the exception of the hat, which, at the period we are now describing (1795), took several fantastic shapes, having in some cases an enormously broad brim turned up at the sides.

On the promenade the ladies of fashion threw their hair back over the shoulders, and wore a hat resembling in form that of the other sex, but much smaller, with immense bushes of straw above. This was also the period when parasols came into general use, and they were carried in the manner represented by Gillray in the following figures, taken from a caricature published on the 15th of June and entitled *Parasols for* 1795. The lady's hair in this instance appears to be spread out and plaited at the ends, and it extends over her back in such a manner as to answer almost the purposes of a mantle. The fashionable pair are represented in full promenade costume. The gentleman's hat and the lady's parasol answer much the same purpose.

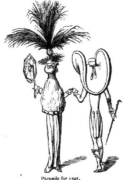

Parasols for 1795.

During this year the loose dresses, especially for indoor parties, continued in fashion with the lofty feathers, which, to judge by their representation in the engravings of the time, must have had a picturesque effect in large assemblies. The short waists also still furnished matter for ridicule. In a caricature published on the 4th of August, 1795, the ladies' dresses are ridiculed under the title of "*Waggoners' Frocks, or No Bodys of* 1795. The satirists began also at this time to cry out against short petticoats, and it appears to have become the fashion to expose the legs. Straw was becoming more and more into vogue, and was more especially used in the head-dresses and in the out-of-doors costume, and was sometimes so profusely scattered over the head and body that a print published on the 12th of July represents a fashionable lady under the title of *A Bundle of Straw*. It was at this period that straw bonnets began to come into use. An epilogue spoken at Drury Lane in November jokes on the prevailing fashion :—

> "What a fine *harvest* this gay season yields !
> Some female heads appear like *stubble-fields*.
> Who now of threaten'd famine dare complain,
> When every female forehead teems with *grain* !
> See how the *wheat-sheaves* nod amid the plumes !
> Our *barns* are now transferred to drawing-rooms ;
> While husbands who delight in active lives
> To fill their *granaries* may *thrash* their wives,
> Nor wives, alone prolific, notice draw,
> Old maids and young ones, all are *in the straw* !"

The absurdities prevailing in costume were further satirized in a caricature issued by Gillray (June 30th, 1795), under the title of *A Lady Putting on her Cap.* A countess is drawn seated before her toilette-glass, rolling yards of muslin round her head.

A Slice of Glo'ster Cheese (June 2nd, 1795) presents what is said to have been a striking likeness in features and figure of the Duke of Gloucester, the King's nephew. The profile of the slim Duke bears a strong resemblance to the outlines of the other members of the Royal Family. He was nicknamed "A Single Slice of Glo'ster." The Prince William of Gloucester was born in the Theodole Palace at Rome in 1776. He entered the army, and became a field-marshal in the progress of time. He succeeded to his title in 1805.

Prince William of Gloucester.

The Duke was elected Chancellor of the University of Cambridge in 1811. In 1816 he married his first cousin, the Princess Mary, fourth daughter of George III. He favoured the Whigs in his political principles, and his marriage with the sister of George the Fourth was not allowed to influence his polished opinions. He voted in

favour of his sister-in-law, the unfortunate Queen Caroline of Brunswick, when the Bill of Pains and Penalties was introduced into the House of Lords. In the diaries of George the Third's reign we often meet the young Duke, who, according to Miss Burney, was a great favourite in the royal household.

The ungenial patronage of George the Third's reign was as unfortunate for the development of science as it had proved unfavourable for the advancement of art and literature.

His favourites were men of mediocrity. He appeared to mistrust high talent, and treated men of genius with coldness and suspicion. The Royal Society had been honoured with the Monarch's patronage. The royal favour had raised the person and attainments of Sir Joseph Banks, who had been subservient to his wishes on a somewhat technical point, into what was then considered an undue eminence, and he was elected President. The King's interference with such appointments was generally resented; his choice excited disapproval and exposed his protégés to hostile criticism.

Gillray sided with the antagonists of Sir Joseph Banks. He published the naturalist's portrait (July 4th, 1795) as *The Great South Sea Caterpillar Transformed into a Bath Butterfly.* Appended to

The Butterfly of Science.

the plate was " A Description of the New Bath Butterfly, taken from the ' Philosophical Transactions' for 1795 :" " This insect first crawled into notice from among the weeds and mud on the banks of the South Sea ; and being afterwards placed in a warm situation by the Royal Society, was changed by the heat of the sun into its present form. It is noticed and valued solely on account of the beautiful red which encircles its body and the shining spot on its breast—a distinction which never fails to render caterpillars valuable."

Gillray represented a bank of the South Sea peopled with grubs and fungi ; the rays of the sun (in the crown) have transformed one of these creatures into a gaudy butterfly, bearing on his wings the figures of starfish, crabs, and cockleshells, and other objects which had attracted the knight's attention.

The " President in butterflies profound," as Pindar has termed him, was a subject of frequent satire.

Sir Joseph Banks had made a voyage round the world, in the company of the famous Captain Cook. On his return he was created Knight of the Bath and Privy Councillor. The bard was very severe on this circumstance :—

> " From Joseph Banks unto Sir Knight,
> Then Privy Councillor, in spite
> Of nature, brain, and education !
> If for the last he hands has kiss'd,
> There's not a *reptile* on his list,
> E'er knew a stranger *transmutation !*

After the knight's death, which occurred in 1820, Cuvier pronounced a public funeral *éloge* upon his respected correspondent. His statue, executed by Chantrey for the Linnæan Society, stands in the British Museum.

The picture of another scientific celebrity was introduced (July 3rd, 1795) as *A Burgess of Warwick Lane.* The print gives the back view of an eccentric figure wearing a huge three-cornered hat—Dr. Burgess, one of the remarkable characters of his day, who was frequently honoured with pictorial notoriety.

The artist's contemporaries professed to derive great entertainment from a quaint etching described as *A Decent Story.* Pages have been written on the suggestive humour of the picture, which represents a comical-looking personage entertaining a select party round his board, with a decanter of port and one of those stories freely seasoned with " Attic salt." Their enjoyment of this scandal is stamped on the faces of the entire circle. A doctor of divinity, and an old lady whose toothless state is admirably expressed, are regarding the speaker with the keenest appreciation. A very buxom matron is indulging

a smile which may be translated "Oh fie! shocking!" while a venerable and bald-headed veteran is grinning over the story and keeping his eye on the lady.

1796.

In the caricatures published by Gillray in this year the Opposition may be traced making active strides towards the recovery of their old influence, while Pitt and his financial policy were held up to fresh criticism. The "peace party" was allowed to gain the day, and the Minister seems disposed to subscribe to their views. Our allies on the Continent, in spite of continual supplies and subsidies, were giving way before the Republican hordes. The character of the Revolution was itself becoming modified, and respect for the French arms was enforced among neighbouring powers, where the threatening organization of the Republic was carried forward with a strong hand. The proposals for peace—welcome to the wearied-out peasantry—were haughtily treated by the Directory; their successes had inflamed their pride, and they announced an intention of invading England. This formidable threat at once changed the political aspect; down sank the influence of the Opposition, the power of the State Pilot was again in the ascendant, and the entire nation was fired into enthusiasm by the dangers which menaced their country. Pitt, intrepid in the hour of danger, seized this opportunity to mulct John Bull of the heavy sums required to carry on the war.

The Royal Family were left by the artist in dignified repose, with the exception of the Prince of Wales.

The beginning of the year was signalized by the birth of a direct heir to the throne. On the 7th of January the Princess Charlotte was introduced to the world. Gillray commemorated the event by a suggestive print, issued under a title which, unluckily, brought the satirist within the jurisdiction of the Ecclesiastical Court.

The Presentation, or the Wise Men's Offering, to which we have alluded in the earlier portion of this work, represents the presentation of the Prince's baby. The royal father—his dress disordered, his features expressing drunken vacancy—is staggering in to receive the heiress. A stout lady, not unlike the Duchess of Gordon, is supporting the royal infant; the wise men are Fox and Sheridan, from whom, as political associates, the Prince had been divorced since the Regency struggle and the Fitzherbert scandal. The "wisdom" of the Whigs is evidenced by their readiness to offer submission to the new arrival in a servile form.

It is curious that the mere title of this print should have subjected the designer to penalties, while his most venturesome attacks were circulated with impunity.

We have traced the frequency of meetings to protest against the restrictive measures of Pitt. The Act against Seditious Meetings provided that a gathering exceeding fifty persons should not take place, even in a private house, without information being first laid before a magistrate, who might attend and, if he saw cause, order the meeting to disperse, and those who resisted would be guilty of felony. In the face of such stringent intentions it is not surprising that the most pacific felt bound to appeal against such an interference. Gillray has commemorated one of these gatherings under the title of *A Hackney Meeting* (February 1st, 1796).

The Sheriff of Middlesex summoned the freeholders to assemble at the Mermaid, Hackney, to obtain a repeal of the unconstitutional Seditions Bill, and to prepare an address to the King. The Duke of Norfolk opened the proceedings, and we meet the "royal" Duke manifesting his sound sense. His Grace took occasion to warn the constituency that they must not be misled by the specious titles of the Bill. "I dare say," he observed, "if the High Priest of the Spanish Inquisition was to come among us to introduce his system of inquisition here, he would call it an act for the better support and protection of religion; but we have understandings, and are not to be deceived in this way."

The print introduces the two members for Middlesex, Byng and Mainwaring, standing on a platform in front of the Mermaid, addressing the electors. The portraits are expressive, and their attitudes are remarkably vigorous. Byng is thundering against the measure, while Mainwaring, the Court repre-

sentative, wearing a double-faced expression, is deprecating hostility to the Government. Mainwaring candidly stated in the House that the meeting had been most respectably attended, and that the requisition to the Sheriff had been signed by three dukes, one marquis, two earls, and numerous freeholders.

We have already traced the satisfaction with which the Whigs welcomed to their ranks the great Duke of Bedford. His assistance was not limited to mere moral influence; his wealth was lavishly expended in promoting the cause of freedom.

The liberal operations of the Bedfordshire Farmer were set forth in a caricature published (February 3rd, 1796) under the title of *The Generæ of Patriotism, or the Bloomsbury Farmer Planting Bedfordshire Wheat*. The Duke of Bedford is drawn in the act of raising a Republican crop. This patriotic nobleman is sowing the seed of golden pieces broadcast; a bag of golden grain is slung across his shoulders, his pockets run over, and a heavy sack of the same seed is strapped on his back. A little farther off Sheridan is ploughing; Lord Lauderdale is driving the docile bull attached to his ploughshare. The "Sun of Democracy," with the face of Fox in its centre, is ripening the crop with his quickening rays, and a prolific harvest of Republican red bonnets and Jacobin daggers is springing up. Fox is smiling at the effect he exercises over the Duke's gold; but a storm of lightning directed by Government influence is scorching up the crop.

The new ally of the Opposition soon came into collision with a Ministerial recruit. The Duke made certain observations in the House of Lords upon Burke's apostacy. Burke replied in a printed letter of remonstrance addressed to the Duke, in which he alluded to his former friendship with the Bedford family. Gillray, as we have seen, satirised the patriot's conversion with uncharitable vehemence, and pictorially embodied the worst constructions which could be fixed to this pamphlet.

Pity the Sorrows of a Poor Old Man, vide Scene in Bloomsbury Square (February 25th, 1796), introduces Burke as a broken-down mendicant making a begging petition at the gates of Bedford House. The ex-advocate of freedom is in rags, his back is bent under the weight of his heavy pack (4000*l*. per annum), in his pocket is seen a parody of his famous work, "Reflections upon Political Apostacy," and his hat is extended for charity, while he offers a bundle of "catch-pennies"—"Last Dying Speech of Old Honesty the Jesuit." He is crying, "Pity the sorrows of a poor old man; add a trifle to what has been bestowed by Majesty to stop my complaints. O give me opportunity of recanting once more! Ah, remember me in your golden dreams! Great Leviathan of Liberty, let me but play and frolic in the ocean of your royal bounty, and I will be for ever your creature; my hands, my brains, my soul and body—the very pen through which I have spouted a torrent of gall against my original friends and covered you all over with the spray—everything of me and about me shall be yours; dispense but a little of your golden store to a desolate old man!" The Duke of Bedford's profile is seen through the half-closed gates. "Harkee, old Doubleface," he replies, "it's no use for you to stand jawing there; if you gull other people you wont bother us out of a single shilling, with all your canting rant. No, no; it wont do, old Humbug! let them bribe you who are afraid of you or want your help; your gossip wont do here!"

This records one impression of Burke's patriotism; it is fair to assume that prejudice had for the moment blinded the Whigs to the dignity of his mind.

Miss Burney, among her portraits of contemporaries, has left a more worthy picture of the statesman. Describing Burke's funeral (1797) in a letter to Dr. Burney, she thus concludes: "That his enemies say he was not perfect is nothing compared with his immense superiority over almost all those who are merely exempted from his peculiar defects. That he was upright in heart, even when he acted wrong, I do truly believe; and that he asserted nothing he had not persuaded himself to be true—from Mr. Hastings being the most rapacious of villains to the King's being incurably insane. He was as generous as kind, and as liberal in his sentiments as he was luminous in intellect and extraordinary in abilities and eloquence. Though free from all little vanity, high above envy, and glowing with zeal to exalt talents and merits in others, he had, I believe, a consciousness of his own greatness that shut out those occasional and useful self-doubts which keep our judgment in order by calling our motives and passions to account."

The profession of extreme opinions occasionally rebounded unpleasantly. We have noticed the progress of the levelling principles as expounded by Earl Stanhope, President of the Revolutionary Society; he quoted in the House of Lords, April 4th, 1794, a large portion of the eighth chapter of the First Book of Samuel, to prove that kings were considered by the sacred writers as a curse upon mankind; that according to the Word of God it had been demonstrated that "He had permitted them only as a chastisement on His disobedient people." Lord Stanhope had also in the House of Peers professed himself a Jacobin, and on every opportunity he had declared his utter contempt for the distinctions of rank, until he was recognised as the paragon of sansculottism. His theories were, however, put to a severe practical test, and found wanting. In 1796 Lady Lucy Rachael Stanhope, his daughter, eloped with Mr. Thomas Taylor, the family apothecary. Instead of rejoicing over this home illustration of the principles of equality the Earl took an opposite course, and declined to be reconciled to his young convert. William Pitt, on the contrary, made the best of his niece's choice. Mr. Taylor was desired to relinquish physic, and the Minister gave him a place under Government. Lord Chatham recognised the marriage, and made the eldest son, his grand-nephew, William Stanhope Taylor, one of his executors, who became in consequence part editor of the great Earl of Chatham's correspondence. Pitt on his death-bed desired, if the public wished to make any acknowledgment of his long services, that it might take the form of an annuity to his nieces. Parliament voted 40,000*l.* for the payment of the debts which his household had incurred, and George the Third granted an annuity of 1200*l.* to the nieces. Lady Lucy Rachel died in 1814, and a small annual provision was granted out of the pension-list to each of her seven sons.

This marriage was a good target for the satirist. Gillray served up the story in his best manner, March 4th, 1796—*Democratic Levelling; Alliance à la Française, or the Union of the Coronet and the Clyster-pipe.* The bridal party are ranged before the altar; the comely bride, whose face is modestly concealed by her hat and veil, is extending her left hand for the wedding-ring. The artist has not flattered the bridegroom; the upper part of his person is composed of a democratic red cap, mounted on a pestle and mortar of huge dimensions; a clyster-pipe and a pair of drug-jars complete his person. Earl Stanhope is assisting his daughter at the ceremony; a French frigate is peeping out of his pocket, and his legs are guiltless of "culottes." Before the "shrine of equality"—an altar-piece of the guillotine chopping down coronets—stands Fox, habited in clerical vestments, and solemnizing the marriage from the "Rights of Man;" while Sheridan, assisting as his clerk, reads from the pages of "Thelwall's Lectures."

Pitt's restless financial energy supplied the wits with constant subjects. One of his novelties was a charge upon dogs. This unpopular tax was proposed by Dent, equally famous as a banker and bibliophile; he was ever after known as "Dog Dent." This speech inveighed so bitterly against the nuisance of dogs that Windham declared "he could almost fancy Actæon was revived, and revenging his injuries by a ban against the whole canine race."

The debates on the Dog Tax appear to have afforded some amusement in the House. In opposing the motion to go into Committee, Sheridan objected that the bill was most curiously worded, as it was in the first instance entitled "A bill for the protection of his Majesty's subjects against dogs." "From these words," he said, "one would imagine that dogs had been guilty of burglary, though he believed they were a better protection to their masters' property than watchmen." After having entertained the House with some stories about mad dogs, and giving a discourse upon dogs in general, he asked, "since there was an exception in favour of puppies, at what age they were to be taxed, and how the exact age was to be ascertained." The Secretary at War, who spoke against the Bill, said "it would be wrong to destroy in the poor that *virtuous feeling* which they had for their dog." In Committee Mr. Lechmere called the attention of the House to ladies' lap-dogs. "He knew a lady who had *sixteen lap-dogs,* and who allowed them a roast shoulder of veal every day for dinner, while many poor persons were starving. Was it not, therefore, right to tax lap-dogs very high? He knew another lady who kept one favourite dog, when well, on Savoy biscuits soaked in Burgundy, and when ailing, by the advice of a doctor, on minced chicken and sweetbread!"

The distinctions between dogs that were liable to the tax and those which were exempt produced

D D

many jokes. Gillray contributed a caricature of *The Dog Tax* (April 12th, 1796). Two dogs—one lean, the other well-favoured, were marked "To be paid for;" they bore the heads of Pitt and Dundas. These lucky dogs are smirking at two unlucky curs which have been seized as "not paid for" and suspended on a gibbet. These forlorn animals wear the heads of Fox and Sheridan, whose chains are linked in dismal fellowship; they are looking into each other's faces with the most mournful expression, and their right-hand paws are joined in a farewell shake; the lines under the drawing fall more heavily on the Ministers :—

> "New grievances so thickly come,
> And Taxes fall so hard, Sir,
> Poor Johnny Bull can't pay his sum,
> For Dogs that are his guard, Sir !
> Bow wow, wow.

> "But though so poor is Johnny's purse,
> How hard it is to say, Sir,
> For Royal Dogs that are our curse,
> Poor John is made to pay, Sir,
> Bow wow, wow."

The Dog Tax supplied Gillray with another suggestion.

John Bull and his Dog Faithful. "Among the faithless faithful only found."—John Bull is reduced to a sorry condition as a blind beggar—his clothes are mere rags, one arm and one leg are lost, an iron hook and a wooden stump supply the place of the missing members—his body is bent under a heavy pack of "Loans." A lank, restless whelp bearing a bone in his mouth is urging John Bull forward, but his footsteps are straying by the side of a precipice. "The dog Faithful," who is stalking on with depressed tail, wears a collar labelled "Licensed to Lead." He bears the pointed features of Pitt, on whose guidance poor John helplessly depends. Fox, as a noisy black cur, is barking unheeded from a safe distance. On his collar is stamped "Licensed to Bark." Another mongrel has spitefully seized the blind man's wooden leg; he bears the face of Sheridan and his collar announces "Licensed to Bite." A fourth dog, rather behind the others, has seized the traveller's coat-tail and is hanging on in the rear. Such, it was declared, was poor Bull's condition, wandering abroad bent down by heavy taxes, and further bothered by a pack of troublesome curs, who hung round the wayfarer in the hope of preying upon the spoils.

In the middle of February Grey again introduced a motion for peace, which was supported by the Opposition and replied to with much less warmth than formerly, and the Minister acknowledged that the Government was not averse to seize an opportunity of negotiating. The face of Europe had indeed changed considerably within a few months. On one side, our allies, in spite of the extraordinary sums expended in subsidies, were becoming faint and falling off before the immense armies of the Republic; and, on the other, the Republic itself, since the overthrow of the Jacobin party, seemed to be changing its character from a democracy to a despotic oligarchy. The fear of propagandism appeared, therefore, to have vanished, while it left us to the prospect of contending single-handed against so powerful an adversary.

These arguments may have inclined Pitt to indulge a vague hope of coming to terms with France; but it does not appear from the progress of the negotiations that his judgment was betrayed into any sanguine belief in a measure opposed to his own convictions. It became evident in the new session, a few months later, that the attitude of the Paris Directory would render impracticable any pacific policy on the part of England.

The financial requirements of the year suggested numerous expedients. Among the new taxes brought forward in the spring of 1796 was an additional duty of twenty pounds per butt on wine, which provoked no little discontent, and Pitt's wine-bibbing propensity furnished the subject of fresh satire. Gillray represented him under the character of Bacchus, and his friend Dundas under that of Silenus, in a caricature published on the 20th of April, 1796, with the title of *The Wine Duty, or the Triumph of Bacchus and Silenus.* John Bull, with empty bottles, exhausted purse, a very long face, and a wasted frame, is appealing to the well-provided Ministers with this remonstrance: "Pray, Mr. Bacchus, have a bit of consideration for old John;—you knows as how I've emptied my

purse already for you ; and its wauudedly hard to raise the price of a
drop of comfort, now that one's got no money left for to pay for it !" The
Ministerial Tippler, from his pipe of wine (which is supported on the
" Treasury bench") hiccups forth his reply : " Twenty pounds a
t-tun additional duty, i-i-if you d-d-don't like it at that, w-why,
t-t-t-then did and I will keep it all for o-o-our own drinking, so here
g-g-goes, old Bu-bu-bull and Mouth !"

Pitt, at the commencement of his career, had been called to the
post of Prime Minister in the face of an unmanageable Opposition, and
almost in defiance of the Parliamentary voice. As we have seen, he
boldly resorted to Parliamentary dissolution, and by his election
tactics disembarrassed himself of the troublesome majority. Opposi-
tion, overcome for a time, was revived, as the progress of these
caricatures has illustrated, and every new measure which exerted
any unpopular pressure weakened the Government influence. Pitt,

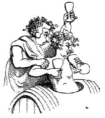

Bacchus and Silenus.

anticipating the struggle, boldly resorted to his old tactics, and the intention of dissolving Parliament
was announced in the speech from the Throne which closed the session of 1796.

Gillray's ingenuity in setting forth political situations is exhibited in a caricature on the new elections.

May 21st, 1796. *The Dissolution, or the Alchymist Producing an Æthereal Representation.*—Pitt,
the alchemist, seated in a chamber appropriated to the dark arts, is distilling, with alembic and furnace,
a new Parliament from the dissolution of the old one. He is seated on a square of bricks, the model of
his new barracks, warmly attacked in the late session ; in his pocket is his recipe for the " Antidotus
Republica," and he is busily engaged in observing his alembic. The furnace is fed with Treasury coals.
Pitt is raising the flame with a pair of bellows contrived from the crown. The dissolution, which the
alchemist is regarding with interest, is startling ; the mace is broken, the Speaker's chair is toppling
over the clerks of the House, who, with the Speaker, are going through the transformation asleep. Fox,
Sheridan, and the occupants of the Opposition benches are bewildered, and the supporters of their side
of Parliament are giving way.

Acts, statutes, rights of Parliament, Magna Charta, Bill of Rights, the cap of liberty, and the
scales of justice are all blown upwards in the process of conversion, to reappear in the form of a foot-
stool for the " Perpetual Dictator," the principal figure in the new aerial Parliament. Pitt, grasping the
mace, is sitting on the throne ; a crowned stork has replaced the royal arms, and the new members are
subserviently bowing down their heads in rows before him on both sides of the chamber. Drugs are
scattered around. In a pestle and mortar is the shield of Britannia ready for pounding ; a vase contains
" Aqua Regia," and a row of stoppered bottles are labelled " Oil of Influence," " Extract of British
Blood," " Spirit of Sal Michiavel," " Ointment of Caterpillars ;" depending from the ceiling, among the
accessories, are a serpent breaking from its egg, the head of a bull hung up blindfolded, and a gaping
crocodile, an executioner's axe, and similar curiosities. According to the first part of the promise held
out in the satire, Parliament was dissolved, the members were sent back to their constituencies, and the
general election commenced.

Gillray has left two plates on the subject. One, published in ironical anticipation (May 21st, 1796),
represents *The Hustings.* The candidate for Westminster is currying popular favour with his rough
supporters, by recalling his patriotic services on a question in which the rabble is supposed to take the
strongest interest : Fox, in court-dress, bowing deferentially over the railings, is pressing to his heart a
scroll inscribed " Pewter Pot Bill ;" he is observing, " Ever guardian of your most sacred rights, I
have opposed the Pewter Pot Bill ! ! !" A pot-boy is present with a string of pewter measures marked,
" Jack Slang, Tree of Liberty, Petty France ;" he is holding forth a foaming tankard for the refresh-
ment of the popular candidate ; while a sweep and various denizens of Covent Garden are in ecstasies
with their champion. A quotation from the *Mayor of Garret* is appended : " Vox populi— we'll have
a mug ! a mug ! a mug !"

Gillray's second allusion to the subject of the elections is less definite. It is called *A Proof of the*

Refined Feelings of an Amiable Character, Lately a Candidate for a Certain Ancient City. It represents a stout person wearing spectacles, booted and spurred, flourishing a formidable horsewhip over a lady whom he is holding by the hair; the ungallant castigation is announced "Pro bono Patriæ." A body of Church dignitaries are much scandalized at this proceeding. The print was probably executed to order as an electioneering weapon.

The Jacobin legions had triumphed in Germany and Italy, and the entire Continent was awed by the prestige of the Republican leaders. The commercial interests of England suffered from the depression of trade, and the increased taxation pressed heavily on every class. It was decided to make overtures to the Republic, either to insure a satisfactory peace or to convince the people that such negotiations were impossible. The Portland party were adverse to treating with the Republicans. The most determined and eloquent opponent of these pacific overtures was Edmund Burke, the lustre of whose latter days was concentrated in his "Letters on a Regicide Peace," a work which exhibited the full powers of his ardent genius, in which every argument of wit, eloquence, and rhetorical skill were combined to convince his countrymen that the reverses of war should only stimulate them to fresh exertions.

When the new Parliament met, on October 6th, the speech from the Throne announced that steps had been taken which had opened the way towards direct overtures for securing peace throughout Europe, and that an ambassador would be immediately sent to Paris with full powers to treat. It was intimated, moreover, that the wish for negotiation was hastened by the declared intention of France to attempt an invasion of this island. Lord Malmesbury was accordingly sent to Paris to open negotiations, and arrived there on October 22nd. It is assumed that there was but little sincerity in the exertions of the Ministry to secure peace. It was felt that any compact with the Republicans would rebound injuriously on the Government at home; the effort was made in compliance with the popular will, but the Government organs anticipated the results by inflaming the imaginations of the people with forebodings of the alarming prospects which they freely pictured before them.

When we consider all the excited speeches, pamphlets, and graphic satires addressed with but one object, that of influencing the people against the very power our Ambassador had set out to conciliate, which were actively circulated at the moment public feeling should have been most lenient, it becomes evident that a vigorous prosecution of the war was the cherished object of the far-seeing Pitt.

A terrific parody upon the dreaded revolutionary scenes of Paris appeared in Mrs. Humphrey's shopwindow just one week in advance of the print announcing the arrival of our Ambassador in France.

October 20th, 1796. *Promised Horrors of the French Invasion, or Forcible Reasons for Negotiating a Regicide Peace. Vide the Authority of Edmund Burke.*—According to the evidence of the print the French have effected their long threatened landing; their ferocious legions are pouring from St. James's Palace, which is in flames, and they are marching past the clubs. Their practice of patronizing democracy in the countries they had conquered has been carried out by handing over the Tories, the Constitution, and the Crown to the Foxite reformers and to the Whig party. The chief hostility of the French troops is directed against the aristocratic clubs; E.O. tables and packs of cards are thrown to the ground, and an indiscriminate massacre of the members of White's is proceeding in the doorways, on the balconies, and wherever the Republican levies have penetrated. The princes, who have taken refuge on the balcony, are stabbed and thrown over into the street. The lamp, battered and broken, has been turned to the use of the Paris "lanternes." Canning and Jenkinson are lashed back to back and suspended by the neck. Before them hangs the evidence of Hawkesbury's promised investment of the French capital—"New March to Paris, by Betty Canning and Jenny Jenkinson." A rivulet of blood is running down the street in front of the Tory Club; the head of the Duke of Richmond is seen in the stream, by the side of his "Treatise upon Fortifying the Coast."

In the centre of the picture is a tree of liberty, wreathed with garlands and topped with the "bonnet rouge." The Whig chief is taking his revenge on his rival, Pitt, who is stripped and bound to the pole. Little M. A. Taylor, as a bantam cock, is strutting on the fatal axe, and crowing at Pitt in security perched between the legs of his leader. In the right of the picture appears the head of Scotch Dundas with his bagpipes packed up in a basket, directed "To the care of Citizen Horne Tooke," after the hideous Parisian practice.

The "Acts of Parliament, Bill of Rights, and Statutes" are tied together as waste paper, "6 lbs. for

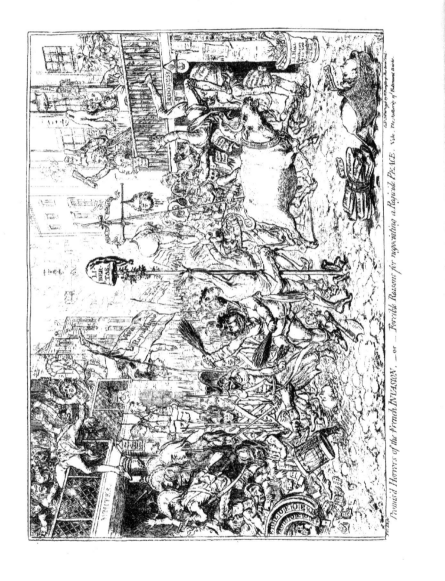

Promis'd Horrors of the French INVASION. — or — Forcible Reasons for negociating a Regicide PEACE. *Vide. The Authority of Edmund Burke.*

ad." The Duke of Bedford, in the figure of "The great Bedfordshire Ox," has broken loose; the Radical orator, Thelwall, is goading him to spread destruction around. The philosophic Burke, as the first sacrifice to subversion, is tossed into the air, while his "Reflections on a Regicide Peace" and his "Letter to the Duke of Bedford" fly over the ox's head. Earl Stanhope, with his "equality" steelyard, is weighing the head of Lord Grenville against his bulkier quarters; and Lord Lauderdale is chuckling over the scene. "Brookes's," the Whig club-house, is a scene of general rejoicing. Sheridan, as a porter, supports on his knot the "Remains of the Treasury" and a "Requisition from the Bank of England." These spoils are being carried into the stronghold of Whiggery : the impecunious "Sherry" is always depicted taking care of the main chance. The members of Brookes's are seen on their balcony, in the centre of which Lord Lansdowne has planted the guillotine; he has just "worked off" the head of Lord Loughborough, and is offering the Chancellor's wig to Erskine, who is holding forth with great vigour on his "New Code of Laws" to supply the place of the "Magna Charta," which he has lighted as waste paper. Three heads are arranged on a salver—Sydney, Windham, and Pepper Arden—"killed off for the public good." Derby, Norfolk, and Grafton are enjoying their triumph. A pestle and mortar, marked "J. Hall, Apothecary to the New Constitution," contains various coronets to be rounded to a proper democratic consistency.

This exaggerated picture of republican vengeance, published as an ironical foreshadowing of the realization of Burke's prophecies, formed an extraordinary prelude to Pitt's proposed overtures.

The negotiation, perhaps, arose from a sudden misgiving on the part of the Minister, for it seems never to have been fully approved of by his own party, and its expediency appears to have been very generally doubted. Earl Fitzwilliam entered a protest against it in the journals of the House of Lords, on the occasion of the debate on the Address.

Lord Malmesbury arrived in Calais on the 21st of October. The British Ambassador was courteously received by the authorities. As he passed through the provincial towns the lower classes expressed their enthusiasm for peace. At the posts nearest to Paris deputations of the "Poissardes" and members of the musical bodies came forward to offer demonstrations. They presented him with flowers—*en attendent des Lauriers.* They opened his carriage-doors and freely embraced the envoy and his companion, Mr. Ellis; but as all these manifestations invariably ended in requests for money, Lord Malmesbury was inclined to question their sincerity. On the 22nd his lordship entered Paris. He seems to have concluded that the greatest ferocity would characterize his reception. Delacroix, Minister for Foreign Affairs, was appointed by the Directory to negotiate with him.

As soon as the news of Lord Malmesbury's reception arrived in England, and the circumstances transpired which attended the welcome of that unlucky negotiator, Gillray communicated the cheerful tidings to the public after his own fashion, by issuing a print of *The Glorious Reception of the Ambassador of Peace, on his Entry into Paris* (October 28th, 1796). The plenipotentiary and his secretary are overwhelmed with democratic greetings, the fishwives have thrown open the doors of the travelling chariot, which is emblazoned with the Royal arms, and they are smothering the modest nobleman with kisses, to his evident consternation. The whole sansculotte public, military and civil, are shouting and waving their caps as the Ambassador's carriage is drawn into the capital by the jaded, half-starved, broken-kneed foreign post-horses.

Lord Malmesbury's instructions were merely provisional; his diplomatic delays rendered the French Government both suspicious and impatient. Two months were consumed in futile preliminaries and pretended arrangements. Delacroix then peremptorily insisted on Lord Malmesbury delivering in his ultimatum. His lordship desired time to communicate with his Government. The Minister returned his passport, with orders to quit Paris in forty-eight hours, as he appeared merely a passive agent and unprovided with the necessary powers to bring the pacific negocians to a termination.

This peremptory treatment of our plenipotentiary was resented as an insult, and thus destroyed all hope of obtaining peace, under any circumstances, from the government then ruling France, which had too deeply imbibed the thirst for conquest and plunder, and moreover possessed an immense army it would have been dangerous to reduce. England was thus plunged deeper than ever into the war, and, feeling that her only safety lay in conquering, the nation entered upon the renewed contest with more resolution and unanimity than ever.

The failure of our negotiations had this advantage, that it kindled throughout the island a flame of patriotic enthusiasm, and a determination to resent to the utmost the threat of invasion. In the midst of such feelings it is not surprising that the alarming budget which the Minister was obliged to announce in the beginning of the session was allowed to pass with less absolute discontent than usual ; and that even a voluntary loan, which the Government was obliged to open, was filled up with extraordinary rapidity.

On the 17th of November Gillray published a caricature entitled the *Opening of the Budget, or John Bull Giving his Breeches to Save his Bacon.* Pitt, attending at the Treasury gate with a large bag inscribed as the "Requisition Budget" open before him, is obliged to excite John Bull's apprehensions in order to extract his money from his pocket. He exclaims : "More money, John !—more money ! to defend you from the bloody, the cannibal French—they're a-coming !—why, they'll strip you to the very skin !—more money, John !—they're a-coming—they're a-coming !" The money was not all expended against French invaders, for Burke, Grenville, and Dundas, as representatives of the host of pensioners, are seen behind the bag scrambling for the gold, and seconding Pitt's exhortations with their several assertions, "Ay, they're a-coming !"—"Yes, yes, they're a-coming !"—"Ay, ay, they're a-coming—they're a-coming !" John Bull, in his alarm at the report of invasion and his distrust of the professed patriots, throws money and breeches and all into the bag, with the sullen declaration : "A coming I are they ?—Nay, then, take all I've got at once, Measter Billy ! vor it's much better for I to go ye all I have in the world to save my bacon, than to stay and be strip'd stark naked by Charley and the plundering French Invasioners, as you say." Charley (Fox), alarmed at the formal appropriation which is going on without his assistance, is inviting foreign assistance. He is seen behind declaiming across the Channel (with the fortifications of Brest in the distance) : "What ! more money ?—Oh ! the aristocratic plunderer !—*vîte ! citoyens, vîte !—dépêchez-vous !*—or we shall be too late to come in for any smacks of the *argent !—vîte ! citoyens ! vîte ! vîte !*"

In times of threatened agitation the Minister's first resource was to embody the Militia, to march out the Trainbands, and make an imposing show of good order. This policy was now embraced by Pitt, as we find from a caricature designed 25th November, 1796—*Supplementary Militia, Turning Out for Twenty Days' Amusement.* "The French invade us, hay ? Damme, who's afraid ?"—A corpulent butcher heads the cohort ; his professional apron and sleeves are retained to protect his uniform ; he is carrying the regimental colours, representing St. George and the Dragon. A one-eyed and wooden-legged drummer has evidently seen severe service ; his instrument is inspiring the civilian force with martial ardour. A bandy-legged cobbler, a gouty architect, a half-starved artist, a deformed tailor, and a dandy hairdresser compose the front rank. The rear, which is in ludicrous confusion, is made up of similar materials.

As Pitt had decided that John Bull should fight France, he was no less determined that the necessary supplies should be forthcoming. We have found him stripping his master by the Budget ; the moneys gathered in through this recognised channel were insufficient to further the Minister's projects. Taking a hint from Le Sage's novel of "Gil Blas," Pitt is represented as inviting John Bull's subscription to a "voluntary loan"—one of the stratagems by which he enlisted the sympathy of the patriotic.

Gillray published (December 10th, 1796) a plate of *Begging No Robbery, i.e., Voluntary Contribution, or John Bull Escaping a Forced Loan—a Hint from Gil Blas.*—The national prototype is on a doleful pilgrimage ; he has come down "Constitution Hill," and his face is turned towards "Slavery Slough and Beggary Corner." His pockets are not quite emptied, and a provision of broad pieces for the future is preserved in his hat. His person has lost much of its rotundity, and he can afford but a sorry nag in the last stage of decrepitude. This worn-out hack may be intended for the once famous White Horse of Hanover. A nest of highwaymen have surprised the defenceless rider ; all chance of escape is out of the question. The chief of the bandits is robbing under an ingenious pretence—"There is no compulsion." A hat is laid on the ground for charitable offerings, and a paper sets forth their "Humble petition for voluntary contributions, subscriptions, and new taxes, to save the distressed from taking worse courses." Pitt has levelled a most formidable blunderbuss, labelled "Standing Army," at the head of John Bull, and his finger is on the trigger. In his pocket are pistols and bludgeons, marked

"Forced loans in reserve." The Premier is servilely soliciting alms: "Good Sir, for charity's sake, have pity upon a ruin'd man; drop, if you please, a few bits of money into the hat, and you shall be rewarded hereafter." These persuasions are backed by three huge horse-pistols presented by Pitt's comrades—Dundas, Grenville, and Burke, the latter wearing his quill pen as a feather. John Bull, looking dismally into the muzzle of the Standing-Army blunderbuss, of which he is in evident dread, is pouring his donations into the hat with a liberal hand. An earlier writer alluding to this satire records:—

"Whether Pitt was an able financier as respects political economy is a question we presume not to unravel: his fiscal schemes are said to have reduced the 'bulls and bears' of the period to hopeless confusion; but his talents for raising the wind were exerted with effects which placed the incantations of the witches in *Macbeth* at a discount.

"The 'Voluntary Loan,' the 'Loyalty Loan,' and many another financial scheme set on foot by this political Colossus, were almost as extravagant speculations as the bubble companies which were so suddenly 'blown into thin air' by a powerful blast from that great reservoir of wind, the Lord Chancellor's woolsack."

The figure of the great Edmund Burke does not reappear in these caricatures. The death of his favourite son, who had succeeded him in Parliament, hastened his bodily decay, and the year ensuing he followed the object of his hopes to the tomb, July 9th, 1797.

Canning has bequeathed us an interesting record of the immediate impressions which were elicited on Burke's death: "Burke is dead. It is of a piece with the peddling sense of these days that it should be determined to be imprudent for the House of Commons to vote him a monument. He is the man that will mark this age, marked as it is in itself by events to all times."

Fox, ever ready to bear his manly and generous testimony to greatness, in friend or foe, lamented in affecting terms his political difference with Burke; he spoke of the philosopher (vide debate on Quebec Bill, 1791) as his master, for so he was proud to call him. "That all he ever knew of men, that all he ever read in books, that all his reasoning faculties informed him of or his fancy suggested to him, did not give him that exalted knowledge, that superior information, which he derived from the instructions and learned from the conversation of his right honourable friend. To him he owed all his fame—if fame he had any."

We have now traced the political year to its conclusion; 1796 terminated in a declaration of war and the preparation which it entailed. England was now fairly entered upon that desperate struggle which eventually, after great sacrifices, raised our national glory to a far higher pitch than it had attained at any former period. The dangers to which this country was then exposed were of no trifling character; with a great burthen of taxation already weighing upon it, it was threatened with the whole resentment of a powerful enemy, who expected to find disaffection at our very heart, and who had Ireland ready to rise in rebellion at the first signal that France was advancing to her assistance. Although there must have been more of faction than of real patriotism in those who could embarrass the Government at such a moment, we yet, perhaps, owe to the obstinate resistance of Fox and his party to the Ministerial measures that English liberty was not, in the enthusiasm of the moment, sacrificed to Court supremacy to a degree almost as disastrous even as the effects of foreign invasion.

A domestic topic divided the interest of our foreign relations. After his marriage the Prince of Wales lived in retirement, but his conduct was freely canvassed by the multitude.

We now refer to the testimony of the Rev. George Croly, who in most instances stands forward as an apologist for his patron:—

"The royal marriage was inauspicious; and it was soon rumoured that the disagreements of habit and temper, on both sides, were too strong to give any hope of their being reconciled. Of an alliance contracted with predilections for others existing in the minds of both parties, the disunion was easily foreseen; a partial separation took place, and the tongue of scandal availed itself fully of all its opportunities.

"Lady Jersey has been so distinctly charged with taking an insidious share in the separation, and with personal motives for taking that share, that the public voice must be acquiesced in, peculiarly as no defence was offered by herself or her husband. The charges were repeated with every aggravation,

yet those noble persons suffered them to make their unobstructed way through society; more to the scorn than to the surprise of the country.

"Never was there a more speaking lesson to the dissipations of men of rank than the Prince's involvements. While he was thus wearied with the attempt to extricate himself from Lady Jersey's irritations another claimant came; Mrs. Fitzherbert was again in the field. Whatever might be her rights, since the royal marriage, at least the right of a wife could not be included among them; but her demands were not the less embarrassing. A large pension, a handsome outfit, and a costly mansion in Park Lane at length reconciled her to life; and his Royal Highness had the delight of being hampered with three women at a time, two of them prodigal and totally past the day of attraction, if attraction could have been an excuse, and the third complaining of neglect, which brought upon him, and even his two old women, a storm of censure and ridicule. But the whole narrative is painful, and cannot be too hastily passed over."

Gillray, never very delicate, although constitutionally shy, frequently indulged in allusions which would not be tolerated in this generation.

The Prince's incomprehensible liaison with the elderly Lady Jersey, the mother of a family, is served up in numerous piquant plates.

In May, 1796, *The Grand Signor Retiring* represents great George, splendid in dressing-gown and bursting with corpulent grandeur, quitting his own apartment in Carlton House for that of his attendant, the notorious Lady Jersey, while her venerable lord, in deshabille, respectfully touching his night-cap, is holding a candle to light the sultan's footsteps. On the door is hung a chart of Jersey. A second cartoon exhibits the Prince's apartment; on the wall is a "map of the road back to Brunswick." The Princess of Wales has left her chamber, in which is the cradle of the infant princess; she has entered the room bearing a candle, which throws its light upon the contraband occupant of his bed. This print is styled *The Jersey Smuggler Detected, or Good Cause for Separation—Marriage vows are false as dicers' oaths!* (May 24th, 1796).

The sympathies of the people were strongly in favour of the Princess Caroline, and Gillray expressed the general sentiment. *Fashionable Jockeyship* (June 17th, 1796) is a similar view of this subject.

Lord Jersey is seen playing at Buck-buck with the Prince of Wales. We have ventured to reproduce this figure as the uniform is interesting at this date, as illustrative of the eccentricities of military costume. In the original a picture on the wall represents Cupid piping his erotics to a dancing sow.

"During the Carlton House dissensions the King paid the most marked civilities to the Princess of Wales; he visited her frequently, made her presents, wrote letters to her, and on all occasions evinced his determination to protect her under every circumstance. She was, unfortunately, totally deficient of prudence; a violent temper and a feeble understanding laid her at the mercy of the female intriguers who surrounded her, with the twofold malice of personal rivalry and defeated ambition. In defiance of all warnings she spoke with open scorn of all she suspected of conspiring against her; and there were few she did not suspect. Her opinions, even of the Royal Family, were highly sarcastic, and she had the folly to put those opinions on paper, with mischievous results."

"Buck, Buck!" The Prince of Wales and Lord Jersey.

The remonstrances of the Princess were passed unheeded; she then appealed to the King; Lady Jersey was removed and the injured wife was spared the infliction of her presence.

The King was extra sensitive on behalf of the Princess. She looked to him as her natural guardian. He arranged that the Princess of Wales should continue to reside under her husband's roof, and this partial reconciliation was welcomed as a promising sign of future harmony. Gillray celebrated the disgrace of Lady Jersey and the reinstation of the Princess Caroline in a cartoon (June 30th, 1796) entitled *Enchantments Lately Seen upon the Mountains of Wales, or Shon ap Morgan's Reconcilement*

to the Fairy Princess. On a Welsh peak appears the Prince of Wales, in the national emblem of a goat, embracing the Princess of Wales. The Duke of York, Lord Loughborough, and a third person, whose good offices may have promoted this favourable turn, are exhibiting their satisfaction by dancing on a second peak. Lord Jersey and his wife appear in a distant part of the principality. A black cloud is breaking over them, and from it issues the King's "What! what! what!" like lightning, to strike these shameless schemers into the sea.

The Reconciliation.

A few months later " fresh scandals were unloosed;" in the interval the Princess of Wales had apartments in Carlton House, while the Prince spent his time chiefly at Brighton. Charlton, a village near Blackheath, was finally fixed on for her residence, and there, with the Princess Charlotte and some ladies in attendance, she lived for several years.

According to Croly, " In the whole transaction the Prince was culpable. With habits of life totally opposite to those of domestic happiness, he had married for convenience; and the bond once contracted, he had broken it for convenience again. Following the fatal example of those by whom he was only betrayed, he had disregarded the obligation fixed upon him by one of the most important and sacred rites of society and religion; and without any of those attempts ' to bear and forbear,' and to endure the frailties of temper as well as the chances of fortune which he had vowed at the altar, he cast away his duties as a toy of which he was tired; and thus ultimately rendered himself guilty of every error and degradation of the unhappy woman whom he had abandoned."

In January the artist entertained the outside world with a quaint picture of his own interior life, represented in the persons of his publisher and her maid, the then well-known Betty. A reduction of this caricature is introduced into the earlier part of this work. The print known as *Twopenny Whist* forms a droll comment on the extravagance of play then prevalent. Mistress Humphrey, a German neighbour, Mortimer, the picture restorer, and Betty are deeply engaged in the game.

The immensely high plumes which had attracted the satirist in the past year reappeared in 1796. *A Modern Belle Going to the Rooms at Bath* (January 13th) represents a member of the fashionable world borne to the assembly in a sedan-chair. The top of the conveyance is opened to accommodate the lady's head-dress, a monstrous feather projecting yards above the sedan; a parasol, fastened to a long pole strapped on the back of the hindermost porter, protects the top.

The insufficiency of female apparel still engaged the attention of moral censors. Our artist published a caricature on the 20th of January intended to improve on the actual manners of the day and picture *A Lady's Dress as it Soon Will Be;* it represents the loose frock, so arranged as to expose to view at every movement a considerable portion of the body below the waist. According to other caricatures, the dresses actually worn were approaching fast towards such a consummation; for the body is represented as covered with little more than a mere light frock, the very pocket-holes of which became the subject of many a wicked joke. Gillray, in a caricature published on the 15th of February, 1796, endeavours to show that these pocket-holes, when placed sufficiently high, might be made useful; a lady of rank and fashion, dressed for the rout, could perform the duties of a mother while her carriage waited at the door, without any derangement of her garments. The title of this print is, *The Fashionable Mamma, or the Convenience of a Modern Dress; vide The Pocket-hole,* &c.

A Fashionable Mamma.

On the 25th of February Gillray published the portrait of a hand-

E E

some Creole from the Havanna, under the title of *La Belle Espagnote, ou la Doublure de Madame Tallien*. This lady was a well-known favourite of the ballet, and she is said to have borne a striking resemblance to Madame Tallien, who was also a Creole.

If we believe the numerous caricatures published at this time, ladies who carried fashion to the extreme were not content with this paucity of covering, but they had it made of materials of such transparent texture, that they rivalled the celebrated costume among the ancients of which Horace has told us—

> " Cois tibi pœne videre est,
> Ut nudam."

Gillray presented the public with an elaborate view of an assembly in good society, as it might have appeared to the spectator in 1796. *Lady Godina's Rout, or Peeping Tom Spying out Pope Joan; vide Fashionable Modesty* (March 12th). Lady Godina's name is a travesty of Lady Godiva; the fair representative of the Coventry heroine is Lady Georgiana Gordon, shortly afterwards married to the Duke of Bedford. Her ladyship is undressed in the height of the transparent taste of the period; the gentleman acting as candle-snuffer, otherwise Peeping Tom, is allowing his attention to wander over the attractions of the lovely Godina to the detriment of the office he is endeavouring to perform.

The caricatures are of course considerably exaggerated, but they leave no room to doubt that the peculiarities which they ridicule were carried often to an extent that we should now have a difficulty in reconciling with propriety.

Lady Georgiana's head-dress furnishes a good example of the fashionable turban and feathers, which, with most of the other characteristics of the costume of this period, continued more or less during 1796 and the following year.

Gillray's graver was sometimes enlisted to champion the fair. The roughness of manners affected in his day was far from finding toleration in the artist's mind.

High Change in Bond Street, ou La Politesse du Grande Monde (March 27th, 1796), exhibits the simpering dandies who then formed the glories of that fashionable promenade monopolizing the pavement, and discourteously obliging the fair pedestrians to walk in the road. These Bond Street loungers form an animated picture of the out-of-door aspect of life in 1796. Costume had then undergone those modifications which remove the earlier part of George the Third's reign so far away from its close. The "bucks" with their high neckcloths, their huge coat-collars and buttoned-up coats, their "tights" and half-boots—are given at length. One of the gentler loungers offers a back view of the loose sack-like dresses then in fashion, and also illustrates the manner of turning the hair over the turban.

The Height of Fashion in 1796.

It is evident from the commentary of an earlier writer that Gillray's pencil was enlisted in a good cause : " A broad hint this to the Broad Street loungers, touching their politeness in narrow ways. ' The only gentlemen in any civilized country who take the wall of the ladies are to be found in England,' said an observant citizen of the world; and we fear the observation is but too true. ' It avails not to attempt to cut blocks with a razor,' said Goldsmith; hence this satire was thrown away upon those whose manners it was intended to correct. Ill breeding, as exhibited in Bond Street by the patricians of the land is one of the many traits of nationality at which a philosopher must blush, and at which an English gentleman should hide his face for shame."

Poll and my Partner Joe (April 18th, 1796) is a print depicting a rough pair, probably dwellers in Ratcliffe Highway. This interesting couple are executing a Bacchanalian dance under the influence of a measure of gin.

In somewhat similar taste the artist published (May 2nd) a print of *Cymon and Iphigenia*, in which the classic couple are burlesqued in the persons of two vulgar substitutes. Iphigenia appears as a fat, ragged gipsy wench sleeping near the roadside; a remark-

A Back View.

ably simple Cymon, in the person of a clownish country squire, is struck with awkward admiration by the graces of the sleeping beauty.

About this date it was in contemplation to ornament the open spaces of the metropolis with statues. The idea was the source of many sly jokes. Our artist, whose winged shafts brought down every order of game, furnished (May 3rd, 1796) a sketch he had taken of the Prince of Wales from the life—*A Hint to Modern Sculptors, as an Ornament to a Future Square*—" Pater urbium subscribi statuis;" adding the quotation from Shakspeare's *Henry the Fourth* :—

> " I saw him with his beaver on,
> And his cuises on his thighs, gallantly armed,
> Rise from the ground like feather'd Mercury,
> And vaulted with such ease into his seat,
> As if an angel dropt down from the clouds,
> To turn and wind a fiery Pegasus
> And witch the world with noble horsemanship."

Gillray, from his vantage-ground in St. James's Street, observed with critical eye all that passed his windows; where the most distinguished personages unconsciously became his models.

A writer, previously quoted, has recorded : " Amongst others the illustrious equestrian figure who forms the subject of this ' Hint to Modern Sculptors,' preparing to review the crack regiment of which he was the redoubtable colonel, little thought he was passing muster before an unsparing *Martinet*. A French painter humorously enlarged this portrait, and hoisted it on a straddling post before a cabaret, as the sign of an ' English Light Horseman' !"

"A Light Horseman." A Hint to Sculptors

The caricatures and other social chronicles of 1796 clearly illustrate that public morality had fallen very low. Profligacy had been aided, petted, and abetted through every channel which could contribute to its extension. The most flagrant breaches of decorum which had hitherto passed unnoticed now excited the reprobation of moralists. The taste for masquerades, fostered under the influence of Mrs. Cornelys, had reached its highest extravagance; the unbridled licence in which these exhibitions terminated had finally disgusted their more moderate patrons.

The Opera had lost somewhat of the novelty which it had possessed under George II., and for a while it seemed to be almost eclipsed by the popularity of the masqued balls which took place at Carlisle House and the Pantheon. Foreign singers no longer attracted that extraordinary worship which had been bestowed on them formerly, and towards the end of the century the managers seemed to have aimed at moving the passions of the audience by the small quantity of apparel which was allowed to the *danseuses*, and the freedom with which they exposed their forms to public view. An English dancer, Miss Rose, who joined to a very plain face an extremely elegant figure and graceful movement, enjoyed great reputation in 1796, and seems to have led the new fashion for this kind of exhibition. A caricature picture of her by Gillray, published on the 12th of April, 1796, bears the motto, *No Flower that Blows is Like this Rose*. On the 5th of May following, Gillray caricatured this new style of dancing in a caricature entitled *Modern Grace, or the Operatical Finale to the Ballet of " Alonzo e Caro."* Miss Rose is represented in drapery so slight and transparent that the figure is disclosed without reserve. A male dancer in a Watteau costume is in the centre, while a third performer is almost naked to the waist. The following years witnessed a struggle between the Bishop of Durham and the opera-dancers, during which the prelate, in the interests of public decorum, considerably reformed the primitive fashions of our first parents, to which the dancers were rapidly approximating.

No single vice was contributing so much to demoralize the nation as the passion for gaming, which

ran through all ranks in society, but which was carried to an extraordinary pitch in the fashionable circles. It was well known that ladies of rank and fashion in the world associated together to support their private extravagance by seducing young men to the gambling-table, and stripping them of their money in the manner professionally termed "pigeoning." Faro-tables for this purpose were kept in the houses of some of the aristocracy. Three ladies in particular enjoyed this reputation, Lady Buckinghamhamshire, Lady Archer, and Lady Mount Edgcumbe; who from this circumstance became popularly known by the epithet "Faro's daughters." Numerous caricatures, among which are some of Gillray's happiest conceptions, have preserved the features and renown of this celebrated trio. Their infamous conduct had provoked in an especial degree the indignation of Lord Kenyon, who, on the 9th of May, 1796, in summing up a case connected with gambling,* and lamenting in forcible terms that that vice so deeply pervaded the whole mass of society, animadverted with great severity on the higher orders who set the pernicious example to their inferiors, adding, with some warmth, "They think they are too great for the law: I wish they could be punished." And then, after a slight pause, he added: "If any prosecutions of this nature are fairly brought before me, and the parties are justly convicted, whatever be their rank or station in the country—*though they should be the first ladies in the land*—they shall certainly *exhibit themselves on the pillory.*" If they escaped the ordeal to which the angry judge had devoted them, there was another pillory which exposed these gaming ladies to equal scandal, if not to an equal punishment; and instead of being pilloried once, their ladyships stood for the public view, for weeks instead of hours, in the windows of every print-shop in the town. On the 12th of May Gillray published a caricature entitled *The Exaltation of Faro's Daughters,* in which Ladies Buckinghamshire and Archer are placed side by side in the threatened pillory, exposed to a shower of mud and

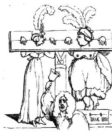

Ladies of Elevated Rank.

rotten eggs, which testify the joy of the mob at their disgrace; a placard attached to the stocks describes this process as a "Cure for gambling, published by Lord Kenyon in the Court of King's Bench, on May 9th, 1796." An imitation of this print appeared on the 16th of May, under the title of *Cocking the Greeks,* in which the same ladies are similarly exposed; but the short and plump Lady Buckinghamshire is obliged to stand on the tip of her toes upon her own faro-bank box, to raise her neck on a level with that of her taller companion. Lord Kenyon, in the character of public crier, is making his proclamation: "Oh yes! oh yes! —this is to give notice that several silly women, in the parishes of St. Giles, St. James, and St. George, have caused much uneasiness and distress in families, by keeping bad houses, late hours, and by shuffling and cutting have obtained divers valuable articles:—Whoever will bring before me"

The following spring these ladies, as we shall find, were brought before the Rhadamanthus, but they escaped with a fine.

The Prince of Orange resided in England after the differences in Holland. The ex-Stadtholder frequently appears in Gillray's satires. An allusion to his admiration for English beauties occurs in a suggestive print (September 16th, 1796) called *The Orangerie, or the Dutch Cupid Reposing after the Fatigues of Planting, vide the Visions in Hampton Bower.* Prince William, as a corpulent Cupid, is slumbering on a bank in the palace-grounds. His pillows consist of bags marked twenty-four million ducats; recently potted slips of orange-trees are arranged round the sleeper, bearing crops of little orange heads. Various deputies of the fair sex—a Billingsgate fishwife,

* A profligate having won 15*l.* at a card-table held in a public-house on the Sabbath-day, payment of the money was refused, and an action was brought for its recovery before Lord Kenyon ; when that intrepid judge, in summing up, expressed great indignation, and lamented that gambling had so greatly pervaded the whole mass of society. It was on this occasion his lordship pronounced his determination of suppressing gambling by making a severe example.

a milkmaid, a housemaid, and a whole regiment of female farm-servants—appear in the vision, trooping down to reproach the Royal Cupid with his transgressions.

One of the nobles best known in Gillray's day was the Earl of Derby, remarkable for his Punch-like proportions, his capacious forehead, and his pig-tail. This talented and eccentric personage had a great respect for the stage, and more es-pecially a particular admiration for a most accomplished actress, the elegant and popular Miss Farren. The remarkable fortune of this lady, and the dignity with which she bore her elevation to the peerage as Coun-tess of Derby, gained her many enemies; but the most serious charge which her detractors advanced against her reputation was an absence of liberality to her companions of the buskin. The integrity of her moral character was unquestionable. Gill-ray had evidently an aversion to this lady, and as she became the topic of general attention the artist had numerous opportunities to in-dulge his satire. A few months be-fore Miss Farren became the second wife of Lord Derby Gillray made a study of the loving pair indulging their taste for the fine arts. It is called *A Peep at Christie's, or Tally-ho and his Nimeney Pimeney Taking their Morning Lounge.* Miss Farren, by her inimitable perfor-mance of the character of Nimeney Pimeney, in General Burgoyne's *Heiress,* had obtained this nick-

A Peep at Christie's. Tally-ho and his Nimeney Pimeney.

name. The tall, slight figure of the future Countess appears in remarkable contrast to the droll person of "Tally-ho," who carries in his hand the catalogue of a gallery of pictures on view at Christie's, then as now the famous haunt where the finest works of art were dispersed. Lord Derby is admiring a sporting picture, "The Death of Reynard," in allusion to his tastes and circumstances; while Miss Farren is scrutinizing the merits of a different subject, "Zenocrates and Phryne." In the background, engaged in the study of "Susanna and the Elders," is a group of fashionable loungers, dressed in the height of the prevailing mode.

A Corner near the Bank, or an Example for Fathers (September 26th, 1796), exhibits the likeness of "Old P——," a clerk in the Bank, well known for his devotion to the frailer members of the sex. This elderly voluptuary appears with a roll of "Modest prints" in his pocket.

Lord Camelford, an extraordinary young nobleman of high and peculiarly wayward spirit, makes his appearance in an incident which Gillray's pencil has recorded. It is called *The Caning in Conduit Street,* and is dedicated to "the Flag Officers of the British Navy" (October 1st, 1796). His lordship, a tall stripling, wearing the uniform of lieutenant, has seized a short and stout captain, and is aiming blows at his discomfited opponent with his cane; a gentleman in civilian costume is restraining the aggressor and averting the strokes; two urchins are grinning at the struggle, which takes place in front of the South Sea Fur Warehouse, "from China." Lord Camelford is

crying, "Give me satisfaction, rascal! draw your sword, coward! What, you wont! why then, take that, lubber! and that, and that, and that," &c. Captain Vancouver, the person assaulted, is calling out lustily, "Murder! murder! Watch! constable! Keep him off, brother, while I run to my Lord Chancellor for protection! Murder! murder! murder!" From the Captain's pocket hangs a "List of those degraded during the voyage; put under arrest, all the ship's crew; put into irons, every gentleman on board; broke, every man of honour and spirit; promoted, spies," &c. On his shoulders hangs a fur-cloak. This present from the King of Owyhee to George III. is labelled "forgot to be delivered." In his brother's pocket is—"Charles Renroover, letter to be published after the parties are bound to keep the peace." On the ground behind the Captain is a bundle of irons, "For the Navy."

Lord Camelford, whose character, though vigorous and manly, was wilful and unmanageable, had entered the Navy by his own desire. He accompanied Captain Vancouver in the "Discovery," in his voyage round the world. Disregard of the commander's orders was visited by punishments which his uncontrollable spirit could not endure. In the Indian Seas he exchanged into the "Resistance," commanded by Sir Edward Pakenham, who promoted him to a lieutenancy. Camelford's father died during his absence, and on his return he succeeded to the title and family estates. His first act was to send a challenge to Captain Vancouver, who declined, pleading the necessity of maintaining discipline. Lord Camelford then threatened personal chastisement; the Captain, anxious to avert a public insult, was on his way to the Lord Chancellor's Office, to put himself under the protection of the laws of his country, when Lord Camelford surprised him in Conduit Street. It is said the disgrace of the transaction weighed on Captain Vancouver's spirits and hastened his end.

Similar hostile messages directed by subordinates to their superior officers (notably in the case of Sir J. Orde's challenge to Lord St. Vincent) have been declined, on the grounds that the principals were not personally responsible for their public measures.

The career of Lord Camelford was violent throughout. Eight years later he fell a victim to his own impetuosity, being killed in a duel he had forced on Captain Best. His overbearing disposition would have left his memory unregretted, but for a codicil to his will added by his own hand the night before his last encounter. He exonerated his opponent from all responsibility; he declared the quarrel, "in spirit and letter," of his own seeking, and addressed a plea to the King to relieve his antagonist from the consequences of the duel if it should terminate in his death. He directed his body might be interred in a part of Berne which had moved his sympathies by its tranquil beauty; he further desired his relatives would not go into mourning.

A marriage having been arranged between the Princess Royal and the Duke of Wirtemberg, Gillray took an early opportunity of presenting the public with this great man's portrait. On October 24th, 1796, appeared a print called *Sketch'd at Wirtemberg*, offering a profile of the Prince's figure in court-dress. The corpulence of this sovereign was remarkable, and the wits of the day christened him the "Great Bellygerent" in consequence.

The likeness of another royal personage appeared in November as *The Arch-Duke*—Charles of Austria, remarkable for the peculiarities which were attributed to him. In Gillray's print the Archduke, who was a brave and skilful leader, is represented as directing an engagement. An enormous cocked hat, with tassels before and behind, topped with a huge sprig of laurels, nearly conceals his face and back; his pig-tail reaches below his waist, and the remainder of his costume appears equally extravagant. A contemporary account records: "Many stories of the eccentricities of this illustrious commander were told with sly, dry German humour behind the hero's back. Amongst other things, it was asserted that the prince never rode against the rain but with a mouthful of water. 'How happens it,' said his Highness; 'does the rain get into your mouth, General?' 'No, sire,' was the reply; 'for I ride with my mouth shut.' 'Lord,' said the prince, 'I never thought of that.' This story was parodied by the *John Bull* newspaper, and fathered upon a prince of our own dynasty. The Royal Duke, however, did not swallow rain; but the wicked wag made his Highness's mouth a *fly-trap!* 'I never ride out in the sun but my mouth gets full of flies; is it not strange?' 'Perhaps your Royal Highness rides with your mouth open!'"

Colonel George Hanger, afterwards Lord Coleraine, who was introduced in the earlier part of this series as the inseparable companion of the Prince of Wales—the sharer of his fortunes and misfortunes—

appears to have ultimately dropped out of favour with his patron. As we have already traced, the Colonel was an extraordinary personage, but the funds at his disposal seem to have been generally at a low ebb. His "Rambling Memoirs" affect a perfect frankness, and the reader is made familiar with his drollest resources. A reputation for eccentricity was one of Georgey's hobbies. Gillray was able to gratify him in this respect, and the Colonel, with his famous big stick, was often transferred to his plates.

Georgey's guiding principle in life was elasticity and a desire to make the best possible appearance under all circumstances. Gillray presented the town with a portrait of *Georgey a' Cock-horse* (November 23rd), as he may have been seen riding down Grosvenor Street on his way to a convivial club. Georgey was neither rich nor poor at this period; his income was derived from two appointments connected with the army supply and with recruiting for the forces abroad, the more considerable post being in the gift of the East India Company. Georgey's cock-horse is selected with a due regard to the means of the rider; it is a round-bodied, short-legged, rough-headed pony, not many hands high; the rider's legs might easily touch the ground on either side. The satirist has drawn the equestrian passing before a famous tavern in Lower Grosvenor Street, known as the Mount, celebrated in its day as the rendezvous of "choice spirits." A contemporary paragraph thus reports of "Georgey a' Cock-horse:" "About this period (1796) George's notoriety had reached its climax. He was to be seen daily in Bond Street, St. James's Street, and the immediate vicinity, riding upon a little pony, his hat cocked knowingly on one side; he wore an Indian silk-handkerchief round his neck, and carried a pondereus 'supple-jack'—a bludgeon then all the fashion among the bloods and bucks of the town. The tavern at which he seems about to alight is the celebrated Mount, in Lower Grosvenor Street, famous for a club of wits, at whose meetings Frank North, George Colman, *cum multis aliis*, used to assemble."

The caricature of Hanger's Scotch pony and the jokes which his friends may have cut on his steed evidently betrayed the gallant gentleman into unconscionable stories, which Gillray possibly overheard; the Colonel declared, in defence of the weight-carrying qualities of his "Punch," that in Scotland he had seen as many as thirteen dead calves on a similar "cock-horse." The satirist went to work, and at once etched out a plate of the horse and its burden; the pony's head is barely visible under a pile of calves, heaped up to the height of a dromedary. The Colonel is perched on the apex of the pyramid. This burlesque is called *Staggering Bobs, a Tale for Scotchmen, or Munchausen Driving his Calves to Market* (December 1st). The story put into Georgey's mouth is told in rather forcible vernacular, but it bears the closest possible resemblance to the language and style he adopted in the "Memoirs," of which it is a fair parody. An easy accomplishment of swearing was, it must be remembered, the special qualification of the "bucks" of those days; as a conclusive evidence of refinement and gentlemanly breeding, slang or "cant" terms were in high repute, and the imagination of this vivacious celebrity seems to have coined expressions for his own particular convenience. Lord Galloway, also an amateur of ponies, is supposed to have been the person addressed: "Here they are, my lord," says Georgey; "here's the stuck calves, by G—; no allusion, d—mme! almost forgot you were a North-countryman! Runt carries weight well! no less than thirteen, d—mme! Come, push about the bottle, and I'll tell you the story. In Scotland they eat no veal—no veal by G—! On my honour and soul I mean no insult! but Tattersall, he swore, d—mme if he didn't, that on a small Scotch runt he saw, d—n my blood, how many d'ye think he saw? ('Saw what, Georgey!') Why, calves, 'staggering bobs,' to be sure—why, d'ye think he saw seventeen?—no! but d—nme, by G—, he saw thirteen!!! and all just upon such another little 'cock-horse' as my own!"

The profanity of this style of conversation may be considered alarming, but it is not an exceptional realization of what was then listened to without any particular suspicion of blasphemy. Honest George Hanger was elaborate in his abjurations, but he swore no more than did the highest personage in the realm, if report may be credited. We have treated the portrait of the Colonel at this length, as his character is not without its interest as typical of the fast man of his time.

In the same month another distinguished Bond Street lounger found his figure and peculiarities noted. Lord Sandwich, a representative of the good-natured, easy-living nobles of his day, was exhibited attracting the attention of a bouncing barrow-wench, in a print called *Sandwich Carrots! Dainty Sandwich Carrots!* (December 3rd, 1796). A chatty contemporary writer, well posted in the stories of that

time, has enlightened us on the felicity of this engraving : "And very like to the gallant old peer, always peering about Bond Street and St. James's Street, and other streets in quest of something new. This titled worthy was constantly to be recognised in the fashionable season in his morning peregrinations from about Faulder's to Stevens's, and then back again on the other side, when his friends would smile on his twitching some smart flower-girl or itinerant fruitress who had waylaid the old beau, casting 'a side-long glance' at her noble patron, prepared for his usual bounty—a golden guinea. His lordship was a great sportsman and *bon vivant*. Hitchinbrook has recorded many a scene of conviviality, which will be remembered by the old stagers of Huntingdonshire, and quoted perhaps by their grandsons. His lordship's wine was excellent, his story delectable, and his hospitality noble. Once in the autumn of life his lordship, with another joyous old peer, on their way to Hitchinbrook, stopping to change horses at the Sun Inn, Biggleswade, and feeling themselves fresh with the bracing air of October, called for a broiled chicken for lunch. They ordered a bottle of claret by way of adding to its zest. 'This is capital stuff,' said their lordships; 'have you any more of it, landlord?' 'About thirteen bottles, my lord.' To make the story short, they were so comfortable that they sat at the inn till a late hour, entertained each other in humorous chat, and finished the whole of the landlord's claret."

1797.

The year 1796 concluded with the prospect of invasion ; an expedition was prepared by the Republic to assist the disaffected in Ireland, and thus strike the kingdom in its most vulnerable point. Gillray's caricatures follow the progress of hostilities with France ; they trace the solitary dominion of Pitt, managing the country according to his will and driving the disconcerted Opposition fairly out of Parliament. We follow Pitt's bold finance—the restrictions he imposed on the currency, and the new and unpopular taxes he levied. Amidst the troubles which agitated the public mind, another royal marriage raised a temporary rejoicing. The failure of the French armada which was to have landed in Bantry Bay encouraged a strong exhibition of animosity against those who were suspected of participating in Republican opinions.

On January 20th Gillray published a spirited print indicating the position of the French fleet hopelessly tossed about by a furious tempest. The elements are doing battle with the Republican Navy, and a terrific storm is raised from four quarters, which renders destruction inevitable. The familiar faces of the Ministers who excited the outburst against the invaders appear as the four winds. Pitt, behind whose profile is the sun of royal power, is directing his mighty breath full at the largest ship, "Le Révolutionnaire," bearing as figure-head the person of Fox. This huge vessel of democracy is already disabled. Lord Grenville has concentrated the force of his lungs against the doomed "Egalité," and the unwieldy craft is sinking to destruction. Dundas and Windham are raising blasts which promise to clear the seas of the invaders. The Opposition, who were represented rejoicing over the prospect of an Irish rebellion and a foreign invasion, have abandoned their fleet and taken refuge in the Revolutionary "jolly-boat," which is swamped by the surge of Fox's unmanageable leviathan ; Sheridan, "Liberty Hall," Erskine, M. A. Taylor, Orator Thelwall, &c. are in various stages of immersion.

The grandeur of Pitt's power suggested the conception of a Colossus seated astride the Speaker's chair, with Parliament beneath his feet, playing at cup and ball with the great globe. This idea was embodied in the cartoon of *The Giant Factotum Amusing Himself*, published the day following the picture of the armada's destruction. The lean figure of Pitt occupies this proud elevation with burlesque awe ; his capacious pockets are distended with the resources he has raised for continuing the war abroad, while peace at home is maintained by the firmness of his foot. Opposition is effectually crushed under his heel, which threatens annihilation to his helpless antagonists, who are writhing under its pressure. Fox, Sheridan, Erskine, Grey, and M. A. Taylor (as a monkey), are all struggling at the mercy of the giant. The badly-attended Opposition benches present a mob of horrified spectators. Pitt's right foot is resting on the shoulder of stout Dundas ; Wilberforce is assisting, and Canning is kissing the toe with profound respect. The occupants of the Ministerial side, arranged in bowing rows, are kneeling

SANDWICH-CARROTS! dainty SANDWICH-CARROTS!

before the great factotum. The extensive character of Pitt's preparations for carrying on the struggle with France is indicated by his mighty pocketful of official returns of the forces to be placed at his disposal—200,000 seamen, 150,000 regulars, volunteers, militia, &c., while the corresponding pocket forms a repository for golden pieces, the funds destined as subsidies for our Continental allies. An earlier writer, describing this cartoon, remarks: "The grandeur of this thought is worthy of Michael Angelo himself. On seeing this magnificent personage thus exalted, the facetious Caleb Whiteford first whistled the air, and then parodied the song as follows:—

> " ' Jove in his chair,
> Of the skies Lord Mayor,
> When he nods, men, yea gods ! stand in awe ;
> O'er St. Stephen's school,
> He holds despotic rule,
> And his word, though absurd, must be law.'

" ' This is a climax,' added old Caleb; ' he does put his giant foot upon whom he lists. Sirs, in entering the House, he neither smiles nor bows to the right or left, but stalks into his seat with the authority of a schoolmaster; and then, how he flogs the trembling urchins.'"

The Ministers, indeed, now confident in their power, began to treat the Opposition with scornful superiority. When Fox continued to declaim against the dangers to which they were exposing the country by their ill-conduct and improvidence, Dundas is said to have spoken of the Whig alarmist in his reply in the following terms: "For a dozen years past he has followed the business of a Daily Advertiser, in daily stunning our ears with a noise about plots and ruin, and treasons, and impeachments, while the contents of his bloody news turn out to be only a daily advertisement for a place and a pension." The allusion to the Whig paper told with great effect; and shortly after, on January 23rd, the idea was embodied in a caricature by Gillray, representing Fox in the character of a ragged newsman, with his horn, shouting the news of the *Daily Advertiser*, and thundering, but in vain, at the Treasury gate. The knocker is designed in a Medusa-like likeness of Pitt, and all the newsman's bawlings of "Bloody news, glorious bloody news for Old England ! traitorous taxes! swindling loans! murderous militias! ministerial invasions! ruin to all Europe! alarming bloody news! bloody news!" merely provoke this discouraging reply : "Lord ! fellow, pray don't keep up such a knocking and bawling there ; we never take in any Jacobin papers here, and never open the doors for any but such as can be trusted : True Britons and such !" On the patriot's head is the red bonnet, under his arm is a roll of Paris papers; the *Daily Advertiser*, which he is hawking about, contains a list of "Places wanted"—"Want places"— and " Wanted;" but the several advertisements relate to but one object—provision for the alarmist. "*N.B.* The above mouth-stoppers will be purchased on any terms! For particulars apply to the Fox and Grapes, in Starvation Lane, or at the Box and Dice, in Knave's Acre." A placard on the Treasury wall announces, "Just published, a new edition, 'The Cries of the Opposition, or the Tears of the Famished Patriots, dedicated to the consideration of the ministry.'"

While darkness and desolation were assigned to the Opposition, the grateful public judged no reward disproportioned to Pitt's services. In these caricatures, as in life, Pitt is more generally presented as the cold, stiff statesman, inflexible, unfitted for the familiarities of friendly intimacy or for domestic happiness His friends have drawn a more genial picture of his hours of relaxation, when wit and wine were circulated simultaneously. Pitt's personal household was, it must be confessed, rather frigid ; his reticent intercourse with the fairer portion of creation gave rise, in that free-living age, to many sly sallies.

" EPIGRAM ON THE IMMACULATE BOY.

> " Incautious Fox will oft repose,
> In fair one's bosom thoughts of worth ;
> But Pitt his secrets keeps so close,
> No female arts can draw them forth."

The houses of Wilberforce and Dundas were the refuges to which Pitt retired when suffering from over-pressure. His niece, Lady Hester Stanhope, presided over his own establishment, and the influence

of that remarkable lady does not appear to have exercised a cheering effect upon the mind of the Premier. The suggestions of marriage were in more than one case entertained, and the State pilot seemed likely to descend from his chilling solitude.

February 13th, 1799. *The Nuptial Bower,* published by Gillray, conveys the impression of an

The Nuptial Bower, Pitt and the Charms of Eden.

anticipated change. The grasshopper figure of Pitt is conducting a lovely and blushing lady to the portals of Eden, hung round with Treasury grapes, while coronets, stars, and ribbons spring up spontaneously under their feet, or twine in "rank" luxuriance over the heads of the happy pair. The very banks, which invite their repose, consist of sacks of Treasury gold. Fox is introduced as the Evil One, peeping at the charms of Eden. The "Eden" was the Hon. Catherine Isabella Eden, daughter of Lord Auckland. Pitt weighed the consequences of this union—which his heart approved—against his devotion for his country, and his head carried the argument. He determined to admit no rival to his love of country. "The tattle of the town," wrote Burke to Mrs. Crewe, "is of a marriage between a daughter of Lord Auckland and Mr. Pitt, and that our Statesman, our *premier des hommes,* will take his Eve from the Garden of Eden. It is lucky there is no serpent there, though plenty of fruit."

Lady Hester Stanhope has recorded that Pitt loved this lady "ardently;" she cordially approved his choice, and paid a visit to Beckenham to get a sight of her uncle's anticipated bride. When Pitt had determined that he would be obliged to neglect his wife in the interests of the State, Lady Hester wrote: "Poor Mr. Pitt almost broke his heart when he gave her up. But he considered she was not a woman to be left at will when business might require it; and he sacrificed his own feelings to his sense of public duty. 'There are other reasons,' Mr. Pitt would say; 'there is her mother, such a chatterer, and the family intrigues. I can't keep them out of my house; and for my King and country's sake I must remain a single man.'"

After this hard resolution the Statesman became more inflexible than ever, sterner to his enemies, more haughty to his friends, as he took refuge in his isolated greatness, every vexation and impediment appeared to cut more deeply into his proud spirit.

After Pitt's decease, in 1806, the lady married the Right Hon. Nicolas Vansittart, afterwards Lord Bexley. She died prematurely in 1810.

An earlier matrimonial venture had been proposed to Pitt from a foreign source, according to the testimony of his friend Wilberforce.

When Pitt was staying in Paris, after the dissolution of the Shelburne Administration, it was hinted to him, through the intervention of Horace Walpole, that he would be an acceptable suitor for the hand of the daughter of the then powerful Necker, a lady whose name in later years became historical as Madame de Staël. Necker was reported to have offered a dower of 14,000*l.* per annum; but Pitt declined, declaring "he was already married to his country."

While Pitt deliberately refused to improve his own future, the Whigs were complaining of their prospects. In their mortification at the increasing power of their Ministerial opponents, the political societies gave utterance frequently to imprudent sentiments and expressions, which were turned to the disadvantage of the Liberal party as a body. Thus, the following sentiment is said to have been expressed in the Whig club, on the 14th of February :—"The tree of liberty must be planted immediately! this is the 'Something which must be done,' and that quickly, too, to save the country from destruction." Gillray's pencil immediately pictured the *Tree of Liberty* (February 14th, 1797), the planting of which, in the opinion of the Whigs, would be the salvation of England—its foundation is a pile of ghastly heads, among them are recognised the faces of Sheridan, Stanhope, Erskine, Ray, Horne Tooke, M. A. Taylor, George Hanger, Byng, Lauderdale, Derby, Thelwall, and other active agitators in opposi-

tion to Government; while its stalk, a bloody spear, sustains as its fruit the drooping head of the arch-agitator, Fox. The likenesses are all admirable.

The statements of the Ultra-Tories induced Fox to repel their insinuations, by declaring in one of his demonstrations at the time of the threatened French incursion that, "so far was he from wishing well to the enemies of his country that he would be one of the foremost to take up arms in its defence."

The manly appearance of this new volunteer led Gillray to design a cartoon of *The Republican Hercules Defending his Country* (February 19th, 1797).

Fruit of Liberty.

The hirsute and massive form of Fox is spanning the Channel, one foot rests on the land of the Union Jack, the other is slyly lifting the standard of "Liberty." A Fox's hide supplies the place of the Lion's skin. The chief is making ferocious exertions to frighten the unseen intruders; the mighty "Whig club" is flourished like a twig in the hand of the giant. "Invade the country, hay?" he cries; "let them come,—that's all! Zounds, where are they? I wish I could see 'em here; that's all! ay, ay! only let them come,—that's all!!!!" The speaker carefully avoids looking in the proper quarter, where the danger is evident; his left hand grasps a number of cables, dragging over the French fleet to betray his country. Fox's patriotism, which his goodness of heart would prove to have been genuine and disinterested, encountered distrust and misrepresentation. The sincerity of his principles was questioned, although his earlier career had demonstrated that he could sacrifice his personal interest to his political convictions.

The French had pronounced for the invasion of England without having decided on the method of their operations. At the latter end of February, a force made a descent on the coast of Wales, without any apparent object or utility. The Opposition quickly raised a cry against the Government. A caricature by Gillray, published on March the 4th, represents the hold which the Whigs thought they had thus gained on the Minister, as, "Billy in the Devil's Claws," the unfortunate Premier is held in the brawny grasp of Fox, disguised as a Republican fiend. "Ha, traitor!" he cries, "there's the French landed in Wales! What d'ye think of that, traitor?" "The Tables" are quickly turned by the arrival of the Gazette announcing the "defeat of the Spanish fleet by Sir John Jarvis." Pitt is released from the grasp of his grim captor, who is escaping chagrined, while Pitt slyly exclaims, "Ah, Mr. Devil, we've beat the Spanish fleet! What d'ye think of that, Mr. Devil!"

The French force which had the audacity to land in Pembrokeshire was immediately captured. In the interval the news of Sir John Jarvis's victory over the Spanish fleet opportunely arrived to reinstate the administration in the confidence of the people.

A new cause of alarm was now furnished by the embarrassments of the Bank of England, arising from the immense sums which had been advanced to Government, and the anxiety of people in general to withdraw their money, under the apprehension of an invasion; to the general consternation, in the month of February, the Bank announced its inability to continue cash payments. Pitt came forward to its assistance with an Act of Parliament making bank-notes a legal tender; from this time the enforced circulation of gold coin became almost obsolete, and a national disaster was converted into an increase of prosperity.

The measures adopted by Pitt to preserve the Bank from the consequences of his financial policy naturally attracted attention; the Opposition fought resolutely against the innovation, but the majority approved of Pitt's expedient. Gillray set to work on this subject, and produced several caricatures, confirming confidence in these measures. On March the 1st the artist published a cartoon of *Bank Notes.*—"Paper money—French alarmists—O, the Devil, the Devil! ah! poor John Bull!!!" The spectator is introduced to the interior of the Bank, the Ministers, as "Barons of the Exchequer," are bringing in huge bales of their new paper currency:—five-pound notes, twenty-shilling notes, five-shilling notes, &c. &c. Pitt is presiding in person, as paying cashier. Beneath the counter are heavy sacks of specie, securely padlocked, and held in charge by the authorities.

The Premier is offering the new currency to John Bull, whose hand is extended for the paper-money, while the Opposition, increasing the embarrassments at home for the benefit of our enemies abroad, are

using all their persuasions to induce poor John to refuse Pitt's substitute. "Don't take his d——d paper, John," expostulates Fox; "insist upon having gold to make your peace with the French, when they come!" Stanhope, and other alarmists, are repeating Fox's arguments, while Sheridan, with an expression of pantomimic anxiety cries, "Don't take his notes; nobody takes notes now! *They'll not even take mine!*" John Bull adheres to his own convictions:—"I wool take it! a' may as well let Measter Billy hold the gold to keep away yon Frenchmen, as save it to gee it you, when ye come over with your dom'd invasion!"

Sheridan is said to have felt the full force of Gillray's hit. His notes of hand, certainly never considered equivalent to gold, were generally received with mistrust. He is said to have frequently quoted the speech attributed to him in "paper-money."

Before a week had elapsed Pitt was again introduced to the public, as director of the paper stream. A classic figure furnished the satirist with his text. The great commoner was exhibited (March 9th, 1797) in the character of *Midas*, transmuting all into —— "paper," substituted in the place of gold.

Gillray has taken certain liberties with the original fable. Midas Pitt, wearing his Exchequer robes, is awkwardly straddling across the Bank of England. His body consists of a golden money-bag, a huge padlock chained round his golden neck, bears the inscription, "Power of securing public credit;" on his little finger hangs the "Key of public property." The Crown, which does not conceal his ears, is made of one pound notes. A stream of golden pieces, blown into circulation by this modern Midas, is becoming paper under the influence of his breath. The specie descending into the rotunda of the Bank reaches the expectant dividend holders in the shape of notes. The artist has inserted his own version of the "History of Midas.—The great Midas having dedicated himself to Bacchus, obtained from that deity the power of changing all he touched. Apollo fixed ass's ears upon his head for his ignorance, and although he tried to hide his disgrace with a regal cap, yet the very sedges which grew from the mud of the Pactolus whispered out his infamy, whenever they were agitated by the wind from the opposite shore. *Vide* Ovid's 'Metamorphoses.'" The "opposite shore," in Gillray's version, is Brest; the wind has blown over a shower of Jacobin assassins, bearing daggers in their hands. The reeds bowing before the wind bear the red-capped heads of Fox, Sheridan, Erskine, Grey, and M. A. Taylor; their faces wear mischievous expressions, and they are hissing forth the irritating secret, "Midas has ears! Midas has ears!" Three cherubim, in the likeness of Grenville, Dundas, and Windham, hold up a statement of the "Prosperous State of British Finances and the New Plan for Diminishing the National Debt, with Hints on the Increase of Commerce."

A contemporary allusion records:—"The facetious old Parson Lloyd once bantered a distinguished placeman thus: 'Ah! by-and-by your immaculate Minister will be laying his rapacious claws upon the gold in the Bank of England.' 'Sir,' replied the placeman, 'if Mr. Pitt stepped over the threshold of the Bank to propose such a thing the Directors would order the beadle with his bell to turn him out.'" Strange as it may seem, within three months after this dialogue cash payments were stopped at the Bank, and the Old Lady of Threadneedle Street refused to honour her notes. The fulfilment of her "promise to pay on demand" was then found to consist in the mere change of one rag for another. It must be acknowledged, however, that these rags, stamped by State necessity and national credit, and taken in exchange with patriotism and loyalty, served the cause of Old England quite as well as gold; thus proving that public good-will always leads to national prosperity. Confidence remained unshaken while the feeling continued that the gold was merely held in the Bank cellars for the security of John Bull's property. The Bank had been forced to negotiate Government loans on so extensive a scale that its resources in specie were for the time exhausted, and Pitt's paper currency was introduced to remedy the suspension of cash payments.

The impression was circulated that Pitt's policy was a mere subterfuge to secure the ready money to be sent to the Continent in support of the war. The obligation to issue paper for specie was looked upon as an act of violence, and Gillray's graver gave a revised version of the story under the title of *Political Ravishment, or the Old Lady of Threadneedle Street in Danger!* The venerable Old Lady, who has now adopted Pitt's paper substitute, is completely clad in "one pound notes." Having conformed to the wishes of the financier, she is seated in fancied security on the strong-box of the Bank of England,

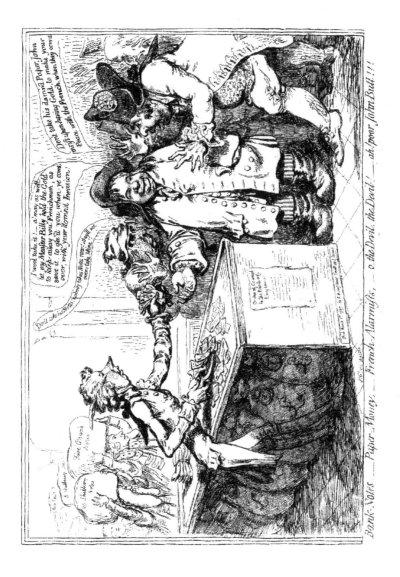

Bank-Notes — Paper-Money — French-Alarmists, — o the Devil, the Devil! — ah poor John-Bull!!!

which contains her gold. The venturesome Pitt has surprised the worthy dame, his arm is round her waist and his hand is rifling the fastnesses of her pocket; a scroll of forced "Loans," which has fallen on the Bank pavement, explains his intentions. The Old Lady is screaming "Murder! murder! rape! murder! O, you villain! what have I kept my honour untainted so long, to have it broke up by you at last? O, murder! rape! ravishment! Ruin, ruin, ruin!!!"

This satire is said to have caused the illustrious statesman—whose figure is by no means flattered—the most "boisterous merriment," which was shared by his colleague Dundas.

While the alarms circulated by the Opposition were founded upon visions of return to office, the menaces from without were real and unaffected. In the face of his foes the national prototype assumed a more martial exterior.

John Bull's courage and patriotism, indeed, increased in intensity, and his dislike of war diminished as the danger approached nearer and became more imminent. The insolence of the French Directory and of their agents, and the atrocious threats which they held out against England, only tended to unite all classes in the defence of their native land. The commander of the army of invasion, General Hoche, had already, in imagination, plundered our capital. "Courageous citizens," he said to his followers, in an address which was circulated through France, "England is the richest country in the world—and we give it up to you to be plundered. You shall march to the capital of that haughty nation. You shall plunder their national bank of its immense heaps of gold. You shall seize upon all public and private property—upon their warehouses—their magazines—their stately mansions—their gilded palaces; and you shall return to your own country loaded with the spoils of the enemy. This is the only method left to bring them to our terms. When they are humbled then we shall dictate what terms we think proper, and they must accept them. Behold what our brave army in Italy are doing—they are enriched with the plunder of that fine country; and they will be more so when Rome bestows what, if she does not, will be taken by force. Your country, brave citizens, will not demand a particle of the riches you shall bring from Great Britain. Take what you please, it shall be all your own. Arms and ammunition you shall have, and vessels to carry you over. Once landed, you will soon find your way to London." These lines, which were published in most of the English newspapers and magazines in the month of March, added to the martial spirit of the people, whose property was thus threatened, and volunteer troops began to be formed in all parts of the country. The metropolis and its volunteers began again to look like Old London and its trained bands, and caricatures on these soldier-citizens soon became numerous. One by Gillray, published on the 1st of March, may be compared with the satires against the city soldiery in the days of George I.—it represents, *St. George's Volunteers Charging down Bond-street, after Clearing the Ring in Hyde Park, and Storming the Dung-hill at Marybone;* and the assailants are evidently gaining an easy victory over the fashionable loungers of the former locality. "Charging the French" was the original style of this print, the invaders who are thus expelled being confined to the fair sex. The volunteer uniforms have a very droll appearance at this distance of time. Gillray turned the citizen force into good-humoured fun, and on the 8th of March he published a small sketch of a *Leadenhall Volunteer dressed in his Shawl.*

John Bull still grumbled at being taxed, although he was so earnestly assured that it was for his own advantage. One of the taxes proposed during the spring of 1797 which gave most room for satire and ridicule was a duty on hats, which people evaded by wearing caps. Gillray, in a caricature published on the 5th of April, entitled *Le Bonnet Rouge, or John Bull evading the Hat-tax,* intimates the danger that such taxes might drive John Bull to adopt the Republican costume of his neighbours, and he certainly does look "transformed." John chuckles in contemplation of the astonishment that his ruler must feel when he beholds the strange effect of his taxes—"Waunds! when Measter Billy sees I in a red cap how he will stare!—egad, I thinks I shall cook 'em at last!—well, if I could but once get a cockade to my red cap,

John Bull in Bonnet Rouge.

and a bit of a gun—why, I thinks I should make a good stockey soldier." The Stamp Office is turned into an emporium, "Licensed to deal in Hats and Swords." At Bull's feet is a heap of cats, and a list of the number of the animals "Slaughtered for making skin-caps, 20,000 red, 5000 tabby," &c.

The Opposition attacked the increasing system of taxation, and the Minister with whom it originated, with great severity; they represented him as practising a continued deception — of making professions which he never intended to fulfil, and talking of objects which he took no steps to gain—in order to extract the money from John Bull's pocket.

Amid so many subjects of uneasiness, with preparations for invasion without, and when our fleets were in open mutiny at Spithead and the Nore, the question of Parliamentary Reform was again agitated from one end of the country to the other. In the month of May Fox and his party made two important efforts in the House of Commons to force the Ministry to more liberal measures. On the 23rd Fox himself moved for the repeal of the Acts passed in the preceding session against sedition and treason. The Ministers defended warmly their coercive measures, and one of their party declared " that he considered this motion as a tissue of the web that Mr. Fox had been weaving for the last four years, which had tended to degrade this country in the eyes of foreign powers; had it not been for these Acts he believed that the French national flag would have been hoisted on the Tower of London." After a long debate, Fox's motion was rejected by two hundred and sixty votes against fifty-two. On the 16th Mr. Grey moved for leave to bring in a Bill to reform the representation in the country, and explained at considerable length the principal details of his plan. The motion was seconded by Erskine, and the debate lasted till three o'clock in the morning, when it was rejected by a majority of a hundred and forty-nine against ninety-one.

Pitt, as we have seen, entered Parliament as a professed advocate of reform; he now, however, defeated the measure by bringing up his overwhelming majorities.

The debate on the Reform Bill appears to have been the final struggle made by the Opposition against the all-powerful Pitt, until a general change of feeling became evident. The leaders of " the party" retired, disheartened at the corruption which they assumed was exercised against them. They despaired of making any impression on the House of Commons, and announced their intention for the present of taking no further part in its proceedings. The voice of Fox was scarcely heard again within the walls of St. Stephen's till after the close of the century. Sheridan alone remained at his post, and it was commonly believed that he had disagreed with his party, and that he was looking out for encouragement to desert to the Ministerial side of the House. Upon this occasion the Tories complained louder than ever of the factions behaviour of the Opposition; they said that the Opposition had remained in the House as long as there remained any prospect of doing mischief, and then showed their patriotism by leaving their country to its fate. Gillray published a caricature on the 28th of May, the spirit of which is sufficiently explained by its title of *Parliamentary Reform, or Opposition Rats leaving the House they had Undermined.*

From the entrance a view is obtained of the scene within. Pitt is on his legs, holding forth on the " Rights of Parliament." The Opposition benches are hastily evacuated, their late occupants converted into a herd of rats, are leaping from the gallery and escaping in a terrible haste. Among the foremost scufflers are Fox, Grey, Sheridan, Erskine, and M. A. Taylor.

A cartoon published some days later, represents Fox slinking away from the neighbourhood of the House, after his partisans have laid the trains that were to blow up the Constitution. Other caricatures traced the Opposition leaders into their retreats, and showed them encouraging and aiding sedition without the House, now that their efforts had proved useless within.

Homer singing his Verses to the Greeks (June 16th, 1797), introduces us to the great Whig chief in his forlorn retirement, he is leaning disconsolately on the table, while Sherry is devoting himself to the bottle. Captain Morris, a rugged Homer, is invited to cheer these discarded Greeks with his lays. The gallant songster, grasping his glass, has thrown himself into a jaunty attitude, and is carolling forth an entirely new ditty, to the tune of 'the Plenipotentiary.' Fox, weighed down by gloom, is entreating the Anacreon of Opposition to sing him a song. " to make him merry."

The alleged occupations of Fox's retirement were further censured in a severe cartoon, published

November 24th, under the title of *Le Coup de Maître*, copied from the French original. Fox is drawn as a Republican citizen, his "certificat de civisme" is in one pocket, while "Delenda est Carthago" peeps from another. His cocked hat is marked "Liberté," and a miniature red-bonnet of "Egalité" is attached as an ornament to his button-hole. Suspended to a branch of the English oak hangs a target, in the centre is the Crown, and the outer circles are marked "Lords and Commons." Within a few feet of this mark "the Political Brigand" is aiming his pistol "La mort" at the very heart, while a dagger, inscribed "Fraternité," is grasped in readiness to inflict a deadly stab.

A contemporary writer deprecating the bitterness of these attacks, remarks : "Certain persons have been pointed at as the prompters of most of these personalities. The great Charles Fox might be a zealot—but he was all heart. How noble was his defence of the absent Pitt, when in the House of Commons the charges were first brought against that great Statesman's friend and able colleague, the kind-hearted Melville! Pitt, alike great, generously apostrophized his illustrious rival Fox for his noble candour! When shall we again see the like of such Senators as these ?"

It is certain that, after the secession of the Opposition in the House of Commons, the agitation throughout the country became greater, and the activity of the political societies increased. Political meetings to discuss the necessity of Parliamentary reform became more frequent. The newspapers, too, became more violent and abusive, and less scrupulous in their statements, when they could serve their party by falsehood or misrepresentation.

It was to combat the seditious tendency of the Opposition press, the attacks of which assailed the Ministers with incessant gall, that the celebrated *Anti-Jacobin* was established in the latter part of November, 1797. It was conducted by some of the most talented men connected with the Administration, and is remarkable for the bitterness of its satire, and the boldness of its personalities. In this respect one party was quite as little scrupulous as the other. The second number of this paper, published on the 27th of November, contained that admirable burlesque by Canning (one of the principal contributors) of Southey's Sapphics, known as the *Friend of Humanity and the Knife-Grinder*, designed as an exposure of the pains taken by the political agitators and so-called philanthropists to instil discontent into the lower orders of society, even when of themselves they were not at all inclined to be disaffected.

This burlesque was reprinted in a broadside, on the 4th of December, with a large engraving by Gillray, in which the "friend of humanity" carries the features of Tierney; it is dedicated "to the independent electors of the borough of Southwark," of which constituency Tierney was the representative.

The Friend of Humanity and the Knife-Grinder.

"THE FRIEND OF HUMANITY AND THE KNIFE-GRINDER."

"Friend of Humanity.

"'Needy knife-grinder! whither are you going?
Rough is the road, your wheel is out of order—
Bleak blows the blast—your hat has got a hole in't,
So have your breeches!

"'Weary knife-grinder! little think the proud ones,
Who in their coaches roll along the turnpike
road, what hard work 'tis crying all day, "Knives
and Scissors to grind, O!'

"'Tell me, knife-grinder, how you come to grind
knives?
Did some rich man tyrannically use you?
Was it the 'squire? or parson of the parish?
Or the Attorney?

"'Was it the 'squire for killing his game? or
Covetous parson for his tythes distraining?
Or roguish lawyer made you lose your little
All in a lawsuit?

" '(Have you not read the " Rights of Man" by Tom
Paine?)
Drops of compassion tremble on my eyelids,
Ready to fall, as soon as you have told your
Pitiful story.'

" *Knife-grinder.*

" 'Story! God bless you! I have none to tell, sir,
Only last night, a-drinking at the Chequers,
This poor old hat and breeches, as you see, were
Torn in a scuffle.

" 'Constables came up for to take me into
Custody; they took me before the justice;
Justice Oldmixon put me in the parish-
stocks for a vagrant.

" 'I should be glad to drink your honour's health in
A pot of beer, if you will give me sixpence;
But, for my part, I never love to meddle
With politics, sir.'

" *Friend of Humanity.*

" '*I* give thee sixpence! I will see thee damn'd first'—
Wretch! whom no sense of wrongs can rouse to
vengeance!—
Sordid, unfeeling, reprobate, degraded,
Spiritless outcast!' "

(*Kicks the Knife-grinder, overturns his wheel, and exit in
a transport of republican enthusiasm and universal
philanthropy.*)

The only relief which diverted the public from political contests and vexed questions, was the
rejoicings attending a royal marriage.

The great "Bellygerent," introduced in 1796, had come over to claim his handsome bride. Gillray
commemorated the prince's reception by a satire called *Le Baiser à la Wirtembourg* (15th April). The
Princess Royal, who was portly and well-favoured, is saluted by her High German suitor. This Prince
of Wirtembourg is finely dressed, orders hang from every button-hole, stars and cordons innumerable,
of every size and shape, are bespattered all over his Court-habit and suspended round his stout
person.

A sly quotation accompanies the plate:—

" Heaven grant their happiness complete,
And may they make both ends to meet;
—in these hard times."

The marriage took place on the 19th of May; Gillray anticipated the popular interest by publishing
(on the 18th) a remarkably clever caricature in broad burlesque, of the great personages of the English
Court, under the title of *The Bridal Night.* The guests are conducting the illustrious pair to the nuptial
chamber, the torches of Hymen figure over the door. The clumsy person of Lord Salisbury, as
Chamberlain, appears subserviently opening the door for the royal party.

Gillray has given unmistakable portraits of the King and Queen, although he has chosen to hide
their faces. A tall pillar intercepts the view of the monarch's profile,—he is bearing in two guttering
candles, his awkward stride is quite life-like. Queen Charlotte is half-buried under one of the ex-
traordinary bonnets she patronized. The husband's portly figure forms a base for the suspension of
innumerable ribands crossed and recrossed, chains, stars, orders, garters, devices, and every embellish-
ment, even the tie of his bag-wig is decorated. The princesses act as train-bearers, bridesmaids, &c.
The Prince of Wales, in a tight-fitting uniform of his own design, is regarding the transaction with heavy
composure; next to the Heir-apparent is the pouting profile of the Duke of Clarence, the Duke of
York's face appears between. Nearer the foreground is the straggling person of Prince William of
Gloucester, followed by the elegant little Duchess of York, the obese Prince William of Orange,
apparently asleep, princesses and members of the Court continue the train of distinguished guests.

William Pitt appears in his usual capacity of furnishing the money required on these occasions, he
bears a sack marked 80,000*l.* On the wall hangs a suggestive picture " Le Triomphe de l'Amour,"
representing Cupid seated on the head of an elephant, and lending the brute captive by the dulcet strains
of his flute.

Another stout slave of the tender passion crossed the satirist's field, and straightway his person was
transferred to copper. The personage who received this distinction was his future majesty King
William the Fourth, then rejoicing in the title of Duke of Clarence. A broad thick-set figure is
represented laboriously dragging a miniature carriage on a broiling hot day, followed by a lady dressed
in imitation of male habits—with hat, stock, frill, and buttoned coattee. This interesting group is

The BRIDAL NIGHT.

christened *La Promenade en Famille—A Sketch from Life.* "Nauticus" is conveying his family from Richmond to Bushy. The Sailor Prince is painfully warm, a handkerchief, disposed under his hat and over his pigtail, shades his strongly marked features, his coat and waistcoat are both unbuttoned, and toys are stuffed into every pocket. A miniature of the prince with toy whip and reins is urging on his suffering sire. An infant in tears, and a girl nursing a dog, "speaking portraits of Nauticus," fill the "go-cart." Beside the chaise walks Mrs. Jordan,[*] deeply absorbed in the study of a theatrical part, she is reciting from a play-book, "Act III., enter Little Pickle."

"Some ages hence," remarked a contemporary writer, "this group will serve to make one of a series of illustrations of the exaltation of the daughters of Thespis." On beholding this print an old officer exclaimed, in parody of Pope's satire :—

> " Who but must *laugh*, if such a one there be !
> Who but must *weep*, if Nauticus were he ! "—

[*] On the stage Dorothea Jordan was equally successful in comedy and tragedy. Her life was spent in comedy—her end was an awful tragedy. It is sad to reflect that this elegant and amiable woman, after the intimate relationship the satire conveyed, was suffered (in 1816) to spend her last hours in cruel misery—friendless, unknown, and without the most ordinary comforts ; her end premature, hastened by despair and a broken heart. An animated picture of this lady, her attractions, her grace, and talent, her elevation, and its sad reverse, has been preserved by Sir Jonah Barrington :—

"It was not by a cursory acquaintance that Mrs. Jordan could be known ; unreserved confidence alone could develope her qualities, and none of them escaped my observation. I have known her when in the busy, bustling exercise of her profession. I have known her when in the tranquil lap of ease, of luxury, of magnificence. I have seen her at the theatre surrounded by a crowd of adulating dramatists ; I have seen her in a palace, surrounded by a numerous, interesting, and beloved offspring. I have seen her happy ; I have seen her, alas ! miserable : and I could not help participating in all her feelings—her countenance was all expression, without being all beauty. Her features and eloquent action at all periods harmonized blandly with each other, not by artifice, however skilful, but by intellectual sympathy. She was throughout the untutored child of nature. Her voice, clear and distinct, modulated itself with winning ease. she sang without effort, and generally without the accompaniment of instruments, and those who heard the gentle, flute like melody of her tones, if they had any soul, must have surrendered at discretion."

Her last days were a cruel contrast. She occupied shabby apartments in a gloomy old mansion at St. Cloud, and was awaiting, in great mental distress, "the answer to some letters by which was to be determined her future conduct as to the distressing business which had led her to the Continent. Her solicitude arose, not so much from the real importance of this affair as from her indignation and disgust at the ingratitude which had been displayed towards her, and which, by drawing aside the curtain from before her unwilling eyes, had exposed a novel and painful view of human nature. There was no occasion for such entire seclusion ; but the anguish of her mind had by this time so enfeebled her, that a bilious complaint was generated, and gradually increased. Its growth, indeed, did not appear to give her much uneasiness. So dejected and lost had she become. Day after day her misery augmented, and at length she seemed, we are told, actually to regard the approach of dissolution with a kind of placid welcome ! No English comforts solaced her last moments. In her little drawing-room, a small old sofa was the best-looking piece of furniture ; on this she constantly reclined, and on it she expired. The account given to us of her last moments, by the master of the house, was very affecting ; he likewise thought she was poor, and offered her the use of money, which offer was of course declined."

From the time of her arrival at St. Cloud, it appears Mrs. Jordan had exhibited the most restless anxiety for intelligence from England. Latterly she appeared more anxious and miserable than usual ; her uneasiness increased almost momentarily, and her skin became wholly discoloured ; from morning till night she lay sighing upon the sofa. At length an interval of some posts occurred, during which she received no answers to her letters ; and her consequent anxiety, my informant said, "seemed too great for mortal strength to bear up against. On the morning of her death this impatient feeling reached its crisis. The agitation was almost fearful ; her eyes were now restless—now fixed ; her motion rapid and unmeaning, and her whole manner seemed to bespeak the attack of some convulsive paroxysm." The master of the house went to the post to inquire for her letters. "On his return she started up and held out her hand as if impatient to receive them. He told her there were none. She stood for a moment motionless, and looked towards him with a vacant stare ; held out her hand again, as if by an involuntary action ; instantly withdrew it, and sunk back upon the sofa from which she had arisen. She wept not, no tear flowed ; her face was one moment flushed, and another livid ; she sighed deeply, and her heart seemed bursting, and in a minute her breath was drawn more hardly, and as it were sobbingly." These sobs had preceded the moment of dissolution. Her soul was released ! "Thus terminated the worldly career of a lady who had reached the very head of her profession, one of the best-hearted of her sex ! Thus did she expire, after a life of celebrity and magnificence, in exile and solitude, and literally of a broken heart."

William the Fourth, after his accession, ordered Chantrey to prepare a statue to be placed over Mrs. Jordan's remains in the cemetery of St. Cloud.

The peculiarly ungainly exterior of the King was exhibited to his loving subjects, as he might have been seen shuffling along in the sunshine on his daily promenades at his favourite watering-place. The picture is called *The Esplanade*, it evidently reproduces a scene familiar enough in those times, when the monarch took the air at Weymouth. An admiring and awe-struck circle of visitors and natives stand around to catch the royal nod, which overwhelmed the loyal souls with happiness.

Two tall military commanders stand a little way off, on either side, both favoured with the monarch's confidence, Lord Cathcart and Sir David Dundas—they bow down their pig-tailed heads before the royal sun. The motto "Medio tutissimus ibis," is suspended over the figure of "Great George." He is evidently gratifying the generals with a running fire of qustions, beginning, "What, what?" and ending in much the same fashion.

On January 2nd, 1797, Gillray satirized the behaviour of Sir John Jervis on the question of prize-money, which has too frequently given rise to animosity and dissatisfaction. The islands of Martinique and St. Lucia had been captured by the admiral during his expedition against the French West India Islands in 1793–4. Guadaloupe surrendered in April, thus putting England in possession of all the Leeward Colonies. Sir John Jervis returned in May, and received the "thanks" of the House of Commons. In 1797 we find the prize-money due to the seamen was still withheld. The admiral is seated before a table, marked "Unclaimed dividends," covered with a pile of gold pieces. The print is entitled *The Lion's Share.* Jervis is quoting from the fable of "Phædrus"—"The first share is mine, because I bore my part in killing the prey; the second falls to my lot, because I am king of the beasts; and if any one presumes to touch the third!!!"

Pictures of "Peculation," "Thieves dividing Spoil," "Loaves and Fishes," "St. Vincent's," &c., hint at the application of the fable. A number of torn petitions from sailors' widows, disabled seamen, &c., are trodden under the commander's feet.

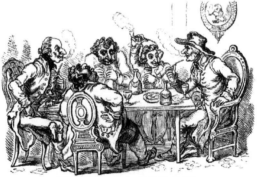

"The feast of Reason and the flow of Soul." The wits of the age.

Gillray's pencil spared neither friend nor foe. He bearded the men in power or he satirized their antagonists. He ran a tilt against the magnates who held in the terrors of the law. Whatever the satirist voted mean, pretentious, or deceptive, he fearlessly held up to ridicule.

On February 14th he served up the Opposition wits, whose sallies were directed against the Treasury benches. *The Feast of Reason and the Flow of Soul—i.e., the Wits of the Age Setting the Table*

in a Roar—assembles the choicer spirits of the Whig party round a convivial board. Courtney, the Thersites of the House—the antagonist whose polished wit Pitt ordinarily repaid with courteous smiles —occupies the seat of chairman ; over his chair hangs a parody of Juvenal. Georgey Hanger is seated opposite, in his usual jaunty attitude. His favourite "supple jack" is thrust into his boot; his broken glass and spilt liquor (the colonel patronized "blue ruin") are indicative of his uproarious disposition.

Sheridan, slyly hugging a brandy-bottle, is looking round exultingly. The figure next the "brandy-tippler" is generally considered to have been intended for the "law-chick," M. A. Taylor ; it also resembles George Colman, who was the choicest spirit of the convivial frequenters of the Mount. Charles James Fox, a Falstaff-like figure, is thrown back in his chair in extravagant enjoyment of Courtney's humour. The sarcasm of this cartoon is conveyed by placing a weak and silly remark in the mouth of the chairman, which elicits a similar repartee from the "vice." Their auditors hail the trite exchange as "the best thing they ever heard."

About the middle of 1796 we left *Faro's Daughters* trembling before offended justice.

Lord Kenyon's threat, and the noise it then made abroad, seem to have had equally little effect on the patrician offenders to whom it was designed to serve as a warning. Other caricatures followed with as little success. One, published apparently about the beginning of 1797, represents these gambling dames "dividing the spoil" after a successful night, and compares them with a party of unfortunate women in St. Giles's, who are shown in another compartment, sharing the various articles they have purloined from the pockets of their casual admirers. On one occasion, at the period just alluded to, Lady Buckinghamshire's faro-bank was stolen, while she and her party were closely occupied at their game. It was freely hinted that this robbery was a mere fiction invented for the convenience of the table-holders. These ladies were occasionally reduced to desperate straits by the fortunes of play.

This circumstance produced a caricature by Gillray, entitled *The Loss of the Faro Bank*, published on the 2nd of February, 1797, and gave rise to a mock-heroic poem entitled *The Rape of the Faro Bank*, which made its appearance about the same time. On the artist's plate depicting the *Rooks pigeoned*,—"when Greek meets Greek then comes the tug of war,"—Lady Buckinghamshire as banker is sitting opposite to the empty pool, and the persons represented as her confederates are lying in wait for the unwary. The Greeks of the card-table are victimized by the Whigs. Lord Buckinghamshire who has been despatched for the cash-box containing the capital of the table-holder, returns in consternation. "The bank's stole !" he cries; "we're ruined, my lady ! But I'll run to Bow Street and fix the saddle upon the right horse, my lady." "The bank stole, my lord ! Why, I secured it in the housekeeper's room myself ! This comes of admitting Jacobins into the house ! Ah, the cheats ! Seven hundred gone smack without a single cock of the cards !" "Bank stole !" gasps Mrs. Concannon. "Why, I had a gold snuff-box stole last night from my table in Grafton Street." Lady Archer exclaims, in amazement, "Stole ! bless me ! Why, a lady had her pocket picked at my house last Monday." Fox, with a deeply guilty look, cries behind his hand, "Zounds ! I hope they don't smoke me." Of course "Sherry" is in the plot. "Nor me," he cries." Georgey Hanger wears a bolder front. He is grasping his bludgeon in preparation for an interview with the Bow Street runners—"Oh, if they come to the Mount, if I don't tip them *shilalee* !"

The insinuation connecting Fox with the scandals of play at this period is a pictorial licence; the Whig chief, whose earlier reputation was deeply concerned in the eventualities of gambling, had renounced play for some years. It was not long after this event that the offending ladies did fall into the power of their foe of the Bench. At the beginning of March, 1797, an information was laid against Lady Buckinghamshire, Lady E. Lutterell, and some other ladies and gentlemen of rank, for keeping faro-tables in their houses; and on the 11th of that month they were convicted of that offence, but Lord Kenyon seems to have forgotten his former threat, and he only subjected them to rather severe fines. This disaster furnished matter during several successive weeks to the newspapers for continual paragraphs, and the caricaturists took care to remind the judge of the disproportion between his present punishment and his former threat. In a caricature published on the 25th of March by Gillray, Lady Buckinghamshire is undergoing the punishment of being publicly flogged at the cart's tail, while two of her companions, Lady Archer and the more graceful Mrs. Concannon, are suffering in the pillory in

the distance; over the cart a board is raised with the inscription, "Faro's daughters, beware!" This print is entitled, *Discipline à la Kenyon.* Another, published by the same artist on the 16th of May, is entitled *Faro's Daughters, or the Kenyonian Blow up to the Greeks.* Four ladies here figure in the pillory, and Fox (who in former years had often made one of the gambling party), himself in the stocks, supports one of the sufferers on his shoulders. Lord Kenyon is busily occupied in burning the cards, dice, and faro-bank. The lesson this time seems to have been more effectual than the former, and we hear little of Faro's daughters after this scandal had passed away.

The pernicious effects of the passion for gambling on society are but too evident in the manners and condition of the time. It was rapidly demoralizing all classes, and was accompanied everywhere with a general increase of crime, of which we evidently see but a small portion reported in the news-

Miss Farren's contemplations upon a Coronet.

papers. Various pamphlets on the criminal statistics of the metropolis, show us the alarming danger that existed, and the difficulty of grappling with it.

Gillray's aversion to Miss Farren produced several cartoons, regarding her elevation to the Peerage as the wife of Lord Derby. A short time before her marriage the artist spitefully published the portrait of this exalted daughter of Thespis making her re-flections upon the object of her ambition. *Contemplations upon a Coronet* (March 20), introduces the lady seated at her toilet table, before her future lord's coronet stuck on a wig-block which bears a droll resemblance to Lord Derby's head. "A coronet!" solilo-quizes the actress, "O bless my sweet little heart! ah, it must be mine; now there's nobody left to hinder! and then for my Lady Nimminney Pimminney! O Gemmini! No more straw-beds in barns, no more scowling managers, and curtsying to a dirty public, but a coronet on my coach! Dashing at the Opera; shining at the Court! O dear, dear; what I shall come to!" When Miss Farren became Countess of Derby she addressed a

The Marriage of Cupid and Psyche. Lord Derby and Miss Farren.

letter to Queen Charlotte, to ascertain her Majesty's views respecting her reception at Court. The Queen replied that she should be very happy to receive her there, as she had always understood her conduct was most exemplary. In the satirist's *Contemplations on a Coronet* " there are many allusions which are both ungenerous and unjust. A map on the wall marks " the road from Strolling Lane to Derbyshire peak." Cosmetiques, " Bloom of Ninon," and various suggestive appliances of the toilet are disposed on the dressing-table ; a comb is thrown across the " Genealogical Chart of British Nobility," and a bottle of " Hollands" is seen beneath the hangings. " Tabby's Farewell to the Green-Room" is at the lady's feet.

When Miss Farren was at last led to the altar, Gillray commemorated the event in a design appropriately borrowed from the " antique." A parody of Payne Knight's beautiful gem (commonly known as the Marlborough Gem), representing *The Union of Cupid and Psyche*, was made the medium of a graceful burlesque engraved in bolder dimensions than the original figures, which were said to be " scarcely larger than a fairy's span."

" She is like a mile in length, and he is like a mile-stone !" quotes one of the authorities we have already cited. " The marriage of the Earl of Derby with Miss Farren was not the first instance of an actress being raised to the rank of a peeress. Miss Fenton, the first Polly in the " Beggars' Opera," was a prize contended for by several noble suitors ; she had the good fortune to become Duchess of Bolton. It is certainly to be considered a coincidence that the *mother* * of the first Duke of St. Alban's should have been an actress, and the wife of a later Duke of the line should have been of the same profession."

The abdicated Stadtholder appears to have been a favourite with the caricaturist. *Pylades and Orestes* (April 1st, 1797), introduces the stout exile as he exhibited himself in his daily promenades down the inevitable Bond Street, shuffling heavily along ; a pedestrian somnambulist fast asleep on the arm of Count Nassalin, the Prince's Secretary.

The picture of *Wicked Old Q.*, the " little gamesome Piccadilly duke," with his leering wrinkles and his incorrigible ways, was issued on April 17th, 1797. The notorious reprobate is engaged at " push-pin,"

"Old Q. playing at Push Pin."

one of the intellectual games then in fashion. The lady with whom " Old Q." is spending his leisure is Mrs. Windsor, whose name occurs frequently in the more equivocal allusions of the time, as a notorious " lady abbess," whose novices attracted the highest admiration when they appeared in public.

* Nell Gwynne.

. We have already alluded to the Duke's short-comings. At the date of the caricature he might be seen lounging over the south-west balcony of Queensberry House, since pulled down, which occupied an admirable position for catching " the balmy breezes which blew over the shrubberies of the Green Park."

It was wicked old Q.'s practice to pass the afternoon in the balcony, exhibiting his pink cheeks,*" whose maiden complexion at seventy was as fair as that of Phillis at fifteen," ogling every woman who came within the range of his glass, and exchanging disreputable pleasantries with the fair reprobates who shared his nightly dissipations.

The rich Duke of Bedford, courted by political intriguers, was no less sought by the mothers of marriageable daughters. In *The Gordon Knot, or the Bonny Duchess hunting the Bedfordshire Bull* (April 19th), the stout Duchess of Gordon is giving chase to the Bloomsbury Duke, represented as the great Bedfordshire ox. The Duchess is holding a noose of ribands, marked "Matrimony," at which the bull is taking fright. Pitt's fair ally, who was conspicuously eager to secure this prize for her daughter, Lady Georgiana, is crying, " Deel burst your weam, ye overgrown fool, what are ye kicking at?—are we not ganging to lead ye to graze on the bank o' the Tweed, and to mak ye free o' the mountains o' the north. Stop, stop, ye silly loon!" Lady Georgiana, in her anxiety to secure the prize, cries, " Run, nither, run; how I long to lead the sweet bonny creature in a string!" Three daughters of the handsome duchess are dancing in the distance as graces. Lady Charlotte is leading a spaniel of the " King, Charles' breed " (she married the Duke of Richmond). Lady Susan, marked " Manchester velvet," became Duchess of Manchester, and the third is drawn with a broom to indicate that she is still in the market. She afterwards married the second Marquis of Cornwallis. The Bedfordshire bull escaped his captors for a time; he went over to Paris, and the Duchess of Gordon, with the lovely Georgiana, followed immediately. The Duke renewed his attentions, and they were ultimately married in June, 1803.

Gillray published (June 5th) an equestrian portrait under the title of *Count Roupee*, representing a little dark-faced person, wearing spectacles, mounted on a horse of extra dimensions. Paul Benfield, the person so distinguished,† was christened Count Roupee, because his large fortune had been acquired in India. After his return he established the house of Boyd and Benfield, one of the most extensive of its day. It failed in consequence of the large investments in the French funds, which were confiscated on the outbreak of the Revolution. By the Treaty of 1814 the creditors were reimbursed, which enabled Count Roupee's firm to discharge their liabilities, with interest for the entire period.

June 9th. *Un Diplomatique settling affairs at Stevens's*, introduces a quaint personage, seated at table, drinking his decanter of wine. It is intended for Baron Haslang, Minister for Bavaria, who was a frequenter of Stevens's in Bond Street.

June 9th. *Heroes Recruiting at Kelsey's, or Guard-Day at St. James's.*—We follow the veterans of 1797 after their dismissal from " Parade " to mount guard at St. James's for a " Drawing Room Levee." Kelsey's shop, in which the heroes are recruiting, was a famous fruiterer's in St. James's Street. The officers are seated before the counter, regaling themselves in effeminate fashion. A lengthy Ajax, Colonel Burch, of the Royal Household troops, is demolishing creams by whole regiments, and reserves are held in readiness by a stout nymph in attendance. A very Liliputian captain hoisted, like " humpty dumpty," on a tall stool, is recruiting his martial vigour from a large bag of sugar-plums. Strawberries, oranges, and other dainties have fallen before these determined assailants. In the door-way is a third officer, watching the equipages proceeding to Court.

* " Slip slop Slander averred that the preservation of the ruddiness of his cheeks cost a nightly supply of delicate Veal-Steaks, which forming a lining to the ears of his lace bordered cambric nightcap, renovated the fading carnations during sleep; and thus he was enabled, after two hours at the toilette, to appear at the balcony again, with his wonted morning bloom."

† It is worthy of remark, that Pitt happened to hold a brief when a very young man on his first circuit for Paul Benfield, who was prosecuted for bribery on his return to Parliament. The senior counsel being indisposed, the future Premier conducted the defence. Pitt and Melville (Dundas) were connected with certain transactions relating to an accommodation to Boyd and Benfield, of some forty thousand pounds, to make up the balance of a certain loan which the financiers had contracted to subscribe.

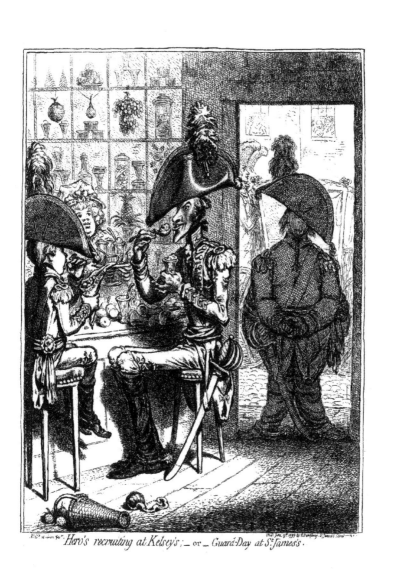

J.G.^y ad vivam fec^t. Here's recruiting at Kelsey's;—or—Guard-Day at S.^t James's.

July 10th. *The Salute,*—vide "the parade," reproduces the usual morning inspection at St. James's, known as "trooping the colours." Three officers are stiffly saluting as they pass their commander.

November 3rd, 1797. *Pattern Staff, Weymouth,* presents the rear view of a very slim general, all legs and wings, overbalanced with a huge cocked hat, intended for a back of Lord Weymouth.

On the 2nd of November Gillray published one of his most elaborate compositions, the *Venetian Secret.* The quackery it was designed to expose is almost unknown in the present day, and it would probably have remained so had not the artist commemorated its temporary success. In 1797 a female pretender to art, Miss Provis, professed to have discovered the grand "Venetian Secret," by which it was reported, Titian and the great painters of his school, produced their gorgeous colouring. It appears that a large proportion of the members of the Royal Academy became her dupes, and purchased the secret at high prices. The beauty of the print and the drift of its satire were most evident in the coloured copies; brilliant tints are effectively introduced, and a rainbow hue pervades the composition.

Titianus Redivivus, or the Seven Wise Men consulting the new Venetian Oracle,—a scene in ye Academic Grove. No. I.—Mounted on a rainbow stands the ragged impostor, boldly dashing off a head in positive light and shade. A rainbow tinges the lady's paint brush. Above the canvas rises a phœnix, bursting forth from flames and lightnings, with the precious Venetian Manuscript. Fame cries through his trumpet, "You little stars, hide your diminished heads," whereon the stars (Michael Angelo, Raphael, &c.), with a proper sense of their insignificance, drop out of the firmament. "Pegasus," as a scrubby jackass, is kneeling down to drink from the magic paint-pot. The wings of the inspired steed explain the secret of the lady's popularity. "Puffs and squibs," "articles in magazines," in daily papers, &c., the artifices of the press accounting for the publicity which imposed on her dupes. The tattered figure of the impostor ends in a train of peacock's feathers. The three Graces, originally tinted in the gayest colours, are submissively supporting the appendage of Vanity by an inscription, contrasting the deception with other notorious quackeries of the time,—"Ah, ha, Messrs. Van Butchell, Ireland, Charles Lane, and Lackington! what are you now? ha, ha, ha!!!" The lower compartment exhibits the interior of the Royal Academy. The foremost seats are occupied by the academicians, Farringdon, Opie, Westall, Hoppner, Stothard, Smirke, and Rigaud, the chief dupes of the secret, who are immersed in the new discovery. Behind the "Seven Wise Men" are crowds of artists, all changing into monkeys, and clambering up the rainbow after the deluding Miss Provis. The names of Northcote, Hamilton, Eldridge, Tresham, Lawrence, Devis, Humphrey, Downman, Daniel, &c., are distinguishable amidst their palettes. A mischievous imp, resting on a folio "List of Subscribers to the Venetian Humbug, at Ten Guineas the dupe," is spurning the works of Fuseli, Beechey, Loutherbourg, Cosway, Sandby, Bartolozzi, Rooker, and Turner.

The figure of Sir Joshua Reynolds, rising up from the grave, is expressing amazement at the infatuated Academicians. He is apostrophizing the scene in the language of Shakspeare:—

> "Black spirits and white, blue spirits and grey,
> Mingle, mingle, mingle, you that mingle may!"

Three figures in the immediate foreground are stealing off in mistrust: Benjamin West, the president, who was not a convert to the "Venetian Humbug," Alderman Boydell, in alarm for the prospects of his gallery under the innovation, and Macklin as a dwarf, bearing a sack of tickets marked "Lottery, Five guineas a dip," with his Bible in his pocket, indicating his anxiety respecting the success of his lottery for these grand illustrations.

The Royal Academy, Somerset House, erected by Chambers, is cracked by the shock of the recovered secret, while the Temple of Fame, on the opposite side, is being repaired for the emergency.

November 14th. *Loyal Souls, or a Peep into the Mess-room at St. James's,* introduces, as its title implies, the officers' table, surrounded by officers representing the various regiments of the Guards, who are tossing off their bumpers to the toast of "The King."

November 15th, 1797. *Brigade-Major Weymouth,* furnishes the portrait of a stout commander, Major Reid, with his back to the spectator, mounted on a charger, and assisting his directions with a cane.

On December 16th Gillray published an engraving of a head surmounted by a military hat and plume, peeping out of a jack-boot; below it was the inscription, *Thirty Years have I lived in the Parish of Covent Garden, and Nobody can say, Mistress Cole, why did you so?* This allusion, taken from Foote's farce of the "Minor," refers to a lady who carried on the profession of Hogarth's Mrs. Needham. Mrs. Cole was scrupulous in her religious duties; she combined her attendance at tabernacle with her researches for sinners. It was her boast that nobody could say, "Mrs. Cole, black is the white of your eye." The portrait looking out of the boot is assigned to Colonel Watson, who had probably transgressed against the lady's prohibition of "knock-me-down doings."

Among the numerous interesting portraits which have reached our day through Gillray's industry is that of Samuel Ireland, the Shaksperian Forger, published (December 1st) under the title of *Notorious Characters, No. I.*, with the quotation—

Samuel Ireland.

"Such cursed assurance
Is past all endurance."—*Maid of the Mill.*

Added to this was an inscription by the Rev. William Mason, "under a picture of the editor of Shakspeare's manuscripts"—

"Four forgers, born in one prolific age,
Much critical acumen did engage :
The first * was soon by doughty Douglas scar'd,
Tho' Johnson would have screen'd him had he dar'd.
The next had all the cunning of a Scot ;†
The third, invention, genius—nay, what not !‡
Fraud, now exhausted, only could dispense
To her fourth son, their threefold impudence."

Samuel Ireland was so incensed at this publication, that he is said to have broken the windows where it was exposed.

Samuel Ireland, favourably known for his "Picturesque Tours," announced that his son had received a present from an unacknowledged source, which could not be explained, of many important mementos and manuscripts, originally the property of Shakspeare. These were exhibited to various distinguished but credulous literary men with such art, that their authenticity was generally accepted. Ireland now proceeded further; he announced that an entire manuscript play, *Vortigern and Rowena*, from the pen of the immortal bard, formed part of these treasures. This discovery excited universal attention; the two great theatres were eager to secure it, and Drury Lane obtained the precious document for 300*l.* and a stipulated half of the receipts for the first sixty nights. The prologue boldly asserted, "Before the court immortal Shakspeare stands;" and the play commenced. It was at once recognised as a failure. The piece proceeded to the line, "And when this solemn mockery is o'er," pronounced, in the fifth act, by Kemble, who played Vortigern, and upon this apposite cue the uproarious behaviour of the audience convinced the manager that the piece was an impudent forgery. Ireland's audacity exceeded belief. In an interview with Sheridan and Kemble he urged a second trial. Sheridan dissented; and when Ireland was dismissed, Kemble said, "Well, sir, you cannot doubt that the play is a forgery." "Damn the fellow," replied Sheridan, "*I believe his face is a forgery ;* he is the most specious man I ever saw!"

The social studies of this year were concluded in another military sketch entitled, *A Dash up St. James's Street*, which represents a gallant officer, Captain Cunningham, of the Coldstream Guards, marching about the town in a fantastic uniform. The points of the Captain's boots terminate in peaks like skates.

* Lauder. † Macpherson. ‡ Chatterton.

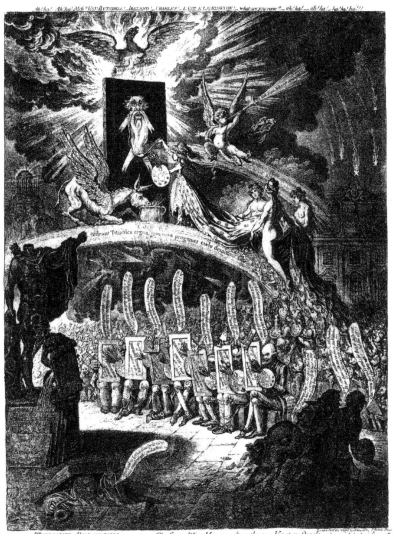

Ah!ha! Ah!ha! Mʳˢ VᴏN BᴜᴛᴄHELL! IRELAND! CHARLES! LANE & LACKINGTON! what are you now? — ah!ha! — ah!ha! — ha!ha!ha!!!

TITANUS REDIVIVUS.... or ... The Seven-Wise Men consulting the new Venetian Oracle...a Scene in yᵉ Academic Grove. Nᵒ 1.

1798.

The year commenced with the gloomiest threats. The sister island was ripe for rebellion, and sedition was rampant at home. The great Whig party indicated their intentions of converting the troubled state of the Government into an opportunity to advance their own aims. The Jacobins announced their plans of invasion, and people were in daily expectation of learning that they had landed in Ireland. The French were constantly boasting of their preparations for the invasion of this country. Threatening paragraphs from the French papers found their way continually into the English journals, and helped to keep up the alarm. It was announced that Bonaparte, now one of the most distinguished of the Republican generals, elated with the victories of his Italian campaign, was to lead his veteran armies against England. A paragraph from a Parisian paper of November 26th, 1797, proclaimed that "the army of England is created; it is commanded by the conqueror of Italy. After having restored peace to the Continent, France is at length about to employ all her activity against the tyrants of the seas." The London newspapers, at the end of December, published the address of the President of the Directory to Bonaparte on his arrival from the south: "Citizen-General! crown so glorious a career by a conquest which the great nation owes to its outraged dignity. Go, and by the punishment you inflict on the Cabinet of London, strike terror into all the Governments which shall dare to doubt the power of a nation of freemen. Pompey did not disdain to crush a nest of pirates. Greater than the Roman general, go and chain down the gigantic pirate who lords it over the seas: go and punish in London crimes which have remained unpunished but too long. Numerous votaries of liberty wait your arrival; you will find no enemy but vice and wickedness. They alone support that perfidious Government; strike it down, and let its downfall inform the world, that if the French people are the benefactors of Europe, they are also the avengers of the rights of nations."

This constant declaration on the part of France that she expected to secure powerful assistance in England injured the cause of the Opposition in this country, and appeared to confirm the charges brought against them by the Tories, whose indignation was raised to the highest pitch, when, in February, the French papers brought over a printed copy of the letter by which the notorious renegade, Paine, conveyed his sentiments on the subject to the Council of Five Hundred: "Citizen representatives, though it is not convenient to me, in the present situation of my affairs, to subscribe to the loan towards the descent upon England, my economy permits me to make a small patriotic donation. I send a hundred livres, and with it all the wishes of my heart for the success of the descent, and a voluntary offer of any service I can render to promote it. There will be no lasting peace for France, nor for the world, until the tyranny and corruption of the English Government be abolished, and England, like Italy, become a sister Republic."

In England the alarm was great, and every measure was again practised that was likely to stir up and sustain a flame of patriotism, as well as to make people suspicious of the motives and designs of those who were in opposition to the Ministers. Loyal songs became suddenly more popular than all others, and new ones were regularly given to the world in the columns of the *Anti-Jacobin* and other publications. The following excellent parody appeared in this journal early in December :—

"LA SAINTE GUILLOTINE.

" From the blood-bedew'd valleys and mountains of
 France
See the genius of Gallic *invasion* advance !
Old Ocean shall waft her, unruffled by storm,
While our shores are all lin'd with the *friends of
 Reform.*
Confiscation and Murder attend in her train,
With meek-eyed Sedition, the daughter of Paine ;
While her sportive *Poissardes* with light footsteps are
 seen
To dance in a ring round the gay *guillotine.*

" To London, 'the rich, the defenceless,' she comes—
Hark ! my boys, to the sound of the Jacobin drums
See Corruption, Prescription, and Privilege fly,
Pierced through by the glance of her blood-darting
 eye.
While Patriots, from prison and prejudice freed,
In soft accents shall lisp the Republican creed,
And with tri-coloured fillets, and cravats of green,
Shall crowd round the altar of *Sainte Guillotine.*

H H

" See the level of Freedom sweeps over the land—
The vile aristocracy's doom is at hand !
Not a seat shall be left in the house *that we know,*
But for *Earl* Buonaparte and *Baron* Moreau.
But the rights of the Commons shall still be re-
 spected—
Buonaparte himself shall approve the elected ;
And the Speaker shall march with majestical
 mien,
And make his three bows to the grave *guillotine.*

" Two heads, says our proverb, are better than one ;
But the Jacobin choice is for Five Heads or none.
By Directories only can liberty thrive,
Then down with the *one*, boys ! and up with the *five !*
How our bishops and judges will stare with amaze-
 ment,
When their heads are thrust out at the *national case-
 ment !*"
When the *national razor* has shaved them quite clean,
What a handsome oblation to *Salute Guillotine !*

Gillray's graver obtained worthy occupation in signalizing the dangers which threatened our shores from abroad, and the fatal consequences which might be foreseen if the safety of England was entrusted to the democrats at home.

The favourite scheme with our Gallic neighbours for the conveyance of their armies to our island was a floating raft. This plan had been suggested by General Hoche, and a few years later it was again entertained by Napoleon.

The artist treated this unwieldy contrivance as an accomplished fact, and on February 1st people were gratified with a view of the French legions struggling amidst the waters of the Channel, which threatened their destruction. *The Storm Rising, or the Republican Flotilla in Danger,* gives the picture of a huge raft, constructed like a fortress, which has put out from Brest Harbour, and is being towed across the Channel by the " Friends of Liberty." A strong windlass is worked for this purpose by Fox, Sheridan, Tierney, and the Duke of Bedford. Fox has thrown off his coat and his ragged shirt reveals his poverty ; a list of the new Republican Ministry—"Citizen Volpone, President"—is lying on the ground. In the pocket of the Duke of Bedford is a paper marked "1400*l.* fine for false entry of servants." The sea is calm on the French coast, but a tremendous storm is bursting from our own shores. The head of Pitt, as " Boreas," is blowing up a terrific tempest, the waves sweep over the flotilla, while lightnings, from the same source, threaten to blast the armament ; the flashes bear the names of Duncan, Howe, Gardiner, Curtis, St. Vincent, Parker, Trollope, and other admirals who were making England mistress of the seas. The standard of " Liberty" is at the head of the floating batteries, but " Slavery" is inscribed on a smaller flag on the stern. A vast bulwark forms the centre of the raft, and numerous turrets protect the sides, while cannons bristle at every point ; various ensigns hold out the prospects which must have followed suc-cess ; " atheism," " requisitions," " plunder," " beggary," " murder," " destruction," " anarchy," &c. On the other side of the water are seen the fortifications of Brest, with the guillotine raised on its principal tower, and the devil dancing over it in delight and playing the tune of " Over de vater to Charley !" (Fox.)

In their mortification at the steady and overwhelming ministerial majorities in Parliament, the Opposition seceders seem to have vented their ill-humour in ultra-Liberal toasts and speeches at public dinners and entertainments, and under the genial influence of the god to whom their devotions were always fervent, they sometimes uttered sentiments that were not of the most prudent description, and which were eagerly seized upon by their opponents. On January 24th, 1798, a grand dinner was held in the rooms of the Crown and Anchor, to celebrate the birthday of Charles James Fox. Not less than two thousand persons are said to have been present. The Duke of Norfolk presided, and was supported by the Duke of Bedford, Earls Lauderdale and Oxford, Sheridan, Tierney, Erskine, Horne Tooke, and others. Captain Morris produced three new songs for the occasion. After dinner had been withdrawn, in the great room, the Duke of Norfolk, as reported in the newspapers, addressed the company nearly as fol-lows : " We are met, in a moment of most serious difficulty, to celebrate the birth of a man dear to the friends of freedom. I shall only recall to your memory, that not twenty years ago the illustrious George Washington had not more than two thousand men to rally round him when his country was attacked. America is now free. This day full two thousand men are assembled in this place. I leave you to make the application. I propose to you the health of Charles Fox." After this toast had been drunk and warmly applauded, the Duke gave successively, " The rights of the people ;" " Constitutional

* *La petite fenêtre* and *le rasoir national* were popular terms applied to the guillotine by the mob in France.

redress of the wrongs of the people;" " A speedy and effectual reform in the representation of the people in Parliament;" "The genuine principles of the British Constitution;" "The people of Ireland, and may they be speedily restored to the blessings of law and liberty." The health of the chairman was then drunk, to which the Duke responded by giving " Our Sovereign's health—*the majesty of the people !*" The Court gave a much less favourable interpretation to these proceedings than it was probable that the actors in them ever contemplated, and the Tory press was loud in its outcries. The Duke of Norfolk waited on the Commander-in-Chief, and assured him that "he had been misrepresented and misunderstood; the principles he had inculcated were those which had seated his Majesty's family on the throne; an invasion of the enemy was generally anticipated; he requested his regiment might be assigned the post of the greatest danger, that he might be allowed to prove his loyalty and attachment to the Throne." The Duke of York listened courteously, but he could afford him no assistance. The result was, that within a few days after the meeting the King dismissed the Duke of Norfolk from his offices of Lord-Lieutenant of the West Riding of Yorkshire and Colonel in the Militia, which caused no less outcry in the newspapers of the Opposition.

Gillray's hand was at once employed to commemorate the transaction. The artist published a print (February 3rd) under the title of *The Loyal Toast*, representing the noble chairman in the act of proposing the objectionable sentiment. He is trampling on his peer's robe. The Duke of Bedford is holding out a bumper to the toast, " Our Sovereign, the Majesty of the People !" A paper, inscribed "Grants from the Crown, an Old Song by the Bedford Farmer," is suspended from his chair. Fox, Sheridan, Nichols, and other members of the Whig party are hailing the sentiment; sweeps, barbers, and a rough crowd are pledging the toast in bumpers. The Duke's seat, in place of a coronet, bears the figure of a bonnet-rouge. Above his head appear two hands; one, holding the scales of justice, is enforcing the warning, " Jockey of Norfolk, be not too bold !" the other hand, with a pair of shears, is snapping off the offices of Colonel of the Militia and Lord-Lieutenant of Yorkshire from the long list of "Gifts and Honours bestowed by the Crown," comprising "First Dukedom, first Earldom, first Barony, Earl Marshalship, rank next the Blood Royal, and 60,000*l.* per annum."

At the next meeting of the Whig Club, Fox, in a powerful speech, deprecated the objections which could be advanced against the "Loyal Toast." " It is," said he, " whimsical enough to deprive the noble Duke of his appointments for an offence which, if he had not committed during the

A Noble Toastmaster.

reigns of George I. and George II., would have subjected him to the charge of being a Jacobite and an adherent of the exiled family."

Just three months later, at a meeting of the Whig Club, at the Freemasons' Tavern, on Tuesday, the 1st of May, Fox gave as a toast, " The Sovereignty of the people of Great Britain," and accompanied it with a speech strongly condemnatory of the conduct of Ministers, whom he compared with the French Directory. A similar mark of resentment was shown towards Fox, as had already been exhibited in the case of the Duke of Norfolk; the King immediately ordered his name to be erased from the list of the privy council. Another caricature by Gillray, published on the 12th of May, represents the *Dismay of the Two Disgraced Patriots*, in a "Meeting of the unfortunate *citoyens.*" Pitt and Dundas stand as sentinels at the entrance to St. James's. Fox, who appears to have just been refused admittance, exhibits a truly rueful countenance, and meeting the duke, exclaims, "Scratch'd off!—dish'd !—kick'd out, damme !"[*]

Patriots in Dismay.

* Fox appeared to court this act of resentment, he anticipated the indignity.

H H 2

His companion in misfortune, from whose pocket hangs a paper containing the announcement of his dismissal from the lieutenancy, replies, " How ? what ! kick'd out !—ah ! morbleu !—chacun à son tour ! morbleu ! morbleu !"*

Plenty of pictures were now published to show the disastrous state of things to be expected in this country, when the Whigs should have helped the French to the mastery. Of these the most remarkable was a series of four plates, engraved by Gillray, and published on the 1st of March, and said, in the corner of each plate, to be " invented" by Sir John Dalrymple. They are entitled, *The Consequences of a successful French Invasion.* The first represents the House of Commons occupied by the triumphant democrats ; the mace, records, and other furniture of the house are involved in one common destruction, and the members are fettered in pairs, in the garb of convicts, ready for transportation to Botany Bay, to which the House is adjourned *sine die.* Fox and Dundas are secured—by extra

padlocks—back to back. The Royal arms are snuffed out by the bonnet-rouge. " We've come to recover your long-lost liberties," is the motto of the print.

In plate the second, *We explain de " Rights of Man" to de Noblesse.* The House of Lords is made the scene of similar havoc ; a guillotine, supported by two Turkish mutes with their bows, occupies the place of the Throne ; and the commander-in-chief, in his full Republican uniform, pointing to the mace, says to one of his creatures, " Here, take away this bauble ! but if there be any gold on it send it to my lodging."

The tapestry, representing " the defeat of the Spanish Armada, and the portraits of the immortal English commanders," is being torn down and destroyed as of ill omen. The bust of Felton is placed on the table between the heads of Damiens and Ravaillac.

The third plate, *We fly on the wings of the wind, to save the Irish Catholics from persecution,* is a lesson for Ireland ; having come over with the specious pretext of delivering the Catholic faith from Protestant supremacy, they abuse the Catholic clergy and plunder and profane their churches. A venerable priest is stabbed in the sanctuary, the altar is desecrated, and the Communion vessels and other insignia are trampled under foot. A French Minister of Justice cries " Good, the justice of it pleases ; 'tis thus that the gratitude of the French Republic always pays three favours for one."

In plate four the English democrats are offered a hint of their probable fate—*We teach de English Republicans to work. Scene—a ploughed field.* The betrayed natives are set to hoe garlic. An overseer stands by them with a brace of carter's whips. Clergy, farmers, gentry, sailors, indiscriminately, old and young, male or female, are set to work ; ragged and in wooden shoes, to toil like beasts of the field, for their foreign masters, who feed them on " soup maigre," and litter them in the pigsties. In the background four wretched Englishmen tied to the plough, are urged forward with whips and iron-tipped goads. A " recantation of the English and Irish Republican husbandmen and manufacturers" is lying on the ground ; but their repentance has arrived too late.

Ireland was at this time breaking out into open rebellion, and occupied the attention of both political parties in England as seriously as the threatened invasion from France. The Whigs accused the Tories of having provoked the Irish into resistance by their tyrannical measures, and affected sympathy for their sufferings ; the Tories accused the Whigs of having encouraged disaffection by their example, and by the propagation of their Republican doctrines. Among those who preached most about English injustice in the sister island, was Lord Moira, who has been mentioned before as Lord Rawdon, and who was incessant in his declamations against English misrule. His lordship had early embraced the military profession ; he served with great distinction in the American war ; he was engaged at the

* An allusion to these caricatures and the impression they excited will be found in the Introduction (p. 13.)

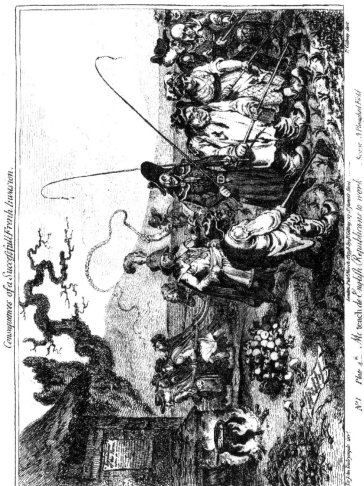

Consequences of a Successful French Invasion.

Published March 1st 1798 by J. Gillray. 27 St James's Street.

Js. Gillray invt. & del.

F. Galway fecit.

No. I. Plate 4th. — We teach de English Republicans to work. Scene... A Ploughed Field.

celebrated battle of Bunker's Hill, June 16th, 1775, and was one of the seven of his whole company—5th Grenadiers—who were not wounded. His valour and activity on that occasion were signally pointed out by General Burgoyne, the Commander-in-Chief, who in his official report recorded "Lord Rawdon has this day stamped his fame for life." On his return from America he assisted the Duke of York in Flanders with skill and efficiency. On the retreat of our army he was assigned the command of a body of troops quartered at Southampton, and several battalions of French emigrants were placed under his directions. He entertained the officers with such splendour that his residence at Southampton resembled a Court ; he was supposed to have expended at least 30,000l. of his private fortune in these hospitalities. At the period now under consideration he was devoting his abilities to politics, and especially to the improvement of the state of Ireland. He brought forward a conciliatory measure in the English House of Peers without success ; he next addressed himself to the Irish House of Peers, representing the condition of the people ; their hard usage and pacific intentions, and enlarging on the severity of the British military rule. He again urged a lenient course : "The time for recovering the affections of your countrymen," he declared, "has not yet passed ; conciliation might be deferred, but every day increased the difficulty of suppressing the spirit of discontent. Be united, you may then defy France and the world ; although you have not a ship on the sea." These arguments did not meet with the sympathy they deserved.

Lord Longbow the Alarmist.

Gillray expressed the conviction generally entertained of the Earl's mistaken policy. On the 12th of March the artist published a clever cartoon of *Lord Longbow the Alarmist, discovering the miseries of Ireland ; with the puffing out of the little farthing rushlight, and ye Story of Moll Coggin.* The engraving represents the tall figure of Lord Moira standing on the English shore, while an extravagant scene is enacted in Ireland, according to a burlesque of his speech, which accompanies the plate. Major Longbow had declared that great wrong was inflicted by a curfew tyranny, which insisted that all lights should be extinguished at nine o'clock ; the satirist has drawn him in the act of blowing the light of a farthing candle into a flame, which threatens to destroy the whole establishment. The British soldiery are committing gross excesses ; and a witch, in whose authenticity the Earl was understood to believe, is riding in mid-air on the back of a goat. Lord Moira in his speech alluded to the loyalty of the tenants on his own extensive estates at Ballynahinch, and he expressed his dependence on their devotion. Unfortunately his confidence proved to have been misplaced, for an open rebellion soon after broke out in his own town, and a number of pikes were found secreted in his woods, which gave rise to the spirited song of—

"BALLYNAHINCH.

"A certain great Statesman, whom all of us know,
　In a certain Assembly, no long while ago,
　Declared from this maxim he never would flinch,
'That no town was so loyal as Ballynahinch.'

"The great Statesman, it seems, had perused all their faces,
　And been mighty struck with their loyal grimaces ;
　While each townsman had sung like a throstle or finch,
'We are all of us loyal at Ballynahinch.'

"The great Statesman returned to His speeches and readings,
　And the Ballynahinchers resumed their proceedings ;

They had most of them sworn 'We'll be true to the French,'
So loyal a town was this Ballynahinch.

"Determin'd their Landlord's fine words to make good,
　They hid pikes in his haggard, cut staves in his wood ;
　And attacked the King's troops—the assertion to clinch,
　That no town is so loyal as Ballynahinch.

"Oh ! had we but trusted the rebels' professions,
　Met their cannon with smiles, and their pikes with concessions,
　Tho' they still took an ell when we gave them an *inch*,
　They would all have been loyal—like Ballynahinch."

The threats of France and her ostentatious preparations had greatly injured the cause of the Whigs in England, where the warlike spirit had been increased by the victories gained by Duncan and other

admirals at sea. Our fleet seemed to be rapidly rising in glory since the repression of the memorable
mutiny at the Nore. The enthusiasm was kept up by every kind of incentive, even by " loyal " per-
formances at the theatres. On the 9th of February a tragedy, entitled " England Preserved," an inter-
lude, and the farce of the " Poor Sailor," were acted at Covent Garden Theatre, and the receipts of the
house appropriated to the voluntary contribution for the defence of the country. There were present
Lord Bridport and Lord Hood, whose healths being drunk in the interlude occasioned such extra-
ordinary bursts of applause, that both these naval heroes were obliged to come forward and show
themselves to the audience. This and other performances were accompanied with appropriate prologues,
epilogues, and addresses, all calculated to produce the same effect. Even Captain Morris became loyal
and wrote some truly patriotic songs, of which the following, which was very popular, is one of the
best :—

"A LOYAL SONG.

" Ye brave sons of Britain, whose glory hath long
Supplied to the poet proud themes for his song,
Whose deeds have for ages astonish'd the world,
When your standard you've hoisted or sails have un-
 furled ;
France raging with shame at your conquering fame,
Now threatens your country with slaughter and
 flame.
 But let them come on, boys, on sea, or on shore,
 We'll work them again, as we've worked them
 before.

" Now flush'd with the blood of the slaves they have
 slain,
These foes we still beat swear they'll try us again ;
But the more they provoke us, the more they will see,
'Tis in vain to forge chains for a nation that's free ;
All their rafts, and their floats, and their flat-bot-
 tom'd boats,
Shall not cram their French poison down Englishmen's
 throats.
 So let them come on, &c.

" They hope by their falsehoods, their tricks, and
 alarms,
To splits us in factions, and weaken our arms ;

For they know British hearts, while united and true,
No danger can frighten, no force can subdue ;
Let 'em try every tool, every traitor, and fool,
But England, old England, no Frenchman shall rule.
 So let them come on, &c.

" How these savage invaders to man have behav'd,
We see by the countries they've robb'd and enslav'd ;
Where, masking their curse with blest Liberty's
 name,
They have starv'd them, and bound them in chains
 and in shame.
Then their traps they may set, we're aware of the
 net,
And in England, my hearties, no gudgeons they'll
 get.
 So let them come on, &c.

" Ever true to our king, constitution, and laws,
Ever just to ourselves, ever staunch to our cause ;
This land of our blessings, long guarded with care,
No force shall invade, boys, no craft shall ensnare,
United we'll stand, firm in heart, firm in hand,
And those we don't sink, we'll do over on land.
 So let them come on, &c."

The Irish troubles assumed more formidable proportions, and several persons were arrested in
England who had been implicated in promoting insurrection. The " violation of the liberty of the
subject" provoked the censure of the Opposition organs, while Gillray turned the transaction against
the Whigs.

He published (March 20th) a caricature entitled *Search Night, or State Watchmen Mistaking Honest
Men for Conspirators* (vide State Arrests), in which Pitt and Dundas, as state watchmen, are breaking
through the door of the secret apartment in which the Corresponding Society are supposed to be
deliberating. They find the room to be full of daggers, caps of liberty, &c., and a party of conspirators
brooding over Irish insurrection and plans of invasion. The approach of the watchmen has been the
signal for a general flight; the Dukes of Bedford and Norfolk make their escape through the chimney ;
Fox and Sheridan mount through a trap-door; Tierney, Nichols, and Horne Tooke seek concealment
under the table; Moira alone, who boasted that he managed well with both parties, stands his ground :
over the mantel-piece are portraits of Robespierre and Bonaparte. In June people were excited against
the Irish by pictures of the atrocities committed by the rebels, which rivalled almost the doings of
French Republicanism : and among other caricatures on the same subject published in October, is a
picture of *The Allied Republics of France and Ireland*, in which the French ally, after enriching himself

by plunder, is riding upon poor Ireland transformed into a donkey. This picture is accompanied by a mock song, burlesquing the national burthen of "Erin go bragh:"—

"From Brest in the Bay of Biskey
Me come for de very fine whiskey,
To make de Jacobin friskey,
 While Erin may go bray.

"Me have got de mealy pottato
From de Irish democrate,
To make de Jacobin fat, O,
 While Erin may go bray.

"I get by de guillotine axes
De wheats and de oats, and de flaxes,
De rents, and de tydes, and de taxes,
 While Erin may go bray.

"I put into requisition
De girl of every condition,
For Jacobin coalition,
 And Erin may go bray.

"De linen I got in de scuffle
Will make de fine shirt to my ruffle,
While Pat may go starve in his hovel,
 And Erin may go bray.

"De beef is good for my belly,
De calf make very fine jelly,
For me to kiss Nora and Nelly,
 And Erin may go bray.

"Fitzgerald and Arter O'Connor
To Erin have done de great honour
To put me astride upon her,
 For which she now does bray.

"She may fidget and caper and kick, O,
But by de good help of Old Nick, O,
De Jacobin ever will stick, O,
 And Erin may go bray."

The Whigs both in England and in Ireland were persistently represented as the promoters of French invasion. It was generally credited that their Republican principles would be rewarded with responsible offices under the new systems which our conquerors would establish after the Revolution; and great transformations were expected to follow their arrival in this country. The French love of show was manifesting itself in the costumes and appointments allotted to the members of their Government. The old distinctions of dress and rank—swept away by the early democratic fury—were succeeded by costumes and official decorations which had their origin in the Republic.

Gillray, under the title of *French Habits*, issued a series of drawings of the new official costumes, ingeniously converting the designs into what were then conceived effective exposures of the ambitions of the Whig section.

The portly figure of Fox was draped as *Le Ministre d'État en Grand Costume*, it being generally credited that this was the office the leader of the Opposition had in view. In the second plate—*Les Membres du Conseil des Anciens*—the ancients are caricatured in the persons of three representatives of this branch of the French Legislative body—the Marquis of Lansdowne, and the Dukes of Norfolk and Grafton.

The third plate—a detachment of the *Council of Five Hundred*—introduces Lords Stanhope and Lauderdale, the Earl of Derby, Byng, and M. A. Taylor. Plate four, *A Member of the Executive Directory*, appears in the person of the wealthy Duke of Bedford. The "Directory" was at the date of this sketch dictating the fortunes of Europe. Behind the figure is a curtain with the word "Egalité" concealing the ducal coronet. Plate five represents the *President of the Municipal Administration*. Parson Horne Tooke, whose voice was heard in every political agitation, is seen exercising his influence as president before the chair of the municipal body. The state executioner wearing a heavy black cloak bears the features of the patriotic Tierney.

Plate seven represents the *Advocate of the New Republic*. Erskine, the great Whig counsel, appears as the head of his profession in the new order of things. Sir John Shuckborough is introduced as a member of the high court of justice, earnestly expounding the principles of the Republic. The responsible post of "Juge du Tribunal Correctionnel" is occupied by Courtney, the wittiest of Opposition orators. The grim jests which a heartless judge might indulge at the expense of those brought before him, are supposed to be suited to the veteran joker. Nicholls is exhibited as the Republican justice of the peace. He was known as an ardent advocate of Opposition principles. The treasurer of the new Administration is Sir William Pulteney: a gold key embroidered on the front of his coat. He was notorious for his wealth and eccentricity; he was also a zealous reformer. The new treasurer is scrutinizing the condition of the finances. The motive for assigning this office to Pulteney may be explained from the circumstance that an attempt had been made in 1797 by a considerable number of members of the

House of Commons, who were dissatisfied with Pitt's conduct of the war and alarmed at the embarrassed condition of our resources, to form a third party, to be led by Lord Moira. Lord Thurlow was to be reinstated in office, while Pitt and Fox would be excluded. Sir William Pulteney was to have been Chancellor of the Exchequer.

Plate twelve—a print of *French Habits*—introduces Sir Francis Burdett as a State messenger. This officer, though occupying a post of no great consequence, is clad as finely as the highest functionaries. Sir Francis Burdett, one of the most conspicuous men of this day, long occupied a foremost position in the fashionable world. The baronet was recognised as the "arbiter elegantiarum" of his age. At the date of this series he was cultivating popularity as a patriot; his zeal soon gained notoriety in this field. A higher office than the one designed in jest was a few years later allotted to him, prospectively, by one who generally carried out his most visionary projects. Napoleon declared that he intended to establish a Republican form of government in the United Kingdom after its conquest, and he considered Sir Francis Burdett would be the most fitting person to direct it as president.

At this date things were going badly with the democratic clubs and secret associations. Various prosecutions were commenced against the members, and a sense of danger spread alarm through all bodies formed for purposes of political agitation. Gillray promoted this feeling by his print of the *London Corresponding Society alarmed. Vide Guilty Consciences* (April 20th). A cellar is designed as the meeting-place of a party of sedition-mongers and outlaws bearing the most repulsive exteriors. They are thrown into consternation by the list of State arrests, which includes the names of "O'Connor, Binns, Evans," &c. This sketch, engraved in mezzo-tint, is an effective exposure of the obscure ruffians who often formed the basis of these secret societies.

In the relentless spirit which had prompted the artist to devise his bitter sarcasms against Fox and the Whig Club since the outbreak of the Revolution, Gillray published his view of *The Tree of Liberty with the Devil tempting John Bull* (May 23rd). The tree of Liberty is drawn as the emblem of corruption. Its trunk is marked "Opposition," its roots are "Envy," "Ambition," and "Disappointment;" its branches, "the Rights of Man" and "Profligacy," bear various rotten fruits of "Conspiracy," "Revolution," "Deism," "Age of Reason," "Corresponding Society," "Whig Club," &c. The devil, in the form of a mighty serpent, bearing the head of Fox, is gliding from behind the trunk to tempt John Bull with the apple of "Reform." "Nice apple, Johnny! nice apple!" John Bull has filled his pockets with golden pippins from a neighbouring tree, with the name of "Justice" on its trunk, its roots spring from Kings, Lords, and Commons;—its branches, "Law" and "Religion," produce fruits totally different to those raised by the tree of "Liberty."

Party excitement prevailed at the date of this design with unusual animosity. The Whigs declared that the Ministers were insidiously opening the way for the re-establishment of despotic power, that the suspension of the Habeas Corpus Act, and the restrictions upon the "Liberty of the Press" were designed to facilitate this end. We can readily trace the stigmas which the Tories showered on the men they excluded from office; the foremost patriots they denounced as Jacobins darkly plotting to betray the institutions of their country. Both sides succeeded in obscuring the characters of their opponents with such good will that it is difficult to distinguish between patriotic graces and political deformities.

"We live in times of violence and extremes," said Fox, "and all who are for creating, or even for retaining checks upon power, are considered as enemies to order."

We have alluded to the Whig chief's retirement from the Parliament. The base motives which the Court party persistently attributed to his exertions, and the impossibility of controlling the action of the Ministers, led him to this determination. Before we follow the patriot to his retreat at St. Anne's Hill, we offer the opinions which some of his contemporaries entertained of the famous Whig Club.

"The Whig Club, remarked a libellous author, owned for its father a political mercer in Chandos Street." It was originally formed in 1780, the memorable year of the riots, to answer an electioneering purpose, and to support the pretensions of Mr. Fox to represent the city of Westminster. But the leaders of the party which established it, soon found that it might be extended to greater designs.

"Men of splendid talents, high birth, and fortune enrolled themselves among its members; it was considered as the organ of those who acted in opposition to Administration : its sentiments, and even its

toasts, were industriously circulated throughout the kingdom, its resolutions not unfrequently claimed the attention of Parliament; it maintained from the capital a political correspondence with the distant counties. The Whig Club of Dublin and of Southwark, with a variety of other clubs in the provincial towns of the kingdom, may be considered as the offspring of this prolific parent.

"At first the Whig Club contained many members whose views extended no farther than to guard the ancient barriers of the Constitution from encroachment. Many of the members of this period subsequently withdrew themselves from the society, whose designs they could no longer approve. That some respectable Whigs still attached themselves to the club, more from personal regard to its distinguished leader than to the principles which it maintained, is not to be doubted; the greater part, however, enlisted under the banners of its chief, in the vain hope of lending their feeble aid to effect the discomfiture of that party which kept the Whigs out of office.

"The history of this renowned club forms one of the most extraordinary features of the memorable reign of George the Third. Not so much from the congregated talents of its members, although some few were eminently distinguished for their abilities, as for the strange *mélange* of morals of which it was composed. Since the days of Charles the Second such a knot of questionable characters of high family, birth, and public notoriety were never clubbed together for any political purpose. It was not Whiggism that rendered their meetings odious to Royalty, but rather such Whigs as were enrolled in this club.

"In all the political caricatures by Gillray subsequent to a certain period of the French Revolution, the satirist is merciless in his attacks upon the Man of the People. Even admitting what has been asserted, that the satirist was influenced by the party opposed to this illustrious orator, yet the frantic zeal with which Fox stood forward as the advocate of the direful anarchy of France, not only deprived him of many respectable friends who had hitherto been enrolled with him in the cause of patriotism, but laid him fairly open to much of the graphic libelling which he experienced. The Whig chieftain's pertinacious adherence to his opinions in favour of the inveterate foe, to say the least of it, argued bad taste; for not only the English people, but the whole community of the civilized world, felt alike in their genuine abhorrence of the atrocities perpetrating in France.

"It was this extraordinary conduct on the part of Mr. Fox which seemed to sanction the bitter invectives of the author of the 'Whig Club,' who says, 'That copious stream of words which he pours forth at pleasure, is indeed justly the theme of admiration, but as the viper bears in herself the antidote of her poison, so does his character prevent his abilities from doing all the mischief he otherwise might, by pulling off the mask and showing his plans too soon for their accomplishment.'

"His labours to effect the overthrow of the Ministry and to obtain power have been compared to those of Sisyphus—'eternally to roll the stone upwards, which ere it reached the summit of the hill descended again upon him.'

"His early rival Pitt acquired power and kept it.

"'How much have we to regret,' says a political writer, 'that the late Mr. Fox during his long exclusion from public employment, between 1797 and 1802, while in retirement at St. Anne's Hill did not occupy himself in composing the history of his own time. Aspiring as he did not only to the fame of a statesman and orator, but to the praise of an historian, how infinitely more valuable a legacy might he have bequeathed to his countrymen, how much more durable a monument might he have erected to himself by such an exertion of his talents, than by exhausting his efforts on the reign of James the Second!'

"It was thus that Clarendon beguiled the hours of unmerited disgrace and exile when he wrote his 'History of the Great Rebellion.'

"The Cardinal de Retz, a man to whom Fox bore some analogy in certain features of his political life, of his character and fortune, made the best atonement to his country and to posterity for the irregularities and agitation of his political career, by tracing with his own hand in his decline the outline of those transactions which he had guided or produced. We forget his deviations from prudence, his faction and his ambition, in the elegance of his genius and the ingenuous disclosure of his errors."

The greatness of Fox's mind was never more manifest than in retirement. By one exertion he

seemed to have forgotten all the ambitions, the struggles, and the disappointments of his political career; the battle of life—if its sounds reached him—did not disturb his tranquillity. His favourite classics, the Italian poets, the planning and planting of his grounds, the simplicity and regularity of a country life, supplied his never-failing enjoyments. Surrounded by the endearments of domestic happiness Fox considered the five years of his secession from Parliament as the happiest period of his life.

On the 24th of January, 1799, he spent his fiftieth birthday in this retirement, and addressed the following lines to Mrs. Fox:—

> " Of years I have now half a century past,
> And none of the fifty so blest as the last;
> How it happens my troubles thus daily should cease,
> And my happiness still with my years should increase,
> In defiance of Nature's more general laws,
> You alone can explain, who alone are the cause."

The occupations of Fox's life were misinterpreted in the ardour of political prejudice, sinister motives were assigned for his retirement, the serenity of his retreat was tortured into an unlawful secrecy—courted for his own equivocal ends.

The Shrine of St. Anne's Hill (May 26th) introduces the cropped head and bulky figure of the political hermit, kneeling before a democratic altar of his own erecting. A guillotine is the principal object; a tablet is inscribed, "Les Droits de l'Homme," in parody of the Decalogue. The cap of Egalité and the busts of Robespierre and Bonaparte are before the altar. Six harpies, wearing the bonnet-rouge, supply the place of the conventional cherubim, they are the Dukes of Norfolk and Bedford, the Marquis of Lansdowne, Lord Lauderdale, Tierney, and old Nicholls.

About this time a remarkable instance occurred of the length to which Pitt was prepared to carry his sense of honour. The Ministry proposed, May 25th, 1798, to bring in a Bill for the more efficient manning of the navy, and to augment the forces by ten thousand men. This measure was peculiar from the manner of its introduction; Pitt wished it to be carried through the different stages and sent into the Lords for their concurrence on the day of its presentation. Tierney objected to this precipitancy, he had heard of no emergency justifying this extraordinary proceeding. Pitt referred the honourable gentleman's opposition to a "desire to obstruct the defence of the country." Tierney appealed to the Speaker, and Pitt was requested to explain his expressions; he declined to do so: Tierney immediately left the House, and a hostile message was afterwards delivered to Pitt. On Sunday, May 27th, the antagonists met by appointment on Wimbledon Common. Pitt was accompanied by Mr. Ryder, Tierney's second was George Walpole. A brace of pistols were discharged without effect at twelve paces; a second pair were produced, and this time Pitt fired in the air; the seconds interposed, and insisted that the affair should go no farther—"it being their decided opinion that sufficient satisfaction had been given, and the business was ended with perfect honour to both parties."

Gillray has assisted to keep alive the remembrance of this memorable duel; he published a print under the title of *The Explanation* (May 30th). The opponents are a short distance apart, Lord Camelford is Pitt's second, and General Walpole stands behind Tierney, who has just discharged his pistol, crying, "Missed, by G——!" "Missed him!" observes his second. "O Lord! if he had but been popped off how nicely we might have popped on." Pitt, firing in the air, is exclaiming, "The only explanation I give is this! There, that's to show you that I bear no personal enmity; but that no consideration of my own safety shall deter me from doing my duty to King and country—so fire away!" Sir Francis Burdett, in the figure of a bird, is perched upon Abershaw's gibbet.

The condition of Ireland and the troubles which had so long agitated that unhappy country broke out at this juncture into open outrage, and the Rebellion of '98 commenced its sanguinary details; the tendency of English opinion was fatal to sympathy with the rebels. Gillray represented "the patriots" in popular colours. *United Irishmen in Training* (June 12th) pictures a herd of half-clad ruffians preparing their arms and training for the struggle. The uniform of an English Footguard is stuck on a pike. They are practising at the straw effigy; their efforts are more ludicrous than deadly,—a huge blunderbuss allows the ammunition to roll out before the piece is discharged, and a crooked-barrelled

pistol, with which a Pat is taking accurate aim, sends the bullet in a totally different direction. Swords, pikes, daggers, &c., are being sharpened at the grindstone. "Irish powder," in the form of whisky, is liberally distributed among the volunteers at the sign of the Tree of Liberty, which deals in "true French spirits." The second plate, *United Irishmen upon Duty*, realizes the effects of their training. The artist has drawn a vivid picture of atrocities resembling those perpetrated in France. Towns in flames, flocks and herds driven off to feed the rebels, private property recklessly plundered, cottages demolished and their inmates dragged forth to be butchered: a general scene of rapine, murder, plunder, and ruin.

During the Irish rebellion Gillray published a portrait of Grattan, *An Irish Chief, Drawn from the Life, at Wexford* (July 10th). Grattan is dressed in the famous green uniform, his belt strung with pistols, and a cutlas by his side; he is crying, "No Union! Erin go Bragh! ("Ireland for ever"). In May, 1798, the Rebellion broke out in Wexford, and the rebels made themselves masters of the city and held it as their chief post. The print is presumed to be founded on an interview which took place between Grattan and Arthur O'Connor at the house of the former. Grattan declined to connect himself with the "United Irishmen," but Government struck his name out of the Privy Council on suspicion of complicity.

The arrest of O'Connor followed the information laid by Reynolds, who betrayed the rebels to Government. Upon these disclosures the Tories professed to suspect their opponents of encouraging the movement. Gillray flattered these prejudices by representing under the title of *Nightly Visitors at St. Anne's Hill* (September 21st) the slumbers of Fox disturbed by visions of these victims whose lives had been forfeited to their temerity. Fox is sitting up in bed, in profound horror; two big tears roll down his cheeks, while a brace of imps, wreathed with serpents, are suspending the confessions of O'Connor, Bond, &c., over his head. A plan of the Irish rebellion is lying under the bed. Four headless trunks, with halters round their shoulders, represent Grogan, Hervey, Lingley, and Shears. The figure of Lord Edward Fitzgerald—

> "In glided Edward's pale-eyed ghost,
> And stood at Carlo's feet.

And pointing to his wounds, thus apostrophizes Fox:—

> Who first seduced my youthful mind from virtue?
> Who plann'd my treasons, and who caus'd my death?
> Remember poor Lord Edward, and despair!"

Fox is crying in alarm—

> "Why dost thou shake thy gory locks at me?
> Dear, bravest, worthiest, noblest, best of men!
> Thou canst not say 'I did it!'"

Mrs. Fox is sleeping undisturbed.

Lord Edward Fitzgerald, fifth son of the Duke of Leinster, by Emilia Mary, daughter of the second Duke of Richmond, had at an early age entered the army, for which his abilities were admirably adapted. He distinguished himself with his regiment in America, and Lord Rawdon (Earl Moira) appointed him his aide-de-camp, as a proof of his appreciation. On his return he unfortunately plunged into politics. In Paris he had made the acquaintance of Tom Paine, and shared his apartments. Lord Edward was married in France to the beautiful and accomplished Pamela (natural daughter of the Duc d'Orléans and Madame Genlis). A Republican toast, proposed in Paris, had compelled his dismissal from the British army. In 1793 he became acquainted with O'Connor, but it is believed that he did not become a member of the Society of United Irishmen until 1796. His military training and experience rendered his acquisition important, and he at once became one of the foremost organizers of the insurrection. He accompanied O'Connor to Hamburg to negotiate with the French Directory for the invasion of Ireland (*General Hoche's expedition*), which proved a failure. O'Connor and Lingley were arrested at Dover on their way to Calais. Lingley was hanged for high treason and O'Connor was acquitted, but was instantly re-arrested and conveyed to Ireland by a warrant from the Duke of Portland. Alarmed for his safety he, with several others, entered into terms with Government and made a full disclosure of the conspiracy. Every opportunity was, it is declared, offered Lord Edward to escape

from the consequences which would attend his arrest. He imprudently resisted every inducement to abandon the enterprise, and his capture became inevitable. He was discovered at a house in Dublin. The Town Major Sirr, Major Swan and Ryan, publisher of *Falkener's Journal*, at once desired him to surrender. He shot Ryan in the stomach, and the wound proved fatal; he stabbed Swan in two places, but was himself wounded in the right arm by a pistol which Major Sirr discharged to disable him. After lingering a considerable time he died on June 3rd from the effects of this injury. Lord Fitzgerald's qualities had attracted every one who knew him. The Prince of Wales, the Duke of York, and the Duke of Portland exerted their influence on his account. Later on the Prince Regent consented to pass a Bill repealing his attainder in the interest of his widow and children, and he further evinced his respect for Lord Edward's memory by giving his son a commission in his own regiment (the 10th), as soon as he reached his sixteenth year.

A ludicrous instance of the tendency to connect the leaders of the Opposition with the Irish rebels is furnished in a plate by Gillray on the trial of O'Connor, issued under the title of *Evidences as to Character, being a Portrait of a Traitor by his Friends and by himself.*

The convict is standing at the bar with a halter round his neck, and the sword and scales of Justice suspended over his head. The foremost Whigs are present in court to give their testimony to the character of the accused.

O'Connor is abjectly admitting his treason. "I confess I became a United Irishman in 1796, and a member of the National Executive from 1796 to 1798. I knew the offer of Frenchassistan ce was accepted at a meeting of the Executive in the summer of 1796. I accompanied their agent (the late Lord Edward Fitzgerald) through Hamburg to Switzerland, and had an interview with General Hoche, who afterwards had the command of the expedition against Ireland, at which everything was settled between the parties with a view to the descent. I knew that in 1797 a fleet lay in the Texel, with 15,000 troops destined for Ireland, and I knew of the loan negotiating with France for half a million for this new Irish Government."

Fox stands foremost, in his pocket are letters to Lord Edward Fitzgerald and O'Connor, the Whig chief kisses the book, and in his favourite declamatory attitude, declares, "I swear that he is perfectly well affected to his country. A man totally without dissimulation—I know his principles are the principles of the Constitution." Sheridan is equally earnest, a list of the Irish Assembly peeps under his coat, but "Old Trusty" is kissing the "Four Evangelists," asserting unabashed, "I know him intimately. I treated him, and he treated me, with confidence; and I swear that I never met with any man so determined against encouraging French assistance."

Erskine is affirming, "I never had any reason to think that his principles differed from my own;" while the Duke of Norfolk testifies, without compromising his conscience, "I consider him attached to constitutional principles in the same degree as myself."

The rebellion was not suppressed without considerable bloodshed, unnecessary cruelty was indulged on both sides. On the disappearance of hostilities, it was proposed to ameliorate the condition of Ireland by a union with the mother country. This project provoked considerable opposition, especially amongst the Irish. Their distrust of the intentions of the home Government was attributed to Whig agitators. This impression is illustrated in a caricature published (December 24th) under the title of *Horrors of the Irish Union—Botheration of Poor Pat, or a Whisper across the Channel.*

England, rich and well-favoured, is spread out by the side of Ireland, devastated by fire and tumult; the Irish Channel forms a narrow division between the two islands. Britannia, on the one hand, seated on bales of merchandize, with an inexhaustible cornucopia by her side, is offering golden stores to the Irish, her spear and shield are laid aside, her foot is crushing the serpent "Discord," she lays her hand on her heart while extending a treaty—"Union of Security, Trade, and Liberty"—to poor Pat, who is

standing on the other shore, sadly perplexed, ragged and shoeless, with a broken pike at his feet, and his hands in his empty pockets. His botheration is produced by the difference between Britannia's evident good intentions and the sinister warnings of Fox and his friends, who, concealed behind the British Oak, are insinuating libels to Pat, who is inclined to accept her friendship. "Hip! my old friend, Pat, hip!" whisper the Whigs; "a word in your ear! take care of yourself, Pat, or you'll be ruined past redemption. Don't you see this d—d Union is only meant to make a slave of you? Do but look how that cursed hag is forging fetters to bind you, and preparing her knapsack to carry off your property and ravish your whole country—man, woman, and child! Why, you are blind, sure! Rouse yourself, man! Raise all the lawyers and stir up the corporations, fight to the last drop of blood, and part with the last potato to preserve your property and independence." Pat listens to this warning with evident amazement. "Plunder and knapsacks! and ravishing and ruin of my poor little Island! Why, by St. Patrick, it's very odd now; for the old girl seems to me to be offering me her heart and her hand, and her trade—and the use of her shelalee to defend me into the bargain! If you was not my old friend, Charley, I should think you meant to bother me with whisperings to put the old lady in a passion that we may not buss one another, or be friends any more!"

In the May of this year an expedition was sent out to Ostend to blow up the basin, gates, and sluices of Bruges canal, and to destroy the internal navigation between Holland, Flanders, and France. The canal formed the receptacle for the boats and craft which were to bear the invaders to our shores; its destruction put an end to the chance of conveying the transports fitted out at Flushing by inland transit to avoid our cruisers. The expedition was successful, the works which had taken five years to complete were entirely destroyed, and the boats destined for the invasion were burnt. When the troops reached the shore the roughness of the sea hindered their embarkation. The little army was hemmed in, and obliged to capitulate after a sanguinary engagement which lasted two hours.

Jekyll, the member for Calne, on the 20th informed Parliament that the expedition had virtually failed; on the 21st he stated that he was sorry to have mislead the country, but it appeared from an official account that his intelligence was erroneous. Gillray burlesqued these conflicting statements, June 25th, as *Opposition Telegraphs, or the Little Second-sighted Lawyer giving a True Specimen of Patriotic Information.* Jekyll is represented in the telegraph box on the 20th of June, he is using the *Morning Chronicle* for a telescope, and has made the discovery that the sluices, basins, and gunboats are uninjured; on the 21st he is seen working the telegraph with a totally different story, according to "Captain Popham's information," and he awakes to the conviction that their object has been fulfilled. A view of the canal shows the works all blown into the air, the gunboats sunk, and the waters flooding the country.

Jekyll, whose name frequently occurs in the anecdotes of his time, was esteemed for his witty bon mots and his agreeable society; he owed his advancement to his friend the Marquis of Lansdowne. The brilliant little lawyer was a great favourite at Carlton House, and the Prince of Wales insisted with good natured perseverance that Lord Elden should appoint him to a Master-ship in Chancery which became vacant in 1815. Elden did not consider Jekyll qualified for the office, and was reluctant to appoint him, but the Regent was inflexible. Jekyll succeeded admirably; invariably consulting the other Masters before deciding on any difficult point. Age and indisposition at last obliged him to resign. Chatty old Elden finishes the subject in his own fashion—"I met him in the street the day after his retirement, when according to his usual manner, he addressed me in a joke, 'Yesterday, Lord Chancellor, I was your Master, to-day I am my own.'"

The arrests which had spread consternation throughout the London Corresponding Society were employed as a warning to the Opposition, whose complaints against the repressive measures of the Ministers were both loud and frequent. Amongst the satires which assailed those who had discovered the despotic tendencies of the Administration, it is singular that Gillray does not give the Whigs credit for the evident check they imposed on measures which could not have accorded with his personal convictions. We find this subject pictorially treated (June 22nd), under the title of *Pigs' Meat, or the Swine Flogged out of the Farmyard*, Burke's unfortunate phrase " of the swinish multitude " having been caught and kept up long after the death of its originator. A publisher of seditious writings, Spence,

who kept a small shop in Little Turnstile, Holborn, had christened a series of cheap tracts *Pigs' Meat*, and this title suggested Gillray's parody. The foremost members of the Opposition, disguised as pigs, are being driven out of the Ministerial " stackyard " by Pitt and Dundas. A copy of verses attached to the plate recounts that—dissatisfied with their own piggish fare, these discontented grunters, acting under the advice and leadership of an overgrown boar (Fox), have torn up the palings which kept them out of the farmyard, and commenced despoiling the stacks. The whips of the Ministers play around the intruders, they are ignominiously expelled, and in a trice :—

> " Their noses ring'd and ears cut off they found ;
> Some lost their tails, and some clap'd up in pound,
> While timber neckcloths, clap'd on great and small,
> Now keep them safe and make them known to all.
> And Johnny Bull a gaping grins,
> And cries, ' Poor pigs, you suffer for your sins !'
> Waunds, how it makes a body laugh !
> To see that folks wont know when they're well off !'

In the pound are the weeping swine, in a similar fix to " the Corresponding Society." Fox, as a savage black boar, the Duke of Bedford (much overgrown), the Duke of Norfolk, Earl Derby, Tierney, Sir Francis Burdett, Nicholls, Erskine, and M. A. Taylor (as very small porker), are the prominent representatives of " the swinish multitude."

On August 1st Gillray prepared an elaborate cartoon for his friends on the " Anti-Jacobin," entitled the *New Morality, or the Promis'd Instalment of the High-priest of the Theophilanthropes, with the homage of Leviathan and his Suite*. Before a rude altar stands the high-priest of the new faith. Justice, Philanthropy, and Sensibility—after French models—are set up as objects of worship. Justice appears as a fury, belted with Equality, an assassin's dagger in either hand ; she is trampling on the emblematic sword and scales. Philanthropy is embracing the whole globe—that she may devour it, she is treading down " Amor patriæ" and " the ties of nature." Sensibility, holding Rousseau's works in one hand, is weeping over a dead bird, while her foot rests on the decapitated head of the martyred Louis. The High-priest, Stanhope, is mounted on a stool preaching from the " Religion de la Nature." Torches and newspaper trumpets are borne by—

> " Couriers and stars, sedition's evening host,
> Thou Morning Chronicle and Morning Post."

The devotees of the new creed are pouring in offerings in harmony with the doctrines of the Theophilanthropists. A huge " Cornucopia of Ignorance," supported by democratic imps, is discharging its inflammatory contents. Southey, Coleridge, Lamb, &c., transformed into asses and reptiles, are tendering odes and Republican verses. Earl Moira is offering his sword and a motion—" Relief for Irish Philanthropists." Priestley (with his sermons) and Wakefield are subscribing as representatives of the clergy. Paine, a weeping crocodile in stays ; Goodwin, Holcroft, and Williams (a serpent) are tending their influence and voices for the occasion. The principal feature is the homage of the great Leviathan—the Duke of Bedford. In his nose is the hook with which " Burke brought the monster from his depths." Thelwall, soiled from recent peltings, is declaiming his lectures from the Duke's head ; Fox is lending his voice ; Tierney is bringing addresses, and Nicholls is reciting his speeches. Whitbread, the patriotic brewer, represented as a barrel of his own " Entire," is frothing forth a perfect " yeasty main," in the suds of which swim the foremost Whigs as lesser monsters in the Leviathan's suite. Erskine is holding his " Causes of the War ;" the Duke of Norfolk is contributing " Whig Toasts and Sentiments," pledged in a foaming bumper ; Sir Francis Burdett is holding the " Glorious Acquittal of O'Connor ;" Sir John Shuckborough appears above the surface ; Earl Derby is waving his cap ; Byng is offering " Coco's Address to the Electors of Middlesex ;" and Courtney is displaying his " Stolen Jests on Religion."

In the air are various monstrous birds of prey. The Marquis of Lansdowne, Lord Lauderdale, the Duke of Grafton (with a long neck), M. A. Taylor, and Horne Tooke, may be traced among these adherents. The book of Common Prayer is tied up as waste paper ; bishops' mitres, sacramental plate,

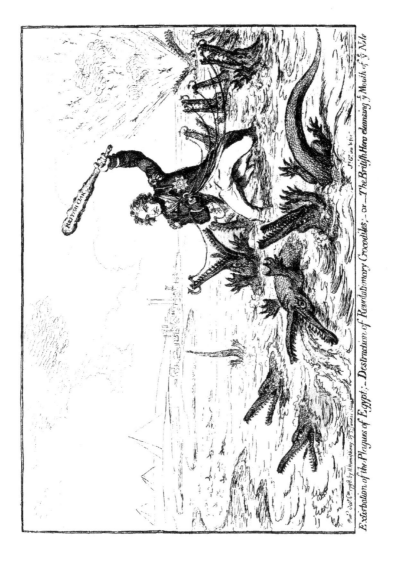

BRITISH OAK

Pub.ᵈ Oct.ʳ Cᵐ 1798. by I. Humphrey St James's. J.G. in. & fec.ᵗ

Extirpation of the Plagues of Egypt:— Destruction of Revolutionary Crocodiles;— or —The British Hero clearing y.ᵉ Mouth of y.ᵉ Nile

and ecclesiastical vessels are packed up in a sack as a "Philanthropic Requisition." A second cartoon, by the same artist, entitled: *A Peep into the Cave of Jacobinism* (September), was also distributed with the *Anti-Jacobin Review*. The motto is "Magna est Veritas et prævalebit," the goddess of Truth, pointing in triumph to the "Anti-Jacobin," is throwing the light of her torch into the cave which contains the monster, whose mask is falling, and the supplies of gall are upset; the light of truth is consuming his seditious tracts; and reptiles, meaner inmates of the den, are taking refuge in the Lethean stream from the light of truth.

In the progress of these graphic landmarks we are introduced to England's naval hero, the most formidable antagonist of Bonaparte.

During the fear of invasion the duty of *watching the French fleet at Toulon* had been confided to Horatio Nelson. The apprehensions in that direction subsided when Bonaparte and his squadron set out for Egypt. Nelson followed the French fleet, but without overtaking them; and murmurings were becoming frequent amongst the discontented at home, when unexpectedly the young Admiral surprised the Republican navy in Aboukir Bay. The story of that engagement belongs to the stirring annals of our naval triumphs. The action was terrific, and in a single day the fate of the French squadron was sealed. "Victory!" said Nelson, "is not a name strong enough for such a scene." The Admiral was severely wounded in the head from a piece of langridge shot, which cut the flesh from his temple, causing the skin to hang over one eye; and the other being sightless, he was left in total darkness, and concluded his wound was mortal.

At the beginning of October the news of the great and decisive victory of the Nile came to cheer all hearts, except those of the seditious few who had built their prospects on the assistance of French bayonets. The Tories exulted over the supposed mortification and chagrin of men who certainly did not lament their country's glory, and a print by Gillray, published on the 3rd of October (the day after the announcement of the battle in the *Gazette*), under the title of *Nelson's Victory, or Good News Operating upon Loyal Feelings*, represents the different Whig leaders who had predicted a different termination to the war, giving unequivocal evidence of their disappointment.

Sir Francis Burdett, whose long hair is combed over his eyes, is reading the "Extraordinary Gazette of Nelson's Victory." He cries, "Sure, I cannot see clear?" "I can't hear! I can't hear!" protests the Marquis of Lansdowne, who is suffering from the gout, and is closing his ears to the unwelcome tidings which little Jekyll, as a footman, is communicating in despair: "Captured nine French ships of war." The Duke of Bedford, seated on his strong box, and surrounded by money-bags, is tearing up the news of the "complete destruction of Bonaparte's fleet." He exclaims: "It's all a damn'd lie!"—"I shall faint! I—I—I—!" cries "Counsellor Ego!" meditating before "his Republican briefs," and swooning at the intelligence of "Bonaparte's captured despatches." The Duke of Norfolk, overcome beyond the restorative influence of the bottle, sighs—"What a sickening toast!"—"Ah, our hopes are all lost!" is the conclusion arrived at by Tierney, with a paper before him. "End of the French Navy! Britannia Rules the Waves." A second roll announces "End of Irish Rebellion." Sheridan, with doleful face, pondering over the long list of Republican ships taken and destroyed, resolves: "I must lock up my jaw!" while Fox cries, "And I—end with éclat!" A rope is settling his mortifications.

The assurance of safety afforded by Nelson's victory was manifested in numerous cartoons put forth on the occasion. Gillray improved the opportunity by publishing practical versions of the triumph. *Extirpation of the Plagues of Egypt;*

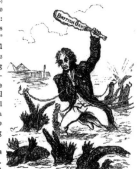

"The Hero of the Nile."

Destruction of the Revolutionary Crocodiles, or the British Hero Cleansing the Mouth of the Nile (Oct. 6)."

The valiant Admiral is dispersing the French fleet treated as crocodiles. He has destroyed numbers

with his cudgel of British oak; he is beating down others; a whole bevy, with hooks through their noses, are attached by strings to his iron hook. In the distance a crocodile is blowing up, and casting fire and ruin on all sides, in allusion to the destruction of the gigantic *Orient*, the flagship of the Republican Admiral, the heroic Brueys, who declined to quit his post when literally cut to pieces.* The victory was signal; of thirteen ships of the line nine were taken and two burnt. "The British loss in killed and wounded amounted to 895; 3105 French captives, including wounded, were sent on shore by cartel,† and 5225 perished.

A hearty appreciation of England's stability, secured by our command of the ocean, was expressed in a cartoon describing the danger from the daily intelligence of new victories at sea, to which John

John Bull taking a Luncheon.

Bull was exposed of becoming surfeited with the multitude of his captures. On the 24th of October Gillray published his caricature of *John Bull taking a Luncheon, or British Cooks cramming old Grumble-Gizzard with bonne chère.* John sitting at his well-furnished table is almost overwhelmed by the zealous attentions of his (naval) *chefs*, foremost among whom the hero of the Nile is offering him a "fricassée à la Nelson"—a large dish of battered French ships of the line. The other admirals, in their characters of cooks, are crowding round, and we distinguish among their contributions to John's table, "fricando à la Howe," "Dessert à la Warren," "Dutch cheese à la Duncan," and a variety of other dishes, "à la Vincent," "à la Bridport," "à la Gardiner," &c. John Bull is deliberately snapping up a frigate at a mouthful, and he is evidently fattening fast upon

his new diet; he exclaims, as his cooks gather round him, "What! more frigasees! Why, you rogues you, where do you think I shall find room to stow all you bring in?" Beside him stands an immense

A Good Caterer.

jug of "true British stout" to wash them down; and behind him a picture of "Bonaparte in Egypt," suspended against the wall, is concealed by Nelson's hat, which is hung over it. Through the window we see Fox and Sheridan running away in dismay at John Bull's voracity. It was now pretty generally the hope of some, and the fear of many, in France as well as in England, that Bonaparte would never be able to get back to his own country, and all eyes were fixed with anxiety upon the East. Gillray published a caricature on the 20th of November, entitled *Fighting for the Dunghill, or Jack Tar settling Bonaparte,* in which Jack is manfully disputing his enemy's right to supremacy over the world; the nose of the latter gives evident proof of "punishment." Jack Tar has his advanced foot on Malta, while Bonaparte is seated, not very firmly, on Turkey. A wound, marked "Nelson," inflicted in a vital part,

is exhausting the Corsican's system.

The patriotic were betrayed into extremes by the exultation consequent upon the French reverses Gillray displayed a premature impression of the downfall of the Republican arms under the title of the *Destruction of the French Colossus* (November 1st)—"Shall the works of a wicked nation remain? Shall the monuments of oppression not be destroyed? Shall the lightning not blast the image which the destroyers have set up against the God of Heaven and against His law?" The Colossus, whose span, resting on the pyramids of Egypt, reaches to France, where it is supported on the guillotine of "Fraternité" and the down-trodden emblems of religion and justice. Jove's lightnings, inflicted under cover of Britannia's shield, have doomed the monster to destruction; its death's head, wreathed with

* The *Orient* had 600,000*l.* sterling on board, the plunder of Malta.
† An agreement regulating the exchange of prisoners.

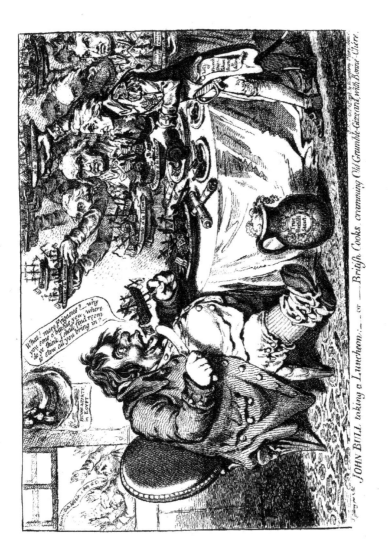

JOHN BULL taking a Luncheon:— or —British Cooks cramming Old Grumble-Gizzard, with Bonne-Chère.

vipers, is falling into the sea; its arms, hands, and wide-stretching limbs are broken and crumbling; its guiding principles, the "Religion de la Nature," injustice, oppression, murder and destruction, drop from the blood-stained hand, and the head of the murdered Louis hangs about its neck, a mark for the avengers.

The Colossus staggered before the successes of the British flag, but its course ran on in defiance of these anticipations. The victory of the Nile raised its hero to the highest popularity. Congratulations, honours, and rewards were forced upon Nelson in rapid succession. Besides presents from the Grand Seigneur, the Czar Paul, and the King of Sicily, he was created a peer by his own Sovereign, being made Baron Nelson of the Nile and of Burnham Thorpe, with an augmentation to his arms and a pension of 2000*l.* for his own life and for the lives of his two immediate successors. *

Disputed Possession.

Gillray published a carefully executed likeness of *The Hero of the Nile* (December 1st). The engraving is highly successful. Nelson's figure is full of character and his attitude is natural and dignified; his hand rests on "L'épée de l'Admiral de la Grande Nation," the cutlass which had belonged to the French Admiral; in his cocked-hat appears the famous diamond aigrette, the costly plume conferred on him by the Sultan. Below the portrait is the motto, "Palmam qui meruit ferat," granted by royal authority, with augmentations to the victor's arms and supporters, all of which are fully set forth in the design of Nelson's armorial bearings.

We thus find the British champion covered with glory and honourable distinction while hisredoubtable opponent, who from this period plays a most conspicuous part in Gillray's historical satires, was covered with obloquy.

Napoleon had already pushed his arms to Cairo when the news of the destruction of his ships reached him; the artist has conceived the scene which ensued. *Bonaparte, hearing of Nelson's Victory, swears by his Sword to Extirpate the English from off the Earth* (see Bonaparte's speech to the French army at Cairo, published by authority of the Directory in Volney's letters (December 8th). Gillray has drawn the commander in an excess of fury on hearing of "Nelson's victory over the fleet of the Republic;" his sword Egalité is drawn from its scabbard, and the great captain, with an ingenuity of calculation not unworthy of the valiant Bobadil, cries, "What! our fleet captured and destroyed by the slaves of Britain? By my sword and by holy Mahomet I swear eternal vengeance! Yes, when I have subjected Egypt, subdued the Arabs, the Druses, and the Maronites; become master of Syria, turned the great river Euphrates, and sailed upon it through the sandy deserts; compelled to my assistance the Bedouins, Turcomans, Kurds, Armenians, and Persians; formed a million of cavalry and passed them upon rafts six or seven hundred miles over the Bosphorus, I shall enter Constantinople. Now I enter the theatre of Europe. I establish the Republic of Greece; I raise Poland from its ruins; I make Prussia bend the knee to France; I chain up the Russian bear; I cut the head from the Imperial Eagle; I drive the ferocious English from the Archipelago; I hunt them from the Mediterranean and blot them out from the catalogue of nations! Then shall the conquered Earth sue for peace, and an obelisk be erected at Constantinople, inscribed, 'To Bonaparte, Conqueror of the World and Extirpator of the *English Nation*.'"

This elaborate theory was carried no farther than Acre, where the intrepidity of the amphibious Sydney Smith, with a spirit untameable as his adversary's, first checked the victorious progress of Napoleon, which had threatened to extend its advances to the shores of the Dardanelles.

* Captain Hallowell, of the *Swiftsure*, picked up the mainmast of *L'Orient* and ordered it to be fashioned into a coffin, which he presented to Nelson, in order that when he had finished his course of glory in this world he might be buried in one of his trophies.

The apprehensions of a French descent were now removed; the Republican fleet was destroyed, the plans of the French Directory had been modified. The invasion was now to be made through Ireland, and the command of the army destined for this purpose was given to the Republican General Hoche. But while Jack Tar was thus settling Bonaparte in the East, General Hoche died unexpectedly in France, from poison, it was suspected, and so entirely had the success of our fleets restored the feeling of security in England, that his disappearance from the stage would hardly have been perceived, had it not been announced by the grand print of Gillray, entitled *The Apotheosis of Hoche*, published on December 11th, 1798, representing in one vast panorama the horrors of the French Revolution crowded around its youthful hero.

December 11th, 1798. *The Apotheosis of Hoche.*—The plains of La Vendée, deluged in blood, are seen at the base of this elaborate composition. The Republican troops are driving the unhappy inhabitants into the river, the villages are in flames, and the Vendéans are shot down or beheaded by scores. The scourge of famine and war, a monster bearing a flaming sword, is exhausting the vials of wrath over the doomed cities and upon the unhappy inhabitants. Above the scene the figure of General Hoche, seated on a rainbow, is transported to a Jacobin paradise. The heavy cavalry boots and the earthy vestments are relinquished in the transformation which is converting the boldest agent of the young Republic into a heavenly saint. Two pistols are stuck in his waistband. He is chanting the anthem of " Equality " in his upward flight; the guillotine is his harp, while a hangman's noose provides the new saint with an appropriate glory. A ring of decapitated and red-bonneted cherubim are welcoming the ascension of Hoche with hymns of " Ça ira " and the " Marseillaise;" crowds of Republican seraphim are bearing offerings of " assignats " and " mandats d'arrêt," while a second and more demoniacal horde bring daggers, bayonets, scourges, and every implement of barbarous murder. Innumerable hosts of victims are pouring down to welcome the arrival of their high priest. Some of the troop bear palm-branches in one hand and caps of liberty in the other; all are headless—martyred to the guillotine. On the other side is a similar train of Revolutionary victims, sacrificed by poison, starvation, the halter, the pistol, the dagger, &c. Roland, Barbaroux, Petion, Condorcet, Marat, and others associated in this world with the great revolutionary general are trooping down in melancholy procession to congratulate him on his arrival. The altar of Equality is displayed before the faithful, while the laws of the rational religion enforce the direct violation of every command of the Decalogue; a radiating glory of dagger-points and bayonets surround the new tables, before which certain composite monsters are exhibiting their ferocity. This symbolic arrangement is surrounded by three circles of cherubim wearing the heads of monkeys, donkeys, and goats.

While the enemies of England were punished abroad, all those who were accused of sympathy with the Revolution or with a desire to see Republican institutions established in our island were severely treated by the Ministers, who in the hour of triumph displayed their despotic leanings. Gillray's graver was employed to bring the members of the unfortunate Opposition into contempt.

Their legal adviser, Erskine, was caricatured under the red bonnet, or with a roll of Republican causes, as *Counsellor Ego*—i.e., *little i, i myself, i.* It appears that Erskine was fond of giving undue prominence to the first person.

During the spring and summer of 1798 the prosecutions for political offences had increased in number, and the whole country seems to have been invaded with an army of spies and informers. Men were dragged into court on informations of the most trifling and ridiculous kind, and it was long before this country was relieved from the evils of a disgraceful system which, in the blindness of momentary enthusiasm, the Ministry of William Pitt had been allowed to establish. An amusing caricature on this subject, published on the 2nd of April and alluding apparently to some incident that had occurred at Winchester, is entitled *The Sedition Hunter Disappointed, or D—g by Winchester Measure.* An honest farmer is dragged into court by an informer, who accuses him of having uttered the *treasonable* expression, " D—n Mr. Pitt !" The sensation against the informer is unequivocally expressed; and the judge in this case comes to the sage opinion in the matter of law, " If a man is disposed to d—n, he may as well d—n Mr. Pitt as anybody else."

The Tories continued to exult over the defeat of " the party." There had taken place at the

The Apotheosis of HOCHE.

beginning of the year a sort of coalition between the Foxites and some of the more violent democrats, such as Horne Tooke and Frend, who had formerly repudiated Fox as not sufficiently democratic in his views, but who now expressed themselves satisfied at his declaration in favour of Parliamentary *Reform* and proclaimed the necessity of union. On the 30th of October, after the glorious successes which had added so much to the strength of the Ministers in power, Gillray published a caricature entitled *The Funeral of the Party*, in which the bier of party is borne along with a lugubrious procession, Fox, Sheridan, and their friends marching behind it as chief mourners. The Duke of Norfolk leads the procession, bearing the banner inscribed the "Majesty of the People," and behind him Horne Tooke reads the service from the "Rights of Man."

Fox's motives were still the subject of misrepresentation. It was argued that his retirement was due to the circumstance that he could not conceal his mortification that all his schemes were frustrated.

The satirist published a print (November 6th) *Stealing Off, or the Prudent Secession*, with the motto, "Courageous Chief the First in Flight;" indicating Fox, with guilty face and alarmed gestures, hastily escaping from a post which had become untenable and followed by two frightened dogs—the lank and ferocious greyhound, Grey, and the diminutive pug, M. A. Taylor. The panic is shared by the Opposition in the House. Pitt is electrifying them with "O'Connor's list of secret traitors" (which did not implicate a single member of the English Whigs in any treasonable design). The Premier is holding a list of successes presumed to be distasteful to "the party." "Read o'er this," he cries, "and after this; and then to breakfast with what appetite you may!" The background displays a "Democratic déjeûner — Opposition members eating their own words." Sheridan is compelled to swallow his "Loyalty to the Irish nation;" Erskine is devouring "My own loyalty;" Nicholls is digesting his "Letter to Mr. Pitt;" Tierney, Sir F. Burdett, Sir J. Shuckborough, and others, are forced to make similar meals in antagonism to their tastes.

The "study of heads," after the principles of Lavater, was highly popular at this period. The Swiss physiognomist sketched the portrait of Fox when he met the statesman at Berne in 1788. One point of the study, which is highly laudatory throughout, sets forth: "Front—Inépuisable : plus de richesses d'idées et d'images que je n'ai jamais vu peint sur aucune physiognomie au monde."

Gillray drew a cartoon illustrative of Lavater's theory, which he converted into a fresh satire against the heads of "the party" (November 1st).

Doublures of Character, or Striking Resemblances of Physiognomy. "If you would know men's hearts look in their faces."—Lavater.

Fox is described in the duplicate readings of character as, "The patron of liberty;" doublure, "The arch-fiend." Sheridan, carrying "the bag," is introduced as "A friend to his country," or "Judas selling his Master." The Duke of Norfolk is styled respectively, "Character of high birth" and "Silenus debauching." The Duke of Bedford appears as "A pillar of the State;" doublure, "A Newmarket Jockey." Earl Derby, with his large forehead and his pig-tail, is the representative of "Strong sense;" his doublure is "A baboon." Sir Francis Burdett, the man of refinement, appears as the "Arbiter elegantarium;" his doublure is "Sixteen-string Jack." Tierney, the eloquent member for Southwark, is severally indicated as "A finished patriot" and "The lowest spirit of hell."

Any attempts to oppose the Go-

Doublures of Character.—Striking Resemblances in Physiognomy.

K K 2

vernment were treated as direct expressions of French sympathy. Sir John Sinclair, the member for Caithness, urged a reduction of 10,000 seamen from a proposal brought forward by the Admiralty "to employ 120,000 men for the sea service," on the grounds that the ruined state of the French fleet and the skill and spirit displayed by our own navy rendered such increase unnecessary. He demonstrated the expediency of economy and the prudence of a gradual disbandment of our soldiers and sailors, leaving hands sufficient for the purposes of agriculture and commerce." (See Hansard, vol. xxxiii.)

Gillray published a spirited sketch of Sir John Sinclair's tall figure testing the weight of the "Union Jack" by the "democratic steelyard of Egalité" as *An Improvement in Weights and Measures, or Sir John Sinclair Discovering the Balance of the British Flag* (December 1st). The weight held out against the national standard is the red cap of liberty, while bunches of carrots and turnips and other produce indicate the "laird's" exertions in the cause of agriculture. Various papers make up the balance—such as "Advantages of cold economy," "10,000 heavy reasons for giving the enemy a fair chance of getting out of their ports;" "Navy of England—to be retained, 50,000 seamen and half-a-dozen ships of war; 500,000 sailors to be sent to plant potatoes."

The Administration, which had imposed a temporary check on the Republican arms, now presented its bill for the cost and demanded renewed supplies to carry the contest forward. The enormous expense of our naval and military armaments and the subsidies which were incessantly furnished to our allies had absorbed the greater part of the gold currency and drained the resources of the country. Taxation was already overstrained through the channels of excise and customs, land tax, and a triple assessment of the assessed taxes; but the revenue continued quite disproportioned to the expenditure, while Pitt's foreign policy demanded fresh grants. The remedy was discovered; a new tax was designed to reach every contributary—an income tax of 10 per cent. was substituted for the triple assessment. The inquisitorial nature of this exaction excited general discontent. The Opposition were highly indignant; their antipathy to this impost exceeded all their former expressions of disapproval.

Gillray exhibited at one view the individual denunciations of "the party" as *A Meeting of the Moneyed Interest; Constitutional Opposition to the 10 per cent.; i.e., John Bull's Friends Alarmed by the New Tax* (December 13th). Fox in the centre with his "Begging-box" is declaring against the objectionable placard: "Ruination; new tax; one-tenth of income and property to support the accursed war of the infamous Minister." The chief is appealing to his followers: "Gentlemen, we are all ruined! we shan't have five guineas left to make a bet with! One-tenth dead without a single throw of the dice. Why, it's worse than the French game of Requisition; for in that there would be some chance of coming in for snacks." Erskine, in professional attire, with his usual bag of "Republican causes," cries, "I wish it was to come on in the King's Bench, for I would take up a brief against him there gratis; but I don't like to say anything to him in t'other place." Erskine's voice was not often heard in the debates, his eloquence seemed to desert him in Parliament. The Duke of Bedford, in Newmarket trim, is exclaiming, "D—n their 10 per cents.! I'll warrant I'll jockey 'em as I did with the servants' tax!" alluding to the manoeuvre with his four-and-twenty footmen. The Duke of Norfolk, with a bottle of port in each pocket, declares, "Why, it will ruin us all! One whole tenth taken away from the majesty of the people! Good Heavens! I must give up my Constitutional toasts, and be contented with four bottles a day!" Earl Derby, in his hunting dress, cries, "I must sell my hounds, and hang up my hunting-cap upon my horns." Sir Francis Burdett is suggesting that "my Lady Ox—d" will have to submit to certain economies. Old Nicholls, with his one eye and his spyglass, is observing, "I see clearly he wants to keep us out of place and fill his own pocket." Earl Stanhope cries "Mum!" as if proposing to escape undetected; Sir John Shuckborough is in silent dismay. Little M. A. Taylor, standing at Fox's feet, observes, in alarm, "One-tenth! why, he takes us for boys or chicks! Zounds, what a funk I am in!" Tierney, who is already in rags, declares, "10 per cent.! Why, it will make bankrupts of all my friends in the Borough. Ah, the villanous cut-throat, he wants to bring us to St. George's Fields at last!" Horne Tooke cries, sullenly, "One-tenth! Mum! Get it out of me if you can tell me how to get blood from a post, or from one of the gibbets at Wimbledon. Why, it's a better subject to halloo about than the Brentford election!"

Sir John Sinclair, who was inconsistently deprived of his seat at the Board of Agriculture by Pitt

because he had voted from conviction against the impeachment of Warren Hastings, exclaims, "De'il tak' me, but it gees me itch all o'er to be prime minister mysel'; out o' the 10 per cent. I could mak' up for the loss o' my place at the Board." Little General Walpole is demanding, "Pistols! I say, pistols for the villain! Zounds, I wish I had my long sword here and a few Maroons, I'd teach him how to humbug us out of our property."

Earl Moira is observing, "An upright man can see things out at a distance; yes, I can plainly perceive he would cut us down one-tenth that he may be above us all." Sir W. Pulteney, one of the wealthiest men of his day, is closely examining the question through his glass: "10 per cent. Mercy upon me! Where am I to get 10 per cent.? Ay, I see I shall die a beggar at last."

An earlier writer has accompanied his comment on this print with contemporary anecdotes. When the collector of the income tax called on John Horne Tooke at his house in Richmond Buildings he refused to pay. He was summoned before the Commissioners and still refused. "How do you contrive to live and keep two houses?" inquired the Commissioners. "On my wits," replied Parson Horne. They could make nothing out of him, and his wit certainly exempted him from farther trouble about it. "Prove that I have a settled income," said he, "and I will thank you. I live on the bounty of Providence." Fox, too, bamboozled the Commissioners. "Sirs," said he, facetiously, "I have not as much land as will furnish me a grave!" Sheridan is aptly left out. "My financial reputation is a security against all annoyance," said he, and laughed heartily at the wit of Gillray in thus letting him alone.

Horne Tooke had now become one of the most prominent members of the Reform confederacy; at one period of his career, when acting (as it was said) in the pay of Government, he had published a pamphlet, under the title of "Two Pairs of Portraits," in which he contrasted, much to the advantage of the former, the two Pitts with the two Foxes. A caricature by Gillray on this subject, was published on the 1st of December, with the *Anti-Jacobin Review;* Horne Tooke is redaubing his portrait of Charles Fox, and is surrounded on every side with pictures allusive to the varying principles of his life.

Among the minor subjects for 1798 may be noticed a print of old Stockdale—the publisher of much that was objectionable to the Government and distasteful to the reigning family—brought up as "Lying Jack" to be condemned by the Bow Street justices.

In the preceding years we have traced the growing licence of the stage and the freedom with which the dancers displayed their figures. An episcopal champion now undertook to reform the ballet. On the 2nd of March, 1798, there was a debate in the House of Lords on a Divorce Bill, in the course of which the Bishop of Durham took occasion to complain of the frequency of such Bills, and laid the fault upon the French Government, who, he said, sent agents into this country on purpose to corrupt our manners. "He considered it a consequence of the gross immoralities imported of late years into this kingdom from France, the Directory of which country, finding that they were not able to subdue us by their arms, appeared as if they were determined to gain their ends by destroying our morals; they had sent over persons to this country who made the most indecent exhibitions in our theatres." He added that it was his intention to move, on some future day, that an address be presented to his Majesty beseeching him to order all such dancers out of the kingdom as people who were likely to destroy our morality and religion, and "who were very probably in the pay of France!" This appeal seems to have produced some interference of authority; for on the very next night, Saturday, the 3rd of March, the ballet of "Bacchus and Ariadne," which was to have been performed at the Opera-house, was postponed, and another substituted until other dresses could be procured. The improvement, as we learn from the newspaper reports, consisted in substituting white stockings for flesh-coloured silk, and in adding a certain quantity of drapery above and below. The change made no little noise abroad, and was the subject of abundance of ridicule; the bishops and the opera-dancers figured together in numerous caricatures.

In one by Gillray, published on the 14th of March, a group of danseuses are made to conceal a portion of their personal charms by adopting the episcopal apron; it is entitled *Operatical Reform, or la Danse à l'Evêque,* and is accompanied with the following lines:—

" 'Tis hard for such new-fangled orthodox rules,
 That our opera troop should be blamed ;
Since, like our first parents, they only (poor fools !)
 Danced naked, and were not ashamed."

The figure to the right will be recognised as that of Miss Rose. Another caricature by Gillray, published on the 19th of March, and entitled *Ecclesiastical Scrutiny, or the Durham Inquest on Duty*,

The Danse à l'Evêque.

represents the bishops attending at the dressing of the opera girls, where one is measuring the length of their skirts with a tailor's yard, another is arranging their stockings in the least graceful manner possible, a third in giving directions for the form of their stays, and rough shoes are offered for Bacchus and Ariadne.

In July appeared *More Short Petticoats, or the Highland Association under Episcopal Examination*. The Bishop of Durham is seen inspecting the skirts of three Highlander's assisted by the Lord Chamberlain (Salisbury) as stage licenser. The Scots assure the Bishop, " You'll find them exactly according to the rules of the Highland Association." " Don't tell me of rules, I say it's abominable ! It's about half a foot too short according to the opera standard. Bring the large breeches directly ; why, the 'figurantes' would be ashamed of it."

The evil was subdued, to reappear later on. In January, 1807, we find the subject revived under the title of *Durham Mustard too powerful for Italian Capers, or the Opera in an Uproar*. The Bishop, in full canonicals armed with his pastoral staff, is gallantly leaping on to the stage, sternly disregarding the fascinations of the coryphées, to encounter personally the spirit of the Evil One embodied in bare legs and open bosoms. He cries, " Avaunt thee, Satan, I fear thee not ! Assume whatever shape or form thou wilt, I am determined to lay thee, thou black fiend."

How long the episcopal censure kept the opera in order we are not told, but the rage for stage dancing increased under the influence of Vestris.

A Country Concert, or an Evening's Entertainment in Sussex (September 1st, 1798.) This print has been attributed to a scandal concerning Mrs. Billington, the *prima donna* of her day, and the Duke of Sussex. In the engraving the two principal figures are seated with their backs to the spectator ; the lady is playing, and the noble amateur is accompanying her on the violoncello. Mrs. Billington spent the year 1798 in Italy, where she had married her second husband, M. Felissent.

Gillray also published a portrait of General Manners, with the quotation—

" Gentle Manners, with affections mild,
 In wit a man, simplicity a child !"

1799.

The French expedition to Egypt occupied a considerable share of attention this year. The Republican campaign, in spite of easy victories, was not considered satisfactory, and the siege of Acre was followed by repeated disasters. Reverses also attended the armies of the Directory in Europe. The close of 1799, however, witnessed the return of Bonaparte and the inauguration of a new order of things.

The Parliamentary session of 1799 opened at the end of November, 1798, when Fox kept his word of absenting himself from the debates ; yet in the caricatures he was always placed foremost in the Opposition. It was in this year that the outcry against sedition was greater than at any previous period, and extraordinary measures were taken to restrain the liberty or licence of the press. In July the Ministry put in effect the extreme measure of subjecting printing-presses to a licence. The Tory

caricatures still boasted of the absolute defeat of Opposition, and they imagined that in its despair it was laying secret trains for the destruction of the Constitution, and were continually calling for severer political persecutions. The King's Bench and Newgate and Coldbath Fields began to be filled with political offenders; the last had received the popular epithet of the "Bastile." A caricature published with the *Anti-Jacobin Review*, and entitled *A Charm for Democracy Reviewed, Analyzed, and Destroyed, January 1st, 1799, to the Confusion of its Affiliated Friends*, represents the members of the Opposition assembled in the Cave of Despair, where Tooke and two of his violent colleagues as witches are mixing up the caldron of sedition, under the immediate presidency of the Evil One. The incantation is—

> " Eye of Straw, and toe of Cade,
> Tyler's brow, Kosciusko's blade,
> Russell's liver, tongue of cur,
> Norfolk's boldness, Fox's fur;
> Add thereto a tiger's chaldron,
> For the ingredients of our caldron."

Above, in the sky, appears the King on his throne, backed by his Ministers, throwing a glare of light on the machinations of the disaffected patriots. The King says: " Our enemies are confounded!" Pitt urges: " Suspend their bodies!" But the Chancellor, more careful of the forms of law, says, " Take them to the King's Bench and Coldbath Fields."

Sir Francis Burdett had been informed that various abuses were practised on the unfortunates confined in the new State prison in Coldbath Fields. He visited the building, and having ascertained the facts he brought the subject before the House. Great indignation was expressed. Airis, the governor, received orders not to admit the baronet again; but a subsequent investigation proved these charges well founded.

Gillray issued a plate on the subject under the title of *Citizens Visiting the Bastile* (vide Democratic Charities), January 16th. The baronet has been driven to " Coldbath College"—the stone front of which is marked " House of Correction for the County of Middlesex." Sir Francis is represented knocking at the iron-bound gate : " Hush !" he cries to the gaoler. " Harkee, open the door. I want only to see if my brother citizens have candles and fires and good beds, &c., for their accommodation ; that's all. Hush ! open the door ; quick !" The turnkey is answering : " Hay, what ! let you in, hay ? No, no ! We're bad enough here already. Let you in ? No, no ; that would be too bad. You're enough to corrupt the whole college !"

On the 22nd of January the proposition for a union with Ireland was laid before Parliament in a message from the Crown. This subject, with the Rebellion of the preceding year, caused the affairs of the sister island for some time to occupy a considerable share of public attention in this country. Comments on the subject were very numerous, as well as prints exhibiting respectively the violence and cruelty of the rebels and the consequence of French influence.

The property and income tax was a fruitful source of popular complaint. Gillray published on the 13th of March a caricature entitled *John Bull at his Studies, Attended by his Guardian Angel;* in which John Bull is seen puzzling himself over an immense mass of paper, rather ironically entitled " A plain, short, and easy description of the different clauses in the income tax, so as to render it familiar to the meanest capacity." He remarks, very gravely : "I have read many crabbed things in the course of my time, but this for an easy piece of business is the toughest to understand I ever met with." Above, Pitt appears as John's guardian angel, playing to him upon the Irish harp—

> " Cease, rude Boreas, blust'ring railer,
> Trust your fortune's care to me."

A Guardian Angel.

A paper on the table bears the descriptive lines—

> " The sweet little cherub that sits up aloft,
> To keep watch for the purse of poor Jack."

The French expedition to Egypt was frequently satirized at home, although the consequences of Bonaparte's schemes were fairly recognised; the armaments sent out under Sir Ralph Abercrombie and Sir Sydney Smith prove the conviction that no sacrifice should be spared to oppose him.

Siège de la Colonne de Pompée (March 6th, 1799).—A party of Bedouin Arabs and natives have surrounded Pompey's famous Pillar and surprised the French savans mounted on the top. There is no chance of escape. The artist has introduced some ingenious contrasts. The inventor of a project for rendering men immortal is suspended in danger of instant death; various discoveries and fantastic inventions appear in the hands of the doomed philosophers; the stout projector of wings which will enable human beings to fly has an excellent opportunity to test his apparatus. A balloon—" La Diligence d'Abisynié"—has exploded ; two aeronauts are falling upon the spears of the Arabs, followed by their treatises on " The Velocity of Descending Bodies" and " A Theory of Aerostation." The scientific instruments have already come to grief. A native seer is looking through the wrong end of a "leveller;" a dark chieftain is placed *hors de combat* by the descent of a " Projet de Fraternisation avec les Bedouins." Turks, Egyptians, and representatives of the wild tribes are united for vengeance on the intruders.

It has been suggested that the men of science deserved more respectful consideration. " The magnificent work which Denon and his enlightened colleagues have given to the world upon this ancient and most interesting region will be considered by posterity as a noble monument of fame to the scientific corps who are thus ludicrously exalted by the satirist."

The Institute founded by Napoleon at Cairo and the proceedings of the French savans, whose instruments added considerably to the train of the invading army, were turned into the broadest ridicule. Gillray designed a series of *Egyptian Sketches*, published March 12th, said to be extracted from the portfolio of an ingenious young artist attached to the National Institute at Cairo, found on board a "small vessel intercepted on its voyage to Marseilles." The introduction sets forth : " The situations in which the artist occasionally represents his countrymen are a sufficient proof of an impartiality and fidelity which cannot be too highly commended; indeed, we must suspect that his view of the flagitious absurdities of his countrymen in Egypt is nearly similar to ours, and that he took this method of portraying them, under the seal of confidence, to his correspondent in Paris."

The title page represents the Sphynxes wearing cocked-hats with Republican cockades. A monkey dressed as the Republican commander is scrambling up the Pyramids to cap the labours of antiquity with the bonnet-rouge ; a naked philosopher, as Folly, is arresting his ambitious leader by the coat-tail.

The first subject, *L'Insurrection de l'Institut Amphibie—the Pursuit of Knowledge*, introduces a theory " Sur l'éducation du crocodile," proposing to employ their amphibious qualities to tow boats, draw curricles, and serve as cavalry chargers. A naturalist has gone down to the Nile ready booted and spurred, with a huge whip, saddle, stirrups, and bridle especially adapted for the exploit ; the tables are turned—a huge crocodile has caught the would-be rider, and is snapping him in half. A theorist, who has been endeavouring to enlighten the monster of the Nile on " The Rights of Crocodiles," is devoured by his disciples.

The second plate is *L'Infanterie Française en Egypte—Le Général l'Asne converted to I-bra-him Bey*. It was found necessary to mount the troops upon asses. The ragged legions are accordingly mounted on rows of donkeys. The general in command is shouting his orders, but the braying of his ass renders him inaudible.

Plate the third, *Prætor-Urbanus—Inauguration of the Coptic Mayor of Cairo, preceded by the Procureur de la Commune*, refers to the French project of reorganizing the political and municipal condition of Cairo after the Republican model. The Attorney-General of the new Government appears in native nakedness, set off by a cocked-hat, and with a large quill pen stuck behind his ear. This high functionary is leading an ass which bears the worshipful Mayor, a monstrous Egyptian, dressed in full

SIEGE DE LA COLONNE DE POMPÉE. Etched by J.Gillray from the Original Intercepted Drawing. SCIENCE IN THE PILLORY.

official embellishments, without shirt, waistcoat, shoes, or stockings; his solemn progress is accelerated by a thrust from a bayonet's point slily administered by a soldier of the Republic.

Théologie à la Turque, the Pale of the Church of Mahomet, represents French theologians arguing at a disadvantage. A body of Mahometans have captured a brace of philosophers; one carries a heavy work demonstrating the impositions of Mahomet, and a tract on "The Prophet Unmasked." His conversion is proceeding, the Alkoran is offered, and the pale of the church is represented by an iron stake for the impalement of unbelievers. Another philosopher is sheltering himself under the Mahometan turban relinquishing his spiritual convictions for the protection of his body.

Mamalouk et Hussard Républicain, General Result of Bonaparte's Attack upon Ibraham Bey's Rearguard. The Mamelukes proved formidable antagonists. Gillray has burlesqued the Republican cavalry; the attack is in reality a flight. The Mameluke is mounted on his swift Arab, the reins between his teeth, a scimitar in either hand, two pistols slung over his shoulders, and a spike-headed club "in rest." The hussar's horse is in a wretched condition, and his rider iss surrendering his sabre, stamped with the words "Vaincre ou Courir"—"Victory or flight."

The last picture represents a *Tirailleur Français et Cheval Léger de l'Armée du Pacha de Rhodes; Evolutions of French Mounted Riflemen.* A rifleman mounted on an ass is disturbed by the animal's kicking. The rider is disabled by the catastrophe, his piece is discharged in the air, and a ferocious Oriental, mounted on an Arab horse, is preparing to transfix the unfortunate invader with his lance.

Various seizures were made at home about this time of the persons and papers of some of the active

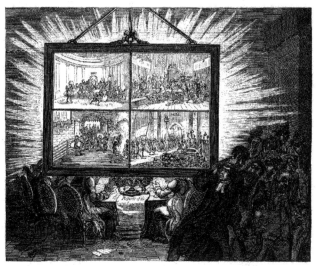

Exhibition of a Democratic Transparency. The Secret Committee examining Evidence.

members of the political societies, and the latter were laid before a secret committee of the House of Commons—appointed to inquire into the proceedings and designs of these bodies; but although much

noise was made on the subject, very little of importance was found among them. The populace, how-ever, was made to believe the contrary; and the report of the Commission pointed to treasonable corr-spondence, alleged to have been kept up with the French Republicans. In Ireland this evidence was used as the grounds for severe prosecutions. The dismay, it is pretended, extended to the Whigs.

Gillray treated this impression in an elaborate cartoon: *The Exhibition of a Democratic Trans-parency*, with its effect upon patriotic feelings; representing the Secret Committee throwing a light upon the dark sketches of a Revolution, found among the papers of the Jacobin societies lately apprehended. "N.B.—The truth of the picture is referred to the consciences of the swearers to the innocence of O'Connor; and is dedicated to the bosom friends of Fitzgerald—Lingley, Shears, Tone, Holt, and all other well-wishers to their country." The members of the Parliamentary commission are examining the evidence; their attitudes express amazement at the documents before them; they are preparing "Reports of the Secret Committee of the House of Commons." Among other treasonable evidence is an "Invitation to the French Republic," a "Scheme to overthrow the British Constitution, and to seize on all Public Property;" "Account of the Lodges of United Englishmen, and of the Monks of St. Anne's Shrine;" "Proceedings of the London Corresponding Society, with a List of all its Members;" "Oaths of the Members of the Society of United Irishmen in London;" "Names of Traitors now suffered to remain at Large." The foremost Whigs, who have stolen into the chamber, are making their escape dismayed by the startling transparency which exhibits their designs in the strongest light. Erskine, M. A. Taylor, the Duke of Norfolk, Fox, Tierney, Sheridan, Nicholls, Sir Francis Burdett, Sir John Sinclair (in a Scotch bonnet), Lord Moira, Lord Derby, and the Duke of Bedford (in a jockey-cap), are all confounded at their own misdeeds. One compartment of the *Democratic Transparency* displays "Plundering the Bank." The patriots have secured the national wealth; Tierney is bearing off one sack of specie, and Pulteney is carrying two. Walpole has more than he can carry; Sheridan is heavily loaded; and Lord Moira has filled his cocked-hat with sovereigns. The second tableau is "Assassinat-ing the Parliament." Walpole has pulled down the Speaker, while Burdett is beating him with the mace; a general slaughter ensues. Jacobin daggers are uplifted on every side: each member of the Opposition is despatching his rival. Nicholls is stabbing Windham; Sinclair and Taylor are immolating Grenville; Fox, Sheridan, and Tierney are disposing of Pitt; Erskine is making short work of Dundas, while others are similarly engaged.

"Seizing the Crown; Scene the Tower," pictures the building on fire; the Records and Charters are thrown into the flames; the Duke of Bedford is carrying off two sacks of new guineas; Lans-downe has the Crown under his arm; Stanhope is making off with the Regalia in a sack; and other patriots follow with their plunder.

"Establishing the French Government; Scene, St. James's Palace," is the closing subject. The French legions, with their banners flying, are marching into the old Palace: a cap of Liberty mounted on a pike is planted in the centre of a heap of heads—of royalty, nobles, and clergy. Stanhope, Norfolk, Derby, Moira, and other prominent Whigs are welcoming the invaders.

There must have been few persons left who would pay much attention to such exaggerated improbabilities as these. Yet the Tories persisted in their tactics of identifying English Whigs with French Republicans; and Gillray, whether in jest or earnest, merely illustrated the expected proceed-ings of the Democrats in power, as they had been described over and over again in the Ministerial organs during the few preceding years.

In another caricature by Gillray, published on the 1st of May, Fox is represented in bed, ridden over by the Hiberno-Gallic Republican nightmare; a parody on the well-known picture by Fuseli. On the 7th of May he published a fresh series of studies, still ridiculing Pitt's opponents. *The New Pantheon of Democratic Mythology* represents the Whigs under the disguise of Pagan divinities. In the first plate a cornucopia, formed of a reversed cap of Liberty, is discharging its contents before the Democratic altar; it displays the emblems attributed to the various mythological personages; the thunderbolts of Jupiter, Minerva's owl, the caduceus of Mercury, the love-birds of Venus, Cupid's bow and arrow, Neptune's trident, Vulcan's hammer and pincers, the spear of Mars, Apollo's lyre, the club of Hercules, and a shield bearing Medusa's head.

In " Hercules Reposing," the massive figure of Fox appears perfectly in character ; the hero is tranquilly resting amidst the shades of St. Anne's Hill, and his head is reclining on a work suggestive of the occupations of his retirement ; he is wrapped in a donkey's hide, in place of a lion's skin ; his harp is suspended on a drooping willow ; and the apples of discord are rotting at his feet ; his bow is unstrung, the point of his barb is turned, and the mighty Whig Club is cast aside.

The second figure represents Mars. General Walpole, the fierce advocate of Liberal principles, exhibits his small person as the God of War. His shield is as large as himself, his spear is thrice as tall, his height is assisted by the addition of an elaborate helmet, a cocked-hat surmounted by a huge flaming dragon of the sansculotte order breathing flames. His sword, armour, and buskins are colossal, A turkey-cock nearly as big as the General is imitating his attitude.

In plate three, " Harpies Defiling the Feast," Sir John Shuckborough, Jekyll, and a third figure are drawn as polluting " John Bull's comfort " of roast beef, plum-pudding, and porter.

Plate four, Cupid, is personified by the ill-favoured and deformed figure of Nicholls, whose features were irregular and repellent. He was also blind of one eye ; his expression is most spiteful, and he is preparing a deadly shaft with no tender aim. This burlesque is most cutting. Nicholls was ungracious in speech and violent in action ; he was said to exhibit the contortions of the Sibyl without her inspiration.

The Anti-Jacobin hits off his graces in a duet between Fox and Horne Tooke :—

> "*Fox.*—Well, now, I own my favourite preacher's NICKLE,
> He keeps for Pitt a rod in pickle ;
> His *gestures* fright th' astonish'd gazers,
> His sarcasms cut like *Packwood's razors !*"

Berkeley and Sturt, brewers and Whig politicians, who shared a reputation for hostility to the Ministers, are presented with their stout persons floating in mid-air, lovingly entwined as the Twin Stars of Castor and Pollux. The froth of their ale supplies a nimbus.

The last parody displayed in the *New Democratic Pantheon* pictures " The Affrighted Centaur and the British Lion." An excellent portrait of the Duke of Bedford, renowned for sporting tastes, appears as the Centaur. He is dressed in jockey cap and striped jacket, and is exhibiting the greatest consternation at the advance of the infuriated British Lion.

The French arms in Italy were repulsed and driven back during Napoleon's absence in Egypt by the Austro-Russian forces under the command of Suwaroff, who obtained successive victories, until Massena successfully opposed him in Switzerland, and put a period to the progress of the northern arms.

Gillray published the portrait of *Field-Marshal Count Suwarrow Romniskoy* (May 23rd), from a drawing taken from life by an Austrian officer, at the time his successes made this Russian commander popular in England. It represents a tall slight figure. The expression of the face is ferocious, his bald head displays a terrible scar, and his huge sabre is dripping with blood ; a burning village forms an appropriate background. The plate is accompanied by an extract from the *Vienna Gazette :* " This extraordinary man is now in the prime of life, six feet ten inches in height, never tastes either wine or spirits, takes but one meal a day, and every morning plunges into an ice-bath ; his wardrobe consists of a plain shirt, a white waistcoat and breeches, short boots, and a Russian cloak ; he wears no covering on his head either by day or night ; when tired he wraps himself up in a blanket, and sleeps in the open air ; he has fought twenty-nine pitched battles, and been in seventy-five engagements."

We may add that Suwaroff was remarkable for ferocious courage and for his cruelty to the conquered. He served with distinction in the Seven Years' War and in the Polish campaign. He stood high in the esteem of Catherine, who made him head of her forces. The storming of Ismailoff (1790) was one of the greatest stains in the life of this able commander. Forty thousand inhabitants were put to death with every accompaniment of horror. The Field-Marshal was sixty-nine years of age at the date of Gillray's portrait. His death occurred in the year following (1800).

The State of the War, or the Monkey-race in Danger (May 20th), exhibits the hopes entertained of the French prospects, then suffering a succession of reverses. The swarming legions of France, represented as monkeys, are being decimated by the efforts of Turkey, Russia, Austria, and England.

The Crescent is holding Bonaparte captive, and the British Lion is making fearful havoc with his teeth and claws, in allusion to the siege of Acre. The Russian Bear, hugging the monkeys to death by armfuls, symbolizes the defeats in Italy, while the Imperial double-headed eagle of Austria, rending the cap of Liberty, is dealing destruction on all sides. Napoleon's energy dissipated these prospects in a few months.

A similarly ungenerous spirit marked the plate of *The High German Method of Destroying Vermin at Rat-stadt.* "Now you shall see how the cruel Austrians turned the heads of two French gentlemen whose brains were deranged." The French plenipotentiaries at Rutstadt were waylaid and assassinated, 28th April, 1799, by a party of Austrians wearing the uniform of Szeckler's hussars. This disgraceful breach of the laws of nations naturally excited the greatest indignation in France.

In the engraving the travelling carriage of the plenipotentiaries is stopped; the travelling trunks marked Roberjot, Bonnier, and Debry enlighten us as to their names. The despatch-boxes are broken open, and the bodies of two Frenchmen are treated with indignity by the troopers who have cut off their heads. A third figure, Jean Debry, fearfully hacked, is running away from the soldiers; this gentle-man, who was left on the field for dead, afterwards recovered to tell the story of the outrage.

French Generals Retiring on Account of their Health, with Lepaux Presiding in the Directorial Dispensary (June 20th). Lepaux, surrounded with astrological instruments, is prescribing for the French generals; the medicines lying before the physician are "preparation of lead," "Archduke boluses," and "Russian regimen." Suggestive curiosities are exposed round the apartment: a huge stuffed crocodile; a terrestrial globe suspended topsy-turvy; mummies of Bonaparte and Kleber; the spirit of Robespierre, resembling the guillotine, preserved in a jar. On the shelves are various preparations of "Projets Avortés" labelled as "Ireland," "Commune de Pékin," "Département de Mont Caucasus," "Directoire d'Abissinia," "Armée du Ganges," &c.

The climate and the diseases produced by it were the most destructive foes which Napoleon's army encountered; the troops suffered terribly. At the date of this caricature several of the generals decided to abandon the country, and under the excuse of recruiting their health were permitted by the Directory to return to France.

Allied Powers, unbooting Egalité (September 1st). The French reverses lessened the terrors inspired by the Republic, her conquests appeared in danger, and she seemed in a fair way of succumbing to the miseries she had created on all sides. Egalité, hung round with weapons, and holding an assassin's dagger in either hand, is pinioned by a jolly British tar, whose hat displays the names of Nelson, Duncan, and Bridport. A Turk is threatening to add Egalité's nose to the string of trophies with his scimitar "St. Jean d'Acre." The unbooting is accomplished by a fierce Austrian hussar, whose exertions are seconded by a sturdy Russian bear. The Gaul's leg has been thrust into the boot of Italy, stuffed with golden spoils, which are emptied out by his antagonists. The English tar and the French-man have severally planted a foot on a Dutch cheese, in allusion to the State of Holland, while the ex-Stadtholder, kneeling on a secret treaty, is slyly endeavouring to rescue his native produce from bondage.

The position of William of Orange is more clearly set forth in a cartoon published (September 8th), under the title of *The Reception in Holland.* The Stadtholder, in his usual somnolent condition, has returned to his native kingdom; he is enjoying an overwhelming reception from all branches of the community; the florid fair are throwing their fat arms round his neck, kisses are showered on all sides, his countrymen embrace his legs, and kneeling, pipe in mouth, express their transports on his return— even his amphibious subjects the frogs are welcoming their liege, and the Dutch army with broad grins of satisfaction are tramping down to complete the joyful manifestation. The sea is filled with ships loaded with British soldiers, who have come over to support the Stadtholder. It is to be regretted that these anticipations were premature: in a few months the armies of France, re-organized by the mighty Bonaparte, reversed the hopes of tranquillity which were indulged in 1799.

An expedition undertaken in the August of this year to restore the Prince of Orange proved a failure; the Dutch offered no support to the English troops, and the campaign ended in a precipitate retreat.

Anecdotes of the Stadtholder, who was welcomed in England as a good-natured guest, were popular in his day; an earlier writer, commenting on the drollery of the "Reception," recounts:—" This pleasing

fiction of the arrival in Holland of the royal exile quite tickled the fancy of the late Stadtholder, who felt, and perfectly understood, the humour of the English caricaturist. His Royal Highness took pleasure in an occasional visit to Billingsgate to look at the *fishwives*, with whom he would condescend to 'crack a joke.' 'It podes me in mindt of mine good beoples of Amsterdam,' would the somnolent Prince say to his companion, as he perambulated the fish-market, apparently quite at home, and evidently enjoying the scene."

The attention of England, and of all Europe, was anxiously fixed on Egypt. Napoleon had gained the brilliant victory of Aboukir, but in the hour of success his penetration discovered that the expedition was, in sober fact, a failure. His army decreased daily, from the combined influence of the climate and the sword. The destruction of their fleet exposed the troops to constant harass. Their very triumphs insured their final destruction, for no reinforcements could be expected from France, nor could any recruits be raised in the country on whom it was possible to depend. Acting on this knowledge, and determined by the intelligence he received of the reverses which the Republican armies had sustained in Europe, Bonaparte resolved on his own return to France.

Having directed two frigates to be secretly prepared in the roads of Alexandria, the General embarked with Berthier, Marmont, Murat, and other generals, on the 23rd of August, 1799. The command of his army had been previously consigned to Kleber. Bonaparte's usual good fortune attended him during the voyage; he escaped from an English squadron of seven ships; and on the 16th of October he landed safely at Fréjus, in Provence, and proceeded to Paris.

Gillray commemorated his departure from the East in a clever and far-seeing cartoon, which appeared some few months later.

Bonaparte Leaving Egypt (March, 1800). The vessels are prepared for the departure of the leader; a boat is waiting to receive the deserters. Two generals on board are hugging their plunder; Bonaparte, with a traitorous expression on his countenance, is about to abandon his followers, his right hand points to a vision in the clouds of the Imperial crown, sceptre, and fasces; Fame is taking her flight, her trumpet is removed to make way for a contemptuous smile. In the distance is the sleeping camp; the troops, reduced to mere skeletons, are rendered furious by this desertion.

This plate has been highly commended. "For an illustration of the above, see the intercepted letters from the Republican General Kleber to the French Directory, respecting the courage, honour, and patriotic views of 'The Deserter of the Army of Egypt.'" Gillray's opinion of Bonaparte's conduct at this juncture was shared by many of his compatriots. The return of Napoleon entirely changed the aspect of affairs; he arrived in Paris at a critical moment. The dissolution of the Directory had long been planned; and the execution of the scheme, with the rank of first magistrate of the Republic, had been successively offered to Generals Moreau and Joubert, both of whom declined to betray the Government. Bonaparte was, however, less scrupulous, and he warmly entered into the conspiracy.

The first measure adopted was to appoint a private meeting of certain members of the Council of Ancients, to whom an outline of the intended revolution had already been communicated. November 9th, 1799, they nominated Bonaparte commandant of the armed force of Paris, and adjourned to St. Cloud, confiding the execution of their mandate to his discretion. The first use he made of his new appointment was to invest the garden of the Tuileries with a strong body of troops; and he next compelled the resignation of those of the Directory who would not co-operate with him. The Council of Five Hundred held a stormy discussion under the presidency of Lucien Bonaparte, who took advantage of the tumult to adjourn the Assembly. At night strong patrols of troops paraded the squares and streets of Paris. At length, on the memorable 10th of November, the troops took possession, at a very early hour, of all the avenues leading to St. Cloud. Later on the Council of the Five Hundred, in which were many Jacobins, commenced their deliberations. The influence of the conspirators over the Assembly was inconsiderable; but few of the members were acquainted with the real motives of this extraordinary session. Accordingly, many propositions were made and carried directly adverse to their designs; among others, an oath of fidelity to the constitution was tendered to each member. Alarmed and irritated, Bonaparte repaired to the Council of Ancients, and addressed them with considerable vehemence. He subsequently entered the council-room of the Assembly, accompanied by a few grena-

diers, all unarmed. His presence increased the tumult to frenzy. In vain did Lucien attempt to exercise his authority as President. The danger of his brother's position increased momentarily, and he was only rescued from immediate death by the grenadiers, who finally carried him out of the saloon in their arms. When he had withdrawn, several members proposed to outlaw both him and Lucien, and the situation of the latter became so perilous that Bonaparte, after addressing the soldiers, and receiving assurances of their fidelity and attachment, caused the door of the saloon to be opened, and rescued his brother, who immediately repaired to the Council of Ancients.

"The last scene of this singular drama was approaching. Napoleon, availing himself of the outrage offered to his own person, gave the division a command to clear the council-room, which was accordingly occupied in a moment by soldiers with fixed bayonets. The *pas de charge* was beaten; after some vain efforts on the part of certain members to convert the troops the senators precipitated themselves out of the windows." The Council of Ancients appointed a commission of three members, who were to replace the Directory; a decree was next passed in the Council of the Five Hundred, designating the names of the new Consular Committee, they were Bonaparte, Sieyes, and Roger Ducas. The administration now became essentially military, and therefore despotic in its system of action; but the best part of the liberties of the French nation—security for persons and property—now appeared more assured, and the new *régime* of Consular government was commenced under auspices which were slightly Utopian in their promises.

Gillray's cartoons trace the career of Bonaparte with the familiarity of a contemporary. On the 21st of November the artist published a graphic version of the momentous scene lately enacted in France, *Exit Liberté à la Française, or Bonaparte closing the Farce of Egalité at St. Cloud, near Paris,* November 10th, 1799, showing the dissolution of the hostile Directory by Napoleon's soldiers, historically known as the Revolution of the 18th Brumaire. Gillray recognised a certain dignity in the young leader, and the figure of Bonaparte is imposing and well drawn. The wild legions of the late Republic are pouring into the chamber, the charge is beaten on a drum marked "Vive la Liberté," and a banner with the inscription "Vive le Triumvirate—Bonaparte, Sieyes, Ducas," is unfurled in the Council of the Five Hundred, while the general's foot is trampling upon a list of the members. The representatives exhibit the most ludicrous terror; daggers which had threatened the life of Napoleon are thrown away; benches are upset. A few indignant figures are vociferating against this treatment, but bayonet points are unanswerable arguments, and the terrified legislators scramble to the windows in undignified confusion.

During the summer of 1799 domestic agitation seems to have experienced a calm, but when the Parliament opened at the end of September, the necessity of levying new taxes soon stirred up fresh subjects of discontent. Among the taxes now announced was one upon beer, which would have the effect

Death in the Pot.

of raising the price of porter to fourpence the pot, and which would weigh especially heavy upon the labouring classes. The satirists on the Tory side pretended to sympathize most with the stanch old Whig Dr. Parr, who was a great porter drinker and smoker, and no less an opponent of the Government of William Pitt; and on the 29th of November Gillray published a spirited sketch of the supposed *Effusions of a Pot of Porter, or Ministerial Conjurations for supporting the War, as lately discovered by Dr. P—r, in the Froth and Fumes of his Favourite Beverage.* A pot of fourpenny is placed on a stool, with the doctor's pipe and tobacco beside it; from the froth of the porter arises Pitt, mounted on the white horse, brandishing a flaming sword, and breathing forth war and destruction on everything around. The doctor's "reverie" is a satire on the innumerable mischiefs which popular clamour laid to the charge of the Minister:—"Fourpence a pot for porter!—mercy upon us! Ah! it's all owing to the war and the cursed Ministry! Have not they ruined the harvest?—have not they blighted all the hops?—have not they brought on the destructive rains, that we might be ruined in order to support the war? and bribed the sun not to shine, that they may plunder us in the dark?

(*Vide the Doctor's reveries, every day after dinner*)."

A note has been preserved, illustrative of those straightforward times.

Soon after the rise in the cost of John Bull's favourite beverage—the stamina of the industrious and the strong—the King and Queen went to the theatre. As usual they were received with the National Anthem, and the joyous looks of the splendid audience, in boxes and in pit ; but the honest worthies in the galleries—who always speak out—during the cessations between the acts kept up many a loud and facetious dialogue upon the subject of this grievance. One bawled to another, "What sayst thou to a pot of porter, friend Jack ? " " With all my heart, Tom," replied Jack ; " but, harkee, fetch it from the Old King's Head, for there thee'll get it for threepence the pot." The King heard this bold address, and, it is said, expressed a wish that his honest subjects could continue to enjoy their beer at the old price.

As we have traced, the rebellion was suppressed at the close of this session, but it took nearly two years to complete the union with Ireland ; difficulties of various kinds arose, and had to be overcome ; and some of these led eventually to the resignation of the Minister. It was not till the first day of the new century that the two sisters were allowed at last to join in that kindly " buss" which a former caricature insinuated it was the aim of the Whigs to hinder.

Among the minor plates which appeared in 1799 may be noticed a subject bearing on the infirmities of the Prince of Wales, who had comparatively dropped out of the satirist's field. On the 7th of May Gillray issued an engraving of *Duke William's Ghost.* The figure of the Heir Apparent, insensible and half-undressed, is thrown across his bed—it is evidently the conclusion of a late debauch ; decanters, bottles of spirits, and broken glass are lying about ; a bottle of brandy appears to have escaped from the hand of the drunken sleeper. The curtains are uplifted by the substantial ghost of Duke William, girt with his great sword—the stout Cumberland, who had early indoctrinated the Prince into every froward indulgence. It would seem this burly phantom has arrived from the realm of spirits to warn the sleeper of his prospect of soon joining his preceptor in the other world. The shadow warningly raises his hourglass, from which the sand has nearly run, conveying the apprehension that the slumberer's excesses would terminate fatally.

On the 10th of May Gillray produced a full-length portrait of the Earl of Moira, as *A Man of Importance.* The gallant nobleman wears his military hat jauntily " cocked," a high stock, buttoned-up coat, leather breeches, and stout cavalry boots. His whiskers, then a novelty, are worn in the Peninsular fashion. A few lines from the " Anti-Jacobin" accompany the print.

> " Ne'er may his whiskers lose their hue,
> Changed (like Moll Coggin's[*] tail) to blue !
> But still *new grace adorn his figure ;*
> More stiff his boots, more black his stock,
> His hat assume a prouder cock,
> Like Pistol's (would 'twere bigger !)"

The bacchanalian Sheridan was constantly introduced intriguing for the sweets of office. He appeared at this date as Pizarro soliloquizing over his newly acquired riches. Drury Lane flourished under his proprietorship, and with the dramas which have given celebrity to his name, while it enabled him in more ways than one to support his position as a statesman, although his thoughtless extravagance often drained its resources, and sometimes clogged the regular movements of the company. In the September of 1788 John Kemble became the stage-manager, and gave strength to the company. On the 24th May Sheridan's tragedy of "Pizarro" was produced, and at once achieved a remarkable success. King George, whose patronage was not extended to Sheridan's house, attended a representation, and expressed his gracious appreciation. The popularity of this play was so great, that it produced a number of pamphlets relating to its hero, and made multitudes read the history of Peru who had never thought of it before. Twenty-nine editions of the tragedy were called for in a very short time, and their sale of course increased the author's gains. One of the most flattering eulogies on this extraordinary man was pronounced by a critic who claimed the reputation of being one of the most refined

* Moll Coggin was an alleged witch, supposed to be visible to his lordship's family. She was reported to have been seen by the Earl riding through the air on a black ram with a blue tail. (*Vide* Major Longbow.)

judges of his day. "Whatever Sheridan has done," said Lord Byron, "has been *par excellence,* always the best of its kind. He has written the best comedy, the best opera, the best farce, the best address (the monody on Garrick), and, to crown all, delivered the very best oration ever conceived in this country."

Sheridan's successes as manager and playwright provoked fresh satires on his character as a patriotic statesman. A few days after the production of the tragedy appeared Gillray's caricature of Sheridan in the character of *Pizarro, the Spanish Adventurer,* "*contemplating the product of his new Peruvian Mine*" (June 4th). The tinselled hero is handling the gold pieces, which fill his helmet, and gloating over the unaccustomed ready money, he cries, "Honour? Reputation?—a mere bubble! Will the praises of posterity charm my bones in the grave—psha! my present purpose is all! O, gold, gold, for thee I would sell my native Spain as freely as I would plunder Peru."

The Tory press, in the excess of party feeling, attributed the success of *Pizarro* to Kemble's acting; and the *Anti-Jacobin Review* (Oct. 1st) published a print, by Gillray, of Sheridan borne to wealth and fame upon the great tragedian's head.

"In Pizarro's plans observe the statesman's wisdom guides the poor man's heart."

"This season, true, my principle I've sold,
To fool the world I pocket George's gold;
Prolific mine, Anglo-Peruvian food
Provok'd my taste, and candidate I stood;
While Kemble, my support, with loyal face,
Declares the people's choice with stage struck grace."

Sheridan upon Kemble.

On the 9th of June the artist published the likeness of a stout individual, with bald head and full whiskers, with one hand buried in the pocket of a capacious waistcoat, snapping the fingers of the other at the person he is addressing. The print is called *Independence.* The scene is the House, and the person indicated is Tyrwhitt Jones, whose portrait occurs in later cartoons. "I am an independent man, Sir," he declares, "and I don't care that who hears me say so! I don't like wooden shoes—no, Sir, neither French wooden shoes, no, nor English wooden shoes neither! And as to the tall gentleman over the way (Pitt) I can tell him that I'm no Pizarro! I'll not hold up the Devil's tail to fish for a place or pension!! I'm no skulker! no, nor no seceder neither! I'll not keep out of the way for fear of being told my own! Here's my place, and here I ought to speak! I'll warrant I'll not sneak into taverns to drink humbug toasts that I'm afraid to explain,

"The Gout."

not I! My motto is 'Independence and Old England!' And that for all the rest of the world! There—that, that, that," &c.

Gillray also published a portrait (July 20th) of the Duke of Cumberland, afterwards King of Hanover.

Among the humorous plates produced by our artist in 1799, "The Gout" (May 14) has been considered one of the cleverest of his numerous conceptions. Gout was almost universal in the "portwine" days. The demon of torture, who is inflicting indescribable agonies upon the helpless limb, presents a harrowing combination of hooks, barbs, forks, and tearing teeth. The monster is unassailable, and his hold is fixed too firmly for removal.

On the 13th of July appeared another "gout" subject, three invalids illustrating the old catch :—

> "Punch cures the gout, the cholic, and the 'tisic;
> And is by all agreed the very best of physic."

Seated round a table, bearing a capacious bowl of punch, are three unfortunate sufferers from the respective complaints set forth in the couplet, chanting in chorus the virtues of the compound with which they are relieving their miseries.

The caricatures on dress became less frequent after 1796, until 1799 and 1800, when they were again numerous. The principal change which had then taken place is the altered shape of the ladies' hats, which assumed the form of a rounded bonnet, and the reappearance of the waist. The general dress of the ladies now approached nearer the natural form of the body, but there was still an outcry against its transparency, and it is represented as exhibiting distinctly to view the form of the limbs, and even the garters. Examples may be seen in a caricature by Gillray, entitled *Monstrosities of* 1799— *see Kensington Gardens*, published on the 25th of June in that year, in which the fair promenaders are presented in the most scanty garments, made in the gauziest materials, which disclose the figure with every movement. The face is the only part of the person treated with reserve; the huge hats and whisks of hair arranged over the eyes provide a complete screen for the features. It would appear that this taste for transparencies vanished in the severe winter which closed the year just mentioned, as a caricature, dated on the 5th of January, 1800, represents the ladies forced by the rigour of the weather to cover their bosoms, and adopt drawers and petticoats under their thin robes; it is entitled "Boreas effecting what health and modesty could not do."

The male costume among people of fashion had gone through a greater change during the last years of the eighteenth century than that of the ladies. Among the "monstrosities" of the June of 1799, in the print already alluded to is a beau in full dress. He wears large Hessian boots, with a coat of a new construction, buttoned close, and having big bunches on the shoulders; he has a large high cravat, rising above the chin, and a hat approaching nearer in shape to those worn at the present day. This costume, which was extremely ugly, was imported directly from France. The coat, perhaps from its inventor, was known by the name of a "Jean-de-Bry." If in former days of peace with France, which then under its King possessed the most polite Court in Europe, our countrymen cried out against the importation of French fashions, we need not be surprised if they did the same now that the two countries had been so long engaged in a war distinguished by bitter animosity on both sides, and when Englishmen had been taught to look upon our republican neighbours as models of everything that was barbarous. This impression is illustrated in Gillray's engraving of *A French Gentleman under the Court of Louis XVI.*, who is decked in embroidered coat and speckled hose, all bows, curls, powder, wig-bag, sword, ribbons, laces, and ruffles; a tiny three-cornered hat, for show, held daintily forth by two fingers. The antique dandy, laying his hand on his heart, is averring—"Je suis votre très humble serviteur." *A French Gentleman under the Court of Égalité*, who wears a high hat, cocked, straight hair, a monstrous queue, a great coat with lappels,

One of the Monstrosities.

strings for garters, and half boots shaped like skates, his throat is wound round with a "bandanna," and a heavy stick is thrust in his pocket; he is striding along with democratic contempt for the usages of civility.

A caricature by Gillray, published on the 18th of November, 1799, represents a *French Tailor fitting John Bull with a Jean-de-Bry.* The tailor is equipped in the detested bonnet-rouge and its cockade, and appears delighted with his exploit :—"A-ha! dere my friend, I fit you to de life!—dere is liberté!—no tight aristocratical sleeve to keep from you do vat you like!—a-ha!—begar! dere be only want von leetel national cockade to make look quite à la mode de Paris!" Poor John, who stands

M M

in his great Hessian boots on a book of "Nouveaux Costumes," and has evidently no taste for French liberty in any shape, exclaims in disgust, "Liberty! quoth'a! why, zound, I can't move my arms at all! for all it looks woundy big!—ah! d—n your French à la mode, they give a man the same liberty as if he was in the stocks! Give me my old coat again, say I, if it is a little out at the elbows!"

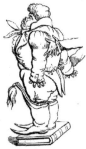

But John Bull's disgust availed little in counteracting the infection of French example in this respect; and in the very year when we were about to be terrified with the most extraordinary preparations for French invasion, our enemies sent us a costume which was uglier even than that last spoken of. (See 1803.)

The frivolity of manners and sentiments which gave rise from time to time to so much exaggeration of bad taste in dress, was no less frequently exhibited in the other paths of life, not only among the votaries of fashion, but through a large portion of society. Routs and balls had become objects of profuse extravagance; masquerades were revived, and became again the fury of the day; gambling and intriguing formed the chief occupation of immense numbers in all classes of society; and novelty, however absurd, was the object of adoration of the multitude.

John Bull Transformed.

A few portraits conclude the studies of this year. *Elegance Démocratique—a Sketch found near High Wycombe,* represents the Earl of Wycombe, son of the first Marquis of Lansdowne. Gillray has drawn the noble pedestrian as a stout and slovenly figure, dressed somewhat after the type of a French citizen. A quotation from Lord Chesterfield is attached:—"Whenever I wish to form an estimate of a man's mind I observe his manners and dress." The Earl of Wycombe opposed the French war, and supported the Liberal party.

August 6th. *Penetration* represents a simple-looking person, with stout face, open mouth, awkward hands, wearing a "Jean-de-Bry" coat, tights, and pumps, his toes turned out until his lower extremities resemble the tail of a fish. This figure is intended for John Penn, of Stoke Park, the descendant of William Penn; he was the last proprietary and hereditary Governor of Pennsylvania; he sold his quit rents on the outbreak of the American Revolution, for a hundred and thirty thousand pounds.

The satirist's definition of "Penetration" is not flattering to Mr. Penn:—"N.B. This title has no affinity to Pen—as connected with the goose-quill; nor has it any allusion to Penguin, a stupid creature between a fish and a fowl, the word is simply derived from pen, as the instrument used to express the deep researches of the mind; see the "St. James's Street Chit-chat," respecting a keen Pen, a witty Pen—and a pen often cut, but never mended."

August 1st. *Half Natural.*—The back view of an ill-shapen and absurd figure, wearing a "Jean-de-Bry" coat, all sleeves and padding, with white cords, and a large bunch of white ribbon, suspending short top-boots, with pointed toes. The portrait is that of Sir Lumley Skeffington, one of the most notorious fops of his age. His figure occurs in the "Union Club," and it is unnecessary to reproduce this sketch. "This exquisite fop," observed a contemporary, "once 'The Skeffington,' lisped by all the lordlings and ladylings of the opera, is said to have complained to his mamma of having caught cold by dining in a public room where a damp stranger sat at a distant table. 'Such folly,' Swift said, 'makes manhood sick.'" "Skiffy," who lived far into our own day, was one of the last of the Carlton House circle. It is recorded that even the great Prince Regent considered him an authority on dress. The beau's tastes were dramatic; he was on intimate terms with the theatrical world, and his own pieces were performed with success. Of these, "The Sleeping Beauty," and "Maids and Bachelors," are the best known. We shall have occasion to allude to "The Skeffington" in the progress of this work.

The artist seems to have charitably exercised his skill for the benefit of "the unwary," by distributing at a low price the portrait of *Mrs. Gibbs, a notorious Street-walker and Extortioner,* with an account of her appearance, manner of speech, and general method of imposture. Gillray's etching represents a spare figure, dressed in country fashion, in the act of swearing, on the four Evangelists, to a false charge of robbery.

The above are true Likenesses of CAMBACERES, LEBRUN, the ABBE SIEYES, and BUONAPARTE, drawn at Paris Nov. 1799.

The French-Consular-Triumverate, settling the New Constitution,
with a Peep at the Constitutional-Pigeon-Holes of the Abbe Sieyes in the Back Ground.

On the 6th of December appeared a portrait of *The Military Caricaturist*, General Davies, with the inscription, "—— his satires are as keen as the back of a razor ; and having but three ideas in the world, two of them are borrowed, and the third nobody would own." General Davies, a well known amateur in his own day, had spoken slightingly of Gillray, who thus expressed his resentment. The General is in uniform, cocked hat, boots, and big sword; his figure appears humpbacked, a pencil is in his mouth, and a portfolio of caricatures under one arm. Around the apartment are various designs, in questionable taste. A folio, labelled, " Hints from Bunbury, Darby, Lord Townshend, &c. &c." introduces a suspicion of the "amateur's" originality.

The burden of a song—then fashionable—"Oh! listen to the voice of Love," was parodied in a droll little plate (Nov. 14), wherein an extremely plain swain is tendering his affections to an equally ill-favoured fair, who appears delighted with the soft avowal.

1800.

The year 1800 witnessed the inauguration of Bonaparte's personal government, and the progress of "the Corsican Phœnix" absorbed public attention from this date until his career terminated at St. Helena, fifteen years later.

The nineteenth century opened in this country with political prospects by no means of the most cheering description. With a burden of taxation infinitely beyond anything that had ever been known before, England found herself in danger of being left single-handed in an interminable contest with a Power which was now rapidly humbling at its feet the whole of the Continent of Europe, and which had already adopted, with regard to us, the old motto of *delenda est Carthago*. We had no longer to contend with a democratic republic, as heretofore, but with a skilful and unscrupulous leader, who was already a sovereign in fact, and who was marching quickly towards a throne.

The strides to power were rapid : the Provisional Government was succeeded by a Consular Triumvirate, in which the whole executive authority was vested in the First Consul, the nominal sharers of his office possessing only the shadow of authority.

On the 1st of January Gillray introduced the members of the Consulate to the English public as *The French Consular Triumvirate settling the New Constitution*. Napoleon, Cambacères, and Le Brun are seated at their official table, framing the new *code*. The second and third Consuls are provided with blank sheets of paper, for mere form—they have only to bite their pens. The Corsican is compiling a Constitution in accordance with his own views. He has set down " *Grand Consul*— Buonaparte; *All-in-All*, Buonaparte," and so on. Before him is a Constitution in preparation for the future. It is endorsed "Buonaparte, Grande Monarque." The conqueror's sword of "Liberty" is hanging by his side; enormous branches of laurel ornament his heavily plumed hat; his military boots are trampling upon the torn " Constitution of 1793," the " Droit de l'Homme," and other " Constitutions;" while a batch of confiscations are under consideration. A band of imps are beneath the table, forging new chains for France and for Europe. In the background is the Abbé Sièyes and his constitutional pigeon-holes, with dockets of the new military despotism. It may be remembered that the chart was drawn up by Sièyes, whose experience rendered his assistance eminently valuable to Buonaparte. The Abbé, even at that date, was an advocate for Monarchy.

Feb. 24th, 1800. " *The Apples and the Horse-dung, or Buonaparte among the Golden Pippins ;* from an old fable. Explanation.—Some horse-dung being washed by the current from a neighbouring dunghill, espied a number of fair apples swimming up the stream, when, wishing to be thought of consequence, the horse-dung would every moment be bawling out, ' Lack-a-day, how we apples swim!' *See* Buonaparte's ' Letter to his Majesty,' and Mr. Whitbread's 'Remarks upon the Correspondence between Crowned Heads.'" By the side of a rapid stream is "the Republican Dunghill;" the faces of "the party" are traceable amongst the refuse. Fox is crying "Ça ira, ça ira! chacun à son tour! we shall have our turns." "Yes, yes," asserts Tierney ; "none of us were born to be drowned!" The faces of Sheridan, Burdett, Erskine, Nicholls, M. A. Taylor, &c.,

are mingled up with " Atheism, Regicide, Paine's ' Rights of Man,' Voltaire, Licentiousness, Hypocrisy,'' and other objectionable matters.

The " Golden Pippins" are swimming swiftly past — with crowns to distinguish them. The English pippin is leading the race, the Russian and Imperial (Austrian) pippins are swimming next in order, the Turkish and Neapolitan pippins are hurrying on. The Prussian pippin is making small headway, a crowd of the objectionable matter is arresting its progress. Robespierre and Marat are disappearing under the surface, but Bonaparte—the new Consul (as first Horse-dung), is swimming gaily along, under his plumed hat, making a tremendous stir among his rivals. " Aha! par ma foi ! how we apples swim !" he cries. The second and third Consuls are clinging to their leader, the Abbé Sièyes (who had planned the counter-revolution of the 18th Brumaire). Massena, Talleyrand, and others are following in Bonaparte's train. The Spanish pippin has suffered from a collision, while the Papal pear and Sardinian pippin are left behind.

Bonaparte, as absolute ruler of France, occupied general interest at home. John Bull's hatred and contempt were excited by every means—fair or foul. Gillray's graver was enlisted in the cause. His biting satires were poured forth incessantly ; and although his caricatures on this subject are less coarse than the average of contemporary prints, his animosity appeared more implacable.

May 12th, 1800. *Democracy, or a Sketch of the Life of Buonaparte,* is a good example of this inveterate hostility. The print, which is in eight compartments, traces the Consul through the successive stages of his elevation.

" Democratic Innocence" represents " young Buonaparte and his wretched relatives in their native poverty, while freebooters in the island of Corsica." The future masters of France occupy a miserable cabin, their bed is straw, and Napoleon is disputing a bone with his hungry brothers and sisters. The father appears in the doorway with his gun, returning from a poaching expedition. " Democratic Humility" introduces the boy " Buonaparte received through the kindness of the King's bounty into the École Militaire at Paris." A director of the institution, wand in hand, is leading the half-clad urchin to the governor of the Military School.

" Democratic Gratitude" exhibits " Buonaparte heading the regicide banditti which had dethroned and murdered the monarch whose bounty had fostered him." The young lieutenant is seen at the head of the tattered legions, directing the destruction of the palaces.

" Democratic Religion" follows the General to Egypt, and introduces " Buonaparte turning Turk at Cairo for interest, after swearing on the Sacrament to support the Catholic Faith." Napoleon is seated before his astonished generals, cross-legged, in a tent, smoking a Turkish pipe ; while the venerable priests of Mahomet are going through the ceremonies observed on the admission of a neophyte. The turban is placed on his head, and he has subscribed to the Alcoran. His departure for France is exhibited as " Democratic Courage"—" Buonaparte deserting his army in Egypt, for fear of the Turks, after boasting he would extirpate them all." The leader is stealing off on board the vessel prepared for his flight, while his followers are asleep.

" Democratic Honour"—" Buonaparte overturning the French Republic which had employed him, and entrusted him with the chief command"—presents the returned commander directing his troops to disperse the General Assembly ; his foot is trampling upon the " Constitution de l'an 3 ;" the members of the " Convention, une et indivisible," are scattered like chaff before the bayonets of the soldiers charging in files.

" Democratic Gratitude."—" Buonaparte, as Grand Consul of France, receives the adulations of Jacobin sycophants and parasites"—represents the First Consul seated on his throne, which is surmounted by an eagle, with the great globe in his claws. A row of abject senators are presenting the " Hommage du Sénat Conservatif." The members of the " Corps Législatif." are offering their congratulations. Behind the throne is the Abbé Sièyes, his face expressing the deepest cunning.

" Democratic Consolations" represents " Buonaparte on his couch, surrounded by the ghosts of the murdered, by the dangers which threaten his usurpation, and all the horrors of final retribution." Napoleon is suffering from his nightly visions. A guillotine is the head of his bed, and a demon's face is leering below the dripping blade. Treachery haunts the dreamer. The jewelled hand of a fair assassin presents the poisoned cup, and a pistol and dagger are aimed by unseen hands. Death, armed with his spear, and a venomous serpent, are emerging from beneath the bed ; the flames of the infernal regions

are surging onwards to consume him; while hosts of victims, martyrs of the Revolution and of his wars, are trooping down to denounce the agent of their murder.

The interest of subjects nearer home was secondary. On the 1st of February, 1800, Gillray published his *Design for the Naval Pillar*, it having been proposed to erect some suitable monument to commemorate the successes of our fleets. The artist offered a pictorial suggestion. This trophy is based upon a rock, round which the waters are breaking. The stones on which it is raised are inscribed "Howe, Parker, St. Vincent, Bridport." Nelson is the keystone—Duncan, Gardiner, Keith, and Hood form a second line. A tablet is uplifted by the figures of Fortitude and Justice, "To perpetuate the destruction of the Regicide Navy of France, and the triumph of the British Flag." The pillar is formed of relics of the French defeat, battered flags of Égalité, "Liberty" without her head, dismantled anchors and broken cannons, wooden shoes, the bodies of Jacobin assassins stuck on pikes, red caps, revolutionary cockades, with the plumed hats of the Republican Generals to form the capitals. A group of Tritons are supporting a conch shell in which is seated Britannia, armed with shield and trident, holding a figure of Victory; by her side is the British lion grasping the globe; his paws rest on the empire of the sea. The waters dash against the monument, and the lightnings play around it without endangering its stability. An adaptation from "The Pursuits of Literature," "Britannia Victorious," is appended —

> "Nought shall her column's stately pride deface ;
> The storm plays harmless round the marble base,
> In vain the tempest, and in vain the blast,
> The Trident is confirmed."

The small person of Michael Angelo Taylor formed the principal figure of a cartoon issued February 15th, 1800. *The New Speaker (i.e., the Law Chick) between the Hawks and Buzzards—poor little Michee !—just mounting, and then funked and frightened out of all his hopes.* "The Law Chick" is about to take his seat as Speaker of the House of Commons, when a storm of squibs assail him from both Opposition and Ministerial benches; he is driven back from the coveted chair, while his wig and robes are struck off. The foremost of the sibilant birds bears the features of Sheridan. At the commencement of his parliamentary career M. A. Taylor uniformly voted with the Ministry. He differed with his party on the Westminster Scrutiny, and declared his opinion that the High Bailiff's Court was an illegal judicature. "He did not presume to contend with the learned gentlemen who preceded him. He was young, he was but—what he might call himself—a *Chicken* in the profession. He expressed his intention of voting for the first, and not improbably the last, time with the Opposition."

Sheridan, after dwelling on the brief nature of this auxiliary's alliance, concluded, "He was sorry to find the Chicken was a bird of ill-omen, and that its augury was so unpropitious to their future interests. Perhaps it would have been as well, under the circumstances, that the Chicken had not left the barn-door of the Treasury, but continued side by side with the old Cock to pick up those crumbs of comfort which would doubtless be dealt out in due time with liberality proportioned to the fidelity of the feathered tribe."

Taylor's disappointment on the loss of the Speaker's chair excited little sympathy, owing to his pompous manner. The Opposition, in whose ranks he consistently appeared, must have entertained a favourable opinion of his legal attainments, for they nominated him one of the managers of Hastings' impeachment. The parliamentary business of this session excited slight attention, and Gillray's political satires were unimportant. The union with Ireland had been completed, and was put into effect; but the sister isle remained dissatisfied and turbulent, and but a few months passed over before a new rebellion broke out, of a serious character. The union itself had not passed without considerable opposition in this country, and the advantages which its advocates promised as the result were ridiculed or disbelieved. Among the more obscure caricatures on this subject which appeared during the year 1800, one represented Pitt from the State pulpit publishing the banns of union between John Bull and Miss Hibernia. In another, under the title of *A Flight across the Herring-pool*, the Irish gentry are seen quitting their country in crowds to share in the good things which Pitt is laying before them in England, thus setting the example of that evil of absenteeism which has been so much complained of in more recent times.

The twentieth anniversary of Fox's election for Westminster was celebrated by a public dinner held

at the Shakspeare Tavern on the 10th of October, 1800. The appearance of the Whig chief, after his prolonged retirement from public business, was peculiarly interesting to his partisans, who were eager to demonstrate their attachment to his person, and anxious to learn his opinion on their prospects.

Gillray ridiculed this enthusiasm with great spirit. On the 13th of October appeared the artist's view of this memorable Liberal gathering, as *The Worn-out Patriot, or the Last Dying Speech of the Westminster Representative.* The toasts which succeeded the banquet are supposed to be in progress. Above the chairman's seat is the red bonnet and the motto "Vive la Liberté." Fox is represented infirm and broken down—he requires sustaining; Erskine is supporting one arm, and is offering a bottle of brandy to revive his vigour; Harvey Combe, in his Lord Mayor's robes, is also supporting the chief. In his hand is a "Petition to the Throne—a new way to Combe the Minister's wig." A pot of "Whitbread's Entire" is placed before Fox. A body of sweeps, with marrowbones and cleavers, are applauding the patriot's address. Tierney and others are seated round the table. The speech put into Fox's mouth is a smart parody of the one actually delivered:—"I feel the deepest gratitude to you, and to all the people of England who honour me with their approbation, but I must inform you that I still mean to seclude myself from public business. My time of action was over when those principles were extinguished on which I acted. I have at present no more to say; but that I will steadily adhere to the principles which have guided my past conduct. These require that I should continue absent from Parliament, but I shall ever maintain that the basis of all politics is Justice—that the basis of all constitutions is the Sovereignty of the people, and that from the People alone, kings, parliament, judges, and magistrates derive their authority."

In later years these caricatures exhibit the "Worn-out Patriot" managing the interests of his country to the satisfaction of his Sovereign, and for the honour of England. "Who," remarks an earlier writer on the subject of the "Worn-out Patriot," "in reviewing Fox's noble adherence to the cause of liberty, as it affected the American nation, and weighing the wisdom of his forewarnings of the fatal consequences of the American war, but must admire the prophetic spirit with which he foretold all the direful events which resulted both to the mother country and her colonies from that unnatural fratricidal war." Fox, by both Whig and Tory, is admitted to have been a veritable prophet in all that related to America.

Amongst the minor productions of this year may be noticed the reappearance of the Prince of Orange, who is introduced in a slightly free caricature, on the subject of "the ladies' indispensable pockets."

The portraits of individuals published in this year were very numerous. Sir Lumley Skeffington, the most exquisite of fops, who has been previously introduced as *Half Natural,* was favoured with a second portrait; he is decked out in the elaborate finery he adopted at a Court ball (February 1st, 1800). His awkward figure appears more ungainly from the contrast of his embroidered coat. A quotation from the "Birthday Ball" accompanies this picture of the "jigging" dandy—"so Skiffy-Skipt-on with his wonted grace."

March 25th, 1800. *Symptoms of Deep Thinking: "Sinking from thought to thought, a vast profound."*— This quotation accompanies the portrait of a remarkably absent old gentleman, who is walking to St. Stephen's with one hand in his breast and the other in the pocket of his small clothes. The deep thinker, vacantly staring into space, is unconsciously walking in the gutter. The portrait represents Sir Charles Bunbury, whose name is famous in connexion with the turf; it was observed of him that although he never wore gloves, *he had always clean hands,* which could not be said of every patron of horse-racing.

Sir Charles Bunbury married the lovely Sarah Lenox, daughter of the Duke of Richmond, whose beauties had fluttered the heart of King George in his younger days. It is well known that this charming lady, weary of the neglect and estrangement which her husband's pursuits rendered unavoidable, eloped with the Hon. George Napier, from a masked ball given by her sister, Lady Holland. A divorce was obtained, and she became Lady Napier, the mother of the gallant Napiers.

March 11th, 1800. *A Prince of the Old School,* portrays an old fop, stalking in rigid perpendicular;

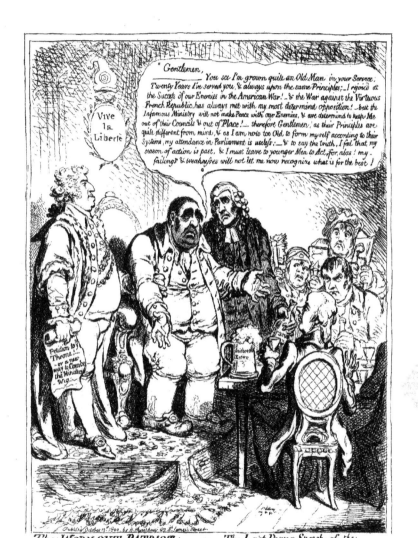

The WORN-OUT PATRIOT; — or — The Last Dying Speech of the Westminster Representative, at the Anniversary Meeting on Oct 10th 1800, held at the Shakespeare Tavern.

under his arm is carried an umbrella of large dimensions. The plate bears a quotation from " Chesterfield's Letters :" " There's an easiness of deportment, and an elegance of indescribable débonair, about the beaux of the old school, which would be ridiculous for the puppies of the day to think of imitating." The picture is intended for Boothby Clopton, an eccentric frequenter of White's and Boodle's, better known in his day as Prince Boothby. After wasting a large fortune, the venerable " buck," in a fit of mental aberration, terminated his career by suicide.

April 8th, 1800. *How to Ride with Elegance through the Streets*, represents Lord Llandaff, an exquisite dandy, dressed in the height of the fashion. His seat is studiedly careless. Below the plate are the lines :—

" 'Tis not in mortals to command success ;
Sirrah, but we'll do more, Sempronius—we'll deserve it."

On the 19th of May appeared the likeness of a military gentleman in full uniform—Captain Townshend, of the First Grenadier Guards, a well-known man of fashion, and one of the constant promenaders of St. James's Street.

May 28th, 1800. *A Standing-dish at Boodle's ; vide a deuced good Cocoa-tree Pun.*—A stout old gentleman, Sir Frank Standish, is leaning over the back of his chair at the open window of his club.

On the 12th of June appeared *A Portrait of Count Rumford*, the introducer of stoves. His comical face is turned to the spectator, and his back to the fire. He is thoroughly enjoying the warmth :

" So every parlour, drawing-room I see,
Boasts of thy stoves, and talks of nought but thee."—PINDAR.

A contemporary records :—" Count Rumford purchased several proof impressions of *The Comforts of a Rumford Stove*, and presented them to his most intimate friends, facetiously observing, " This is so much more like the Count than he is himself, that when you look upon it you cannot fail to think of your humble servant, the donor."

June 11th, 1800. *A Military Sketch of a Gilt Stick, or Poker Emblazoned*, represents a stiff figure in uniform : a portrait of General Cathcart.

July 1st, 1800. *Georgey in the Coal-hole.*—Colonel Hanger, whose history may be traced in these caricatures, in the year 1800 had chanced on bad times; his appointments were cancelled (the title to which he afterwards succeeded was then unthought of). Florizel's early comrade, " the Ajax of Carlton House," turned his thoughts to earning an honest living, and commenced business as coal-merchant. He draws attention to this reverse in his eccentric Memoirs. " A man is never more respectable than when by honest industry he can obtain a livelihood." Gillray has drawn the man of fashion in his coal-shed. His broken hat retains its redoubtable cock, although the wearer is bending under a sack of coals. He is without a coat, and his nether garments are ragged, but he retains his gold-laced waistcoat and the "bandanna" neckcloth which he introduced into fashion. The Colonel was irrepressible; he made a fresh start in life, and once more reappeared in his true colours as the gay, careless trifler, " the veteran man about town."

Among the artist's more grotesque sketches we may notice :—

January 20th. *Waltzer au Mouchoir.*—The newly imported waltz, performed in an "assembly-room."

February 6th, 1800. *Comfort to the Corns*, represents, as its title implies, an old woman seated, spectacles on nose, before a blazing hearth, removing her corns with a carving-knife. This print has been commended as one of Gillray's happiest efforts in the grotesque walk.

Among the designs which the artist engraved for amateurs may be mentioned a series—still occasionally seen in shop-windows—treating the various inconveniences incident to sickness, from a burlesque view. *Taking Physic, Gentle Emetic, Breathing a Vein, Charming-well Again*, and similar subjects of a coarser nature. Part of this series did not appear until 1804.

Feb. 16th. *Ars-Musica* introduces a trio, in which discord, rather than harmony, seems to have gained the ascendancy. The design is by an amateur.

Jan. 22nd. *German Luxury, or Repos à l'Allemand*—designed as a satire upon the German Legion, when employed in England. The picture represents a long-haired German lying in a bed considerably shorter than his figure. His feet are hanging over the back ; a feather cushion is arranged as a

covering, and the Sybarite is enjoying his pipe, puffing thick volumes of smoke at the portrait of Frederick the Great.

In 1800, Gillray issued two sets of sporting prints, engraved from the drawings of an amateur.

April 8th. *Hounds Finding*, represents a rider thrown over a ditch; the hounds have scented his lunch, and are fiercely "unearthing" a portion of cold game from his pocket.

Hounds in Full Cry, pictures a hard-mouthed horse bearing his rider right through the hounds, who are trodden down, ridden over, and yelping in all directions, while the huntsman is despairing at the destruction of his pack.

Hounds Throwing Off.—Three sportsmen are dislodged from their seats by the barking of the pack.

Coming in at the Death represents two riders leaping a bush, and plunging headlong into a pool beyond.

These sketches are spirited, the drawing is fair, and the engraver has done his best.

It has been reported that "the Sporting subjects afforded the King many a hearty laugh. His Majesty usually, as they were brought to his table, illustrated them with some pleasant story to the point. The Royal Hunt furnished incessant amusement to the happy group at Windsor. Mr. Carbonel, the wine-merchant who served his Majesty, was a great favourite with the King, and used to join in the Royal Hunt. Returning from the chase one day, his Majesty graciously entered into chat with this worthy, riding side by side with him a considerable way. Lord Walsingham being *in* attendance, watched an opportunity, took Carbo aside, and whispered to him. 'What's that! hey!—what's that Walsingham has been saying to you, hey?' quoth the King. 'I find, Sire,' said the wine-merchant, ' that I have been unintentionally guilty of disrespect to your Majesty; but your Majesty will please to observe, that whenever I hunt my hat is fastened to my wig, and my wig is fastened to my head, and I am mounted on a skittish horse; so that, if anything goes *off*, we must all go off together!' This idea afforded the Monarch a hearty laugh."

A second series, published November 12th, pictures the adventures of two Cockneys out for a day's sporting. The initial given is C. A stout sportsman, "in tops," and a more fashionable " Nimrod" in " tights" and " Hessians," have left the counting-house, and sallied out " a shooting." Hornsey Wood is their destination; their dogs are a poodle and a mongrel.

In plate the first, *Cockney Sportsmen marking Game*, we find the younger sportsman elated by the discovery of a flock of carrion crows, which are hovering over a dead knacker. The stout sportsman, in the act of climbing a stile, is blown head over heels by an incautious discharge of his companion's piece. "Shooting Flying" represents the younger sportsman jumping over a fence on the appearance of a flock of pigeons. He has carried off his friend's hat; but the pigeons, which are close to his barrel, escape without damage. "Recharging" indicates a later stage of the day. The younger sportsman, who has secured a "barn-door cock," is reloading his gun, but his attention is diverted, and the ramrod is pushed wide of the charge. His stouter companion is recharging himself with a substantial meal and a bottle of porter. "Cockney Sportsmen Finding a Hare," indicates the worthies—who have discovered a hare lying in some furze—stealing on tiptoe, oblivious of their sporting character, endeavouring to catch the animal with their hats.

December 8th. *Venus Attired by the Graces* is a broad parody — the Venus, a coarse, lumpy country wench; and three awkward rustics, assisting at the rude toilette, are the Graces. The artist's contemporaries admired the humour of this burlesque. The subject is rudely treated, and would now be voted vulgar.

1801.

During this year our attitude towards France seemed likely to be modified. Once more the interest of home politics was revived. Pitt's lengthened tenure of office approached its close, and on the King's refusal to ratify the promises held out to the Catholics on the completion of the Union, the Minister conscientiously retired from office, upon finding himself unable to redeem the pledges he had held out to Ireland.

The earliest caricature issued in this year was a portrait of the Emperor Paul of Russia, who was then peculiarly unpopular. He had proclaimed himself Grand Master of Malta, which had been conquered by England in 1800. The Government declined to recognise his authority, and the Emperor revenged himself by laying an embargo upon all British ships in the Russian ports, and induced the Swedish, Danish, and Prussian Courts to enter into a convention to protect their commerce against the encroachments of the English.

The dwarfed person of the Emperor was introduced, January 20th, under the title of *The Magnanimous Ally*. His coat descends to his heels, and his crescent-shaped hat is nearly as long as himself. He is stamping upon the Treaty of Alliance into which he had formerly entered with Austria and England. Malta is seen in the distance. The artist's motto is " Mens turpe, corpore turpi." Some two months after the appearance of this portrait, the wayward tyranny of the Emperor—whose mind was evidently disordered—became so insupportable, that his abdication was determined on; but Paul obstinately refused to abandon the supreme power. The disgusted nobles formed a conspiracy, entered the palace, and strangled him with his own military scarf. Certain excuses may be pleaded for this monarch. His father, Peter III., had issued a ukase declaring he was not his son. His mother, the dissolute Catharine, had put her husband to death on the publication of this statement. Paul's youth had been spent under disadvantages, and his mother's last act was a futile effort to exclude him from the succession. His reign commenced auspiciously : acts of clemency and munificence distinguished his Government. He was looked upon as the head of the Alliance against France, the legitimate champion of crowned heads. After sharing the defeats sustained by the Allied armies, his views underwent a remarkable change. Bonaparte—with his matchless discrimination—flattered the Emperor's vanity ; and, among other strokes of policy, returned all the Russian prisoners, newly clad and well armed. Paul now entered into an offensive and defensive Alliance with France, to drive the English out of India, and to humble our maritime supremacy. The Northern Confederation was established to further this object.

The Emperor published an advertisement in the *Court Gazette* of St. Petersburg, stating, to the astonishment of all Europe, that as " the Powers could not agree among themselves, he intended to point out a spot to which all the other Sovereigns were invited to repair, TO FIGHT IN SINGLE COMBAT, bringing with them as seconds and esquires their most enlightened ministers and ablest generals." His subjects were continually annoyed by minor acts of oppression—such as an edict against " round hats" and pantaloons, which he expressly forbade any person to wear in the Russian Empire. He enforced the revival of hair-powder and pigtails, and issued a proclamation to compel all persons whom he encountered in the street to leave their carriages and prostrate themselves before him. No one was safe from the paroxysms of his rage. A mad emperor was a formidable evil, and, in spite of his precautions, a conspiracy was organized, and Alexander, the intrepid antagonist of Bonaparte, was appointed his successor.

We have traced the progress of the Union with Ireland. The Act which completed this measure came into effect upon the 1st of January, 1801, and on the next day appeared the proclamation of the King's new royal titles, from which that of King of France, with the fleur-de-lis, was omitted.

Among the popular expressions manifested by the event may be noted the establishment of the Union Club, whose meetings were held in Cumberland House, Pall Mall. It became for a short time the fashion of the day, and gained a proportionate celebrity. One of Gillray's most elaborate plates is founded on this Union Club, in which he has included persons of every shade and party.

January 21st. *The Union Club—*

A Kiss at Last.

> " We'll join hand in hand, all party shall cease,
> And glass after glass shall our Union increase ;
> In the cause of Old England we'll drink down the sun,
> Then toast little Ireland, and drink down the moon."

A scene of the most hilarious merrymaking is proceeding. A throne, bearing the design we have engraved, has been raised for the president; the chair is placed on the board, the Prince of Wales's hat and plume occupy the seat; but the royal chairman has disappeared under the table amidst a heap of "his slain." The Duke of Bedford, with his back to the throne, is sleeping off the effects of his wine. Tierney, indisposed, is by his side. Behind the member for Southwark stands little General Walpole, pledging the Union in the centre of a select circle. On the left hand of the throne Erskine is tipsily unconscious, with a gin measure in his hand. The heavy form of Fox is asleep in an arm-chair, his feet resting on the table. Lord Stanhope has gone down bottle in hand, and "dead men" are piled around him. Lord Moira preserves his military stiffness even in his cups; he is seated on the table, the principal figure of the whole tumultuous assembly, grasping the hand of the veteran Manners, who sits on the opposite side of the board, wearing a shovel hat and a pigtail. "Sherry" is peculiarly in his element, he is honouring the Union with a full bottle. The "Jockey of Norfolk" is stretched at full length, suffering from repeated "loyal toasts." A fashionable figure, dressed in the costume affected by Young England at the commencement of the century, is placed with his back to the spectator; it is intended, we are inclined to believe, for Lord Camelford. The Sibyl-like head of old Nicholls lies stretched on the ground, glass in hand; two Irish waiters, bearing in a tub of "whisky punch," are trampling upon his person. The overdressed figure of Sir Lumley Skeffington is dancing in on the arm of Lord Llandaff (or of his brother, Colonel Matthews, the "exquisite trio" being nearly identical in dress and figure). Skiffy is holding a goblet over his head, while his companion is bespattering him with the contents of two bottles of Burgundy, which he is flourishing in the air. Lord Derby's balloon-shaped head is distinguished at the board. Leering old Queensberry is daintily sipping by the side of Doctor Parr, who, provided with pipe and pot, is sending a volume of smoke into the painted face of the "little gamesome Piccadilly Duke." Parr's hand is resting on the shoulder of the Marquis of Lansdowne, who advocated the concessions to the Irish Catholics. He is using a crucifix for a tobacco-stopper; before him is "Belendenus, his box." The portly Lord Cholmondeley is pledging the toast with his hat raised aloft; and the deformed figure of Lord Kirkcudbright is peeping through his quizzing-glass. The usual accompaniments of Hibernian revelry reign triumphant in the body of the picture; friendship and faction fights are the passions prevailing. Sturt, the stout brewer, is backed by Tyrwhitt Jones—whose whiskers and bald head are easily recognised—in a stand-up fight against Colonel Georgey Hanger, who has received a black eye. The orchestra is performing "God save the King," and rings of patriots (mostly portraits) are dancing hand-in-hand, *carmagnole* fashion. Sir Jonas Barrington and other patriots are indulging in various confused combats: swords, whips, bottles, fire-irons, candlesticks, chairs, stools, &c. are freely employed as offensive weapons on every side, enlivening the general effect. A timepiece in the background, topped by the figure of "Time grasping the hand of Bacchus," bears the name, "W. Pitt," 1801, as the constructor, in allusion to the heterogeneous mechanism of the Union.

The first Imperial Parliament met on the 22nd of January, 1801, and was attended with two remarkable circumstances—the election of the Rev. John Horne Tooke for the borough of Old Sarum, and the reappearance of Fox at his post in the House of Commons. Fox reappeared in the house for the first time on the 2nd of March, and one of the earliest signs of his returning activity was his support of the right of Horne Tooke to a seat there. A caricature, published on the 14th of March, entitled *The Westminster Seceder on Fresh Duty,* represents Fox bending his broad back to enable the reverend candidate to get into St. Stephen's chapel through the window, while Lord Temple is shutting the door against him. Tooke had been returned for Old Sarum by Lord Camelford. His admission was opposed on the ground of his clerical profession, and it led to a Bill making clergymen incapable of sitting in Parliament. Tooke held his seat for a very brief period, during which he did no act of importance. A caricature, by Gillray, published on the 15th of March, under the title of *Political Amusements for Young Gentlemen, or The Old Brentford Shuttlecock,* represents the head of Tooke formed into a plaything, the inscriptions on the feathers of which sufficiently intimate his character, tossed backwards and forwards between Lord Camelford, to whom he owed his election, and Lord Temple, who led the opposition to his admission.

"If William's hand is't; hand, all Party shall cease;
And if of a fresh Flag shall our Union ere cease:

The UNION-CLUB.
London. Design'd & made by W. Hogarth & Engrav'd.

In the reign of Old England we'll drink down the Sun
Then toast Little Ireland, & drink down the Moon'.

"There's a stroke for you, messmate," cries the former; "and if you kick him back, I'll return him again, if I should be sent on a cruise to Moorfields for it!" "Send him back!" replies Temple; "yes, I'll send him back twenty thousand times before such a high-flying Jacobin shuttlecock shall perch it here in his clerical band."

This lively game is played before the door of "St. Stephen's School;" the members are in an uproar, and Fox is shouting, "The Church for ever!"

A Shuttlecock.

Before the question of Horne Tooke's election came under discussion Pitt had quitted the Ministry. Having in his anxiety to procure the support of the Catholic body in Ireland for his grand project of union made an implied promise to support the cause of Catholic Emancipation, and finding the King obstinately opposed to it, he seized upon this as the occasion for retiring from office.

In February Pitt unexpectedly resigned, and on the 16th of that month he explained his reasons:—"As to the merits of the question which led to my resignation, though I do not feel myself bound, I am willing to submit them to the House. I shall rather leave it to posterity to judge of my conduct; still I have no objection to state the fact. I and some of my colleagues in office did feel it an incumbent duty upon us to propose a measure on the part of Government which, under the circumstances of the union so happily effected between the two countries, we thought of great public importance, and necessary to complete the benefit likely to result from that measure. We felt this opinion so strongly that when we met with circumstances which rendered it impossible for us to propose it as a measure of Government, we felt it equally inconsistent with our duty and our honour any longer to remain a part of that Government. What may be the opinion of others I know not; but I beg to have it understood to be a measure which, if I had remained in the Government, I must have proposed. What my conduct will be in a different situation must be regulated by a mature and impartial review of all the circumstances of the case. I shall be governed—as it has always been the wish of my life to be—only by such considerations as I think best tend to insure the tranquillity, the strength, and the happiness of the empire."

Thus we see the King's obstinacy and indifference to the voice of justice, which pleaded the admission of the Catholics to the privileges of his more favoured subjects, drove Pitt, the unrelaxing pilot, who had steered him safely through times which were stormiest for kings, from office at the very juncture when his skill was most needed.

February 24th, 1801. *Integrity Retiring from Office!*

> "Men, in conscious virtue bold,
> Who dare the honest purpose hold,
> Nor heed the mob's tumultuous cries,
> And the vile rage of Jacobins despise."

Pitt and his colleagues are retiring, with an air of conscious dignity, from the Treasury-gates they had defended since 1784. In the late Premier's hand is a scroll, which displays the grounds of his resignation, "Justice of emancipating the Catholics." His firm ally, Dundas, is leaning on the arm of his chief, holding the "Advantages of the Union," while a document, marked "Success in the East," proclaims his management of the India Board. Lord Granville follows with a list of "Requisitions gained in the war—Malta, Cape of Good Hope, Dutch islands, &c." Lord Loughborough, in his Chancellor's wig, is walking by his side. Windham is carrying a statement of the "Enemies' ships taken and destroyed;" while other members of the administration follow in their order. The grenadier on guard, sentinel at the Treasury-gate, (Addington, Pitt's nominee, who succeeded to the posts he had vacated), is complying with the instructions posted on his watch-box, "G.R. Orders for keeping all improper persons out of the public offices," by thrusting back the disorderly mob which is rushing forward to insult the fallen patriots. The prominent Whigs are introduced, promoters of the confusion, by which they hoped to profit.

Tierney appears as a slovenly cobbler; he is holding a dead cat ready for the assault. Sheridan, as a journeyman butcher, is menacing the ex-Ministry with his cleaver in one hand and a formidable bone

N N 2

in the other. The Duke of Bedford is encouraging the rabble, as a Newmarket jockey, crying, "Push on, damme!—work on!—it's our turn now!" "Your turn!—no, no!" replies the sentry on guard, "whoever goes out you'll not come in!" The Duke of Norfolk is aiming an empty bottle at the ex-Minister. Little Jekyll, as a legal sweep, is threatening them with broom and shovel; Sir Francis Burdett is waving a ragged hat with the Republican cockade; old Nicholls, his malignant features unusually excited, is flourishing the Jacobin ensign; Tyrwhitt Jones brings up the rear. Ragged newsboys from the *Morning Chronicle* are trumpeting their exultation; a pot of "Whitbread's entire," squibs, stones, sticks, pamphlets of Jacobin charges, speeches, essays, and refuse are hurled at the retiring Ministers, who do not condescend to notice their persecutors. It is remarkable that Fox is absent from this demonstration.

One of the caricaturist's contemporaries has bequeathed us a comment of his day. "His predecessors," said a loyal independent old high sheriff, "may have taken deuced good care to feather their nests; but as for *Integrity* here," holding a bumper of claret in one hand and Gillray's print in the other, "he left the candle-ends and cheese parings to be scrambled for by others, according to *their* liking, while *his* liking was no other than the love of Old England."

The Opposition accounted for Pitt's resignation on more interested grounds than were afforded by the disappointment attending the evident breach of good faith brought about by the King's obstinate determination. The party declared that, alarmed at the difficulties into which he had plunged the country, Pitt wished to withdraw from personal responsibility, and they prophesied that he would continue to be, in fact, as much Minister as before. This seems to receive some confirmation from the fact that Henry Addington, the son of Dr. Addington, one of the physicians who had attended on the King in his derangement, and the special protégé of the Pitt family, was nominated for his successor. A caricature, published on the 20th of February, under the title of *The Family Party*, represents Pitt, Dundas, Grenville, and Canning seated round the card-table; Pitt gives his hand to Addington, saying, "Here, play my cards, Henry; I want to retire a little;" and the other players join him in the wish to remain awhile behind the screen.

An unexpected event added to the embarrassments of this situation of public affairs. The King, in consequence of the agitation and uneasiness caused by Pitt's resignation, was suddenly attacked with his old malady, in the midst of the negotiations for a new Ministry, and he remained in an uncertain state of health during three weeks. Although the public were kept in ignorance of the exact state of the King's indisposition as long as possible, enough was known to create general uneasiness; and it was this circumstance, probably, which drew Fox to town, and restored him to the House of Commons, for it was still believed that the formation of a regency would be, under any circumstances, attended by the dismissal of the present Ministry, to make place for one under the Whig leader.

In the middle of March, immediately after the King's recovery, the new Ministry was publicly announced. Addington was First Lord of the Treasury and Chancellor of the Exchequer; the Duke of Portland remained President of the Council; Lord Eldon was made Chancellor; Lord Pelham, Home Secretary; Lord Hawkesbury, Secretary for Foreign Affairs; and Lord Hobart, Secretary for the Colonies; the Hon. Charles Yorke, Secretary at War; Lord Chatham, Master of the Ordnance; and Lord Lewisham, President of the Board of Control for the Affairs of India.

On the 28th of May Gillray made a humorous comparison between the old Ministers and their successors, in a caricature entitled *Liliputian Substitutes*, a title which was not ill bestowed on the latter, for they were men of so little influence in politics, that it was evident from the first they could only retain office by indulgence. Lord Loughborough's vast wig appears to hide his successor, Lord Eldon, whose person is lost on the woolsack; he is crying, "O, such a day as this, so renowned, so victorious; such a day as this was never seen!"

Next to the buried Chancellor stands on the Treasury bench "Mr. Pitt's jack-boot," in which Addington is plunged to the chin, yet he imagines that it, and the rest of Pitt's clothes, are made exactly to fit him—"Well, to be sure! these here clothes do fit me to an inch!—and now that I've got upon this bench, I think I may pass muster for a fine tall fellow, and do as well for a corporal as my old master Billy himself." Lord Hawkesbury, who had talked of marching to Paris, has his spare form

INTEGRITY retiring from Office!

When, in conscious Virtue bold,
Who dare their Wrongs purport old;

Nor heed, the Mobs tumultuous cries,
And the vile rage of Jacobins —despise

enveloped in Lord Grenville's capacious breeches—"Mercy upon me! what a deficiency is here!—ah, poor Hawkie! what will be the consequence if these d—d breeches should fall off in the march to Paris, and then should I be found out a sans-culotte!" Lord Hobart, a portly individual, is flourishing and swaggering with "Mr. Dundas's broad sword," which with his Scotch bonnet and "breeks" are totally disproportioned to his figure. His theatrical outpourings do not conceal his unfitness for the part. "Ay! Ay! leave us to settle them all; here's my little Andrew Ferrara! Was it not us that tip'd 'em the broadside in the Baltic? Was it not us that gave the crocodiles a breakfast in Egypt? I'm a rogue if it is not us that is to save little England from being swallowed up in the Red Sea."

Large Shoes for Little People.

Another individual, with no less plumpness in his proportions, is quarrelling with "Mr. Canning's old slippers"—"Ah! d—n his narrow pumps! I shall never be able to bear them long on my corns!—zounds! are these shoes fit for a man in present pay free quarters?" Charles Yorke is lost under "Windham's cap and feather" (as Secretary at War). The inkstands and quills of G. Rose and C. Long (Trea-

A New Minister in an Old Boot.

sury Secretaries) serve their more diminutive successors for helmets and muskets.

At the beginning of the year, England had been again threatened with French invasion; but Addington's Administration set out as a peace Ministry, and it proceeded so resolutely in this course, that on the 1st of October, preliminaries had been agreed to and were signed, and Lord Cornwallis was soon afterwards sent over as Minister Plenipotentiary. Bonaparte himself was evidently desirous of a cessation of hostilities that he might be left for awhile to pursue his ambitious designs at home. After many crosses and difficulties, and sufficient evidence of bad faith on the part of the French Government, the definitive treaty of peace was signed at Amiens on the 27th of March, 1802.

There was still a strong war-party in England, and many with keen foresight looked at it as an unnecessary sacrifice of our own dignity, rendered futile by the certainty that no peace could be of long duration with the then ruler of France, unless purchased with an unconditional submission to his will. The opposition was strong in Parliament, and when the terms of peace were known, there was a loud complaint at the yielding up of so many of our recent conquests, while France was allowed to keep her overwhelming influence on the Continent. The peace was, however, lauded by Fox and the Whigs, and approved by Pitt.

Gillray's convictions were strongly and consistently set forth against making terms with the French; his opinions on this point were immovable. On the 6th of October appeared a cartoon on the subject of the negotiations, *Preliminaries of Peace, or John Bull and his Little Friends Marching to Paris.* A rotten plank, cracked in the middle, and mislabelled "Heart of Oak," bridges the two countries. The French are pictured as a party of apes, wearing red bonnets and dancing round a huge cap of liberty stuck on a Maypole before the entrance of a rat trap. Lord Hawkesbury, the "Jenky" of former years, had threatened in a speech delivered at the commencement of the war, in the early days of the Republic, "to march to the gates of Paris." He is here represented putting his threat into execution, but with no hostile front. Britannia's four hundred millions (expenses of the war), a "List of the Soldiers and Sailors Killed," and "Restoration of the French Monarchy" are, with our recently acquired conquests—Malta, Cape of Good Hope, &c.—abandoned and thrown into the Channel. Lord Hawkesbury is drumming John Bull to Paris, a branch of laurel and a roll of the "Preliminaries" (signed on the 1st of October) form his drumsticks. "Instructions from Park Place" appear in his pocket, and the

Duke of Norfolk is peeping under his coat tail. Hawkesbury cries, "Allons! enfans de la Patrie! Now's your time, Johnny! My dear boys, did I not promise long ago to take my friends by the hand and lead them on a march to the gates of Paris? Allons! vive la Liberté!" To which John Bull replies joyously, "Rule Britannia!—Britannia rules the waves!—Ça ira! ça ira!" His sword has slipped out of its scabbard, and he is in a fair way to spit himself upon its point. The "Little Friends" are leading "the Party." Fox blows a horn (Johnny is marching in his footsteps), and M. A. Taylor, a Liliputian copy of the chief, is running between his legs; Nicholls with his quizzing glass, and Lord Derby with his hunting horn, are drawn as pigmies; Tierney and the Dukes of Norfolk and Bedford are pulling John forward; while Sheridan, Moira, Burdett, and General Walpole are pushing in the rear.

A month later Gillray published a more pungent view of the evils supposed to be prepared for poor Britannia under the treaty with France.

November 9th, 1801. "*Political Dreamings!—Visions of Peace!—Prospective Horrors.*"— Windham, leader of the opposition to peace, had employed his eloquence to conjure up the evils which one section of the community anticipated :—

> "Windham's in prognostics stout,
> But who the deuce can find them out?"

His rest is disturbed by political dreamings, which convey the most lugubrious forebodings. A vulture, symbolical of France, perched on a branch of laurel, is hissing "peace," while its talons are dug into

Britannia Victhained.

the heart of a hare, its victim. The treaty of peace is marked England's "Death Warrant." Lord Hawkesbury is sleepily signing it, while Pitt, his finger to his lips, is guiding the hand of his protégé. Bonaparte is dragging Britannia to the guillotine; she is in fetters, and her shield and trident are broken; a ghastly skeleton of Death is holding the cord in readiness to release the knife. This figure, which wears a gory bonnet-rouge, is mounted upon stilts—darts of Death; the points are destroying all that Englishmen were supposed to regard with peculiar pride: her list of conquests—Cape of Good Hope, Malta, Egypt, &c. &c.—

crowns, mitres, and ensigns of the Monarchy, besides the national roast-beef, plum-pudding, and old stout. St. Paul's Cathedral is in flames, a Republican ensign is floating over the Tower, and a French fleet occupies our waters. Fox, as the demon of revolution, is chanting "Ça ira." On one side are the headless ghosts of the French nobility and clergy, early victims of the new Government, and a long file of decapitated British peers are petitioning the dreamer——"Ah! see what is to become of us, poor Englishmen of consequence!" Justice appears at the side of the bed, in agonized condition; her sword and scales are powerless.

The Whigs, supposed to count upon Britain's downfall for their personal gratification, are represented as rats eager for the smallest pickings. "The hunger of the party is too great for the national larder," said Horne Tooke; "hence they are reduced to the necessity of cutting a small loaf into many slices, and tearing a little fish into many pieces." The spoilers are feasting on a box of "Treasury candle-ends." Erskine and Sheridan have secured the tit-bits of "place;" Tierney and the Dukes of Bedford and Norfolk have the run of office; M. A. Taylor, Lord Derby, and Walpole are hastening to secure their share of the "cheeseparings" of pension and place, upon which Nicholls, Colonel Hanger, Horne Tooke, Sir F. Burdett, and Sir John Shuckborough are greedily regaling.

At first the new administration went on smoothly; it escaped any rough assaults, in the eagerness of the old Whig opposition to attack its predecessors. They imagined that Pitt and his colleagues had been overthrown by the weight of their own iniquities, and they talked of visiting them with parliamentary censure, and even with impeachment. The leader in the projected attack was to be Sir Francis Burdett, and great threats were held out, which, however, had no serious result. A caricature by

POLITICAL DREAMINGS.—VISIONS OF PEACE!—PERSPECTIVE HORRORS!

Gillray, entitled *Preparing for the Grand Attack, or a Private Rehearsal of the Ci-devant Ministry in Danger,* published on the 4th of December, 1801, represents Burdett rehearsing for his speech against the Ministry. The chivalrous Baronet is mounted on a "List of the London Corresponding Society;" his action is most energetic; scraps of "clap-trap" are fluently poured forth—"See the causes of all our woe:—Oh, my ruin'd country!—Enslaved!—Oh, traitors!—Expiring Liberty!—Aristocratic villains!—Oh, unaccounted millions! murdered myriads!—Oh, gallows!—Block!—Guillotine!—Ça ira! Ça ira!" Fox is supporting a formidable scroll of "Ministerial Crimes and Misdemeanors;" the chief offence is "rejecting the proffered reconciliation with the enemies of loyalty and Old England until peace could be ratified upon honourable terms!" This document, many yards in length, is engaging Horne Tooke's attention, who acts as scribe, and is engrossing fresh charges, while Sheridan is encouraging the pupil to employ stronger emphasis.

We have now to consider the studies of society issued in this year.

Gillray, as we have traced, lived in times and amidst surroundings which are remarkable for the interest attaching to them historically. We have noticed the cartoons published upon the "Hero of the Nile" in his public capacity; we have now to remark on another phase of his career—his attachment to Lady Hamilton.

February 6th, 1801. *Dido in Despair,* introduces us to the interior of Sir William Hamilton's sleeping apartment. The open window displays the British fleet sailing away; the Admiral's flag-ship is the last to leave. This prospect is too affecting for the emotions of Lady Hamilton; she has forsaken her slumbering lord, and with tearful eyes and outstretched arms is manifesting anguish at her hero's departure. The satirist has drawn Nelson's mistress as a lady of huge proportions and exaggerated rotundity. The name of Lady Hamilton (Mary Ann Hart) is surrounded with an air of romance; her beauty; the grace of her figure; her elevation; the influence she exerted at Naples; the fascination she exercised over Nelson, and the neglect she encountered after the death of the hero, by whose last wishes she was confided, a dying trust, to the country for whose cause his life was given, and which was so much indebted to his valour—all these circumstances promote the interest attaching to Lady Hamilton. Romney has painted Lady Hamilton as Ariadne, and in this character she will be long remembered. The charm of her face is evident in these portraits. Romney, besides innumerable sketches, is said to have finished thirteen pictures of the lady. She also sat for the Cleopatra in Boydell's Shakspeare, and for many other pictures. In Gillray's print an open scrap-book is lying on the sofa, "Studies of Academic Attitudes, taken from Life," a volume of classic studies from Greek and Italian artists having been notorious as Aretine's, or "Lady Hamilton's Attitudes." A group of suggestive antiquities from Herculaneum, Naples, and Caprea connect the lady with the antiquarian researches of her husband; below the plate appears this parody :—

> "Ah where, and ah where, is my gallant sailor gone?
> He's gone to fight the Frenchmen, for George upon the throne;
> He's gone to fight the Frenchmen, t' lose t'other arm and eye,
> And left me with the old Antiques to lay me down and cry!"

A companion print was issued a few days later (February 11th), containing a portrait of Sir William Hamilton, as *A Cognoscenti contemplating the Beauties of the Antique.* The quaint figure of the diplomatist and antiquarian, clad in out-of-date garments, is peering through his spectacles at a damaged head of the beautiful Lais; busts of Midas, Apis, and Cupid, and various other curiosities, the allusions of which are easily fathomed, are scattered about the chamber. On the wall is a clever caricature of Sir William as Claudius (the venerable collector had the reputation of a bon-vivant); a picture of Mount Vesuvius in eruption, and sketches of Lord Nelson as Mark Antony, and Lady Hamilton as Cleopatra, pledging her admirer in a glass of gin. There is preserved by the hand of an eye-witness a curious picture of Nelson and his party during a visit they paid to Dresden. The Admiral and his train were entertained by Mr. Elliot, the official representative of England at the Court of the Elector. This gentleman foretold a future for his fair guest which was not realized: he prophesied that Lady Hamilton would play a great part in England, and captivate the Prince of Wales, "whose mind," he said, "was as vulgar as her own." Lady Hamilton went through her attitudes where she visited in Dresden; and

the writer describes her imitations of the best known statues and pictures, which, it is recorded, were remarkably graceful, accurate, and rapid in execution. Her chief imitations were from the antique. " One or two Indian shawls, some antique vases, a wreath of roses, a tambourine, and a few children were all the appliances required." Her dress consisted of a simple gown of calico, " very easy," with loose sleeves. " It was a beautiful performance, amusing to the most ignorant, and highly interesting to the lovers of art."

While under the roof of Mr. Elliot the Admiral and his party exhibited themselves in bold colours. " Lady Hamilton," in the words of our authority, " repeated her attitudes with great effect; after dinner she declared she was passionately fond of champagne, and took such a portion of it as astonished me. Lord Nelson was not behindhand, called more vociferously than usual for songs in his own praise (a poetess formed part of the escort—she composed the lyrics which Cleopatra sang in honour of her hero), and after many bumpers proposed the Queen of Naples, adding, ' She is my queen; she is queen to the backbone.' Their host, who was anxious to prevent an exposure, endeavoured to stop the effusion of champagne, and effected it with some difficulty; but not until Moll Cleopatra and her Antony were pretty far gone. She then acted Nina, and danced the *Tarantola*. During her acting Lord Nelson expressed his admiration by crying, ' Mrs. Siddons be ———!' Lady Hamilton was offended at the want of respect on the part of the Elector, who it appears declined to receive her at Court. Mrs. Elliot, to console her, good-naturedly assured her it would not amuse her—' the Elector never gave dinners or suppers.' ' What?' cried she, ' no guttling!' Sir William, the grave diplomatist and man of science, wound up the evening by performing feats of activity, hopping round the room on his backbone, his arms, legs, star and ribbon all flying about in the air."

We also extract an opinion expressed in an earlier description of *Dido Forsaken*. " Though it is well known that the great captain was the object of her ladyship's idolatry, it is equally well known that Sir William's devotion to the hero was equally ardent—for did he not dance himself within an inch of his life in honour of the victory over the Danes? It was said in Italy ' that they were both bewitched by the gallant admiral.' "

" That the correspondence between the modern Æneas and his Dido—however it might have been a subject for private regret or public animadversion—produced incalculable and universal benefit is too well known to admit of dispute; for to Lady Hamilton's influence at the Neapolitan Court alone was Lord Nelson indebted for those indispensable resources without which his fleet could not possibly have proceeded to Aboukir Bay. Had he then returned to England there had been no battle of the Nile; and had he not achieved that glorious victory what might have been the fate of England, of Europe, and the whole world? That this lady is now a Dido dumb (according to Professor Porson's pun on the Latin *gerund*) is past all doubt, though fame should not be dumb in praise of such a Dido." Lady Hamilton died in France; her latter years were spent in obscurity—embittered by absolute want.

May 15th, 1801. *Playing in Parts.*—This plate, which is etched from the design of an amateur, has enjoyed a large share of popularity. The picture is remarkably spirited; it reproduces the appearance of a musical gathering, such as might be realized at the beginning of the nineteenth century. A fair performer, dressed in the height of the mode, is playing with animation upon the instrument which represented the infancy of the pianoforte. In 1801 wigs, of the quaintest shapes, had not entirely disappeared before the custom of wearing the natural hair; pigtails and queues, or " clubs," were still plentiful. It may also be observed, that regimentals maintained their place, and gentlemen in the service of the King wore their uniforms indifferently, on duty or in private, " mufti" being then almost unrecognised amongst professional men. Two gentlemen, of modern exterior, are playing on the flute. Behind the quartet an animated flirtation is proceeding unsuspected by the musical amateurs. An officer, in the background, while impressively shaking hands with a corpulent general, is practically demonstrating that a sword is an awkward appendage to carry into gentle society.

Another print, *Forming a Line*, indicates a remarkably active officer, who is regulating the position of his men, drawn up in files, by lunging his cane straight out from the shoulder in a fencing position, to the serious danger of any private who may be in advance of his ranks. Gillray's talent for embodying abstract ideas in a tangible form was peculiarly striking. *Gout*, to which we have already alluded, was a

good example of this facility. The figure of "Care," published (June 16th, 1801) under the title of *Begone, dull Care; I prithee begone from me!* is also an excellent example. "Care," sitting like a dead weight, with a melancholy, brooding, nerve-tortured countenance, with knitted brows and down-drawn mouth, seems lost in painful contemplations; his long, lean, sinewy body, twisted into uncouth shapes, is unclothed,

Playing in Parts—An Evening Concert.

save by a mop of loose ragged hair; his heavy hands rest on his knees, the long lean fingers stretch their nails a dreadful distance, while his feet are lengthened in proportion. This weird conception has dropped in to inflict his company on a jolly parson, who is fortifying himself into contempt of his lugubrious visitor by drowning his nervous perceptions in the bottle. "A list of tithes of the parish of Guttledown" pinned to the wall enlightens us as to the fact, that the fuddled personage with blossomy face—who is snapping his fingers and raising his gouty foot at "Care"—is the vicar in person; his clerical dress is disordered, his wig is thrown on hind part before; and his smoking pipe and full glass appear to have temporarily deadened his sensibility to the power of "Care;" but there the figure sits immovable, and it is easy to recognise that in the end his empire will reign paramount.

November 11th, 1801. *Metallic Tractors*, represents a humpbacked doctor (Perkins), with grave professional face, and wearing a pigtail, which sticks straight out like a bell-pull. He is performing an operation with a long pin of metal, on the nose of a stout person seated in an arm-chair, who suffers unceasingly from the effects of this novel treatment; the "Metallic Tractors"—which in this case may be exercised to cure a "jolly nose"—are drawing jets of flame from the organ in question. Materials for brewing brandy-punch are scattered over the table; they sufficiently account for the flaming condition of the gentleman's proboscis. An advertising page of the *True Briton*, displayed before the patient, explains the quackery: "Perkinsism in all its glory; being a perfect cure for all disorders, red noses, gouty toes, &c. &c." Doctor Perkins pretended to the discovery of an invention to cure every sort of disease, and the gullibility of the public enabled him to realize a considerable amount of profit during the success of his empiricism.

Dec. 1st, 1801. *Anacreontics in Full Song*—

> "Whilst snug in our club-room we jovially 'twine
> The myrtle of Venus with Bacchus's wine!"

We are here introduced to one of the convivial meetings which were pretty generally patronized at the beginning of this century. "The feast of reason and the flow of soul" has evidently been freely indulged; the clock indicates the hour of four.

Clubs of this description were numerous at the date of this caricature. A curious history might be written of the convivial clubs which have flourished within the century: the old and new "Beefsteak Club," the "Humbug Club," the "Anacreontic Society," and a host of jovial companies, which under titles more or less eccentric have "had their day." The members were recruited from every class, extending from the Prince of Wales to the linkmen!

The group pictured by Gillray is tolerably representative. A deformed figure, in spectacles, is croaking over one of Captain Morris's Bacchanalian staves; above him hangs a portrait of their patron saint, Anacreon. The figure of Time, seated astraddle a cask, is painted on the clock-case. Each of the members is marked by some indication of his profession.

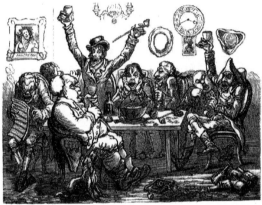

Anacreontics in Full Song.

Among the social portraits issued by our artist in this year we may particularize—March 10th— *A pair of Polished Gentlemen.* Two large boots, of shapes then in fashion, with long-pointed toes, serve as pedestals for the heads of a brace of notorious fops. The face of Skeffington, who with his ordinary vacant grin was once an institution, is leering over the brim a tasselled "hessian;" while the delicate features of the Hon. Montague Matthews, a more refined dandy, appear above an elegant riding boot.

Blacking, it may be remembered, engaged the attention, at one period of our history, of the very highest in the realm. The Prince Regent in person devoted his noble mind to this absorbing study. Brummel and other historical dandies were vastly curious on this point. Much as a man of taste collected works of art, "bucks" who pretended to refinement accumulated "blacking," in studios set apart for the researches to which their mornings were dedicated. This print in some degree embalms the oddity. "A Bottle of Royal Blacking" is broken and disregarded; a cake of Holdsworth's is by its side; two huge tomes on chemistry, a flask of "pine-apple," and a vial of "spirit of salt," indicate the experiments of Matthews. A bottle of "The Prince's Recipe," a vial labelled "Mr. Broomhill's Recipe," a pair of brushes, a pestle and mortar, an "Essay on Blacking" (a ponderous work), and a pat, evidently of his own mixing, attest the activity of "Skeffy" in pursuit of this science.

On the 15th of April, 1801, Gillray published the portraits of two noblemen interested in the Union, as *Corporal Stamina* and *Mental Energy.*

Corporal Stamina represents a portly personage, as the title implies—Lord Cholmondeley. His

lordship, who aspired to be a man of fashion, wears a great length of hair, gathered into a tie; his coat, abounding with buttons, exhibits a large proportion of waistcoat; striped "shorts" and stockings, heavy top-boots, and large spurs complete the details.

Mental Energy. This figure, which represents an old-fashioned promenader, wearing a close black wig, is described as Lord Clare, who was especially active during the completion of the Union.

Tommy Onslow—"the Father of 'Whips.'"

"WHAT CAN LITTLE T. O. DO?

"What can T. O. do?
Why, drive a phaeton and two ! !
Can little T. O. do no more ?
Yes, drive a phaeton and four ! ! ! !"—(May 1st, 1801.)

The artist here introduces us to a celebrity of the past, the patron saint of "four-in-hands," and one of the traditional promoters of "coaching tastes." In Gillray's plate we meet "little Tommy Onslow" (afterwards Lord Cranley) much as he might have been seen in the flesh in the artist's own day. The vehicle the honourable whip is "tooling" is almost an antiquarian curiosity, long numbered with the past. The springy body, from its elevated appearance, excites the impression that a sudden jerk must shoot the driver high into the air. The fidelity of T. O.'s coachee-like exterior is worthy of notice. The greatcoat is a wonder of art: the collar, the quadruple capes, its length, and the arrangement of buttons, must have provoked the envy of professional Jehus; his pigtail twisted like a riding whip, and the haybands wound round his ankles, attest the consistency of the entire "turn-out."

"This noted gentleman," observed a writer who had witnessed his exploits, "was so skilful a whip, that he might be daily seen, in the high spring-tide of fashion, picking his way, four-in-hand, in and out, amidst the crowded cavalcade of Bond-street, driving to a hair's breadth. The feats of the charioteers of antiquity have survived in the lyrics of their poets. We only want a British Homer to do justice to the merits of such a native whip."

One of the equestrians riding behind little T. O.'s splendid phaeton appears, from his deformity, to be intended for Lord Kirkcudbright.

The success of Tommy Onslow's "turn-out" induced the artist to satirize the equipage of another notoriety, under the title of "A Welsh Tandem" (June 21st). Three stout gentlemen, seated in a row, occupy an imitation of T. O.'s chariot, made on a scale proportioned to the steeds—which, in compliment to the nationality of the riders—are a team of goats. A rocky landscape, and a finger-post, pointing "to Wynnstay," indicate the country through which the tandem is travelling. The riders, who are intended for Sir Watkin Williams Wynn and his two brothers, wear leeks in their hats, with the motto, "Ich dien."

July 13th, 1801. *A Lioness*, pictures an immoderately corpulent figure of a middle-aged lady, wearing an Elizabethan ruff of vast proportions. Her person would, in the present day, be considered insufficiently covered, but the light costume then prevalent for evening undress is hardly exaggerated.

The lady—whose head is adorned with a bird of paradise, and other trifles—is intended for Mrs. Lyons, the wife of a financier and loan contractor, the Rothschild of his day. The exterior of his lady warrants the assumption.

December 22nd, 1801. *Mandane—a Bravura Air*—represents the famous Mrs. Billington, "drawn from the life." The portrait presents a stout lady, dressed in theatrical style; a plume of feathers in her hair and a profusion of jewellery dispersed over her person. Her right hand, loaded with rings, is placed over her heart, the left hand is extended. The eminent vocalist is evidently singing "a Bravura" with impassioned feeling. "Mandane," in Dr. Arne's opera of *Artaxerxes*, was one of Mrs. Billington's famous impersonations. Her career was surrounded by the air of romance which marked so many of her fair contemporaries. The youth of this lady was devoted to the most arduous study. Her early talents were cultivated to the utmost perfection attainable by rigid practice, and by studying under the best masters at home and abroad. The life of Mrs. Billington was one succession of operatic triumphs. She was allowed to be the greatest native vocalist this country had produced. Her voice and accomplishments were so remarkable that all Italy—the land of song—competed to offer her engagements. Her first husband, Mr. Billington, died suddenly at Naples, while proceeding to the theatre. Some years later she married Mr. Felissent. At the date of Gillray's portrait, Mrs. Billington had recently returned from Italy. The whole town became frantic about her performances, and both opera-houses were so eager to secure her services, that an arbitrator decided she should appear at each theatre alternately. Her incessant exertions (it appears that the rigorous study commenced almost in her infancy was never relaxed) rendered her retirement imperative in 1809. Mrs. Billington finally quitted England in 1817, and retired with her husband to her estate of St. Artien, near Venice, where she died unexpectedly, from poison it is suspected. Mrs. Billington is described as the foundress of the English school of singing. Her portrait occurs in a later caricature.

1802.

The political events of this year were unimportant. The ad interim Addington Ministry remained in office, to the general surprise. The First Consul Bonaparte took advantage of the peaceful relations towards England to forward his ambitions on the Continent, unchecked by his traditional enemy. Paris was once more opened to pleasure-seekers, and we find at the close of the year, Fox, with other celebrities, availed themselves of the circumstance to gratify their curiosity.

March 1st, 1802. *Sketch of the Interior of St. Stephen's, as it now Stands.*—The Speaker and one of the clerks of the House are introduced, together with the table, mace, &c., while the caricaturist admits us to a glimpse of the new occupants of the Treasury benches. "Dr. Addington" is mildly holding forth on the "Treaty of Peace with the Democratic Powers." His pocket contains a "List of the New Administration." His supporters—a mixed group of Whigs and Tories—are ranged round him. Lord Hawkesbury, the leading member, is seated in a contemplative attitude; he uniformly affected caressing his chin with his finger and thumb. Dickinson, Nicholls, Tierney, Wilberforce, and others make up the motley assembly.

On the 8th of April, Gillray published a pair of subjects entitled *Despair* and *Hope*, which originated in a somewhat singular circumstance.

A Government acceptance, given by the "Sick and Hurt" Office, had been returned unpaid. Robson enlarged on this circumstance in a Committee of Supply. He charged the Administration with profuse expenditure, and observed—"The finances of the country were in so desperate a situation, that Government was unable to discharge its bills, for a fact had come within his knowledge, of a bill accepted by Government having been dishonoured."

The artist took advantage of this extreme statement, due to some informality, to picture Robson, the image of "Despair," thus addressing the Ministers—"We're all ruinated, sir! all diddled, sir!! —Abused by placemen, sir!!!—Bankrupts all, sir!—not worth sixteen pounds, ten shillings, sir!" Bundles of papers are seen in the pocket of the indignant member—"Ignorance of the old Administration"—"Stupidity of the New Administration"—"Charges," &c. Tyrwhitt Jones is making notes on

Sketch of the Interior of S^t *Stephens as it now Stands.*

the incompetence of the Ministry. His hat contains various hostile documents—"Ministerial Tricks—Plunder, Blunder, Collusion"—"Impeachment," &c. Sir Francis Burdett is behind.

"Hope" tells a different story. Dickinson is ruminating in the lobby, musing on the question before the House:—"Let me see—25 Millions! how are we ruined?—Ten per cent. for my money!—Income Tax taken off! Well! well!"

The interior of Parliament is seen through the half-opened door. Addington is holding forth on his finance, a paper, marked "25 Millions," in his hand, while his colleague, Hawkesbury, is grasping a "Treaty of Peace," in a meditative attitude.

The repeal of the income-tax gave universal satisfaction; and the people in general believed in the efficacy of Pitt's grand project of the sinking fund to relieve them from much of the burden of the public debt. Some of the caricaturists ridiculed the popular credulity on this point. The mania for balloons had been revived, after the reconciliation with France, where they still remained fashionable, and were more satirized than in England; and in a caricature entitled *The National Parachute, or John Bull conducted to Plenty and Emancipation,* published on the 10th of July, Pitt is represented supporting John Bull in the air in a parachute, to which is attached a wicker basket, marked—"Sinking Fund." The simple John is delighted with the glimpse he has obtained of his own United Kingdom—"the Land of Emancipation." The parachute is covered with "Interest" and "Compound Interest." Above is a ballast weight of "Millions per annum;" the strings of "National Debt" are burst asunder.

To quote an earlier writer on this cartoon—"'The national debt,' said the 'immaculate one,' 'is a national blessing.' John rubbed his hands. 'Give us a few millions more annually, and we will pay it off,' said the State logician. John did not understand how; but Pitt said it, and Johnny huzzaed, and swore it was orthodox."

While the new peace occupied everybody's attention, the Parliament was allowed, without much opposition, to vote a million sterling to pay off debts contracted on the Civil List. On the other side, Republicanism still appeared to have some advocates, and the close of the year witnessed the discovery of the mad conspiracy for the assassination of the King, and the overthrow of the constitution, by Colonel Despard and his companions, who were executed early in 1803. A new Parliament had been elected in autumn, in which Westminster was again contested with obstinacy. In France, on the 6th of August, 1802, Bonaparte advanced another step in his course of ambition, by obtaining the appointment of Consul for life: it was but another name for a crown.

The peace with France, definitely signed at Amiens 25th March, was at first hailed with joy throughout the country. It produced within a few weeks illuminations, feasts, congratulatory addresses, sermons, and poems, in great profusion. Englishmen went to visit Paris in hundreds and thousands, and this country was inundated with French fashions and inventions. Among the English visitors to France was Charles James Fox, who went to pay his respects to the future Emperor, in company with his nephew, Lord Holland, and with Erskine, Grey, and some other members of the Opposition in Parliament. They were treated with marked attention by Bonaparte; and their admiration was carried to a degree of indiscretion which did not increase their popularity in England, where they were accused of obsequious flattery to the oppressor of Europe. On the 15th of November, Gillray published a caricature entitled *Introduction of Citizen Volpone and his suite at Paris—Vide the* "Moniteur" *and* "Cobbett's Letters."

The First Consul, surrounded by the glitter of his new empire, is seated on his ceremonial throne. The Janissaries attached to his person from the Egyptian campaign, form "Little Boney's" guard of honour. Fox, in full Court dress, and Mrs. Fox, whose ample dimensions are extravagantly displayed, are making their deferential obeisances at the Court of the Tuileries. In the Whig chief's pocket are "Original Jacobin manuscripts," in allusion to the avowed object of his visit to Paris. O'Connor, who had previously negotiated with the Directory for the invasion of Ireland, is acting as Master of the Ceremonies, and introducing Napoleon to the select knot of his English admirers. In O'Connor's pocket is a paper referring to his trial at Maidstone. Erskine, in his lawyer's gown, is bowing impressively. Lord and Lady Holland are in the rear; while another member of the party is saluting the floor in his eager respect. Revolutionary odes, by Citizen Bow-ba-dara (Bob Adair), and "Intelligence for the *Morning Chronicle*," are seen in his pockets.

Fox's visit to Paris was undertaken while preparing his "History of James the Second and the Revolution." He professed to take advantage of the opportunity offered by the peace to consult the original papers and documents contained in the archives of the Paris Foreign-office. Mr. Adair (afterwards Sir Robert Adair), Mr. (afterwards Lord) St. John, and Mr. Trotter, Fox's private secretary (who prepared his "Memoirs"), assisted Fox's researches. Every facility was afforded by Bonaparte's Government, and copies were obtained of important despatches and correspondence. Lord Macaulay, when engaged on the same period of history, had access to the materials Fox had collected on this occasion. He speaks highly of the judgment and minute accuracy which influenced Fox's researches.

The arrival of the untiring advocate of peace was hailed by the French nation with popular enthusiasm; but the retiring disposition of the statesman, and his dislike to ovations, disappointed his admirers.

Fox attended a levee at the Tuileries. In passing through the state apartments he observed that busts of himself and "the hero of the Nile" occupied conspicuous positions.

After the introduction of the diplomatic circle, the English Ambassador presented Mr. Fox. Quoting from Trotter's "Memoirs," "The First Consul was of a small and by no means commanding figure, dressed plainly, though richly, in an embroidered coat, without powder in his hair, looking, at first view, like a private gentleman, indifferent as to dress, and devoid of all haughtiness in his air." Bonaparte was a great deal flurried, and, after indicating considerable emotion, very rapidly said, "Ah, Mr. Fox! I have heard with pleasure of your arrival. I have desired much to see you. I have long admired in you the orator and friend of his country, who is constantly raising his voice for peace, consulted that country's best interests, those of Europe, and of the human race. The two great nations of Europe require peace; they have nothing to fear, they ought to understand and value one another. In you, Mr. Fox, I see with much satisfaction that great statesman who recommended peace, because there was no just object of war, who saw Europe desolated to no purpose, and who struggled for its relief." Mr. Fox said little or rather nothing in reply; to a complimentary address to himself he always found it repugnant to answer; nor did he bestow one word of admiration upon the extraordinary and elevated character who addressed him. A few questions and answers relative to Fox's tour terminated the interview.

Erskine was next presented. Bonaparte seemed to be ill-informed as to the reputation of the Whig Chancellor. "Etes-vous légiste?" (are you a lawyer?) was the slighting remark passed on this advocate of freedom. After attending a second levee, Fox was invited to dine at the Tuileries. The intercourse on this occasion was less reserved. Bonaparte deprecated the inconveniences a government might experience from an abuse of the liberty secured by the British Constitution; and Fox brusquely replied, that was the very reason he admired it. The First Consul indignantly expressed his personal antipathy to the members of Pitt's late Cabinet, and particularly referred to Windham. It was his conviction that Pitt's return to office would signify a continuance of the war.

Miss Burney was in Paris the year of Fox's visit; she attended a levee held in the Tuileries. Her observations on the scene are worthy of being recorded. Bonaparte was naturally the special object of her attention. She describes the audience as too enthusiastic for his strength; his health had suffered severely from the effects of the Egyptian campaign, and the events which had succeeded his return to France. The showy generals deemed it prudent to rescue their little chieftain by force from the importunities of numerous petitioners, whose entreaties seemed to bewilder him.

"As it was," continues the Diary, "I had a view so near, though so brief, of his face, as to be much struck by it. It is of a deeply impressive cast, pale even to sallowness; while not only in the eyes, but in every feature, care, thought, melancholy, and meditation are strongly marked, with so much of character—nay, of genius, and so penetrating a seriousness, or rather sadness, as powerfully to sink into an observer's mind. Yet though the busts and medallions I have seen are in general such good resemblances that I think I should have known him untold; he has by no means the look to be expected from Bonaparte, but rather that of a profoundly studious and contemplative man, who 'o'er books consumes' not only the 'midnight oil,' but his own daily strength, 'and wastes the puny body to decay' by abstruse speculations and theoretic plans, or rather visions, ingenious but not practicable.

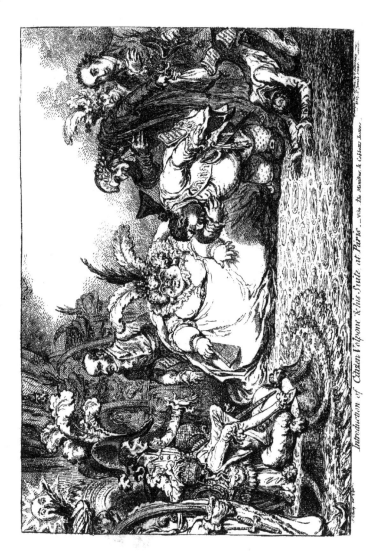

Introduction of Chrism Volpone & his Suite at Paris. —Vide *The Member & Cabinet Letters.*

But the look of the commander who heads his own army; who fights his own battles; who conquers every difficulty by personal exertion; who executes all he plans; who performs all he even suggests; whose ambition is of the most enterprising, and whose bravery is of the most daring cast;—this, which is the look to be expected from his situation, and the exploits which have led to it, the spectator watches for in vain. The plainness also of his dress, so conspicuously contrasted by the fineness of all around him, conspires forcibly with his countenance, 'so sicklied o'er with the pale cast of thought,' to give him far more the air of a student than of a warrior."

The unsubstantial peace of 1802, and the Ministers by whose exertions it had been brought about, found small favour from Gillray; he persistently exposed their weak points to an appreciative public.

December 4th, 1802. "*The Nursery, with Britannia reposing in Peace.*"—Britannia, an overgrown baby, is laid to sleep in a cradle too small for her proportions. "Requiescat in pace" is painted above her head. The promoters of the treaty of Amiens are acting as nurses. "The Doctor" (Addington), as an old woman, holding a bowl of "French pap," is rocking the sleeper into fancied security, singing a nursery song of her own composing :—

> "O By—my Baby, my Baby,—
> O By—in Peace! my Dearee!
> For such a sweet Nap as this,
> You never had, far nor nearee!"

Lord Hawkesbury is second nurse, while Fox, as a brawny beldame, is warming "French cambrics" at the fire for the infant Britannia. A "composing draught," a box of "opiate pills," and a "rod in pickle," indicate the nature of Fox's specifics.

Gillray's caricatures of manners and fashions issued in 1802 are unusually interesting, as they preserve many details worthy of attention. Among other subjects he satirized the fashionable mania for theatricals.

The general taste for the drama had certainly increased towards the end of the last century, and it was evinced in the new taste for private performances amongst the aristocracy. The houses where this fashion was indulged in with greatest splendour were Wynnstay, the seat of Sir W. W. Wynne; Wargrave, the seat of Lord Barrymore; and Crewe Hall, near Chester. The parties at Wynnstay were especially distinguished for their elegance. At the commencement of the century a society of private, or, as they termed themselves, "dilettanti" actors, was formed in London, and assumed the name of the Pic-Nic Society, from the manner in which they were to contribute mutually to the general entertainment.

An earlier writer upon this subject has recorded the history of the celebrated "Pic-Nic" Society; although its notoriety was the theme of universal gossip at the beginning of the present century, it is now almost lost in obscurity. Fortunately the fame of kindred institutions of the mighty of the *beau monde* is fated to fade ignobly.

"The 'Pic-Nic' was formed upon the plan prevalent among the French, wherein a certain number of ladies and gentlemen formed entertainments, to which every one brought some eatable or drinkable, all of which went to compose the common feast. Lady Albina Buckinghamshire, the biggest and most dazzling star in the hemisphere of fashion, established one in London, on a scale commensurate with the mighty space which she filled in society. Her ladyship, knowing that all lords were not to be viewed as Timons, nor all ladies considered as devoid of meanness, procured a silken bag, from which all the members were directed to draw tickets, each being inscribed with what the drawer was to furnish. This contrivance afforded *lots* of fun. Some rich stingy wight drew a perigord pie, value five pounds, and some younger brother half a dozen China oranges. *Vice versâ*, some angelic fair, with nothing in the world but her face for a fortune, would draw strawberries at a guinea a dozen; and some smart lieutenant of dragoons a dozen of champagne.

"The meetings were first held at the rooms of Monsieur Texier (the finest French reader of his age), and ultimately removed to the Argyll Rooms, where farces and burlettas were performed, in which Lady Albina appeared in the character of "Cowslip," and the huge Lord Cholmondeley actually attempted the personification of 'Cupid.'"

This harmless piece of fashionable amusement produced a greater sensation than it is now possible to conceive. The populace had been so long accustomed to hear of aristocratic depravity, that they could understand nothing private in high life without attaching to it ideas of licentiousness, and there was a notion that the Pic-Nic Society implied some way or other an attack upon public morals. Complaints were made against it which led almost to a pamphlet war. The professional theatricals were angry and jealous, because they thought that the aristocratic love of theatrical amusements which had supported them in their exertions would evaporate in private parties.

Nearly the whole periodical press attacked the Pic-Nics without mercy, and the daily papers teemed with abuse and scandal. The members were ridiculed and caricatured on every side. Gillray produced no less than three caricatures on this subject. The first of these was published on the 2nd of April, 1802—*Blowing up the Pic-Nics, or Harlequin Quixote attacking the Puppets—vide Tottenham Street Pantomime.* The exclusive Society is displayed indulging in one of the orgies the scandal lovers attributed to their gatherings. The members of the Pic-Nic Society are dressed in character for the play of *Tom Thumb.* "King Pic-Nic," a compound Sovereign, is represented by Lord Cholmondeley, who is throwing up his arms in consternation; the figure next to him is said to be General Granville; little Lord Valletort is clad in armour as "Tom Thumb." Lady Buckinghamshire (whose figure is treated somewhat freely), and Lady Salisbury, are horror-struck at the exposure of their revels to the light of publicity. "Harlequin Sheridan"—whose tattered dress and empty purse indicate the loss which his exchequer had suffered by his rivals, the "stage-struck" lords and ladies—is leading the onslaught with spirit. His pen supplies a startling squib; its flashings have disconcerted the noble amateurs. Sheridan was supposed to have been the chief instigator of the attacks which were led off in the columns of the *Courier, Morning Post, Morning Herald, Morning Chronicle,* &c. "Black Jack" Kemble, manager of Drury Lane, recoiling in tragic horror, is supporting his proprietor; Mrs. Siddons, grasping the dramatic dagger, is looking deadly aversion to the revellers; the stout Mrs. Billington, placed on the left, is appropriately warbling forth her own sentiments; Lewis and the leading performers of the day are following the crusade which "Sherry" has instituted. The shade of Garrick, an admirable portrait of the great actor, has burst the stage-boards in his amazement at the degeneracy of the age which has succeeded him.

April 23rd, 1802. *The Pic Nic Orchestra* represents, as its name implies, the musicians who might have accompanied the *Dilettanti Theatricals.* The extensive person of Lady Albina Buckinghamshire is presiding at the piano; behind this fair musician is the Liliputian figure of Lord Valletort, described by Miss Burney as "the neatest of little beaux, with the roses and lilies as finely blended in his face as in that of his pretty wife;" he is sawing away at a large violoncello, while the colossal Lord Cholmondeley is piping on the flute. Lady Salisbury, in allusion to her sporting tastes, is represented blowing a hunting horn.

It has been said, in reference to this *Pic-Nic Orchestra :* "These lords and ladies played their own music. Descendants of the mighty barons, no longer cased in armour, employed that case for their fiddles; while he whose ancestor wielded the battle-axe at Cressy here drew the longbow across a violin; and he whose blood, thrice ennobled, was directly transmitted from the Norman Conquest, conquered the hearts of his hearers with the softer strains of his flageolet. Hence the legitimate sons and daughters of Melpomene and Thespis and the children of Apollo took the alarm, lest their professional services might soon be altogether dispensed with."

Before dismissing the "Pic-Nics," which gradually lost their notoriety, either sinking out of fashion or subsiding before hostile criticism, we will insert a caricature levelled against them early in the following year.

February 18th, 1803. *Dilettanti Theatricals, or a Peep at the Green Room—vide "Pic Nic Orgies."* This print is well elucidated by a contemporary of the caricaturist: "In this busy stirring scene the satirist suggests a reminiscence of Hogarth's well-known picture of *Strollers Dressing in a Barn.* The humorous composition represents a rehearsal and scene of general preparation. The great Lord Cholmondeley, with his quiver-girdle inscribed 'Amor Vincit Omnia,' implies his boasted powers in the field of Venus. Under him is 'the great Alexander, little Lord Valletort, who lost his

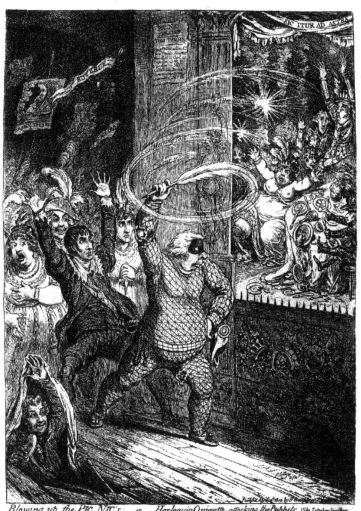

Blowing up the PIC NIC's — or — Harlequin Quixotte attacking the Puppets. Vide Tottenham Street Books.

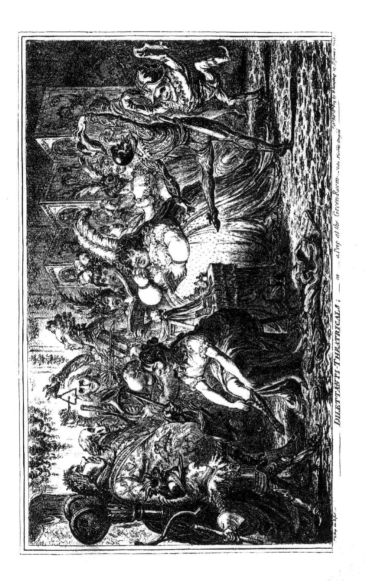

DILETTANTI THEATRICALS; — or — a Peep at the Green-Room.—Vide Public Oregon.

life in a pair of too tight stays!' Lady Salisbury is drawing on the huntsman's boots, and about to assume the breeches, necessary for the part of the 'Squire's Groom;' her noble lord, the tall figure, Polonius *à la toupé*, is playing the fiddle. Lord Carlisle is fitting the bassoon, and Lord Spooner is tingling the triangle. The singers are the celebrated professionals, the Misses Abrahams. Lady Albina Buckinghamshire is touching up her charms at the toilette. Behind, the Heir-Apparent is tripping it with Lady Jersey and Mrs. Fitzherbert. The quintessence of foppery, Sir Lumley Skeffington, is harlequin; and that annoyance of milliners' apprentices, Lord Kirkcudbright, is a sort of human monkey. Behind the screen old Queensberry, the Piccadilly Duke, is saluting Lady ——, and George Hanger is touching the lips of her pretty sister. Lord Derby, as usual, is entertaining the fashionables with a flourish on the horn."

A pair of social sketches issued at this time proved a great hit; their reputation has outlived many contemporary works.

February, 1802. *Tales of Wonder: An Attempt to Describe the Effects of the Sublime and Wonderful. Dedicated to M. G. Lewis, Esq.*—A handsome woman, in the height of the fashion adopted for evening undress, is entertaining three ladies, grouped round the table in attitudes indicative of extreme terror; they are listening with uplifted hands, and countenances expressing the horrors recited from the pages of the famous "Monk" of M. G. Lewis. Pictures of violent abductions and images of supernatural monsters form the ornaments of the apartment.

February 15th, 1802. The second print is entitled *Advantages of Wearing Muslin Dresses; Dedicated to the serious attention of the Fashionable Ladies of Great Britain.*—The costume then prevalent was remarkable for the lightness and transparency of the materials. In the print Gillray has indicated a stout dame receiving genteel company at tea. A heated poker has fallen upon the light robes of the portly hostess; the flames have so terrified the visitors that the table is overset, the urn, the teapot, and the porcelain service are all swept on to the carpet, while the partakers of the meal are paralysed with consternation.

The Royal Institution, a fashionable novelty recently founded, provided our satirist with the materials for a cleverly worked-out picture of the Lecture Theatre, containing the portraits of the leading patrons of science.

May 23rd, 1802. *Scientific Researches. New Discoveries in Pneumatics, or an Experimental Lecture on the Powers of Air.* The lecture-table displays air-pumps, receivers, and pneumatic toys. Doctor Garnet (the lecturer on chemistry, who died in 1802) is practically illustrating his discourse by experimenting upon Sir J. C. Hippesley, who is considerably embarrassed by the active effects of air. Sir Humphry (then Mr.) Davy is assisting the operator. The droll head of Count Rumford (who with Sir Joseph Banks founded the Institution in 1801) is distinguishable near a cabinet of electrical apparatus; behind the Count peers the hawk-like beak—surmounted by spectacles—of Isaac Disraeli. The profile of the Marquis of Stafford (then Earl Gower) may also be recognised. Near Lord Stanhope (in top-boots, and leaning on a stick) is a pamphlet, "Hints on the Nature of Air required for the new French Diving-Boat." Lord Stanhope's immediate neighours are understood to be Earl Pomfret and Sir Henry Englefield. Among the persons interested are Miss Lock (afterwards Mrs. Angerstein), Mr. Sotheby, Mr. Denys (with a maulstick and palette, holding his little boy), Lady Charlotte Denys, Mr. Thodal, a German attaché, and several others, whose likenesses cannot be identified at this date.

The objections raised by the old-fashioned practitioners against vaccination, which had been introduced some six years before this date by Dr. Jenner, furnished the artist with an excellent opportunity for burlesquing the evils which most of the faculty ascribed, in their deeply-rooted prejudices, to the new invention.

June 12th, 1802. *The Cow-Pock, or the Wonderful Effects of the New Inoculation—vide the Publications of the Anti-Vaccine Society.*—Dr. Jenner, an excellent portrait, is seen in the exercise of his discovery; a workhouse lad, impressed into the service as his assistant, is holding a milk-pail filled with "vaccine pock hot from the cow." A second doctor is in attendance, dispensing medicines to promote the effects of the vaccination, which are strongly developed on all sides. Various whimsical results are pictured in the unfortunate subjects with whom the process may be said to have "taken." A

picture in the background, founded on the worship of the golden calf, represents the adoration of a cow.

Among the minor subjects issued in this year may be particularized *A Pinch of Cephalic* (June 25th, 1802), which pictures a comfortable citizen seated before his fire, enjoying the parliamentary debates over pipe and glass; the drowsy effect of thatorder of literature, even in those times of party agitation, has obviously necessitated an antidote against the approaches of Morpheus—an extra-liberal pinch of snuff. Both the face and figure of the reader are thrown into comical spasms, relieved by violent sneezings; his dog is awakened by the reports.

In 1802 Gillray also etched several caricatures of individuals. We may notice :—

January 6th, 1802. *Lordly Elevation*, representing Lord Kirkcudbright, whose dwarfed and deformed figure is perched on the only elevation he is said to have possessed, that of his coronet, upon which the misshapen fop is raised high enough to reflect his vain simper in the toilet glass.

> "Methinks I'm now a marv'llous proper man,
> I'll have my chamber lined with looking-glass,
> And entertain a score or two of tailors,
> To study fashions to adorn my body."

January 16th, 1802. *Fat Cattle, A sketch of Tavistock Farm-yard. Dedicated to the Society for Improving the Breed of Cattle.* The homestead of the Bloomsbury farmer is represented filled with cattle whose superabundant fat hardly allows them to waddle; their no less comfortably provided owner is classed with his thriving live stock, under the head of " Fat Cattle." He cries, pinching the side of a massive ox—" Ah, here's your sort! here's your nine-inch fat, my boys ! Oh, how he will cut up! as my old friend Burke said. How he will tallow in the caul and on the kidneys!"

March 10th, appeared the study of a well-known figure, sketched from the rear, and published without any title. The public of that day had no difficulty in recognising the person represented—the Prince of Wales, dressed in the height of the fashion. A nearly identical portrait is given in *Visiting the Sick* (July 20th, 1806).

March 16th, 1802. *Diana Returned from the Chase.* The Marchioness of Salisbury is introduced as the classic huntress; her habit and under garments have suffered by the mishaps of a rough chase ; a fox's tail is arranged above her hunting-cap. Below the Diana of Hatfield are the lines :—

> " Outstript the winds in speed upon the plain,
> Flies o'er the fields, nor hurts the bearded grain ;
> Men, boys, and women, stupid with surprise,
> Where'er she passes fix their wandering eyes."

February 1st, 1802. *A Bouquet of the Last Century*, a lady in profile proceeding in her chariot to Court. Her stomacher supports a bouquet of formidable dimensions. The likeness is referred to the Dowager Lady Dacre.

July 21st, 1802. *Governor Wall's Ghost*, represents a tall antiquated personage, who frequented the Cider Cellars. He was remarkable for a resemblance (which gained him his nickname) to Governor Wall, who was executed for causing a soldier to be wantonly flogged to death during his government of Goree, Africa.

November 15th, 1802. *Mary of Buttermere*, sketched from the life, pictures a pleasing and graceful rustic figure, bearing a glass of ale to an evil-looking old man. This print revives a story which excited much attention at the time. John Hatfield, a swindler, who represented himself as the Hon. Colonel Hope, member for Dumfries, took up his residence at the house of Mary's father, on the banks of Lake Keswick. He entrapped her into a marriage, and induced several of the credulous inhabitants to cash his drafts before the imposture was detected. In his trunk was discovered the evidence of a former marriage, and other accusing papers. He was arrested and executed on the charge of forgery. Both wives declined to appear as prosecutors on the charge of bigamy.

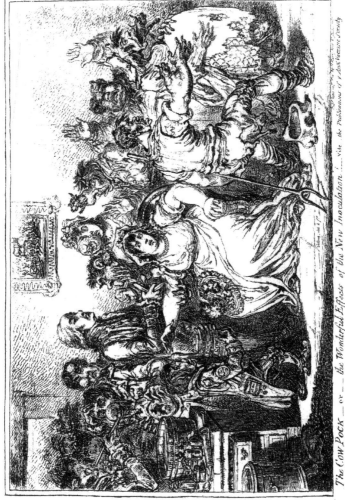

The COW POCK — or — the Wonderful Effects of the New Inoculation! — vide the Publications of the Anti-Vaccine Society

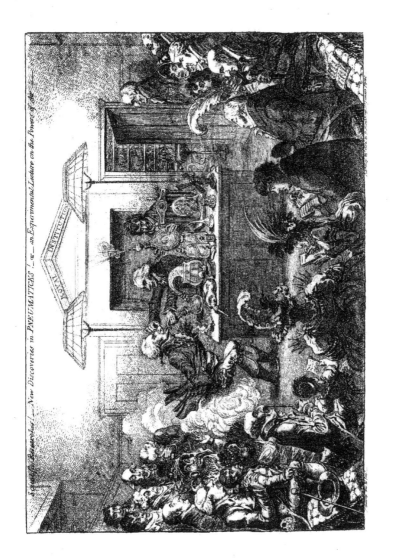

Scientific Researches! —New Discoveries in PNEUMATICKS! —or— an Experimental Lecture on the Powers of Air. —
ROYAL INSTITUTION

1803.

The incapacity of Addington's Ministry, and the descent anticipated from the coasts of Boulogne—the much-talked-of French invasion—furnished Gillray with admirable subjects during the progress of this year.

Although the general dissatisfaction in England was increasing, the peace continued popular till the end of 1802. On the 1st of January, 1803, Gillray satirized the posture of affairs in a humorous caricature, entitled, *The First Kiss this Ten Years, or the Meeting of Britannia and Citizen François.*

Britannia, who has suddenly become corpulent, appears as a fine lady in full dress, her shield and spear leaning neglected against the wall, while the Frenchman has unbuckled his sword and placed it on the ground. The citizen expresses his joy at the meeting in warm terms—" Madame, permittez me to pay my profound esteem to your engaging person; and to seal on your divine lips my everlasting attachment !!!" The lady, blushing deeply at the salute (in the coloured copies a strong tint of red is bestowed on her cheeks), replies—" Monsieur, you are truly a well-bred gentleman !—and though you make me blush, yet you kiss so delicately that I cannot refuse you, though I was sure you would deceive me again !" On the wall, just behind these two figures, are framed profiles of King George and Bonaparte scowling on each other. This caricature enjoyed an unusual degree of popularity; many

The First Kiss these Ten Years.

copies were sent to France, and Bonaparte himself is said to have been highly amused by it.

An earlier writer, describing the feeling at the date of *The First Kiss,* continues—" We have here an allegory of Peace, which, formed into a transparency at the general illumination, would have delighted the mob. The word 'Concord,' set up at the French Ambassador's, being misconceived by the British tars, had nearly brought Monsieur Otto's great hotel about his ears. Had this loving embrace been substituted, John Bull could not have mistaken its meaning."

This most playful ebullition of the satirist's fancy, appearing on the 1st of January, 1803, was bought up as fast as it could be printed, to send into the country as a peace-offering or new year's gift. From this time, however, the communications between the two countries began to take a much less pacific character, and it was more and more evident that the peace could not be of long duration.

A second print, published on the same day, indicates the animosity prevailing against France and her ruler. *German Nonchalance, or the Vexation of Little Boney ; vide the Diplomatique's late Journey through Paris.*—A post-carriage, bearing the Austrian arms, is dashing through Paris, the *valises* on its top are directed " à Londres," its occupant, the Austrian Minister, is taking snuff with an air of infinite composure, nonchalantly surveying the transports of the Little Corsican, who, surrounded by his moustached warriors, is dancing about with frenzied indignation : " Vaten !" he cries; " is there one man on earth who not worship Little Boney ?" The tall hussars have their swords half drawn, ready to avenge the wounded pride of their chief. It appears from this cartoon that an informality on the part of the Austrian Minister, who passed through Paris without paying his respects at the Tuileries, was held in England as an expression of proper contempt for Little Boney, who did not conceal his sense of the omission.

January 5th, 1803. *The Deceptive Nature of the Peace set forth in a Phantasmagoria : Scene, Conjuring up an Armed Skeleton.*—An unholy incantation is proceeding ; within a necromancer's circle Addington, Lord Hawkesbury, and Fox are performing their " black devices;" and Wilberforce, in attendance as their familiar imp, is chanting his " hymns of peace." The British Lion has been boiled down in their caldron; his head is held in reserve, and a little French bantam cock, wearing the cap of Liberty, is crowing over the decapitated member.

Lord Hawkesbury is boiling the pot, by the sacrifice of our conquests. Egypt, Malta, the Cape, Dominion of the Seas, &c., are thrown into the fire. Ireland and Gibraltar are also held in readiness. Addington is presiding over the incantation ; a sack of gold pieces, "to make the gruel thick and slab," is ready by the doctor's side, while a branch of laurels, entwined by a serpent, forms his divining rod. Fox represents the third witch. They have succeeded in conjuring up a Spectre of Peace, with Britannia's diadem, shield, and spear. Her figure is reduced to a ghastly skeleton. Such—the majority argued— would be the result of a hollow peace with a treacherous enemy, undertaken by men who were too feeble for the situation.

The influence secured by the "peace party" was insufficient support for the Ministers in the face of forthcoming difficulties. They endeavoured to strengthen their position by holding out inducements to attract those who enjoyed a reputation for patriotism. Their peace professions neutralized the hostility of Fox. Sheridan, Tierney, and others were now tempted to lend their allegiance. Gillray illustrated this official "netting" under the title of *Bat-catching*, January 19th, 1803. The two Ministers are reduced to snaring. According to a mock quotation from Buffon's Natural History, article "Birds of Night," "bat-catching does not require much art, for flying always in the night they are easily attracted by a dark lantern, and being always hungry may be easily caught by a few cheese-parings or candle-ends. They are so rapacious, that if they once get into the granary they never cease devouring while there is anything left."

The Treasury-gates represent the "granary." Lord Hawkesbury has disposed his net in readiness for the prey, while Addington, kneeling down, is displaying a dark lantern over a hat filled with official candle-ends—"place, pensions, sinecures, annuities," &c. ; while a sack, labelled "Sterling British Corn," is overflowing with golden pieces. Three fine specimens of the bat tribe seem likely to be caught —Sheridan, Canning, and Tierney.

Meanwhile our relations with France were rapidly drifting in the direction of war. The French Consul was anxious to obtain possession of Malta, and while he accused England of breaking the faith of treaties, he acted in everything contrary to the spirit of the treaty which he had so recently concluded with her. He required that we should drive the Royalist emigrants from our shores, demanded that the English press, which he looked upon as one of his most dangerous enemies, should be deprived of its liberty as far as regarded French affairs, and he actually asked for modifications in our constitution. At the same time he was actively employed in exciting a rebellion in Ireland, and distributing agents, under the character of consuls, along our coasts, with treacherous objects, which were accidentally discovered by the seizure of the secret instructions to the consul at Dublin, which contained, among other matters of the same character, the following passages :—"You are required to furnish a plan of the ports of your district, with a specification of the soundings for mooring vessels. If no plan of the ports can be procured, you are to point out with what wind vessels can come in and go out, and what is the greatest draught of water with which vessels can enter the river deeply laden." There began to appear other indications equally distinct of ulterior designs against this country, which it was of the utmost importance to anticipate. Even Fox and his party, while they advocated peace as long it could be maintained, acknowledged that there was room for suspicion. A patriotic indignation was raised throughout the country in the March of 1803, by the publication of an official document, signed by the First Consul, in which he declared that "England alone cannot now encounter France." It was now universally believed that Bonaparte only delayed open hostilities as long as he could gain anything from us by pretended negotiations, and that he was preparing to crush us by the magnitude of his attack. It was the misfortune of this country to have at such a moment an Administration remarkable for its incapacity. Pitt is said to have made a secret attempt to return to power ; but Addington began to love the sweets of office, and was not inclined to quit, and his submissive pliancy to the Crown had gained him the King's favour. The Foxites were afraid that if they entered into Opposition, they would only throw the Doctor, as they all styled him contemptuously, into the arms of Pitt ; and Bonaparte declared publicly that if Pitt returned to power, France would lose all hopes of obtaining further concessions from England.

A caricature by Gillray, published on the 9th of February, is entitled *The Evacuation of Malta.*

The French ruler has seized Addington by the throat, and flourishing his long sword, is forcing him to evacuate Egypt, the Cape of Good Hope, Martinique, Guadaloupe, St. Domingo, Malta, and one conquest after another, until the Minister cries, in consternation, "Pray do not insist upon Malta! I shall certainly be turned out, and I have got a great many cousins, and uncles, and aunts to provide for yet." "All, all!" insists Bonaparte; "and think yourself well off if I leave you Great Britain." A French officer, who is receiving what the Minister gives up, expostulates with Boney's commands: "My General, you had better not get him turned out, for we shall not be able to humbug them any more."

The statement officially made by the French Government, that England was not able to contend with France single-handed, produced a violent outburst of indignation in the House of Lords on the 9th of March. The day before, a Royal message had been laid before both Houses, stating that the King had received positive information that very considerable military preparations were carrying on in the ports of France and Holland, and that he had judged it expedient to adopt additional measures of precaution for the security of his dominions. At the same time proclamations were issued encouraging the enlisting of seamen and landsmen, calling up the militia and volunteers, and ordering the formation of encampments in the maritime counties. The volunteer associations, which had been formed two years before in anticipation of invasion, also began to reassemble. On the debate upon the King's message, Fox seemed to think the apprehensions were premature, and advised caution; Windham, who had violently opposed the peace, now said that it had placed us in a position of weakness towards France, which had rendered us less able to defend ourselves than we should have been had the war continued; but the most patriotic of all patriotic speeches made in the House of Commons was that of Sheridan. He accused Windham of entertaining the same sentiments on the weakness of this country which had been expressed by Bonaparte. "Whatever sentiments both of them may entertain," he said, "with respect to the incapability of the country, I hope and trust, if unhappily war be unavoidable, that we shall convince that right honourable gentleman, and the First Consul of France, that we have not incapacitated ourselves by making peace, to renew the war with as much promptitude, vigour, and perseverance as we have already evinced. I trust, sir, we shall succeed in convincing them, that we are able to enter single-handed into war, notwithstanding the despondency of the right honourable gentleman, and the confident assertion of the First Consul of France. By the exertions of a loyal, united, and patriotic people, we can look with perfect confidence to the issue; and we are justified in entertaining a well-founded hope, that we shall be able to convince not only the right honourable member and the First Consul of France, but all Europe, of our capability, even single-handed, to meet and triumph over the dangers, however great and imminent, which threaten us from the renewal of hostilities."

This debate was made the subject of a clever caricature by Gillray, published on the 14th of March, under the title of *Physical Aid, or Britannia Recovered from a Trance ; also the Patriotic Courage of Sherry-Andrew, and a Peep through the Fog.*—The "peep" exhibits in the distance Bonaparte leading on the French boats, which are to carry over the army of invasion. Britannia, waking suddenly from her trance of security, is struck with the imminence of the danger, and implores assistance in a parody of the words of Shakspeare, "Doctors and ministers of *dis*-grace defend me!" Her armour has been suffered to fall into decay. Addington and Lord Hawkesbury stand by her, giving encouragement; the former, applying a bottle of gunpowder to her nose to revive her, cries in evident fright, "Do not be alarmed, my dear lady! The buggaboos (the honest gentlemen, I mean) are avowedly directed to Colonial service; they can have nothing to do here, my lady—nothing to do with us! Do take a sniff or two to raise your spirits, and try to stand, if it is only on one leg." Jenky, feebly supporting Britannia's cracked shield and broken pointed spear, is observing, "Yes, my lady, you must try to stand up, or we shall never be able to 'march to Paris!'" The torn "treaty of peace" is thrown aside. Sherry-Andrew, decked out in a tattered harlequin's suit, and wearing a fool's cap, with a paper, "Ways and means to get a living," thrust into his belt, is holding a shield on which is Medusa's head, surrounded with "bouncing, envy, stale wit, stolen jests, puffing, detraction, abuse," &c. Sherry, flourishing his lath-wand of "dramatic loyalty," has thrown himself into an attitude of pantomimic threatening against the invaders; he blusters out his menace, "Let 'em come, damme!—damme!!—

where are the French buggaboos?—single-handed I'll beat forty of 'em!!　Damme, I'll pay 'em like renter shares, sconce off their half-crowns, mulct them out of their benefits, and come the Drury Lane

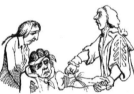

A Theatrical Hero.

slang over 'em!"　A crowd of people are excited in different ways. Fox, half concealing his face in his hat, and with the smoke in his eyes, is very naturally unable to detect the invaders, and wonders "why the old lady has woke in such a fright."

An earlier writer, familiar with the performers in this scene of theatrical defence, has added a note respecting the Addington family :—

"It is said that the father of Lord Sidmouth was a gentleman of the medical profession, a country practitioner of celebrity, from whom perhaps the son early imbibed a desire for political distinction.

"This provincial Hippocrates was so possessed with politics—was so wrapt in the affairs of nations—that he is said to have talked of the *balance* of power when he meant to weigh a drachm. So absent, indeed, was Dr. Addington when his patients wished him present (by whom he was held in reverence), that every member of a family, where the Doctor visited professionally, were enjoined, by all the obligations of affection, neither to leave a newspaper in sight nor drop a hint of Whig or Tory until the patient was pronounced in a state of convalescence."

The negotiations were still persevered in, although it was daily more evident that they would fail to avert hostilities.　Even as late as the 2nd of May caricatures appeared ridiculing John Bull's submission to the continued demands made upon his forbearance. The date just mentioned is that of a caricature by Gillray, entitled *Dr. Sangrado Curing John Bull of Repletion—a hint from Gil Blas—with the kind offices of Young Clyster-Pipe and Little Boney.*—John Bull is so sick and emaciated that even Lord Hawkesbury's assistance is welcomed to prop him up, while Addington performs the operation; the blood which issues from the incision is inscribed with the names of Malta, Ceylon, and the other conquests that were to

John Bull in Bad Hands.

be restored, which Bonaparte is receiving in his hat.　Fox and Sheridan are bringing warm water, and they all exhort the patient to have courage.

Behind Addington the figure of a child is noticeable, holding out his hat, marked "Clerk of the Polls," into which the paternal lancet is directing a stream from John Bull's exhausted arm of 3000l. per annum.　This allusion to a piece of fatherly patronage is said to have proved peculiarly offensive to the "Doctor."　It was freely commented on by contemporary writers.

"The wisest, the greatest, nay even the best of men are not proof against the annoyance of a nickname.　My Lord Sidmouth is understood to have felt exceedingly annoyed by the application to him of the title under which he figures in this plate; hence it has been asserted by some, and believed by others, that this great Minister had rather been sent shirtless to Siberia or to Nova Zembla than consented to have made one of the snug party at the warm, comfortable feast of the loaves and fishes with this marked cognomen placarded on the back of his easy chair.　There is another annoyance hinted at in the title of this piece, 'with the kind offices of Young Clyster-Pipe,' &c., which is supposed to allude to that kind fatherly act of the provident Minister in bestowing on Master Addington, in his tender age, a Clerkship of the Pells, that famous nest for sinecurists, amounting to somewhat more annually than the pension which was bestowed on Nelson, after he had fought nearly a hundred battles, had lost an arm and an

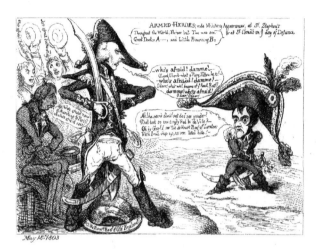

ARMED HEROES

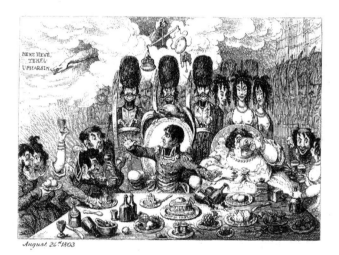

THE HAND-WRITING ON THE WALL

eye, and been otherwise ungenteelly battered and bruised in the service of his country against the enemies of Old England."

A similar pension was declined by Pitt on his earlier retirement from office; the independent young ex-Minister, although unprovided with private resources, declared, when the acceptance of this post was urged on him, he would practise at the Bar rather than become the recipient of a bounty drawn from his country.

It was but a few days after this that our ambassador, who had been personally insulted by Bonaparte, and who had long perceived that the latter had carried on the negotiations merely for the sake of gaining time, received final orders to leave Paris, and the French ambassador, Andréossi, was ordered to quit England. The declaration of war was received throughout England with enthusiastic joy. The falsehoods and prevarications which Bonaparte had made use of throughout the negotiations, which now exposed his true character to the world; the infamous manner in which he had treated the countries that had fallen under his power, and the reckless contempt of the laws of nations with which he seized as prisoners of war the crowds of English visitors whom his peaceful declarations had allured into France—all made the ruler of France an object of such abhorrence and hatred that war seemed to every one preferable to peace, and the Ministers were only rendering themselves unpopular by continuing the friendly relations between the two countries so long. Gillray has perpetuated the memory of this feeling in a clever caricature, published on the 18th of May, entitled *Armed Heroes.* Addington is represented in a ridiculous dilemma, between assumed courage and real fears, boasting aloud, with whispered misgivings in between; the happy contrast of the swaggering attitude and the craven face has been highly commended. Lord Hawkesbury, seated behind him with an equally passive appearance of courage, calls to mind his old threat of marching to Paris. Two other members of the Addington family, for whom the Doctor had provided snug berths, are working up their courage with martial vapourings, which their lengthened faces contradict.

At length the petulant irritability of the First Consul carried him into an excess of fury which could receive but one interpretation.

This scene was graphically pictured by Gillray (May 24th, 1803). *Maniac Ravings—Little Boney in a Strong Fit. Vide Lord Whitworth's Account of a Visit to the Tuilleries (vide Dispatch* dated March 14th). Bonaparte is drawn in his private study. The Consular chair is overturned, the writing table is capsized, and a globe kicked over, on which the whole of Europe is, with the exception of Great Britain, carved out. A heap of English publications are thrown on the floor. "Cobbett's Weekly Register," "Windham's Speeches," "Anti-Jacobin Review," and other evidences of hostility to the ruler of France, have excited Napoleon to dance about in a fit of unrestrained exasperation—tearing his hair and stamping on the offending prints. Napoleon's meditations, suspended during this access of passion, are represented by his "Plan for Invading Great Britain, with a List of the Members of the British Republic;" "List of Future Conquests—Turkey, Persia, China," &c.; "A Plan to Set the Thames on Fire, dedicated to 'Milord Stanhope.'" Decrees to be inserted in the "Hamburg Gazette," "Moniteur," &c., are thrown down with the contents of the inkstands. The Consul's ravings are represented by a torrent of broken denunciations of English newspapers, conquests, trade and commerce, statesmen, prosperity, liberty, Parliament, &c., thus ending—"Hated and betrayed by the French! Despised by the English, and laughed at by the whole world! Revenge! revenge! Come fire, sword, famine! Invasion! invasion! Four hundred and eighty thousand Frenchmen—British slavery and everlasting chains!"

The actual occurrence, as described in Lord Whitworth's despatch (March 14th, 1803), did not fall far short of Gillray's parody, according to the "Annual Register." The exasperation and fury of Bonaparte broke out into ungovernable rage in his own Court, on his public day and in the presence of the diplomatic body of Europe there assembled, thus violating every principle of hospitality, of decorum, of politeness, and the privileges of ambassadors—ever before held sacred. On the appearance of Lord Whitworth in the circle, he approached him with equal agitation and ferocity, proceeded to descant in the bitterest terms on the conduct of the English Government, summoned the Ministers

of some of the Foreign Courts to be witnesses to this vituperative harangue, and concluded by expressions of the most angry and menacing hostility. The English Ambassador did not think it advisable to make any answer to this brutal and ungentlemanly attack, and it terminated by the First Consul retiring to his apartments, repeating his last phrases till he had shut himself in, leaving nearly two hundred spectators of this wanton display of arrogant impropriety in amazement and consternation.

Bonaparte commenced hostilities by seizing upon Hanover and raising a rebellion in Ireland. The former was an inevitable evil, and the latter was soon subdued. But the immense preparations for invasion were a cause of more serious alarm, and called forth a unity of patriotic exertions such as had never been seen before. The volunteers raised in the course of the summer and autumn, who were well armed and soon well trained, amounted to not less than three hundred thousand. Meanwhile France seemed for once earnest in her threats, and she was marching to the opposite coast her best troops in fearful masses. Bonaparte came in person to overlook the preparations, and to take the command of the invading forces when they were completed. He established his head-quarters at Boulogne, on the roads to which finger-posts were erected to remind all Frenchmen that it was the way to London. Every possible means was resorted to for exciting the people against the English, and attracting them to his standard. The soldiers were promised indiscriminate plunder, and they were reminded that English women were the most beautiful in the world, and that no restrictions should be placed on the gratification of their passions. Inflammatory addresses from the cities and towns to the First Consul were followed by equally inflammatory answers. Atrocious falsehoods were published and placarded over the country to raise the national exasperation to the greatest height.

Equally efficacious means were resorted to in England to raise up an enthusiastic spirit of hatred of France and its ruler. People exerted themselves individually, as well as in associations, in printing and distributing what were known as "loyal papers" and "loyal tracts," which were bought up in immense numbers, and the proceeds often applied to the defence of the country. Some of these consisted of exaggerated and libellous biographies of Bonaparte and his family; accounts of the atrocities perpetrated by himself and his armies in the countries they had overrun; burlesques, in which he was treated with ridicule and contempt; parodies on his bulletins and proclamations; and accounts of his preparations for the invasion and conquest of England. Others contained words of encouragement; exhortations to bravery; directions for acting and disciplining; promises of reward; narratives of British bravery in former times; everything, in fact, that could stir up and support the national spirit. Every kind of wit and humour was brought into play to enliven these sallies of patriotism; sometimes they came forth in the shape of national playbills, such as the following:—

<p style="text-align:center">"THEATRE ROYAL, ENGLAND.</p>

"In Rehearsal, and meant to be speedily *attempted*, a farce in one act called THE INVASION OF ENGLAND. Principal Buffo, Mr. Buonaparte, being his first (and most likely his last) appearance on this stage.

"*Anticipated Critique.* The structure of this Farce is very *loose*, and there is a *moral* and radical defect in the ground-work. It boasts however considerable novelty, for the characters are *all mad*. It is probable that it will *not* be played in the *country*, but will certainly never be *acted* in *town*; wherever it may be represented, we will do it the justice to say, it will be received with *thunders* of—CANNON ! ! ! but we will venture to affirm will never equal the success of JOHN BULL. It is, however, likely that the piece may yet be put off on account of the *indisposition* of the principal performer, Mr. Buonaparte. We don't know exactly what this gentleman's merits may be on the tragic boards of France, but he will never succeed here; his figure is very diminutive, he struts a great deal, seems to have no conception of his *character*, and treads the stage very badly; notwithstanding which defects, we think if he comes here, he will get an *engagement*, though it is probable that he will shortly after be reduced to the situation of a *scene-shifter*.

"As for the Farce, we recommend it to be withdrawn, as it is the opinion of all good political critics, that if play'd it will certainly be *damned*.

<p style="text-align:center">"*Vivant rex et regina.*"</p>

Sometimes they were coarse and laughable dialogues between the Corsican and John Bull, or some other worthy, who gave him small encouragement to persevere in his undertaking. Then we had laughable proclamations to his own soldiers, or to those he was threatening with invasion. Now the

invader was compared to a wild beast, or some object of curiosity, for a promised exhibition. Such bills as the following were common :—

"Most wonderful wonder of wonders ! !

"Just arrived, at Mr. Bull's Menagerie, in British Lane, the most renowned and sagacious *man tiger or ourang outang,* called Napoleon Buonaparte. He has been exhibited through the greatest part of Europe, particularly in *Holland, Switzerland,* and *Italy,* and lately in *Egypt.* He has a wonderful faculty of speech, and undertakes to reason with the most learned doctors in law, divinity, and physic. He proves incontrovertibly that the strongest poisons are the most sovereign remedies for wounds of all kinds ; and by a dose or two, made up in his own way, he cures his patients of all their ills by the gross. He *picks the pockets* of the company, and by a *rope* suspended near a *lantern* shews them, as clear as day, that they are all richer than before. If any man in the room has empty pockets, or an empty stomach, by taking a dose or two of his *powder of hemp,* he finds them of a sudden full of guineas, and has no longer a craving for food : if he is rich, he gets rid of his *tædium vitæ ;* and if he is overgorged, finds a perfect cure for his indigestion. He proves, by unanswerable arguments, that *soup maigre* and *frogs* are much more wholesome food than *beef* and *pudding,* and that it would be better for *Old England* if her inhabitants were all *monkeys* and *tigers,* as, in times of scarcity, one half of the nation might devour the other half. He strips the company of their clothes, and, when they are stark naked, presents a *paper* on the *point* of a *bayonet,* by reading which they are all perfectly convinced that it is very pleasant to be in a state of nature. By a kind of hocus-pocus trick, he breathes on a *crown,* and it changes suddenly into a guillotine. He deceives the eye most dexterously ; one moment he is in the garb of the *Mufti ;* the next of a *Jew ;* and the next moment you see him the *Pope.* He imitates all sounds ; bleats like a lamb ; roars like a tiger ; cries like a crocodile ; and brays most inimitably like an ass.

"Mr. Bull does not choose to exhibit his *monkey's* tricks in the puffing way, so inimitably played off at most foreign courts ; as, in trying lately to puff himself up to the size of a *bull,* his monkey got a sprain, by which he was very near losing him.

"He used also to perform some wonderful tricks with *gunpowder ;* but his monkey was very sick in passing the channel, and has shewn a great aversion to them ever since.

"Admittance, one shilling and sixpence.

"N.B.—If any gentleman of the corps diplomatique should wish to see his ourang outang, Mr. Bull begs a line or two first ; as, on such occasions he finds it necessary to bleed him, or give him a dose or two of cooling physic, being apt to fly at them if they appear without such preparation."

The strongest incentives to British valour were supplied by the caricaturists. John Bull began to believe in his invincible courage ; he recognised his own martial exterior on paper, as it appeared in the prints, and laughing over the pictured discomfiture of Boney's lean hordes, the honest folks were inclined to treat the threats of invasion with contempt.

June 10th, 1803. *French Invasion, or Buonaparte Landing in Great Britain.*—The French fleet has reached our coast, and the Republican legions have effected their landing. Two pieces of ordnance, served by a little band of artillerymen wearing the uniforms and pigtails which were then in vogue, and mounted on a rising ground, are about to spread destruction through the ranks of the enemy, who are trying to escape in confusion, with the dreaded Boney at their head.

It is difficult, even with the assistance of the actual prints and publications, to realize that at the beginning of this century our ancestors were in daily anticipation of invasion from across the Channel. A writer, commenting on this cartoon in 1818, has recorded the impressions then current.

"The 'French Invasion,' so long talked of, is now become a subject of such ancient date as to have taken its place with the half-remembered events of our past history—or rather to be classed with the vain speculations of ambitious folly—in distant ages ; there may, however, still be met veterans who by an effort of memory, still recall the period when the mighty flotilla of France was every day expected to appear on our shores. Thousands, no doubt, laughed to scorn the threat of the Corsican ; but thousands also believed that he would certainly come. The panic indeed became pretty general at one time ; every croaker dreamed of flat-bottomed boats, and rafts, worked by mighty machines, already afloat—every one of which would furnish barracks and ammunition for ten thousand men, and as many horse ! Credulity, increased by fear, magnified even the chimeras of its own invention. The *Sans-culottes,* it was affirmed, were to erect a flying bridge from Calais to Dover, to facilitate the march of the invaders, and the staff were to direct their operations from air balloons ! That the French made mighty preparations for the promised invasion of England, no one, with the circumstantial records of the famous Boulogne camp, can presume to question ; but that Bonaparte really intended to try his

Q Q

fortune in crossing the Channel, was then, and has been since, doubted by many a long and wise head."

It was the fancy of that day to ridicule the conqueror of the greater part of Europe as a mere pigmy, when compared to King George and his valiant Britons :—

> " Come, I'll sing you a song, just for want of some other,
> About a *small* thing, that has made a *great* pother ;
> A mere *insect*, a *pigmy*,—I'll tell you, my hearty,
> 'Tis the Corsican *hop-o'-my-thumb* Buonaparte.
> Derry down, &c.

> " This *Lilliput* monster, with *Brobdingnag* rage,
> Hath ventured with Britons in war to engage ;
> Our greatness he envies, and envy he must,
> If the *frog* apes the *ox*, he must swell till he burst.
> Derry down," &c.

One of the best illustrations of patriotic feeling is furnished by Gillray's famous plate of *The King of Brobdingnag and Gulliver* (June 26th, 1803), which has been extensively quoted.

Great George is pictured holding Napoleon on the palm of his hand, and peering curiously at him through a magnifying glass. The future Emperor has a drawn sword, enormous boots, and a hat and feather fit for a colossus, and struts magnificently about upon his moving platform. " My little friend, Grildrig," says the King, " you have made a most admirable panegyric upon yourself and country ; but from what I can gather from your own relation, and the answers I have with much pains extorted from you, I cannot but consider you to be one of the most pernicious little odious reptiles that nature ever suffered to crawl upon the surface of the earth." The first suggestion of this design is attributed to Lieut.-Colonel Bradyll, of the Coldstream Guards.

Songs innumerable, of encouragement and defiance, were distributed about the country in the same form of loyal broadsides, as well as in tracts and collections.* Of many of these the following will furnish a good example :—

"SONG ON THE THREATENED INVASION.

> " Arm, neighbours, at length,
> And put forth your strength,
> Perfidious bold France to resist ;
> Ten Frenchmen will fly
> To shun a black eye,
> If one Englishman doubles his fist.

> " But if they feel stout,
> Why let them turn out,
> With their maws stuff'd with frogs, soups, and jellies ;
> Brave Nelson's sea thunder
> Shall strike them with wonder,
> And make the frogs leap in their bellies.

> "'Their impudent boast
> Of invading our coast,
> Neptune swears they had better decline ;
> For the rogues may be sure,
> That their frenzy we'll cure,
> And we'll pickle them all in his brine.

> " And when they've been soak'd
> Long enough to be smok'd,
> To the regions below they'll be taken ;
> And there hung up to dry,
> Fit to boil or to fry,
> When Old Nick wants a rasher of bacon."

The following song was sung in the theatres, and drew the most enthusiastic shouts of satisfaction :—

* These loyal papers were almost the only broadsides for which purchasers could be found, and it is not improbable that this first gave the blow to the old English popular ballad literature, which had hitherto kept its ground almost undiminished.

"THE ISLAND.

"If the French have a notion
Of crossing the ocean,
 Their luck to be trying on dry land ;
They may come if they like,
But we'll soon make 'em strike
 To the lads of the tight little Island.
 Huzza for the boys of the Island !—
 The brave volunteers of the Island !
 The fraternal embrace
 If foes want in this place,
 We'll present all the *arms* in the Island.

"They say we keep shops
To vend broad cloth and slops,
 And of merchants they call us a sly land ;
But though war is their trade,
What Briton's afraid
 To say he'll ne'er sell 'em the Island.

They'll pay pretty dear for the Island !
If fighting they want in the Island,
 We'll show them a sample,
Shall make an example
 Of all who dare bid for the Island.

" If met they should be
By the Boys of the Sea,
 I'll warrant they'll never come nigh land ;
If they do, those on land
Will soon lend 'em a hand
 To foot it again from the Island !
 Huzza ! for the king of the Island !
 Shall our father be robbed of his Island ?
 While his children can fight,
 They'll stand up for his right,
 And their own, to the tight little Island."

In these papers, as well as in the caricatures, it was confidently prophesied that, if the enemy should escape our ships at sea, it would only be to meet certain destruction on landing. Gillray published several caricatures during the months of June and July, setting forth the consequences of the landing of Bonaparte. In one, our brave volunteers are driving him and his army into the sea.

It was our fleets, indeed, that offered our best guarantee against the vengeance of France, for as long as our ships swept the Channel, and insulted the French coasts, destroying towns and shipping with impunity, there was little chance that our enemies would be able to put their threats in execution. They stood there manœuvring, and blustering, and threatening, while Jack Tar was waiting very impatiently for their coming out.

"They've fram'd a plan
(That's if they can)
 To chain us two and two, sirs ;
And Gallia's cock,
From Cherbourg rock,
 Keeps crying Doodle do, sir."

However, with the distinguished courage so much boasted of in the proclamations and bulletins of their leader, it was said that they waited for the first fog, that they might slip over unseen.

" It seems in a fog these great heroes confide,
When unseen, o'er the sea they think safely to ride ;
For taught by our sailors, they know to their shame,
With Britons to see and to conquer's the same."

The fate of Bonaparte was set forth in a fanciful design, which, in spite of its seeming improbability, was ultimately realized :—*Death of the Corsican Fox—Scene the Last of the Royal Hunt* (July 20th, 1803).
The Royal Windsor Hunt forms the subject of the cartoon : King George has dismounted from his horse at the cover-side, his figure is placed with its back to the spectator ; in his right hand he grasps the struggling Corsican fox, wearing the features of "Boney." " Tally-ho !—tally-ho !—ho—ho !" sings, the King ; while his good hounds, who have just swam across the water, are tearing up, eager for the fray. Their collars bear the names of Vincent, Nelson, Cornwallis, Sydney Smith, &c. Pitt and others are galloping up to be in at the death.

This prophecy was fulfilled, and the Corsican fox literally ran into King George's hands for protection from his pursuers. But the Royal hunter had lost the capacity to appreciate his triumph. Another anticipation of the end which awaited the invader was issued a few days later (July 26, 1803), *Buonaparte Forty-Eight Hours after Landing ! Vide John Bull's Home Stroke, armed "en masse."* " This is to give information, for the benefit of all Jacobin adventurers, that policies are now opened at Lloyd's, where the depositor of one guinea is entitled to a hundred, if the Corsican cut-throat is alive forty-eight hours after landing on the British coast."

Napoleon Forty-eight Hours after Landing.

A sturdy ploughman-volunteer, with a branch of oak in his hat, and a "favour" inscribed "Britons, strike home!" is exhibiting the Corsican's head on his pitchfork. "Ha, my little Boney!" he cries; "what dost think of Johnny Bull now? Plunder Old England, hay? Make French slaves of us all, hay? Ravish all our wives and daughters, hay? O, Lord help that silly head! To think that Johnny Bull would ever suffer those lanthorn jaws to become King of Old England's roast beef and plum-pudding!"

According to a contemporary :—"This hyperbolical compliment to the phalanx of Loyal British Volunteers was, no doubt, pleasant enough to their brave spirits. It is easy to make conquests on paper; and such victories as this served to keep up their patriotic zeal, in the absence of others of a more substantial nature." "Such subjects," said Gillray, "help to boil the pot." The yeoman cavalry, anxious for the brunt of war, in their excursions to London, eagerly bought up every satire on *Boney,* which served, upon their return, to make their neighbours laugh. But this subject, of all others, tickled the fancy of the yokels, who simultaneously echoed, on unrolling the print—"Ah! if he be a-coming, why don't he come?"

The sturdy Britons who are making light of the Corsican's hosts are all militia men; nearly every one was liable to be drafted into this service, regardless of personal qualifications. Much sly fun was raised at the expense of these ready-made defenders: a *jeu d'esprit,* circulated on this occasion of general alarm, is attributed to Professor Porson :—

"LINGO DRAWN FOR THE MILITIA.

"*Ego nunquam audivi.* Such terrible news
At this present *tempus* my *sensus* confuse ;
I'm drawn for a *miles*—I must go *cum marte,*
And, *concinus casu,* engage Bonaparte !

"Such *tempora nunquam ridebant majores*
For then their opponents had different *mores,*
But soon we will prove to the Corsican *vaunter*
Though times may be changed, Briton's never *mutantur.*

"*Mehercle!* this Consul *non potent* be quiet,
His words must be *lex*—and when he says *fiat,*
Quasi Deus, he thinks we must run at his nod ;
But Britons were ne'er good at running by G— !

"*Per mare,* I rather am rather led to opine,
To meet British *mares* he would not incline ;
Lest he should *in mare profundum* be drown'd,
Et cum algâ, non laurâ, his *caput* be crown'd !

"But allow that this boaster in Britain could land,
Multis cum alvis at his command :
Here are lads who will meet, aye, and properly work 'em,
And speedily send 'em *ni fallor, in orcum.*

"*Nunc,* let us, *amici,* join *corda et manus,*
And use well the *vires Di Boni* afford us.
Then let nations combine, Britain never can fall,
She's *multum in parvo*—a match for them all."

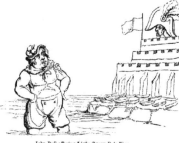

John Bull offering Little Boney Fair Play.

People became impatient under this lengthened suspense; no decided movements were undertaken after the extensive preparations at the haunted camp of Boulogne. The English began to taunt the boasting invaders with inactivity. The impetuous courage of the Jack Tars was set forth in a caricature by Gillray, published on the 2nd of August, in which John Bull is represented as taking to the sea in person, to chant the serenade of defiance. The head of Bonaparte is just seen over the battlement, uttering the threat which he had now been repeating several

weeks: "I'm a-coming!—I'm a-coming!" His boats are safely stowed up under the triple fort in which he has ensconced himself for personal security, and John Bull taunts him with some ill humour—

> "You're a coming?
> If you mean to invade us, why make such a rout?
> I say, little Boney,—why don't you come out?
> Yes, d— you, why don't you come out?"

"Fair play is a jewel! It would have been no joke though had he come, for all our vapouring," gravely observed a Jacobin alderman; "for your favourite Windham, in the Commons, made no ceremony of dubbing the whole body a 'Repository of Panic!'" "Did he?" indignantly exclaimed Sir W. Curtis, "then more shame for him! What my old friend Lord Bridport said upon the subject was more becoming the speech of a Briton: 'They may come, but I'll be d—d if they come by water.'"

Peter Pindar, who had "an eye for expression," as Rowlandson used to say, declared that he never saw this little Beau-frightful peeping over the battlements, but he thought of his ill-natured old grandmother crying, "I'm a-coming—I'm a coming!"

Every event stimulated the patriotic feeling to a thoroughly unanimous intention of resisting the French to the last man. These loyal effusions are unsupported by the proofs of self-sacrifice which beyond question must have followed any attempt to subjugate this island, but there is little doubt that the patriots would have thoroughly acted up to the spirit of their heroic professions.

"INSCRIBED TO R. B. SHERIDAN, M.P. (4th June 1803.)

"John Bull's answer to Buonaparte's declaration that England was, single-handed, not now equal to France, written at Portsmouth on hearing the men-of-war at Spithead fire in honour of the anniversary of his Majesty's Birthday, 4th June, 1803.

> "England not equal single-hand, to France!
> Who dares a boast so arrogant advance?
> Not Buonaparte's self can make it good,
> While still in British veins flows British blood."
>
>

After patriotic allusions to Sir Sidney Smith and Acre, Nelson and the Nile, Hutchinson and Egypt, Abercrombie and Alexandria, the rhymer refers to the memories of Cressy, Poictiers, and Agincourt:—

> "Or Ramilies? or Blenheim's crimson'd plain?
> Turennes may fall, and Marlboroughs live again!
> Be timely wise, recall the vain conceit!
> Hark to the thunders of the British fleet!
> If, on this day, to Britons justly dear,
> Their loyal notes strike awful on the ear,
> Who shall withstand the Broadsides that they pour,
> When *fighting* for their King and native shore!
>
> Not in Ambition's cause Britannia draws,
> But to defend her liberty and laws;
> Her rights, her independence to maintain,
> And order to the world restore again.
> If (which may heaven avert!) it should befall
> A breach were made in Albion's wooden wall,
> In such a cause *so recreant* shall be found—
> We'll die or conquer on our native ground!"

One of the songs distributed in the "loyal papers," which seems to have been a very popular one, furnishes us with:—

"BUONAPARTE'S ANSWER TO JOHN BULL'S CARD.

> "My dear Johnny Bull, the last mail
> Brought over your kind invitation,
> And strongly it tempts us to sail
> In our boats to your flourishing nation.
> But Prudence she whispers 'Beware,
> Don't you see that his fleets are in motion?
> He'll play you some d—d *ruse de guerre,*
> If he catches you out on the ocean.'
> Our fears they mount up, up, up,
> Our hopes they sink down-y, down-y,
> Our hearts they beat backwards and forwards
> Our heads they turn round-y, round-y.
>
> "You say that pot-luck shall be mine:
> *Je n'entend pas ces mots,* Monsieur Bull;
> But I think I can guess your design,
> When you talk of a good belly-full.
> I have promis'd my men, with rich food
> Their courage and faith to reward;
> I tell them your puddings are good,
> Though your dumplings are rather too hard.
> Oh my Johnny, my Johnny,
> And O, my Johnny, my deary,
> Do, let us good fellows come over,
> To taste your beef and beer-y.

"I've read and I've heard much of Wales,
　Its mines, its meadows, and fountains;
Of black cattle fed in the vales,
　And goats skipping wild on the mountains.
Were I but safe landed there,
　What improvements I'd make in the place!
I'd prattle and kiss with the fair,
　Give the men the fraternal embrace.
　　O my Taffy, my Taffy,
　　Soon I'll come, if it please ye,
　　To riot on delicate mutton,
　　Good ale, and toasted cheese-y.

" Caledonia I long to see,
　And if the stout fleet in the north
Will let us go by quietly,
　Then I'll sail up the Frith of Forth.
Her sons, I must own, they are dashing;
　Yet, Johnny, between me and you,
I owe them a grudge for the thrashing
　They gave that poor devil Menou.
　　O my Sawny, my Sawny,
　　Your bagpipes will make us all frisky;
　　We'll dance with your lasses so bonny,
　　Eat haggis and tipple your whisky.

"Hibernia's another snug place,
　I hope to get there, too, some day,
Though our ships they got into disgrace
　With Warren near Donegal Bay.
Though my good friends at Vinegar Hill,
　They fail'd; be assured, Jack, of this,
I'll give them *French liberty* still,
　As I have to the Dutch and the Swiss.
　　O my Paddies, my Paddies,
　　You are all of you honest good creatures
　　And I long to be with you at Cork,
　　To sup upon fish and potatoes.

"A fair wind and thirty-six hours,
　Would bring us all over from Brest ;
Tell your ships to let alone ours,
　And we'll manage all the rest.
Adieu, my dear boy, till we meet;
　Take care of your gold, my honey ;
And when I reach Threadneedle Street,
　I'll help you to count out your money.
　　But my fears they mount up, up, up,
　　And my hopes they sink down-y, down-y ;
　　My heart it beats backwards and forwards
　　And my head it runs round-y, round-y."

The effect of the songs and papers was confined to home, but the caricatures were carried abroad, and gave no little uneasiness to Bonaparte, for they were often coarsely personal, and the First Consul was particularly sensitive to anything like ridicule against himself or his family. The caricature which gave him the greatest offence was a rather celebrated one by Gillray, published on the 24th of August, 1803, under the title of *The Handwriting Upon the Wall—a parody of Belshazzar's Feast.*

The French Court, temporarily removed to London, is indulged with a banquet which fairly rivals the feast of the Assyrian monarch. The solids are dismissed, and the sweets occupy the table. The First Consul of course presides ; the eagle of his destinies is carved on his chair ; his eye has wandered from the fine things displayed before him to the handwriting on the wall, which has turned his enjoyment into dismay. At the sight of this vision of judgment the goblet falls from his hand, and his fork remains unlifted stuck into the palace of St. James's on a plate before the conqueror. The Bank of England is turned into a centre-piece ; the French tricolour is floating over the well-known building. A second dish, inscribed, " Oh! de Roast Beef of Old England!" bears the head of a bishop, as a hint of the possible fate awaiting the Established Church if French institutions gained their hold in England. One of Napoleon's generals is panic-stricken at the expression of fear overspreading the face of his leader, another is swallowing the Tower of London served up as a pasty. The Empress Josephine, who was at that date conventionally represented as a monstrously stout figure, is freely indulging in " Maraschino." In the left-hand corner may be distinguished a bottle labelled " Maidstone," in allusion to the trials held there of Arthur O'Connor, Quigley, and other Irish rebels, who were arrested at Dover on their way to France to promote the operations they had concerted with the Republican Government for the invasion of Ireland under General Hoche. Behind Josephine stand, in spare attire, the three princesses of the afterwards Imperial family, the Princess Borghese, the Princess Louise, and the Princess Joseph Bonaparte. Files of hussars are drawn up round the apartment. The balance is suspended over the Corsican's head, the red bonnet and the fetters of arbitrary force are capsized, and the old legitimate crown of Louis XVIII. is weighing down the scale.

The spirit of antagonism was further promoted by a cartoon issued in September, under the title of *The Corsican Carcase Butcher's Reckoning Day. New Style—No Quarter-day !* Little Boney, the Continental butcher, is exhibited in the interior of his slaughter-house, girded with his steel, and flourishing his knife and chopper in a fit of rage, his seven-league boots are in readiness to carry him across the

Channel, where the British bull, perched on his island, and surrounded by the English squadron, is lowing defiance to the little conqueror. The Russian bear, growling round the corner of the butchery, is adding to the Corsican's frenzy; Talleyrand, half soldier, half ecclesiastic, has seized the First Consul in his arms, and is forcibly restraining him from violence; the crafty Minister consistently opposed any attempt to invade England. The premises of the carcase butcher are well furnished. A row of "Moslems" are arranged in a trough, marked "Jaffa cross-breed;" a ram hung on the wall is ticketed "True Spanish fleec'd;" a skinned monkey, suspended by the neck, is labelled, "Native breed;" Switzerland is hung on the wall, in the figure of a donkey, and the carcase of a pig strung up on a hook, is labelled "from Holland;" the "Germanic body" is completely mutilated, the hand—Hanover—is just lopped off. The live stock is represented by a brood of foxes "from Rome," shut up in a coop inscribed "Not worth killing;" a lean hound chained in a kennel, marked "Put up to fatten," represents Prussia, exhausted, and tied up to fatten on "Consular whipt syllabub."

The House of Commons, which was not prorogued till late in the summer, added by its votes to the general patriotic spirit of the country. Sheridan was there the foremost in praising and encouraging the volunteers, and in calling attention to the important service done by the multitude of placards and songs that were thus distributed about the country. Those of his party who followed Fox in still wishing for friendship with France, and believing it possible, set him down for a confirmed alarmist; and in a print, published on the 1st of September, Gillray has caricatured him as a bill-sticker, attempting to startle John Bull with the announcements of peril and danger, which he is so busy scattering over the land. Under his arm is a sheaf of "loyal bills to be distributed pro bono publico," while a bundle of playbills has just been thrust into his pocket with a red bonnet. The walls are placarded with numerous sensational hand-bills and notices, all of the most sanguinary description. John Bull, however, sturdy as usual, is turning an indifferent ear to the "alarmist;" his right hand is grasping his strong oak cudgel, the top carved into the head of a bulldog; with the left he is raising a measure of foaming porter, stamped with the crown; his broad arm-chair, bearing the royal arms, is placed by the side of the *London Gazette*, in which is published a list of recent captures. A picture on the wall represents the fable of the bull and the frog. This print was issued as a broadsheet; John Bull is quoting one of the verses which accompanied it :—

An Alarmist.

"JOHN BULL AND THE ALARMIST.

" John Bull as he sat in his old easy chair,
An alarmist came to him, and said in his ear,
' A Corsican thief has just slipt from his quarters,
And's coming to ravish your wives and your daughters.'

" ' Let him come and be d—d :' thus roar'd out John Bull,
' With my crabstick assur'd I will fracture his skull,
Or I'll squeeze the vile reptile 'twixt my finger and thumb,
Make him stink like a bug if he dares to presume.'

" ' They say a full thousand of flat-bottomed boats,
Each a hundred and fifty have warriors of note,
All fully determined to feast on your lands,
So I fear you will find full enough on your hands.'

" John smiling arose upright as a post,—
' I've a million of friends bravely guarding my coast
And my old ally Neptune will give them a dowsing,
And prevent the mean rascals to come here a lousing !' "

In a similar spirit of hatred to the French ruler, Gillray issued his cartoon of *The Corsican Pest, or Beelzebub going to Supper* (October 6th, 1803).—A copy of verses appended to this etching are attri-

buted to the well-known Paul Sandby, the reputed "father of water-colour drawing," a remarkable caricaturist, as his burlesques, published in ridicule of Hogarth's " Analysis of Beauty," amply testify :—

"THE CORSICAN PEST.

" Buonaparte, they say, aye good lack a day !
 With French legions will come hither swimming,
And like hungry sharks, some night in the dark,
 Mean to frighten our children and women !
 Tol de rol.

" When these Gallic foisters gape wide for our oysters,
 Old Neptune will rise up with glee,
Souse and pickle them quick, to be sent to Old Nick,
 As a treat from the god of the sea.
 Tol de rol.

" Belzebub will rejoice at a supper so nice,
 And make all his devils feast hearty,
And the little *Tit-bit* on a fork he would spit,
 The Consular Chief *Buonaparte !*
 Tol de rol.

" And like a Lord Mayor, in his ebony chair,
 Eager feasting while his gutt'lers partake on't,
Crack his jokes with his guest, and to give it more zest
 Cry presto ! and make a large Jakes of on't.
 Tol de rol.

" Then each Devil suppose, closely stopping his nose,
 And shrinking away from the smell,
' By Styx,' they would roar, 'such a d——d smell before
 Never entered the Kingdom of Hell.'
 Tol de rol.

" Full rotten the heart, of the said Buonaparte,
 Corrupted his marrow and bones,
French evil o'erflows, from his head to his toes,
 And disorder'd his brains in his sconce !
 Tol de rol.

" His pestiferous breath has put millions to death,
 More baneful than mad dog's saliva,
More poisonous he, all kingdoms agree,
 Than the dire Bohau-Upas of Java !
 Tol de rol.

" By the favour of Heaven to our monarch is given,
 The power to avert a dire evil ;
His subjects are ready, all loyal and steady,
 To hurl this d——d pest to the Devil.
 Tol de rol."

According to the description, his Infernal Majesty is seen seated on his throne—the guillotine ; he wears the Red Bonnet of Liberty ; his long pitchfork is employed as a spit/the terrified figure of little Boney is wriggling on its point ; the First Consul is roasted like a lark over a piece of toast before a fierce fire, which is kept up by the fuel of his own bad actions. A satellite is basting the General with brimstone ; a second imp, disguised as a cook, working the bellows, is seated on a sack of " fuel for everlasting flames"— the discreditable actions ascribed to Napoleon ; other imps are preparing scorpions, vipers, and frogs to garnish the *tit-bit.* The armée d'Angleterre are strung up as a row of monkeys, ready for roasting. "Invasion of Great Britain ; a catch, to be performed after supper, with a full chorus of his Highness's band," is seen on the ground ; the skulls of Marat, Robespierre, and other wholesale homicides, are thrown aside ; and similar allusions fill up this fantastic plate.

Napoleon's levees were not treated more respectfully. One print describes the *French Volunteers Marching to the Conquest of Great Britain. Dedicated by an Eye-witness to our own Volunteers* (October 25th, 1803). A lean scarecrow-like officer is escorting a whole file of enthusiastic Frenchmen, all secured to his horse's saddle, with chains round their necks ; the hands of these half-starved victims are bound with ropes, their figures are almost naked ; one of the party rejoices in wooden sabots, the rest are shoeless. These unfortunates are followed by a donkey, bearing a basket into which three wretches, tied hands and feet, are thrown like bundles of wood ; another volunteer is bound to a truck, and the line is ended by an emaciated creature, evidently at his last gasp. A flock of carrion crows are suggestively hovering over the party in anticipation of their carcases.

A contemporary account records of this print :—" ' Pleasant enough, certainly,' as the veteran Captain Baillie, of Enniskillen, remarked on peeping in at Mrs. Humphrey's window through his spy-glass. This may be the order on the other side of the water, but let the French wits take up the pencil and pen, and cry *Lex talionis,* and show up the manner of impressing seamen to man the British navy ! Sirs, by the powers ! it is one and the same thing ; when expediency is the order of the day, Governments, whether despotic or democratic, are not very nice as to their modes of recruiting. There, the conscript volunteers can chant—

 " ' Ye sons of France, awake to glory !'"

The incessant conscriptions in later years well nigh drained the manhood of France, but in the days when England was the prize held out, the inducement was sufficient to kindle enthusiasm. " A

consummate charm was given to the plan of invasion by the promise of a Republican Constitution, on the model of the days of Robespierre. England was to acquire new opulence from general confiscation, liberty from French free-quarters, and regeneration from universal chains. Of this Republic Sir Francis Burdett had the honour to be, in the judgment of Napoleon, ' the fittest man in England' to fill the Presidential chair."

In the days of menace we find the King and his sturdy sons busily engaged in reviewing troops and making fine speeches to the volunteers. Public men took active parts in the preparations for defence. Pitt was Colonel of the Cinque Port Volunteers; Fox is said to have carried his gun as a modest private in the Chertsey Volunteers. The Duke of Clarence commanded a corps near his seat of Bushy, to whom he addressed this Spartan encouragement:—" My friends, wherever our duty calls I will go with you, fight with you, and never come back without you!" The Prince of Wales, during this national crisis, was eager to emerge from his retirement; he applied for some military rank which would enable him to stand prominently before the public. This request was not complied with, for reasons which no amount of Parliamentary badgering could elicit from Addington. The Prince wrote to the Minister, and then appealed to the King. His father replied affectionately, but firmly persisted in his former decision, and pointed out, that " should the implacable enemy succeed so far as to land, the Prince would have an opportunity of showing his zeal at the head of the regiment of which he always held the command." " It will be the duty," wrote the King, " of every man to stand forward on such an occasion ; and I shall certainly think it mine to set an example, in defence of everything that is dear to me and my people." The Prince did not submit with resignation to the decision which doomed him to inactivity. Remonstrances and farther correspondence ensued. The Duke of York and Addington were associated in his displeasure. Letters were published, and a great deal was said on both sides of the question. The Prince contrived to disturb the general unanimity, and embarrassed the consideration of the public security with personal squabbling. The connexion with Mrs. Fitzherbert was continued, and his behaviour to the Princess gave great offence to his father. This may account for his inflexibility to the wishes of the Prince.

The King entertained a conviction of the fatuity of the French projects. Writing to Bishop Hurd (November 30th, 1803)—in whose diocese " he preferred all he valued most in life should remain during the conflict"—he stated : " We are here in daily expectation that Buonaparte will attempt his threatened invasion. The chances against his success seem so many, that it is wonderful he persists in it. I own that I place that thorough dependence on the protection of Divine Providence that I cannot help thinking the usurper is encouraged to make the trial that the ill success may put an end to his wicked purposes. Should his troops effect a landing, I shall certainly put myself at the head of my troops and my other armed subjects to repel them. But as it is impossible to foresee the events of such a conflict, should the enemy approach too near to Windsor, I shall think it right that the Queen and my daughters should cross the Severn, and shall send them to your Episcopal Palace at Worcester," &c.

These illustrations sufficiently reproduce the actual state of anxiety prevalent throughout the kingdom in 1803, and, in a modified degree, some three years later.

It was believed that Napoleon looked forward with no regretful feeling to the immense sacrifice of life which was inseparable from an attempt to carry out his plans of crossing the Channel and landing on the English shores. It was felt that the huge military hydra—born of the Revolution, and developed under his later auspices—had overgrown his power of control, and threatened to interfere with his ambition. Napoleon's callousness and disregard for human life was proverbial throughout his career. His wars were computed to have cost France more than two millions of men; " they mowed down the whole rising generation." " I can afford ten thousand men a day," is said to have been the boast of this iron homicide.

Gillray has pictured this feeling in his plate, *Destruction of the French Gun Boats, or Little Boney and his Friend Talley in High Glee* (November 22nd, 1803). Little Boney is perched on the shoulders of Talleyrand, who wears a composite uniform. The Corsican, protected behind his own ramparts, is using his " Plan for Invading Great Britain" as a telescope, through which he is watching the destruction of his crowded gun boats under volleys of shot which our men-of-war are pouring into the doomed

craft, and sinking in all directions. "O my dear Talley," cries the disembarrassed ruler, "what a glorious sight! We've worked up Johnny Bull into a fine passion! my good fortune never leaves me! —I shall now get rid of a hundred thousand French cut-throats, whom I was so afraid of!—O my dear Talley, this beats the Egyptian poisoning hollow!—Bravo, Johnny! pepper 'em, Johnny!"

The attitude of "the Radicals" was summed up in an etching published with the "Satirist." Cobbett, as a many-tailed monster of sin, is represented in the "porcupine's den," shedding his quills of envy, lies, &c. at the light of truth, which has penetrated his cavern, and revealed the mischief within; the porcupine, by whose side is a paper of "instructions from Lord E. Fitzgerald," is penning a page of the "Register," wherein Sir Francis Burdett is set down as a god, Pitt as a devil, Horne Tooke as an angel, "England at her Last Gasp." Burdett is concealing Cobbett's "Political Register" for 1802, wherein Mr. Horne Tooke and Burdett are set down as seditious demagogues, Mr. Pitt as a god, Horne Tooke as a devil, and "England Happy"—ridiculing the change which success had brought about in Cobbett's views, as set forth in the "Register."

Several of the "loyal papers" contain expressions which show that there were still apprehensions that many people in this country were so discontented with King George's government that they would join the invaders, or at least be very lukewarm in resisting them. To counteract this feeling, the associations distributed strong appeals to the patriotism of all classes, showing that the evils which they complained of at present were trifling in comparison with those that were threatened from abroad; placing before them the atrocious ravages committed in Holland, Switzerland, Germany, and Italy, and even in France itself, by the Republican plunderers, and admonishing them that these were only to be avoided by uniting vigorously and heartily in the common defence. English, Scot, and Irish, it was represented, had an equal interest at stake—if they acted together, they were invincible. One of the garlands (to use an expression of the olden time) of loyal songs introduces them discussing "the Invasion" in the following terms:—

> "At the sign of the George, a national set
> (It fell out on a recent occasion),
> A Briton, a Scot and Hibernian, were met
> To discourse 'bout the threat'n'd invasion.
>
> "The liquor went round, they joked and they laughed,
> Were quite pleasant, facetious, and hearty;
> To the health of their king flowing bumpers they quaff'd,
> With confusion to great Buonaparte.
>
> "Quoth John, 'Tis reported, that snug little strait,
> Which runs betwixt Calais and Dover,
> With a hop, step, and jump, that the Consul elate
> Intends in a trice to skip over.
>
> "'Let him try every cunning political stroke
> And devise every scheme that he's able;
> He'll find us as firm and as hard to be broke,
> As the bundle of sticks in the fable.'
>
> "The Scot and Hibernian replied—'You are right—
> Let him go the whole length of his tether;
> When England, and Scotland, and Ireland unite,
> They defy the whole world put together.'"

In spite, however, of all this courage and enthusiasm, and of the great measures taken for the defence of the country, it was a year of alarm and terror in England, such as it is to be hoped will not be experienced again. It was but a gloomy Christmas which closed it, and ushered in a new year with little improvement in our prospects. Every intelligence from abroad spoke of the marching of troops from all parts of the French territory to the coast from which the invasion was to be made. It was known that Bonaparte had been at Boulogne just before Christmas, to visit and inspect the preparations. The general uneasiness was increased towards the end of February by the information which gradually spread abroad that the King was suffering under a new attack of the dreadful disorder to which he was constitutionally subject, and the country was thus in danger of losing the active assistance

of its monarch at the moment of peril. Fortunately, however, the King's illness was not this time of long duration. The general anxiety was gradually relaxed, and the apprehensions of invasion lost much of their terror, although an immense army was still concentrated opposite our coasts, with the avowed object of invasion.

The caricatures issued in 1804 indicate a modified feeling; it was concluded that Napoleon meditated other projects.

In July, 1804, the Paris papers, as quoted in our newspapers, declared that "The invasion has been only deferred, to render it more terrible when the whole strength of the French empire, destined to make the attack, shall be collected."

This quieted the alarmists; the fears of invasion began to wear away, and public attention was called off to political changes of another kind.

Among the social studies published in 1803 we may notice a caricature of *Germans Eating Sour-krout* (May 7th, 1803). Gillray has associated five Germans, of various ages and professions, all voraciously "crowding down" platefuls of their beloved sour-krout with fork and spoon. According to the inscriptions on the plates and tankards, we learn they are dining at Weyler's eating-house, in Castle Street. According to the bill of fare, the first, second, and third courses are—sour-krout, and the dessert is the same. Weyler is seen in the doorway, bearing in a fresh supply. A portrait, in burlesque, of the Archduke Charles, a painting of five pigs feeding at a trough, and a chart of the "mouths of the Rhine," are introduced to carry out the satire.

The portraits of individuals published by Gillray during this year include two admirable likenesses of the venerable Earl of Galloway, who was notorious for the pride he took in his tinsel star, which he persisted in wearing on his coat long after such decorations had disappeared. According to an arch-wit of his day—

> "We'll sing Lord Galloway, a man of note,
> Who turn'd his tailor, much enraged, away,
> Because he stitched a star upon his coat
> So small, it scarcely threw a ray;
> Whereas he wished a planet huge to flame,
> To put the moon's full orb to shame."

This eccentric nobleman is also introduced as *An Old "Encore" at the Opera!* (April 1st, 1803), in his box, clapping his hands with marked enthusiasm, crying "Bravo! bravo!" The peer, whose face indicates great age, wears a full dress wig, of elaborate construction, and his famous star is, of course, conspicuous. *A Scotch Pony, commonly called a Galloway* (June 4th, 1803), represents the same personage in his out-of-door costume, with his decoration stitched on his coat, mounted on a "Galloway" pony.

April 14th, 1803. *The Bulstrode Siren.*—Mrs. Billington paid a visit to the Duke of Portland at his mansion of Bulstrode a short while before his death. The artist has taken advantage of this circumstance to picture the stout songstress seated on a sofa by the side of the Duke, who is sitting up stiffly, his gouty legs immovable, listening with ecstacy to the prolonged streams of notes which are proceeding from the throat of the accomplished vocalist. A music-book lies open at an "Epithalamium." Below this gallant picture are the famous lines:—

> "Blest as th' immortal gods is he
> The youth, who fondly sits by thee,
> And sees and hears thee all the while
> Softly sing and sweetly smile."

It has been observed of this group:—"The noble Duke, however, well versed in classic lore, may be supposed to have engaged this fair enchantress by way of medical experiment, in the hope that she might put him on his legs again. Martinus Capella assures us that raging fevers were cured by song. Asclepiades cured deafness by the sound of the trumpet. But there were no feats compared with that of Thelates, the Cretan, who delivered the Lacedæmonians from the ravages of the pestilence by the sweetness of his lyre. The Phrygian pipe cured the sciatica. Peter Pindar, the wag, supposes it must have been a tobacco-pipe."

May 7th, 1803. *Equestrian Elegance or, a Noble Scot Metamorphosed.*—This portrait represents a very tall, formal personage, the Duke of Hamilton (then Marquis of Douglas), who is seated bolt upright in his saddle, riding with long stirrup-leathers. The equestrian wears a long greatcoat, his hair is dressed in a long queue, and a long cane is suspended to his wrist; the *tout ensemble* gives an exaggerated impression of length. The Duke's horsemanship was proverbial.

June 16th, 1803. *The Three Mr. Wigginses.*—Three exquisite dandies, Lord Llandaff and his two brothers, the Hon. Montague and the Hon. George Matthews, are promenading the flags of Bond Street, much as they were to be seen in their own day. They are all dressed alike, in the costumes introduced during the French Revolution. They wear short beaver hats with broad brims, long and flowing hair, powdered, with a "club" hanging down the back; high muslin neckcloths, great double frills, bob-tailed coats, with broad facings; white waistcoats, with the lappels turned over on the coat; white knee-breeches, tied with a bunch of white ribbons, and top-boots complete the elaborate *ensemble.*

July 7th, 1803. *A Great Man on the Turf, or Sir Solomon in all his Glory,* a profile portrait of the Duke of Bedford, in sporting costume. The racecourse is drawn in the distance, and "Sir Solomon" is probably his favourite racehorse.

December, 1803. *Inspecting a Volunteer Corps in Hyde Park,* pictures the state of preparation which was then kept up under the dread of invasion. A very droll figure, intended for the Earl of Huntingdon, wearing a crescent-shaped cocked hat of pantomimic dimensions, is reviewing the gallant defenders.

The figure of another personage, *The Duke of Marlborough,* was published in this year (March 9th, 1803), probably in allusion to the reliance which, in the time of French menace, had been reposed in the name of Marlborough. A quaint, dapper little personage, with his hat smartly stuck on one side,

The Mode in 1803.

wearing a droll little pigtail bobbing on his collar, his coat tails extended out behind, with Hessian boots, and carrying a slight cane, represents the foppish little Duke, who is stepping jauntily along with the air of a dancing master. A quotation from Lord Chesterfield's Letters forms the title of the print:—"The irrepressible air of dignity, the incomprehensible *je ne sçais quoi* of elegance, which appertains solely to men of high fashion."

In 1803 we find a noticeable change was effected in costume. The French anticipated their invasion by sending over the most unsightly fashions which had ever appeared. The distinguishing features were the coverings of the head, which consisted, in the one sex, of an enormous military cap, and in the other of a bonnet, probably of straw, of a very ungraceful form. They are represented in the accompanying cut, taken from a caricature entitled *Two of the Wigginses—Tops and Bottoms of* 1803, published on the 2nd of July in that year.

1804.

The year 1804 witnessed several notable changes. The Addington Ministry was driven from office, and Pitt regained the power he had ceded to "the Doctor." The fears of invasion were gradually allayed, and Bonaparte's ambition took another direction—the road to the Imperial throne. At home we notice the growing notoriety of the Radicals. The close of 1804 also marked the reconciliation between the King and the Prince of Wales.

The King of Brobdingnag and Gulliver (Plate 2nd). Scene—Gulliver Manœuvring with his Little Boat in the Cistern. Vide Swift's Gulliver.—The design of this highly popular caricature is attributed to Lieut.-Colonel Bradyll, who suggested the earlier plate on the same subject. The pigmy Boney is amusing the Court circle by his endeavours to manage his little craft, while two of the pages are raising a very tempest by blowing into the tank. The Princesses are smiling at the drollery of the

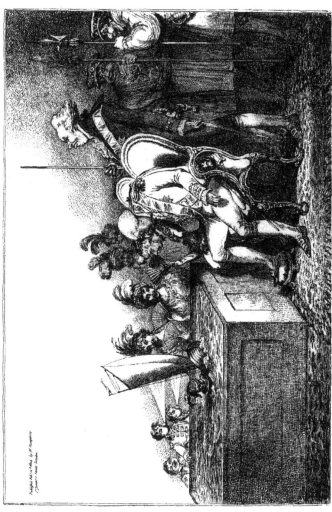

The KING of BROBDINGNAG and GULLIVER. (Plate 2.) Scene. Gulliver manœuvring with his little Boat in the Cistern.

'I often used to Beef for my own diversion, as well as that of the Queen & her Ladies, who thought themselves well entertained with my skill & agility. Sometimes I would put up my Sail and then my art of steering Starboard & Larboard. However my attempts produced nothing else besides a loud laughter, which all the respect due to her Majesty from those about him, could not make them contain. This made, me reflect, how vain an attempt it is for a man to endeavour in to himself honour among those, who are out of all degree of equality or comparison with him.'

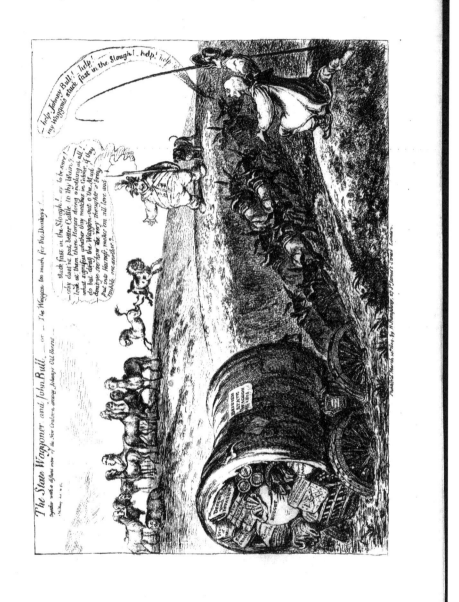

exhibition, and the King and Queen are looking on with great interest; but it is evident that they find it difficult to distinguish the Liliputian personage who is exhibited for their entertainment. Lord Salisbury, planted behind his Sovereign, is regarding the show with stoical contempt.

According to an earlier account:—" It has been said by those acquainted with the private habits of the revered Sovereign, that on exhibiting this playful effusion of Master Gillray's fancy to her Majesty, the Royal pair were as much amused as the most mirthful of their loving subjects, and that they laughed as heartily as the artless gazers before the windows of the publisher in St. James's Street. As for the quizzical figure of the Lord Chamberlain—Polonius—standing behind the Royal chair, as much interested in the sight as an undertaker's mute at a funeral, her Majesty and the Princesses laughed as merrily as the Queen and the ladies of Brobdingnag are recorded to have done in the Dean's elaborate satire."

The feverish excitement of our foreign relations was calming down, and the interest of home politics increased proportionately. Pitt, who had previously supported the Addington Ministry, suddenly quarrelled with it in the spring of 1804, and placed himself in the Opposition. This defection was at first evinced in frequent observations on the incapacity of the present Government to help the country out of its difficulties, and in wishes for the formation of a strong Administration on a " broad bottom" which should include " all the talents" of the different parties. It was soon known that Temple and the Grenvilles had joined Fox's party, but Pitt cautiously avoided compromising himself, although he spoke as much as anybody in favour of a coalition of parties. On the 14th of March Gillray published a caricature entitled *The State Waggoner and John Bull, or The Waggon too Much for the Donkeys—together with a Distant View of the New Coalition among Johnny's Old Horses.* Addington, the State-driver, has run his waggon into a deep slough, from which the donkeys that are harnessed to it are unable to drag it. The unfortunate driver screams out—" Help, Johnny Bull! help!—my waggon's stuck fast in the slough!—help! help!" John Bull, dressed in the then fashionable accoutrements of a volunteer, and attended by his faithful dog, replies—" Stuck fast in the slough?—ay, to be sure!—Why doesn't put better cattle to thy wain?—Look at them there horses doing o' nothing at all!—What signifies whether they matches in colour, if they do but drag the waggon out of the mud? Don't you see how the very thought o' being put into harness makes 'em all love and nubble one another?" The horses to which he points occupy a neighbouring bank, and present the well-known faces of the various political leaders. Lord Grenville and Fox (a dark horse) are now attached by political friendship, and Pitt is looking on with an affable smile; Lord Castlereagh

John Bull turned Volunteer.

stands next to Pitt. Grey and the Marquis of Buckingham are pairing together. Erskine and Wilberforce are in confidential proximity, while the noses of Canning and Lord Carlisle are rubbing together. Windham and Sheridan (a piebald colt) are exchanging kicks as the rival Thersites and wits of their respective parties. The " dead lock" to which the Doctor has driven the State waggon may be partly ascribed to its overweighted condition; a basket of family medicine is hanging at the side, the contents within are thrown together in helpless confusion. The Budget and Taxes for 1804, with fixed 'loans,' are side by side with barrels of gunpowder; the Treasury chest is suffering from a leak; muskets for the volunteers and bags of money for secret services are all crowded together, while a bundle of family pickings is partly hidden round a corner of the tilt.

The day after the date of this print, on the 15th of March, Pitt made a direct attack on the Ministry in a motion on the naval defence of the country, which was supported by Fox, but opposed by Sheridan, who seemed to have deserted his old party to league with Addington. After the Easter recess the Opposition took a much more decisive character. On the 23rd of April Fox brought forward a motion relating to the defence of the country (the subject now nearest to everybody's heart); and he was opposed by Addington, who insinuated that the mere object of the mover was to embarrass and overthrow his Ministry. Pitt then rose to support Fox; he declared that he had no confidence in

Ministers, whom he blamed severely for their want of intelligence and foresight. In the course of the debate which followed the coalition was openly spoken of; but it was denied by Fox and Pitt, who declared that they were only united in a common opinion of the inefficiency of the men then in office. On a division, the usually large Ministerial majority was reduced to fifty-two. Two nights afterwards this majority was further reduced to thirty-seven. Before the end of the month Pitt was in communication with the King for the formation of a new Cabinet.

The Parliamentary attitude supplied Gillray with the hint for one of his most masterly conceptions, which appeared on the 1st of May, under the title of *Confederated Coalition; or, the Giant's Storming Heaven, with the Gods alarmed for their Everlasting Abodes.* " ' They never complained of fatigue, but, like giants refreshed, were ready to enter immediately upon the attack!'—Vide the Lord Chancellor's (Eldon) Speech, 24th April, 1804.—' Not to destroy, but root them out of heaven.' (Milton.)" The Ministerial gods appear but feeble opponents; they are supported on the clouds which surround their Treasury stronghold. One discharge from Fox's mighty blunderbuss has turned aside Addington's feeble squirt, planted a bullet in the Doctor's eye, and pierced a shield, with the emblem of an owl, which Hawkesbury, in the character of Minerva, is extending for his defence; Jenky's lance is broken, and will not reach his foes, his quiver is upset, and the arrows are all falling out. Earl St. Vincent is displayed as Neptune, and his gouty leg is laid up on a cushion. The eagle, grasping his thunderbolt, is almost out of sight. A group of Titans have scaled a rocky platform. Pitt, wearing a general's cocked-hat, is poising a bundle of " knock-me-down arguments," which he is preparing to heave into the midst of the Olympians; two bundles are reserved as final shots, marked " Coup de Grace," and " Death and Eternal Sleep." Dundas is aiming a thrust of his broadsword, " true Andrea Ferrara," at the First Lord of the Admiralty; Canning is following his leader Pitt with a mass of " killing detections;" and other adherents are casting up their charges. Wilberforce has brought his " Duty of Man." Windham, with Medusa's head on his shield, is hurling his fiery lance. Lord Mulgrave and others are advancing. Cobbett appears as a barking dog; he is protected by Windham.

Stanhope, M. A. Taylor, Grey, and Derby have bent their bows, and are drawing their barbs to the point. Mounted on a rock, in the foregound, the stout figures of Grenville and Buckingham elevate the Esau-like frame of Fox, whose formidable blunderbuss is doing tremendous execution. The Duke of Norfolk is beating the charge on a punchbowl, with two bottles. Lord Carlisle is rattling his marrow-bone and cleaver of " Coalition Roast Beef." Sir Francis Burdett is acting as standard-bearer. An ex-Ministerial supporter, in the character of Mercury, is extending a friendly hand to Sheridan, Erskine, and others of the Opposition, who are scaling, as monkeys, a secret ladder leading into Olympus by the back way.

On the 12th of May the Gazette announced that William Pitt was restored to his old place of Chancellor of the Exchequer. In forming his Cabinet, Pitt neither coalesced with Addington nor took in Fox. His quarrel with the former had ripened into personal hostility. He appears to have wished to conciliate Fox, and to give him a place in his Cabinet; but here he had to contend with the hostility of the King, who met his proposal with a flat refusal. Lord Temple and the Grenvilles, who had engaged that Fox should come in, refused to take office without him. In the new Administration the Duke of Portland was President of the Council; Lord Eldon, Chancellor; the Earl of Westmoreland, Lord Privy Seal; Lord Chatham, Master-General of the Ordnance; and Lord Castlereagh, President of the Board of Control. These had all formed a part of the Addington Ministry. Pitt's friend, Dundas, who had now been raised to the Peerage under the title of Lord Melville, was appointed First Lord of the Admiralty; Lord Harrowby succeeded Lord Hawkesbury as Secretary for Foreign Affairs; Lord Camden was made Secretary for the Colonies, and Lord Mulgrave Chancellor of the Duchy of Lancaster. Mr. Canning, who was now Pitt's main support in the House of Commons, was made Treasurer of the Navy, without a place in the Cabinet.

The change in the Ministry produced a clever caricature from Gillray, published on the 20th of May, under the title of *Britannia Between Death and the Doctors—Death may decide when Doctors disagree.*—Britannia, long treated as a helpless invalid, has just escaped from a bed of sickness, to which she has been confined by the Doctors Addington and Fox. Bonaparte (who kept his immense army on

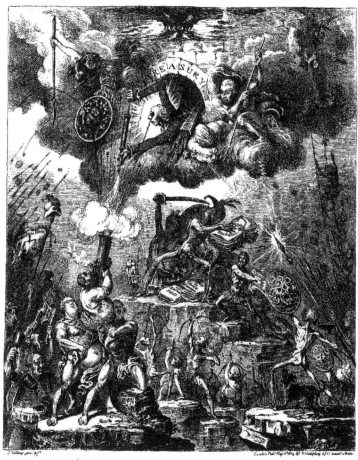

J. Gillray invt. & ft. *London Pub. May 9.1804. by H. Humphrey St. James's Street.*

Confederated-Coalition, — *or* — *The Giants storming Heaven* : — *with the Gods alarmed for their everlasting __ab-odes.*

— *"They never complaind of Fatigue, but like Giants refreshd were ready to enter immediately upon the attack"* ———

— *Not to destroy but root them out of Heaven"* *Milton.*

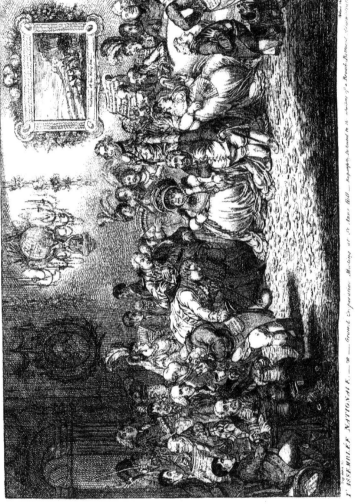

L'ASSEMBLÉE NATIONALE. — or — Grand Cooperative Meeting at St Ann's Hill. — Respectfully dedicated to the Admirers of a British Revolution Legion Rectitude

the opposite shore under the profession of making a descent on the English coasts), as "Death," has awaited the proper moment to aim his fatal dart. Pitt, the great State Physician, has arrived at the critical juncture. Doctor Fox, with his Red Cap of Liberty and his "Republican Balsam," is thrown on his back, his mouth is unceremoniously closed by Pitt's heel, and his Whig pills (a set of dice) are thrown out. Pitt is triumphantly exhibiting his "Constitutional Restorative ;" his sword is ready for service, his right foot is assisting the exit of Addington, against whom he is closing the door. The late Minister has dropped his quack "Composing Draught," his usual clyster-pipe appears in his pocket. "Death" is struck with consternation at the spectacle of losing his prey.

The Opposition, thus swelled by the accession of Addington and his friends, as well as the party of the Grenvilles, was very formidable, and Pitt actually came in with smaller majorities than those upon which Addington went out. The first trial of strength was on the 5th of June, when Pitt brought forward his plan for the military defence of the country. Sheridan attacked the new Ministers with great bitterness, pointed out their weakness in the House of Commons, and expressed his opinion that they ought not to remain in office with such a strong feeling there against them. Pitt showed more anger than it was usual for him to exhibit ; he said in reply to Sheridan, that, " as to the hint which had been so kindly given him to resign, it was not broad enough for him to take it ; even if the Bill were lost, he should not, for that, consider it his duty to resign—his Majesty had the prerogative of choosing his own servants ;" and he complained much of the opposition of the Grenvilles. Other members of the Opposition now rose in succession, and attacked the Ministry. Fox declaimed against Pitt's indecent defiance of the opinion of the House ; and the Grenvilles defended themselves.

Pitt, however, was evidently embarrassed by the hostility he had to encounter. It was clear that the old and compact party with which he had so long ruled the country had been entirely broken up, and he seemed confused and irritated among the discordant materials that now lay before him. The singular position in which the little parties that had thus sprung up stood towards each other, and the personal intrigues they engendered, afforded subjects for the caricaturist on every side, and these were not overlooked. On the 18th of June Gillray caricatured the whole body of the Opposition in a large print, entitled *L'Assemblée Nationale, or grand Co-operative Meeting at St. Anne's Hill. Respectfully Dedicated to the Admirers of a " Broad-bottomed Administration."*

Fox had latterly assumed a much more moderate tone than when Pitt's supreme influence left him no hopes of power ; he spoke with less bitterness of his political opponents, rested his opposition on the necessity of joining all parties in the support of the country and its constitution ; he still showed a little partiality for France and its rulers, but he called for vigorous exertions to carry on the war, now that we were irretrievably engaged in it. But there was another party now gaining head, much more extreme in its political principles than the Foxites, and which a little later assumed the name of Radicals. The leader of this party in the House of Commons was Sir Francis Burdett, who was taking the position in politics which had been held by Wilkes at the beginning, and by Fox in the middle of this reign ; and it was supported out of doors by Horne Tooke—still an active agitator—by Cobbett, who had already commenced his political writings—and by a number of other zealous partisans. Burdett embarrassed the Ministers in the Middlesex election in August, 1804, as Wilkes had done on the same scene of action. This occurrence has been com- memorated in an elaborate caricature by Gillray, published on the 7th of August, and entitled *Middlesex Election—a Long Pull, a Strong Pull, and a Pull Altogether.* The scene is laid in the neighbourhood of the hustings, to which Burdett is carried in triumph in his barouche, with Horne Tooke, his pocket full of speeches, as driver. Behind stand Sheridan, Tierney, and Erskine, carrying flags and banners : that held

Britannia Scourged.

up by Sheridan bears the representation of Britannia fixed in the pillory, and scourged by Pitt, in allu- sion to the punishment of political offenders in the prison of Coldbath Fields, the key of which is carried

by Tierney, while Erskine hoists the standard of the "good old cause." On the panels of Burdett's barouche are painted Peace, Plenty, and the Torch of Liberty; the wheels are passing over a dog (Sir W. Curtis)—"A squeeze for the contractors," according to Tooke's pamphlet. Tyrwhitt Jones, Fitzpatrick, Walpole, and others, dressed as butchers, attend the procession with marrowbone-and-cleaver music. Lord Moira is performing the part of drummer—his instrument bears the Prince of Wales's feathers— and a newspaper-boy from the "Morning Chronicle" is assisting with his horn. The Opposition, disguised as "roughs," are dragging Sir Francis's carriage, from which the horses have been removed. Lord Carlisle appears as a tailor, the Duke of Bedford as a farm-helper, Lord Derby as a postboy, and Fox as a ragged sweep. In a second file are Colonel Bosville, Grey, the Duke of Northumberland, wearing a leather apron, the Marquis of Lansdowne, and the Duke of Norfolk. Scattered about this animated print are allusions to Mainwaring (the Court candidate), who, although supported by the most powerful interest, only obtained a majority of five votes.

In the midst of this parliamentary strife at home, our inveterate enemy, Bonaparte, had made the last grand step in his political ambition. He was proclaimed Emperor of the French, under the title of Napoleon I., on the 20th of May, 1804, and crowned in Paris with extraordinary ceremonies on the 2nd of December following. A few days before this latter event, on the 26th of November, Gillray rejoiced all loyal volunteers, who hated the very name of the new Sovereign, with a new caricature, entitled *The Genius of France Nursing Her Darling,* in which the genius is represented in the form of a veritable *poissarde,* her garments stained with blood, and her spear, dripping with gore, supported against the wall. On her shield "Vive la République," is painted the decapitated head of Louis XVI., and the significant motto—"The last of Kings." The lady is tossing Napoleon, armed with his sceptre, and wearing the Imperial robes, as a child in one hand, and endeavouring to pacify his cries for a rattle surmounted with a crown, which she holds in the other. She sings a parody on the old nursery rhyme—

> "There's a little King Pippin!
> He shall have a rattle and crown!
> Bless thy five wits, my baby!
> Mind it don't throw itself down.
> Hey, my kitten, my kitten!"

In Gillray's caricatures may be traced the successive acts of hostility which estranged the Sovereign from his eldest son. A hint that the Heir Apparent might, after his early irregularities were forgotten, prove a worthy occupant of the throne, was set forth in a plate entitled *A Morning Ride* (February 25th, 1804). The Prince of Wales, mounted on a tall horse, is riding past the gates of Carlton House; his Secretary, Colonel M'Mahon, a small personage, is riding by his side. An apt quotation from Burns indicates the transformation anticipated :—

> "Yet aft a ragged cowte's* been known
> To mak a noble aiver,†
> So ye may doueely fill a throne,
> For a' their clish-ma-claver ;‡
> There, him at Agincourt wha shone,
> Few better were or braver ;
> An' yet wi' funny, queer Sir John,
> He was an unco' shaver.
> For monie a day."

In *The Reconciliation* (published Nov. 20th, 1804) we find these differences adjusted to the satisfaction of the entire community. Pitt and Lord Moira, the confidential advisers of the King and Prince respectively, are said to have effected this restoration to favour. The story of the Prodigal's Return is happily fitted to the situation. The monarch, in his gay-flowered suit, is falling upon the shoulders of the tattered Prince, whose contrition is attributable to his emptied pockets. Queen Charlotte is ready to take the wanderer to her bosom. Pitt, holding his "New Union Act, England's Best Hope," wears an air of gratified interest.

* Colt. † Horse. ‡ Talk or bother.

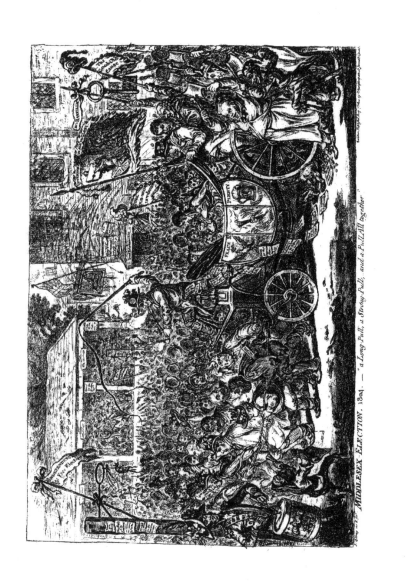

MIDDLESEX ELECTION. 1804. — "a Long Pull, a Strong Pull, and a Pull All together"

The RECONCILIATION.

Luke 15 v 20. — "And he arose and came to his Father, and his Father saw him which came from afar, & had compassion, & ran, & fell on his Neck, & kissed him."

A caricature portrait of the Duke of Clarence was published (June 26th, 1804) under the title of *The Royal Lounger*, with the motto, "Post tot Naufragia tutus." The Prince's figure is represented in a front view; he wears a beaver hat; the brim is resting on his nose; he is dressed in a buttoned-up coat, tight breeches, and top-boots. The entire costume gives the impression of a remarkably tight fit. The Duke of Clarence, as we have seen, was a popular frequenter of Bond Street.

A reminiscence of Lord Moira and the Sheridan family is preserved in the print of *A Hint to Young Officers; vide Edinburgh Chronicle* (July 7th, 1804). Lord Moira is standing in his dressing-gown at the door of Edinburgh Castle, holding a pair of lighted candles; a young officer, in his regimentals, is evidently startled at his reception, and his enormous cocked-hat is removed in involuntary respect. A Scotch watchman indicates the advanced hour. Lord Moira, out of friendship for Sheridan, became the patron of his son, "young Tom," who enjoyed the reputation of a "notorious Pickle." Lord Moira appointed Tom Sheridan his aide-de-camp. During his residence at Edinburgh Castle his servant was unpunctual in calling him in time for a review; the man excused himself on the ground that he had overslept himself, as he was obliged to sit up till four or five o'clock every morning for the aide-de-camp. Lord Moira sent his servant to bed, and sat up in his stead, and when the Bacchanalian Tom knocked at his usual hour, he was electrified at the reception pictured by Gillray. It is related of this lively youth that, "complaining one day to his father of that afflicting malady, 'Argentum paucitas,' he laughingly bade him go upon the highway. Tom replied he had tried that way, but without success. 'How?' exclaimed the father. 'Why, sir,' rejoined the son, 'I stopped a caravan full of players, who roundly swore that they had no money, for they belonged to Drury Lane!'"

On the 20th of November appeared four of those humorous pictures which formed in their day the diversions of the fireside, and which, in our own, illustrate the manners of the past, and register the changes of society. The designs are due to Brownlow North, a talented amateur, many of whose sketches were worked out and published by Gillray.

A Broad Hint of not Meaning to Dance, exhibits an incident of the ball-room. The evening is advanced, a merry cotillon is being danced by "the entire strength of the company," with three exceptions. A gentleman, with cocked-hat and cane, is nonchalantly taking snuff, turning his upraised coat-tails to the fire, without the slightest consideration for the presence of two fair neighbours—a trait of the "bucks" of the early part of the century.

Company Shocked at a Lady Getting Up to Ring the Bell, is a still more animated composition. Only one lady is present, probably a well-to-do widow, entertaining her admirers at tea. She has just risen to ring the bell. The politeness of her guests is outraged; they are eager to spare her this trouble. One military gentleman has upset the tea-urn and milk-ewer in his activity. A dog, whose propriety is also startled, has fixed his teeth in the offender's knee. A stout suitor has crammed an entire roll into his mouth, and is making a rush at the officer's pigtail, as the closest approach to a bell-pull. One guest is transfixed in an attitude of horror; another has thrust his knife through a loaf, with which he is belabouring the stoutest and least active of the guests—whose food is knocked into his eye by the concussion.

An Old Maid on a Journey, pictures the arrival at an inn of a resolute old lady on her travels. She is dressed in somewhat masculine habits, her fan and parasol are carried in one hand, she hugs her poodle with the other; a servant follows with boxes, bags, and a tambour frame; another carries a bird-cage. The landlord, napkin in hand, is ushering his guest into the apartment selected, "the Ram," his back is turned to "the Union." A stout landlady attends with a long bill of fare. The person represented is, it is believed, Miss Banks, sister of Sir Joseph Banks, a lady well known in her day; her collection of curiosities was added to the British Museum.

Mr. North's fourth sketch is entitled *Fortune-Hunting*.—An old gentleman and his comrade have fallen out of the hunt, and have dismounted in the midst of a party of ragged gipsies. An artful-looking hag is holding the hand of the stout Nimrod, and is foretelling him a fortune which excites his amazement; while a second harridan, with a child on her shoulders, is cautiously relieving his pocket of its contents. His companion is in the hands of a strapping and highly picturesque gipsy wench. Their horses are tied to a tree, and a man concealed in the branches is dexterously securing the contents of the saddle-bags.

S S

1805.

The year 1805 was marked by numerous interesting events. Napoleon was climbing to his giddiest elevation; England was mistress of the seas; and while universal dismay was produced by the news of the disastrous surrender of Ulm, intelligence arrived of the glorious victory of Trafalgar, saddened by the death of the gallant Nelson.

A conspiracy formed against the Consular Government by Georges and General Pichegru was made a stepping-stone to empire by the Corsican's sagacity. The defection of so esteemed a commander alarmed Napoleon, and afforded him an excuse for fortifying his position by the assumption of the Imperial title, which was confirmed by the votes of the Senate and the legislative bodies. Bonaparte had now reached the crowning step of his ambition. He was proclaimed Emperor of the French under the title of Napoleon the First, on the 20th of May, 1804, and was crowned with extraordinary ceremonies in the cathedral of Notre-Dame, on the 2nd of December, 1804. The aged Pontiff was compelled, by mandate, to repair to Paris, to assist at the coronation. Gillray's graver was employed to ridicule the solemnities observed on the occasion. The theatrical splendours of the new Court were constantly satirized at home. Napoleon's brothers, Louis and Joseph, were created princes; the dignities of arch-treasurer and arch-chancellor of the empire were conferred upon the two ex-consuls, Cambacères and Le Brun. The most distinguished officers were created marshals, a magnificent civil list was appointed, and a new constitution was prepared.

January 1st, 1805. *The Grand Coronation Procession of Napoleon the First, Emperor of France, from the Church of Notre-Dame, Dec. 2nd, 1804.* "Redeunt satania regna, jam nova progenies, cælo demittitur ulto!"—The sumptuous costumes and appointments, designed under the Empire, and encouraged by Napoleon to gratify the French taste for display, form admirable burlesque subjects. Hosts of troops, all bearing the imperial N, are drawn up to form the line of procession. His Imperial Highness Prince Louis Bonaparte is strutting at the head of the train, decked as High Constable of the Empire. The three Bonaparte Princesses, Borghese, Louise, and Josephine, clad in very meretricious garments, appear as the "Three Imperial Graces," to scatter flowers in the path of the new Emperor. A very

The Graces.

Talleyrand, King-at-Arms.

stout person, Madame Talleyrand ("*ci-devant* Mrs. Halhead, the prophetess") is conducting the Heir-Apparent in the path of glory. The crippled Prince Talleyrand-Perigord, Prime Minister and King-at-

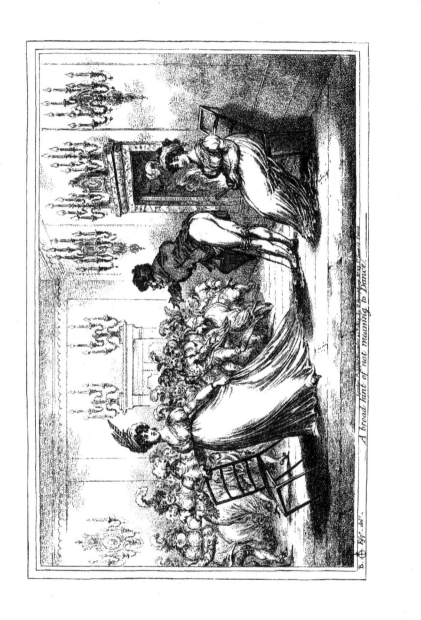

B. Eff. del.

A broad hint of not meaning to Dance.

I

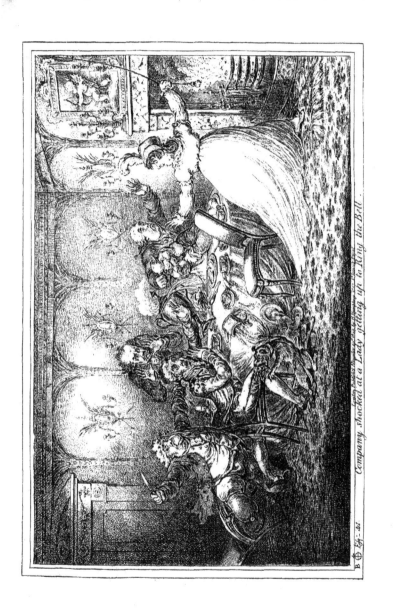

B ⊕ Eng. 4.

Company shocked at a Lady getting up to Ring the Bell.

Arms, bears his master's genealogical tree, springing from Buono, Butcher. Pope Pius the Seventh, with the support of his old friend, Cardinal Fesch, is led by a cloven-footed imp of darkness, bearing a candle. The incense is "Hommages des Scélérats," &c. The Empress Josephine, covered with jewels, is conventionally represented of extravagant corpulence. The Emperor is marching gravely, arrayed in all the elaborate trappings which his fancy revived. Puissant Continental Powers, represented in the persons of an Austrian hussar, a Spanish Don, and a Dutch boor, are supporting the Imperial cloak. The earlier Republican leaders, who were supposed to regard Bonaparte with jealousy, Generals Berthier, Bernadotte, Angerou, and others, are compelled to grace the ceremony in handcuffs and fetters. Senator Fouché, Intendant-General of the Police, follows, with the sword of Justice displayed in one hand and an assassin's dagger in the other. A guard of honour; a jailor with the keys of the Temple prison, and a bunch of fetters for dissentients; an executioner with his noose; Fouché's spies, and a secret poisoner with his arsenic, prepared to dispose of the refractory, form a "guard of honour." Gay emblematic banners, topped with the eagle, are seen in all directions; on one of them a comet, inscribed N, is pictured setting the globe on fire as it rushes through the firmament.

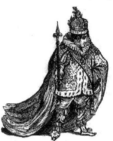

Napoleon in his Coronation Robes.

Scandals were promulgated attributing the gravest immoralities to Napoleon and his family. The dark insinuations directed against their reputations obtained ready credence in England. One of the least objectionable of these reports has been preserved by Gillray's graver; it forms a curious illustration of the inveteracy of popular feeling.

Feb. 20th, 1805. *Ci-devant Occupations; or, Madame Tallien and the Empress Josephine Dancing Naked before Barras in the Winter of 1797—a fact.*

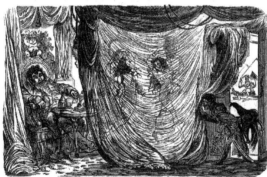

Ci-devant Occupations.

" Barras (then in power), being tired of Josephine, promised Bonaparte a promotion, on condition that he would take her off his hands. Barras had, as usual, drank freely, and placed Bonaparte behind a screen while he amused himself with these two ladies, who were then his humble dependents. Madame Tallien is a beautiful woman, tall and elegant. Josephine is smaller, and thin, with bad

s s 2

teeth, something like cloves. It is needless to add that Bonaparte accepted the promotion and the lady, now Empress of France!" This subject obtained wide notoriety. A certain mixture of fiction doubtless underlies the story. It is well known that Josephine de la Pagerie, widow of Viscount Beauharnais, who fell one of the earliest victims to the revolutionary tribunals, was herself preserved from a similar fate by the downfall of Robespierre on the very morning appointed for her execution. It is historical that, in those days of social contracts, she lived under the protection of Barras, then at the summit of power ; the young General Bonaparte was also his *protégé*; affection and a fusion of interests became the basis of an alliance between the ex-confidante of the murdered Queen of France and the youthful leader of the Revolution. The circumstance is best related in a letter written by Josephine while she was deliberating on the proposed marriage.

" ' Do you love him ?' (General Bonaparte) you will ask. Not exactly. ' You then dislike him ?' Not quite so bad ; but I find myself in that state of indifference which is anything but agreeable, and which, to devotees in religion, gives more trouble than all their other peccadilloes. . . . Barras gives assurance that if I marry the General he will so contrive as to have him appointed to the command of the army of Italy. Yesterday Bonaparte, speaking of this favour, which already excites murmuring among his fellow-soldiers, though it be as yet only a promise, said to me, ' Think they then I have need of their protection to arrive at power ? Egregious mistake ! They will all be but too happy one day should I condescend to grant them mine. My sword is by my side, and with it I will go far.' What say you to this security of success ? is it not a proof of confidence springing from an excess of vanity ? A general of brigade protect the heads of government ! that truly is an event highly probable. I know not how it is ; but sometimes this waywardness gains upon me to such a degree that almost I believe possible whatever this singular man may take it into his head to attempt ; and with his imagination who can calculate what he will not undertake ?"

The commencement of 1805 found Pitt surrounded with difficulties, before which his vigour seemed to forsake him—his health, impaired by anxiety, was rapidly breaking down. He did not venture to meet Parliament until the 15th of January, 1805, when, after vain efforts to bring over the Grenvilles, he at last succeeded in detaching Addington from the Opposition ranks. " The Doctor" was rewarded with a peerage, under the title of Viscount Sidmouth, and the office of President of the Council, vacated by Lord Portland on account of his advanced age. Still Pitt was not strong in his majorities, and the opposition he encountered was remarkably pertinacious and annoying. His own friends combined to add to his uneasiness. Wilberforce, at the beginning of the session, persisted in bringing forward the question of the Abolition of Slavery, in spite of the Minister's entreaties ; and later on, he persisted in the impeachment of Dundas. Pitt's attitude towards France had, however, lost none of its dignity. Overtures had been made by Napoleon in January for a reconciliation with England. The rival pretensions of these great men were displayed in a highly popular caricature, published 26th February, 1805—*The Plum-pudding in Danger, or State Epicures taking un Petit Souper.* " ' The great globe itself, and all which it inherit,' is too small to satisfy such insatiable appetites." This cartoon has been described as one of Gillray's luckiest hits, adapted to all comprehensions. Pitt is seated at one end of the table and Napoleon at the other ; both are covered, armed, and in regimentals. The sole dish between them is the Globe, served up on a shallow plate, and wearing the appearance of a plum-pudding. No grace seems to have been said, nor any act of courtesy passed between them. Boney's sword has sliced off the Continent—France, Holland, Spain, Italy, &c., his fork being spitefully dug into Hanover, then an appendage of the British Crown. Pitt's trident is stuck in the ocean, and his carver is modestly dividing the Globe down the middle, with an evident chance of " coming again."

Pitt and Sheridan had continued the bitterest antagonists throughout their parliamentary careers ; whenever the course of debate brought them into collision their attacks were sharpened by a spirit of personal animosity which they rarely exhibited on other occasions. An instance of this occurred in 1783, when Pitt was Chancellor of the Exchequer, under Lord Shelburne's Administration, on the motion for censuring the preliminaries of the American Peace, upon which occasion Sheridan said :—" If the right honourable gentleman's youth and very early political exaltation had allowed him time to

The Plumb-pudding in danger :— or State Epicures taking un Petit Souper.

"— the great Globe itself and all which it inherit," is too small to satisfy such insatiable Appetites.

look for precedents, or to attain a knowledge of the journals, his discretion might have imposed some restraint on his precipitation. He would not have manifested so much indignation at the questions put to Ministers, and which it became their duty to satisfy. These facts convince me that he is more of a practical than an experienced politician."

Pitt, in defending the preliminaries, was pointedly severe on all who opposed the Address, but he selected Sheridan for his most cutting sarcasms. "No man," he said, "admired more than he did the abilities of the hon. gentleman, the elegant sallies of his thoughts, the gay effusions of his fancy, his dramatic turns, and his epigrammatic points, and if they were reserved for the proper stage they would no doubt receive, what the hon. gentleman's abilities always did receive, the plaudits of the audience, and it would be his fortune, *sui plausu gaudere theatri*. But this was not the proper scene for the exhibition of those elegances."

Sheridan's rejoinder was worthy of his genius. "On that particular sort of personality which the right hon. gentleman had thought proper to introduce, he need not comment; the propriety, the taste, the gentlemanly point of it, must have been obvious to the House. But let me assure the right hon. gentleman, that I do now, and will at any time he chooses to repeat this sort of allusion, meet it with the most sincere good humour. Nay, I will say more: flattered and encouraged by the right hon. gentleman's panegyric upon my talents, if ever I again engage in the species of composition he alludes to, I may be tempted to an act of presumption—to attempt an improvement on one of Ben Jonson's best characters—the character of the Angry Boy, in the 'Alchemist.'"

On the 6th of March, 1805, an equally spirited exchange of hostilities took place between these gifted rivals. Sheridan made a motion for the repeal of the Additional Force Bill. After demonstrating the inefficiency of the measure, he proceeded to dwell on the constitution of Pitt's new Cabinet. "Pitt," he said, "had himself denounced the incompetency of the majority of his present colleagues; but he supposed the talents of Lord Hawkesbury, Lord Castlereagh, Lord Eldon, and others had been wonderfully changed and improved by being removed from Addington's Cabinet and transplanted into his own."

Mr. Pitt's reply was not conciliatory. "The hon. gentleman," he said, "seldom condescends to favour us with a display of his extraordinary powers of imagination and of fancy; but when he does come forward, we are prepared for a grand performance. No subject comes amiss to him, however remote from the question before the House. All his fancy suggests, or that he has collected from others, all that he can utter in the ebullition of the moment, all that he has slept on and matured, are combined and produced for our entertainment. All his hoarded repartees, all his matured jests, the full contents of his commonplace book, all his severe invectives, all his bold, hardy assertions he collects into one mass, which he kindles into a blaze of eloquence, and out it comes altogether, whether it has any relation to the subject in debate or not. Thus it is that the hon. gentleman finds a new argument for the repeal of the present Bill because the House and the country has less confidence in the present than in the late Ministers."

Sheridan, it appears, was unusually moved by this counter-attack. He went into Bellamy's refreshment-room, ordered a bottle of Madeira, poured it into a bowl and drank it off, and thus primed returned to his seat, and made a most cutting retort, in the course of which he remarked:—"The right hon. gentleman intended, I suppose, to contrast my violent language with his own singular gentleness and meekness of manners. No man is more ready to acknowledge his great and eminent talents than I am. No man esteems them higher than I do. But if I were to characterize his Ministry, I should say, in language which the right hon. gentleman may recollect to have heard before—namely, that he has added more to the burdens and subtracted more from the liberties of the people than any Minister that ever governed this country."

Gillray has illustrated the scene in a famous cartoon, published immediately after the debate.

March 10th, 1805. *Uncorking Old Sherry.*—Below the print appears a version of Pitt's speech, adapted for the occasion:—"'The honourable gentleman, though he does not very often address the House, yet when he does, he always thinks proper to pay off all arrears, and like a bottle just uncorked bursts all at once into an explosion of froth and air; then, whatever might for a length of time lie lurking and

corked up in his mind, whatever he thinks of himself or hears in conversation, whatever he takes many days or weeks to sleep upon, the whole commonplace book of the interval is sure to burst out at once, stored with studied jokes, sarcasms, arguments, invectives, and everything else which his mind or memory are capable of embracing, whether they have any relation or not to the subject under discussion.'—See Mr. Pitt's Speech on the General Defence Bill, March 6th, 1805." The grasshopper figure of Pitt, the State butler, with a serviette, marked G. R., under his arm, is seen tapping the liquors in the St. Stephen's vaults. A bottle of "Medicinal wine," painted of a sickly hue in the coloured versions, bearing the features of Addington, is upset, and its weak contents are suffered to leak out. "Old Sherry" is undergoing the process of uncorking; the froth of egotism is overflowing, and "Fibs" are bursting on all sides: with "bouncings, growlings, abuse, invectives, old puns, damned fibs, groans of disappointment, stolen jests, invectives, lance puns, loyal boastings, dramatic readings, low scurrilities, stale jests," &c. Grey figures on a flask of "gooseberry;" Windham is exhibited as "brandy and water;" Fox is drawn as "true French wine;" Tierney is a glass of "all sorts." A bottle labelled "Spruce beer" bears the features of Erskine. "Brentford ale" exhibits the face of Sir Francis Burdett; next to him stands a bottle of Whitbread's small beer. The other members are represented as "Mum," "Elder wine," &c. Gillray's contemporaries were delighted with this cartoon.

"It is said that this most spirited design was composed by our caricaturist in a moment of enthusiasm. He seized the pencil, and dashed it on a scrap of paper quick as the thought; transferred it to the copper, etched it, and bit it in; and it was ready for the press within almost as many hours as one of the prosing declamations of a certain member of that House, of which this print so strange, though far-fetched, yet so well understood and accepted, is an allegory. How truly the artist understood the quality of each various liquor, to use the phraseology of the cellar, judging per label, time has developed. No member of the British Senate laughed more heartily at this caricature than the ruby-nosed 'Sherry,' which all the world ran about quoting.

"What inexhaustible variety played before the fancy of this inimitable artist. His prolific invention never slept until excess of genius obscured the very inward light which gave it birth. This graphic designer, in that sad state of mental deprivation which clouded his last years, still had his lucid moments, when he would form new schemes, and rave enthusiastically about his favourite art."

Allusions to the dissensions between the Prince of Wales and the Princess Caroline occur in the caricatures of the year. A dispute had arisen as to the proper person to be entrusted with the education of the Princess Charlotte. The Prince desired to entrust her to Mrs. Fitzherbert; the Princess insisted on her own maternal rights. Bitter feelings and plentiful intrigues were produced by the question. The King pronounced his decision in favour of his niece, in whose custody the Princess accordingly remained until circumstances rendered her removal expedient.

The dangers which attended the Prince's desire were set forth in a clever parody as *The Guardian Angel** (April 2nd, 1805)—the hint taken from the Rev. Mr. Peter's sublime idea of "an Angel conducting the soul of a child to Heaven." The stout figure of Mrs. Fitzherbert is bearing the Princess from the gaieties of the Brighton Pavilion to the altar of the Romish faith; a Brighton breviary, an incense charger, and various images of saints, &c. are disposed in her lap as "playthings," suitable for the diversion of a princess of the Protestant Church. A flowered and tinselled altar of the Virgin is

* This subject was suggested by an attempt to deprive Mrs. Fitzherbert of the guardianship of the orphan daughter of Lord Hugh and Lady Horatia Seymour. She had been left undisturbed for several years under Mrs. Fitzherbert's charge, and, at the period when the subject of "Catholic Emancipation" was stirring up intolerance, precisely when the propriety of removing a Protestant ward from the charge of a Catholic guardian was likely to arouse much dissension, the claim was put forward as a "party" tactic. The Prince "had worked himself up," writes Lord Holland, "to believe that Mrs. Fitzherbert's life and his own happiness depended on the society of this child." It was deemed imprudent to appeal to equity. The subject of the marriage would probably be revived, and it would go forth that the Prince was upholding the Papist party. Lord and Lady Hertford were asked to intercede, as the nearest relatives to Lady Horatia Seymour. In the interviews on this subject originated the notorious liaison with Lady Hertford, and the insults and neglect with which the Prince repaid the devotion of the high-minded lady whose reputation he had compromised.

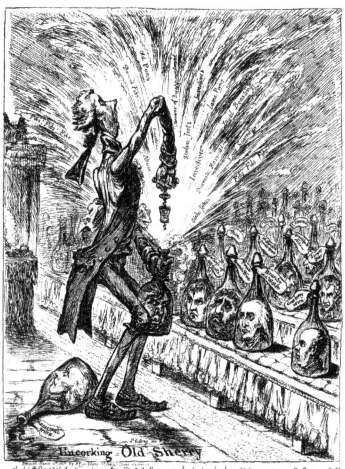

Uncorking Old Sherry

...the hon.ble Gent: tho' he does not very often address the House, yet when he does, he always thinks proper to pay off all arrears, & like a Bottle just uncorked bursts all at once, into an explosion of Froth & Air;— then, whatever might, for a length of time lie lurking & corked up in his mind, whatever he thinks of himself or hears in conversation, whatever he takes many days or weeks to sleep upon the whole common place book of the interval is sure to burst out at once, stored with studied Jokes, Sarcasms, arguments invectives, & every thing else which his mind or memory are capable of embracing whether they have any relation or not to the Subject under discussion.— See M.r Pitts Speech, on J.no Debate &c —

surrounded by a circle of " Indulgences, Absolutions, Luxuries, and Dissipations. ' The leading members
of "the party"— Stanhope, Grenville,
Grey, Erskine, Carlisle, Sheridan, Norfolk,
Fox, Burdett, and Derby, &c.—appear as
cherubim.

In May Pitt had to contend with the
question of all others most disagreeable
to him at the present moment, from the
part he had already taken in it—that of
Catholic Emancipation, which, however,
he opposed on the ground of the inexpe-
diency of bringing it forward under
the circumstances of the time. The
Irish Catholics petitioned both Houses of
Parliament for emancipation from the
penal statutes then in force against them.
Lord Grenville brought the subject for-
ward in the Lords, and Fox presented
their petition in the Commons; in both
Houses the claims were rejected by large
majorities.

Gillray commemorated these defeats
in an elaborate cartoon, issued May 17th,
1805, under the title of *End of the Irish
Farce of Catholic Emancipation.* The
friends of emancipation are represented in
grand Popish procession, mounting the
globe and pressing towards a flight of
steps leading direct to the "good things
above," through the wicket of "Popish

The Guardian Angel.

Supremacy," which St. Peter is respectfully opening in expectation of their arrival. Lord Grenville,
in full pontificals, is at the head of "the party;" he has already advanced several steps of the
ascent, but his progress is arrested by a flaming sword of truth; the emblems of Romanism are
weighed against the Bible and Crown, and found deficient, and the lightnings of Revelation are con-
founding the hosts. Pitt, as we have traced, retired from office with Grenville on the rejection of the
measure he brought forward with the same object. The Minister now exerted his influence against the
cause; he is seen, with Hawkesbury and Addington, employing the full vigour of his lungs to con-
found the advocates of emancipation. The Catholic petition, shattered in the blast, is borne out of Pope
Grenville's reach; all the accompaniments of the Romish faith, the elements, images, relics, dispensations,
pardons, &c. are being whirled off to a limbo described on the plate as "the Paradise of Fools."
The Marquis of Buckingham has lost his "decretals;" Lord Moira is completely overturned, his sword
is snapped, and his fall has upset Mrs. Fitzherbert, who was suspected of lending her influence for the
relief of the Romanists; as the Brighton Abbess, she is clinging to her "system of education for
the benefit of Protestant children." An Irish bull, with Napoleon's miniature suspended round his neck,
is provided as a charger for the great Cardinal; Fox, the Legate, and his hierarchical powers, are completely
upset; Lord Stanhope is stealing behind the Cardinal as incense-bearer; Sheridan is elevating the Host;
Lord Lauderdale is dropping the bell; Lord Holland is candle-holder; Lord Henry Petty is chanting
his prayers. A band of Inquisitors are attached to the procession. Tierney is carrying a crozier, topped
with the Cap of Liberty; Windham, bearing a banner representing an "Auto-da-Fé in Smithfield," is
vehemently flourishing a flaming torch of the "Weekly Register;" Erskine is rehearsing from "Instruc-
tions for the Advocate of the Holy Order." The Duke of Clarence is "holy-water" bearer; the Duke

of Bedford is meditating on " Transubstantiation;" the Duke of Norfolk, as a bucolic friar, is filling a communion vessel with Whitbread's bottled porter; Lord Derby, Lord Carlisle, Sir Francis Burdett, Lord Thanet, Grattan, &c. attend as monks, chanting their own favourite vespers.

It has been remarked :—" The same ingenious hand that produced the satire upon the illustrious political group had previously complimented the heaven-born Minister, in his print of *Integrity Retiring from Office*, for his dignified and consistent conduct on the failure of his proposed measure of Irish Emancipation ! Such are the political anomalies which occur in the public actions of public men ! What Pitt's private thoughts might be on this question must remain matter for speculation; but that Fox was sincere in his endeavours to remove these religious disqualifications from our fellow-subjects, no one who judges fairly of the tolerant spirit of that great orator can for a moment doubt. The love of liberty, civil and religious, ' grew with his growth, and strengthened with his strength,' and continued to be evinced in his public conduct to the final close of his career."

One of the blows which accelerated Pitt's decline was dealt by certain members who insisted on the impeachment of his old and steadfast ally, Dundas, who was charged with employing certain public moneys for his own personal accommodation, in contravention to an Act he had introduced to regulate the office of Treasurer of the Navy. In the course of investigating the charges brought against Lord Melville, it transpired that Pitt had advanced 40,000l. of the public money, in 1796, to enable Boyd and Benfield, the contractors, to make good their instalment of a Government loan, without sacrificing their scrip at a ruinous discount. Pitt's more violent opponents professed their belief that the advance was traceable to a corrupt understanding between the Minister and the contractors. When Mr. Whitbread brought this question before the House, Pitt inquired whether he should retire during the discussion of a subject affecting him personally. Fox and a large majority eagerly denied the necessity. Fox availed himself of the occasion to express his deep sense of Pitt's incorruptibility. It is doubtful whether this act may be assigned to the generous expression of his own conviction; whether it was an involuntary testimony on his part; or whether, as some have suggested, it was the first step to a coalition between England's two greatest statesman. This smoothing away of traditional hostilities furnished the satirist with an admirable text, and on the 21st of June, 1805, Gillray favoured the country with a prospect of the harmony to be anticipated in the future, as *Political Candour; i.e., Coalition Resolutions of June 14th, 1805—Pro bono Publico.* On the Speaker's table is a formidable list of Resolutions, all directed against Pitt; the occupants of the Opposition benches are prominently represented : Fox, whose bushy hair is cropped and whitened, is addressing the Premier in disavowal of the Whitbread prosecution. He observes, in parody of his own speech—" Yes, sir, I do assure the Right Honourable Gentleman, though our lives have ever been opposite, though in almost every instance we have disagreed, and though I have constantly blamed the whole of his conduct, yet I should be everlastingly unhappy had it turned out that he had acted wrong, or had soiled his hands in the manner we meant to attribute to him. I do say, sir, that during my whole life I never had the least suspicion of anything dishonourable in the Right Honourable Gentleman; solemnly, my mind has always most completely acquitted him ! He will be held up to posterity and cited as a bright example of purity, integrity, and honour !" Fox's hand, held behind his back, grasps the draft of " Arrangements for a New Coalition;" while in his hat is a bundle marked " Political union to save the country from Buonaparte and the Doctor." A porter measure—Whitbread's entire—is upset, and its contents are escaping as froth, indicative of the end of his Resolutions. Grey, who has his papers ready for " Inquiries into the Public Offices" is thrusting them out of sight, observing, " I find they'll be all proved honest, so I'll destroy my papers too." Pitt is seated in solitude on the Treasury bench; he is pointing in gratitude to the vacant place by his side, crying, " Here, here, here !" Tierney cries, " Oh, how I shall enjoy to sit down with him upon the bench of honesty !" Lord H. Petty declares, " An immaculate statesman ! just like my own papa !" Wilberforce, in pious ecstasy, ejaculates, " Oh, he's an angel of light, a cherubim of glory !" Windham, with notes and speeches for the " Political Register," held in readiness, is exclaiming, " Why, he deserves a statue of gold, more than Porcupine (Cobbett) himself !" Erskine is somewhat professionally asserting, " He scorns a dirty cause, I vow !" Other conspicuous members of the Opposition are indicated behind and in the gallery above.

This caricature, beyond suggesting a possible fusion between Pitt and Fox, is also interesting as the last appearance of Pitt in these political satires.

We have noticed that Wilberforce insisted on pressing forward measures injurious to his party. He was eager in promoting the impeachment of Pitt's old friend, Lord Melville (Dundas), for whom he had contracted a sort of puritanical dislike, because he was a hard drinker and sometimes a rather profane joker. Wilberforce's conduct on this occasion is said to have given great annoyance to Pitt.

Gillray's political prints trace Lord Melville in his various capacities—as Pitt's confidant, the sharer of his labours, and the companion of his social relaxations; as the Comptroller of India, and of our naval resources. The versatile Lord Advocate of Scotland had filled the various offices of Treasurer of the Navy, Secretary for the Home Department, Secretary for the Colonies, with the management of the French war, and First Lord of the Admiralty.

> "Alike the Advocate of North and Wit,
> The Friend of Shelburne and the Guide of Pitt."

While holding the office of Treasurer of the Navy he had introduced an Act which prohibited the Treasurer from making any use of the money in his hands—an emolument which had been allowed previously. Earl St. Vincent, as First Lord of the Admiralty under the Addington Administration, obtained a commission of inquiry into the affairs of the Navy. The report proved that Lord Melville had himself employed certain public moneys for his own personal accommodation. "It was admitted that the whole had been repaid, and that no loss had been sustained by the public, but it was clearly a violation of the salutary provisions of his own Act, and led to his impeachment. He was acquitted of corruption, but his political career was terminated."

Gillray took the popular side, and produced a cartoon commenting upon the members who conducted the impeachment.

July 16th, 1805. *The Wounded Lion.* "'And now all the skulking herd of the forest, some out of insolence, others in revenge, some in fine upon one pretence some upon another, fell upon him by consent. But nothing went so near the heart of him in his distress, as to find himself battered by the heel of an ass.'—Vide Æsop's Fables."—Lord Melville, a noble and venerable lion, is lying at Britannia's feet; his paw rests upon his "Plans for Manning the Navy," "List of Ships Built in 1804," and "Abolition of Impress." Earl St. Vincent, from the shelter of a wood, is discharging a monster piece of artillery; the muzzle resembles a pewter measure of "Whitbread's entire." Whitbread led the attack; according to an epigram published at the time :—

Earl St. Vincent.

> "Sansterre forsook his malt and grains,
> To mash and batter nobles' brains,
> By lev'lling rancour led;
> Our Brewer quits brown stout and washey,
> His malt, his mash-tub, and his quashea,
> To mash a Thistle's head.'

A shower of invectives—Popular Clamour, Disappointed Jacobins, Envy, Malice—have struck the lion; while a stray shot, "Condemnation without Trial," has wounded Britannia to the heart; and her spear is snapped and her shield discarded. Grey, as a serpent, has fastened on the lion's shoulder. Fox, as his four-footed namesake, and Kinnaird, as a wolf-dog, are worrying the rear. Erskine, Jekyll, and others are hastening, as legal rats, to share in the spoliation. The unkindest blows of all are dealt from the hoofs of the Addington family, represented as asses. Lord Sidmouth is laden with "Physic for the Lion," clysters, emetics, &c. Hely Addington and Bragge, his brother-in-law, loaded with "Provisions for the Doctor's Family," and "Trifles procured through the Lion's Generosity," are laying their heels together. "Very highly indebted to the lion, Brother Heeley!" "Then give him another kick, Brother Braggey!" Wilberforce, in the character of an ape, is perched in a tree over St. Vincent's

T T

head, emitting "Cant, Envy, Abuse, Hypocrisy, Cruelty," &c., distilled from his "Solution of Vital Christianity."

While these persecutions were distressing Pitt at home, Napoleon was rapidly assuming the dictatorship of the entire Continent. The imminent danger which threatened the commonwealth of States produced a coalition against France of Russia, Austria, Sweden, and England; the latter being, as usual, paymaster. The Austrian preparations provoked Napoleon to recommence hostilities. It was anticipated that the Allies would be able to strike a fatal blow at the power of the new Emperor. A print, published August 2nd, 1805, embodies the English view of the question, under the title of *St. George and the Dragon.* The Corsican Dragon has overthrown Britannia, her shield and spear have escaped her grasp; she is rescued from this perilous position by a stout champion of Christendom, in the person of King George, dressed in his Guards' uniform, and mounted on a fiery steed. The King's blade has cleft the monster's crown, and a second blow promises to leave him at the mercy of "St. George." It has been observed of this print that :—"The constancy of George the Third, in maintaining the glorious struggle against the almost overwhelming dynasty of Napoleon, and against all the world, single-handed, will form a feature in British history which may well cause future generations to feel proud on looking back to certain periods of the reign of this indomitable King."

At the commencement of the campaign the Allies committed an error fatal in their calculations. The Austrian army marched into Bavaria, and occupied it as a conquered State; no steps were taken to conciliate the Elector; the immediate consequences are well known. Bavaria, Wirtemberg, and Baden naturally resented this treatment. Bonaparte, taking advantage of this short-sighted policy, offered the most flattering proposals; they lent him their troops and resources, and became a part of *his military system* until, in later years, they forsook France in the hour of extremity, and turned their arms against her.

After securing this assistance, the French crossed the Danube, detached and pursued the Arch-Duke Ferdinand, surrounded General Mack, and electrified Europe by becoming masters of the most important fortress in Germany. Few events have ever produced more universal consternation than the astounding surrender of Ulm by the Austrian Commander, on the 17th of October, 1805. This disgraceful capitulation on the part of General Mack entirely disorganized the plans of the Allies. Gillray published his own comment on the transaction :—

November 6th, 1805. *The Surrender of Ulm, or Buonaparte and General Mack coming to a Right Understanding, intended as a Specimen of French Victories ; i.e., Conquering without Bloodshed !*—Mack and his Generals are grovelling on their knees, depositing their swords and the keys of the fortress at the feet of Napoleon, who is drawn as a pigmy seated on a drum-head. The conqueror is pointing to the stipulated bribe, three sacks of money, held by his soldiers. "There's your price!" he cries. "Ten Millions—Twenty ! It is not in my army alone that my resources of conquering consist. I hate victory obtained by the effusion of blood !" "And so do I, too !" replies the prostrate Mack. "What signifies fighting, when we can settle it in a safer way ?" A list of "Articles to be delivered up" is lying beside the guns, shot, and materials of war relinquished by Mack. "One Field-Marshal, 8 Generals-in-Chief, 7 Lieutenant-Generals, 36,000 Soldiers, 80 Pieces of Cannon, 50 Stand of Colours, 100,000 Pounds of Powder," &c.

The actual speech made by Bonaparte to the assembled Austrian officers, on the occasion of the 30,000 troops depositing their arms on the glacis, was eminently specious and showy, as became the situation :—"Gentlemen, your master wages an unjust war. I tell you plainly, I know not for what I am fighting; I know not what can be required of me. My resources are not confined to my present army. These prisoners of war now on their way to France will observe the spirit which animates my people, and with what eagerness they flock to my standard. At a single word 200,000 volunteers crowd to my standard, and in six weeks become good soldiers; whereas your recruits only march from compulsion, and do not become good soldiers until after some years. Let me advise my brother, the Emperor, to make peace. All States must have an end; and in the present crisis he must feel serious alarm lest the extinction of the dynasty of Lorraine should be at hand. I desire nothing further upon

the Continent. I want ships, colonies, and commerce; and it is as much your interest as mine that I should have them."

A contemporary account thus refers to the subject of this print :—"Amidst the catalogue of disasters which thwarted the plans of Mr. Pitt, and which his evil genius seemed to accumulate as the great Minister approximated the termination of his career, the surrender of Ulm holds a place disgraceful to the military history of Germany, which will remain a recorded memento of one of the many gulfs into which, during this memorable war, John Bull beheld his hard-earned gold swallowed up, and disappear for ever.

"A vast loan had been furnished by this country to our German Allies, on the strength of which glorious results were anticipated by those who had the faculty at will of dreaming golden dreams. When, alas for Pitt! the fatal news arrived that General Mack had betrayed his country—had been corrupted by French gold; and, with a force under his command of about 36,000 men, had given up the important post which he held, surrendering himself, with his whole army, as prisoners, almost before even a show of attack had been made by the enemy; and prodigal England, as usual, had now only to calculate how much it had cost her per man to recruit and equip that vast and hopeful army, which surrendered to the common enemy without firing a shot. General Mack, after this disgraceful capitulation, was permitted to return to Vienna, where he was tried before a military tribunal, and received the sentence of death. His doom was, however, commuted to imprisonment, and he was, after a time, released, and died in obscurity, the Emperor leniently determining it unnecessary to order him to be shot, like Admiral Byng, ' pour encourager les autres.' "

The Austrian forces in Italy were commanded by the Archduke Charles; the French, under Massena, compelled him to withdraw after an obstinate struggle. The operations against Austria progressed rapidly. The French advanced guard arrived before Vienna, and favourable terms were accorded to the city. The Russian army had retrieved its position, and reinforcements had arrived. After a considerable display of finesse and strategy, in which Napoleon affected to shun an engagement, the Russian forces were compelled to become the assailants. On the 1st of December they commenced an offensive movement, to which Napoleon offered no resistance; and at night the Allies occupied a strong position in front of the French army; the forces, some 80,000 on both sides, were about equal. On the following day (the 2nd December) was fought the fatal battle of Austerlitz, which terminated, after a sanguinary contest, in the signal victory of Napoleon; the Allied armies were reduced by nearly one-half; their aggregate loss in killed, wounded, and prisoners, amounted to some 40,000 men, and almost their entire artillery was captured. The Emperor Francis was compelled to submit to terms dictated by the conqueror at the sword's point, and Napoleon at once set about the combinations known as the Confederation of the Rhine, in which he assumed the preponderance previously enjoyed by the House of Austria.

The news of the fatal issue of the battle of Austerlitz was perhaps the most disheartening which ever reached our shores. It was a death-blow to Pitt. The general consternation was, however, much allayed by the previous intelligence of Nelson's glorious victory at Trafalgar, fought on the 21st of October, which annihilated at one blow the French and Spanish fleets. The enthusiasm consequent on this valiant action, so worthy of the name of Nelson, was moderated by universal mourning for the loss of England's greatest naval hero.

Gillray contributed his small offering to the innumerable expressions of sorrow. *The Death of Admiral Lord Nelson, in the Moment of Victory, Designed to Commemorate the Death of the Immortal Hero, &c.* (published 29th of December, 1805). The action is raging around; the figure of the dying hero, leaning on a cannon, is sustained by Britannia, who is passionately weeping over the fate of her lion-hearted son. A captain is stanching the wound, just below the unfortunate decorations, which the admiral had insisted on retaining*—a mark which had directed the aim of the sharpshooters, who, in the mizen-mast of the *Redoubtable*, were able to pick out any person on the deck immediately below them.

* "In honour I gained them and in honour I will wear them," persisted Nelson in reply to Hardy's caution to remove these insignia.

The dying admiral is relinquishing his sword. The figure is dignified, and the likeness is successful and worthy of the occasion. The other portions of the picture are, however, less meritorious. The captured flag of the *Santissima Trinidada*, the opponent fixed on by Nelson, is vainly waved to the stricken admiral; while Fame, hovering over his head, is proclaiming the " immortality" of England's favourite hero.

The close of the year 1805 was occupied with the admiral's funeral. Perhaps in no country before have higher public honours been paid to the memory of a national benefactor than those that were spontaneously conferred on Lord Nelson. His body was brought home for interment. (" Don't throw me overboard," had been the dying admiral's request to Hardy.) The corpse was exhibited for three days in the proudest state at Greenwich, from whence it was conveyed by water with due pomp by members of the Admiralty; and the next day, January 9th, 1806, it was drawn upon a funeral car to the cathedral of St. Paul's, where it was most solemnly buried. His funeral, conducted at the public expense, is said to have been the most religiously magnificent spectacle ever witnessed in this country. Seven of the sons of his Sovereign attended to pay the last respects to the body of England's redoubtable defender.

Thus, with the battle of Austerlitz and the burial of Nelson, while Pitt's frame sank gradually under accumulated vexations, the year 1805 reached an unpropitious close.

We may particularize among the social studies for this year an allusion to Sheridan's " methods of raising the wind." A previous caricature has traced the support which Sherry Andrew derived from John Kemble, and from " Pizarro," his gold mine of Peru. After these profitable hits the performances at Drury Lane seem to have been falling in interest and in pecuniary productiveness, when on the 5th of December, 1803, a " serio-comic romance" was brought out under the title of " The Caravan," the chief characteristic of which was the introduction on the stage of real water and of a large New-foundland dog, which was made to rush into it and drag out the figure of a child. A contemporary criticism tells us that " the main object of the author seems to have been to produce novelty, and through novelty to excite surprise. The introduction of real water flowing across the stage, and a dog acting a principal part, chiefly attracted attention, and seemed amply to gratify curiosity." This piece, in spite of the puerility of the idea, had an extraordinary run, and, to use the words of the critic just quoted, was " very productive to the treasury." The Tory opponents of Sheridan as a politician represented this as a well-timed and very necessary relief.

The Drury Lane company appears to have been now under the frequent necessity of having recourse to expedients of this kind to catch popular favour. The year 1805 witnessed the sensation produced by

A Bubble.

the "infant Roscius" (Master Betty), who was brought on the stage at Drury Lane when only twelve years of age. The extraordinary sums of money which this child produced were an important assistance at this moment to Sheridan, who made the most of his good fortune. His political opponents were loud in their declamations against *The Theatrical Bubble*, a title under which Gillray published a caricature on the 7th of January, 1805, in which he represented Sheridan as Punch on the boards of Old Drury, with a few additional gems added to his ruby nose from the profits of his theatrical treasury, blowing the bubble which had replenished it, and surrounded by some of his friends who had been loudest in their patronage of the prodigious infant, among whom we easily recognise Lord Derby, Lord Carlisle, Mrs. Jordan, and her admirer, the Duke of Clarence. Fox is expressing somewhat boisterously his joy at the success of his political friend. On a table behind the manager stands a barber's basin, filled with soapsuds, labelled " Materials for bran-new pantomimes for Johnny Bull's amusement;" one bubble represents the " Forty Thieves;" another, placed in the neck of a decanter, revives the " bottle conjuror, close to be repeated the first opportunity." Beneath the table is seen the strong box of Drury Lane, duly padlocked, while the famous dog Carlo is sleeping by its side. A shower of gold has rewarded the " great Politico-Punchinello," and his " bubble Roscius."

HARMONY before MATRIMONY

MATRIMONIAL - HARMONICS.

This appears to have been the most prosperous period of Sheridan's finances. On the 24th of February, 1809, Drury Lane Theatre was burnt to the ground, while Sheridan was at his post in the House of Commons. With it ended his theatrical and parliamentary prospects.

Jan. 23rd, 1805. *Palemon and Lavinia:*—

> "He saw her charming; but he saw not half
> The charms her downcast modesty concealed."

These well-known lines are rather cleverly burlesqued from the suggestion of an amateur. An old hag is seated beneath the shade of a hedge, and a yokel, pitchfork in hand, is staring at her with a grin, which distends his mouth to frog-like dimensions.

Gillray also engraved a pair of droll studies—incidents of travel—from the pencil of C. Lorraine Smith.

April 8th, 1805. *Posting in Ireland.*—The traveller is seated in an Irish post-chaise, the wheels are broken, the spokes are missing, and the tires are fractured; the chaise is without glass, the roof is thatched to keep out the rain, the flooring is missing, the panels are full of holes. Two skeleton horses are attached to the tumbledown conveyance by harness, made of rope-ends. The driver, and a helper armed with a pitchfork, are vainly urging the starved beasts to move. "Forward immediately, your honour," cries the coachman to a nobleman within; "but sure, ain't I waiting for the girl with the poker just to give this mare a burn, your honour? 'Tis just to make her start, your honour!" A half-savage female is bringing up the red-hot poker. A nailed-up barn is described as the "New Thatched-House Tavern."

May 25th, 1805. The companion picture, *Posting in Scotland.*—A bleak Highland landscape is the scene of similar discomforts. In the foreground a Highland shepherd is tending some lean and ragged sheep. The post-chaise is of a solid description; a cart horse and a donkey are harnessed to the vehicle, the kicks of the latter and the jolting of running down a hill have parted the fore wheels from the body of the conveyance, and a violent upset is the result.

June 10th, 1805. *A Cockney and His Wife Going to Wycombe.*—The Cockney's conveyance bears the driver's crest—a pestle and mortar; the horse—a worn-out screw, which might have been reared on his master's physic—can scarcely crawl. The apothecary is dressed in the height of town fashion: his corpulent better half is gaily decked out, her veil and feather are blowing like streamers in the wind, some distance behind the phaeton. The Cockney's reflections are thus set down:—"Vednesday vas a veek, my vife and I vent to Vest Vycombe, and vether it vas the vind, or vether it vas the veather, or vat it vas! ve vhip'd, and vhip'd, and vhip'd! and could not get off a valk."

August 20th, 1805. *Clearing a Five-Barred Gate.*—This print, designed by I. C., probably owes some of its force to Gillray's execution. A stout rider has been hesitating about clearing a gate; his horse—taking fright at a bull on the other side—has shortened his deliberations by throwing the rider over the barrier, dangerously near the beast's horns.

On the 25th of October Gillray issued a pair of pictures—*Harmony Before Matrimony* and its opposite, *Matrimonial Harmonics,* which are considered the happiest of the artist's fancy sketches. The contrasts they work out and their felicitous allusions are suggestive of Hogarth.

Harmony Before Matrimony.—A highly fashionable and well-favoured pair are passing the evening in congenial pursuits, warbling "duets de l'amour" from the same music book, which the lady is accompanying on her harp. A volume of Ovid is open upon the table. The decorations of the wall represent the torches of Hymen, and the bow and quiver of Cupid, festooned with flowers; while in the centre the "rosy God" is about to "bag" a brace of "turtle doves." Two kittens are at play on the ground. Everything is paired—twin roses on one stem, twin gold fish in a bowl, &c.

Matrimonial Harmonics present a dismal contrast to the earlier subject. The lady, in morning cap and wrapper, is banging away on her piano the reverse of ante-nuptial melodies: "The wedding ring—a dirge;" "Separation—a finale for two voices, with accompaniments." The fair performer is singing with significant vigour, "Torture, fury, rage, despair, I cannot, cannot, cannot bear." An infant is squalling at the pitch of his lungs. The husband, clad in dressing-gown and slippers, is deep in the "Sporting Calendar;" his fingers are stopping his ears. The accessories of the picture carry out the

dismal story. A dog, with "Benedick" on his collar, is barking at a cat perched on the sofa; a pair of macaws are shrieking against one another; the bust of Hymen has a broken nose; the thermometer has fallen to freezing. The chimney ornaments assist the satire: Cupid is reposing under a weeping willow, his quiver is emptied of its contents, and "Requiescat in pace" is inscribed on the base; a pair of vases are entwined with two serpents, looking defiance at one another. The breakfast table is neglected and disordered, and "The Art of Tormenting" is open for reference.

In the November of 1805 Gillray published a set of four prints — *The Elements of Skating*, peculiarly suggestive of the wintry season.

Plate the First—*Attitude—Attitude is Everything!* is described by its title.

Plate Two—*The Consequences of Going Before the Wind*—pictures a skater carried before the breeze by his open umbrella, which is borne into the face of another amateur of the sport, who is knocked backwards, with the umbrella point in his mouth.

A Fundamental Error in the Art of Skating.—Two skaters have run into collision: one has fallen and starred the ice; he has overbalanced a neighbour, whose stick in the struggle is thrust into the eye of the first unfortunate.

Making the Most of a Passing Friend in Case of Emergency.—A skater has fallen into a pond, by the side of which is a board warning the public that it is "very deep and dangerous." The victim has seized the leg of a passing skater, who seems in a fair way to share in the "emergency."

1806.

In 1806 Napoleon's successes had raised him to the proudest ascendency, and the name of France was universally feared. The beginning of the year was ushered in by a sad event, which for a time tempered the nature of our relations with Bonaparte. The great William Pitt, whom we have followed in these political satires, as the person of the very first importance, early succumbed to exhaustion, and disappeared from the scene. The end of the great statesman was eminently pathetic. "On the 1st of January, 1806, Pitt was driving out in his carriage. It was the last time that he ever left his house. In the afternoon his brother, Lord Chatham, paid him a visit; that day also Lord Wellesley came. Pitt remarked to him of his brother, Arthur Wellesley, afterwards Duke of Wellington, who was a favourite of the great premier, 'I never met any military officer with whom it was so satisfactory to converse. He states every difficulty before he undertakes any service, but none after he has undertaken it.'"

"Notwithstanding Mr. Pitt's kindness and cheerfulness," writes Lord Wellesley of this interview, which was too trying for Pitt's enfeebled frame, "I saw that the hand of death was fixed upon him. This melancholy truth was not known or believed by either his friends or opponents. I warned Lord Grenville of Mr. Pitt's approaching death; he received the fatal intelligence with the utmost feeling in an agony of tears, and immediately determined that all hostility in Parliament should be suspended."

Pitt's nephew, the Hon. James Stanhope, who, with his sister, Lady Hester, ministered the last consolations to the expiring statesman, has recorded the sorrowful incidents of his decease.

"His mind seemed fixed on the affairs of the country, and he expressed his thoughts aloud, though sometimes incoherently. He spoke a good deal concerning a private letter from Lord Harrowby, and frequently inquired the direction of the wind; then said, answering himself, 'East; ah! that will do; that will bring him quick.' At other times he seemed to be in conversation with a messenger; and sometimes cried out, 'Hear, hear!' as if in the House of Commons. During the time he did not speak he moaned considerably, crying, 'O dear! O Lord!' Towards twelve the rattles came in his throat, and proclaimed approaching dissolution. At half-past two Mr. Pitt ceased moaning. . . . I feared he was dying; but shortly afterwards, with a much clearer voice than he spoke in before, and in a tone I never shall forget, he exclaimed, 'Oh, my country! how I leave my country!' From that time he never spoke or moved, and at half-past four expired without a groan or struggle. His strength being quite exhausted, his life departed like a candle burning out."

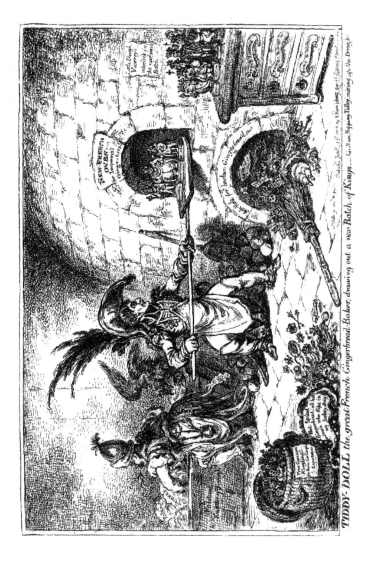

TIDDY-DOLL the great French Gingerbread-Baker, drawing out a new Batch of Kings.—his Man, Hopping Talley, mixing up the Dough.

We find from Mr. Rose's statement that the remembrance of the "innocency of his life" was the one recollection which consoled Mr. Pitt in his dying hours.

Canning, the *protégé* and pupil of Pitt, who resembled his great master in the vexations of his career, has left this sketch of our noble statesman :—

"Dignity, strength, discretion—these were among the masterly qualities of his mind at its first dawn. He was devoted to the State. Its interests engrossed all his study, and engaged all his care. It was the element alone in which he seemed to live and move. He allowed himself but little recreation from his labours. His mind was always in its station, and its activity was unremitted. He had a proud reliance on himself, and it was justified. Like the sturdy warrior leaning on his own battle-axe, conscious where his strength lay, he did not readily look beyond it."

Parliament voted 40,000*l.* for the payment of the debts incurred by Pitt's household, the expenses of which he treated with injudicious negligence. A public funeral and a monument in Westminster Abbey were conferred on his remains.

Gillray commenced the political caricatures issued in 1806 by his famous plate, published the 23rd of January (the day Pitt breathed his last), of *Tiddy Doll, the Great French Gingerbread Baker, drawing out a New Batch of Kings, his man, 'Hopping Talley,' mixing up the Dough.*—The great gilt gingerbread baker is represented busily employed in manufacturing his ephemeral ware, at the mouth of his new French oven for Imperial gingerbread. The active little Boney is just drawing out a fresh batch of his own particular baking—his recently acquired Allies, the late Electors of Bavaria, Wirtemberg, and Baden, now turned into Kings. The fuel by which this conversion was effected is scattered around in the form of cannon-balls. The "Corsican Besom of Destruction" has been employed for a general sweeping of rejected materials, into the "ash-hole for broken gingerbread." Holland, Switzerland, Austria, Italy, Venice, Spain, &c. are following the fate of the French Republic. On the store cupboard for "Kings and Queens," "Crowns and Sceptres," "Suns and Moons," is arranged a gay parcel of little dough Viceroys, intended for the next batch. The newly gilt figures of Fox, Sheridan, Derby, Moira, Stanhope, &c. are traced among his projected Viceregents. A basket contains a plentiful supply of "true Corsican Kinglings, for home consumption and for exportation;" and a fool's cap, marked "hot spiced gingerbread, all hot; come, who dips in my lucky-bag?" is filled with crowns, coronets, sceptres, principalities, cardinals' hats, &c. &c. Talleyrand, Boney's journeyman archbishop, is merrily working away, pen in mouth, at his political kneading-trough. Turkey, Poland, and Hungary are set aside, as dough to be re-kneaded; while the Prussian eagle is feeding on Hanover. The plate of *Tiddy Doll* is a spirited realization of the wanton exercise made by Bonaparte of his despotic power at this period. Sovereigns, whose empires dated from the earlier ages, were calmly set aside to make way for the men of the hour, relatives or favourites of the despot. The reign of the "House of Braganza" was announced at an end; and immediately after the Emperor's brother-in-law, "the beau sabreur Murat," was announced to succeed them. A year or two later the conflicting branches of the royal family of Spain were by the most insidious cunning persuaded to repose their respective rights in Napoleon; both factions, betrayed alike, were deprived of their power, and his brother Joseph was pronounced King of Spain—completing her virtual annexation to France, for which the exhausting wars of Louis XIV. had been vainly waged.

Sheridan, referring in the following year to the state of Ireland, made this memorable speech on the subject :—"I cannot patiently think of such petty party squabbles, while Bonaparte is grasping the nations; while he is surrounding France, not with the iron frontier, for which the wish and childish ambition of Louis XIV. was so eager, but with kingdoms of his own creation; securing the gratitude of higher minds as the hostage, and the fears of others as pledges for his safety. His are no ordinary fortifications. His martello towers are his allies, crowns and sceptres are the palisadoes of his entrenchments, and kings are his sentinels."

At home Parliament met on the 21st of January, 1806, only to witness Pitt's death, which occurred on the 23rd. A new opening was thus made for the intrigues of parties, and the task of forming a Ministry was not an easy one. The King still detested the name of Fox; but after several persons had refused to take the responsibility of forming a Ministry, among whom were Lord Hawkesbury, Lord

Sidmouth, and, it is said, the Marquis Wellesley, he was at length obliged to throw himself on the Grenvilles and Foxites, and consent to the formation of the comprehensive Coalition Ministry, which became known by the title of "All the Talents." In this Ministry, the formation of which was announced on the 4th of February, Lord Grenville was First Lord of the Treasury; Fox, Secretary for Foreign Affairs; Lord Sidmouth, Lord Privy Seal; Earl Fitzwilliam, President of the Council; Grey, now Lord Howick, First Lord of the Admiralty; the Earl of Moira, Master-General of the Ordnance; Earl Spencer, Home Secretary; Windham, Secretary for the Colonies; Lord Henry Petty, Chancellor of the Exchequer; Erskine, Lord Chancellor; and Lord Minto, President of the Board of Control. Among the minor places, Sheridan, who was notoriously unfit for business, obtained that of Treasurer of the Navy.

This extraordinary Cabinet contained far too many jarring elements to be lasting, and from its formation a shower of squibs was discharged incessantly against its various members. One of the first caricatures directed by Gillray against the new state of things was published (February 8th, 1806), under the title of *Le Diable Boiteux, or the Devil upon Two Sticks, Conveying John Bull to the Land of Promise. Vide Le Sage.*—The figure of Fox makes an admirable "Devil upon Two Sticks;" his crutches bear the faces of Sidmouth and Grenville, typifying Fox's famous Coalition, known as the "Broad Bottom Administration." The devil's wings are inscribed, "Honesty" and "Humility;" the bonnet-rouge covers his head, and the Prince of Wales's feathers wave over him. "Come along, Johnny," he says. "Take fast hold of my cloak, and I'll bring you to the land of milk and honey!" Fox's cloak is marked, "Loyalty, Independence, and Public Good;" but John Bull finds this garment a slippery support. "O yes, I will try to hold fast!" he cries, as he is whirled above the clouds; "but I'm damnably afraid that your cloak may slip off before we get there, and I may chance to break my neck." St. Paul's Cathedral and the Palace of St. James's are already left behind, and the devil is winging his flight towards Carlton House, illuminated by the rising sun of the new Constitution; the portico is inscribed—"Carolus II. Redivivus." Scenes are displayed in the fashion of "Asmodeus." "Liberty" is pictured in a gambling party, "Chastity" in one of the Prince's liaisons, and "Temperance" in a drinking bout. An allusion to the complications which had attended the formation of the new Ministry appeared under the title of *The Cabinetical Balance.* The balance is supported on a ray which is thrown from the new sun, surmounted by the Prince of Wales's feathers. According to the artist's description, "this representation of the astonishing strength and influence of the rays from the rising sun is taken from Sir Isaac Newton's theory of light." The setting sun of the Crown is sinking behind the horizon, while the spirit of Pitt is weeping over the sinking orb. The two scales of the cabinetical balance contain—"No Bottomites" and "Broad Bottomites:" Fox, Grey, and Lord Moira are in the former; while Grenville, Temple, and Windham are weighing down their side by the preponderance of their parts. Addington, with Lord Ellenborough on his shoulders, is standing on the balance; his foot is inclining the scale in favour of the "Broad Bottomites."

Lord Sidmouth responded to the overtures of Fox and Grenville, on the condition that he might be allowed to name one friend as a member of the Cabinet, and selected Lord Ellenborough. This appointment was the most unpopular act the "Man of the People" ever committed. The friends of liberty justly complained that the Chief Justice of the King's Bench, the Judge in trials instituted by the Crown, should himself form a part of the executive government.

It was, as these caricatures have abundantly illustrated, part of the Tory tactics to represent their opponents as men in necessitous circumstances, although the great Whig aristocracy were certainly as well provided as their opponents; the Dukes of Northumberland, Devonshire, Bedford, Norfolk, &c. &c. could well afford to smile at this insinuation. It was suggested that the Whigs had been so long out of office that considerable modifications were essential to make a decorous appearance at Court. This ludicrous conception was worked out in Gillray's good-humoured satire of *Making Decent,* i.e., *Broad Bottomites getting into the Grand Costume* (February 20th, 1806). Fox has thrown off his red bonnet and his blue-and-buff coat; they are put out of sight under the chair which displays his Court-dress; the somewhat tattered chief is shaving himself before a mirror on which the Royal Arms are topped by the plume of the Heir Apparent; Lord Howick (Grey) is cleaning his teeth at the same glass, to enable him

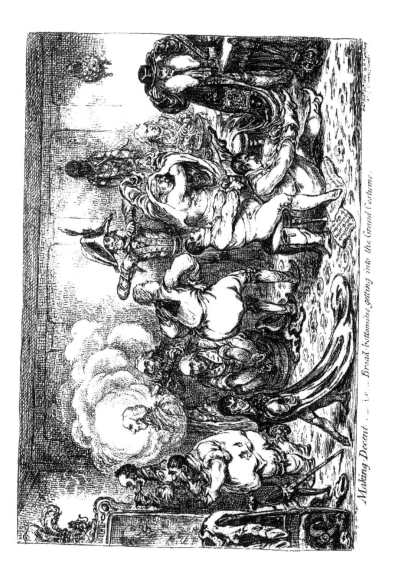

Making Decent : — i.e ... *Broad-bottomites getting into the Grand Costume.*

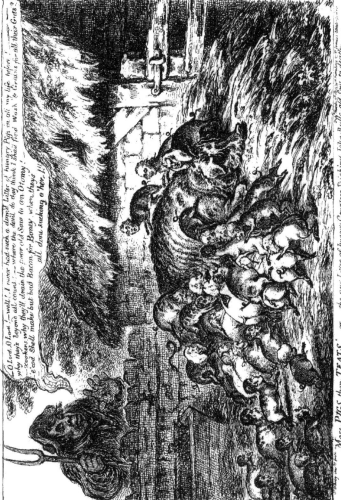

— O Lord, O Lord! — well! I never had such a damn'd Litter of hungry Pigs in all my life before! — why they're beyond all count! — where the devil do they think I shall find Wash & Grains for all their Guts? — zookers why they'll drain the poor old Sow to an Otomy! — ecod She'll make but bad Bacon for Boney when they're all done sucking o'her —!!

More PIGS than TEATS; — or — the new Litter of hungry Grunters Sucking John Bull-old Sow to death —

to eat his own words. The diminutive person of Lord Henry Petty is seen strutting about, with turkey-like admiration for the train of his new Exchequer robe; Sidmouth has pocketed his clyster-pipe, while another member of the Administration is reviving his queue with the powder-puff. Lord Grenville is adjusting the new Broad Bottomite appendages, turning his back on certain colleagues; Windham is applying to the washing-tub—"Tread softly on my corns" being his motto on the occasion. The Duke of Bedford is drawing on his boots, in readiness to set out for Ireland as Lord Lieutenant; his foot is resting on a plan of the "Road from Woburn Farm to Ireland," and a "New way of improving the Irish breed of black cattle." Tierney is seated below the Duke, his boots are also drawn on in readiness. Sheridan, who, it is reported, declared that this caricature hit off Fox to a "shaving," has thrown off the "blue," and is preparing to hide the "buff" under a clean shirt; his harlequin's dress is hung on the wall. Lord Moira, whose regimentals were always in readiness, is arranging a fresh stock; Lord Robert Spencer is washing his hands—a work requiring exertion; while Erskine has laid aside his Counsellor's wig, and is decking his small figure in the extensive robes of Lord Chancellor.

A certain interest attached to Fox's first appearance at Court after his lengthened exclusion, and particularly as the King had so long opposed his reinstation in the Cabinet. We learn from Trotter's Memoirs that the great Whig went to meet his Sovereign in "the simplicity of a plain dress, and without powder." The interview between the King and his patriotic and long-neglected Minister exhibited none of that embarrassment which many had anticipated would mark the occasion; the King possessed too much respect for his dignity to display any party animosity, and Fox naturally preferred to approach the Sovereign with the deference due to his rank and to the monarchy which he venerated. Fox was much pleased with his reception; "he uniformly appeared, all the time he was in office, full of just respect for his Majesty, attention to his wishes, and anxious to conduct matters so as to merit the continuance of his approbation. From the time of Mr. Fox's entering the Cabinet, in February, 1806, till his illness, his Majesty had never occasion to testify disapproval; with his mode of conducting a negotiation he was much pleased; his despatches obtained ever his Majesty's admiration—and of official writing there was no better judge—and there can be little doubt that, with such a Minister of Foreign Affairs the name of the Sovereign and of Great Britain (had he been spared) would have risen to great and proud estimation abroad."—*Vide* Trotter's "Memoirs."

The accession of Fox and the Whigs to office was not an unmixed benefit, either for John Bull or themselves; their numerous adherents all expected to share the crumbs of office, now the good times were arrived; these requirements were a source of perplexity to the Ministers, and a severe drain on the national resources. The innumerable hungry mouths demanding provision increased the list of "hangers-on," who were already reducing poor Johnny's supplies to the last degree. This view was set forth in a famous cartoon, one of the most deservedly popular of the artist's works. It is recorded of the notable caricatures issued by Gillray about this time, that their appearance in Mrs. Humphrey's window was hailed with shouts by the passing crowd. *More Pigs than Teats, or the New Litter of Hungry Grunters Sucking John Bull's Old Sow to Death* (March 5th, 1806). The national pig-stye is the scene of this homely satire; John Bull's sow is quite exhausted, and the voracious brood have their own way entirely. Johnny is thrown into consternation at the prospect of this ravenous brood. "O Lord!" he cries. "Well! I never had such a dom'd litter of hungry pigs in all my life before! Why, they's beyond all count! Where the devil do you think I shall find wash and grains for all their guts? Zookers! why, they'll drain the poor old sow to an otomy! 'Ecod, she'll make but bad bacon for Boney, when they's all done sucking o' her!" Lords Moira, Robert Spencer, and Ellenborough are running over the prostrate brute; Lords Sidmouth, Grenville, and Howick have each secured a teat; Fox, mounted on the Duke of Buckingham, has managed to reach a good place; Windham, Sheridan, Erskine, and Lord Henry Petty are struggling over the body to snatch their turn; Lords Temple, Lauderdale, St. Vincent, Pulteney, and others, are scrambling around, while in their rear the remainder of the squadron are shown tearing up to share in the spoliation; Lord Derby, a fat little squeaker, the Duke of Bedford, and Tierney are galloping side by side; Lord Carlisle, Horne Tooke (a black pig with a parson's band), Sir Francis Burdett, General Walpole, Fitzpatrick, and others, are all rushing full cry to participate in the meal. A contemporary of this great statesman, describing this

caricature, writes, "nothing could be more sagacious than Fox's candid declaration on this occasion, that the people must prepare themselves for new sacrifices and new privations;" for he was well aware of the many hungry mouths that would open wide, vociferous for more than he had to bestow. Indeed, such was the clamour of the disinterested Whigs for place, that the good-humoured Minister, shaking his head and smiling, was obliged to reply to their importunities by acknowledging that "his conscience already smote him for having assisted in laying such additional burdens on the country, previously quite exhausted."

A similar distrust of the Coalition Ministry, and their promises, appeared in the artist's plate of *A Tub for a Whale,* representing an empty barrel, tossed out to amuse the great Leviathan, John Bull, in order to divert him from instantly laying hands upon the new Coalition packet—*vide* Swift's preface to the "Tale of a Tub." (March 14th, 1806.) The Broad Bottom packet, an unwieldy craft, is tossing about on the troubled waters, the mast is broken, and a broom is lashed to the stump, indicating that the vessel is for sale. The Prince of Wales, a huge composite cherub, is filling the patched sail with his breath, and urging the packet to smoother waters. John Bull, as a huge whale, is lashing the billows, and threatening to swamp the ship; he is spouting jets of "Contempt" and "Ridicule" over the discomfited crew, who have sacrificed an empty cask, labelled "Real Constitutional Spirits," to divert the attentions of the Leviathan. Lord Ellenborough is at the helm; Grenville is captain; Fox, Windham, Petty, Spencer, Grey, Sheridan, and Erskine, as sailors, are earnestly observing the result of their manœuvre. The Sun of "Power," shooting forth rays of pluralities, private pickings, candle-ends, cheeseparings, &c., is fast sinking out of sight.

Bonaparte was at this time master of the Continent; he had successively overcome every one of his opponents, and compelled them either to retire or to become his allies. England had alone suffered no diminution of her empire. The conquests secured to her by the Treaty of Amiens were still retained; the East and West Indies remained intact; the Cape of Good Hope, Malta, Trinidad, and the Ionian Islands still formed part of her dominions; but Hanover, the King's hereditary possession, had been appropriated by Prussia, a Power bound to us by every tie of gratitude, for by the assistance of England she had been enabled to maintain an attitude of independence. Napoleon still professed his desire for a peaceful alliance with England. He meditated a blow which would effectually crush Prussia, already estranged from her consistent ally, and render any danger from that Power utterly impossible. Before striking the decisive blow, he desired to widen the breach by creating mistrust between England and the Continent. Napoleon recognised that it was Fox's ambition to become the peacemaker of Europe; and presuming on this generous disposition, he offered to negotiate for peace. His demands were avowedly based on the Treaty of Amiens, but their extravagance at once alarmed the patriots at home.

April 5th, 1806. *Pacific Overtures; or, a Flight from St. Cloud's "over the water to Charley"— A New Dramatic Piece now Rehearsing.*—The peace negotiations are treated in a theatrical guise well adapted to their fictitious character.

According to this cartoon, King George has quitted the state-box—where the play-book of "I Know you All" still remains open—to approach nearer to little Boney, who, elevated on the clouds, is directing attention to his proposed treaty. "Terms of peace:—Acknowledge me as Emperor; dismantle your fleet; reduce your army; abandon Malta and Gibraltar; renounce all Continental connexion; your colonies I will take at a valuation; engage to pay to the Great Nation for seven years annually 1,000,000*l.*; and place in my hands as hostages the Princess Charlotte of Wales, with ten of the late Administration, whom I shall name." King George, with his sword drawn, standing at the foot of Pitt's statue, "Non sibi sed patriæ vixit," the anchor at his side, and his ships commanding the seas, replies :—" Very amusing terms indeed, and might do vastly well with some of the new-made little gingerbread kings; but we are not in the habit of giving up either 'ships, or commerce, or colonies,' merely because little Boney is in a pet to have them!" Talleyrand has drawn up the terms; he is supported upon a "cornucopia," which is disgorging money-bags to bribe the press, addresses to the Papists, and various means of corruption. O'Connor, as prompter, is seen behind the arch diplomatist; he carries a placard, alluding to his trial, and is stealthily reminding Fox of a former understanding : "Remember,

Pacific-Overtures.— or.— a Flight from St CLOUDS.— over the Water to Charley.— a new Dramatic Peace now Rehearsing.

my friend, your oath—our politics are the same!" Three starved grenadiers bear the standards prepared for the armies of England, Ireland, and Scotland, it having been Bonaparte's practice to christen armies of occupation for every fresh expedition. "All the Talents" are combined to provide an appropriate orchestra, they are performing a "pacific overture." Erskine is banging the kettledrum with his chancellor's mace. Lord Ellenborough is endeavouring to lead time with his "Bill of Indemnity." The Duke of Bedford is strumming "St. Patrick's harp," a serious ballad, "Burke to the Duke," appears in his pocket. Grey is scraping "Rule Britannia" on a violoncello. Grenville is requesting "Attention;" "Broad Bottom Concert" is seen in his pocket, and "Britons, Strike Home" is the piece before him. Fox—"Charley over the Water"—has "God save the King" placed on his desk. Lord Robert Spencer is fiddling by the side of Windham, whose piece is "Cheeseparings." Sheridan, "the alarmist," hugging his bassoon, has fallen asleep over "the Midwatch." Lord Moira is blowing "See the Conquering Hero Comes." Tierney is playing on a double flute—Grenville and Fox—"How Happy could I be with Either." Lord Lauderdale is blowing a post-horn; his air is "Brissot's Delight," the democratic leader whom he had warmly eulogized during the Revolution. Addington, with his inevitable clyster-pipe, has "Water Gruel" before him; and Lord Henry Petty is performing "The Little Jesuit's Jig," on a triangle. In an upper box are the Duke of Clarence and Mrs. Jordan, as "Jobson and Nell;" Horne Tooke and his pupil, Sir Francis Burdett, are applauding Napoleon's acting; the stage-box below contains Lord Derby and Mrs. Fitzherbert.

According to earlier accounts—"This print excited unusual displeasure in the breast of the King, as the stage-box, on its first appearance, contained the Prince of Wales and Mrs. Fitzherbert; and in deference to the Royal feelings, as well as in obedience to a message, accompanied by a douceur (as was whispered), the author scratched out the Prince, and substituted a Whig, in the person of Lord Derby."

April 21st, 1806. *Comforts of a Bed of Roses—Vide Charley's Elucidation of Lord Castlereagh's Speech. A Nightly Scene near Cleveland Row.*—Lord Castlereagh, dwelling on the advantageous circumstances under which the Coalition Ministry had come into power, concluded by congratulating his political rivals upon occupying "a bed of roses." Fox, in reply, eloquently summed up the numerous difficulties which harassed his position, and indignantly observed—"Really it is insulting to tell me I am on a bed of roses, when I feel myself torn and stung by brambles and nettles whichever way I turn."

Gillray has illustrated this situation in a remarkably ingenious cartoon. Fox and his wife are in bed; they are lying upon branches of huge thorns—"India Roses, Emancipation Roses, French Roses, Coalition Roses, Volunteer Roses," &c. Fox's slumbers are desperately disturbed; the spirit of Pitt has seized the sleeper by the collar on one side, and is endeavouring to shake him into consciousness of the dangers which environ him—"Awake, arise, or be for ever fallen!" The red-bonnet has fallen from Fox's head. On the opposite side is Napoleon, who from his cannon "pour subjuguer le monde," is threatening the Minister with the "horrors of invasion," shadowed in the rear. A bulldog is tearing off the rose-spangled coverlid in his exertions to seize the Corsican; while the declining health and physical sufferings of the statesman are conveyed with ungenerous severity—the figure of Death, armed with his spear, is raising an hour-glass, with the warning, "Intemperance, dropsy, dissolution!" The Prussian eagle is treacherously swooping over Fox's head.

Prussia had wilfully fallen into Bonaparte's snare. It was stipulated by the Convention held at Vienna, 1st December, 1805, that Prussia should cede her ancient possessions of Anspach and Bayreuth, and as a compensation, she was to appropriate Hanover. On the 10th of April, 1806, the King of Prussia proclaimed himself King of Hanover, and closed its ports against the ships of Great Britain.

Fox was naturally indignant that a Power, which "from all time and by every circumstance" was bound to respect England, should have been betrayed into an act equivalent to a declaration of war. He concluded by moving an Address, promising support to the King under the mortification attending the seizure of his Electorate.

Fox's energetic declarations on this occasion, contrasted with his previous professions for peace, drew down upon him the irony of the press.

May 2nd, 1806. *The Magnanimous Minister Chastising Prussian Perfidy—vide the* "Morning Chronicle." *April 28th*, represents Fox, in his Court suit, trampling on the sword of Prussia, and threatening the prostrate King with his cutlass, while he surreptitiously displays behind his back an exposure of "the state of the nation," which Bonaparte is eagerly consulting. It had been insinuated that Fox's speeches while in Opposition had encouraged Napoleon to attempt the invasion of this country. "Oh, you Prussian marauder, you!" cries Fox. "What, I've caught you at last! What, you took me for a double-faced Talleyrand, did you? Did you think I was like yourself, to look one way and row another? What, you thought because I make loyal speeches now, that I must be a turncoat. O you Frenchified villain! I'll teach you to humbug and insult my poor dear, dear Master, and to join with such rascals as Boney and O'Connor!" The King of Prussia, dressed in the uniform of a dragoon, is crying, with clasped hands and in great alarm, "Indeed, indeed, indeed! I could not help it."

According to the testimony of an earlier writer—"Among the many admirable personifications of the Man of the People which are recorded by the skilful etching-tool of our satirist, none is more characteristic, or more truly the great man in office than this. It speaks a world upon the subject. Certainly, with all his professions about noble independence, patriotism, and the rights of man, this great orator was everlastingly emulous of office; and, as his Grace of Queensberry observed to King George, 'Sire, you would have found Mr. Fox as subservient to your wishes as any of your Majesty's Cabinet.' No one could be more elated at coming in once again than the old favourite of the electors of Westminster: but even his warmest admirers admitted 'that it was rather obsequious in the Secretary of State for the Foreign Department to aver that the preservation of Hanover was as incumbent on England as the maintenance of Hampshire.'"

Another account records—"When Fox did come in, he certainly played the courtier well, and affected outrageous zeal for the honour of the Sovereign, leaving the *sovereignty of the people* rather in the lurch. Fox is said to have laughed heartily at this whimsical portrait of himself, and to have made the same remark upon Gillray's burlesque Fidelity, that John Wilkes did upon Hogarth's caricature of his obliquity of sight: 'I'faith,' said each of these patriots, 'I think I grow every day more like my graphic resemblance.'

"Certainly, there were unusually gay doings with 'Mistress Fox at home,' in the house of the Minister in the Stable Yard,* on the birthday of Queen Charlotte; they exceeded everything of the kind indeed, excepting the rival splendour exhibited on the same loyal occasion by his faithful colleague, the old favourite of the electors of Stafford: but as the one great man jocosely said to the other one, shaking his head and both shaking their sides, 'Ah, Sherry, we are all mortal!'"

Meanwhile the Coalition Ministry grew daily unpopular; it was necessary to increase the expenditure, and taxation became burdensome in proportion. According to Croly's summary, "All was failure. Their financial discoveries, which had been heralded for years with all the pomp and all the mystery of the new 'Illuminés' of political economy, were found only fit to glitter in the pages of a Review, and evaporated upon trial into two abortive taxes. But if the relief was visionary, not so was the burden." Whig finance left its mark in two tremendous impositions. The hated property-tax was raised from six and a half to ten per cent., and ten per cent. was added to the assessed taxes.

May 9th, 1803. *A Great Stream from a Petty Fountain, or John Bull Swamped by the Flood of New Taxes: Cormorants Fishing in the Stream.*—The petty fountain is gushing from the mouth of Lord Henry Petty in a never-ending stream of fresh imposts, flowing into the "unfathomable sea of taxation." Poor John Bull has lost his oar, "William Pitt," his bark is swamped in the rush of waters, and he is sinking under the "new property-tax." Lord Henry Petty's Budget provoked universal dissatisfaction; it was discovered that it had been found necessary to add to the burdens already existing, and the opponents of the Coalition reproached the Ministers with their profusion, and hinted that the ravenous anxiety for the good things of office would entirely strip John Bull. In Gillray's illustration

* Fox, during his latter ministerial tenure, occupied a house belonging to the Duke of Bedford, Stable Yard, St. James's.

A Great Stream from a Petty-Fountain.___ or ___ John Bull swamped in the Flood of new Taxes: Cormorants fishing in the Stream

to this text we find the State cormorants feeding with remarkable greediness. Lord Grenville had always manifested a marked partiality for lucrative offices. He was First Lord of the Treasury under the Broad Bottom Administration; he had previously secured the Auditorship of the Exchequer (four thousand a year for life), and reflections were freely passed on the retention of two offices obviously incompatible with one another. Why, demanded the public voice, should the disbursement of the public money and the check upon that expenditure be vested in the same officer? Why, with one hand in the public purse, should he pass his accounts with the other, be the supervisor over his own conduct, and give himself a receipt in full for his own integrity?

Lord Grenville is exhibited as the largest and best fed of the cormorant tribe: a whole pile of well-fed fish are laid up in readiness—his capacious maw is already filled; but two extra fine fish—Treasury and Exchequer—prove difficult to swallow. Addington and Sheridan, hungry and ill-provided, are pillaging Grenville's superfluous stores; Fox has opened his mouth, and a whole shoal of gold fish are eagerly leaping down his throat; Windham is feeding on crabs, while Lord Moira is trying to swallow a lobster; Grey is struggling in the waters—slippery eels furnish his fare; Erskine is diving for a fresh supply; Tierney is swooping down for a share; and Parson Horne Tooke, with empty maw, followed by Sir Francis Burdett, is hurrying up to participate in the feast. A little further on Lord Temple has rather overloaded himself, while Lord Derby is fishing on his own account. The faces of Lauderdale, Fitzpatrick, &c. may be distinguished among a fresh flock of birds fluttering up to participate. An earlier writer, alluding to this cartoon, has declared—"The popular Whig cry against the Pitt Ministry had been 'Corruption and Taxes!' 'The Whigs, however,' said some of the violent Pittites, 'were no sooner in office than the most obnoxious taxes were doubled; and as for corruption, new places were now manufactured wholesale, while the old ones were cut, split, and divided to an extent perfectly unprecedented, until the bearer of the brunt, poor John Bull, was almost completely back-broken.'"

The moderation of Fox's language and the tractable support he afforded Lord Grenville, suggested the satire of *The Bear and his Leader* (May 19th, 1806). "What, tho' I am obligated to dance a bear, a man may be a gentleman for all that. My bear ever dances to the genteelest of tunes." "Don't be afraid of my bear, ladies and gentlemen," cries Lord Grenville: "I have tamed and muzzled him, and reformed his habits." The leader is holding a "cudgel for disobedient bears," and his pocket is filled with rewards for obedient bears. Fox is treading on his old tunes, "Ça ira," and "A begging we will go." Lord Henry Petty, as a monkey, has hold of the bear's tail, while Addington, a lame and broken-down blind fiddler, is scraping "God save the King." Advertisements of forthcoming exhibitions are posted on the wall:—"Pro Bono Publico: Superbly Fine Exhibition at the Bear Garden, Broad Bottomed Alley—Orpheus Charming the Brutes, with a Grand Accompaniment by Doctor Sangrado." "Peace Soup, or Bruin's Delight," &c.

The Bear and his Leader.

The insinuation that Fox, whose introduction to power was due to Lord Grenville (the King having given that nobleman *carte blanche* to form an Administration), danced according to his patron's wishes, is somewhat ungenerous. Lord Grenville appreciated the value of his alliance. Fox was perhaps the only man who could have led the Commons with equal success, and he was practically the head of the Administration. It is certain that he exerted his influence over the discordant elements of the Cabinet so adroitly, that until his death they acted together with mutual confidence.

The oppressive nature of the Broad Bottomite enactions soon drew forth fresh comments. Gillray issued a print on this subject (May 28th, 1806), *The 'Friend of the People,' and his Petty New Tax Gatherer Paying John Bull a Visit.*—Fox and Lord Henry Petty, with a terrible book of new taxes (including the ten per cent. property-tax), and bearing a heavy bag of "poundage," are making their call on John Bull, who has shut up his shop (which is announced "To Let"): he has removed his

starving family to the first floor, from motives of economy. Lord Henry Petty knocks, and raises the cry, " Taxes! taxes! taxes !" to which John Bull responds from the window above—" Taxes! taxes! taxes !—why, how am I to get money to pay them all ? I shall

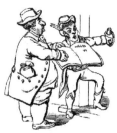

Tax Gatherers.

very soon have neither a house nor hole to put my head in." The Man of the People, little touched by this appeal, shouts to him, " A house to put your head in ?—why, what the devil should you want with a house ? Haven't you got a first-floor room to live in ? and if that is too dear, can't you move into the garret or get into the cellar !—Taxes must be had, Johnny—come, down with your cash !—it's all for the good of your dear country !"

Fox's argument is a happy burlesque of his actual speech (May 15th, 1806), in defence of the property-tax. Everything is going to ruin ; a " new tax-cart" in the distance is bearing off the furniture of the oppressed ratepayers ; and a " Broad Bottomed Pop-shop" is set up to complete John Bull's ruin. Two casks of " home-brewed" are marked " ten shillings a barrel duty ;" a broken stave of Whitbread's Entire is all that remains to recall the previous prosperity ; some starved urchins are drinking at a pump, " Erected 1806 ; J. G. Volpone, Overseer," labelled " New Brewery for the benefit of the Poor."

The beer question came before the public at this time ; the tax upon private breweries contributed to the monopolies enjoyed by the great brewers ; the alleged substitution of " quassia" for hops stimulated the artist to connect the Government with those double abuses. *The Triumph of Quassia* (June 10th, 1806), pictures a grand procession of Ministers and brewers. Whitbread and Combe, as draymen, wearing favours marked " Quassia for Ever !" are supporting a barrel of " True Quassia—free from taxation ;" a hideous black Bacchus is straddling across the cask, with a branch of quassia berries marked " Kill Devil for Ever," and flourishing a tankard of quassia. The brewers are trampling upon hops ; Barclay carries a placard, " Pro Bono Publico—Quassia for Ever !—Down with all the private Breweries !—Kill Devil and Quassia for Ever !" Stacks of hop-poles are ticketed " to be sold for firewood." Fox, Grenville, and Petty, dressed in Court-suits, their pockets overflowing with gold pieces, are mounted on a rough dray-horse ; its panniers run over with gold—" Grains from the quassia breweries, for the new piggery." The Chancellor of the Exchequer is shaking two taxes out of his hat—one upon private breweries, the other upon maid-servants.

The Impeachment of Lord Melville excited the greatest attention ; it was made a party question, and contested with peculiar animosity. The influences brought to bear against Dundas are readily detected in the caricatures which mark the various stages of the trial. *Bruin in his Boat, or the Manager in Distress* (June 20th, 1806).

" So shall my little bark attendant sail,
Pursue the triumph, and partake the gale."

Fox, as Bruin, the manager of the impeachment, is represented as having put to sea in a tub, " The Vanity Cooler ;" the sail is made of " reports" pasted together ; the oar of " Public Clamour" is lost in the troubled waters ; three obscure birds, Derby, Wilberforce, and Stanhope, with butterfly wings, hinting their proceedings were prompted by vanity, are urging on the half-capsized tub with their breath. Lord Melville, a stout Scottish Thane, is standing firmly on the " Rock of Innocence." The " shield of Justice" is held over his head, and the " scales of Impartiality" are held out to prove that " Integrity" outweighs " Defamation." Melville is applying two torches—Reason and Truth—to the touch-holes of his " great guns," Plomer and Adam, the counsel who conducted his defence ; the discharge has disabled the cumbersome vessel " Impeachment ;" the masts are shot down, the flag of " Faction" is torn away, and the waters are rushing over the hull ; Whitbread, the most prominent mover in the trial, is thrown overboard, he is swimming to a barrel marked " East India Rupees." Addington, half-drowned, is clinging to the " Broad Bottom Goose Coop," while the geese are spitefully hissing the Thane. In the distance is the " Rock of Honour ;" the sun of " Posterity," rising on the horizon, is gilding a pyramid inscribed with the name of

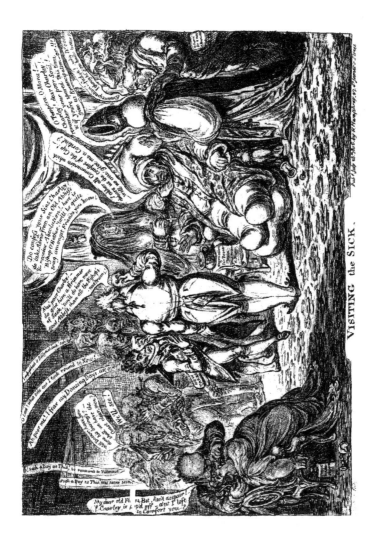

VISITING the SICK.

" Pitt." Ten articles of impeachment were preferred by the Commons against Lord Melville; he was unanimously acquitted of certain charges, and the majority of votes pronounced him " Not Guilty" on all. The Lord Chancellor Erskine thus pronounced the judgment of the House of Peers:—" Henry Viscount Melville, I am to acquaint your lordship, that you are acquitted of the articles of impeachment exhibited against you by the Commons for high crimes and misdemeanors, and of all things contained therein."

The termination of this trial was signalized by Gillray in a *Sketch for a Monument of Disappointed Justice* (July 29th, 1806). The group is arranged in a niche, inscribed " Fiat Justitia, Ruat Cœlum." Lord Chief Justice Ellenborough personifies disappointed Justice; his seat is the Broad Bottom Cabinet. He is supported on the shoulders of Addington, Lauderdale, and Stanhope. Lord Grenville's figure is designedly kept in the background. The Lord Chief Justice is holding the scales; in one balance is the " decision of the Peers," " the opinion of Lord Eldon, and of the eleven Judges," and " the vote of the bishops;" all these authorities pronouncing Lord Melville " Not Guilty." The weight of this evidence completely overbalances " the impeachment," which, with a pot of " Whitbread's Entire," and the " Sword of Justice" is thrown by Lord Ellenborough into the opposite scale.

We now approach a subject which, associated with the lighter evidences of this work, is peculiarly saddening. We have marked the disappearance of the two great orators, Burke and Pitt, patriots and statesmen alike. Fox, the greatest luminary of our Parliament, was soon to follow. " He had reached the prize for which he had been labouring through life, and was at last Prime Minister (Lord Grenville held the nominal rank, but Fox was Premier in actual fact). This honour came only to escape from his hand. The fatigues of the office were too incessant for a frame already exhausted by incessant mortifications." He appears to have had some presentiment of this speedy termination of his existence. On hearing of his great rival's death, " Pitt," said he, " has gone in January; perhaps I may go in June." It happened, by a curious coincidence, that his disorder, a dropsy, exhibited its first dangerous symptoms in June. In the middle of that month he was forced to discontinue his attendance in Parliament. About the middle of July he became unable to consult with his colleagues, and at the end of August he fell into a state of languor. That the sick-room should be turned into a theatre for the display of political satire seems unfeeling and irreverent; while it illustrates the bitterness of party feeling. Gillray, in his *Visiting the Sick* (July 28th, 1806), has introduced us to the last sufferings of Charles James Fox, surrounded by his friends and political colleagues, when his malady had precluded any thought of business.

The afflicted patriot is propped up in his mighty arm-chair; his features are furrowed by pain, and his gouty legs repose on a cushion. A prelate, half Protestant, half Romanist, with a crucifix by his side, is reminding him of his pledge to measures which he had postponed, in deference to the King. " O Tempora! O Mores!" cries Bishop O'Bother. " Charley, dear Charley! remember your poor soul! And if you're spared this time, give us " Emancipation or ——!!" Sheridan is presented in a Jesuitical mood. " Emancipation!" he cries, alarmed at the sacrifice of his place, which would inevitably follow a defeat. " Emancipation! fudge! Why, Dr. O'Bother, I thought you knew better!" A scheme for a new Administration is peeping from Sherry's pocket. Mrs. Fitzherbert, then familiar as the " Brighton Abbess," is exerting herself for the welfare of the Whig patriot. " Do confess your sins, Charley! Do take advice from an old Abbess, and receive absolution! Here is Bishop O'Bother; 'twill be quite snug among friends, you know!" Fox is replying to these united exhortations: " I abhor all communion which debars us the comfort of the cup! Will no one give me a cordial?"

The negotiations for peace between Great Britain and France are laid by the side of the sick man. The Prince of Wales, faithful to his early friend, is weeping profusely—much as he is recorded to have done on various critical occasions. " Alas, poor Charley!" he cries; " do give him a brimmer of sack; 'twill do him more good, Abbess, than all the Bishop's nostrums." Lord Howick (Grey) is also weeping. Petty, Windham, and Moira are deeply affected, but their emotions proceed from personal causes. " Projected new taxes for 1806" appears under Petty's arm. " Ah, poor me!" he sobs; " I fear my dancing days are over." " O Lord!" cries Windham, in despair; " what side can I tack round to *now*?" Lord Moira is soliloquizing, " I must get back to Ballynahinch—och! och!" The stout figure of Mrs. Fox is fainting away in the arms of Lord Derby, who is reviving her with

smelling-salts. "My dear old flame, Bet,* don't despair! If Charley is popp'd off, ain't I here to comfort you?" All the members of the Grenville family party are stealing off on tiptoe. "Well, Doctor, have you done his business?" whispers the Prime Minister to Addington, escaping after administering one of his fatal composing draughts. "We'll see," replies Dr. Sangrado. "O such a day as this! so renowned, so victorious!" cries the Marquis of Buckingham. "Such a day as this was never seen," adds Lord Temple.

Fox's last illness was soothed by the affectionate attentions of the numerous persons his fine qualities had attached to him. The deep feeling exhibited by Lord Holland and his sister (Fox's nephew and niece) resembled filial affection. Lord Robert Spencer and General Fitzpatrick, his early friends, endeavoured to sustain his spirits. The Duke of Devonshire was unremitting in his attentions; and when a change of air was rendered desirable for his failing health, his noble mansion at Chiswick was placed at the sufferer's disposal.

While Fox remained in the Duke of Bedford's house in Stable Yard, the Prince of Wales was also a constant visitor. According to Trotter's "Memoirs of Fox," "almost every day he called and saw Mr. Fox. There was no affectation in his visits; the countenance, full of good-natured concern—the manner, expressive of lively interest—the softened voice, evinced that not all the splendour, the flattery, or pleasures of a Court had changed the brightest feature of the human character—attention to a sick and drooping friend."

The negotiations with France were, at the most critical moment, frustrated by Fox's decease. The commencement of these overtures is probably unexampled. A real or pretended emissary appeared from France, and unfolded to Fox a scheme for the assassination of the Emperor at Passy, as the only security for the crowned heads of Europe. The eloquent abhorrer of assassination was suddenly presented in his closet with one who avowed the crime, and invited his complicity. Of all the stimulants art could devise there was none more certain to kindle his manly honour. Fox, filled with generous indignation, instantly wrote to apprize Napoleon of his danger. The letter was answered by bland homage; the Emperor recognised "the honour and virtue" of his feelings. This was followed by a still blander promise of peace, with an extract from a speech to the Legislative body, made almost at the moment this mysterious stranger had quitted Paris—"I desire peace with England. On my part, I shall never delay it a moment. I shall always be ready to conclude it, taking for its basis the stipulations of the Treaty of Amiens." This was but one link, according to certain writers, in the chain of artifice which was employed by the wily Talleyrand to environ England, while the Corsican effectually disabled our late Ally. Napoleon's purpose from the day of Austerlitz had been the fall of Prussia. Her threat of assisting Austria had mortified his dignity: he was determined that, whatever European capital he might seize in future, he would not have an army of one hundred and fifty thousand Prussians to frown on and menace his flank. Prussia was to be smitten; but it was necessary that England should be blindfolded until her assistance had been rendered out of the question. We have traced how the seizure of Hanover had completely effected his object at the outset. England was indignant at the treacherous acceptance. Still the approach of direct hostilities might rouse England, and even Russia to her aid. It was essential to distract the attention of both, while France was collecting that storm of havoc which was to convert the monarchy of Frederick into a passive vassal. A negotiation with England would at once paralyse the warlike preparations of the country, make Russia distrust our alliance, and cut off Prussia from all hope.

The next step was to make England commission an ambassador. One of the *détenus* at Verdun was Lord Yarmouth (afterwards Marquis of Hertford), a nobleman of enormous fortune, but whose diplomatic faculties were yet in the bud. Fox had written privately to Talleyrand to request his liberation, as a friend of the Prince of Wales. His release was granted, and Talleyrand improved the occasion by intimating that he might act advantageously as the agent for secret and confidential communications between the two Governments. He hinted that Hanover should be restored to King George, and that France would forego her pretensions to Sicily. Thus instructed, he was dismissed to Fox; who

* Bet Armistead.

determined he would only negotiate in conjunction with Russia. Talleyrand objected to interpositions between "great Powers capable of adjusting their own differences;" but suggested that as the negotiators of the three powers would reside in Paris, "the object of Mr. Fox might be attained by private communication with each other." The Emperor Alexander directed his ambassador to sign no preliminaries without a complete understanding with England. The Russian Minister was deluded by the superior inducements which Talleyrand offered for a separate treaty. D'Oubril weakly acceded, in direct contravention to his master's instructions. The demands of the French Government now rose; they determined to make Lord Yarmouth a responsible agent, and insisted on the production of his full powers. The great master of diplomacy completely dazzled him. Talleyrand convinced him that the fate of Europe depended on the simple production of the documents which he retained in his pocket. "There was Germany," said the arch tactician; "a week ago you might have saved her if you were empowered to negotiate, but the Emperor could wait no longer—the fate of Germany was sealed, *and we never go back.* Russia is now in the scale; will you save Russia, or her fate will be sealed in *two days?* We are on the point of invading Portugal; nothing on earth but a peace with England can prevent our seizing it; our army is already gathering at Bayonne. Prussia insists on our confirming her possession of Hanover, and we cannot consent wantonly to lose the only ally France has had since the Revolution. Will you save Hanover, and thus permit us to prefer England to Prussia? Produce your full powers!"

The powers were produced. Lord Yarmouth's despatches announcing this transaction utterly astounded the Cabinet. The necessity of some other negotiator was immediately felt; and the important charge was entrusted to Lord Lauderdale, a nobleman whose discernment and talents eminently qualified him for the task, and whose uniform disposition towards a pacific policy was a strong earnest of the sincerity of the British Cabinet to obtain peace.

The health of Mr. Fox at this time began to decline. The nomination of his personal friend and tried political adherent was a pledge that the Cabinet continued to promote his views and to consult the spirit of his policy. It was in the midst of these complications that Fox's career reached its close. The statesman's last appearance in these cartoons occurred a few days before his death.

September 1st, 1806. *Westminster Conscripts under the Training Act.*—Napoleon, the drill-sergeant, is elevated on a pile of cannon-balls; he is giving his authoritative orders to "Ground arms." The invalided Fox has been wheeled to the ground in his arm-chair; the Prince of Wales's plume appears on the back of his seat. He is performing on his "grand double drums:" one bears the Imperial N., the other is marked G. R., implying a partizanship of both sides. Lord Lauderdale, as a Scotch dove, with a Jacobin cap on his head, is carrying the Terms of Peace in his claws. Lord Grenville, as "flugel man," is setting the example of grounding arms. The "Loyal Westminster" ensign is lowered to the ground. Corporal Windham, looking hatred to the "drill sergeant," is stiffly following the order. Lord Howick is awkwardly subservient. Lord Holland submits gracefully, with a look of admiration. Blustering Sheridan is giving his gun a vengeful thrust. Lord Robert Spencer has closed his eyes. Addington's gun is knocked out of his hand, and he is tripped backwards. Lord Henry Petty seems afraid to relinquish his piece. The mouth of Lord Ellenborough's blunderbuss is in dangerous proximity to Lord Moira's head. Colonel Hanger, the Duke of Clarence, and other "conscripts," are seen in the rear. Talleyrand, as "Constable of the Corps," is placed at the Treasury gate, ready to receive the arms of the docile Ministers. Lord Chancellor Erskine is surrendering his weapon; and the stout Temple is equally obedient.

Fox, throughout these negotiations with France, although his own communications were conducted with unreserved frankness, evinced no inclination to allow the two wily strategists, Bonaparte and Talleyrand, to gain any undue advantage; he contrived to keep up a spirit of conciliation which it was impossible to preserve after his death. Upon his removal to Chiswick it became evident that Fox's sickness was mortal. On the 13th of September death was manifestly approaching. Mrs. Fox summoned a clergyman. According to Russell's "Fox and His Times:"— "Towards the end of the prayers Mrs. Fox knelt on the bed, and joined his hands, which he seemed faintly to close with a smile of ineffable goodness." "Whatever it betokened," says Lord Holland, "it

was a smile of serenity and goodness, such as would have proceeded at that moment only from a disinterested and benevolent heart—from a being loved and beloved by all that approached him."

During the whole of the 13th of September his state was manifestly hopeless. The last words which he uttered with any distinctness were, " I die happy," and "Liz" (the name by which he always called his wife).

About six o'clock in the evening of the 13th of September he expired, without a groan, and with a serene and placid countenance, " which seemed," says Lord Holland, " even after death, to represent the benevolent spirit which had animated it."

" If," continues Lord Holland, " a consciousness of being beloved and almost adored by all who approached him could administer consolation in the hour of death, no man could with more reason or propriety have closed his career with the exclamation of 'I die happy!' for no man ever deserved or obtained that consolation more certainly than Mr. Fox."

" He had not," Lodge records, " like Mr. Pitt, the honour of a funeral and monument voted by the Parliament of his country; but the spontaneous affection of his countrymen, and the number of his private friends and political adherents, in some measure supplied the place. The attendance of rank, talent, distinction, and numbers, at the last mournful ceremony which consigned him to the grave, was almost unexampled; and a splendid monument in the Abbey, together with a bronze statue in Bloomsbury Square, were raised to his memory by munificent subscriptions."

It is interesting to notice the conversion which the feelings of George the Third had undergone in respect to the great statesman. Upon hearing of his decease, the King declared to the Princess Mary, afterwards Duchess of Gloucester: " I never thought I should have regretted the death of Mr. Fox so much as I do." His Majesty is said to have made a similar remark to Lord Sidmouth. " Little did I think that I should ever live to regret Mr. Fox's death !"

The patriot's career when death had closed his ambition, was judged in a more generous spirit, and full credit was accorded to his honourable intentions. " Fox thought," observed one writer, " in 1793 and 1803, that the name and reputation of England, and with them her interest, would best be supported by an honest endeavour to continue in peace with France. It may be thought that he was wrong in this opinion, and that Pitt was right. But those who think he was wrong ought to admit that, having ample means of judging, he was right to act according to his convictions, and did not forget his character of a Briton on that account. Those who think he was right will ever revere him for defending the cause of humanity, justice, and peace against a prevailing but unfounded clamour."

" As an orator, Fox was," as Burke declared, " the most brilliant and accomplished debater that the world ever saw." Horace Walpole said, " He declaimed argument." Lord Erskine observed, in an appreciative summary of Fox's eloquence, " If the shorthand writer, like the statuary or painter, has made no memorial of such an orator, little is left to distinguish him; but, in the most imperfect relics of Fox's speeches, *the bones of a giant are to be discovered.*"

One of the noblest testimonies to the memory of the greatness departed was paid by the pen of generous political opponent, Sir Walter Scott :—

"For talents mourn, untimely lost
When best employed and wanted most ;
Mourn genius high, and lore profound,
And wit that loved to play, not wound ;
And all the reasoning powers divine,
To penetrate, resolve, combine ;
And feelings keen, and fancy's glow—
They sleep with him who sleeps below,
And if thou mourn'st they could not save
From error him who owns this grave,
Be every harsher thought suppress,
And sacred be the last long rest !
Here where the end of earthly things
Lays heroes, patriots, bards, and kings ;
Where stiff the hand and still the tongue
Of those who fought, and spoke, and sung ;

Here, where the fretted aisles prolong
The distant notes of holy song,
As if some angel spoke again,
All peace on earth, goodwill to men ;
If ever from an English heart,
O here let prejudice depart,
And, partial feeling cast aside,
Record that Fox a Briton died !
When Europe crouched to France's yoke,
And Austria bent, and Russia broke,
And the firm Russian's purpose brave
Was bartered by a timorous slave,
E'en then dishonour'd peace he spurned,
The sullied olive-branch returned,
Stood for his country's glory fast,
And nailed her colours to the mast."

Sir Walter Scott has also made a beautiful allusion to a touching coincidence in the last resting-place of the two great spirits of their age, the graves of Pitt and Fox being placed immediately opposite one another :—

"Genius, and taste, and talent gone,
For ever tomb'd beneath the stone,
Where—taming thought to human pride !—
The mighty Chiefs sleep side by side,
Drop upon Fox's grave the tear,
'Twill trickle to his rival's bier ;
O'er Pitt's the mournful requiem sound,
And Fox's shall the notes rebound.

The solemn echo seems to cry,
' Here let their discord with them die ;'
Speak not for them a separate doom,
Whom Fate made brothers in the tomb ;
But search the land of living men,
Where wilt thou find their like again ?"

On the 13th of September (the day of Fox's death), Gillray issued a satire, which portended that France was entering into fresh complications. *News from Calabria ! Capture of Buenos Ayres ; i.e., the Comforts of an Imperial Déjeûner at St. Cloud.* The Emperor is breakfasting, surrounded at a respectful distance, by his relations, who are all decorated with diadems. Talleyrand has brought the news of the defeat at Maida, and the taking of Buenos Ayres by the English. This sinister intelligence has plunged his impulsive master into one of those violent exhibitions of passion commonly attributed to him. Talleyrand is seized by the ear, a kick has rewarded his ungracious services, and the tea-urn, fashioned like the Globe, is uplifted for his chastisement. " Out on ye, owl ! not'ing but song of death !" cries little Boney. Lord Lauderdale's despatch-box has been recently consulted ; the contents are scattered about. " Negotiations for Peace," " Preliminaries," " Terms of Peace," are all countersigned "Inadmissible—C. J. Fox." The breakfast-table and a service, marked with the inevitable N., are kicked over. The Empress Josephine is involved in the general dismay, and the hot water from the tea-urn is increasing her confusion. The Imperial dependents are looking on in terror, evidently anticipating their turns. Representatives of all the foreign Powers are promoting the consternation, by tendering announcements of a general revolt against France—" All Germany rising, and arming *en masse*," " The Emperor of Russia's refusal to ratify the treaty extorted from his representative," " Spain in despair," " Prussia rising from the trance of death," " Holland starving, and ripe for a revolt," " Swedish defiance," " Charles XII. redivivus," " Switzerland cursing the French yoke," " Suspicions of the Confederation of the Rhine," " Italy shaking off her chains," " Sicily firing like Ætna," " Portugal true to the last gasp," " Denmark waiting for an opportunity," " Turkey invoking Mahomet."

With the calamitous death of Fox all hopes of peace were at an end. Lord Grenville became Prime Minister in actual fact ; and Bonaparte probably remembered the haughty despatches which his lordship, as Secretary of State, had addressed to the Directory and to the Consular Government. Lord Lauderdale, it is admitted, behaved with the greatest discretion, but the lost ground was irrevocable, the spirit of conciliation had departed, and the preparations were complete with which all France had been ringing for months. Napoleon and Talleyrand tossed the ambassadors (Lord Lauderdale and his colleague, Dugald Stewart) between them like toys ; their object was to gain time, and it was not till the actual hour when they had gathered the whole mass of destruction, which a touch was to let loose on Prussia, that they condescended to take the bandage from their eyes and send them back to their insulted country. Lord Lauderdale, whose passports were withheld till the last, received his papers on the 6th of October ; on the 9th Napoleon was in sight of the Prussian army, and on the 14th he fought the fatal battle of Jena. In three hours he drove the Prussians from the field, with the loss of 60,000 killed, wounded, and prisoners ; and followed up the battle by the capture of *all* the Prussian soldiery, the surrender of *all* the fortresses, the seizure of the capital, and the pursuit of the King—the total subjugation of the Prussian monarchy.

The death of Fox produced no immediate change in the Ministry of any importance. He was succeeded as Foreign Secretary by Lord Howick (Grey), who was now the true representative of Fox's principles. Mr. T. Grenville succeeded Lord Howick as First Lord of the Admiralty ; Sidmouth became President of the Council in place of Lord Fitzwilliam, who had resigned, and was succeeded as Keeper of the Privy Seal by Lord Holland, the only new member introduced into the Cabinet. For reasons which are not very evident, an immediate dissolution of Parliament was resolved upon, and the

new elections were not altogether favourable to the Ministers, who, moreover, had never enjoyed the confidence of the King.

After these stirring events on the Continent general attention was thus once more absorbed in the excitement of a "general election." Sheridan flattered himself that his popularity and his intimacy with Fox would point him out as the natural successor of the illustrious chief to the seat for Westminster vacated by the death of Fox. He reckoned on the popular voice, he counted on the Government support, and he felt secure of the Prince of Wales's interest. The Duke of Northumberland sorely disappointed Sheridan by proposing his eldest son, Lord Percy. Lord Grenville deemed it expedient to conciliate the influential Duke, and Sheridan was obliged to decline the contest : he could not be expected to fight against the wealth of Northumberland and the weight of Government patronage united.

The general election in November, 1806, afforded Sheridan fresh hopes. Lord Percy stood for the county of Northumberland, and Westminster was accordingly open to him. Paull, the son of a respectable tailor, who had filled an appointment in India, and returned with a moderate fortune, was also announced as a candidate; he was most energetically supported by the influence of the more advanced party—the Ultra Liberals or Radical Reformers.

The election contests at this date fully occupied the pencil of Gillray. The numerous well-finished and elaborate cartoons he thought proper to produce on these ephemeral subjects may be explained by the circumstance that party feeling ran high in those days, that the interest was general, and "squibs" or "satires" were freely purchased at election times for universal circulation. One of the earliest cartoons on this subject is entitled, *Triumphal Procession of Little Paull the Tailor upon his New Goose* (November 8th, 1806). Little Paull, in the guise of a journeyman tailor, is mounted in shopboard fashion upon Sir Francis Burdett, "the famous green goose." Paull's seat is an "India cabbage," he carries a book of "Patterns for the New Parliament Dress;" his shears enclose a "true Perth cucumber." The goose, with a halter round his neck, is led by Horne Tooke, as "an old monk from Brentford;" a book of "Hints for New Patriots" is held under the "parson's" arm. "Come along goose," he cries, "come along; Paullee says he will go with you if it is to the scaffold!" "Paull and Public Good" is pasted on his hat. The mob are shouting enthusiastically for Paull. Colonel Boswell, whose wealth and eccentricities have been noticed, is propagating his own liberal convictions. His hat is filled with money, which he is distributing freely to the urchins. "There's a penny apiece for you, lads; and now hollo out 'Paul for Ever!' and I'll give each of you a ride in my coach and four. Hollo, boys!" Cobbett, "Political Register" in hand, is shouting through his news-horn, "Glorious News! Paull for Ever! Damnation to the Whigs!" A card, marked "Independence and Public Justice," introduced in his hat, refers to certain charges which Paull had brought against the Marquis of Wellesley on his return from India, preparatory to moving his impeachment. According to the inscription, "Porcupine is dirtying his boots in attempting to give poor goose a shove out of the kennel." Ballad singers, at "five shillings a day," close the procession, which is supposed to be proceeding to the hustings, Covent Garden.

The second print which our artist issued on this contest introduces the Ministerial candidates, Admiral Sir Samuel Hood and Sheridan, who had combined their interests. They are sending "the High-flying Candidate (*i.e.*, Little Paull Goose) mounting from a blanket"[*] (Nov. 11th, 1806). Paull, as a slip-shod tailor, is tossed high in the air from the "Coalition Blanket;" his goose, shears, and tape measures are sharing his flight. Hood, with his one arm, and Sheridan, in mourning for his late friend,

* Impromptu by a lady on Lord Cloncurry (who owed his descent to a dealer in blankets) laughing in a box at the Dublin Theatre at the dilemma in stage representation of a squire tossed in a blanket :—

"Cloncurry ! Cloncurry !
Come here in a hurry
And look on *my* comical squire ;
Though tossed up so high,
Yet, 'twixt you and I,
The blankets have toss'd *you* much higher !"

Fox—with the play of " The Devil among the Tailors" in his pocket—are managing the tossing. At the feet of the Coalition candidates is a monument, inscribed " Sacred to the memory of poor Charley, late member for the City of Westminster—' *We ne'er shall meet his like again !!* " The stone is thrust aside by the departed, who is exclaiming, in despair, " O tempores ! O mores !" The scene is the hustings before Covent Garden Church. On one side, a party of volunteers are shouting and waving flags—" Sheridan and Hood—Volunteers and the Navy." On the other side, a body of Hood's sailors are cheering for the admiral, bearing banners for—" Hood and Sheridan—no skulking to Bonaparte ;" while the friends of Paull are displayed as sweeps and " hungry snips."

Gillray's third caricature on the general election is a very spirited sketch, entitled *Posting to the Election ; a Scene on the Road to Brentford, Nov. 1806.*" Each of the various parties interested is hastening on in its own way. Sheridan, who was supported by Whitbread, is dashing through thick and thin on a brewer's horse, which looks as if it had just broke loose from the dray. He carries Lord Hood behind him ; hung to the horse's side is a pannier of " Subscription malt and hops from the Whitbread brewery ;" in his pocket a manuscript, entitled " Neck or Nothing ; a New Coalition." They still retain each other's favours in their hats. A kick of the horse behind is overthrowing Paull from his donkey. The " Impeachment of the Marquis of Wellesley" falls to the ground ; a dog—Peter Moore—is barking at the spill. Burdett's marrowbone-and-cleaver men are also run down. On the other side, rapidly gaining ahead of them, is Mr. Mellish, one of the victorious candidates for Middlesex, driven by Lord Gren-ville in a coach and four, with the flag of " Loyalty and

Coalition Candidates.

Independence for Ever !" " Rule Britannia and the Bank for Ever !"—" Integrity and the Monied Interest !" &c. are posted on the chariot of the Court representative ; behind which, as footmen, stand the Marquis of Buckingham, Lord Temple, and Lord Castlereagh. They are followed close by Mr. Byng, in a post-chaise drawn by two spirited hacks, which the Marquis is helping along. The " tried member" represents the old Whig interest, and has " the good old Whig block"—a wooden bust of Fox—on the box before him. Last comes Burdett, in a cart slowly dragged through a pool of muddy water by four donkeys, with Bonaparte, as a sweep, " acting as post-boy, " to insinuate that *his* candidate favoured the Republic which he had threatened to introduce into England — on its conquest. Sir Francis Burdett, with a " Liberty" favour stuck in his hat, and the " Life of Oliver Cromwell" in his pocket, is seated in front, lustily responding to the cheers of his supporters. Horne Tooke and Colonel Bosville, arm in arm, are seated behind. " Liberty" cockades are displayed in their hats. The former is holding a banner nailed to a prop, inscribed " Liberty and Equality ! No Placemen in Parliament—no Property Taxes ! No Bastiles ! Liberty for Ever !" Bos-ville has Paine's " Rights of Man" in his pocket. Cobbett is placed in the back of the car, acting as drummer, employing his " Political Register" and " Inflammatory Letters" as drumsticks ; his drum has for its badge the Republican *bonnet-rouge.* A parcel of sweeps are pushing the cart to help it forwards. Among the crowd of noisy followers may be traced the stout " Orator Broadface, of Swallow Street," whose repartees proved too discomfiting for Sheridan at the hustings.

A Radical Drummer.

The political caricatures of the year were concluded with an election cartoon of peculiarly happy conception—*View of the Hustings in Covent Garden—Vide the Westminster Election* (15th December, 1806). (Published for the " History of the Westminster and Middlesex Elections.") The booth is placarded " Loyal Parishes of St. Paul's and

St. Giles's." Sheridan and Paull are placed on either side of the post. Little Paull, hat in hand, is appealing to the multitude with great animation; he is pointing to his disconcerted opponent, denouncing him as "the sunk—the lost, the degraded Treasurer." "Peter Moore," as a mongrel cur, is barking at the speaker. Sir Francis Burdett, wearing a dignified air, Cobbett, with his "Register," and Colonel Bosville are placed among Paull's supporters; and the Duke of Northumberland is chuckling over "Sherry's confusion:" a "No-Coalition" card is stuck in his hat. Sheridan, surrounded by the eminent Whigs, does not appear to relish his position, and Sir Samuel Hood is turning away his head, and hiding his face with his hand. Whitbread, with "Hood and Sheridan" marked on his hat, is offering the comfort of a foaming tankard of his "new Loyal porter."

The multitude are lustily expressing their sentiments—"No Placemen in Parliament!" "No Harlequin Turncoat!" "No Stage Tricks!" "No Vagabond Representative!" "Pay your Debts, Mr. Treasurer!" "Where's my Renter's Share? d—n you!" &c. A band of supporters of "Sherry"—bludgeon-men—are shouting—"Sherry and Liberty!" A band of Hood's sailors are cheering their admiral, while his opponents are crying—"No Picton!" "Two Faces under a Hood!" "No False Votes!" &c. Paull is favoured with similar clamours: shears, a tailor's goose, a cabbage on a stick, &c. are exhibited in ridicule: "No Paull Goose." "No Stitching Representative!" "No Cabbaging Candidate!" while his ragged, red-bonneted admirers are crying—"Paull and Independence!" "Paull and Plumper!" &c.

This election was, it seems, a terrible penance for Sheridan. His appearance on the hustings was the signal for the most violent uproar, and for the most unequivocal abuse. Sheridan, well seasoned and experienced in mob demonstrations, was doubtless prepared for this. He trusted to his playful wit, his sarcasms, and his jokes to convert the mob to good humour, and he endeavoured to cajole them with his popular weapons into a more friendly disposition; but he had reckoned without allowing for rivalry. "There was one man in the crowd who fairly beat him, and compelled the wit of the Commons to retire abashed. It was in vain that Sheridan tried ridicule, sarcasm, and abuse of 'hireling ruffians' by turns, 'the broad-faced orator in the green coat' seemed stimulated by these counter-attacks. A comedy was then popular, in which a dandy was repeatedly quizzed by inquiries, directed to the various items of his apparel, of 'Who suffers?' This artillery was constantly played off upon Sheridan. 'Sherry, I see you have got a new coat; who suffers? Sherry, who suffers for that new hat?' Sheridan, painfully conscious of his notorious pecuniary irregularities, could not endure this raillery before his highly respectable supporters; his spirit gave way, and the veteran champion of this order of encounter fairly broke down. He avoided the hustings; it was announced that his health would not allow him to be present, and young Tom Sheridan attended and spoke for his father. Sheridan gained the election, but it is said that the conflict of the hustings, and the shafts from 'Porcupine' Cobbett's quills, left a wound to rankle in his breast."

A fifth caricature on this subject, published by Gillray in December, is entitled *Peter and Paul Expelled from Paradise.* They are on their way to Wimbledon, where Tooke resided; and their condition is intimated by a parody on Milton—

> "The world was all before them, where to choose
> Their place of rest, and parson Tooke their guide."

The social sketches issued in 1806 are below the artist's average. The most noticeable is a large plate, published Jan. 24th, 1807, under the title of *A Morning Promenade upon the Cliff, Brighton,* which he engraved from the design of Captain J. Morse. The scene is a bustling and animated picture of the Prince of Wales's head-quarters, which became a place of extreme fashion during his residence at the Pavilion. Officers in gay uniforms, long since obsolete, are lounging over the railings, ogling the fair promenaders dressed in muslins and sun-bonnets, who—strange spectacle for Brighton—are riding on donkeys. The ladies are all graceful and pretty. Parasols closely allied in dimensions to the modern umbrella protect their complexions.

The artist has arranged his picture under three heads :—"Passive Set," whose donkeys are crawling sleepily along; "Active Set," where the riders are evidently being "well shaken" in a brisk trot; and

"Kicking Set," wherein the donkeys are indulging their own sweet devices, while an upset is indicated in one corner.

On the 22nd of October appeared a series of plates—*The Rake's Progress at the University*—in burlesque of the temptations which environ a "freshman." The execution is tolerable, but the designs —broadly caricatured—are not favourable examples of the artist's ability. A couplet accompanies each plate, which will describe the series sufficiently for our purpose :—

> "Ah me ! what perils doth that youth encounter,
> Who dares within the Fellow's place to enter."

> "Ah me ! that thou the Freshman's Guide shouldst read,
> Yet venture on the hallowed grass to tread."

> "The Master's wig the guilty wight appals,
> Who brings his dog within the College walls."

> "Expulsion waits the son of Alma Mater,
> Who dares to show his face in boot or gaiter."

> "Convened for wearing gaiters, sad offence !
> Expelled, nor e'en permitted a defence."

November 1st, 1806. *Fast Asleep.*—A stout old gentleman, probably a taproom politician, has "dropped off" to sleep before a table, on which are a jug of beer, a pipe, and the "Political Register."

November 1st, 1806. *Wide Awake*—a companion print to the former. The hero has fallen asleep in his arm-chair before the fire ; two cats, snarling at each other, have startled his slumbers. The fright and astonishment attending this violent awakening are vigorously expressed.

1807.

The year 1807 witnessed the downfall of the famous "All the Talents," and the installation of a new Cabinet under the Duke of Portland. In the latter part of the year we trace the general exasperation provoked by Napoleon's projected naval confederation of the Northern Powers. The most notable events of the year were the bombardment of Copenhagen and the capture of the Danish fleet.

The Westminster election, as we have seen, occupied the greatest share of attention at the close of 1806. During its progress, Sir Francis Burdett remarked in one of his speeches—"Mr. Paull is fixed upon a rock, and be assured he will prove the fulcrum by means of which the present Broad Bottomites will be overset."

This metaphor suggested a clever parody of *Political Mathematicians Shaking the Broad Bottomed Hemispheres* (Jan. 9th, 1807). "To that last hope of the country, this representation of Charley's old breeches in danger, is respectfully submitted." Little Paull, in the satirist's favourite guise of a tailor —surrounded by the belongings of his trade—is seated, as "the fulcrum of the Constitution," on the "rock of independence;" he is cutting off the Broad Bottom measures, surrounded by mushrooms, cucumbers, cabbages, &c. A huge lever, capped by the *bonnet-rouge*, is poised upon Paull's head. Cobbett, Sir Francis Burdett, and Horne Tooke are using their exertions to raise the "Broad Bottomed hemispheres"—represented as "Charley's old breeches," from their support on the Prince of Wales' feathers, which are gnawed at the stalks by rats. The incubus is shifted by the Radical Reformers, while a select Tory band, consisting of Canning, Castlereagh, Hawkesbury, Spencer Perceval, and their colleagues, are preparing to haul it down. Behind this group Britannia is seated weeping, at the base of a monument to "the pilot that weathered the storm"—a statue of Pitt leaning on "the pillar of fortitude"—partly concealed in the clouds. The members of the Broad Bottom Ministry are comfortably feasting on the Treasury and Exchequer fishes secured within the breeches of the "Man of the People." Temple, Buckingham, Grenville, and Ellenborough are conspicuous for the breadth of their proportions ; Sidmouth, Howick, Sheridan, Lauderdale, Moira, Petty, Erskine, Windham, and Spencer are ranged round the board in the order described. The feasters are too greedily occupied with "the good things"

before them to take heed of danger. The ghost of Fox has burst from the grave, crying in apprehension—" O save my breeches, Heaven !"—a parody of Pitt's last words. Fox's tombstone is engraved " HIC JACET PATER BROAD-BOTTOMOS. He lent his raiment to cover the needy, and to hide his enemies from shame he went naked to the grave." In the foreground are displayed the instruments and writings of the " New Political Mathematicians," with a new planetary system, in which Napoleon, as a monkey, is teaching the bull to dance. " Scheme for a New Patriotic Administration—pro bono publico ;"—President, Horne Tooke; Lord Chancellor, Paul Goose; Secretary of State, Sir Francis Burdett; Lord Chief Justice, W. Cobbett," &c. " New Scale of Justice—No Taxation—No Bastile—No Places—No Pensions." " Thirlwall's Lectures." " Intended Funeral Oration for the Downfall of the Broad Bottomites, by Gale Jones," &c. are scattered around. The French coast is represented in the distance. Little Boney, at the head of his standards, is peering through his telescope at these novel experiments. " Oh gar !" he cries, alluding to the difficulty of crossing the Channel ; " if I could but once put my foot on the lever, I'd give their Broad Bottoms a shake with a vengeance ! !"

The prodigality of " All the Talents," and the open hand with which they rewarded their friends and supporters at the national charge, is further held out to public attention in a cartoon, published February 29th, 1807, under the title of *John Bull and the Sinking Fund — A P(r)etty Scheme for Reducing the Taxes and Paying Off the National Debt.* John Bull, rugged and patched, is sprawling on all fours, on the " rock of broad-bottom security." The " sinking fund—*i.e.,* taxations of forty-two millions per annum," is represented by a huge sack of gold pieces, over which Lord Henry Petty is striding with a long-handled shovel showering down a rain of wealth upon his friends. John Bull is groaning under the pressure. " Toss away ! toss away, my good boy ! toss away ! Oh, how kind it is to ease me of this terrible load !" " Patience, Johnny !" replies the active little Chancellor. " Arn't I tossing away as fast as I can ? Arn't I reducing your taxes to seventeen-and-sixpence in the pound ?— Why, you ought to think yourself quite comfortable and easy, Johnny !" Lord Grenville is, as usual, securing the largest share ; his robe is overflowing, and Lords Temple and Sidmouth are catching the surplus. Windham, Buckingham, Howick, Ellenborough, and Spencer have filled their hats. Lord Moira's cocked hat is ornamented with the Prince of Wales's plume ; in his hand is a memorandum of the " price of stocks." The Duke of Norfolk is holding out his punchbowl—the " majesty of the people." Sheridan, Erskine, Lauderdale, and the Duke of Clarence are, with numerous adherents, securing comfortable provisions. At the base of a broken pillar " Sacred to the Memory of Departed Greatness," which is overshadowed with a drooping willow, the members of the Opposition are stamping in despair that the golden shower is directed away from them. Lord Eldon is crying—" Not a single fee ! not one shovel for us ! O ! O ! O !" Lord Castlereagh, hat in hand, is remarking deferentially— " A few scatterings this way would be very acceptable indeed !" Canning is furious—" O the Petty cheat ! That 'sinking fund' was our invention—and not to have a snack of it at last ! oh ! oh ! oh !" Vansittart, holding his scroll of " financial resolutions," exclaims in consternation—" My sinking plan would have cleared it off in half the time."

Financial schemes for the relief of John Bull were plentiful throughout this period ; their practical action, in most instances, did not differ widely from the views worked out by the satirist. Lord Grenville's Ministry had come into power pledged to support Catholic Emancipation, which the King was determined to resist : they had accordingly never enjoyed his entire confidence, and he made no secret of this mistrust. The Catholic question, which they contrived to elude during Fox's tenure of office, was at last approached in a " Bill introduced by Lord Howick, for securing to all his Majesty's subjects the privilege of serving in the army and navy upon taking an oath prescribed by Act of Parliament, and leaving them the exercise of their religion." This measure was brought forward to remedy a great inconsistency existing between the laws of England and Ireland ; for, although by the provisions of the latter, Roman Catholics were permitted to hold commissions, and to rise to any rank, with the exception of the three highest offices, they were disqualified from serving in England ; and since the Act of Union rendered all regiments liable to this duty, Catholic officers would have been compelled, on their regiments being ordered for service in England, either to resign their commissions, or to retain them in

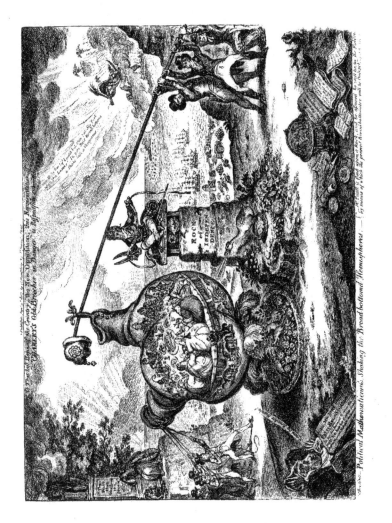

defiance of the law, and with the liability of penalties. Lord Howick's Bill provided for this anomaly. The King objected to the measure on its first submission, but had been prevailed on to give his reluctant assent after consulting the clauses of the Act of Union. Perceval opposed the Bill, although he admitted the justice of the motive. He questioned whether the penalties could be enforced since the Union, and he regarded Lord Howick's measure as a mere preliminary to ulterior and more extensive emancipations.

The usual machinery was put in motion, a strong Protestant impulse set in, and the cry of " No Popery" was raised. Lord Sidmouth became alarmed at the prospect of Catholic concession, and he was jealous of certain overtures which at that date promised to attach the gifted Canning to "All the Talents." He tendered his resignation to Lord Grenville, and on the same day proposed to join Perceval in opposing the Bill.

On the 11th of March the King informed his Ministers that the provisions of the Bill went further than he had originally understood, and he would never consent to such a measure. On the 12th his Majesty communicated with the Duke of Portland, who, prompted by Lord Malmesbury, had addressed a letter, warning him against the concessions required by the Catholics, and assuring him that, in case of extremity, persons would be found to carry on the business of Government with talents and abilities equal to those claimed by the men in power.

In the interval Lord Howick's Bill was withdrawn, and the King commanded Lord Sidmouth to withdraw his resignation. The difficulty was merely postponed. The Ministers held a Cabinet Council, and determined to present a memorial to the King, reserving to themselves the right of tendering advice to his Majesty on this subject whenever it was deemed expedient. The King regarded this message with disfavour. He complained of it as an act of gratuitous annoyance. He reiterated his decision that during his reign no Catholic disabilities should be removed ; and he insisted on a written pledge that they would not at any future time address him on the subject. This was firmly declined, as unconstitutional and contrary to law. "His Ministers were bound by their oaths to tender advice to his Majesty on all subjects they might esteem essential to the interests of the Crown and the country."

This refusal furnished the King with the pretext he had long desired, and he informed them that "he must look for new Ministers elsewhere." He immediately summoned Lords Hawkesbury and Eldon to Windsor, and they were directed to the Duke of Portland, with *carte blanche* to form a fresh Administration.

The King's attitude in respect to the dismissed Cabinet formed the subject of a remarkably animated cartoon, issued March 23rd, 1807, under the title of *A Kick at the Broad Bottoms*, i.e., *Emancipation of " All the Talents."* The Ministers have presented their Bill "for bringing the Papists into power and supporting the Broad Bottom Jesuits in their places ; for securing the Papists in command of the army, the navy, and all the public offices." The King has quitted his chair of State, near which the Crown and Bible are placed side by side ; he has risen in sudden animosity, his left hand is grasping Lord Grenville's bag-wig, and his foot is raised to impart celerity to the Broad Bottomite progress. "What, what," cries the incensed monarch, "bring in the Papists ! Oh, you cunning Jesuits, you ! What, you thought I was like little Boney, and would turn Turk or anything ? But if you have no faith or conscience, I have !—ay, and a little old Protestant pluck too ! So, out with you all !—out with all your Broad Bottom'd Popish plots !—out with you !—out, out, out !" A pillar conceals the angry face of the King, but the resemblance of his figure is admirably expressed. A scene of general confusion is presented by the retiring Ministers, most of whom are supposed to have received the assistance which is administered to Lord Grenville. Grey's torn Bill is sent flying over his head, and the attitudes of Lords Ellenborough and Temple indicate that they have already received practical marks of dismissal. Buckingham, Windham, Moira, Lauderdale, Sidmouth, Whitbread, Sheridan, and others, are stealing off in apprehension ; Lord Henry Petty, in his Exchequer robes, and Erskine as Lord Chancellor, are thrown on their backs in the hurried retreat. "There is much address exhibited in this and many other subjects wherein the visage of the Sovereign is hidden by an intervening object, as a post, a tree, or column ; yet the figure of the Royal person was so familiar to the pencil of the artist that, accepting it

Y Y

with the usual allowance for the exaggeration of caricature, there is no mistaking the resemblance for any other personage." The Duke of Portland had undertaken a bold task; the offices at his disposal and the seats in his Cabinet were declined in various quarters. The opinion prevailed that he could not succeed in forming an Administration sufficiently powerful to resist the talents and parliamentary weight of the late Ministers. The Marquis of Wellesley, after due deliberation, declined the Foreign Office; Mr. Yorke also refused, as he mistrusted the stability of the new Cabinet. An infusion of activity was secured by Canning's acceptance of the Foreign Office, in which that eminent statesman proved himself a worthy pupil of Pitt. Neither Melville, Canning, nor their friends would support an Administration which included the name of Lord Sidmouth. Increased hostility and opposition were apprehended from Lord Grenville's party, if the Doctor was suffered to continue in office. Lord Sidmouth discovered that he was rejected by both sides. The new Ministry was definitely formed in April. It consisted of the Duke of Portland, First Lord of the Treasury; Lord Hawkesbury, Home Secretary; George Canning, Secretary for Foreign Affairs; Lord Castlereagh, Secretary for War and the Colonies; Spencer Perceval, Chancellor of the Exchequer; Earl Camden, President of the Council; the Earl of Chatham, Master of the Ordnance; the Earl of Westmoreland, Keeper of the Privy Seal; Earl Bathurst, President of the Board of Trade; Lord Eldon, Chancellor; and Lord Mulgrave, First Lord of the Admiralty. Perceval, who was notorious for his opposition to the Catholic claims, was considered as the chief. Though "All the Talents" were dismissed from office, their unpopularity was not diminished. The "No Popery" cry was eagerly set up on all sides; squibs, broadsides, and caricatures were poured against them for months. Sheridan, who possibly estimated State sincerity by a low standard, looked upon Grey's Bill as a "tub thrown to the whale." "He had no forgiveness for the sport in which his own office was wrecked." "Why did they not put it off, as Fox did?" said the angry ex-Treasurer of the Navy. "I have heard of men running their heads against a wall; but this is the first time I ever heard of men building a wall, and squaring it and clamping it, for the express purpose of knocking out their brains against it."

Gillray published, among other caricatures, a reminiscence of his funeral of "the Regency," under the title of the *Funeral Procession of Broad Bottom* (April 6th, 1807). The ceremony is arranged with due solemnity; the mourning of the followers is not mere outward show, they are shedding real tears— for the loss of their places. Four monks, with crosses fashioned like daggers, are carrying the bier, on which, between four sable plumes, the broad proportions of Lord Grenville are defined, who is supposed to have died "firm in his faith." "Gul. Baro. de Broad Bottom—obiit. die Martis 24°, A.D. 1807," is inscribed on the pall, which is supported by Windham, Lord St. Vincent, Sidmouth, &c. The Pope, in full pontificals, is following as chief mourner, immersed in the deepest grief; he is led by the Marquis of Buckingham and Lord Temple, as friars; while Lord Howick, equally affected, is officiating as trainbearer; Sheridan, in a maudlin state of grief and intoxication, is rolling along in unwieldy emotion, led by Earl Fitzwilliam, shedding "tears of Hedgeland;" Lords Erskine and Ellenborough are concealing their feelings in their forensic wigs; Lords Lauderdale and Moira bring up the rear; Lord Henry Petty, as a chorister boy, with bell and candle, is tripping at the head of the procession, which has reached the place of interment. At this point the entire train is thrown into confusion by the Rector's refusal to extend sepulture to the body. "No burial here for Broad Bottom; he died a Roman; besides, it is a *felo-de-se* case. Take him to the next four cross-roads; and the family has a large stake always ready." "The family stake" refers to a haughty reply made by Lord Temple to Tierney's statement condemning the continuance of the war, which he declared was chiefly supported by placemen, expectant placemen, or persons deriving a profit from it. Lord Temple retorted, that "he must at least allow that he was an independent member, and that his family had a large stake in the country." Tierney remarked, that "although the noble Lord had informed the House both he and his family had *a large stake in the country*, he omitted to add that—*it was stolen from the public hedge.*"

Lord Temple was served up in a separate cartoon, *The Fall of Icarus* (April 28th, 1807). Lord Temple, as joint Paymaster of the Forces under the Fox and Grenville Ministry, occupied the official residence at Whitehall, where he had the arrogance to place his own name, "Lord Temple," on the brass plate affixed to the door. On his quitting office it was popularly reported that some thousand pounds' worth of stationery had been carried away for his private use, and severe comments were pub-

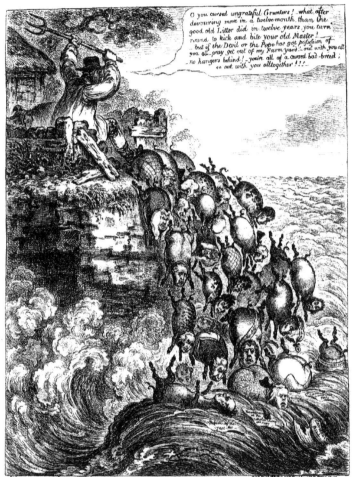

The PIGS Poſſeſſed:— or— the Broad-bottom'd Litter running headlong into ŷ Sea of Perdition.

lished on this proceeding. In Gillray's print, Temple's black servant is handing bales of paper from the Whitehall office, to be conveyed away in a "stationery cart." The stout figure of his lordship has, after the pattern of Icarus, been sustained on paper wings, cemented by official wax; the head of George the Third, like the sun, has penetrated the smoke from Temple's chimney: the wax is melted; the purloined quills drop off, and the aëronaut is falling direct upon a "stake out of the public hedge." The leading member of the "family," with "Tellership of the Exchequer" marked on his stationery pinions, is winging his flight behind a cloud to shelter himself from the fatal influence of the sun.

"In former days, the poet sings,
 An artist skill'd and rare,
Of wax and feathers formed his wings,
 And made a famous pair.

"With which from precipice or tower,
 From hill or highest trees,
When work'd by his mechanic power
 He would descend with ease.

"Why Temple then wants such a store
 You truly ask in vain!
A moment of reflection more
 Will make the matter plain.

"With plumes and wax, and such like things,
 In quantities not small,
He tries to make a pair of wings
 To ease his sudden fall."

A spirited version of the Broad Bottomite interment was attributed to the pen of Canning; it is known as the end of "All the Talents:"—

"When the Broad Bottomed junto, all nonsense and strife,
Resigned, with a groan, its political life;
When converted to Rome, and of honesty tired,
It to Satan gave back what himself had inspired.

"The Demon of Faction that over them hung,
In accents of anguish their epitaph sung;
While Pride and Venality joined in the stave,
And canting Democracy wept on the grave.

"Here lies in the tomb that we hollowed for Pitt,
The conscience of Grenville, of Temple the wit;
Of Sidmouth the firmness, the temper of Grey,
And Treasurer Sheridan's promise to pay.

"Here's Petty's finance, from the evils to come,
With Fitzpatrick's sobriety creeps to the tomb:
And Chancellor Ego, now left in the lurch,
Neither laughs at the law, nor cuts jokes at the church.

"Then huzza for the party that here's laid to rest—
'All the Talents,' but self-praising blockheads at best:
Though they sleep in oblivion, they've died with the hope,
At the last day of freedom to rise with the Pope."

We have seen "All the Talents" pictured as pigs exhausting the mother stock on their dismissal from office. Gillray continued this figure in a bolder conception, which, regarded apart from an objection attaching to Scriptural parodies, has been acknowledged to be one of the most felicitous productions of caricature.

April 18th, 1807. *The Pigs Possessed, or the Broad Bottomed Litter running headlong in the Sea of Perdition. A Supplement to More Pigs than Teats.*—King George is the farmer; his ungrateful pigs, after fattening on his good things, are supposed to have turned against their master. Enraged at their ingratitude, he has knocked out a board or two, and is driving them off the premises. "Oh you cursed, ungrateful grunters! What! after devouring more in a twelvemonth than the good Old Litter did in twelve years, you turn round to kick and bite your old master! But if the devil or the Pope has got possession of you all, pray get out of my farmyard! Out with you all—no hangers behind! You're all of a cursed bad breed; so, out with you altogether!" The old sow is rescued at the last gasp, and the pigs are running headlong into the sea. Lord Grenville, with golden speckles, has headed the flight; the "Catholic Bill" is given to the waters, and "Emancipation of the Catholic Army and Navy" is sinking. Grey (Lord Howick) is floating on his back, over the "Repeal of the Test Act." Lord Temple, tail upwards, is going down with the "Last Stake of the Broad Bottom Family." Whitbread, caught in a barrel of his own "Entire," is floating with his heels in the air. The Marquis of Buckingham is following the "family." Lord St. Vincent has just reached the water. Windham falls next—his body is striped like a tiger; and the face of Lord Holland is seen below. The Duke of Bedford, late Lord Lieutenant of Ireland, is making a determined plunge; his collar, marked "Erin go bragh," has dropped off. Lord Moira is scrambling over his head; Lord Lauderdale, a Scotch pig, appears in plaid; Lord Henry Petty's bristles are all standing on end—he is the smallest of the "grunters." The Duke of

Norfolk is introduced on the outside; Lord Ellenborough, in his Chief Justice's wig, is behind him, and Lord Erskine, turning his face beseechingly to the King, is on the right. Above the ex-Chancellor is the round head of Lord Derby, and Courtney is represented in profile, between them. Lord Sidmouth comes next, with his bag-wig and powder; while Sheridan, in a harlequin's suit, has required an application of the Royal foot to dislodge him from the "land of promise :" as we have seen, the Treasurer of the Navy did not tolerate the suicidal propensities of his leaders. Lord Carlisle, a spotted grunter, is shown in profile; Tierney, with a brindled coat, has jumped over his head, and Lord Spencer is seen between Lord Lauderdale and the Southwark Pet.

"It may be remarked that Mr. Courtney, though conspicuous for his playful humour, and aptitude for wit, which was so commonly and successfully played off against the Treasury bench, rarely appears in the political farces invented by our caricaturist. This print, in consequence, is sought by the collector of heads, as the portrait is admitted to be very characteristic of that patriot's physiognomy. Mr. Pitt, not unfrequently while sitting opposite, and being at the moment the marked object of his satire, would smile, yea, even laugh, and exposing his white teeth to the Opposition, kiss his hand in compliment to his wit, and sometimes hold up his finger and shake his head at the modern Thersites."

During the Ministerial changes several cartoons were published in continuation of the election satires which had occupied the artist at the close of the preceding year. Sheridan's return for Westminster was questioned by Paull, and before the Broad Bottomites were dismissed from office he presented a petition to convict him of bribery and corruption. The fate of this measure is recorded by the caricaturist :—*A Plumper for Paull; or, the Little Tailor Done Over— Vide the Terrible Effects of Provoking a Red-hot Shot from the Broad Bottomed Whig Battery* (March 13th, 1807). The print represents the Bar of the House of Commons. The "Little Tailor" has ridden in on his famous "Green Goose from Brentford," which bears the profile of Sir Francis Burdett. A terrific flash of lightning from the Speaker's wig has thrown the party into consternation. The head of Sheridan is represented as a red-hot shot, with flames issuing from his nose and mouth, and has bounced over the petitioner, and set his "humble petition" ablaze. Paull is thrown on his back; his bonnet-rouge is knocked off, his yard measure is broken, shears, cabbages, and cucumbers are all upset, together with his "scrutiny" and his "impeachment of the Marquis of Wellesley." His fall has capsized Counsellor Clifford, whose bottle and brief, "Paull *versus* Sheridan," are thrown aside. A crowd of Jews and denizens of St. Giles's, brought up as evidences to substantiate Paull's charges, are struck with guilty terror. "Forged letters," and similar documents, are put out of sight; while the list of witnesses includes the respectable names of "Conkey Beau, Bill Soames, Drake, and Hart the Informer." Horne Tooke, his features bearing a vagabond expression, and Colonel Bosville, are leaving the House together ; the latter is holding up his hand in dismay. A paper, "Expenses of the Election," appears in his pocket. Cobbett has dropped his "Political Register," containing an attack on Sheridan. The members are enjoying the Radical discomfiture.

On the dismissal of the Grenville Administration, the new Ministers, finding the Opposition in the Commons likely to prove too powerful for their influence, resolved on a dissolution, trusting to the old cries of "Church and King" and "No Popery." The results of the fresh elections proved these calculations were well founded.

The new elections gave Paull a fresh chance, and, nothing daunted by the recent defeats, he flattered himself that he would be able to beat Sheridan, no longer supported by the Government interest. The candidates were, however, more numerous. Sir Francis Burdett contested Westminster on his own account. Lord Cochrane, and Elliott, the brewer of Pimlico, increased the number. Paull advertised a dinner to be held on the 1st of May, at the well-known "Crown and Anchor." Sir Francis Burdett was announced to take the chair, contrary to his intention; and on the 29th of April he expressed his displeasure at Paull's proceeding :—"I must say, to have my name advertised for such meetings is like 'Such a day is to be seen the great Katterfelto,' and this without my previous consent or application. From any one else I should regard it as an insult. I yielded to your desire that I should nominate you, although I should much rather avoid even that ; but as I highly approve

of your conduct, I do not object to that one act, as a public testimony of approbation; but to that single point I must confine myself." Paull did not think proper to substitute the name of another chairman; and Sir Francis sent his brother to explain to the meeting that he had given no promise to preside, and that his name had been used without his sanction. At the close of the dinner Paull waited on Sir Francis Burdett; a warm altercation ensued, and a hostile meeting was arranged to take place near Wimbledon, at ten o'clock the next morning. The Baronet was attended by Mr. Bellenden Kerr, and Paull by a Mr. Cooper. A brace of pistols were fired without effect. Paull declared he would not be satisfied without an apology, and fresh pistols were loaded. Burdett was struck by the second discharge in the thigh, and Paull was wounded in the top of the leg. This was considered satisfactory to the honour of both parties, and the combatants then returned to town in Paull's post-chaise.

These hostilities between the most conspicuous leaders of "the new school" furnished Gillray with an addition to his series of cartoons on the Westminster election:—*Patriots Deciding a Point of Honour; or, an Exact Representation of the celebrated Rencontre which took place at Combe Wood on May 2nd, 1807, between Little Paull the Tailor and Sir Francis Goose* (May 4th, 1807). Sir Francis Burdett, as the Green Goose, is crying, "What, must I be out! and a tailor get into Parliament!! You're a liar! I never said that I would sit as chairman on your shopboard!" Paull is facing his opponent, a yard measure is round his neck, and a pair of shears is girded at his side in place of a sword. "A liar!" he retorts. "Sir, I am a tailor and a gentleman! and I must have satisfaction." The second pistols are discharged simultaneously. Sir Francis is wounded in the thigh, and a ball is lodged in the front of Paull's leg. Various evidences of the difference are scattered around: bags of Westminster election papers, with Paull's cabbage and cucumbers; "Dangers of Indulging Political Envy, by Sir Francis Goose;" "Cobbett's Character of Paull the Tailor;" "Sir Francis Goose's Letter to the Electors of the Crown and Anchor upon Paull's Advertisements." Bellenden Kerr, with an armful of pistols, is standing behind his principal, and a post-chaise is seen in the distance.[*]

The result of the Westminster election was set forth in a cartoon which was published shortly after:—*Election Candidates; or, the Republican at the Top of the Poll, the Devil Helping Behind (vide Mr. Paull's Letter; Article, Horne Tooke).* Also an exact representation of Sawney McCockran *flourishing the cudgel of Naval Reform; Drury Lane Harlequin trying in vain to make a spring to the top of the poll, his Broad-bottom always bringing him down again; and lastly, poor little Paull the Tailor, done over, wounded by a Goose, and not a leg to stand on* (May 20th, 1807). A pole marked "Westminster Election" is set up before the polling-booth. Sir Francis Burdett has gained the summit; he is represented in the character of a "Green Goose;" "Conceit" and "Vanity" are painted on his wings; he is hissing at the Crown, "The Sun of the Constitution." Horne Tooke, as the Evil One, has planted his cloven foot on the roof of the booth, and he is propping up Sir Francis with his pitchfork; his wings are labelled "Deceit" and "Sedition." Lord Cochrane, in a naval uniform, with the club of Reform in one hand, and charges against St. Vincent displayed in his pocket, is mounting second, Elliott, the brewer, who stood on the Tory interest, has been pushed down; his body is formed of a barrel of quassia, the head is knocked off, and the froth is escaping. "Sixpenny Jack's Address" is falling from his hand; Sheridan, dressed in a harlequin's suit, is making clumsy efforts to ascend. Paull, his leg half blown off from his recent encounter, is dropping down head first, with shears and cabbage. The members of the dismissed Ministry, disguised as a band of sweeps and journeymen butchers, are commemorating Sir Francis's victory with rough music. Lord Henry Petty is knocking his sweep's broom on a shovel, marked "Burdett and Independence." Lord Grenville's cleaver is chalked "Burdett and Opposition;" Lord Howick's, "Burdett and Revenge;" Lord Temple's, "Burdett and Popery;" Windham's, "Burdett and Reformation."

Gillray has enlightened us upon the progress which Napoleon was then making in "King-

[*] An *on dit* published on the occasion declared:—"Mr. Samuel Rogers is reported to have been in the neighbourhood, and hearing the discharge of the pistols, he observed, on learning how the combat terminated—'As I said, this will end in a lame affair!'"

raising." A cartoon published June 25th, 1807, illustrates the Imperial planter at work:—
The New Dynasty, or the Little Corsican Gardener Planting a Royal Pippin-Tree. "All the Talents
are clearing the ground of the old timber.—Vide the 'Berlin Telegraph' of May 21st, 1807; Article,
'The Genealogy of the Royal Race of the King of Ballynahinch.' (See 'Morning Post,' June 17th)."
Talleyrand is digging a hole to receive the trees which are to supersede the old Royal Oak. In his
pocket is a project for enlarging the Imperial plantations. Little Boney, wearing a huge sword, labelled
" Corsican Grafting-knife," is planting the "Royal Pippin;" its root is marked "William the Norman
Robber;" on its branches are various memorials of unfortunate kings. A golden pippin tops the tree,
the crowned head of Lord Moira, who claimed descent from the ancient Royal Irish race of Ballynahinch.
A noble oak, with the British Crown in its centre, and the "Protestant Faith," "Integrity of the
Lords," " Independence of the Commons," and "Liberty of the Press," among its goodly fruits, is con-
demned to fall. Lord Grenville, with his heavy "Catholic cleaver," has made several deep incisions.
Grey (Lord Howick) is lustily hacking away with the "Whig cleaver;" while the Marquis of Bucking-
ham is wielding his "Broad Bottom hatchet." On the ground is a basketful of grafts, ready crowned,
to take the place of the ancient oak. The faces of Sir Francis Burdett, Cobbett, and Horne Tooke top
these sprigs, which bear parchments marked "Grafts of King-pippins from Brentford, Wimbledon, and
Botley." A whole row of fresh pippins line the rear; they are grafted on older trunks with Boney's
renowned "Corsican clay." The kings of Napoleon's own constituting are labelled "Wirtemberg
Pippin," "Italian Pippin," "Saxon Pippin," &c. &c. A likeness of Louis Bonaparte is labelled "The
New Holland Pippin."

In July Gillray dismissed the Broad Bottomites to oblivion under the title of *Charon's Boat, or the
Ghosts of "All the Talents" taking their Last Voyage (from the Pope's Gallery at Rome).* Charon is
ferrying the late Administration across the river Styx to the land of desperate shades, where, according
to the artist, their arrival was anxiously expected. Charon's boat bears the name of "Broad Bottom
Packet." Lord Howick, acting as ferryman, is employing the Whig club as his punting pole. The
sail, "Catholic Emancipation," is torn and split; the mast is broken, "Ich dien" is nailed across it, and
the Prince of Wales's feathers, with the word "Fitz," is bound to the top. The tattered flag bears the
Papal insignia, and "Templa quam dilecta," the motto of the Grenville family. Earl St. Vincent is
managing the rudder; he finds his freight a troublesome one. "Avast!" he cries; "trim the boat, or
these d—d Broad Bottom lubbers will overset us all!" The travellers are variously employed. Lord
Lauderdale is scratching his head in perplexity. The Bishop of Lincoln, with "unction" printed
across his mitre, has his hands devoutly crossed over a brace of money-bags—"Pitt Endowments"
and "Whig Endowments." The Marquis of Buckingham is represented as "Broad Bottom Ballast from
Stowe." Lord Grenville, who retains his Cardinal's hat, is endeavouring to cheer his prostrated comrade;
he proffers the Communion-cup. "Courage, brother! take Extreme Unction, and don't despair!"
The voyage has upset Sheridan. Lord Temple seems also ill at ease. Places, pensions, and
sinecures, together with his paymaster's stationery, are being washed away. Lord Sidmouth has
jumped overboard, and is already sinking in the Styx, where he seems likely to be lost, as no one cares
to fish him out. A Catholic emetic has disturbed Lord Erskine, who by no means relished disgorging
his appointment. And Grey, carrying his companions into their long exile, is thus consoled:—"Better
to reign in Hell than serve in Heaven." Windham is also prepared to exercise his talents in Hades.
He is concocting a "Scheme for drilling imps in Hell!" Whitbread, supplied with the consolation of a
pot of his own "Entire," is farther solacing himself from "Wesley's Hymns." Lord Moira is holding
on to the mast; he is kissing the crucifix, and directing his eyes to the plume of his patron; while
little Lord Petty, to whose dancing Gillray constantly refers, is twanging a dancing-master's fiddle to a
jig, "Go to the devil and shake yourselves." Cerberus is barking at the company midway. The
"Morning Post" and the "Political Register," as obscene birds, are bespattering the crew with "Pro-
testant Letters" and "Cobbett's Letters;" while Tooke and Burdett, as a composite nondescript fowl, are
issuing "Damnable Truths." The three Fates, Lachesis, Atropos, and Clotho, as witches riding in air
on their broomsticks, are weaving, unwinding, and cutting the threads of the late Administration; they
are Canning, Castlereagh, and Hawkesbury. Ghosts are trooping down from the realms of flame to

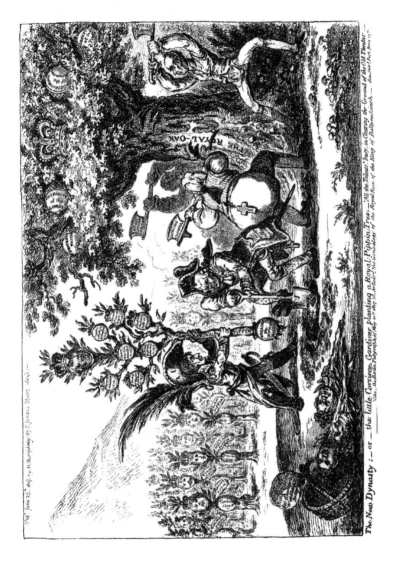

Pub.^d June 25th 1807 by H. Humphrey, 27 S^t James's Street, London.—

The New Dynasty :— or — the little Corsican Gardiner planting a Royal Pippin-Tree.— "All the Idiots' Pray, in Clearing the Ground of the Old Timber"—
"—Vide, the Berlin Telegraph, of May 21st 1807. L'arrival of the Grandsons of the Royal Race, of the King of Beth-mlinach. — Smollet, Part June 14th.

THE ROYAL OAK

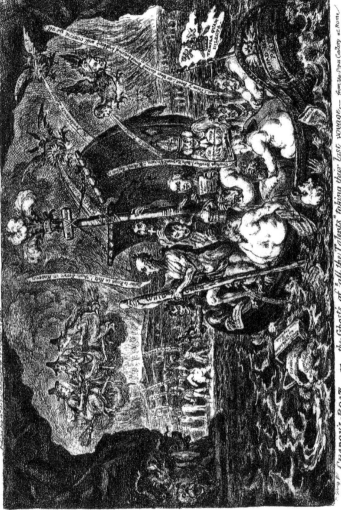

Pub^d CHARON'S BOAT.— or ~ the Ghosts of "all the Talents" taking their last voyage.— from the Popu Cowley at Rome.

welcome "All the Talents" to their shore. "Welcome to Charley," cries the spirit of Fox, which is placed between the ghosts of Oliver Cromwell and the headless Robespierre. Despard, Quigley, and others are coming forward to hail the packet's arrival.

The Continent had, in the meantime, fallen under the iron sway of the conqueror. The Allied armies had been successively tried against Napoleon's resources, and found wanting. England was still unconquered, but she had been severely strained. "Her efforts to sustain the cause of Europe had pressed heavily upon her strength. She had raised all the troops, and lavished her wealth, with no return but that of seeing Europe laid at the foot of the enemy. But the struggle had been at a distance; it was now brought nearer home."

"By the Berlin and Milan decrees, the most extraordinary measures in the annals of warfare, a line of fire was to be drawn round the Continent, and England excluded from the intercourse of nations." When the deputies from Hamburg represented the havoc which these decrees had produced, Bonaparte's answer was characteristic:—"What is that to me? The war must not go on for ever. You suffer only like the rest. England's commerce must be destroyed."

It is to the honour of England that she never gave way, yet the evils of protracted hostility were pressing on her with a weight which required all her fortitude to sustain. The vividness of actual conflict was gone; there was no enemy on the seas to animate her with new triumphs; war on land was hopeless against the bulwark of steel that fenced the Empire and the vassals of Napoleon. Her pillars of State and war had fallen—Pitt, Fox, and Nelson—within a few months of each other. The Berlin and Milan decrees, after working their indescribable ruin on the Continent, were gradually sapping her commerce. These measures were prepared to isolate England, like a huge garrison. Napoleon now meditated a more deadly blow. By a secret article of the Treaty of Tilsit it was stipulated that the Emperor of Russia should assist France in organizing a Naval Confederation of the Northern Powers under the specious pretext of an "Armed Neutrality," formed in reality to compel England to accept any terms which might be dictated. Denmark was unwillingly drawn into this league; the threats of Napoleon were dangerous to small States. The English Government obtained information that a large accumulation of naval stores, concentrated at Copenhagen, was waiting to be conveyed to Brest by the Danish fleet, which was to be placed under the orders of the French authorities. An envoy was despatched requiring the surrender of this fleet to Great Britain until the conclusion of the war, it being represented that the Danish Government could not protect itself against the intended employment of their ships for hostile purposes against England. A solemn guarantee was offered that the entire force should be "restored, with all its equipments, in as good a state as it was received." The Danes rejected this proposal, which was repeated by Admiral Gambier on the 2nd of September. The English fleet then proceeded, according to the ultimatum previously submitted, to bombard Copenhagen—a cruel but inevitable necessity—on the 8th of September. The city was compelled to capitulate. The admiral immediately fitted out the ships, which filled the basins where they were laid up in ordinary; and the entire fleet, with their stores and a vast quantity of material were conveyed bodily to England, where they arrived in perfect order in a short time. The greatest commiseration was expressed throughout England for the loss and sufferings of the unfortunate Danes, involved against their will in this struggle between two belligerents. A friendly sympathy had long inclined the people towards Denmark, and they deplored an act of fearful severity dictated by the duty of self-preservation. This infusion of new vigour in the Cabinet was hailed with universal satisfaction; and Canning, to whose energetic counsel this expedition was attributed, was henceforth respected as the inheritor of Pitt's intrepidity.

Gillray has left a cartoon commemorating the arrival of the Danish squadron, under the title of *British Tars Towing the Danish Fleet into Harbour; the Broad Bottom Leviathan trying to Swamp Billy's Old Boat; and the Little Corsican Tottering on the Clouds of Ambition* (October 1st, 1807). Lords Liverpool and Castlereagh are lustily rowing "The Billy Pitt;" Canning, seated in the prow, is towing the captured fleet into Sheerness, with the Union Jack flying over the forts. In the distance is distinguished Copenhagen, smoking from its recent bombardment. In Sheerness Harbour, the sign of the "Good Old George" is hung out at John Bull's Tavern: John Bull is seated at the door, sheltered under

the British Standard; he is grasping his pot of porter, waving his hat, and shouting " Rule, Britannia, Britannia rules the Waves !" The expedition did not escape censure, as is implied by the figure of a three-headed porpoise which is savagely assailing the successful crew. This monster bears the heads of Lord Howick, shouting " Detraction ;" Lord St. Vincent, filled with "Envy," and discharging a watery broadside ; and Lord Grenville, who is raising his "Opposition Clamour" to confuse their course. The political satires for 1807 are brought to a conclusion with this signal achievement.

Among the social sketches of the year we may notice one subject, somewhat suggestive—*And wouldst thou turn the Vile Reproach on Me ?* (February 2nd), in which a decrepit old bachelor is startled by a delicate accusation from his buxom servant.

12th May, 1807. *Mother Goose*, represents the figure of a remarkably aged flower-seller, a well-known Oxford character at the time—a quaint old body ; engraved from the sketch of an amateur.

A second portrait, from the pencil of the same artist, pictures a stout little "turfite," under the title of *A View of Newmarket Heath, taken from Davis's Straits* (June 9th, 1807). Davis was, it appears, a well-known character on the turf ; he was nicknamed " Goose Davis," from a story which averred that he had been bartered for a goose on the other side of the Pacific.

At this date (1807) the painter Morland was reduced by his extravagance to overstock the market with somewhat meretricious examples of his skill. Gillray, as we have seen, was an early admirer of this gifted painter, but he resented the artifices then contrived to enhance the value of his works. An engraving ridiculing one of these over-puffed collections was employed to assemble the likenesses of certain of the painter's well-known admirers, under the title of *Connoisseurs Examining a Collection of George Morland's* (November 16th, 1807). Various contemporary accounts were published upon the subject of this plate. " That indiscriminate admiration for works of art on the mere reputation of a name, which is so common among the dilettanti, is justly exposed by this satire on a certain junto of connoisseurs, who were well known at Christie's and Greenwood's during the latter part of the last century. Every one acquainted with the history of the modern picture-craft must remember the tricks which were resorted to for keeping up the market, crowded as it was with the works of this eccentric painter. In the zenith of his powers—namely, from about 1790 to 1794—Morland's works were justly admired. *The Farmer's Stable,* and his series of *The Deserter,* are masterpieces. His horses and pigs were faithful transcripts from nature. But soon sinking into the habits of the lowest intemperance, and surrounded by idlers, profligates, and flatterers, whom he supported, his industry could not keep pace with the demands on his purse ; and to supply the means for living in a course of extravagant debauch, he manufactured pictures, and glutted the town with his daubings. Hence frequent sales were made of his works ; and the group here exposed were among those whose dicta maintained a certain reputation for their favourite genius, long after his faculties were on the wane. The old gentleman with the spectacles is the late celebrated Captain Baillie, who, though thus exhibited, was in truth an able connoisseur. Behind the Captain, with his hat under his arm, is the late Mr. Baker,[*] of St. Paul's Churchyard, the friend and patron of Paul Sandby, Michael Angelo Rooker, Hearne, and other practitioners of the art of painting in water-colours. The old gentleman in the wig is the late eccentric Caleb Whiteford, the friend of Garrick, and the inventor of newspaper ' cross-readings.' The tall fat gentleman represents Mr. Mitchell, the banker ; and the worthy portrayed as paying a rather equivocal compliment to one of George's sows, is a free translation of the personal appearance of Mortimer, a well-known picture-dealer in his day, who is here introduced *con amore,* he being a personal friend of the satirist, who has given a more detailed likeness of his 'art crony' assisting at the humorous 'Twopenny Whist' party. Captain Baillie (to Mr. Christie) : ' By the powers, sir, that group of swine is nothing short of perfection. It is the very model of a pig ; it looks the pig, and it smells the pig ; surely well it may, for it was painted *con amore.*' 'Pooh, pooh ! he could not paint a white horse. What do you mean, man ? 'Tis not like Cuyp, nor Wouvermans, nor nature, man ! As for colour, do you perceive, it is a horse of mortar ! Morland enjoyed the joke conveyed in this plate. He cared not one straw for his own reputation, when

[*] The Quisquilius of Dibdin's " Bibliomania."

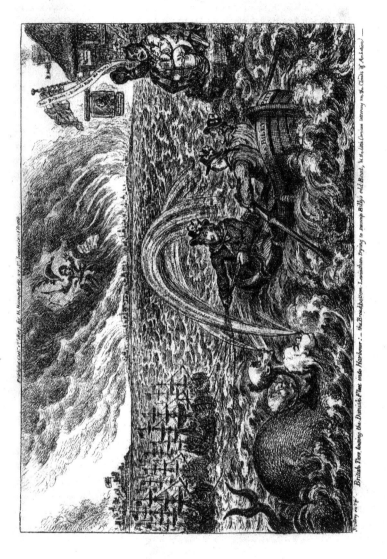

British Tar towing the Danish Fleet into Harbour:— the Broad-bottom Leviathan trying to swamp Billy's old Boat;— & the little Corsican tottering on the Clouds of Ambition) —

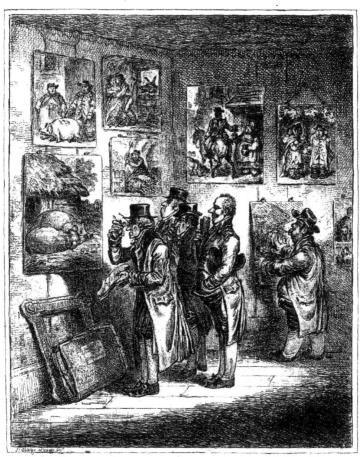

CONNOISSEURS examining a collection of GEORGE MORLAND'S

London Pubd Novr 16th 1807, by H. Humphrey 27 St James's Street.

it involved any of his associates. He despised his convives, laughed at his employers, and slighted his patrons and friends."

On the 1st of December Gillray published an engraving of a sporting subject, "invented" by the same I. C., for whom he had executed previously plates. *The Sound of the Horn, or the Danger of Riding a Hunter.* A gentleman is supposed to be proceeding out upon a quiet ride, his wife is sitting pillion behind him. They are suddenly dismayed by their horse starting off at a hot gallop on catching the sound of the horn, to follow a distant pack of hounds, who are toiling up a hill in full cry. While crossing a pool the lady is capsized; to increase the dilemma, her husband is involved in the fall.

1808.

The course of events, as traced by the caricatures for this year, may be thus summed up: The Portland Administration was still felt to be weak in the face of the opposition offered by the rejected "Talents." The career of Bonaparte remained the chief subject of interest. After subjugating the Northern Powers, he once more turned his attention to the Peninsula: the memorable struggles in Spain and Portugal then commenced, in which the armies of Napoleon were opposed by the valiant handful of English troops who had been sent out to oppose him; the French arms at last sustained a check, which proved they were not *invincible*, and fresh courage was infused into the beaten nations. The Ministers, who had secured a firmer majority in the new Parliament by their Protestant professions, were, from a certain want of unanimity in their ranks, still regarded by the public at large without any feeling of confidence.

This impression is graphically embodied in Gillray's cartoon *Delicious Dreams! Castles in the Air! Glorious Prospects!* (April 10th, 1808). The Duke of Portland, the ostensible head of the Ministry, is presiding over a friendly symposium of his Cabinet colleagues. Punch, Madeira, Port, &c. are placed on the table to imply the individual tastes of the party. The Ministers have all fallen into agreeable slumbers, and are assuming in their dreams that the splendid achievements they meditate are in actual process of accomplishment.

The sleeping Premier is propped up on a crutch, his blue ribbon is used as a sling for the support of his gouty arm. The Duke of Portland was, as the satirist implies, somewhat infirm for the post; he had accepted office in opposition to the wishes of his relatives. Lord Hawkesbury is clasping his hands in ecstacy at the visionary prospect, to which his lordship was only able to contribute by aspirations. Canning, the Secretary for Foreign Affairs—the most active member of the Cabinet—is smiling with delight at his own imaginary successes. A roll of "Secret Correspondence from Copenhagen" enlightens us on the authorship of the recent expedition. His feet are stretched out at ease on the body of Lord Mulgrave, First Lord of the Admiralty, lying asleep under the table, with a bottle beneath his arm. Spencer Perceval, wearing his Exchequer robe, is dreaming, punch-glass in hand. Lord Castlereagh, who has fallen asleep in a somewhat uncomfortable posture, has upset the contents of his tumbler over his person; an endless roll, marked A, B, C—the copy of an intended speech— "nine hours and a half long"—is hanging behind him. A cat, perched on his shoulders, is purring in his ears; she is holding in her paw an "Air by Catalani"—alluding to an implied liaison with that once renowned songstress; much as a similar scandal rendered the musical predilections of the Duke of Portland into an intrigue with Mrs. Billington. The "Treasury plates" are drawn off the table by the eagerness of a tribe of rats, who are feeding on the remnants of the feast, which, according to the "bill of fare," consisted entirely of "Treasury loaves and fishes." In the clouds, mounting from brains of the slumberers, which surround the upper part of the plate, tantalizing visions are set out at length. A bull is drawing Britannia, seated triumphant in a naval car, to which Napoleon is chained with his recent ally, the Russian Bear; the Princes follow; while the sailors, who had recently captured the entire Danish fleet, are huzzaing, and singing "Britannia rules the world."

z z

The Ministerial berths were certainly not "beds of roses;" they had secured the "good things" which the "Talents" were loth to abandon, and impatient to regain. "Foreign affairs" were the most distant part of the Tory embarrassments.

Britannia Triumphant.

"All the Talents" were still eager for office, and they were strengthened by the adhesion of a number of lesser factions included in the same proscription, and eager to combine with them on whatever subject the opposition might be based. The dissatisfaction was increasing out of doors. The voice of the people, encouraged by the "Reformers" and "Radicals," became more clamorous; while Tory principles were thoroughly unpopular. It was at this time, when Canning, menaced on every side, had to hold his way upon a most dangerous path, that Gillray conceived his brilliant allegory of *Phaeton Alarmed*, published March 22nd, 1808, with the lines—

> "Now all the horrors of the heav'ns he spies,
> And monstrous shadows of prodigious size,
> That, deck'd with stars, lie scatter'd o'er the skies ;
> Th' astonish'd youth, where'er his eyes could turn,
> Beheld the universe around him burn ;
> The world was in a blaze !"—OVID's *Metamorphoses*.

Canning appears as the adventurous Phaeton of the political firmament, startled by the terrific constellations which are threatening him on every side, in consternation at the results of his own rashness. Lord Hawkesbury, Spencer Perceval, Lord Castlereagh, and Lord Eldon are represented as the steeds harnessed to the Chariot of the Sun of Anti-Jacobinism, which is lighting up the celestial system. The car is in flames—all the Signs of the Zodiac are brought into operation. *Leo Britannicus* has broken loose, and is springing after the frightened team. *Libra Britannicus* has been run over, and the chariot-wheels are on the point of crushing the scale inscribed "Copenhagen." Every exertion is made by the champions of darkness to extinguish the sun and immolate the daring charioteer. Lord Henry Petty, as *Pisces*, is trying to quench the orb of day; Whitbread, as *Aquarius*, is emptying the contents of a small beer barrel; and Lord Sidmouth, as *Sangraderius*—a satellite which owed its discovery to the artist—is squirting his "doctor's stuff" against the luminary; while Erskine, as *Astrea*, emerging from a Chancellor's wig, is endeavouring to extinguish the charioteer. Lord Ellenborough, with a lion's skin for his wig, is aiming at the horses with his "Herculean club." Lord Lauderdale is spouting as *Aquila*. The wild Irish bull is charging, full butt, at the equipage; his collar is labelled "Erin go bragh;" while a pot attached to his tail, marked "Emancipation," is evidently increasing his fury. Lord Grey, a deadly terror-striking Python, is winging his vengeful flight directly in the path of Canning's horses, and darting his venom full in their faces. *Scorpio* is the most tremendous of all the constellations. The monster bears the head of Lord Grenville; his claws are inscribed "Scorpio Broad Bottomis," and the Whig chiefs are all combined in his construction. His huge body bears the Communion Cup in the centre, surrounded by the heads of Earl Stanhope, Lord Derby, Lord Carlisle, the Duke of Norfolk, Lord Holland, and others arranged as stars. Lord Grenville's claws sustain a brood of lesser scorpions, which, we may assume, have not reached their full growth. Lord Moira and Tierney are thus held, with Lord Temple, Earl Spencer, and the Duke of Bedford. Sheridan, as a bloated *Silenus*, on a braying ass, is threatening Phaeton with two bottles of "port." Earl St. Vincent, a vicious *Cancer*, is snapping his nippers at the horses; and Windham, as *Sagittarius*, is aiming at the driver. Below is the globe, in a state of appalling conflagration, while the Northern Powers are blazing high. Napoleon, as a monkey, is in the thick of the flames, riding *Ursa Major*, the Russian Bear, and chasing the double-headed eagle of Austria. Neptune, rising out of the sea, is dropping his trident in terror at the confusion which meets his view. Fox is introduced as *Pluto*, the secret promoter of these misfortunes; he is concealing his satisfaction; while Pitt, figuring as *Apollo*, is shedding tears and dropping his lyre in horror at the spectacle of his pupil's rashness.

Publishd April 2d 1808 by H Humphrey 27 St James's Street

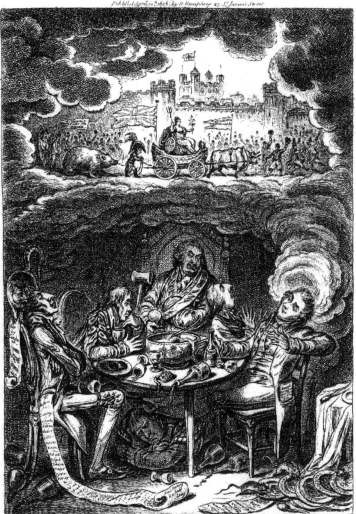

Delicious Dreams!__ Castles in the Air!__ Glorious Prospects!
Vide An Afternoon Nap after the Fatigues of an Official Dinner.

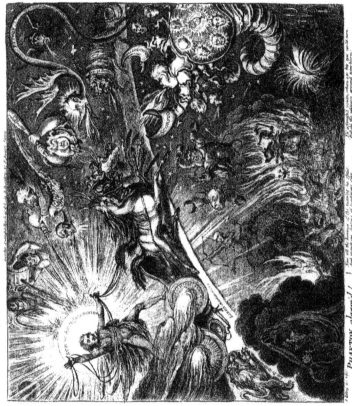

PHAETON alarmed! — !

In April Gillray published a caricature entitled *The Constitutional Squad (i.e. Opposition) Advancing to Attack*, in which the most formidable weapon of the assailants is an immense brass cannon, entitled "Revolutionary argument." The Tories still kept up the old accusation against their opponents of Republicanism and Jacobinism, and they declared that they aimed at the introduction of Popery. Mrs. Fitzherbert was again brought on the stage; and it was intimated that, through her influence, the Prince of Wales, who still supported the Whigs, had been induced to favour the claims of the Catholics for relief. The suspicion of a tendency towards Rome, thus raised, remained years afterwards attached to the Prince in the belief of a considerable portion of English society. Several caricatures which appeared about this time, represented the Opposition as led by the Prince, Mrs. Fitzherbert, and the Pope.

The efforts of the Opposition to dislodge the Tory occupants from the Royal hives, that they might regain their places, and the numerous factions which they were able to lead against Canning and his colleagues, furnished Gillray with the hint for a highly ingenious personification of the state of Parliamentary warfare.

May 2nd, 1808. *Broad Bottomed Drones Storming a Hive; Wasps, Hornets, and Humble Bees Joining in the Attack.*—The hive is surmounted by the Crown, and supported on the Treasury benches; three pots of honey (*i.e.*, broad gold pieces) are stored below. Earl Granville is leading the attack as a huge bumble-bee, with the cross displayed on his back, in allusion to his advocacy of the Catholic claims. He is fulminating against the Ministerial bees; on his wings are inscribed "Ambition" and "Envy." The Marquis of Buckingham (in spectacles) is defiling the Crown; "Catholic Gratitude" and "Catholic Loyalty" appear on his wings. Lord Temple is pouring forth his gall; his wings are of Government stationery, marked "Foolscap, Gilt-post," "Wax, Pens, Wafers," &c. Sheridan is displayed as a bumble-bee, in a harlequin suit; "Stale Jests" and "Joe Millers" are stamped on his wings. The Duke of Clarence is borne to the attack on wings of "Profundity" and "Parts." Earl Derby, a round-bodied bumble-bee, is flying on Cupid-like wings. Earl St. Vincent is supported on wings of "Avarice" and "Detraction." Above him is the Duke of Norfolk; "Republicanism" and "Majesty of the People" are inscribed on his wings. Lord Holland is sustained by "Volponean Rancour" and "Volponean Subtilty." The wings of the Duke of Bedford are marked "Disappointment." He is followed by Lord Ellenborough, in a full wig. Lord Spencer, Lord Carlisle, and Tierney (on wings of "Revenge") are seen among the larger bumble-bees. Windham, on windmill sails of "Folly" and "Fiction," "Reason" and "Truth," is leading the wasps. Lord Stanhope follows, provided with his new "Republican Gills" "for Sailing without Rudder." Lord H. Petty, on wings of "Conceit;" Whitbread on "Froth" and "Quassia;" and M. A. Taylor, have severally suffered from Canning's sharp sting. Sir Francis Burdett is flying off—a long spiteful wasp, on wings marked "No Bastile" and "No Laws"—with Horne Tooke, who resembles a bat. Above the bumble-bees is an auxiliary squadron of hornets and dragon-flies, headed by Lord Howick on wings of "Vanity;" Lord Sidmouth, with a tail inscribed "Clysteria Ministeria," "Cathartic," and phials of "Emetic." The wings of Lord Lauderdale are marked with a Scotch pattern. Erskine is flying on "Protests." Lord Moira is borne stiffly on the Prince of Wales's feathers. Colonel Hanger and Lord Walpole are bringing up the rear; while other depredators are distinguishable amongst the crowd. The Treasury squadron are mustering actively in defence of their strongholds. Canning is valiantly conducting his followers, amongst whom may be recognised the Duke of Portland, Lord Mulgrave (in a chequered Scotch plaid), Lord Castlereagh, Spencer Perceval, &c. Lord Liverpool is directing his efforts amongst the foremost bees against Lord Howick. Lord Eldon, under the Chancellor's wig, and the Earl of Westmoreland, Keeper of the Privy Seal, are in the thick of the battle. Lords Bathurst and Camden, the Earl of Chatham, and Arthur Wellesley, are all swelling the ranks of Ministerial bees; and many less familiar faces from the Treasury hives are assisting in the struggle. The profusion of admirable portraits which appear on all sides distinguishes the cartoon as one of the artist's most elaborate and successful productions. The art and ingenuity which could contrive the arrangement of likenesses, all of which may be easily recognised, is worthy of the highest commendation.

A scandal directed against the political predilections of the Grenville family was furnished the satirist

by a rumour, currently credited, to the effect that a basket, containing a healthy female infant, was left at the door of the Marquis of Buckingham's residence in Pall Mall, directed to the Marchioness. The child was afterwards sent to the workhouse. *L'Enfant Trouvé; a Sample of Roman Charity* (May 19th, 1808). The Grenville family are assembled in full conclave; the entire appointments of the apartment imply the strongest Romanist tendencies: crosses ornament the sconces, the chair-backs, &c., while two candles are burning before a fanciful altar, which is erected to Saint Napoleon. A black servant is placing the basket containing the infant on a centre table, the drawers of which are labelled "Lists of Pensions," "Lists of Sinecures," "Lists of Places," "Crown Grants," &c. The little stranger is kicking up her legs, unconsciously permitting the persons assembled to recognise any mark which may establish a connexion with the family. It has, however, the misfortune to have been born without any indications of the "Talents." "What! a relation to the Broad Bottoms? O, Sainte Marie! why, there's not the least appearance of it! Therefore, take it away to the workhouse directly." The Marquis has risen from his seat, but fails to discover the infallible Broad Bottom proofs. The Marchioness repudiates the infant on the same grounds; she is dressed as a Lady Abbess. Lord Grenville and the Right Hon. Thomas Grenville are standing on one side habited as monks; and Lords Temple and Nugent appear on the other, with their pockets overrunning with gold; they are unanimous in rejecting the foundling.

On the Continent, Napoleon had turned his attention to Spain, while the English Cabinet furnished arms and money to the last Power which resisted the Corsican; and a British contingent was sent out to assist the Spaniards. The firmness of this attitude reflected a certain popularity upon the Government, and Gillray was one of the first to acknowledge their defiance of Napoleon. It was at last realized that Pitt's successors had in some degree shared his mantle. The Scripture history of Elijah was made the vehicle for an ingenious parallel.

June 25th, 1808. *Disciples Catching the Mantle; the Spirit of Darkness Overshadowing the Priests of Baal.*—Pitt is ascending in a chariot of fire, after the manner of the prophet; the light of Immortality illuminates his figure. In his upward progress his mantle, embroidered with the scales of Justice and the flaming sword, is released, and is spreading over Canning and his colleagues, who are reverently raising their hands towards the prophetic garment. The Ministers have planted themselves upon the "Rock of Ages," and they are gathered round the altar of the Constitution, which is supported by the pillars of "Fortitude" and "Prudence," whereon the Crown and the "Word of Truth" are reposing in security. The Duke of Portland, Lord Eldon, in his Chancellor's robes, and Spencer Perceval, as Chancellor of the Exchequer, are kneeling before the altar and invoking Pitt's mantle. Canning, the most conspicuous successor to the "Heaven-sent" Minister, is holding out his arms to catch the garment of his late chief. Lord Liverpool (Hawkesbury) and Lord Castlereagh are supporting the Foreign Secretary on either side. The Earl of Westmoreland, Lord Mulgrave, and others are kneeling behind them. A contrast to the "Vestment of Light" is presented in Fox's "Republican Mantle of Darkness," with which his winged spirit is trying to conceal his worshippers, "the Priests of Baal," who have climbed up the slippery "Broad Bottom Dunghill." Cardinal Lord Grenville is experiencing the "Comfort of Charley's Old Breeches;" those time-worn garments are rent asunder, and his cloak, embroidered with the cross, is too short to conceal the deficiency. Lord Howick, pictured as a veritable fanatic, has allowed the "Torch of Discord" to escape from his hand. His red-bonnet, and Grenville's Cardinal's hat, are carried away by the blast. The Marquis of Buckingham is habited as the Pope of Baal; his tiara and triple crosier are falling. Windham's mask has dropped off. Lord Lauderdale, a Scottish bravo, is displaying abject fear. Lord Holland is striving to retain his red-bonnet of "Equality." Lord Moira's plumed hat is carried off. Lawyer Erskine and Harlequin Sheridan are in dreadful consternation. Lord Sidmouth has upset his "Gentle Emetic," and is sprawling on his back. Old Earl St. Vincent, whose gout prevents his escape, is taking refuge with his crutch between the legs of the Doctor. A beer-barrel is rolled over; the top, which bears the face of Whitbread, is knocked off, and the contents are running down the hill. Sir Francis Burdett, as a dwarfed Guy Fawkes, has a Catholic petition under his arm, in readiness to make a blaze; his dark lantern is falling into the barrel from Whitbread's "Gunpowder Brewery." Fox's Republican cloak is set on fire by a ray of lightning

London Published May 14th 1804 by H. Humphrey St James's Street.

Broad-Bottom Drones storming the Hive, ___ Wasps Hornets & Bumble-Bees joining in the Attack.

INMORTALITY

THE ROCK OF AGES

DISCIPLES, catching the MANTLE. ___ the Spirit of Darkness overshadowing the Priests of Baal.

which issues from Pitt's "Mantle of Light," and several flashes are directed to the annihilation of Bonaparte's legions, which are seen overrunning the Peninsula in the distance.

We have traced how Napoleon had, by masterly dexterity, worked his way into Spain; how, having wound his artifices round the King, the Prince of Asturias, the Queen, and Godoy—an adventurer who ruled them all—he quietly secured the only obstacles in his way, and raised his brother Joseph to the throne of the Peninsula. A massacre in the capital awoke the Spaniards to a sense of their degradation. "That day's blood dyed the robe of the usurper with a colour never to be washed away. The ten millions of Spain rose as one man; without leaders, without arms, without military experience, concert, or knowledge, they rushed upon the invaders, and overthrew them like a hurricane. The French veterans, who had seen the flight of all the disciplined armies of Europe, with their princes at their head, were routed and slaughtered by shepherds and tillers of the ground; with no other fortresses than the rocks, no other allies than the soil and sky, and no other arms than the first rustic implement that could be caught up for the destruction of a murderer."

Talleyrand, who is known to have cautioned Napoleon against the futility of trying to invade England, had, it is also stated, endeavoured to dissuade his Imperial master from attempting the conquest of Spain, predicting this step would be the "beginning of the end."

The general rising in 1808 was the commencement of the "Peninsular war," and the first serious check which Napoleon had to encounter. The French disasters in Spain and Portugal had the result of reanimating the fallen Powers, and their combined action finally brought his career to its bitter end.

The first intimation of Napoleon's check was rejoiced over by Gillray, and the cause of Spain at once became popular.

The Spanish Bull Fight, or the Corsican Matador in Danger, issued by the artist July 11th, 1808, introduces the spectator to the circus of the "Théâtre Royale de l'Europe," where an exciting combat is in its most critical stage. The spirited Andalusian bull has snapped his collar, and broken the Corsican chain which had confined his freedom; Joseph Bonaparte, "the *intrusive* king," as the Spaniards styled him, is knocked down, gored, and trampled on; the deed of his coronation, dated from Gibraltar and signed by Napoleon, is torn under foot; the Emperor has attacked the bull with his sabre, which has snapped in the animal's shoulder; this wound has only added to its fury, and the Corsican conqueror is tossed high into the air to descend on his horns. Bonaparte's plan to "subjugate the world" has dropped to the ground. According to the inscription, "'The Spanish bull is so remarkable for spirit, that unless the matador strikes him dead at the first blow the bull is sure to destroy him.'—Vide 'Baretti's Travels.'" A group of injured cattle, fallen, but not extinguished, are described as "wounded bulls bellowing for help;" they are variously ticketed as "Dutch Bull Beef," "Prussian Bull Beef," "Danish Bull Beef," &c.; they evidently require only a little assistance to resume the contest. A circle of European Sovereigns are seated round the arena. King George, with Neptune's trident in his hand, is enjoying Boney's discomfiture through his spy-glass; British tars are cheering behind the throne. The Kings of Spain and Portugal are placed on either side. Alexander the Great of Russia is concealing behind his hat the satisfaction he enjoys from the spectacle of his ally's discomfiture. The Emperor of Austria is exhibiting a similar gratification. The aged Pope is displaying his "Bull for Excommunicating the Corsican Usurper." The Sultan of Turkey and the Dey of Algiers also manifest their delight.

Napoleon has been often compared to a phoenix. We find Gillray satirizing certain professions of the Emperor's desire for a general pacification. He represents the incendiary of the Continent consuming in the flames of his own raising.

August 2nd, 1808. *The Apotheosis of the Corsican Phœnix.*—A fanciful quotation from "The New Spanish Encyclopedia, Edit. 1808," describes the plate:—"When the phœnix is tired of life he builds a nest upon the mountains, and setting it on fire by the wafting of his own wings, he himself perishes in the flames, and from the smoke of his ashes arises a new phœnix to illuminate the world." On a peak of the "Pyrenean mountains," the world, supported on crossed bayonets, forms the nest of the Corsican phœnix, whose wings are fanning the entire Continent into a blaze. A "cordon d'honneur" of dagger blades is strung round Napoleon's neck, and the Imperial Crown is melting in the conflagration. A

younger phœnix is arising from the smoke, in the shape of a dove, bearing an olive branch; his wings are inscribed "Peace on earth."

Gillray now exerted all his abilities to kindle enthusiasm for the cause of Spain and to embitter the animosity against France, evident on all sides.

The national rising in Spain revived the contempt which, a few years before, had been the feeling universally cherished against Frenchmen.

August 15th, 1808. *Spanish Patriots Attacking the French Banditti—Loyal Britons lending a Lift!* pictures the unanimous rising of the entire Spanish population to drive out the invaders. The Spaniards are rushing upon the intruders and scattering them to destruction; frocked priests are loading the cannons, fair "donnas" are bringing up the ammunition of "British gunpowder." Sturdy abbesses charge furiously at the head of their nuns and do formidable execution. An archbishop, in his canonicals, is riding at the head of the Spanish cavalry, with his pastoral crosier and a drawn sword; a stout friar is blowing the charge. On the rocky heights an English park of artillery is doing terrific execution on the "invincible French legions," which are dispersed or cut down on every side, while British Grenadiers are spitting them on their bayonets, two at one thrust. The standard of the pretender Joseph is flying before that of King Ferdinand.

These successes, the defeat of Dupont and the capture of his army at Baylen, the expulsion of the usurper Joseph from Spain, and the British victories of Vimeira and Cintra over Junot in Portugal, encouraged fresh hopes of resistance. Napoleon again found himself surrounded by foes. These indications of general hostility to France foreshadowed, it was anticipated, the downfall of the Corsican; this premature conclusion was not completely realized until 1814.

The dangers which loomed round Napoleon in 1808 are admirably conceived in Gillray's famous cartoon of *The Valley of the Shadow of Death*, one of the most generally esteemed efforts of his invention, issued September 24th, 1808. The Little Captain is timorously proceeding down a slippery path, bounded on either side by the waters of Styx, and hemmed in by a circle of flame leading to the gulf towards which he is figuratively assumed to be tending; his notched sabre is no protection against the horrors which surround his footsteps. "Leo Britannicus," raging and furious, is ready to tear him to pieces; the "Sicilian Terrier" is worrying him; the "Portuguese Wolf" has burst his chain, and is flying at his throat; while King Death, mounted on a mule of "True Royal Spanish Breed," has cleared at a bound the body of the ex-King Joseph, which has been thrown into the "Ditch of Styx." He is poising his spear with fatal aim, warningly holding up at the same time his hour-glass with the sand exhausted; flames follow in his course. The figures of Junot and Dupont, the beaten generals, are rising from the smoke, linked together by the throats; they are warning Napoleon to avoid their fate. The papal tiara is descending, as a "Roman meteor," charged with lightnings to blast the Corsican. The "Turkish New Moon" is seen rising in blood, the crescent of English influence has eclipsed the waning influence of France. The "Spirit of Charles the Twelfth" is rising from the flames prepared to avenge the wrongs of Sweden with his two-handed sword; the "Imperial German Eagle" is vengefully emerging from a cloud; the Prussian bird, stripped of half its plumage, appears as a scarecrow, making desperate efforts to fly, and screaming revenge against its spoiler. The "American Rattle Snake" is thrusting forth a poisoned tongue from the "Lethian Ditch;" the "Dutch Frogs" are spitting out their spite; and the Rhenish Confederation is personified as a herd of starved "Rats," ready to feast on the Corsican. The great "Russian Bear," the only ally Napoleon had secured, is shaking his chain and growling—a formidable enemy in the rear.

On the 21st of August the French attacked the British position at Vimeira. Junot declared he would drive the English forces into the sea, which could be seen at the rear. A determined effort was made to break their lines; Wellington, then Sir Arthur Wellesley, firmly held his position, and the French were beaten back. A tremendous charge of cavalry, under Kellerman, also failed; the word was then given to the English lines to charge at the bayonet point, and the French lines were broken, the army was thrown into confusion, and a large number of prisoners were made. A second victory at Cintra followed the next day, and the French were compelled to capitulate.

On the 30th of August Sir Hugh Dalrymple signed the unpopular "Convention of Cintra," by which

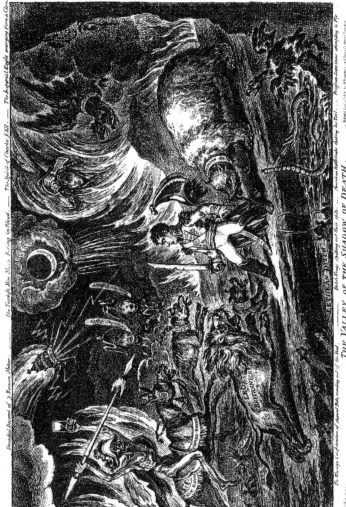

Dreadful Descent of a Roman Meteor. —— The Twelfth New Moon Rising in Blood. —— The Suicide of Charles XII. —— The Imperial Eagle emerging from a Cloud.

BEWAN DUGH —— Dutch Frogs chalking out their route. —— American Rattlesnake shaking his Tail. —— Prussian Eagle Owlet attempting to Fly.

To Europe Confederation of Imperial Philosophy out of the Mud ——

THE VALLEY OF THE SHADOW OF DEATH.

the French were bound to evacuate Portugal. This treaty stipulated that they were not to be considered prisoners of war, and that the entire army, with their arms, horses, cannon, and baggage, were to be conveyed to France. By these terms the invaders were permitted to retain their plunder under the designation of "private property," and the exasperated Portuguese were compelled to see the soldiers they had beaten carrying off the goods of which they had been despoiled.

The English Admiral, Sir Charles Cotton, declined to subscribe to the article in the armistice providing that the English fleet and army, when in possession of the town and port of Lisbon, "were not to molest the Russian squadron during its continuance in the Tagus, nor to disturb its passage when its Commander wished to sail, or to pursue it after it had sailed, until the time fixed by maritime law." He finally concluded a separate Convention, more creditable to our arms, "That the Russian fleet should be delivered up to the English until six months after the peace between Russia and England."

The news of the victory of Vimeira was hailed with the utmost enthusiasm. The Ministers were overjoyed; the Park and Tower guns were ordered to be fired at ten o'clock at night, the hour at which the news arrived. When the particulars of the Convention of Cintra were published this satisfaction was turned to unequivocal condemnation of the leaders; public meetings were held, addresses and petitions poured in to the King from all sides, and a court-martial was demanded to examine the conduct of the Generals. A Board of Inquiry was finally held at Chelsea, Sir David Dundas presiding. Their report alleged it was difficult to decide on the evidence, but that great advantages were secured by the evacuation of Portugal. The King declared his own disapproval of the terms, and returned the report through the hands of the Duke of York, for further consideration. Sir Hugh Dalrymple forfeited the confidence of the Crown, of the army, and of the nation at large, and he was never again entrusted with the command of an expedition. Cobbett was highly indignant; he turned the dissatisfaction into a weapon against the Ministry; the pages of his "Political Register" abounded with fierce attacks on every one concerned, and his pen played a prominent part in encouraging and prolonging the agitation.

Gillray has set forth the manœuvres of the Opposition on this occasion in his plate of *The Loyal Address, or the Procession of the Hampshire Hogs from Botley to St. James's—vide Cobbett's Political Register, October 4th,* 1808 (October 20th). William Cobbett is seated on his Political Hog Trough, which is running over with "Political Registers" censuring the "ignorance" of the Ministry, of "the British Commanders," of "the Admiralty," "the state of the Army and Navy," with "Letters to the Duke of York," &c. Cobbett's trough is drawn by a team of Hampshire hogs, with rings through their noses. Colonel Bosville is encouraging their exertions by scattering "pig's meat" (*i.e.*, gold pieces) before them from a bag by his side; Sir Francis Burdett is flogging the hogs with a carter's whip; Windham is standing behind Cobbett, displaying the "Loyal Petition of the noble and truly Independent Hogs of Hampshire, humbly showing that the Convention with Junot was a cursed humbug on Old England, and that the three damn'd Convention Signers ought to be hanged, drowned, and quartered, without judge or jury." Lords Sidmouth, Howick, and Grenville, as butchers' men, are helping to push the hog-trough along from behind, while a deputation of free and independent hogs, dressed in Court-suits, are bringing up the procession; a whole train of butchers' men, Sheridan, Tierney, Lauderdale, Petty, and others from their ranks, are performing marrowbone-and-cleaver music. "The party" are carrying banners with inscriptions of censure. "The Botley Patriot and his Hogs for Ever!—No Chevalier du Bain!" "Duc d'Abrantes ratifying the Convention," with bags of money; "Given up to Junot—all the plunder, all the horses, all the arms! oh, Diable! Diable!"—"Triumph in Portugal, a new *Catch*, to be sung by the Hampshire Hogs, to the tune of 'Three Jolly Boys all in a Row!'" Effigies of the "Three Jolly Boys" who signed the Convention at Cintra, are carried hung in chains, on three gallows, marked Sir Hugh (Dalrymple), Sir Arthur (Wellesley), and Sir Harry (for Sir David Baird).

Innumerable petitions and loyal addresses were prepared on every side, blaming the Ministry for the conduct of the Commanders. Gillray worked four of these memorials into a caricature, under the title of *Patriotic Petitions on the Convention.*

The Cockney Petition pictures the Address sent from the Corporation of London. By an ingenious arrangement the King's person is left to the imagination; the Recorder is reading the Petition; the

aldermen and the rest of the civic body are present. Messrs. Noodle and Doodle (Aldermen Waithman and Flowers) are bowing low before the throne. "Humble Petition, my Liege," cries Mr. Noodle. "Petition me no such petitions, Mr. Noodle," replies his Majesty; adding to Mr. Flowers, who is said to have flattered himself with hopes of receiving some distinction—"No knighting to-day, Mr. Doodle."

The Westminster Petition, a Kick-out from Wimbledon.—This Address is presented to Horne Tooke, who is still in bed—implying indisposition—Sheridan, Wishart, the Whig tobacconist, who several times proposed Fox for Westminster, and Colonel Bosville have brought in the Westminster Petition, with "Charges of Ignorance, Disloyalty, Negligence, and Inability." Sir Francis Burdett, barging out the deputation with his "Club of Reform," is crying, "Out, monsters!—haven't they cleared Portugal of the Enemy's Army?" Horne Tooke is sitting up in bed, saying, "Out with 'em, they are too bad for us!"

The Middlesex Petition pictures "Hackney Orators inspiring the Blue and Buff Interest." Counsellor Clifford, the O. P. barrister, is addressing the Middlesex Freeholders with their petition in his hand; two bottles are seen in his hat, and he is steadying himself on the shoulder of Little Paull. "O Infamous Convention!" cries Clifford. "Inquiry wont do! Instant Justice! Cut off their heads, and try them afterwards!" Byng, the old member, is standing, hat in hand, ready to communicate with his constituents, and Mellish is by his side, wearing an opera hat.

The Chelmsford Petition. "Broad Bottom Patriots addressing the Essex Calves." The electors are represented as red-bonneted calves; a notice-board contains the information—"Essex Calves to be Sold to the best Bidder. For particulars inquire at the Broad Bottom Market." Earl St. Vincent and the Marquis of Buckingham, gouty pillars of the State, are presented to the calves in uniform; the Marquis is holding St. Vincent's hat, while the veteran, resting on his crutch, is thundering away against the "Ins." "Oh this cursed Convention! It's all the fault of the d—d Ministry, by not sending me out to Portugal! O, damme! if I had had but one of my legs in the Tagus, I'd have conventioned and D'Arbrantes'd 'em! Ah, it is all for want of Me, gentlemen calves! It's all for want of Me that all this happened! All for want of Me!!" "Ay, it's all for want of us!" adds the Marquis. Lord Temple is displaying the *Essex Petition*—"Horrid Convention! Ministers Firing the Park Guns! Armistice in French lingos!" Windham and Petty are on the platform, the latter is cheering.

Among the social sketches produced during the year we notice a series of humorous figures illustrative of the weather; published in February, evidently from the designs of an amateur, but preserving considerable indications of the artist's own handiwork. They are entitled *Delicious Weather, Dreadful Hot Weather, Sad Sloppy Weather, Raw Weather, Windy Weather, Fine Bracing Weather,* and *Very Slippery Weather.* The latter represents the exterior of Mrs. Humphrey's caricature depôt; the window displays the usual selection of Gillray's pictures, before which a crowd of admirers are standing, oblivious of the weather. This characteristic background has been introduced to illustrate an earlier portion of this work. The slipperiness of the streets is indicated in the person of a miserable old body, with a thermometer in his hand, who has slipped on his back—hat, wig, stick, snuff-box, and all are flying different ways.

Another subject we have to particularize for 1808 is styled *Mæcenas in Pursuit of the Fine Arts* (May 9th). It exhibits the portico of Christie's old rooms in Pall Mall; attached to the door-post is the usual catalogue, advertising, in this instance, "800 Capital Pictures to be Sold by Mr. Christie, February 1st, 1808." The snow is lying on the railings. A brisk, stooping figure, clapping his hands for warmth, and wearing a spenser and gaiters, and blue spectacles, represents *Mæcenas,* the Marquis of Stafford (the first Duke of Sutherland), as he actually appeared engaged in forming the celebrated Stafford Collection. "This sight conjures up fond reminiscences of the past!" writes Mr. M'Lean, the well-known publisher of HB.'s political gallery; "who, that has a feeling for the arts, has not formerly, *en passant,* taken many a hasty glance at a catalogue thus appended to the column of Christie's old portico in Pall Mall? and who has not put his best leg foremost, in climbing the steep *escalier,* to revel amidst the scene above?"

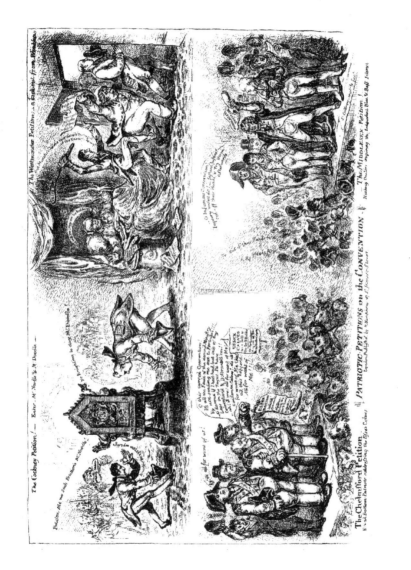

The Cockney Petition! — Enter Mr Noodle & Mr Doodle. —

The Westminster Petition, a Jacobini from Windsor

The Chelmsford Petition.

PATRIOTIC PETITIONS on the CONVENTION.

The MIDDLESEX Petition!

1809.

The year 1809 concluded the artist's labours in political caricature. The prints issued during that year trace the inquiry into the conduct of the Duke of York, and the disclosures of Mary Ann Clarke. They also mark the increasing notoriety and influence of a new body of advanced politicians, whose gradual rise may be followed in the cartoons we have already described.

The earliest sketch published by Gillray in 1809, affords a last glimpse of the statesmen of the past —of the famous old Whigs, whose views, pronounced in their day to be subversive of all sober government—were found to be antiquated, slow-moving, and unsuited to the rapid spirit of the nineteenth century, which ushered in the "Radical Reformers" and other disciples of ultra-political creeds, whose tenets even astonished the Whigs.

February 1st, 1809. *Pillars of the Constitution—Three o'Clock, and a Cloudy Morning.*—Our old friends Sheridan and the Duke of Norfolk, representative men of the age, are reeling out of "Brookes's," where the evening has been spent in mighty libations. Patriotic fervour has laid so strong a hold upon these worthies that they are rolling off to Parliament Street, indifferent to the hour. The "Royal Duke," with a bottle in reserve, is staggering along, with his hands buried deep into his waistcoat-pockets, stammering "And now for the Majesty of the People." "Sherry," with his "Motions to badger the Ministry" ready prepared, is steadying himself by clinging to the Duke; he is thundering away with his disengaged fist, and vowing vengeance—"And now have at the Ministry, damme!"

The Duke of York—King George's favourite "Frederick"—after having slipped out of Gillray's series for some years, suddenly became the object of unenviable notoriety in the beginning of 1809. On the 27th of January Colonel Wardle charged the Duke with corrupt administration of the Half-Pay Fund; the sole control of this fund having been vested in his charge as Commander-in-Chief.

The produce of this fund arose from the sale of commissions falling in by the death or dismissal of officers in the army, and amounts thus realized were applied to the purchase of commissions for meritorious officers, and other beneficial purposes.

Colonel Wardle stated he should prove that the Duke of York had a mistress, Mrs. Clarke, living in great splendour in Gloucester Place, from 1803 to 1806. This lady had a scale of prices for the sale of commissions, and he would lay before the House Mrs. Clarke's prices and the regulation prices:—

A Majority—Mrs. Clarke's prices	.	£900.	Regulation prices	.	£2600.
A Company	"	. 700.	"	.	1500.
A Lieutenancy	"	. 400.	"	.	550.
An Ensigncy	"	. 200.	"	.	400.

Every sale effected by Mrs. Clarke was a loss to the Half-pay Fund of the difference between her price and the regulation price. He then made a statement of a list of sales effected by her, the sums paid, the names and ranks of the officers, a list of exchanges, &c. Her patronage, it was stated, extended also to ecclesiastics. He moved for a Committee of the whole House to investigate the subject. The motion was agreed to, and the witnesses were ordered to be summoned.

On the 1st of February Mrs. Clarke stood at the bar of the House—a lovely Thaïs, eminently self-possessed, with ready wit, and with charms which dazzled the gravest members. She contrived to turn all questions put to her with the object of giving annoyance, or for her degradation, into the means of exposing the Duke of York, who, it appears, had withdrawn his "protection," stipulating to pay her an annuity of four hundred per annum, which had been suffered to fall into arrears, and her applications for payment had been met with threats of the "pillory" and the "Bastile."

Wilberforce, an enemy to every species of corruption, has left the following entries in his diary:— "This melancholy business will do irreparable mischief to public morals, by accustoming the public to hear without emotion shameless violations of decency. The House examining Mrs. Clarke for two hours—cross-examining her in the Old Bailey way—she, elegantly dressed, consummately impudent, and very clever, clearly got the better in the tussle."

3 A

This subject was well suited to the pencil of our artist. Gillray sided with the Court party; but his portrait of Mrs. Clarke, as *Pandora Opening Her Box* (February 22nd, 1809), has dealt due justice to the lady's attractions. Pandora-Clarke, with a face and figure calculated to move a Stoic, is standing at the bar of the House, displaying her Opposition Stink Box, and removing its "Cover of Infamy." A number of serpents are issuing forth with the heavy fumes; their bodies are marked "Ingratitude, Revenge, Deceit, Perjury, Forgery, Lies, and Calumny." The Broad Bottom reservoir and a whole bundle of written evidence are ready for presentation. "Love-letters from Mr. Wadle" (Colonel Wardle), &c.; "Private communications from his Excellency the Morocco Ambassador;"* "Scheme to Destroy the House of Brunswick;" "Forged Letters and Forged Answers from the Duke;" "List of Mrs. Clarke's Pensions," &c. The fumes of Pandora's box are wafted over the Ministerial benches to the great discomfort of the occupants; the Opposition side is crowded, and the members are grinning at the spectacle with mischievous enjoyment.

Colonel Wardle summed up the evidence, and concluded by moving "that the Duke of York had been guilty of corrupt practices and connivance. He accordingly prayed for his dismissal from the command of the army."

Mr. Banks moved an amendment, acquitting the Duke of York of personal corruption, but petitioning the King to remove him for gross irregularities and negligence.

Mr. Perceval moved and carried a resolution absolving the Duke of all personal corruption or criminal contrivance.

But it was evident that his resignation would alone stop further proceedings. Wilberforce and his party succeeded in forcing him to retire from the command of the army, and the inquiry was dropped.

Sir David Dundas succeeded the Duke of York, and after holding the appointment for two years, resigned, and the Duke was reinstated.

A caricature, either by Gillray or not improbably executed by Rowlandson, with Gillray's figures in view, appeared on the subject of the Duke's resignation. It is called *The York March*. The stout York is marching out of office, in his regimentals, with military strut; his back is turned on Mrs. Clarke; and he cries, "If I must march, I must. However, I shall leave my Baggage behind me!" The lady, dressed in the costume she wore before the House, is reproaching her *cher ami* with his desertion. "Oh, you gay Deceiver, to leave a poor woman without protection."

Mrs. Clarke was not appeased by the results of the Parliamentary investigation. All these disgraceful exposures would have been avoided if the Duke had paid her annuity; her only object was to obtain personal justice. The public were on her side, and she accordingly announced a projected "Memoir of her Life," and of her transactions with the Duke of York, accompanied with a series of his letters. This effected her purpose; negotiations were opened for the suppression of these Memoirs. A payment of 7000*l.* is said to have purchased her silence, and the annuity of 400*l.* was guaranteed her for life.

Writing of *Pandora's Box*, it has been stated—"In the army the Duke of York was idolized. Even the maniac who raised his arm against the best of Sovereigns, on the bare mention of the name of the Commander-in-Chief, exclaimed, 'He is the soldiers' friend!'—a compliment which no soldier would be likely to utter concerning a commander who had not taken the right method to render himself the object of general affection." The results of this investigation, although far from proving gratifying to the Duke of York, were somewhat inconsistently celebrated as a Ministerial triumph.

Gillray issued an ingenious cartoon on the conclusion of the inquiry, under the title of the *Overthrow of the Republican Babel* (May 1st, 1809). "And they said, Go to, let us build us a City and a Tower whose top may reach to Heaven, and let us make a name! But they were scattered abroad upon the face of the earth, and they left off to build the city." The modern Babel is founded on the "Sand-Hill of Opposition;" its materials are of paper. Scrolls marked "Disappointed Ambition—Revenge—Envy—Jacobin Principles—Ruin and Spoil—Liberty of the Press without Control—Plan for a New Parliament House to Go upon Wheels—Incontestable Proofs that the Victory of Vimeira was a

* Taylor, a ladies' shoemaker in Bond Street.

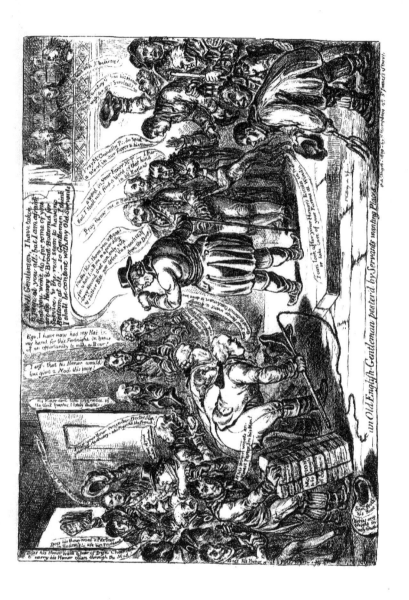

Defeat—Nods and Winks to Bonaparte—Plan for Repairing and New Roofing the Old House of Brunswick—Motion for Planting a new Constitutional Tree," and similar projects. Two bodies of builders are trooping up with contributions; the ladders of "Ambition" are planted on either side to assist the builders to add fresh documents. Their exertions are rendered useless by the apparition of the Ministers, who are blowing the tower to the winds. Speaker Abbott is emerging, like Jupiter, from the clouds, armed with the mace; he is wrapped in a scroll labelled "Justice Triumphant," "Decisions of the Right Hon. the House of Commons," "Majority against the Evidence of a Prostitute," "Majority against the Machinations of Republicans and Levellers;" and his blows are demolishing the pile. Spencer Perceval, Canning, and Lord Castlereagh appear as the Winds; they are toppling over the modern Babel; and a "Royal Water Spout" is completing the confusion of the more venturesome assailants. Mrs. Clarke has gained the highest elevation; she has overbalanced her supporters in her overthrow. She is dropping her "Old Conjuring Muff, to be sold to the highest bidder;" her hair is a tangle of serpents, and bags of "plunder" are tied to her waistband, inscribed, "Ingratitude." She is falling off the shoulders of Colonel Wardle, who has furnished his paper "Abuses in the Army Department incontestably Proved on the Word of a Prostitute and her Paramour." But he in turn is upset, and his "Private Reasons" are discovered. Lord Folkestone has also lost his balance; his hat bears a Republican cockade. "Patriotic Harangues, by Fid-Fad Folkestone," and "Motions for Kicking up a Row in the House of Commons," are scattered in the fall; "Cobbett's Hints" are seen peeping from his pocket. Whitbread is falling with the broken ladder, up which he has been climbing to contribute his "Barrel of Mischief." The head of the cask is knocked off, and its contents of quassia, cocus Indicus, &c., are deluging the bearer. "Essay on Political Brewing Without Malt or Hops" has come to the ground. Lord Lauderdale, as a monkey, is clinging to the broken part of the ladder; his red cap has fallen off. Lord Temple is sprawling; his contributions are bundles of pens, wafers, foolscap paper, and a pile of "Stationery from the Paymaster's Office, for Attacking the Ministry." The Hackney, City, and Westminster Addresses are brought forward to swell the pile. The ultra party are approaching from the opposite side; the "Republican Ladder of Ambition" is planted against the tower; Sir Francis Burdett is blown down with his contribution:—"No Bastile! Liberty for Ever! Loyalty for Ever! Republicanism! Anything to make a Kick-up!—anything to make a Row!" Cobbett is giving the Baronet a gentle lift with his pitchfork. The "Hampshire Hog Driver" has brought his "Political Register" to swell the heap. He appears as a Revolutionary recruiting-sergeant. Horne Tooke (as Guy Fawkes), Wishart, Colonel Bosville, and others are bringing up the rear.

In the meantime the Administration held their places against the cavillers; although there seems to have been a feeling that some change or modification might be anticipated in the Cabinet. On the 16th of May Gillray published a highly ingenious plate, introducing the various applicants for office in one humorous assembly, under the title of *An Old English Gentleman Pestered by Servants Wanting Places.* The old King, with his farmer's dress, his obsolete wig, his big stick, and his perspective glass, is surrounded by vastly civil serving-men, all of whom are eagerly professing their special abilities and usefulness. Lord Grenville, whose nether garments have fallen out of repair, is bowing humbly, whip in hand, demanding, "Does your Honour want a steady Broad Bottomed coachman to drive you?" The Marquis of Buckingham promises, on behalf of the "family," "We'll do anything." And Lord Temple adds, "And in any way." Dr. Sidmouth is smirking in his hat; he is offering his usual specific, "Cathartic." He cries, "Pray, your Honour, remember Dr. Slop, your old apothecary, who physic'd the French." The Duke of Portland, and the King's little circle of "friends," are standing on a raised platform; and the "outs" are soliciting the intervention of the office-holders with his Majesty. Lord Howick, as a lean greyhound, is hungrily beseeching the Duke's favour. "Pray throw me a bone, your Grace, a bone!" "Ha! ha!" returns Portland; "throw you a bone! for what? A bone to a poor silly greyhound that can only yelp, and neither bite nor drive the French wolf from the door!" Tierney has taken Spencer Perceval by the sleeve. "Pray, Mr. Chancellor P.," he cries, "do speak a word in our favour to his Honour!" "A word in your favour, Mr. T.? I fear that I shall not find a word of that kind in all England!" Castlereagh, Canning, and Liverpool are penning away as Secretaries; bags of money are disposed in rows at their backs. The pillars of State, Sheridan and the

Duke of Norfolk, are somewhat disconsolate. "Pray, Mr. Secretary C.," inquires Sheridan, "has his Honour any wish for our services?" Canning is replying, "Not the least wish, I believe." The insinuation in respect to Norfolk was not precisely just: the Duke's independence was remarkable; he even declined the "blue-ribbon," a distinction he was supposed to covet, and which was offered him apart from any political considerations, on the grounds that he could receive no favour from a Ministry whose acts he felt conscientiously bound to oppose. Lord Carlisle, as a decrepit "out-of-date Charlie," is attending with pole and lantern, as an "Old State Watchman." Earl St. Vincent, also superannuated, is hobbling along with a "Crimping Scheme" in his pocket. The Duke of Bedford, as a stout farmer's help, is also an applicant for place; in one hand he holds his triple fork, with the other he is "scraping" his hat with genuine rustic deference; his views are agricultural: "I can look after your Honour's estates in Ireland, or take care of your farms at Windsor."

Whitbread is mopping his forehead after his exertions in carrying into the House a huge pack of "Motions" (against everything). He declares, "If his Honour *wants an honest Porter*, I'm his man!" On the ground lies "Sam Froth, his knot; carries any weight in any weather." Lord Henry Petty is dancing disconsolately. He asks, "Does his Honour want a fiddler to play a jig?" Grattan and a comrade are not indifferent to the King's service. "Does his Honour want a pair of Irish chairmen, to carry his Honour clean through the mud?" Windham and Erskine are standing behind the door, greatly disappointed at being overlooked so long; Windham declares, "His Honour don't take any notice of the civil speeches I lately made." Lord Moira cries, in expectation of being recognised, "I wish that his Honour would but give a look this way!" And Erskine is no less dejected—"Ego, I have had my hat in my hand for this fortnight, in hopes of an opportunity to make a bow!" Townsend, the Bow Street runner, staff in hand, is active in turning out suspicious characters. "Take care of your pockets, gentlemen Broad Bottoms," he cries. Horne Tooke is protesting against an alleged mistaken identity, but the runner is insisting on his withdrawal. Sir F. Burdett, designed by Napoleon for President of the "British Republic," is modestly proposing a division of power. "Does his Honour want a partner in business? Ask him, Townsend." Cobbett is bringing in his "Political Registers" as a recommendation; he inquires, "Does his Honour want a Patriotic Reformer?" King George, after peering at these motley applicants, is declaring his resolution to dispense with their assistance. "Well, gentlemen," he cries, "I have taken a peep at you all; but I am afraid that you wont do:—for some of you are too heavy and Broad-bottom'd for service, and the rest seem to have no bottom at all. So, gentlemen, I think I shall be content with my old servants!"

Gillray issued, on the 14th June, 1809, a cartoon in which the plans of the advanced party were set forth in the form attributed to them by their antagonists:—*True Reform of Parliament—i.e., Patriots Lighting a Revolutionary Bonfire in New Palace Yard.* The Radical Reformers, wearing the Republican cockades, are assembled before the Houses of Parliament to make a sacrifice of the ancient Constitution, together with the Protective Laws and Statutes, with a heap of other documents, all of which are to be consigned to the flames. Sir Francis Burdett is exhibited as the guiding spirit of the wholesale demolition of English Institutions. His foot is trampling on the Sceptre, and the Crown is buried under a Resolution of the Whig Club:—"That it is the decided opinion of this Club that no substantial and permanent good can be derived by the country from any change of Ministry, unless accompanied by an entire change of system, accomplished by an entire reform of the Parliament." Burdett's Cap of Liberty is flourished aloft, and he is declaiming patriotic extracts from his own speech at Westminster (*vide* "Cobbett's Register"). "It is only in the House of Commons, that the people of England are spoken of with contempt, and calumniated! Can things be remedied by Bills? No, it must be done by an honest House of Commons! What is the use of Magna Charta, Habeas Corpus, or the Bill of Rights?" The Marquis of Buckingham and Lord Temple are seen stealing off from the presence of the destroyers, alarmed at the consequences of the measures which they had secretly encouraged; they are carrying away sacks of guineas—"Exchequer pickings" and "Family pickings." "Come away, brother Broad Bottom! come away!" cries one. "Ay, they may want to reform our pockets," replies his companion.

The first step towards the Baronet's contemplated change of system is indicated in the background,

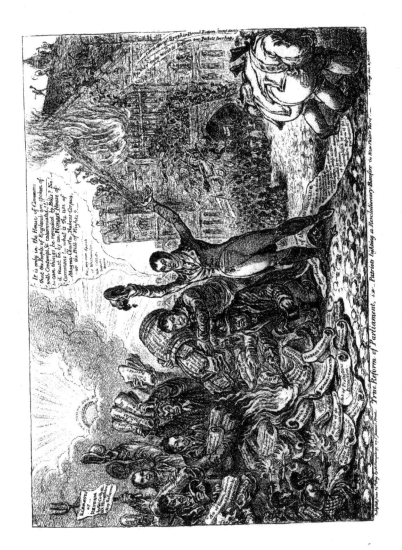

It is only in the House of Commons that the Lords of England are spoken of with Contempt & casur-muated, by Bills? No. it can't things be remudated by House of Commons:—what is the use of Magnas Chartas, Habeas Corpus nor the Bill of Rights?

True Reform of Parliament, i.e. Patriots lighting a Revolutionary Bonfire in the Palace Yard.

which represents the multitude marching—under banners, inscribed "Reform or Ruination"—to reform the Houses of Parliament after their own summary process. The "Acts," the mace, and the Speaker's chair are all hurled out of window. The Houses of Parliament are in flames, and hosts of volunteer patriots, armed with pickaxes, are swarming over front and roof to assist in demolishing the edifice. "The rising sun of Republicanism" is breaking above the clouds· A grand bonfire is piled up in Palace Yard. "The Brunswick Succession," "The Bill of Rights," "Magna Charta," and "Habeas Corpus" form the staple of the fuel. Horne Tooke, as a clerical Guy Fawkes, in a bonnet-rouge, has fired the torch of sedition from his dark lantern, and he is proceeding to set the whole mass in flames. Colonel Bosville, kneeling by his side, is casting in the "Act against Fomenting Treason." Whitbread is introduced as a brewer's man, emptying, Pro Bono Publico, a cask of his own "Entire," "the well-pitched old beer-barrel to crown the bonfire." Counsellor Clifford, the barrister of O. P. reputation, is hurling in "Trial by Jury," "List of Penal Statutes," and "Laws of England." Lord Folkestone has brought down the Acts against Seditious Meetings, and against Bribery and Corruption. Colonel Wardle (of Mary Ann Clarke notoriety) is contributing the "Act against Defaming the Royal Family." Grattan is preparing to dispose of the "Act of Union between Great Britain and Ireland," and the "Law against Irish Rebels;" while Cobbett appears behind them, waving an advertisement of the "Elements of Reform" on a pitchfork. Three mischievous monkeys, the "Edinburgh Review," the "Morning Chronicle," and the "Independent Whig," are contributing their torches.

The satires directed against the Radicals were bitter and uncompromising. Their great Apostle, William Cobbett, had indulged the readers of his "Political Register" with the details of his own autobiography, published in 1809 as "My Own Memoirs." Gillray seized the opportunity to parody these personal recollections, with additional illustrations of his own.

Plate the First of *The Life of William Cobbett, written by Himself*, is best described by the burlesqued text engraved below the etching:—"Now, you lying varlets, you shall see how a plain tale will put you down. Father kept the sign of the Jolly Farmer, at Farnham. I was his pot-boy, and thought an ornament to the profession. At seven years old my natural genius began to expand, and displayed itself in a taste for plunder and oppression! I robbed orchards, set father's bulldog at the cats, quarrelled with all the poor boys, and beat all the little girls of the town, to the great admiration of all the inhabitants, who prophesied that my talents (unless the devil was in it) would one day elevate me to a place in some public situation."

Plate the Second pictures the stout William Cobbett marching off with his bundle, as a recruit, following his corporal to the sea-shore, where boats are waiting to embark troops for the colonies. According to the pretended Memoirs:—"As I shot up into a hobbledehoy I took to driving the plough for the benefit of mankind, which was always my prime object. Hearing that the churchwardens were after me, I determined to become a hero, and secretly quitting my agricultural pursuits and Sukey Stubbs, volunteered as a private soldier into the 51st Regiment, commanded by that tried patriot and martyr Lord Edward Fitzgerald, and embarked for the plantations."

Plate the Third.—"Arrived in safety (according to the proverb). Being a scholar (for all the world knows I can read and write), I was promoted to the rank of a corporal, and soon appointed to teach the officers their duty; found them all so damnably stupid that though I took the pains to draw up the instructions on cards, I could not, with all my caning and kicking, drive one manual movement into their thick heads! N.B.—These cards were so much admired by General Dundas that he made them the foundation of his 'New Military System.'" Tall Corporal Cobbett in the print is thrashing, cuffing, and driving the officers, all of whom are studying his instructions with the greatest bewilderment. The cards give directions, "How to face left right;" "How to run away," &c.

Plate the Fourth.—"I was now made Serjeant-Major and Clerk to the Regiment, and there being only one man in it besides myself who could read or keep himself sober (viz., poor little Corporal Bestland), I constituted him my deputy. Being entrusted with the care of the regimental books, the corporal and myself (though both of us afraid of a pair of bloody shoulders) purloined and copied by night such documents as promised to be serviceable in the great national object which I had in view—namely, to disorganize the army preparatory to revolutionizing it altogether."

Plate the Fifth.—"My next step was to procure a discharge from my ever-lamented associate, the Lord Edward Fitzgerald. With this I returned to England, and directly set about writing 'The Soldier's Friend,' which I nightly dropped about the Horse Guards; and drank 'Damnation to the House of Brunswick !' Moreover, I wrote twenty-seven letters to my Royal Master, to Mr. Pitt, and to the Judge-Advocate against my officers; twenty-three of which letters were stolen by the public robbers, and never came to hand, so that I had no means of obtaining credit for my charges and procuring a court-martial but by solemnly pledging my precious soul to the devil, in the presence of Judge Gould, for the truth of my allegations, and my ability to support them by evidence !" In this print Cobbett, in a civilian dress, is literally pledging his soul to "Beelzebub, Pawnbroker. The Utmost Value for Souls taken in Pawn."

Plate the Sixth.—"The court-martial was assembled at Chelsea, as I requested, and Captain Powell and the other accused persons were placed at the bar; when, b—— my eyes ! I saw the whole of that d—d 51st Regiment, drummers, fifers, and all, marching boldly into the hall, to bear testimony against me ! On this I instantly ran to a boat, which I had providentially secured, and crossed the Thames. D—d infernal idiots ! did the Judge-Advocate and his gang of public robbers think that I would stay to witness my own exposure and condemnation !"

Plate the Seventh.—"I did not look behind me till I got to St. Omer's, and thence fled to America. Here I offered to become a spy for the English Government, and was scornfully rejected. I then turned to plunder and libel the Yankees, for which I was fined 5000 dollars, and kicked out of the country. I came back to England (after absconding for seven years), and set up the 'Crown and Mitre' to establish my loyalty ! accepted 4000l. to print and disperse a pamphlet against 'The Hell-fire Yell of Reform,' but applied the money to purchase an estate at Botley, and left the Doctor to pay for the paper and printing. Being now lord of the manor, I began by sowing the seeds of discontent through Hampshire. I oppressed the poor, sent the aged to h——, and d—d the eyes of my parish apprentices before they were opened in the morning; and being now supported by a band of Reformers, I renewed my old favourite toast of 'Damnation to the House of Brunswick !' and exalted by the sale of 10,000 'Political Registers' every week I find myself the greatest man in the world—except the idol of all my adoration, his Royal and Imperial Majesty Napoleon." The print which this description accompanies represents a gathering at Cobbett's house. His friends are met round the table to drink seditious toasts of their host's proposing. The picture of "Napoleon the Grand" is illuminated, and the editor of the "Political Register" is pledging his toast in "Napoleon spirits." By the side of a "Napoleon wine-cooler" stands a measure of "Whitbread's small beer." An officer in uniform is drinking the toast in a bowl of "Botley grog;" his foot rests on a court-martial paper. Horne Tooke is seated, with his crutch, drinking Botley ale; and Colonel Bosville, with a bottle of the same tap, has a "Plan for a New Convention" displayed in his pocket. Counsellor Clifford is far gone in "French brandy." Lord Folkestone is holding up a bumper of the same spirit. Sir Francis Burdett, waving his bonnet-rouge in the air, is enthusiastically responding to the sentiments of "Peter Porcupine." Colonel Wardle is stretched on the floor at full length—the Botley ales have disagreed with him; his "Charges against the Duke of York" are spread out before him, and a cat, with "Mrs. Clarke" on her collar, is venting her spite on his wig.

Plate the Eighth contains the dénoument of the "Memoirs." Cobbett, seated at his table, is startled by a variety of apparitions; the "Political Register," with its most violent articles, is catching fire, and the Evil One has come to claim his due. "But, alas ! in the midst of my towering prospects, while I was yet hesitating between a Radical Reform and a Revolution, and doubtful whether to assume the character of 'Old Noll or Jack Cade, down came my 'Political Register' (at the date this series was published Cobbett and his "Register" were brought into difficulties, by a libel "calculated to excite mutiny in the army," upon which the Government had obtained a verdict of "guilty"), and the fabric of my visionary greatness vanished; my schemes for my country's good perished by the blaze of my own candles. The ghost of Captain Powell uttered a scream of joy (the ghosts of Seeton and Hall are standing on either side). Little Jessey's brandy-faced mother—Lord pardon me !—called out for justice. The bats and harpies of Revolution hid their heads in the gloom of night (they are flying off in the print in the likeness of Cobbett's political associates); and to complete the horrid scene the rigid pawnbroker of hell, Old Beelzebub, entered, and demanded his property—the forfeited soul which I had

pledged!—Lord have mercy upon me!—to the truth of my accusations. Oh! oh! oh!" Cobbett is supposed to be enwrapped in flames at this juncture.

December 1st, 1809. *The Introduction of the Pope to the Convocation at Oxford, by the Cardinal Broad Bottom.*—The ecclesiastic convocation is assembled; over it is inscribed "Golgotha—i.e., the Place of Skulls." The bishops and other Church dignitaries are represented arranged in a semicircle to receive their pet candidate. Archbishops and bishops bowing low, mitres in hand, are hugging the "Mass Books" of their respective dioceses, in allusion to Lord Grenville's advocacy of the Catholic claims. All the dignitaries are in full canonicals, cheering and waving their "Rituals" and academic caps over their heads. Lord Grenville, in the robes of a Cardinal, with a large cross emblazoned on his nether garments, has removed his broad hat, and is deferentially presenting his "Catholic petition for the vacant Chancellorship, with a plan for erecting a new Popish Sanhedrim on the ruins of old Alma Mater." The venerable head of the Romish Church is officiating as trainbearer, dressed in full pontificals; he bears the crosier and tiara. Bonaparte is contriving to creep into the assembly unnoticed, concealed under the long cloak of the Pope. He wears his crown, and his sword threatens mischief. Lord Temple, remarkably like Friar Tuck, is following as bearer of the consecrated wafer, and Lord Nugent brings up the procession as a candle-holder. The Marquis of Buckingham and the Right Honourable Thomas Grenville, wearing the hats of Grand Inquisitors, are led in on the opposite side by a dark gentleman, whose tail they are holding; the withdrawal of his mask reveals the face of the Author of All Evil, who is crying, "Well done, my children! This is all the Convocation I would have." The black fiend is leading a "Popish greyhound," bearing the face of Lord Grey.

The candidature of Lord Grenville for the Chancellorship of Oxford University, upon the death of the Duke of Portland, occasioned considerable excitement throughout the kingdom. Lord Eldon and the Duke of Beaufort were also invited to allow their names to be put in nomination.

The high classic and literary attainments of Lord Grenville seemed to point him out as the person best qualified to preside over a learned body. Lord Eldon was one of the most distinguished of Lord Chancellors; but immersed in the active duties of his profession, the study of the law had diverted his attention from literature. Eldon, the wiliest of diplomatists, was eager for the honour, and he at once circulated his favourite theory—that the welfare of Church and State was indissolubly bound up with his own. He persuaded himself that his election would confirm and secure the Protestant interest, while his rejection would be the inevitable precursor of Catholic Emancipation. He endeavoured to impress George the Third with this conviction; and he wrote to his brother, Sir William Scott, "The King to-day said it would be hard if Cambridge had a Unitarian Chancellor (Duke of Grafton), and Oxford a Popish one."

The results of the voting were thus declared on the conclusion of the election:—Lord Grenville, 406; Lord Eldon, 393; Duke of Beaufort, 288.

Lord Eldon exhibited remarkable peevishness under his disappointment, and even *talked* of resigning the custody of the Great Seal—an office he was certainly most unlikely to resign under any voluntary inducement.

Among the social skits we notice, January 1st, 1809, *Farmer Giles and his Wife showing off their Daughter Betty to their Neighbours on her Return from School.* A broadly caricatured representation from the design of an amateur, of a familiar scene in a rustic drawing-room. The honest farmer and his wife are in ecstasies over their daughter's performance of the "Blue-bell of Scotland—sung by Mrs. Jordan." Their neighbours are invited to enjoy this display. A dog is introduced, who shares in the tortures inflicted on the rest of the audience.

In September, 1808, Covent Garden Theatre was entirely destroyed by fire. The sacrifice was most disastrous; twenty lives were lost, the actresses' jewels, the performers' wardrobes, Handel's organ and his scores, numerous manuscripts of operas and plays, and the wines of the "Beefsteak Club" were destroyed in the conflagration. John Philip Kemble had the mortification to witness the provision accumulated during his hardworking career disappear in the flames of his theatre. Assistance was generously offered by the actors' friends. The Duke of Northumberland, whose son Kemble had instructed in elocution, offered him a loan of ten thousand pounds on his simple bond; a few weeks later, when the first

stone of the new building was laid, this loan was converted into a gift. "Black Jack," as Kemble was popularly styled, was rather a tempting subject for the satirists; his grave airs, the tragedy grandeur of his manners and conversation were fair subjects. Gillray's graver has been exercised on the circumstance of the actor's misfortune, and the opportune generosity of his friends. The artist's view is somewhat uncharitable, but it must be remembered that the remarkable fondness for money-getting which distinguished the Kembles was a common topic in his day. *New Dramatic Resource—" A begging we will go !"—A Scene from Covent Garden Theatre after the Conflagration* (January 15th, 1809). The theatre is still burning in the background. The tragic Siddons is shedding melodramatic tears; on her arm is a well-filled bag, inscribed "Humble solicitations to the humane and benevolent." Promises of assistance from the Prince, from Lord Castlereagh, and other noblemen are scattered on the ground ; Kemble, in a tattered tragedy habit, is presenting a list of "Donations" to the Duke of Northumberland, who, at the gate of Northumberland House, is dropping his draft for ten thousand pounds into the actor's extended hat. Below the print, which is effectively executed, is engraved "Theatrical Mendicants Revealed"—"Have pity upon all our Aches and Wantès," in ridicule of Kemble's affected pronunciation of certain words, especially in the well-known example of *aches*, which the tragedian persisted in calling *aitches.*

On the rebuilding of Covent Garden, the celebrated O. P. war was waged with riotous confusion. Gillray has preserved an allusion to this singular contest between the public and the managers in a plate of *Counsellor O. P., Defender of our Theatric Liberties* (December 5th, 1809), representing Counsellor Clifford, whose portrait has previously occurred in this series, standing with an incendiary torch in his hand, to imply that his leadership of the O. P. riots had again handed over Covent Garden to the flames. On the 'ground are three brandy bottles, and a verdict "by blunder 5*l.* ;" referring to Clifford's action against the management.

March 28th, 1809. *Venus à la Coquille, or the Swan-sea Venus,* represents a stout lady, somewhat fantastically dressed, who is seated in a shell drawn by two swans; a brace of Cupids, also perched on swans, are riding behind her as pages. They are urging on the birds with their bows. The plate is believed to be a satire upon the person and proclivities of Mrs. Jones, a Swansea lady, who was one of the famous whips of her day.

1810.

In 1810 the labours of the caricaturist were reaching their untimely and sad conclusion; only one political caricature was issued in this year—it forms the last of the series. No indication of the unfortunate artist's approaching malady can be traced in this elaborate work, which represents his final effort in political travesty. We have already described Lord Grenville's candidature for the Chancellorship of Oxford; his "Installation" at the conclusion of the election was commemorated by the artist in one of his most elaborate plates.

August 3rd, 1810. *The Great Balloon.—"* Tentanda via est qua me quoque possim' tollere humo.—*Virgilii Georg.*

> " ' He steers his flight
> Aloft, incumbent on the dusky air
> That felt unusual weight.'—*Paradise Lost,* lib. i. line 225."

In this animated production the city of Oxford is exhibited in grand gala, the various colleges and chapels are indicated in the distance, and the Romish ensign is mounted on a spire which has been rent asunder. Amidst a scene of general acclamation Lord Grenville is ascending in the car of a gigantic balloon, which is modelled after the person of Lord Temple, who is distributing his "promises." The newly elected Chancellor is dressed in his official robes, with the addition of a huge cross; on his head is the triple-crowned papal tiara; in his upward progress he is showering down various suggestive concessions to his adherents. Three bishops, mounted on asses, are straining their hands to catch the "Liber Regis," a cardinal's hat, and various emblems of Romanism. The Oxford theatre is the scene of the ascent. At an upper window is the Marquis of Buckingham; the Marquis of Stafford is peeping

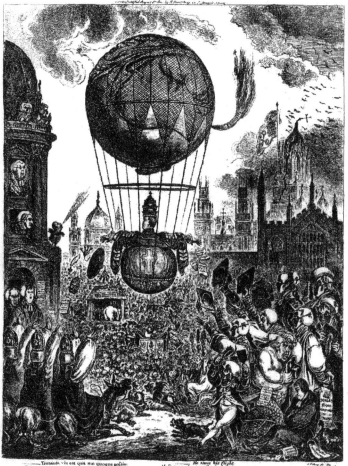

Published August 1 1784 by H. Humphrey N° 51 Strand 1784

He times his flight.

——— Tentanda via est quà me quoque possim
Tollere humo ——— Virgil Geor.

Aloft, incumbent on the dusky air
That felt unusual weight.

J. Gillray fec. 1784

out below him. M. A. Taylor, still represented as "a 'chick," is assisting the flight with his small breath. On the porch of the theatre is posted an order, " That no Doctor of Laws shall be admitted without a bag-wig;" the Hon. Thomas Grenville and Lord Nugent, standing in the doorway, have conformed to this regulation. A motley group of political supporters are ranged on the right hand of the picture; they are all attired in the red gowns of Doctors of Laws; their Doctor's wigs, with bags behind, are arranged according to their fancies, and crape masks disguise their features. Lord Henry Petty is still gaily figuring away at his dancing, with a sweep's brush and shovel. Lord Erskine, Lord Holland, and the Duke of Bedford (without a mask), are waving their college caps; behind them stand Lords Grey and Cholmondeley. Sidmouth, with his "Doctor's" clyster-pipe peeping out, is concealing his face in his hat. Sheridan appears in a very discomfited condition : he wears ruffles but no shirt, his harlequin-breeches need repair, and his hand is raised seeking vainly for his wig; his Doctor of Laws new red gown and bag-wig are lost, "supposed to be stolen," according to an advertisement which is stuck in his harlequin's belt; a joke having been circulated to the effect that Sherry would have been complimented with the degree of Doctor of Laws, but the money was not forthcoming to purchase the gown. A milestone, standing in the corner, is supposed to have originally marked the distance from Oxford to Rome; the figures have been obliterated, as a hint that the journey has been shortened since the election of the consistent advocate of the Catholic claims. A figure, wearing a gown, is propped in drunken indifference against the milestone, a pot of "Whitbread's Entire" is by his side; papers inscribed "Oratio Croweina," thrown down near him, indicate that the Rev. W. Crowe, the public orator, is the person intended. In the distance is a tandem, drawn by goats, which is dashing merrily across the place, Sir Watkin W. Wynne and his brothers, the three W's, are seated inside. The Archbishop of York, who voted for Lord Grenville, is bowing from a state-carriage; Broad Bottomites, as coachmen and footmen, are in attendance on the bishop's chariot. At a booth in the rear is exhibited the "Wonder of the World, the biggest *Flying Elephant* in the whole Fair." This astoundingly huge animal, with small Cupid-like wings, bears the face of Lord Grenville. The whole spectacle is remarkably diversified and full of action.

"What a treat," wrote an earlier commentator on this scene, "would be afforded to some coterie of antiquaries some two centuries hence, should one of the learned fraternity pounce by chance upon this print, describing, as it does, with such originality of thought, and with such infinite humour, thus clothed in allegory, an historical fact—the memorable installation of Lord Grenville in the high and important office of Chancellor of the ancient University of Oxford."

The dismissal of this cartoon abruptly closes the political history of Gillray's days as traced in his plates; his pencil was rendered powerless, and the personages whose careers he had illustrated to this point with so much originality, must now be suffered to pass from our descriptions as suddenly as the extinction of the satirist's faculty drove their figures from his own teeming brain.

The principal social sketches issued by Gillray within a few months of his seizure by the malady which attacked his faculties may be briefly recapitulated. *Les Invisibles* and *Le Bon Genre* (1810), a pair of plates published both in London and Paris, are generally ascribed to our artist. They represent the extravagant male and female fashions prevailing in the two capitals at this period during the revival of the semi-classical costumes, generally described as the fashions of "the Empire."

The two figures we have here engraved, representing the mode in 1810, may be compared with those of 1803, given on a former page. The principal difference consists in the change of the wide cravat for a very large shirt-collar, in the gentleman; and, in the lady, the excess of covering to her person. Between cap, bonnet, collar, and frill, even their faces are

Invisibles.

nearly concealed; and it is for this reason that they are termed in the original print 'Invisibles.'

The second print indicates the evening costume of the same epoch. Two extravagantly attired

couples are indulging in the "giddy waltz," then a dance recently imported, which excited the strictures of the graver section of the community.

Another series, from fashionable life, discloses *The Progress of the Toilette* (February 26th, 1810), in three plates. The titles of the respective prints sufficiently describe the subjects—"The Stays," "The Wig," and "Dress Completed." The designs are by an amateur; to whose pencil another subject may be ascribed, which was published about the same date, under the title of *Grace, Fashion, and Manners, from the Life*, introducing three young leaders of the mode, who are walking in "the Mall." The figures, which are somewhat meretriciously clothed, are described as portraits.

A Petty Professor of Modern History brought to Light (March 20th, 1810), represents the well-known Professor Smyth of Cambridge, lecturing to an audience of slumbering collegians.

A Squall, and *A Calm*—a pair of sea-side scenes, represent the visitors at a watering-place under the conditions described by the titles. These prints are probably due to the design of an amateur, Gillray having only been responsible for their execution on the copper plates.

A Little Music, or the Delights of Harmony (May 20th, 1810), introduces a party of select melodists. Two ladies and two gentlemen are singing with great energy; one of the fair is "torturing" the piano ; a military officer is playing the flute; a boy with a penny trumpet, a howling dog, and a squalling cat are farther contributing to the discord, which, however, fails to disturb the slumbers of a stout old gentleman, who is stretched, snoring, in front of the fire.

The Graces in a High Wind—A Scene from Nature in Kensington Gardens (May 26th, 1810), exhibits three handsome maidens (portraits) contending against a high wind, which is threatening to deprive them of even the slight and transparent clothing in which beauty was then wont to display its graces abroad. The faces, figures, and attitudes of the promenaders are treated with great skill and taste. Judging from the simplicity of the fair ones' attire, this sketch may be fairly classed as a study from nature.

Two portraits mark the last year of Gillray's working life—*Billy the Game Keeper*—the likeness of Bates, a favourite old servant of George the Third; and *Matins at Downing College, Cambridge* (March 23rd), which represents the master of Downing (Sir Beusie Harwood) and his lady enjoying their pipes in bed, in the most eccentric fashion.

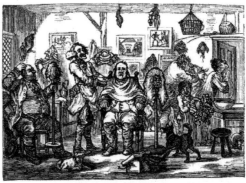

A Barber's Shop in Assize Time.

A Barber's Shop in Assize Time, from a design by W. H. Bunbury (commenced 1810), published May 15th, 1818—the last plate etched by Gillray—has been alluded to in the "Life," which precedes

this work. It is a painful reflection that this animated picture, which we have engraved in reduced outline, was executed at long and uncertain intervals by the artist, after he had become literally dead to the world. Every head in this composition is remarkable for striking character, and the details abound with minute and ingenious humour.

No one unacquainted with the affecting circumstances under which this print was produced, while dwelling on the individual drolleries of the varied actors who figure in the oft-quoted plate of *A Barber's Shop in Assize Time*, would suspect that the hand and brain of the skilful etcher were only subject to the reason of their possessor at fitful and distant intervals.

The story of the artist's times, as told in the comprehensive series of Caricatures which represent his life, may be likened, with due allowance for the development and maturity of his art, to the pictured records, handing down the daily occupations of the races of antiquity. Like sculptured monuments which have survived the influence of decay, they are palpable and expressive; and if they may be judged to bear out the resemblance in regard to their somewhat discursive and fragmental conditions in parts, the student will find a ready reference supplied by Gillray's satires to sustain the continuity of the subject that may interest, while successive graven tablets contribute the necessary points of evidence which render the social and political existences of our ancestors as tangible as our own.

We have now brought our summary of Gillray's works, with the consciousness of many short-comings, to the point at which we must relinquish the subject to the consideration of others. Our great Caricaturist amazed and delighted his contemporaries; it remains to his successors to endorse their verdict, or to reject the enlightenment his materials afford. If, in a practical utilitarian age, *dilettanti* preparations are not suited to every one's palate, it must at least be admitted that the fare we offer is diversified; while the intellectual feast which Gillray has bequeathed to posterity is unequivocally light and easy of digestion. We heartily trust it may prove acceptable to the tastes of our readers.

APPENDIX.

Works, not belonging to the province of Caricature or Satire, executed by
James Gillray as an Engraver.

The Return.—A small medallion, executed in the soft dotted manner. The general effect is in imitation of a drawing expressing great tenderness ; the subject resembles rustic sketches of the Gainsborough School. Dated 1781.

Portrait of a Child (Master Lamb).—The face and figure are pretty and graceful, recalling the style of Sir Joshua Reynolds's studies of children. The whole picture is executed with great taste and lightness, and bears an excellent resemblance to a pencil drawing designed with a free hand. Underneath is engraved : "Sketched by Humphrey, and spoilt by Gillray. Dedicated to all lovers of your bold masterly touches, and published Nov. 1781, by J. Gillray, to show the bad effect of cobbling and altering.

"Fool that I was, thus to cobble my shoe."

In another impression of this plate the engraver has scratched a tangle of fine wiry lines across the work, giving the effect of a drawing that was unsatisfactory to the artist, who had, in a fit of impatience, destroyed his work by scribbling across it with his pen.

Portrait of Dr. Arne, in Profile, seated at his Instrument.—"Done from an original sketch by Bartolozzi," 1782. It is from the well-known portrait of Dr. Arne, which reproduces his peculiarities with a fidelity bordering on the grotesque. The subject is well adapted to the talent of Gillray, who has done full justice to the superabundance of character in the likeness. It is cleverly executed, and realizes the effect of a skilfully touched crayon-drawing.

A Frontispiece representing a Mother and Three Children.—Executed with great delicacy and feeling, somewhat in the manner of the best French vignettes of that period ; altogether a charming little work.

Two Female Figures leaning over an Infant.—Oval. The faces and figures of the girls are very beautiful, and the effect of the drawing is most pleasing. It is executed somewhat in the French manner, and is engraved to give an unstudied sketch-like effect. Not dated.

The Village Train.—"How often have I blest the coming day."
The Deserted Village.—"Good heaven ! what sorrows gloom'd that parting day."

Two Ovals in illustration of Goldsmith, resembling the average "landscape and figure" subjects of the period, such as those preserved by Westall. The groups are slightly formal, and the drawing, as compared with Gillray's better-known productions, is constrained. The expression of the faces is, however, unusually good for the description of work, and a refined feeling pervades the whole. The engraving is neat, clear, and worthy of the artist. Dated June, 1784.

The Wreck of the Nancy Packet.—This vessel was lost on her voyage from India. Portions of the wreck are indicated, but the interest of the picture centres in the long-boat, which a wave is just engulfing. Among the survivors of the wreck who had been reserved for this fate were Mrs. Cargill, the actress, and her infant. The captain (Haldane), who had escaped from the *Fairford*, which was destroyed by fire in Bombay Harbour, finished his career in the *Nancy* packet, among the rocks of Scilly. The terror and despair depicted on the faces of these unfortunates are finely expressed. Prints of disasters at sea were in great demand at the date when this work appeared ; it, however, possesses merits above the average. "Drawn and engraved by James Gillray, 1784."

Duke of Athol, East Indiaman, blowing up in Madras Roads, 1783.—The spirits on board the vessel caught fire, and the gallant men who attempted to rescue the crew were destroyed by the explosion of the ship. The whole scene is very impressively treated. "Gillray design. et fecit. 1785."

Colonel Gardiner's last Interview with his Wife and Daughter before the Battle of Preston Pans, 1745.—An oval, generally printed in vermilion. All the subjects treated by Gillray belonging to the heroic order are in excellent taste, and exhibit a greater command of feeling than the average of contemporary works of a similar nature. 1786.

Loss of the Halsewell.—A shipwreck painted by Northcote, and engraved by Gillray. The picture is very effectively engraved ; the main work being in darkness (the casualty occurred at night), and the light centred on a group of figures arranged on a spar. The attitudes and expressions are conventional. Floating in the foreground are some musical instruments. 1787.

The Happy Mother ; from a drawing by Lavinia, Countess of Spencer. The picture represents a child offering a dove to her mother, who is seated at a tambour-frame. The drawing may be described as pretty ; it has an appearance of affected carelessness, and is evidently executed by an amateur. The expression of the heads is pleasing. The drawing is engraved with great success by Gillray in imitation of the original. 1787.

William Pitt.—An oval. The Premier may have sat for this and the succeeding portrait, with a view to conciliate the "caricaturist" by flattering the artist. The interview between these men of talent would probably have presented very interesting details, had any record of it been preserved. The dispositions of both sitter and painter bore points of marked resemblance. Both were men of deep reserve, both slighted their associates, and treated public opinion with contempt, so far as they were personally concerned; neither was conciliatory; both were bitter in attack and relentless when moved, and both possessed remarkable geniality when circumstances favoured the display of their natural impulses. Considered as a political experiment the portrait may have succeeded; as an actual work of art it must be considered unsatisfactory. The likeness has an air of fidelity, pushed to an extrem bordering on caricature. The mouth is small and peculiar in form, the nose is sharp and pointed, the eyes are eager and partially overshadowed by the pendent flesh of the brow (generally described as "under-cut"), the neck is astonishingly long and appears exaggerated. The head is turned over the shoulder in a position which is neither pleasing nor natural. Painted and engraved by Gillray. 1789.

William Pitt.—The first portrait, unsuccessful as it may appear, was sufficiently encouraging to induce a second attempt. This time the work has more the appearance of historical portraiture, and the traditional curtain, pillar, and background are introduced. The Minister, leaning his hand on the table, points to his scheme for the "Annual Reduction of the National Debt." The general effect is striking, and the resemblance was no doubt remarkable. The attitude is dignified; the hands are drawn with great care; the eyes are clear, penetrating, and inflexible. The characteristics of the earlier engraving are subdued, but the features are too literally marked for agreeable portraiture, in which asperities are, as a rule, treated with a flattering hand, too frequently, it is true, at the sacrifice of fidelity.

Rev. Obadiah Bennett, Minister of Buckingham Chapel, Westminster.—Evidently a good, faithful portrait. The head is benevolent and prepossessing, the arrangement is natural and artistic, and the general effect may be described as reverend. "James Gillray, painter and engraver."

Triumph of Liberty in the Capture of the Bastille.—Dedicated to the French nation. From a painting by J. Northcote, R.A. The picture is conventional; the figures being heavy and commonplace, with unpicturesque outlines; the faces, too, lack expression. The soldiers are grouped on a stone staircase. Cells and cages are broken open, revealing emaciated captives and skeletons. Fetters, racks, wheels, and complicated instruments of torture are introduced, to represent the horrors of the institution which is being overthrown. The effect is extravagant in the accumulation of objects of terror. Engraved by James Gillray, in a bold and striking manner. 1790.

Marquess Cornwallis receiving the Royal Hostages at Seringapatam, by J. Northcote, R.A.—The prevailing faults of this painter are conspicuous in the heavy commonplace disposition of the figures, and the conventional expression of the countenances. Engraved in harmonious and effective style by James Gillray. 1794.

General Count Clairfayt.—Engraved by Gillray from his original drawing, taken at Villers, September, 1793, for "the grand attack on Valenciennes," painted by Loutherbourg. The general effect gives the impression of a good portrait; but the predominance of marked features and unsoftened peculiarities exhibits Gillray's dangerous tendency to preserve characteristics with a literal rendering which verges on the grotesque. 1794.

Prince of Saxe-Coburg.—A companion to the above; drawn and engraved by James Gillray under the same circumstances, and presenting similar characteristics. This face is in profile, and the head is more gently treated than that of General Clairfayt. 1794.

Mendoza.—Portrait of a renowed champion of the prize-ring drawn and engraved by James Gillray. The expression is prepossessing, the character of the face is slightly of the Hebrew type. The figure is light and wiry, and the torso is very broad and fine. The developments of muscle and sinew are kept in harmonious subjection, and the anatomical power is very marked. The picture is drawn from life, and the action is excellently preserved. The faces of the spectators wear agreeable expressions, and are indicated with considerable skill. The outline is executed in bold etching, and the shadows are in mezzotint. It is generally printed in sepia-brown.

Sir Sydney Smith.—From life; drawn and engraved by James Gillray. A very remarkable portrait, calculated to confirm, from the eccentricity of its expression, the anecdotes current concerning its subject. The hair bristles with energy; the eyes are widely opened, and produce the appearance of surprise presented by a person who has been violently awakened from sleep; the nose is drawn down, and the corners of the mouth are pursed up; the face is long in form and dark in complexion. The whole picture is clever and expressive, but the feeling for character is strained beyond the licence of general protraiture. 1799.

Gillray designed and engraved the title-page for a musical work dedicated to Queen Charlotte. The appearance of the name inserted as "inv. et fec." in the corner of this dedication must have awakened strange reminiscences in the mind of the Queen. The constant caricature of her avarice, the accusations of an interested championship of Warren Hastings, the "petticoat" protection hinted in respect to Pitt, and above all that furious embodiment of "Sin, Death, and the Devil," may have all passed before the shrewd intellect of this resolute old Queen. The design is graceful; it presents a lyre and festoons of laurel leaves, whilst the crown, conspicuously disposed, disperses its lustrous rays through the surrounding clouds in the most courtly fashion. A recollection of Gillray's better-known works is irresistibly awakened by three tastefully indicated cherubim, which recall the figures of their burlesqued relatives in many of the artist's boldest caricatures. The book is dedicated: "To the Queen, with her Majesty's most gracious permission, this work is inscribed by her Majesty's most faithful, obedient, and humble servant, Harriett Abram, Park Lane, 1803. James Gillray, inv. et fec."

A work of a satirical character, known as *Hollandia Regenerata,* was also designed by Gillray. It is written in Dutch, and is generally printed in a vermillion-coloured ink. The book consists of twenty designs, all very curious, ridiculing the various administrative bodies—civil, military, judicial, learned, &c.—of the Batavian Republic. The

entire work has a foreign appearance, independent of the circumstance of its being printed abroad, and in the Dutch language. The particulars of the artist's connexion with this series are unknown to us, but the facts would no doubt prove interesting.

Gillray produced on wood a medallion portrait of *William Pitt* leaning against a rustic monument, overshadowed by the branches of an oak, with an anchor and other emblems to assist patriotic allusions. The execution, which is in the Bewick style, is bold, clear, and excellent. He also engraved, or drew for others to execute on wood, a few smaller subjects, among which are, *A Woman crying Fish, A Boy near a Cottage drinking*, and *A Beggar at a Door*.

There exists a single specimen of his acquaintance with the art of lithography, dated 1804. It is excessively rare, and has additional interest from the fact of its affording an early example of the practice of drawing on stone. It has for subject, *A Domestic Musical Party.* The style of character represented is suggestive of Seymour's earlier periods of costume. The mother, whose features are not flattered, is playing on an instrument resembling the modern harmonium. The father, who in his general bearing and buttoned-up coat has some resemblance to one of the more fashionable gentlemen amateurs presented in "Playing in Parts" (May 15th, 1801), is engaged on the flute with great vigour; a girl in the foreground is singing—evidently very shrilly, judging from facial contortions; and a boy, partly in shadow, is also exerting his voice. The execution, which is neat and careful, has a resemblance to the manner of treatment exhibited in woodcuts of the "Bewick" era; solid blacks, in masses, being resorted to in the shadows. Some portions of the manipulation are closely allied to that distinguishing the "William Pitt Medallion;" but in those parts where freedom of handling is essential, the print is treated somewhat in imitation of pen-and-ink drawing. We are thus precise in describing this print, because it entirely differs in execution from modern lithography.

Subjects suggested to Gillray by Amateurs, or of which Rough Sketches are preserved in the Print Room of the British Museum.

Westminster Mendicant, representing a Blind Beggar and his Dog.—Two or three rude lines indicating the position of the group. The verses as published, and the original words inscribed on a scroll.

Gillray's original pencil rendering of the same subject, very boldly and easily touched. The etching very slightly varied. 1784. The published plate is suggestive of Rowlandson, to whom it is commonly attributed.

Fall of Icarus (Lord Temple).—Two rough pencil sketches by an amateur, both feebly indicated. Worked up by Gillray, and published April 27th, 1807.

No Flower that Blows is like the Rose.—Rough sketch, washed with colour, of the danseuse. Worked up and published by Gillray.

Rough sketch of Sir Cecil Wray's Procession, published during the Westminster Election. Similarly ascribed to Rowlandson.

Rough sketch for *Startling the French.*

Fall of the Broad-bottom Dragon.—A mere indication of the coalition-statue, of Fox and North, fallen, and broken on the ground. The tower as an ark. A very crude sketch by an amateur. Generally set down to Rowlandson.

Gillray's original sketch of the above, executed with a pen. Masterly and simple in manner. The etching a literal reproduction. 1784.

Original sketch by Gillray in simple pencil outline for the *Times.* The execution very clear, no hesitation or alteration perceptible. The etching a fac-simile. 1784. This print is commonly assigned to Rowlandson.

Hanoverian Horse and British Lion.—The original rough draft of the combat between the youthful Pitt, who cannot restrain the White Horse of Hanover, and Fox, who is calmly seated on the British Lion. This work is interesting from the fact of its probably representing, with the four preceding subjects, the earlier efforts of Rowlandson in political caricature. It is distinctly in his manner, and the lettering, handwriting, &c., closely correspond with the style of his autograph work on his own later etchings. The story is well made out, and realizes a promising sketch. Gillray's etching has slightly altered the arrangement. 1784.

Madame Blubber, or Aerostatic Dilly.—A rough suggestion for an election squib on the celebrated Westminster contest between Sir C. Wray, who was backed by the Court party, in opposition to Charles James Fox.

Another sketch, suggesting a somewhat similar treatment of the subject, also possibly one of Rowlandson's early efforts, worked up into the subject etched by Gillray in ridicule of Sir Cecil Wray and his "fat and fair" advocate, the rival of Fox's champion, the fascinating Duchess of Devonshire.

Palemon and Lavinia.—Feeble and uncertain in drawing; the expressions good.

"He saw her charming; but he saw not half
The charms her downcast modesty concealed."

Etched on an enlarged scale by Gillray, January 23rd, 1805. Signed "I. C."

Lord Longbow, the Alarmist.—Drawn in ink; poor execution; the position of the figures preserved by Gillray.

Gillray improved the portrait of the alarmist (Lord Moira), put the entire picture into new drawing, and published the etching as *Lord Longbow, the Alarmist, Discovering the Miseries of Ireland.* 1798.

A Standing Dish at Boodle's (Sir Frank Standish), published May 28th, 1800.

Equestrian Elegance (Duke of Hamilton), May 7th, 1803.

Townsend, the Famous Bow Street Runner.—The portrait of this worthy, by an amateur, is interesting, as the likeness by no means resembles the impression which might be formed of the famous "Runner." The face is fat, simple, and boyish-looking; the wig is light flaxen, and the hat is slouched far over the forehead. The figure appears short and stumpy; he wears a light greatcoat, a red handkerchief, cheque pattern waistcoat, and high boots; he is holding a thick stick behind his back. The portrait doubtless gives a general impression of the man whose name was once so significant to a certain class of the community. It is signed "I. L. R.," and bears the inscription—

> "A character well known
> To every rogue,
> From Town's end to Town's end.
> Do you know him?"

A Military Sketch: a Gilt Stick.—A very fair portrait of General Cathcart, one of George the Third's favourite officers. Published in an improved state by Gillray, June 11th, 1800.

Vide Castle, Richmond.—A very droll figure of the celebrated Master of the Ceremonies alluded to in the reference to Gillray's visit to Richmond. Very faintly pencilled and coloured by an amateur.

A Lyoness.—A large sketch in ink, washed in colour, by an amateur, of Mrs. Lyon, wife of a noted loan contractor, the Rothschild of his day. Very indifferent execution. Put into good drawing and etched by Gillray; published 13th July, 1801.

Only look at the General, Madam!—By the same hand. Also etched, without much alteration, and published by Gillray.

Diana.—Portrait of the Marchioness of Salisbury, famous for her devotion to field sports. The attitude is nearly identical with the etching Gillray composed from this portrait, which is possibly by the same hand as the two preceding subjects. Very strongly coloured. Published by Gillray as *Diana Returned from the Chase*, March 16th, 1802.

Artist Volunteers.—A clever skit, produced at the time when England was threatened with French invasion, and trainbands occupied a considerable share of popular attention. Sir Joshua Reynolds, as General, is seated on Pegasus. His helmet bears "P.R.A." A large palette and a sheaf of brushes represent his arms. The standards have insignia of painting and sculpture emblazoned on them. Nollekens wears a square on his hat. Likenesses of Westall and of other members of the Academy of that day are traceable among the volunteers, who wear "R.A." on their helmets.

Gillray published several volunteer caricatures, but he does not appear to have made any use of this particular suggestion—possibly offered by one of the artists of the day.

Portrait of a Commander.—Very spirited; in pen and ink, probably by Gillray; intended to throw ridicule on the monstrous cocked-hats under which the youth services were half buried at that date.

Suggestions for Volunteer Medical Uniforms.—A double hit at the trainbands and the agitation for flannel uniforms, which was the subject of much sarcasm at that period. In the distance is a line of soldiers, bearing umbrellas. Two Guards are exhibited sustaining a blanket over a flannel-clad file of volunteers.

Gillray's published sketches on the flannel question do not contain any figures suggested by this sketch.

Interior of a Leather-breeches Maker's Shop.—Forcing a stout customer into a pair of culottes that are evidently tight. The expressions are admirable and the scene is humorous, but exceedingly coarse. Probably the original sketch from which Gillray traced his plate on this subject, published by Nixon, 1784. The etching falls slightly short of the expression of the drawing.

Sir Cecil's Budget for Paying the National Debt.—An original sketch well worked out, possibly from the pencil of Rowlandson. One of the squibs produced on the Westminster election. Closely followed by Gillray in his etching, published 1784.

An original drawing, probably by Gillray, which does not appear to have been engraved, representing another squib provoked by the Westminster election, treated as a donkey race. Fox, on his animal, gallops along merrily; the Duchess of Richmond, on horseback, is entertained by the failure of Sir Cecil Wray, trying to urge on an obstinate donkey, who kicks out energetically, with his fore-legs firmly fixed, and refuses to advance; while a man behind is endeavouring to accelerate his speed with a liberal supply of kicks. A milestone in one corner is inscribed "To Westminster."

Suggestions for a Monument to Broadbottom, in rough pencil and writing; a skit upon Earl Granville.

Some capital heads, probably portraits of contemporaries, evidently sketched with a view to future use, by Gillray. Unpublished.

A Barrow Knight, referring to some forgotten contemporary incident, which is further alluded to by the inscription on a portal of "Garlick Hall."

Optical Mirrors.—A pair of funny sketches by an amateur. One of the mirrors reflects the face of an observer in monstrous breadth, while the other gives a reflection in doleful length.

Two figures representing extremes of fashion (1799). One of them is introduced, with the simple alteration of improved drawing, into Gillray's etching entitled *Monstrosities of 1799*; published June 25th of the same year.

The Pope of Rome on Broadbottom his Beast, opposed by the British Knight Defender of the Faith.—A rough suggestion, very crude in execution, for a satire on the Bill for Catholic Emancipation introduced by Earl Granville.

The Reform of Parliament, or Whitbread's Entire.—Founded on a resolution of the Whig Club. The root-and-

branch reformers are dragging down the Houses of Parliament, and a bonfire is made of the Habeas Corpus, Bill of Rights, Magna Charta, &c. This sketch probably suggested the fine cartoon published by Gillray under a similar title on June 13th, 1809.

Situation of Affairs in France, or the Allied Sovereigns in 1814.—A rough sketch, possibly drawn by an amateur, or it may be the work of Gillray in one of his intervals of sanity. The execution resembles the pencilling of a child. As the design is made on the back of a proof in red of one of Gillray's anti-republican series of *The Horrors of Invasion*, the suggestion of its being one of his semi-lucid attempts is not improbable. The sovereigns are seated round a huge soup caldron, labelled "European hodgepodge, for to last all through the winter." In the mixture float crowns, swords, and similar objects ; and the whole is heated by pipes connected with "the imperial stove." A figure, which may be intended for the Emperor of Russia, directs the people who are in attendance to "bring some more ingredients to enrich the soup directly." Men approach bending under huge sacks labelled 500,000 francs, &c. A rude representation of Louis XVIII. is seated as a spectator on a rickety throne, his sceptre surmounted by a ladle, ready to satisfy his appetite when the other sovereigns shall retire. On his head is one-half of the French crown. "I must try to get rid of some of my helpers," he observes, "or I shall never be able to taste the soup—I see too many cooks will spoil the broth !"

A series of sketches illustrating *Eloquence*, by an amateur, consisting of Military, Fools, Billingsgate, Opposition, and Ministerial Eloquence, drawn in pen and ink, with little humorous feeling, but similar in attitudes to the etching published by Gillray on the subject.

In Gillray's plate the drawing is improved, the portraits are made to resemble the persons for whom they are intended, and fresh likenesses are added or substituted.

NOTE.—The grateful acknowledgments of the writer are due to Mr. Reid and the officials of the Print Room, and to Mr. Bullen and the officials of the Reading and Great Rooms of the British Museum, for their uniform courtesy and attention during the preparation of this work.

Ingram Content Group UK Ltd.
Milton Keynes UK
UKHW022004170723
425314UK00005B/104